AMERICAN ARTISTS

an illustrated survey of leading contemporary americans

AMERICAN ARTISTS

an illustrated survey of leading contemporary americans

les krantz
Editor & Publisher

Facts On File Publications
New York, New York ● Oxford, England

To Billy, for what we share
with Albert, John and some
other special people who
knew what to do with it.

Manuscript Editor: KENT DEVEREAUX;
Associate Editors: JANIS HUNT-HANEY, JAMIE YOUNG; Contributing Editor: KAREN KODNER;
Research Director: MARJORIE GLASS; Photo Manager: DOYLE CHAPPELL

AMERICAN ARTISTS

AN ILLUSTRATED SURVEY OF LEADING CONTEMPORARY AMERICANS

CORRESPONDENCE regarding editorial material should be
addressed to: The Krantz Company Publishers, Inc., 2210
N. Burling, Chicago IL 60614

Library of Congress Cataloging in Publication Data

Main entry under title:

American artists.

 1. Artists—United States—Biography. 2. Art, Modern
—20th century—United States. I. Krantz, Les.
II. Facts on File, Inc.
N6512.A578 1985 709'.2'2 [B] 84-18747
ISBN 0-8160-0091-3 (cloth)
ISBN 0-8160-0092-1 (paper)

Printed in the United States of America
10 9 8 7 6 5 4 3 2 1

Contents

*Color reprints of illustrations provided by Publisher are often available upon request from the artist's studio or dealer

Acknowledgments

In addition to the authors and editors listed in the bibliography, there are countless researchers and writers of the art media whose information was indispensable. We therefore thank the staff of *Art Forum, Art News, Art in America, Southwest Art, Art Space* and many other art periodicals large and small.

A number of critics, who did not necessarily directly contribute input, provided useful coverage for our research. They include John Russell, Grace Glueck, Hilton Kramer, Alan Artner, Henry Hanson, Tom Albright, Doug Davis, Robert Hughes, Jo Ann Lewis, William Wilson, Suzanne Muchnic, Bill Marvel, and many many more; so numerous, their names could fill another book. We beg their forgiveness for lack of space to salute them all.

Others who contributed information, photography, interviews, and encouragement include: Tony Altermann, Thom Andriola, Joan Ankrum, Al Anthony, Franz Bader, Elane Baum, Hank Baum, Pam Berns, Mary Boone, Hal Bromm, Bill Burford, Electra Carlin, Leo Castelli, Paula Cooper, Jim Corcoran, Marisa Del Re, Andre Emmerich, Allan Frumkin, Wouter Germans Van Eck, Bob Gino, Helen Goldenberg, Ernst Haas, Ron Hall, Jackson and Carolyn Hensley, Paul Hertz, Nancy Hoffman, Joy Horwich, Elane Horwitch, Mike Hunt-Haney, Jane Ivory, Art Kane, Ed Knappman, Ivan Karp, Pierre Levai, Marilyn Levine, Jo Ann Lewis, Donald McKinney, Lou Meisel, Haim Mendelson, Betty Moody, Jack Morris, Louis Newman, Philip Orlando, Arlene Rakoncay, Janelle Reiring, Don Ross, Phil Saltz, William Sawyer, Bob Schoelkopf, Saul Segan, Dick Solomon, Bill Struve, Henry Tabor, Don, Kevin & Cheryl Vogel, Berta Walker, Bill & Addie White, and Andre Zarre.

For the loving care put into the colorplates, we are indebted to Jan Pesut and Al Stevens at New Horizons and Lionel Micinski, Jerry Thomas and Jim Steele at Lithotone. Thanks are in order to Ralph Gutekunst and Deirdre Rittenhouse at AOS Publishing Services who provided the typography, Rusty Pallas at Pallas Photo Labs, and Jean Myers and her entire staff at Maple Vail.

We are indebted to many photographers, and to our mail courier Preston West who tirelessly lugged in the 22,000 pieces of correspondence involved with the book.

Foreword

As the editor of numerous, periodically published art volumes, I am aware that there are certainly more than one thousand outstanding artists in America. It is therefore important for the reader to know what the one thousand artists in this book represent and how the inclusions were chosen.

The artists cited in the text generally represent those American artists whose works are most frequently exhibited, though one should consider the impossibility of making such a determination. In a real sense, "the most exhibited artists" was a goal and not a reality, though great care was taken researching art media and books of the last 10 years (see bibliography and acknowledgments). My staff of editors and I have also taken into account the many thousands of exhibitions we have attended over the years.

The biographical information found in this volume reflects what we deemed to be each artist's highlights and is not intended to be complete. Most of the artists have had numerous additional exhibitions and honors, too extensive to enumerate here.

Our additional research involved corresponding with over 2,000 art museums and galleries and 7,000 artists, most of whom have exhibited at one or more of those 2,000 institutions. We went through their exhibition lists, awards, etc., and, in a judgmental fashion, we picked the best, providing they met our criteria for inclusion—to have achieved a minimum of the following: 1. Two gallery exhibitions 2. Works represented in at least two museum or public collections 3. U.S. citizenship or permanent residency.

We made dozens of lists in editorial meetings to identify the leaders in all movements in American art. Like any reference covering an on-going, contemporary phenomenon, particularly one as giant in scale as American art, one could add to or subtract from our list, a circumstance which is due mainly to the subjective nature of art.

In an effort to make the art reproductions more meaningful, we have tried to position them in a way which allows the reader to compare the different fashions in which artists handle similar art styles or subjects. The constraints of page layout and the need to keep them more or less in alphabetical order make this less than perfect, but we believe it is useful and provides a more interesting presentation.

Les Krantz
Editor & Publisher

ABBETT, ROBERT KENNEDY (Painter)
Oakdale Farm, Bridgewater CT 06752

Born: 1926 *Awards:* Wildlife Artist of the Year *Collections:* Parker Collection; Cowboy Hall of Fame *Exhibitions:* Easton Waterfowl Festival *Dealer:* Martin Wood, Dallas; Dan May, Scottsdale, AZ

After a successful twenty-year career as a New York City illustrator, he began to paint outdoor scenes, showing his work in galleries for the first time. Best known for portrayals of sporting dogs, he also depicts horses and many kinds of wildlife. The subjects of his portraits have included such well known people as the actor James Stewart. Recently he has completed several series for the American Quarter Horse Association. He has also been selected as the 1985 Artist of the Year for the Cheyenne (WY) Rodeo.

ABELES, KIM VICTORIA (Sculptor)
240 S. Broadway 4th Floor, Los Angeles, CA 90012

Born: 1952 *Awards:* Fellowship, Handhollow Foundation *Collections:* Washington & Jefferson College; Fashion Institute of Design & Merchandising *Exhibitions:* Phyllis Kind Gallery, Chicago; Karl Bornstein Gallery, Santa Monica, CA *Education:* University of California at Irvine; Ohio University *Dealer:* Karl Bornstein Gallery, Santa Monica, CA; Phyllis Kind Gallery, Chicago

Employing acrylic, enamel, wood, photography, metal, x-rays, and found objects, her work is a combination of painting, mixed media sculpture, photography and narrative. Previous sculpture consisted of kimonos which were suspended from the ceiling as personas housing visual narratives on the "human condition." Her current work, life-size surrounding structures, allow the perceiver to become an integral part of the piece. "Much of my sculpture is developed through reading, both fiction and non-fiction." Rituals which are self creating or inherited through culture play an important part in her work. In addition, the relationship of the individual to the social mechanism is incorporated in the processes of the media she selects, as well as the issues that she addresses.

ABRAMS, RUTH DAVIDSON (Painter, Sculptor)
18 W. 10th St., New York, NY 10011

Born: NYC *Collections:* Corcoran Gallery of Art; Cornell University Museum *Exhibitions:* Museum of Fine Arts, Caracas, Venezuela; New York University Contemporary Arts Gallery *Education:* Columbia University; Art Students League, NYC

Her earliest solo show included both sculpture and painting but work in following years was exclusively in oils. At first a member of the New York School of Abstract Expressionism, she soon departed from nonobjective painting to work in vastly large scale canvases depicting elegantly brushed still-lifes. Her paintings of still-life scenes, and later images of single women, displayed varying degrees of abstraction. Her imagery conveyed "the fearful but important aspects of inner life" in both waking and dreaming states. More recent work continues to explore the possibilities of large scale figurative painting.

ACCONCI, VITO (Sculptor, Performance Artist)
c/o Sonnabend Gallery, 420 W. Broadway, New York, NY 10013

Born: 1940 *Awards:* National Endowment for the Arts *Collections:* The Museum of Modern Art; Los Angeles County Museum of Art *Exhibitions:* Sonnabend Gallery, NYC; Museum of Modern Art *Education:* Holy Cross College; University of Iowa *Dealer:* Sonnabend Gallery, NYC

Originally a poet, he has divided his time between producing mixed media sculpture, installations, and performance pieces since 1969. In 1970 he began to use use his own body as ground for making art, initially producing performances and video tapes that capitalized on his own, often times confrontational, presence. Soon thereafter he began to examine the traditional contexts for performance and video, and undertook performances in public places dealing with socially "taboo" issues. By 1974 he had removed himself entirely from his installations and transmitted his human presence or "power sphere" entirely through audio and video tapes. While language still remains a very important part of his video pieces and performances, he has concentrated more recently on large scale mixed media installations that utilize both formal and real tensions to communicate their social and political context.

ADAMS, BOBBI (Painter)
215 S. Heyward St., Bishopville, SC 29010

Born: 1939 *Awards:* South Carolina Artist in Residence; Certificate of Distinction, Columbia Museum of Art *Collections:* South Carolina State Art Collection; National Bank of South Carolina *Exhibitions:* Chautauqua National; Butler Institute of American Art *Education:* Art Students League; National Academy of Design

Impressionist paintings in oil and drawings in pastel were the mainstay of her past work. She was heavily influenced by the "plein-air" painters and the subtle use of color and light by the impressionists Degas and Monet. More recent work in monotypes on glass is heavily experimental and delves more deeply into structure and design. The work is more abstract and emotional in feeling than earlier paintings, and the color often more seductive and personal. She also cites the loose free flowing expressionist work done by the young children she teaches as a major influence on her own work. Other influences include Leo Manso and Michael Mazur.

ADICKES, DAVID PRYOR (Painter, Sculptor)
2409 Kingston St., Houston, TX 77019

Born: 1927 *Awards:* Purchase Prize, Museum of Fine Arts, Houston; Purchase Prize, Houston Artists, Contemporary Arts Association *Collections:* Museum of Fine Arts, Houston; James A. Michener Foundation Museum *Exhibitions:* Museum of Fine Arts, Houston; Laguna Gloria Art Museum *Education:* Atelier F. Leger; Kansas City Art Institute *Dealer:* Horizon Galleries, Houston

While living in France, his early oil painting was strongly European in character. The elongated, semiabstract figures, impasto landscapes and still lifes of this work display the influence of Picasso, Braque, Modigliani, and Chagall. His present landscapes and figurative oils are abstracted. The human form assumes such unique, personal proportions and distortions as to appear as an "invented species." Concurrent with painting, he is working in bronze producing busts, small figures, and horses. In his outdoor, public sculpture he is concerned with the head and the figure on a monumental scale.

AFRICANO, NICOLAS (Painter)
c/o Dart Gallery, 212 W. Superior, No. 203, Chicago IL 60610

David Adickes, *Jazz,* 27 x 22 x 10, concrete and steel. Courtesy: Beaux Arts International (Houston TX)

Robert Abbett, *Third Season,* 20 x 30, oil. Courtesy: Wild Wings Gallery (Minneapolis MN)

Born: 1948 *Exhibitions:* Walker Art Center; Institute of Contemporary Art, Boston *Education:* Illinois St. University *Dealer:* Holly Solomon Gallery, NYC; Asher/Faure, Los Angeles

A former poet, his interest in narrative art has always played a predominant role in his oil and acrylic canvases. Small figures playing whimsical, theatrical roles are often the center of his large canvases with additional work being created for gallery walls as well as on canvas. These "New Imagist" works are about human experience, so subject matter is a primary concern. The physical and painterly concerns are minimized, "with the singular purpose of burdening the work with clear intent."

ALBERGA, ALTA W. (Painter, Printmaker)
11 Overton Dr., Greenville, SC 29609

Born: 1923 *Awards:* Weil Award; St. Louis Art Museum *Collections:* The Harvard McCalls *Exhibitions:* Greenville (SC) County Museum of Art; Prescott (AZ) College *Education:* Washington University; University of Illinois *Dealer:* Second Street Gallery, Philadelphia, PA; Art Unlimited, Greenville, SC

She works in paintings, etchings, portraits, and small sculpture. In all her works she draws on her travel experiences in Europe, Asia, South America, Indonesia, and the Yukon Territory. Her approach to etching is inventive, and she always is exploring what the press can accomplish in embossed lines, color combinations, and the effects of different papers and pressures. At present she is working on a series of sea pieces in oil on paper. These portray people at the beach wrapped in fog, spray, and space, suggesting human kinship with natural elements.

ALBUQUERQUE, LITA (Painter, Sculptor)
1670 Sawtelle Blvd., Los Angeles CA 90025

Born: 1946 *Collections:* Los Angeles County Museum of Art; Newport Harbor Art Museum *Exhibitions:* Museum of Modern Art; San Francisco Museum of Modern Art *Education:* University of California, Los Angeles; Otis Art Institute *Dealer:* Janus Gallery, Los Angeles

Influenced by the Light and Space movement begun in California, she uses color, light and shadow to create a sense of mystery in color photographs, paintings and sculptures, employing natural elements such as metals, sand and stones. *The horizon is the place that maintains the memory,* for example, is a large copper circle mounted on a base made of pigment and stone; the circle casts refracted shadows on the wall, creating an enigmatic iconic structure.

ALCORN, JOHN (Illustrator, Designer)
Hamburg Cove, Box 179, Lyme, CT 06371

Born: 1935 *Awards:* Award, New York Times Ten Best Children's Books; Augustus Saint-Gaudens Medal, Cooper Union *Exhibitions:* Hopkins Center Gallery, Dartmouth College; Peter Cooper Gallery, NYC *Education:* Cooper Union

Working in pen and ink drawings and prints, he has executed designs and illustrations in a wide range of styles. He has worked for major publishers and design firms both in the United States and Europe producing posters, book jackets, and book plates. The style of the book illustrations correspond to the literary period. Fine lines and skillful cross-hatching characterize much of his work, reminiscent of the etched book plates of the 18th and 19th Centuries. In other works strong Art

Nouveaux design principles can be identified in flowing, romantic figure drawings within borders of turn of the Century motifs. A contemporary cartoon style is also used in some whimsical illustrations that make use of visual puns.

ALDEN, RICHARD (Painter)
206 Eng Unit C, University Park, PA 16802

Born: 1942 *Awards:* First Prize, Three Rivers Art Festival, Pittsburgh; Springfield (MA) Art League Award *Collections:* Milford (CT) Fine Arts Council; Trenton State College Art Dept. *Exhibitions:* Lillian Heidenberg Gallery, NYC; Capricorn Galleries, Bethesda, MD *Education:* Pratt Institute *Dealer:* Capricorn Galleries, Bethesda, MD

He is a realist painter, whose style is fundamentally traditional. His medium is colored pencils. He is trained as an architect, and his studies in draftsmanship are the basis of the precision in his drawings. The past works were influenced by Edward Hopper and Andrew Wyeth, though the more current work tends toward the abstract. He views colored pencils as a medium whose potential lies somewhere between the painterly style of the old masters and the abstract graphics of modern expressionism. He attempts to achieve the highest possible degree of purely abstract formal order without allowing it to dominate his picture of everyday reality.

ALEXANDER, JOHN E. (Painter)
Dept. of Art, College of Humanities and Fine Arts, 4800 Calhoun, Houston TX 77004

Born: 1945 *Collections:* Contemporary Arts Museum, Houston; Museum of Fine Art, Amarillo (TX) *Exhibitions:* Dallas Museum of Art; Contemporary Arts Museum, Houston *Education:* Lamar University; Southern Methodist University *Dealer:* Janie C. Lee Gallery, Houston; Marlborough Gallery, NYC

Large-scale abstracted landscapes are charged with energy and emotion characterized by colorful, expressive slashes of oil or watercolor on canvas. This expressionistic work seems related to Action Painting, but actually contains the kind of fantastic images associated with Surrealism. Suggestions of violence and pathology are conveyed through natural processes in works such as *Monkey Skeletons Picking Flowers with Fish* and *Devils Dancing Out of the Past.* Birds, creatures and mythical beasts appear within the streaks of color like scenes from marshlands near his native Houston, as in *Untitled (with Pink Flamingos).* "My paintings consist of gestures and emotions made concrete through my approach to nature."

ALEXANDER, PETER (Painter)
P.O. Box 1124, 3233 Tuna Canyon Rd., Topang CA 90290

Born: 1939 *Awards:* Fellowship, National Endowment for the Arts *Collections:* Museum of Modern Art; Los Angeles County Museum of Art *Exhibitions:* Museum of Modern Art; Whitney Museum Annual *Education:* University of California, Los Angeles *Dealer:* Cirrus Gallery, Los Angeles; James Corcoran Gallery, Los Angeles; Hokin/Kaufman Gallery, Chicago

Influenced by the Light and Space movement in California, his primary subject is the play of light over water and clouds. In paintings and drawings he has depicted under-water fantasies, shimmering seascapes, and dark clouds glowing with sunlight or lightning. A series of black velvet paintings was deliberate kitsch, with glitter and garish colors. In a sumptuous yet

John Alexander, *Red Bull Reindeer* (1983), 78 x 84, oil on canvas. Courtesy: Marlborough Gallery (New York NY)

Alta Alberga, *Young Girl*, 24 x 20, pencil drawing. Courtesy: Second Street Gallery (Philadelphia PA)

Robert Amft, *Totem* (Flea Series), 30 x 22, watercolor. Joy Horwich (Chicago IL)

ordered world of fantasy, colors are often exaggerated, and metallic pigments are applied in thick clots and thin ribbons to create shining artificial surfaces. He has also made lithographs.

ALLEN, ROBERTA (Painter)
5 W. 16th St., New York, NY 10011

Born: 1945 *Awards:* Creative Artists Public Service Grant; MacDowell Colony *Collections:* Museum of Modern Art; Cooper-Hewitt Museum *Exhibitions:* John Weber Gallery, NYC; Kunstforum, Munich, Germany

Her work consists of drawings, photo drawings, sculpture, and paintings. She primarily is concerned with the ambiguities that arise when seemingly incongruous images and words are used together. The current paintings on paper use representational imagery with terse verbal statements that continue her exploration of paradox. The results are often humorous, with unexpected correlations.

ALLISON, DAN (Painter)
1100 Studewood, Houston, TX 77008

Born: 1953 *Awards:* Award, Louisiana State University Painting and Drawing Exhibition *Collections:* Atlantic Richfield; Indianapolis Museum *Exhibitions:* Madison Art Center *Education:* Sam Houston State University; University of Houston *Dealer:* Kauffman Galleries, Houston; Elaine Horwitch Gallery, Phoenix; Van Straaten Gallery, Chicago

In his work as a painter and printmaker, he represents objects and images with strong symbolic connotations in a hard-edged abstracted style. Superstition, intellect and humor are present in his work. The influence of Catholicism and Indian beliefs of South Texas and Mexico blend with a personal mysticism in works of strange, primitive spiritualism. The soft, water based inks, of his aquatints are applied in smooth, bold color areas. The images are often floating on an atmospheric, undesignated ground with stark light and crisp shadows. A sense of the surreal is found in the compositional juxtapositions—in one, a string wrapped top spins on its sharp point near a thorny heart bound in ribbons.

ALLMAN, MARGO (Painter)
202 East State Rd., West Grove, PA 19390

Born: 1933 *Awards:* Mildred Boericke Prize, Philadelphia Print Club; Wilmington Trust Bank Prize, Delaware Art Museum *Collections:* Delaware Art Museum; Philadelphia Museum of Art *Exhibitions:* Delaware Art Museum; University of Delaware *Education:* Hans Hoffman School of Art; Moore College of Art

First working as a printmaker, she made abstract expressionist woodcuts during the 1950s and 60s. Her work in sculpture during the 1960s and 70s reflected her strong emphasis on form and an organic biomorphic approach to life's processes. Her influences of this time included Moore, Arp, and Hepworth. Since 1979 her paintings in acrylic on a variety of themes such as heads, figures, couples, children, birth, and slaughterhouses, have been painted solely in black and white in an organic, semi-abstract style. It is a powerful work, expressing totemic images and apocalyptic visions. The most recent pieces are painted on "Tyvek', a "spunbonded" polyethylene paper-like product. Because of its near indestructibility she finds it ideal for her forceful, gouging, watery technique.

ALMY, MAX (Video Artist)
5855 Chabot Rd., Oakland, CA 94618

Born: 1948 *Awards:* Fellowship, National Endowment for the Arts; US Film and Video Festival Award *Collections:* Museum of Modern Art; Stedilijk Museum *Exhibitions:* Museum of Contemporary Art; "California Video', Long Beach Museum of Art *Education:* University of Nebraska; California College of Art and Crafts *Dealer:* Electronic Arts Intermix, NYC

As an artist, she has worked with video as an installation, performance and broadcast medium. On each occasion she has explored new possibilities for the formal presentation of narrative content that is emotionally and psychologically compelling. Work is characterized by a highly polished appearance matching the post-production standards of commercial television, and very often incorporating digital effects. Her recent video tapes, *Modern Times, Leaving the 20th Century,* and most recently *The Perfect Leader,* have become increasingly more concerned with social commentary and political statement, while maintaining a slick, fast paced format that is both humorous and non-didactic.

AMFT, ROBERT (Painter)
7340 N. Ridge, Chicago, IL 60645

Born: 1916 *Awards:* First Prize, New Horizons; Renaissance Prize, Chicago Artists & Vicinity Show *Collections:* H.F.C. Company; Butler Institute of American Art *Exhibitions:* Hammer and Hammer Galleries, Chicago; Joy Horwich Gallery, Chicago *Education:* School of the Art Institute of Chicago *Dealer:* Joy Horwich Gallery, Chicago

His larger-than-life paintings are direct quotations from works by Da Vinci, Van Gogh, Seurat, and others. His "Head" of Mona Lisa smoking a cigarette received the Renaissance Prize in a recent Chicago and Vicinity Show.Currently he is working on a series titled "Crossings." In sharp contrast to the detailed portraits, these large paintings are pure, abstract bands of colors transversed by luminous lines. Like his other works, the new paintings are characterized by a smooth surface and a harmonious use of color. He is exploring the potential of this series in both watercolor and spray paint.

ANDERSON, LAURIE (Performance Artist)
c/o Holly Solomon Gallery, 724 Fifth Ave, New York, NY 10019

Born: 1947 *Awards:* Fellowship, John Simon Guggenheim Memorial Foundation; grant, National Endowment for the Arts *Collections: Exhibitions:* Los Angeles County Museum of Art *Education:* Bannard College *Dealer:* Holly Solomon Gallery, NYC

Early work was in both sculpture and performance, but invariably rooted in language. She cites as strong influences on her early art work the work of Vito Acconci and William S. Boroughs. The influence of Acconci can especially be seen in an early performance of hers, performed in the streets of Rome, where a violin duet between herself and a tape recording of herself playing a violin lasted exactly as long as the solid blocks of ice—into which the ice skates she wore were frozen—took to melt on a hot Italian summer day. For the past six years she has performed almost exclusively her magnum opus performance work, *United States, Parts I-IV* which in its entirety lasts over eight hours. She has performed excerpts from *United States*, under various titles, throughout North America and Europe. Her performances incorporate a host of both visual and audio effects and illusions and masterfully combine the use of slide projectors, film, music synthesizers, and electron-

Carl Andre, *Camemorial to After Ages* (1983), 18 x 180 x 360, quincy granite. Courtesy: Paula Cooper Gallery (New York NY)

Dan Allison, *Ritual*, 18 x 24, etching. Courtesy: Charlton Gallery (San Antonio TX)

ics with her clever sense of humor and charismatic stage presence. She has recently signed a recording contract with Warner Brothers records.

ANDERSON, ROBERT RAYMOND (Painter)
37 Glenfield Road, Bloomfield, NJ 07003

Born: 1945 *Awards:* Grant, New Jersey State Council on the Arts; Grand Prize, New England Exhibition, Silvermine Guild of Artists *Collections:* American Telephone and Telegraph Collection; University of Massachusetts *Exhibitions:* San Jose State; Newark Museum *Education:* Pratt Institute of Art and Design *Dealer:* Jack Gallery, NYC

Past times and places are represented in his early photorealist paintings in acrylic. Disparate costumes and objects come together in strangely romantic compositions. There is a sense of the surreal as the precisely rendered objects appear to exist in space without shadows. In his current work, he composes within a square picture plane measuring fifty by fifty inches. In each painting a female figure appears in the foreground clothed in brightly patterned fabric and set against a background of a similarly patterned textile. Her upper face and lower legs are invariably cropped from the composition transforming the figure into a three dimensional prop against a flat ground. Careful studies in color and design, these paintings are also studies of the idiosyncratic.

ANDERSON, RUTHADELL (Fiber Artist)
3098 Wailani Road, Honolulu, HI 96813 *Awards:* Award, Hawaii Craftsmen Annual *Collections:* Honolulu Academy of Arts; The State Foundation on Culture and the Arts *Exhibitions:* Honolulu Academy of Arts; Greenville County Museum of Art *Education:* San Jose State College; University of Hawaii

The artist is best known for her two monumental woven murals in the House and the Senate chambers of the Hawaii State Capitol. She has also produced three dimensional woven forms—as in her sculptural grouping for the Prince Kuhio Federal Building in Honolulu. Her weavings are typically large scale and are constructed of a wide range of fibers dominated by wool. Hawaiian plant fibers, seed pods, and other natural elements were woven into her early work and are still used periodically. The palette is varied with many pieces executed in earth tones or the warm, vibrant colors of the Tropics. The natural forms in her environment inspire the abstract designs and imbue her work with a particularly Hawaiian spirit.

ANDERSON, WILLIAM THOMAS (Printmaker, Painter)
Department of Art, Humboldt State University, Arcata, CA 95521

Born: 1926 *Awards:* Jurors Choice Selection, Springfield Museum of Art; Best of Show Award, 24th Annual Redwood Art Association Exhibition *Collections:* Downey Art Museum *Exhibitions:* "World Print Competition '77', San Francisco Museum of Modern Art; John Kohler Arts Center *Education:* El Camino College; California State University at Los Angeles

For the last fifteen years he has been working on the techniques for reverse painting and printmaking on transparent plexiglass. This gives an added richness to the luminous colors and provides interesting possibilities for the manipulation of spacial depth. Current techniques include silkscreen, engraving, collage, airbrush painting and photo-transfer processes directly on glass. He considers himself primarily an artist of the Ameri-

can West. "Although my heroes are Thomas Moran, Albert Bierstadt, Frederick Remington, and Russell, my work is more akin to Rauschenberg." Concern for forms, space, and color as well as historical scenes of the American west juxtaposed with contrasting contemporary imagery are characteristic traits of his work.

ANDRE, CARL (Sculptor)
P.O. Box 1001, Cooper Station, New York NY 10276

Born: 1935 *Collections:* Museum of Modern Art; Art Institute of Chicago *Exhibitions:* Solomon R. Guggenheim Museum; Museum of Modern Art *Education:* Phillips Academy *Dealer:* Paula Cooper, NYC

After studying with Hollis Frampton and Patrick Morgan, he met Frank Stella and subsequently developed his own minimalist theories during the late 1950s. Wood and plexiglass, into which he carved geometrical patterns, were his media then. He emphasized architectural design until 1964, when after working on a railroad he decided to make his work "more like roads than like buildings." Considering himself a "post-studio artist," he placed bricks, metal strips and other industrial products of standard size in random arrangements on the floor. The identity of these pieces would change as the elements were stored and later rearranged elsewhere. Using only one medium in each piece, he leaves materials in their natural state, leaving time and the elements to change the surfaces. He questions the notion that art is unique and precious, and seeks to explore the interactions of space with the gravity, mass, weight and placement of forms.

ANDRIS, RUTH INGEBORG (Sculptor)
4106 N. Ozark Ave., Norridge, IL 60634

Born: 1933 *Awards:* Dr. and Mrs. Howard Paule Award, Hew Horizons in Sculpture Show, Skokie, IL; Second prize, Old Orchard Art Festival, Skokie, IL *Collections:* Standard Oil Company of Indiana; Commission on Womens' Affairs, Chicago *Exhibitions:* Traveling Exhibit, Illinois Arts Council; The Art Institute of Chicago *Education:* The Art Institute of Chicago; Contemporary Art Workshop, Chicago

Figurative stone sculpture in soapstone and alabaster comprises the majority of her work. Her sculpture ranges in size from medium scale table pieces to modest free-standing works. Pieces such as *Radioactive Embryo,* carved from glowing red alabaster, and a figurative series, done in black soapstone with inlaid shells, demonstrate her careful choice of materials is almost always determined by the content being addressed. She defines her concerns in terms of content, style and materials as "humanistic, organic ¼ evolving½, and natural ¼ of the earth½." Work in restoration of stone sculpture at the Field Museum of Natural History and interests in Aztec and other ethnic arts has also strongly influenced her own work in stone. She has illustrated several books as well.

ANTONAKOS, STEPHEN (Sculptor)
435 W. Broadway, New York NY 10012

Born: 1926 *Awards:* Individual Artist's Grant, National Endowment for the Arts; New York St. Creative Artists Public Service Program Grant *Collections:* Whitney Museum of American Art; Museum of Modern Art *Exhibitions:* Whitney Museum of American Art; San Francisco Museum of Modern Art *Dealer:* Helene Trosky, Purchase, NY; Works of Art for Public Spaces, NYC

In the 1960s neon was first used non-figuratively in

Robert Anderson, *Cattails* (1984), 50 x 50, acrylic on canvas. Courtesy: Jack Gallery (New York NY)

Ruth Ingeborg Andris, *Clytemnestra & Iphigenia* (1981), 21 high, African Wonderstone. Courtesy: Stuart McCarrell

Mary Ascher, *Chrysantheums,* wash drawing.

order to create "the shock of the unexpected" with "silent streams of color," in works of programmed neon and metal such as *Orange Vertical Floor Neon*. Employing the logic of Minimalism to a formalist vocabulary, during the next decade neon-edged panels and boxes were installed on the outside and inside of buildings, either suggestive of architectural forms or of sculpture. These and recent installations reorganize space using light and color—subtly blending into the setting, or glaringly opposing it.

ANTREASIAN, GARO ZAREH (Painter, Printmaker)
4909 Paseo Del Rey NW., Albuquerque, NM 87120

Born: 1922 *Awards:* Senior Artists Grant, National Endowment for the Arts; Honorary Doctor of Fine Arts Degree, Purdue University *Collections:* Metropolitan Museum of Art; Museum of Modern Art *Exhibitions:* U.S. Pavilion, Venice Biennale; 14th International Biennale of Graphic Art, Ljubljana, Yugoslavia *Education:* Herron School of Art *Dealer:* Kauffman Gallery, Houston, TX; Robischon Gallery, Denver; Wildine Galleries, Albuquerque, NM

His paintings and printmaking work has evolved from a romantic, semi-abstract imagery of the 1950s and 1960s, through abstract expressionism, to an increasingly non-representational and minimal mode in the 1970s. Evocative materials and techniques are employed in the prints to heighten their expressive potential, including such processes as printing on metallic foil, using metallic inks, embossing the print surface, and collaging. In the 1980s he has returned to painting after a long hiatus. Currently his works are based on constructivist and diagrammatic principles in which geometric linear configurations provide both energy and structure to colored fields and shapes.

APPEL, KAREL (Painter, Sculptor)
c/o Martha Jackson Gallery, 521 W. 57th St., New York NY 10019

Born: 1921 *Awards:* Venice Biennale; First Prize for Painting, Guggenheim International Exhibition *Collections:* Museum of Modern Art; Museum of Fine Arts, Boston *Exhibitions:* Solomon R. Guggenheim Museum; Museum of Modern Art *Education:* Royal Academy of Fine Arts, Amsterdam, Holland *Dealer:* Martha Jackson Gallery, NYC

A founding member of the International Association for Experimental Art and of the COBRA group in 1948, this Abstract Expressionist created violent, forceful images with thickly applied paint. Often he applied paint straight from the tube, making many layers of color. He said about his work: "The paint expresses itself. In the mass of paint, I find my imagination." For a while he applied objects to the canvases, but soon returned to two-dimensional work. After COBRA disbanded, he has continued as a prolific artist, active as a graphic artist and as a sculptor. His sculpture, large and bulky like the thickly applied paint of his canvases and accented with lurid colors, is a three-dimensional counterpart to his paintings.

ARAKAWA, SHUSAKU (Painter)
124 W. Houston St., New York NY 10012

Born: 1936 *Awards:* D.A.A.D. Fellowship, W. Berlin *Collections:* Museum of Modern Art; Walker Art Center *Exhibitions:* Museum of Modern Art; Kennedy Center for the Performing Arts *Education:* Musashino

College of Art, Tokyo *Dealer:* Margo Leavin Gallery, Los Angeles; John C. Stoller, Minneapolis; Galerie Maeght Le Long, New York City; Multiples Inc., NYC

He left his homeland of Japan before completing a degree and in 1960 started a "neo-Dada" group. Through "happenings" he explored man's physical bounds, and later gained recognition with a series of *Boxes*. In 1962 he came to New York and created a new series, *Diagram*, in which the silhouettes of such objects as tennis rackets, combs, footprints, arrows, and refrigerators were arranged on canvas. Gradually he replaced the silhouettes of forms with words only, in an attempt "to pictorialize the state before the imagination begins to work" in a "pregnant vacuum" out of which innumerable pictures could arise from the canvas to the observer. Recently he has searched for new ways to define the human consciousness through a systematic investigation of language, and has produced two experimental films.

ARMAN (Sculptor)
380 W. Broadway, New York, NY 10012

Born: 1928 *Awards:* Tokyo Biennial Second Prize; Grand Marzotto Prize *Collections:* Hirshhorn Museum & Sculpture Garden; Metropolitan Museum of Art *Exhibitions:* Museum of Art Moderne, Paris; Fort Worth Art Museum *Education:* Ecole National Art Decoratif *Dealer:* Marisa del Re Gallery, NYC.

His sculpture has been influenced by the collages of Kurt Schwitters, the work of Marcel Duchamp, and the abstract, action paintings of Jackson Pollock. In 1960 he co-founded the New Realist group in France with, among others, art critic Pierre Restany and Yves Klein. His current works are assemblages and sculptures on the theme of man-made objects, either in their natural state or in cast bronze. The objects are either accumulated or dissected in a post-Cubist manner.

ARNESON, ROBERT (Ceramic Sculptor, Printmaker)
110 East E. St., Benecia, CA 94510

Born: 1930 *Collections:* Oakland Art Museum; San Francisco Museum of Modern Art *Exhibitions:* Whitney Museum of American Art; The Museum of Modern Art *Education:* California College of Arts and Crafts; Mills College *Dealer:* Frumkin-Struve Gallery, Chicago; Fuller-Goldeen Gallery, San Francisco

For the last twenty years he has worked as a ceramic sculptor as well as in the inter-related fields of prints and drawings. A cartoonist as a youth, he later became interested in the glazed multi-part clay forms of Peter Voulkos. His skillful and rich color sense in his sculptural works has served him well in his drawings and prints. Even those in a single color tone have a coloristic richness about them which is seen still more fully in his color prints, which employ anywhere from three to seven different hues. In the recent years, a good deal of his work has centered on the subject of the self-portrait and contemporary over-sized ceramic busts glazed in bright colors. Other major concerns in his work are the questions of identity and artistic persona which come so naturally to the subject of the self-portrait. His work pushes explicitness to an absurd extreme. This is the core of his characteristic wit.

ARNEST, BERNARD (Painter)
1502 Wood Ave., Colorado Springs, CO 80907

Born: 1917 *Awards:* Fellowship, John Simon Guggenheim Foundation *Collections:* Walker Art Center; Minneapolis Institute of Art *Exhibitions:* Whitney Museum

Arman, *The Force Within* (1981), 80 high, metal wrenches. Courtesy: Marisa del Re (New York NY)

of American Art; Corcoran Gallery of Art *Education:* Colorado Springs Fine Arts Center *Dealer:* Kraushaar Galleries, NYC He is a figurative artist primarily interested in the drawn and painted picture as a means of comprehension. He believes that observation is the source of insight and imagination, and that images composed pictorially and two-dimensionally are the basic elements of visual thought. His early training in formalist methods has made possible an increasing attention to content and the use of formalist devices as idioms and dialects, even languages, in the expression and definition of perception. His subjects are generally local and commonplace. Occasionally his work is polemical when the subject is political and social material on a national scale.

ARNOLDI, CHARLES ARTHUR (Painter, Sculptor)
11A Brooks Ave., Venice CA 90291

Born: 1946 *Awards:* Wittkowsky Award, Art Institute of Chicago; Fellowship, National Endowment for the Arts *Collections:* Los Angeles County Museum of Art *Exhibitions:* Museum of Contemporary Art, Chicago *Education:* Chouinard Art Institute *Dealer:* James Corcoran Gallery, Los Angeles Originally intent on becoming a commercial illustrator, he quickly turned to painting. He is known for large-scale paintings made of two panels, one resembling an intricate mesh of painted twig shapes and the other consisting of actual twigs affixed to the canvas and painted, as in *Plummet* and *Volcano—Log Jam.* These wood and oil pieces are boldly colored and full of explosive energy. "I have become interested in wood as an alternative to painting. I especially like tree branches, which have a very distinct line quality. They feel hand-drawn, they have a certain gestural quality, a naturalnessIt provides a solution to my desire for subject matter." Sculptures are rendered in wood and bronze.

ARTSCHWAGER, RICHARD ERNST (Painter, Sculptor)
Box 99, Charlotteville NY 12036

Born: 1923 *Awards:* National Endowment for the Arts; Cassandra Award, NYC *Collections:* Whitney Museum of American Art; Museum of Modern Art *Exhibitions:* Venice Biennale; Whitney Museum of American Art *Education:* Cornell University *Dealer:* Leo Castelli Gallery, NYC

After helping Claus Oldenberg put together *Bedroom Ensemble*, he gained recognition with pseudo-furniture of formica on wood, such as *Table with Tablecloth*, and later with urban views, such as *High Rise Apartment*, made of Liquitex on Celotex with Formica. These pop works questioned the utility of art and its place in American culture. Recent paintings use photographs as their base. Hand-execution distorts the photograph's description of reality, and often the frame (the "furniture') becomes an integral part of the work, as in *Left Pinch*, in which space is expanded through the addition of a mirror to the frame.

ASCHER, MARY (Painter, Printmaker)
116 Central Park South #10N, New York, NY 10019

Born: 1900 *Awards:* Huntington Hartford Foundation Fellowship; award, City College of New York *Collections:* Archives of American Art, Smithsonian Institution; The City College of New York *Exhibitions:* Baruch College; Harkness House Gallery, NYC *Education:* Art Students League; New York School of Applied Design for Women

Work is in oil, watercolors, and prints. Paintings are hard edged with flat surfaces and very little textural qualities. Most imagery has been geometric with curvilinear forms in abstract and semi-abstract spatial relationships. Realistic figurative forms are often mixed with abstract imagery. Subject matter is strongly influenced by the Bible and roles of women within society. Prints consist of serigraphs in color and lithographs in black and white, both with corresponding stories.

ASHBAUGH, DENNIS JOHN (Painter)
30 W. Thirteenth St., New York NY 10011

Born: 1946 *Awards:* Creative Artists Public Services Grant, New York Council on the Arts; Fellowship, John Simon Guggenheim Memorial Foundation *Collections:* Seattle Art Museum; Toledo Art Museum *Exhibitions:* Seattle Art Museum; Whitney Museum Annual *Education:* California State College *Dealer:* Janie C. Lee Gallery, Houston

Work of the 1970s featured large-scale oddly shaped canvases containing horizontal and vertical rectilinear shapes, often in only black and white and primary colors. At times these solid bars of color slightly overlapped, charging the junctures with energy as the geometrical planes interlocked across the expansive background, as in *Agitreklama.* In the 1980s cardboard models of the shapes were made, projected onto the wall, and the paintings executed after these images. The canvases became even larger and the geometrical shapes took on bright colors in exploding compositions of visual dissonance, in hot pinks and lime greens. Titles for the works, such as *Champagne, Then Death,* come from the sensationalized headlines of the *New York Post.*

ASHER, LILA OLIVER (Printmaker, Painter)
4100 Thornapple St., Chevy Chase, MD 20815

Born: 1921 *Collections:* National Collection of Fine Arts; Corcoran Gallery of Art *Exhibitions:* Thomson & Burr Galleries, NYC; Howard University *Education:* Philadelphia College of Art

Her medium in print has been the linoleum cut, which suits her clear-cut forms in strong blacks and whites, and her incisive, gracefully stylized lines. Her themes over the years have remained consistent—the mother-and-child, couples, music, and biblical stories. Her figures from the earliest to the most recent are defined by rhthymical contours. Her current work makes use of dramatic foreshortening of images and figures while retaining a sense of classical repose. Her nudes, embracing lovers, and mothers stroking babies are romantic images with classical designs. Touches of orange, brown, and red function as accents in the otherwise black and white prints and silkscreen images.

ASMAR, ALICE (Painter)
1125 N. Screenland Dr., Burbank, CA 91505 *Awards:* Galleria Europa Arte, Ancona, Italy; Harriet H. Woolley Fellowship *Collections:* Smithsonian Museum; Franklin Mint *Exhibitions:* Loker Gallery, California Museum of Science and Industry; Frye Art Museum, Seattle, WA *Education:* Lewis & Clark College, University of Washington *Dealer:* Circle Fine Arts, Ltd., Houston, Los Angeles, Chicago; Senior Eye Gallery, Long Beach, CA

Her past works were done in oils and egg tempera, charcoal and ink. The subject matter included oceanscapes, landscapes, old buildings, and night scenes. The composition of these early works tended toward the abstract. She employs lines to suggest visual rhythmic patterns. The large black-and-white drawings are

Jean Michel Basquiat, *Grazing/Soup to Nuts—MGM 1930* (1980), 66 x 120, oil on canvas. Courtesy: Mary Boone Gallery (New York NY)

Alice Asmar, *Zuni Rain Dancers* (1980), 14 x 27, lithograph. Courtesy: Circle Fine Arts

bold, depicting plants, animals, and people. Her more recent paintings and tapestries use brilliant rainbow colors to show Southwest Indian dances, florals, animals, portraits, seascapes, and landscapes. These works are figurative, with the subjects sometimes floating in space. She works with varying media and techniques, among them casein, mixed media, collage, ink, etching, lithography, and engraving.

ATLEE, EMILIE DES (Painter)
2117 Chestnut Ave., Ardmore, PA 19003

Born: 1915 *Awards:* National Benedictine Art Award; Honorable Mention, National Ogunquit Art Center *Collections:* Franklin Institute; United Airlines *Exhibitions:* Newman Galleries, Philadelphia; Little Gallery, Philadelphia *Education:* Spring Garden Institute *Dealer:* Newman Galleries, Philadelphia; The Gallery, Barnegat, N.J.

Earlier paintings were realistic impressions of nature and portraits, usually painted with a knife. The sea was an especially challenging aspect to her always luminous and colorful paintings. Pastels, especially for portraits, were a favorite medium. As a teacher of art, her experimentations eventually led to abstract expressionism and non-objective styles. Portraits and figures, usually children, are very realistic and luminous when done with her glazing technique. Abstract works are integrated patterns of selected subject matter executed with brush and knife. She has continued to use pastels in all styles of her work, as well as drawings.

AUBIN, BARBARA (Painter, Assemblage Artist)
1500 W. Henderson, Chicago, IL 60657

Born: 1928 *Awards:* Honorable Mention, Dana Medal, Pennsylvania Academy of Fine Arts *Collections:* Art Institute of Chicago; Illinois State Museum *Exhibitions:* Fairweather Hardin Gallery, Chicago; Art Institute of Chicago *Education:* Carleton College; School of the Art Institute of Chicago *Dealer:* Fairweather Hardin Gallery, Chicago

Her earlier works were watercolors, drawings, and collages which were poetically abstract, highly detailed, and texturally involved. The more recent pieces are mixed media combinations employing techniques of collage, assemblage, watercolor or acrylic paint, and minor printmaking devices such as rubber stamps. These works continue to incorporate her long-time concerns with texture and detail. Often there are multiple meanings and undercurrents of humor. Many of the pieces are autobiographical in nature, but universal in intent.Currently she is working on a series of mixed-media images of Chicago-area women artists who have had a commitment to their work over a number of years.

AVAKIAN, JOHN (Painter)
43 Morse St., Sharon, MA 02067 *Awards:* Purchase Prize, Kansas State University; Blanche E. Colman Foundation Award *Collections:* Bucknell University; Tulsa Civic Center *Exhibitions:* DeCordova Museum; Nexus Art Gallery, Boston *Education:* Yale University; Boston Museum School of Fine Arts; Tufts University

He paints the busyness of the city, dwelling frequently on fragmentation and explosion patterns in his hard-edged acrylic paintings and serigraphs. Early work, strongly influenced by Op art, was exclusively in intricate black and white designs. These paintings were created from stenciled letters, overlapping each other and with some elements filled in, others blanked out. The viewer may still see what's left of the letters by studying the work closely. More recent work continues the hard-edged, black and white painting style of prior years but superimposes bright red plus, double plus, or plus/minus signs over the rigidly square or rectangle canvases. Paintings displaying the "plus-sign" horizontal and vertical bands divide the images into four quadrants that help to further centralize and decentralize the geometric configurations.

AVEDON, RICHARD (Photographer)
407 E. 75th St., New York NY 10021

Born: 1923 *Awards:* President's Fellow, Rhode Island School of Design; Hall of Fame, Art Director's Club *Collections:* Metropolitan Museum of Art; Museum of Modern Art *Exhibitions:* Museum of Modern Art; Metropolitan Museum of Art *Education:* Columbia University; New School for Social Research *Dealer:* Norma Stevens, NYC

Influenced by studies from 1944 to 1950 with fashion photographer Alexey Brodovitch, he later became staff photographer for *Harper's Bazaar, Junior Bazaar* and *Vogue.* He also served as a consultant for Paramount Films." Known for formal portraits of notable people, he maintains his style is the result of an art which he describes as allowing his subject to "get close to the camera" and capturing the response. He has recently published several monographs and enjoys status as an interpreter of high style. His famous nude interpretation of Natasha Kinski fondling a giant python best typifies his expertise with sensual subject matter, often bordering on eroticism. Recent commissions include fashion assignments intended for major media.

AVLON, HELEN DAPHNIS (Painter, Sculptor)
463 West St. #632B, New York, NY 10014

Born: 1932 *Awards: Collections:* Museum of Modern Art; Provincetown Art Association *Exhibitions:* United Federation of Teachers Art Gallery, NYC; Brata Gallery, NYC *Education:* Hunter College *Dealer:* Westbeth Arts, Gallery I, NYC

Works vary between figurative realism and abstract expressionism with experimentation in all media. Paintings in mixed media, oil and acrylics range from large scale works eight by ten feet in size to miniatures. Sculpture, likewise, is produced in a variety of materials including marble, clay, epoxy, wood, and polyurethane. The artist also works in photography and graphic design as well.

AXTON, JOHN (Painter)
944 Old Bridge Court, Santa Fe, NM 87501

Born: 1947 *Dealer:* Ventana Fine Art, Santa Fe, NM; Enthios Gallery, Santa Fe, NM; Contemporary Gallery, Dallas

He is known for his paintings and lithographs of traditional Western subjects—buffalos, Indians, and Western landscapes. However, the artist's more recent work focuses on the pueblo in the Southwestern landscape. His oil paintings of adobe and sky emphasize the interplay between light and space. The lithographs, such as *Taos Echoes* and *Silent Passage,* are abstract compositions of houses, walls, and skies, executed with a minimalist technique. His interest in lithography was abetted by his education and training as a graphic artist. He concentrates on developing a unified style in both paintings and prints.

AYCOCK, ALICE (Sculptor)
62 Greene St., New York, NY 10012

Barbara Aubin, *Personal: Of Barbs & Barbarisms,* 20 x 27, mixed media. Courtesy: Fairweather Hardin (Chicago IL)

John Axton, *Chamisa Winds,* 40 x 40, lithograph.

Born: 1946 *Awards:* Phi Betta Kappa; Fellowship, National Endowment for the Arts *Collections:* The Museum of Modern Art; Whitney Museum of American Art *Exhibitions:* "Documenta 6', Kassel; "Retrospective of Projects and Ideas", Stuttgart *Education:* Douglass College; Hunter College *Dealer:* John Weber Gallery, NYC; Protech McNeil, NYC; Klein Gallery, Chicago; Lawrence Oliver Gallery, Philadelphia

Large semi-architectural projects dealing with the interaction of structure, site, materials, and the psychophysical responses of the perceiver comprised her earlier work. Mazes and pitched roofed structures served as a generic image of architecture with dual readings as houses and burial tombs. Her more recent series of sculpture entitled *Time/Creation Machines*, makes use of a general image related to plows, fans, windmills, food processors, turbines, crescent shapes of the moon as it moves through its phases, and theoretical diagrams purporting to explain the order of the universe. This new image of the *Time/Creation Machines* is a generic image of technology and contains the dual reading as both creation and destruction. The *Time/Creation Machines* wed images of the fertile crescent and the plow which gave man access to feeding himself (creation) with the same inquisitive search for invention that led to the development of weapons and finally culminated in the creation of the bomb (ultimate destruction).

AYLON, HELENE (Painter, Mixed Media Artist)
463 West St. 808a, New York, NY 10014

Born: 1931 *Awards:* Grant, National Endowment for the Arts; CAPS *Collections:* Massachusetts Institute of Technology; Flora Irving, President, Whitney Museum of American Art *Exhibitions:* Betty Parsons Gallery, NYC; Max Hutchinson Gallery, NYC *Education:* Brooklyn College

Conceptual concerns expressed in non-traditional techniques have dominated this painter's work. Early silver paintings appeared to change with the angle of illumination and the perspective of the viewer. In a later series entitled, *Transformations*, the illusion of change became actual. A "sac" of oil separated and sagged away from the body of the painting as the work aged. In present works, sacs as a metaphor for change are used again. The sacs are filled with soil gathered from the border of Lebanon, military installations, and other sites of "endangered earth," testifying to her political concerns. The act of collection of the material to become the contents of the sacs is an essential element of the work itself, assuming aspects of performance and ritual.

AZACETA, LUIS CRUZ (Painter)
1729 Greene Ave, Ridgewood, New York 11385

Born: 1942 *Awards:* Grant, Creative Artist Public Service; Grant, National Endowment for the Arts *Exhibitions:* The Chrysler Museum; Allan Frumkin Gallery, Chicago *Education:* School of the Visual Arts *Dealer:* Allan Frumkin Gallery, NYC

He paints and draws primarily scenes of urban violence, personal cruelties, and anxieties. His early work in acrylic and watercolor were cartoon-like images rendered in bright, flat pigment within black outlines. His more recent acrylic paintings exhibit thick, multicolored, "juicy" pigments with the images carved in relief. The influences of Latin American religious folk art and the work of such Europeans as Bosch, Grosz, and others, are seen in his work. His canvases contain a

savage humor while they portray burning cities, attacking dogs, and even self-portraits of the artist—his body split to reveal his skeleton. With these gruesome images and scenes of brutality the artist presents Man as Victim and calls for compassion.

BABER, ALICE (Painter)
c/o Eva Cohon Gallery, 2057 Greenbay Rd., Highland Park IL 60035

Born: 1928 *Collections:* Whitney Museum of American Art; Museum of Modern Art *Exhibitions:* Kunstverein Museum, Cologne, Germany; New York Cultural Center *Education:* Indiana University; Ecole des Beaux-Arts, Fontainebleau, France *Dealer:* Eva Cohon Gallery, Highland Park, IL; Frances Aronson Gallery, Atlanta

In all her paintings—and especially the still lifes—she has pursued the depiction of light. Luminosity was achieved through the softening of edges so that volumes and colors became atmospheric. Early work was sombre, providing dramatic contrasts between darkness and light. Gradually the brightness of her palette increased. In her current paintings color fields are assembled in spatial harmonies and depths, often like clouds of color thrust upward or downward by wind currents. Large and epic paintings are alive with light and dynamic energy.

BACHINSKY, VLADIMIR (Painter)
P.O. Box 576, Woodstock, NY 12498

Born: 1936 *Awards:* National Academy Scholarship; Dr. Ralph Weiler Scholarship *Collections:* Archbishop of Yugoslavia; St. John's Church *Exhibitions:* Salmagundi Club, National Academy, NYC *Education:* *Dealer:* Gallery of the Southwest, Taos, NM

A painter and muralist in the traditional sense, he has also produced numerous surrealist works both in oil and conte pencil. His work is strongly influenced by renaissance art and a classical approach to realism, perspective and composition. Paintings vary from small 8" x 10" works completed in the studio to massive mural projects for churches and public buildings. American Indians and religious themes are common subject matter in his paintings. Religious themes for murals and altar pieces are executed in a realistic yet colorful style.

BACIGALUPA, ANDREA (Sculptor, Painter)
626 Canyon Rd., Santa Fe, NM 87501

Born: 1923 *Awards:* First Place, Art in Public Places, Santa Fe, NM *Collections:* Diocese of Amarillo, TX; Archdiocese of Santa Fe, NM *Exhibitions:* Museum of New Mexico; Cooper-Hewitt Museum *Education:* Maryland Institute; Accademia de Belli Arti, Florence, Italy

Recognized primarily as a liturgical artist whose most monumental public works are in bronze and stained glass, he also produces both secular and liturgical work in painting and ceramics. His emphasis on strong line and form reveals Roman and Renaissance influences. His current works tend to be figurative but highly stylized, with representational images emerging from abstract form. In recent years, most major commissions have been for the "total conceptual design of a sacred environment," wherein he designs the interior spaces of churches and also designs and executes the architectural and sacred arts within those spaces. His work aspires to express spirituality through strength and form.

BAEDER, JOHN (Painter)
1025 Overton Lea Rd., Nashville TN 37204

Born: 1938 *Collections:* Whitney Museum of American Art; Cooper-Hewitt Museum *Exhibitions:* Smithsonian Institution; Pennsylvania Academy of the Fine Arts *Education:* Auburn University *Dealer:* O.K. Harris Works of Art, NYC

A second-generation photo-realist, his work has similarities to that of Richard Estes. However, he does not work from photographs, and in that sense his technique is more like that of West Coast painter Robert Bechtle. Fascinated by diners as mainstays of American life, he depicts their facades in as much accuracy as possible with a nearly imperceptible brush stroke.

BAILEY, WILLIAM (Painter)
223 E. Tenth St., New York NY 10003

Born: 1930 *Awards:* Fellowship, John Simon Guggenheim Memorial Foundation; First Prize Painting, Boston Arts Festival *Collections:* Whitney Museum of American Art; Pennsylvania Academy of the Fine Arts *Exhibitions:* Whitney Museum of American Art; Kansas City Art Institute *Education:* Yale University School of Art *Dealer:* Robert Schoelkopf Gallery, NYC

After study with Josef Albers, his early paintings were figurative New Realist works, his nudes deliberately recalling the interiors of such earlier painters as Jean-Auguste-Dominique Ingres and Edouard Vuillard. More recent still lifes in oil, such as *Eggs,* are precisely executed works that suggest the metaphysical paintings of Francisco de Zurbaran and Giorgio Morandi.

BALCIAR, GERALD GEORGE (Sculptor)
5307 Jellison St., Arvada, CO 80002

Born: 1942 *Awards:* Chilmark Award; Bronze Medal, National Sculpture Society *Collections:* Wildlife World Art Museum *Exhibitions:* National Academy of Western Art; National Sculpture Society *Education:* Self-taught

His sculpture in bronze and marble is in a representational style, nearing realism with an emphasis on anatomical accuracy. Animals are most often his subject; His love of wildlife and nature are reflected in his sculpture. His interests are not only in the creative part of sculpture, but in the technical difficulties and solutions encompassed in such techniques as point up, mold making, and the engineering needed in order to produce the final piece of art. While recently doing a seventeen foot monumental elk sculpture, he devised a point up system that is now being used with great success by other sculptors and replaces the traditional point up machine.

BALDESSARI, JOHN ANTHONY (Photographer, Conceptual Artist)
3552 Beethoven St., Los Angeles CA 90066

Born: 1931 *Awards:* National Endowment for the Arts Grants *Collections:* Museum of Modern Art; Los Angeles County Museum of Art *Exhibitions:* Museum of Modern Art; Documenta 5 and 7, Kassel, Germany *Education:* San Diego St. University; Otis Art Institute, Los Angeles *Dealer:* Sonnabend Gallery, NYC

Originally a painter, his work of the 1960s reflected an interest in Minimalism and the formal and semantic applications of words in the manner of Rene Magritte.*Work With Only One Property*, created in 1966, was a blank white canvas with only the title of the piece professionally lettered upon the pristine surface. As a conceptual photographer, his interests have been similar. He photographed words out of context from various pages of text, with an anonymous finger pointing to a phrase, as in *Scenario (Scripts)* (1972-73). His film loops also repeat words, objects, or actions. In photography and in films, he hypothesizes about what art can be, expanding the definition of Conceptual Art.

BALL, WALTER N. (Painter)
821 Normal Rd., De Kalb IL 60115

Born: 1930 *Awards:* Purchase Award, Evansville (IN) Museum of Arts and Science; First Prize, Washington and Jefferson College, Washington, PA *Collections:* Evansville (IN) Museum of Arts and Sciences; Northeast Missouri State University, Kirksville, MO *Exhibitions:* Owensboro (KY) Museum of Fine Art; Art Institute of Chicago *Education:* Baker University, Baldwin City, KS; University of Wichita; Ohio State University

Early works featured organic, abstract landscapes influenced by Cubism and Abstract Expressionism. In the *Masquerade* series of the late 1960s and early 1970s, he used a gestural painterly approach to figuration. Figures were featured with abstract patterns as motifs. Recently the painterly style has been replaced by the use of large flat areas of color, from which mere suggestions of figures emerge, allowing for numerous interpretations. "The overall effect," he says, "is one of elusiveness, expansiveness and uncluttered elegance."

BAMA, JAMES E. (Painter)
c/o Coe Kerr Gallery, 49 E. 82nd St., New York NY 10028

Born: 1926 *Collections:* Cowboy Hall of Fame; Smithsonian Institution *Exhibitions:* Whitney Gallery of Western Art, Cody (WY); Cowboy Hall of Fame *Education:* Art Students League; City College of New York *Dealer:* Coe Kerr Gallery, NYC

A native New Yorker, he was a commercial illustrator for eighteen years until 1967 when he moved to Wyoming for a drastic change of life-style. He began detailed portraits of the people and places of the American West. Four years later he achieved success in New York City as a contemporary Western painter. Realistic portraits of Indians, cowboys, cowgirls, bronc riders and hunters have been compared to the work of Wyeth, although the subject matter is different. "People are really what interests me and art is a way of expressing it."

BANNARD, WALTER DARBY (Painter)
Box 296, Rocky Hill NJ 08553

Born: 1934 *Awards:* Fellowship, John Simon Guggenheim Memorial Foundation; National Foundation of the Arts Award *Collections:* Metropolitan Museum of Art; Museum of Modern Art *Exhibitions:* Baltimore Museum of Art; Whitney Museum of American Art *Education:* Princeton University *Dealer:* M. Knoedler, NYC

Early influences came from Theodoros Stamos and William Baziotes. Works from the late 1950s until the mid-1960s were executed in hard-edged pastel colors of similar value, with circles and rectangular shapes as their focus. Color fields were motionless and easy to read, emphasizing their interrelatedness. During the late 1960s larger color fields overlapped to form varying layers of pigment, as in *China Spring No. 3.* Gradually the paths of the brushstrokes became more

apparent, as in *Satin Rafters,* in order to explore not only the optical effects of color but also the significance of surface texture and of composition. He has also published written work on the effects of color.

BARAZANI, MORRIS (Painter)
601 S. Morgan, Chicago, IL 60680

Born: 1924 *Collections:* Blue Cross/Blue Shield *Exhibitions:* Art Institute of Chicago; Detroit Institute of Art *Education:* Cranbrook Academy of Art *Dealer:* Gilman Galleries, Chicago

During his early education as an artist, he was preoccupied with the Constructivists and Mondrian and developed a strong sense of order in his work as a result. As he evolved he became influenced by aspects of surrealism and expressionism. Automatic writing and a free approach to paint was dominant over design during this period. Recently he has attempted to fuse both approaches into a unified expression. He is ordering and clarifying his personal vocabulary at present, finding the structural elements that are characteristically his own.

BARKER, AL C. (Painter)
214 Prince St., Bordentown, NJ 08505

Born: 1941 *Awards:* Graham Gallery Award, Salmagundi Club; Artist of the Year, Easton Waterfowl Festival *Collections:* A. Andrews, Michigan; Sen. Daniel Moynihan, New York *Exhibitions:* Sportsmans Edge, Ltd., NYC; Wind Borne Gallery, Darien, CT *Dealer:* Annapolis Marine Gallery, Annapolis, MD; Wind Borne Gallery, Darien, CT

He spent ten years practicing 3KMQIebefore launching a full-timeart career five years ago. He works in watercolor, oil, and etching, with an emphasis on sporting and wildlife scenes. He paints in a traditional manner, working the warm and cool colors of nature into his work. He has specialized in small-sized paintings, but his most recent works are large.

BARNET, WILL (Painter, Printmaker)
15 Gramercy Park, New York NY 10003

Born: 1911 *Awards:* Walter Lippincott Prize, Pennsylvania Academy of the Fine Arts; Childe Hassam Award, Arts and Letters *Collections:* Metropolitan Museum of Art; Whitney Museum of American Art *Exhibitions:* Neuberger Museum; Institute of Contemporary Art, Boston *Education:* Museum of Fine Arts School, Boston *Dealer:* Kennedy Galleries, NYC

Since 1934 when he began making prints, a primary concern has been the figure. The quality of line and the use of brilliant colors are essential to the paintings and prints. In early work of the 1940s he geometrized and abstracted the figures and objects, creating recognizable images which captured "the most symbolic gesture" to represent the subject. In the late 1940s realistic space was eliminated altogether, in favor of "a painting space based purely on the rectangle: the vertical and horizontal expansion of forms," but several years later the abstracted shapes became biomorphic, as in *Janus and the White Vertebra* (1955). In 1962 he returned to the figure, portraits of women and cats, flattened into stylized planes of color in a primitivistic mode. Recent works include many similar portraits which reveal the decorative within the real.

BARR-SHARRAR, BERYL (Painter)
30 W. 9th St., New York, NY 10011 *Awards:* Prix Lefranc; Prix International du Chateau de la Saraz, Lausanne *Collections:* Mount Holyoke College Museum; Los Angeles Savings and Loan Association *Exhibitions:* Art Galaxy, NYC; Gallery Livingstone-Learmouth, NYC *Education:* University of California, Berkeley

Since her first solo exhibition in Paris in 1967, her paintings have been complex, non-figurative works with vibrant, highly personal color and evocative forms.Her latest canvases and works on paper reveal her characteristic calligraphic delicacy, while the gestures are more forceful and the forms more powerful. The space of the new works is constantly in flux. The forms suggest an intuitive observation of nature and an articulate and controlled expression of emotion.

BARSANO, RON (Painter)
P.O. Box 2032, Taos, NM 87571

Born: 1945 *Awards:* William Mosby Scholarship, American Academy of Art; Honorable Mention, Stacy Foundation *Collections:* U.S. Army, Washington, DC *Exhibitions:* Grand Central Art Galleries, NYC; Philbrook Museum, Tulsa, OK *Education:* American Academy of Art, Chicago *Dealer:* Taos Art Gallery, Taos, NM; Wichita Gallery of Fine Art, Wichita, KS; Talisman Gallery, Bartlesville, OK

He is a painter of landscapes, seascapes, portraits, figures, and still lifes. Essential elements in all his works are the mood and beauty of the subject that he is moved to express. He uses oils in his paintings and also draws in conte crayon. Since he moved to Taos in 1970 his works have been increasingly exhibited in galleries and museums. He believes that the depth of communication between a canvas and its viewer is what separates the painter from the fine artist.

BARTA, DOROTHY ELAINE (Painter)
3151 Chapel Downs Dr., Dallas, TX 75229

Born: 1924 *Awards:* Cash Award, Southwestern Watercolor Society; Best of Show, Artists and Craftsmen Exhibition *Collections:* Russell Daniels Trust, El Paso, TX *Exhibitions:* Dallas Museum of Art; Artists and Craftsmen Awards Show, Dallas *Education:* Dallas Museum of Art; Texas Womens University *Dealer:* Barta Originals, Dallas

She is a versatile painter working in oils, pastels, watercolors, and mixed media. Her older works in oil were traditional. Using pastels loosened her style, but it was not until she began using watercolor and mixed media, including collage, that her work became a personal statement. Her favorite subjects are the female figure and waterscapes, particularly reflections. Her commissioned portraits capture a client's personality in his or her own environment, utilizing familiar objects in the composition.

BARTH, FRANCES (Painter)
99 Van Dam St., New York, NY 10013

Born: 1946 *Awards:* Award, National Endowment for the Arts; Grant, John Simon Guggenheim Memorial Foundation *Collections:* Whitney Museum of American Art; Museum of Modern Art *Exhibitions:* Whitney Museum of American Art; Corcoran Gallery, Washington, DC *Education:* Hunter College *Dealer:* Susan Caldwell, NYC

Her early paintings were executed on long, horizontal canvases using geometric shapes derived from heraldic emblems. As she explored the structure of color, her forms became simpler and her colors more intricate. Applied with her characteristic flourishing brushstrokes, the color animates the surface of her recent

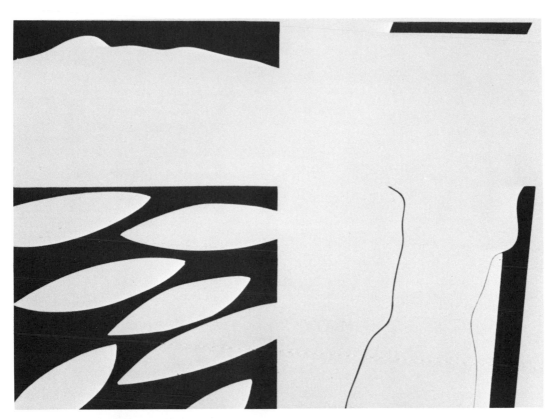

Walter N. Ball, *Leaf Square with two Figures,* 18 x 24, lacquer.

Roger Brown, *Don't Cry for me Argentina,* 72 x 72, oil on canvas. Courtesy: Phyllis Kind Gallery (New York NY)

work. The painting space has become more complex with the intersection of geometric color-forms. The composition is built using layers of pigment often pushing elements into relief.

BARTLETT, JENNIFER LOSCH (Painter)
c/o Paula Cooper Gallery, 155 Wooster St., New York NY 10012

Born: 1941 *Awards:* Brandeis University Creative Arts Award; American Academy of Arts and Letters *Collections:* Museum of Modern Art; Metropolitan Museum of Art *Exhibitions:* Museum of Modern Art; Whitney Museum of American Art *Education:* Yale University School of Art *Dealer:* Paula Cooper Gallery, NYC

Study with Jim Dine, Al Held, James Rosenquist and Jack Tworkov, along with an interest in art history has resulted in her work encompassing a variety of styles. Several series, such as *In the Garden,* a group of about two hundred drawings of a certain garden in Nice, France, explore the processes of perception, impression and re-creation of one particular subject, each composition a small part of a continuous exploration of a single theme. Her media are also varied. *Up the Creek* is a series of ten depictions of water, each one very different in approach from the other, recalling the works of Henri Matisse or Paul Cezanne, a Japanese screen or a computer's image.

BARTNICK, HARRY WILLIAM (Painter)
5 Holly St., Salem, MA 01970

Born: 1950 *Awards:* Massachusetts Artists Foundation Fellowship; Creative Artists Public Service Grant *Collections:* DeCordova Museum; Hyde Collection *Exhibitions:* Helen Shlien Gallery, Boston; Danforth Museum *Education:* Tyler School of Art; Syracuse University *Dealer:* Helen Shlien Gallery, Boston

Initially he was a strict photo-realist painter who captured apparently informal scenes of the middle class and enlarged them to monumental scale in oil on canvas. In the formal aspect, most of the work framed natural forms such as potted plants, with the angular geometry of nature. Currently, the work uses photographic sources more freely, allowing for manipulation of color, texture, form and space. The final image is highly refined and super—realistic, evoking feelings of quiet anticipation and implied human presence. The most recent development in the work involves taking further liberties with the source photos, involving both the juxtaposition of incongruous images as transparent montage and the utilization of the canvas texture.

BASKIN, LEONARD (Sculptor, Graphic Artist)
Luley Manor, Lurley Nr. Tiverton, Devon, England, UK

Born: 1922 *Awards:* Fellowship, John Simon Guggenheim Memorial Foundation; Medal, American Institute of Graphic Artists *Collections:* Museum of Modern Art; Metropolitan Museum of Art *Exhibitions:* Sao Paulo, Brazil; Museum d'Art Moderne, Paris *Education:* Yale University School of Art School of Art; New School for Social Research; Academy of Fine Arts, Florence, Italy *Dealer:* Kennedy Galleries, NYC

Influenced by ancient tombs he saw during his travels in Europe, he began to deal with the themes of death and spiritual corruption in about 1950. A series of large figures in stone, bronze or wood fused traditional art techniques with ideas of the present. Some of his works make death look like man's natural state, such as a representation of John Donne in *Dead Poet.* Others

portray debilitated, decadent figures with awkward, misshapen bodies. He often incorporates animal symbols, especially birds, with the figures or makes the figures animal-like, suggesting mythical beasts.

BASQUIAT, JEAN-MICHEL (Painter)
c/o Mary Boone Gallery, 417 W. Broadway, New York NY 10012

Born: 1960 *Collections:* Asher Edelman; Eugene and Barbara Schwartz *Exhibitions:* Mary Boone Gallery; Musee d'Art Comtemporaine, Paris *Dealer:* Larry Gagosian Gallery, Los Angeles; Mary Boone Gallery, NYC

Born in Brooklyn, New York of Puerto Rican and Haitian parents, this young painter uses acrylic and oil stick on Masonite, blackboard or canvas to create graffiti-like street art. Early subjects included cartoons of Alfred E. Newman, Richard M. Nixon and Alfred Hitchcock, as well as depictions of cars and weapons. Recent work includes cartoon-like pictures with bilingual captions, such as *Back of the Neck* (1983), a hand-painted screenprint in three parts with his signature painted in gold. He has also recorded a "rap" record.

BAUM, DON (Sculptor, Assemblage Artist)
5530 S. Shore Dr., Chicago IL 60637

Born: 1922 *Awards:* Honorary D.F.A., Art Institute of Chicago; National Endowment for the Arts Grant *Collections:* Museum of Contemporary Art, Chicago; Art Institute of Chicago *Exhibitions:* Art Institute of Chicago; Museum of Contemporary Art, Chicago *Education:* Michigan St. University; School of the Art Institute of Chicago; School of Design, Chicago; University of Chicago *Dealer:* Betsy Rosenfeld Gallery, Chicago

Early work of the 1950s reflected an expressionist vocabulary. In the following decade dolls and doll parts were combined with other materials to create expressive three-dimensional assemblages. Unrelated materials such as bones, skulls, shells and dolls were often juxtaposed into sexual images, as in *Bernard and Betty.* Relief constructions made of weathered wood were fetishistic or mask-like. Later constructions of weathered wood became more delicate, without a loss of evocative power. Many featured decals covering the surfaces, as in *The Decal Chair.* Recent sculpture includes miniature houses and barns made of such media as wood, tar paper, twigs, and feathers. Although he has experienced several stylistic changes, an underlying interest in works of fantasy and evocation is maintained.

BAUMBACH, HAROLD (Painter)
278 Henry St., Brooklyn, NY 11201

Born: 1905 *Awards:* First Prize, Brooklyn Artists Society *Collections:* Whitney Museum of American Art; Brooklyn Museum *Exhibitions:* Whitney Museum of American Art; Carnegie Art Institute *Education:* Pratt Institute *Dealer:* Gallerie 99, Bay Island, FL; Associated American Artists, NYC

His work at present is poetic in nature. Though it is figurative and possesses landscape imagery, often with animals, it is not concerned with perspective and naturalistic considerations. His interest lies in the dynamics of color and structure. The early canvases were comparatively small-sized, and the subjects were mostly Brooklyn streets and people. Later the work evolved into an abstract expressionist style. Though the current works are closer to recognizable imagery, they are

ordered by his concern for color and structure, especially the destiny that resides in the materials used.

BAVINGER, EUGENE ALLEN (Painter)
730, NE 60, Norman, OK 73071

Born: 1919 *Awards:* Atkins Museum, Kansas City, MO; Denver Art Museum *Collections:* Addison Gallery of American Art; Springfield (MO) Art Museum *Exhibitions:* Razor Gallery, NYC; Kauffman Galleries, Houston *Education:* University of Oklahoma

His paintings have changed in style and technique several times during his career, but the theme of his work is always his perception of the dynamism of nature. His knowledge of science contributes to his view of nature as vibration. His recent works use jewel-like color and radiance to excite a sense of motion in space. The paintings appear to emit their own light. In his concept of nature, color and light are equated. Geometric line is a new element introduced in these works, creating an experience of color in shifting, shimmering planes. The new works suggest extension of movement in space and in time.

BEAL, JACK (Painter)
67 Vestry St., New York NY 10013

Born: 1931 *Awards:* National Endowment for the Arts Grant *Collections:* Whitney Museum of American Art; Art Institute of Chicago *Exhibitions:* Museum of Contemporary Art, Chicago; Whitney Museum of American Art *Education:* School of the Art Institute of Chicago *Dealer:* Allan Frumkin Gallery, NYC

He first gained recognition as one of the New Realist painters in the late 1960s. Sensuously thin figures were quiet, colorful studies, mere pictorial elements in the composition. The frame was often cropped like a photograph, the subjects in high contrast lighting. Recent realistic works are highly stylistic, vividly colored baroque compositions sometimes depicting social themes, such as *The Harvest* with powerful and energetic images.

BEAR, MARCELLE L. (Printmaker, Painter)
1037 Hendricks Ave., Jacksonville, FL 33207

Born: 1917 *Awards:* Awards, Jacksonville Advertising Federation; Award, Jacksonville Art Museum *Collections:* Wright State University; Ira Koger Corporation Collection *Exhibitions:* Jacksonville Art Museum; San Francisco Museum of Art *Education:* American Academy, Chicago; School of the Art Institute of Chicago; Ecole Des Arts Decoratif, Paris

Known primarily as a painter and a printmaker, her work is abstract, sculptural, and richly colored. Her early works demonstrate an interest in color and color relationships, as well as the influence of impressionism. Years of experimenting took her away from a formal aesthetic of painting and printmaking. She developed a freedom of form, line, color, space, and depth which aligned her work with abstract expressionism. While some of her paintings and prints have been in a hard-edgestyle, the current work has returned to abstract expressionism. The oil and acrylic paintings are executed in a new, pale palette while retaining her characteristic concern with the inter-dependence of design, color, and the illusion of depth and space.

BEARDEN, ROMARE HOWARD (Painter)
357 Canal St., New York NY 10013

Born: 1914 *Collections:* Museum of Modern Art; Whitney Museum of American Art *Exhibitions:* Museum of Modern Art; Corcoran Gallery of Art *Education:* Art Students League; Sorbonne University *Dealer:* Cordier and Ekstrom, NYC

Collages consisting of torn and cut paper painted and mounted on canvas characterize the work of this black artist. He began by applying Cubism to an Afro-American heritage. Unlike other blacks of his generation, he rejected the fashionable negative forms of protest, and instead sought to present the history and life of Blacks in new ways which would overcome the obstacles of his time and place. Subject matter includes scenes from rural and urban life, jazz and folk music, home and street life, and religious rituals, presented in African imagery in cubist space. Combining strong traditional qualities with the innovation of his chosen themes, the figures are made into archetypes.

BECHTLE, ROBERT ALAN (Painter)
4250 Horton St. Apt. 14, Emeryville CA 94608

Born: 1932 *Awards:* National Endowment for the Arts Grant; James D. Phelan Award in Painting *Collections:* Whitney Museum of American Art; Museum of Modern Art *Exhibitions:* San Francisco Museum of Modern Art; Corcoran Gallery of Art *Education:* California College of Arts and Crafts; University of California, Berkeley *Dealer:* O.K. Harris Works of Art, NYC

First influenced by the work of Richard Diebenkorn and Nathan Oliveira, a desire to avoid the current styles of the 1960s brought him to realism. An almost imperceptible brush stroke was employed to depict as closely as possible the actual appearance of things. His photo-realistic paintings depict scenes from the California middle-class—families, houses, suburban streets, and cars—so that the viewer might "find significance in the details of the commonplace."

BEHNKE, LEIGH (Painter)
c/o Fischbach Gallery, 29 West 57th St., New York, NY 10019

Born: 1946 *Collections:* Currier Museum; Xerox Corporation *Exhibitions:* Fischbach Gallery, NYC; Thomas Segal Gallery, Boston *Education:* Pratt Institute; New York University *Dealer:* Fischbach Gallery

All of her work in watercolors and oils is representational and deals with the nature of perception and the phenomenon of "seeing'. In every painting there is a connection between panels. In some it is the repetition of the image itself. In others it may be a sequential progression of color relationships or an exploration of formal compositional elements that exist independently of the "object" represented. The individual panels speak to each other; addressing issues of commonality and difference.

BELL, CHARLES S. (Painter)
c/o Louis K. Meisel, 141 Prince St., New York NY 10012

Born: 1935 *Exhibitions:* Solomon R. Guggenheim Museum; Indianapolis Museum of Art *Dealer:* Louis K. Meisel, NYC

Influenced by Richard Diebenkorn and Wayne Thiebaud, he seriously began an artistic career in California in the early 1960s, choosing still life, on a scale much larger than life. Working from photographs, he painted a series of large-scale oil paintings featuring small toys and other objects of childhood. He was particularly attracted to the challenge of depicting the effects of an outside light source on the surfaces of the toys. The *Gumball Machines* series is the most fa-

mous, painted when he was especially concerned with refracted and reflected light on glass globes. Later he photographed objects in a narrow field of focus, and duplicated these out-of-focus areas in the foregrounds or backgrounds of the paintings. In 1977 he worked with a light source coming from within the subject itself in a series of *Pinball Machines.* Studying the effects of light and focus, he often spends hours over-painting and glazing to obtain his desired depth and glowing colors.

BELL, LARRY STUART (Sculptor)
P.O. Box 1778, Taos NM 87571

Born: 1939 *Awards:* Grant, National Endowment for the Arts; Fellowship, John Simon Guggenheim Memorial Foundation *Collections:* Museum of Modern Art; Whitney Museum of American Art *Exhibitions:* Museum of Modern Art; Solomon R. Guggenheim Museum *Education:* Chouinard Art Institute *Dealer:* Marian Goodman Gallery, NYC; Tally Richards Gallery, Taos, NM

In the late 1950s he made shaped canvases, but turned to sculpture around 1961 like fellow Southern Californian, Robert Irwin. During the next few years media included mirrors, glass and plastics, notably in the form of large cubic floor pieces. He experimented with transparent, translucent and opaque surfaces, redefining space. In 1966 the coated vacuum-glass boxes were placed on transparent bases so that light could be transmitted through every part of the work. Free-standing panels of coated glass also explored varying degrees of opacity and reflection. In the 1970s space technology was used to create large coated-glass screens which were placed at right angles, combining reflection and transparency so that as observers walked around the piece they would seem to disappear and reappear. Recent works include "vapor drawings" made from paper formed in a vacuum chamber. He is exploring the same technique with modular glass panels.

BELL, LILIAN A. (Assemblage Artist)
1970 S. Davis St., McMinnville, OR 97128

Born: 1943 *Awards:* Visual Arts Fellowship, Western States Arts Foundation *Collections:* Portland (OR) Arts Museum; Visual Arts Center, Beer-sheba, Israel *Exhibitions:* American Cultural Center, Tel Aviv, Israel; Rennick Gallery, Smithsonian Institution *Education:* William Morris Technical School, London; Linfield College, McMinnville, OR *Dealer:* Harleen & Allen, San Francisco; Anne Goodman, Marina Del Rey, CA; Lopez Quiroga Galeria De Arte, Mexico City

An assemblage artist, she works with cast paper in small-scale two- and three-dimensional formats. The work is characterized by a dreamy childlike aura, suggested through the use of pastel colors. Her older mixed media works draw from pop art and surrealism, and use juxtaposed elements for both playful and satirical effects. Currently she is using paper and wood in a format that speaks directly about personal issues. In liberating paper from its traditional limitations, she goes beyond traditional printmaking style and fuses the graphic and sculptural media.

BENGLIS, LYNDA (Sculptor, Painter)
222 Bowery, New York NY 10012

Born: 1941 *Awards:* Fellowship, John Simon Guggenheim Memorial Foundation; National Endowment for the Arts *Collections:* Museum of Modern Art; Whitney Museum of American Art *Exhibitions:* Whitney Museum of American Art; Art Institute of Chicago *Educa-*

tion: Newcomb College, Tulane University; Brooklyn Museum Art School *Dealer:* Paula Cooper Gallery, NYC; Dart Gallery, Chicago; Fuller Goldeen Gallery, San Francisco; Margo Leavin Gallery, Los Angeles; Texas Gallery, Houston

Flowing plastic forms are made from such media as liquid rubber, latex, and polyurethane, often poured directly onto the floor of the exhibition space, creating "a freely twining mass . . . mixing fluorescent oranges, chartreuses, day-glo pinks, greens and blues, allowing the accidents and puddlings of the material to harden into a viscous mass." During the 1970s she was involved in video productions; she also made wax paintings featuring oral and genital male and female symbols. Golden knots which symbolize emotional states have been included in her recent fiberglass sculptural. "My work contains an ironic self-parody of sexuality."

BENGSTON, BILLY AL (Painter)
110 Mildred Ave., Venice CA 90291

Born: 1934 *Awards:* Fellowship, John Simon Guggenheim Memorial Foundation; National Foundation for the Arts *Collections:* Museum of Modern Art; Art Institute of Chicago *Exhibitions:* Los Angeles County Museum of Art; Corcoran Gallery *Education:* Otis Art Institute; San Francisco Art Institute *Dealer:* James Corcoran Gallery, Los Angeles; Acquavella Contemporary Art, NYC

After study with Peter Voulkos, from about 1960 until the mid-1970s his paintings and ceramics featured a central motif, either a cross, an iris or the chevrons of an army sergeant. Paintings were stapled to gallery walls, sometimes attached around corners. Crumpled aluminum sheets were often used rather than canvas, and various media included oil, acrylic, lacquer and epoxy. The images were two-dimensional, placed on an undefined translucent background rendered in a rich brushstroke. During this time there was also a series of motorcycle paintings. In the late 1970s central images were replaced with overlapping planes in a cubist mode. He continues a concern with the refinement of a well-crafted surface.

BENJAMIN, GERSHON (Painter)
328 Emerson Lane, Berkeley Heights, NJ 07922

Born: 1899 *Awards:* Bronze and Silver Medals, Council of Arts and Manufacturers, Montreal; First Prize, David Kay Awards, Watercolor Section Annual Exhibition, Newspaper Guild *Collections:* The Art Institute of Chicago; Montreal Museum of Fine Arts *Exhibitions:* Korn Gallery, Drew University, Madison, NJ; Audubon Artists Society, NYC *Education:* Montreal Museum of Fine Art; Art Students League, NYC *Dealer:* Zerolf Gallery, Morristown, NJ.

Urban landscapes of New York City of the 1920s, portraits of friends, and simple still lives of flowers dominate his early oil paintings. Working primarily in monochromatic tones of grey, the forms are accentuated by bold outlines and often set against an expansive, peach-colored sky. His later painting, in a variety of media, continues to reflect his fundamental reverence for nature. Broad, flat areas of subtle color are overlaid to produce a luminosity which creates a sense of poetry and mystery in the compositions. While his style is often compared to that of his long-time friend, Milton Avery, he calls himself a "post-impressionist" and mentions the influence of such masters as Cezanne and Matisse.

Gene Bavinger, *Dark Canyon*, 57 x 64, acrylic.

Karl Benjamin, *#8* (1982), 60 x 60, oil on canvas.

BENJAMIN, KARL (Painter)
675 W. 8th St., Claremont, CA 91711

Born: 1925 *Collections:* Whitney Museum of American Art; Los Angeles County Museum of Art *Exhibitions:* Santa Barbara Museum of Art; San Francisco Museum of Modern Art *Education:* Northwestern University; University of Redlands; Claremont Graduate School

Early oil painting employed both figurative and realistic imagery while later compositions became more abstract. Since the mid 1950s his paintings have been characterized by a hard-edged abstract style employing geometric shapes and XeMQ5fi ese compositions was emphasized by the interaction of discrete jhis disposition to flat shapes and pure hues can be detected even in his early work, especially paintings of flowers whose unmodeled petals flatten the picture plane and bring the compositional elements into a frontal organization. Other canvases of architectural subjects are depicted with transparent colors and surfaces whichaccentuate parallel structure. Paintings after 1959 are almost exclusively tightly structured, abstract oil canvases.

BENNETT, TIM (Painter)
P.O. Box 20781, Seattle, WA 98102

Born: 1958 *Awards:* Ford Foundation Fellowship *Collections:* DKB Development *Exhibitions:* Watcom County Art Museum; Jackson St. Gallery, Seattle *Education:* University of Washington; Sun Valley Art Center

Originally a ceramic artist, his early graphite drawings and paintings in oil explored the two fields of abstract expressionism and formal processes. This led to a series of paintings based upon mandala forms and spiritual iconography. More recent work in large scale oil on canvas is firmly based in the figure and semi-representational aspects of the Pacific Northwest landscape, nature, and animal imagery. The large—some as much as 6 by 12 foot—paintings have retained their expressive qualities, free application of paint, and spiritual basis but have become more colorful. Paint is applied thinly with the artist building up multiple layers of luminescent color to achieve his striking and bold affect.

BEN-ZION (Painter)
329 W. 20th St., New York, NY 10011

Born: 1897 *Awards:* American Jewish Congress *Collections:* Metropolitan Museum of Art; Museum of Modern Art *Exhibitions:* Denver Art Museum; Museum of Haifa

His work is essentially expressionistic, characterized by poetic insight and a unique language of art. In the 1940s he was part of "The Ten," a group of young artists who struggled to create something new in art. He has continued his style of representational painting based on the abstract and is perhaps best known for his Biblical paintings and etchings. In recent years he has created a large body of work in iron sculpture.

BERGSTROM, EDITH HARROD (Painter)
670 Guinda St., Palo Alto, CA 94301

Awards: Sahlin Award, American Watercolor Society; Purchase Award, National Watercolor Society *Collections:* Palm Springs Desert Museum of Art; San Jose Museum of Art *Exhibitions:* Louis Newman Galleries, Beverly Hills; Palm Springs Desert Museum of Art *Education:* Pomona College; Stanford University *Dealer:* Van Doren Associates, San Francisco; Louis Newman Galleries, Beverly Hills

Her work was in abstract expressionist oil paintings, until upon becoming fascinated with the palm tree in 1974, she switched from painting abstract to realistic images. Since that time she has painted primarily in watercolors; her subject the palm tree. Layering pure or nearly unmixed watercolor pigments sometimes fifteen to twenty separate layers thick, she builds up a final, clean, rich color. Current work includes large watercolors depicting close up sections of some of the 3,000 species of palms. "I was attracted by the dramatic light and shadow patterns of the palm." This series of palm patterns is simultaneously abstract and realistic, subtle and dynamic. She seeks to extend the limits of the viewers perception toward the tree.

BERGUSON, ROBERT JENKINS (Painter, Calligrapher)
1211 Robinette Dr., Ruston, LA 71270

Born: 1944 *Awards:* Louisiana Major Works, 1984 Louisiana World Exposition *Collections:* Norfolk Museum of Arts and Sciences; Mississippi Museum of Art *Exhibitions:* "Contemporary Miniatures II", Contemporary Arts Center, New Orleans; 80 Washington Square East Galleries, NYC *Education:* University of Iowa

His style of mixed media, enamel and latex painting has been strongly influenced by the American artists Mark Tobey and Jackson Pollack, and other abstract expressionists. For several years he was involved in developing "Bergo Marks'; calligraphic marks incorporated into the composition of his paintings that were emotional, mental and physical arrangements of lines to create visual esthetics. He is currently working on drawings in graphite on paper that use the figure as a point of departure in an expressive and emotional compositional arrangement of objects in environmental settings. This theme also serves as the inspiration for his present large scale paintings.

BERMAN, ARIANE R. (Painter)
161 W. 54th St., New York, NY 10019

Born: 1937 *Awards:* Award, Pen & Brush, Inc.; Purdue University *Collections:* Metropolitan Museum of Art; Philadelphia Museum of Art *Exhibitions:* Kornblee Gallery, NYC; Butler Institute of American Art *Education:* Hunter College; Yale University *Dealer:* Associated American Artists, NYC; Phoenix Gallery; Ward-Nasse Gallery, NYC

While her earlier representational work was executed in oil and depicted carnival and park scenes, her more recent paintings in acrylic concentrate on figures in recreational scenes. She tries to depict life in all its humor, sorrow, and satiric aspects as well as the dream-like qualities. The superficial cheerfulness of a particular scene she depicts, be it a family outing, picnic, or celebration, is always contrasted with the inner sense of isolation, and basic loneliness evident in her subjects. Her particular use of pattern and color for emphasis and psychological effect in her work is a characteristic trait of her graphics, and sculpture as well as her painting.

BERMAN, FRED J. (Painter, Photographer)
3133 N. Marietta Ave., Milwaukee, WI 53211

Born: 1926 *Awards:* Joseph Eisendrath Award, Art Institute of Chicago; Award, Milwaukee Art Institute *Collections:* Brown University; Norton Museum, West Palm Beach, FL *Exhibitions:* Venice Biennale; Royal Academy of Art, London; *Education:* University of Wisconsin *Dealer:* Bradley Galleries and Posner Gallery, Milwaukee; Perimeter Gallery, Chicago

Frederick Brown, *Good over Evil* (1983), 78 x 48, oil on canvas. Courtesy:
Marlborough Gallery (New York NY)

Fred Berman, *Landscape — Winter* (1982), 54 x 50, oil on canvas.

In both his paintings and photographs, his primary concern is with light and color. His images are taken from the city environment and abstracted through fragmentation, reflecting surfaces, and the reorientation of familiar objects. His early work was somber in color and relatively two-dimensional in character. This was followed by a sequence of "white" paintings and the development of a much lighter palette. His recent paintings are much less structured than his early work and deal with spatial relationships. His earliest photographic studies related directly to his paintings and concentrated on subjects such as weathered surfaces and razed buildings. The recent photographs and paintings have become increasingly atmospheric and ambiguous as to locale, but the predominant image still is the effect of light on the urban scene.

BERNS, PAMELA KARI (Painter)
447 Oakdale, Chicago, IL 60657

Born: 1947 *Awards:* Watercolor Wisconsin prizes *Collections:* Kemper Insurance; Bergstrom Art Center *Exhibitions:* Mongerson Gallery, Chicago *Dealer:* Edgewood Orchard Gallery, Fish Creek, WI

Originally a landscape painter, she currently is working with landscape images in transparent watercolor and acrylic on paper. Her work is recognizable for its use of strong contrasts between highly textured surfaces and soft abstract wash areas. Her past work included a series on broken window panes and a series of human-like trees. In most of her work she employs the integrity and boldness of a single image. Shells, bones, fossils, and trees are frequently her subjects, allowing her to explore the textural and formal interrelationships of elements in nature. Recently she has been working on a series of organic shell pieces.

BERRY, CAROLYN (Artist bookmaker, Painter)
78 Cuesta Vista, Monterey, CA 93940

Born: 1930 *Collections:* Art Institute of Chicago *Exhibitions:* Franklin Furnace *Education:* University of Missouri; California State University at Humboldt *Dealer:* Artworks, Los Angeles; Bookworks, Washington, DC

Her most notable work is in one-of-a-kind artists books which she started doing in 1965, and first exhibited and lectured on in 1969. The unique books are characterized by pages containing clippings from magazines, old novels, encyclopedias and dictionaries. They often contain drawings, paintings in watercolor, and photographs by the artist. The subject may be a general one such as women or genealogy, or particular such as *A Trip to Davis* or *Isabella Mountain Jim*. Additionally, she has contributed to copy art journals and mail art exhibitions. She has also worked in portraits, landscapes, balsa and bronze constructions, watercolors, oil paintings, pastels, acrylic and polyform, as well as collage and assemblage art. She is a prolific writer on women in the arts.

BERTHOT, JAKE (Painter)
105 Bowery, New York, NY 10002

Born: 1939 *Awards:* Fellowship, John Simon Guggenheim Memorial Foundation; Fellowship, National Endowment for the Arts *Collections:* Museum of Modern Art; Whitney Museum of American Art *Exhibitions:* Whitney Museum of American Art; Art Institute of Chicago *Education:* Self-taught *Dealer:* David McKee Gallery, NYC

In the 1960s the grid and the graph were the primary means of organizing rectilinear elements in formalist acrylic works. Two or more canvases were often used together in a single presentation. During the next decade the traditional techniques of oil painting were explored as he discovered illusionistic space and added suggestions of landscape and colorful romantic allusions. *Belfast* is a recent example of his work in which earth tones and close-valued colors are incorporated with hints of rectangles to create a mystical quality.

BERTONI, DANTE H. (Painter)
52-02 8th Ave., Brooklyn, NY 11220

Born: 1926 *Awards:* Gold Medal, NACAL *Collections:* United States Navy Combat Art Collection; United States Coast Guard Historic Art Archive *Exhibitions:* American Watercolor Society; National Academy of Design *Education:* Parson's School of Design; New York University *Dealer:* Chadd's Ford Art Gallery, Chadd's Ford, PA

His early watercolor floral still life impressions were painted in the foremost "wet-on-wet" school, inundated with colorful washes augmented with brush stroking, puddling, wiping, sponging, palette knifing and scraping. They are highly translucent and colorful contrasted to his concurrent work in opaque tempera gouache. Currently he is painting more transparent representational watercolors as expressions of his environment. Opposed to painting something "timeless", he records the signatures of our everyday existence; a car, hotdog, skyscraper, iron-ship, neon-light, machine, aircraft, movies, train, people and dress of the present, and anything else of our time.

BERTONI, MAE H. (Painter)
52-02 8th Avenue, Brooklyn, NY 11220

Born: 1929 l *Awards:* Gold Medal, Catholic League Wolfe Art Club *Collections:* Columbia Presbyterian Medical Center; New York Life Insurance Co. *Exhibitions:* American Watercolor Society; National Academy of Design *Education:* Parson's School of Design; Thor Norheim Studio *Dealer:* Grand Central Art Galleries, NYC

The representational scenes depicted in her transparent watercolors are rich with the subject matter and characters—especially children—from her Bay Ridge locale and the lower east-side of Manhattan. The flow of the watercolors themselves have led to her recent exploration of colorful abstractions, undulating with the illusion of water and light. By working with the "wet-on-wet" method of applying the water color to a dampened surface, she achieves a variety of effects. The different pigments flow together creating a ground upon which glazes and dry-brush effects can be added.

BIBERMAN, EDWARD (Painter)
3332 Deronda Dr., Los Angeles, CA 90028

Born: 1904 *Collections:* Houston Museum of Fine Arts; Los Angeles County Museum of Art *Exhibitions:* Museum of Modern Art; Whitney Museum of American Art *Education:* University of Pennsylvania; Pennsylvania Academy of the Fine Arts *Dealer:* Gallery "Z," Beverly Hills, CA

Since the late 1920s, when he first began to exhibit his paintings professionally, the artist has stayed with a figurative idiom. Thematically his interests have been varied, with portraiture an important constant. With a move to California in the mid-1930s he became intrigued by the local landscape and flora, with many paintings reflecting his interest. The region's architec-

Robert Abbett, *Spring Thaw,* 20 x 30, oil. Courtesy: The May Gallery (Scottsdale AZ)

Alta Alberga, *Cock Fight,* 36 x 48, oil on canvas. Courtesy: Second Street Gallery (Philadelphia PA)

David Adickes, *Virtuoso*, 36 x 12 x 10, concrete and steel. Courtesy: Beaux Arts International (Houston TX)

Barbara Aubin, *A Picture is Worth a Thousand Words*, 46 x 28, mixed medium. Courtesy: Fairweather Hardin (Chicago IL)

Dan Allison, *Attack on Rainbow Valley,* 24 x 36, etching. Courtesy: Stone Press Gallery (Seattle WA)

Robert Amft, *Cat and Birds,* 22 x 30, watercolor. Courtesy: Joy Horwich (Chicago IL)

Arman, *Glory* (1984), 54 x 93 x 8, sliced trombones, welded. Courtesy: Marisa del Re (New York NY)

Ruth Ingeborg Andris, *Stone Delivery* (1984), 36 x 24 x 8, alabaster and burlap. Courtesy: Collection: Stuart McCarrell

Mary Ascher, *Science II*.

Alice Asmar, *The Mills of the Gods Grind Slowly. . . ,* 49 x 25,
collage and mixed media. Courtesy: Asmar Studios (Burbank CA)

Gene Bavinger, *Precipice,* 45 x 60, acrylic.

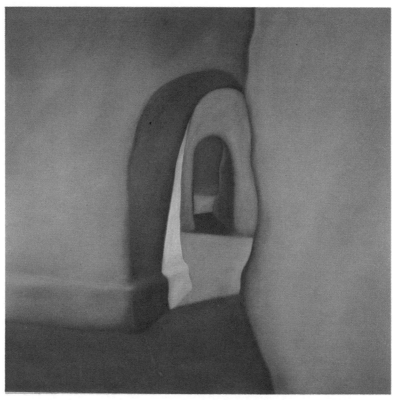

John Axton, *Pecos Shadows,* 40 x 40, oil. Courtesy: Ventana Fine Art (Santa Fe NM)

Robert Anderson, *Mondrian at the Beach,* 46 x 46, acrylic on canvas.
Courtesy: Jack Gallery (New York NY)

Walter N. Ball, *Signal,* 80 x 88, oil.

Karl Benjamin, *#14* (1983), 60 x 60, oil on canvas.

Marcos Blahove, *Sam J. Ervin Jr.,* 32 x 32, oil. Courtesy: Art Gallery
Originals (Winston- Salem NC)

Tom Blackwell, *Herald Square* (1983), 60 x 84, oil on canvas. Courtesy: Louis K. Meisel Gallery (New York NY)

Barry Brothers, *This Space Available (No. 1),* 12 x 36, oil on linen.

41

Fred Berman, *Museum Tavern II,* London, 16 x 20, photograph.

Richard Bogart, *Of Pond and Silent Evenings,* 52 x 60, oil on linen.

James R. Blake, *Two Prisms with Japanese Iris, 25 x 49, oil on canvas. Courtesy: Carlin Galleries (Ft. Worth TX)*

Aaron Bohrod, *Objects D'Arf* (1984), 18 x 24, oil on gesso panel.

Marianne von Recklinghausen Bowles, *Transformations,* 25 x
18 x 5, acrylic on wood.

Edmund Brucker, *Portrait of Bob,* 46 x 36, oil.

M. Booth-Owen, *Jeweled Lady,* 20 x 26, translucent watercolor.

Michael Boyd, *Dows,* 57 x 48, acrylic on canvas. Courtesy: Andre Zarre Gallery (New York NY)

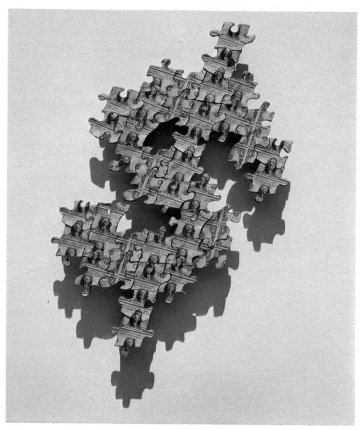

Alan Blizzard, *Cash Flow* (1984), 39 x 23, acrylic and paper
on wood. Courtesy: National Collection (Washington DC)

Anthony Cardoso, *Soccer Players*.

Lawrence Calcagno, *Earth Legend*, 48 x 52, oil. Courtesy: The New Gallery (Taos NM)

Jan Bruggeman, *Cutouts 3-D*, 37 x 40, textile.

Charles Bell, *Pinball #14* (1984), 60 x 80, oil on canvas. Courtesy: Louis K. Meisel Gallery (New York NY)

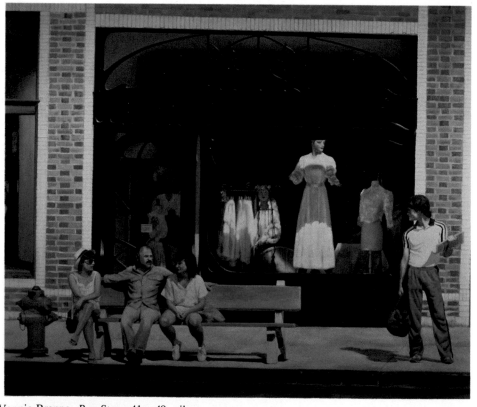

Vonnie Brenno, *Bus Stop*, 41 x 49, oil on canvas.

ture and in particular the freeway systems have provided a springboard for much of his subsequent work. The social climate, from the 1930s through the present, also provides a thematic thread through his work.

BILLIAN, CATHEY R. (Sculptor, Painter)
456 Broome St., New York, NY 10013

Born: 1946 *Awards:* New York State Council on the Arts; Art in Public Places, New Jersey *Collections:* Philadelphia Museum of Art; New York Port Authority *Exhibitions:* Elise Meyer Gallery, NYC; Rutgers University *Education:* Pratt Institute

Her earth paintings of the 1970s gave way to installation environments of solidified earth, lava, and carved beams of light. Environmental approaches have dominated her work since the late 1970s. There is a consistent conceptual investigation of structure and nature, executed in a broad range of materials and projection formats. Her prints and drawings continue a diary of visual ideas on an intimate scale. Current works utilize light beams and projected light images, along with sculpture screens and columns that emit light from within. In some of these projects she collaborates with musicians and dancers to combine performance with a luminous sculpture environment.

BISGYER, BARBARA G. (Sculptor)
50 Lake Rd., Rye, NY 10580

Born: 1933 *Awards:* Presidents Award, Audubon Artists *Collections:* Larry Aldrich Museum; Smithsonian Collection of Small Sculpture *Exhibitions:* Environment Gallery, NYC *Education:* Sarah Lawrence College *Dealer:* Environment Gallery, NYC

After completing her studies, she went on to work with Harold Castor, from whom she learned the technical skills necessary to working in a co-op foundry. From there she studied industrial design with R. R. Kostellow, and welding at a technical school. Her sculpture has been described as "combining symmetry with a sense of incompleteness, of becoming." For her, the work is a means of communicating that moment of recognition.

BISHOP, ISABEL (Painter, Etcher)
355 W. 246th St., New York NY 10471

Born: 1902 *Awards:* Honorable D.F.A., Moore Institute *Collections:* Metropolitan Museum of Art; Whitney Museum of American Art *Exhibitions:* Venice Biennials; Whitney Museum of American Art *Education:* Wicker Art School, Detroit; New York School of Applied Design for Women; Art Students League *Dealer:* Midtown Galleries, NYC

Early works emphasized geometricized forms, but her closest stylistic affinity was with the Ashcan School. From the 1930s to the 1950s she portrayed matter-of-fact, unsentimental views of New York City life. Small graphic works which recall the Dutch Old Masters reflect a recent interest in light and in the relationship between figures and space. Other works display intense juxtapositions of dark and light, a rapid brush stroke and an economy of line, characteristic of seventeenth-century Italian drawing.

BISS, EARL (Painter, Graphic Artist)
c/o Carol Thornton Gallery, 211 Old Santa Fe Trail, Santa Fe NM 87501

Born: 1947 *Collections:* Institute of American Indian Arts Museum; New Mexico Fine Arts Museum, Santa Fe *Exhibitions:* Berlin Festival, W. Berlin; Heard Museum *Education:* Institute of American Indian Arts; San Francisco Art Institute *Dealer:* Linda McAdoo Galleries, Santa Fe; Carol Thornton Gallery, Santa Fe; Joan Cawley Gallery, Scottsdale, AZ

A Crow Indian, his works of the late 1960s and early 1970s were non-objective in an attempt to escape Indian stereotypical modes. In the late 1970s he gained recognition when he returned to Indian subject matter, employing a free brushstroke suggestive of realism and focusing on various aspects of man versus nature. Other themes have included Indian camp rivalries, midnight raids, the hunt, and severe winters in the Big Horn mountains. Because he is intimately acquainted with the subject matter, abstracted representations such as *Crossing Arrow Creek* are full of energy. Yet even more important than portraying his heritage he "loves to move paint" and is highly concerned with the medium itself.

BLACKBURN, ED (Painter)
2237 Warner Road, Fort Worth, Texas 76110

Born: 1940 *Awards:* Grant, National Endowment for the Arts *Collections:* Fort Worth Art Museum; Dallas Museum of Fine Arts *Exhibitions:* "Corcoran Bienniel 1983" *Education:* University of Texas at Austin; University of California at Berkeley *Dealer:* Moody Gallery, Houston

Primarily a painter, he also works in lithographs and drawings. His early style was closely related to German Expressionism. In his paintings of the last decade, he has concentrated on the use of "Media" images as subject. Photographic images which first appeared in newspapers, magazines, and movies are transformed into paintings and prints. A notable series is his translation of stills from "Grade B" Western movies into black and white paintings. The work exhibits a spontaneity and freedom in the marks and brushstrokes, revealing the "hand" of the artist while presenting visual information that is photographic and objective.

BLACKWELL, THOMAS LEO (Painter)
c/o Louis K. Meisel Gallery, 131 Prince St., New York NY 10012

Born: 1938 *Collections:* Solomon R. Guggenheim Museum; Museum of Modern Art *Exhibitions:* Whitney Museum of American Art Annual; Smithsonian Institution *Dealer:* Louis K. Meisel Gallery, NYC

Early abstract work was Pop-influenced, until an interest in motorized forms and in the ways light is reflected from metal surfaces brought him to realistic portrayals of airplanes and motorcycles. Photographs from motorcycle magazines and from his own camera served as models for the large-scale and close-up Photo-realistic paintings of machinery parts for which he is best known. Each shiny surface—chrome, steel or glass—is interpreted differently through variations in color, value and light reflections. His subject is the recording of perception: photography itself. Paintings do have a "painterly integrity," however, built with thin washes for full luminosity. "For me, the richest possibilities exist in a dialogue between opaque and translucent areas." Fascination with machines has led to other subjects, and many newer works feature plate glass windows and storefronts.

BLAHOVE, MARCOS (Painter)
4908 Manning Dr., Greensboro NC 27410

Born: 1928 *Awards:* Eliot Liskin Award; American Drawings Award, Portsmouth Museum *Collections:* National Portrait Gallery; Portsmouth Museum *Exhibi-*

tions: Lowe Art Museum, Coral Gables, FL *Education:* National Academy of Design *Dealer:* Art Gallery Originals, Winston-Salem, NC

After spending his early artistic career in Buenos Aires, Argentina, in 1960 he settled permanently in the United States. Working in oil, charcoal and pastel he established himself as an internationally-known portrait artist. His canvases have been purchased by many prominent American organizations, including The Navy Combat Art Collection, The U.S. House of Representatives, and many American colleges and universities. In 1978 he published a book entitled *Painting Children in Oil*. His goal is to capture as accurately as possible "the likeness and spirit" of the people he portrays.

BLAINE, NELL (Painter)
210 Riverside Dr., Apt. 8a, New York, NY 10025

Born: 1922 *Awards:* Fellowship, John Simon Guggenheim Memorial Foundation; National Endowment for the Arts *Collections:* Metropolitan Museum of Art, Whitney Museum of American Art *Exhibitions:* Fischbach Gallery, NYC *Education:* Richmond School of Art; Hans Hofmann *Dealer:* Fishbach Gallery, NYC

She had her first solo show in 1945 at the pioneer cooperative Jane Street Gallery. Her early work was abstract, but in the early 1950s she gradually became a figurative painter. She is known for her interiors and still lifes, executed in exuberant, painterly, and high-key palette. Her most recent works include oils, watercolors with touches of pastel, and ink drawings. The subjects are Gloucester landscapes, the Austrian Alps, interiors, still lifes, and sports, marked by her transformation of familiar motifs into striking compositions.

BLAKE, JAMES R. (Painter)
c/o Carlin Galleries, 710 Montgomery St., Fort Worth, TX 76107

Born: 1932 *Awards:* Thomas Water Color Award, Artists of Fort Worth and Tarrant Counties; Fort Worth Art Museum Holmes Water Color Award *Collections:* Continental National Bank, Fort Worth; InterFirst National Bank, Fort Worth *Exhibitions:* Dallas Museum of Art; Coe Kerr Gallery, NYC *Education:* Texas Christian University; Los Angeles Art Center *Dealer:* Carlin Galleries, Fort Worth

Early landscapes in gouache were painted directly from nature both in Texas and during travels in Europe. These personal scenes were painted in a contemporary yet realistic style. Later work turned to the medium of oil painting and the still life became the dominant subject. Carefully rendered single flowers were enlarged to become the central image on the canvas. This led to paintings of a magnified and isolated piece of fruit, or a vegetable, and eventually to objects such as a pyramid or a prism. In his present paintings, the prism continues to figure in compositions which now include other shapes with finely worked surface textures.

BLECHMAN, R.O. (Illustrator, Cartoonist)
2 W. 47th St., New York, NY 10036

Born: 1930 *Awards:* Gold medal, Cannes Film Festival; Gold medal, New York Art Directors Club *Collections:* Chase Manhattan Bank; Museum of Modern Art *Exhibitions:* Graham Gallery, NYC; Galerie Bartsch & Chariau, Munich *Education:* Oberlin College *Dealer:* Galerie Schreiner, Basel

Cartoons, illustrations and editorial art for prominent newspaper and magazine publications, as well as several larger collections of cartoons published in book

form comprise his work as an artist in the last thirty years. His drawings are instantly recognizable both for the archetypal characters he portrays and for the unmistakable quality of the line itself. His personal style of pen and ink drawn cartoons have been called "squiggly'. Work in pen and ink with watercolor washes has appeared repeatedly on the cover of New Yorker magazine. His cartoons and books, beginning with the *Juggler of Our Lady* in 1953, are executed in a sparse, "wiggly" style and display a wry, and sometimes bizarre, sense of humor.

BLIZZARD, ALAN (Painter)
c/o Scripps College, Claremont CA 91711

Born: 1939 *Collections:* Metropolitan Museum of Art; Art Institute of Chicago *Exhibitions:* James Ulrich Gallery; Oxford University, England *Education:* University of Iowa; Arizona University; Massachusetts College of Art

Commonplace symbols, objects and phrases are the components of his work. Using emblematic patterns and mass-produced images, he explores the interrelatedness of "component elements" from painting to painting, and from painting to everyday reality. The canvases are hung away from the wall, creating shadows and redefining space "in order to form a connectiveness with the vitality of contemporary life." The paintings, he says, "relate to the contemporary world of technology through their elemental interchangeability and the use of techniques usually reserved to industrial production. Each painting resides comfortably, then, out in the high-tech world after it leaves my studio."

BLOEDEL, JOAN ROSS (Painter, Printmaker)
2207 E. Republican, Seattle, WA 98112

Born: 1942 *Awards:* Betty Bowen Memorial Award, Seattle Art Museum; Artist-in-the-City, Seattle *Collections:* Seattle Art Museum; Rainier Bank, Seattle *Exhibitions:* Rutgers University Museum; Cheney-Cowles Memorial Museum *Education:* Connecticut College; Yale University; University of Iowa *Dealer:* Foster/White Gallery, Seattle

Her paintings have developed from her interest in the use of a variety of brushwork styles combined with printmaking techniques. Her abstract work has its foundation in the organic forms of figurative art and in dynamic color relationships. The layered and textured surfaces of her paintings refer to emotional and kinetic energies. Recent work is composed of large formal shapes which seem to move and sway with vitality from intense colors. The brilliant color and sensuous drawn areas create a pulse which emanates from a rich spatial environment. Titles like *Play Within a Play*, *Churning*, *Moving Tribute*, and *Rockers/Breakers* describe the strength and force of her current compositions.

BOBICK, BRUCE (Painter)
40 Forrest Dr., Carrollton, GA 30117

Born: 1941 *Awards:* Purchase Award, Springfield Museum; Peerman Galleries Purchase Award, National Watercolor Society *Collections:* Illinois State Museum; Krannert Art Museum *Exhibitions:* Pennsylvania Academy of Fine Arts; "Watercolor U.S.A.', Springfield Museum *Education:* University of Notre Dame *Dealer:* Portfolio Gallery, Atlanta His work in watercolors, while derived from a number of different sources, generally has one theme: the life cycle. Although concerned with formal composition, more importantly, by

Marcos Blahove, *Miss Ashley Chase Ferguson,* 32 x 26, oil.
Courtesy: Art Gallery Originals (Winston-Salem NC)

Alan Blizzard, *One Time is no Time* (1984), 36 x 43, Rhoplex on canvas on wood.

employing fantasy in his paintings he tries to give unique insights into the human condition. Currently he is working on two series: a quilt series which grew from his interest in the workings of the subconscious mind. "Imaginary quilts were made by the grandmothers of various historical individuals and while used on their beds in their earlier formative years, the quilt images permeated the individual's subconscious night after night, ultimately leading to a famous invention or discovery, or literary accomplishment." His other recent series is a group of handmade paper "anthropological objects" that are the recently discovered remains of a mythical white culture that lived in the upper Ohio River Valley, prior to the arrival of Christopher Columbus.

BOCCIA, EDWARD EUGENE (Painter)
600 Harper Ave., Webster Grove, MO 63119

Born: 1921 *Awards:* Italian Governor's Citation; Award, St. Louis Art Museum *Collections:* Denver Art Museum; City Art Museum of St. Louis *Exhibitions:* Mitchell Museum; Washington University *Education:* Pratt Institute; Columbia University *Dealer:* Michael Lowe Gallery, Cincinnati

Figure and figure composition along with linear volumetric compositions via color and chiaroscuro are the trademarks of his paintings. Always a figurative painter, his early work shows the figure in dynamic motion. For a while motion dominated and the figure became submerged. The palette was often monochromatic, with light and line weaving in and out of color shapes. These paintings were at first lyrical and mannerist, but they became tonal, the drawing bolder, and expressionistic. His influences moved from Tintoretto to Beckman. The figures became extremely bold, color came out of tone. Occasionally a canvas achieved form through color alone. In his present work, the figurative paintings have taken on surrealistic overtones. They evoke religious, quasi-orthodox statements and the mood is existential. Tonal, but with color, the forms are more often rendered.

BOCHNER, MEL (Conceptual Artist)
c/o School of Visual Arts, 209 E. 23rd St., New York NY 10012

Born: 1940 *Collections:* Whitney Museum of American Art; Los Angeles County Museum of Art *Exhibitions:* Museum of Modern Art; Whitney Museum of American Art *Education:* Carnegie Institute of Technology *Dealer:* Sonnabend Gallery, NYC After formal study, he settled in New York City in 1964 and developed post-Minimalist sensibilities. During the 1960s, drawings visualized set theory and other forms of logic. Experiments in sculpture explored the properties of gravity, weight and measurement. Conceding that things can be described but never fully defined, he examines the appearances of art objects, unconcerned with metaphor and illusion. *Theorem of Pythagoras,* charcoal on paper, describes what can be seen using logic. He seeks to eliminate the intrusive and artificial qualities of art.

BOGART, RICHARD JEROME (Painter)
378 Judd Rd., Easton, CT 06612

Born: 1929 *Collections:* Brooklyn Museum; Yellowstone Art Center *Exhibitions:* Exhibition Momentum; Connecticut Painting and Drawing Exhibition *Education:* School of the Art Institute of Chicago *Dealer:* Meredith Long Galleries, Houston

The ambiguity and mystery of nature have been the foundation of all his art, from the early non-objective and abstract work to the current mystical mirror-images of trees reflected in water. His paint surface is lyrical but obscure, featuring the distillation of rain and mist, a pond under evening "mistwaves," or the solitude of trees shrouded in morning fog. The works suggest an attempt to link 12th-14th century Chinese landscape painting, LN9QUIeFrench Impressionism, and contemporary American color-field painting into an art of historical reverence and personal intimacy.

BOHROD, AARON (Painter)
4811 Tonyawatha Trail, Madison WI 53716

Born: 1907 *Collections:* Art Institute of Chicago; Metropolitan Museum of Art *Exhibitions:* Metropolitan Museum of Art; Solomon R. Guggenheim Museum *Education:* School of the Art Institute of Chicago; Art Students League *Dealer:* Oehlschlaeger Galleries, Sarasota, FL

Influenced by John Sloan, he painted realistic scenes from the daily lives of the people of his home town, Chicago, in brushwork ranging from the highly detailed to the sketchlike. He served as a war artist during World War II and worked in Europe as a *Life* magazine artist. After the war his scenery took on a surrealistic flavor. During the 1950s and subsequent decades he abandoned landscapes and cityscapes, instead placing objects in odd arrangements on wooden screens, and often employing trompes l'oeil, as if he were updating the illusionistic paintings of WIlliam Michael Harnett.

BOND, ORIEL EDMUND (Painter)
7816 Bond Dr., The Ledges, Roscoe, IL 61703

Born: 1911 *Awards:* Illinois State Fair; Burpee Art Gallery *Collections:* James Kohlhorst and Harry Espenscheid Collection *Exhibitions:* Rockford (IL) Art Association; Belle Keith Gallery, Rockford, IL *Education:* Rockford College

A commercial artist by profession, he has pursued fine art as a hobby. He paints landscapes, portraits, and figures, and many of his more recent works have been reproduced in calendars and books. One of his most recent paintings is *Jennifer at the Pump*, in acrylic on Masonite. The subject is a child's fascination with a pump set in an abandoned country school in the Midwest. He has attempted to capture the feeling of sunlight filtering through the foliage of large shade trees. The work shows a particular interest in reflections on a concrete playground overgrown with weeds and dandelions.

BOOTH-OWEN, MARY ANN (Painter)
396l Loch Highland Pass, Roswell, GA 30075

Born: 1942 *Awards:* Best of Show, Powers Crossroads Arts & Crafts Festival, Newnan, GA; Award, 4th Annual Exhibition, Columbia Museum of Arts and Sciences *Collections:* Coca-Cola, Inc; Carnegie-Mellon University *Exhibitions:* Cheekwood Botanical Garden and Art Center, Nashville; Arnold Arboretum, Harvard University *Education:* University of Tennessee; Georgia State University

During the early 1970s, her realistic paintings captured glimpses of the past, establishing her as a regional painter. Moving away from the use of a variety of painted media, and settling on the watercolor technique, botanical studies dominate the present subject matter. Giant flowers, sometimes measuring as much as three by four feet, fill the picture plane. The petals,

Richard Bogart, *Rising Slip Stream,* 48 x 57, oil on linen.

James R. Blake, *Tragedians #1,* 18 x 32, oil on canvas. Courtesy: Carlin Galleries (Ft. Worth TX)

rendered in meticulous detail, appear fragile, translucent, and shimmering with life. While the compositions share concerns with the works of Georgia O'Keeffe or Lowell Nesbitt, the style is more akin to that of the "super-realists.

BOOTHE, POWER (Painter)
49 Crosby St., New York, NY 10012

Born: 1945 *Awards:* Grant, National Endowment for the Arts; Award, John Simon Guggenheim Memorial Foundation *Collections:* Hirshhorn Museum and Sculpture Garden; Solomon R. Guggenheim Museum *Exhibitions:* Institute of Contemporary Art, Boston; Solomon R. Guggenheim Museum *Education:* Colorado College; Whitney Museum Independent Study Program

His oil paintings are abstract compositions constructed in horizontal rows, each row made up of contiguous paint strokes, one row slightly over lapping the other. Earlier paintings were concerned with concepts of time. Within the structure of a grid were notations tracking the movements of the sun. He has also been active in performance, designing sets for Richard Foreman and Mabou Mines, David Gordon and the Pick Up Company, and dancers Lucinda Childs, Charles Moulton, and others. In current work he marks his canvas with well defined strokes—introducing "echoes" that bring certain of his forms into three-dimensional relief. He creates a rhythm of brushstrokes which is then interrupted by intersection. Colors are sensuous within the limited palette he allows for each painting—ranging from atmospheric tonalities to sparkling, "electric" hues.

BOROFSKY, JONATHON (Painter)
c/o Paula Cooper Gallery, 155 Wooster St., New York NY 10012

Born: 1942 *Exhibitions:* Whitney Museum Biennial; Kunsthalle, Basel, Switzerland *Education:* Carnegie Mellon University; Yale University *Dealer:* Paula Cooper Gallery, NYC

Drawing directly onto gallery walls, with such media as charcoal and acrylics, he makes graffiti- and cartoonlike pictures, accompanying them with intentionally obscure statements about himself. Images and monologues come from an "inner world of dreams and other subconscious 'scribbles,' such as doodles done while on the telephone," images which he then records on paper, giving each one a number. (He has been numbering the dreams consecutively since 1968, and has since reached millions.) Later he enlarges them, either projecting them onto walls (*Hitler Dream at 2566499,* for example) or turning them into three-dimensional objects such as *Man with Briefcase,* enamel on plexiglass panels mounted on the ceiling.

BORSTEIN, ELENA (Painter)
451 Broome St., New York, NY 10013

Born: 1946 *Awards:* Award, American Academy of Arts and Letters; National Endowment for the Arts *Collections:* Museum of Modern Art; Neuberger Museum *Exhibitions:* Kathryn Markel Gallery, NYC; Andre Zarre Gallery, NYC *Education:* Skidmore College; University of Pennsylvania *Dealer:* Kathryn Markel Gallery, NYC

Her large, acrylic paintings and pastel studies of Mediterranean buildings, streets, and architectural spaces set in light-drenched haze evoke a certain discomforting feeling of eerie emptiness. These are environments of everyday life's activities, yet not only is a there never a human to be seen in her paintings but any evidence of human presence has been stripped clean from these situations. Her paintings evoke the melancholy aspects of Sheeler and Hopper, yet are executed in a sparser style. Her current work displays an acute formalist reexamination of both space—the plunging obliques of two point perspective—and color—the grays and near grays that operate chromatically. A sense of air brushed razor edged coolness permeates these elegantly beautiful pictures.

BOURAS, HARRY (Painter, Sculptor)
1250 Asbury Ave., Evanston IL 60202

Born: 1931 *Awards:* Fellowship, John Simon Guggenheim Memorial Foundation; Pauline Palmer Award, Art Institute of Chicago *Collections:* Museum of Modern Art; Art Institute of Chicago *Exhibitions:* Museum of Modern Art; Art Institute of Chicago *Education:* University of Rochester; University of Chicago

A colorful Chicago art figure, his name was "spoofed" by a group of Chicago artists in the late 1960s—The Hairy Who Group. Since the early 1960s he has made abstract collage-paintings, ink drawings, assemblages and sculptures made of such materials as concrete and plaster. He was also involved in "happenings." Writing and drawing as much about his life as possible, he then uses these "notebooks" as starting points for the work. "I reject as lifeless and unworthy all stimulations derived from sources other than my own ruminations and games." His subject is "the landscape" of his consciousness. Work of the 1960s was dominated by triptychs; work of the 1970s by "deviation analyses" using "templates, stamps and engineer's tools." Incised concrete slabs appear to be texts of indecipherable ancient or future writings, such as *Message XVI.* The theme of time is prevalent throughout much of the works, including caricature of possible past and future worlds. An art critic for many years, he has hosted a weekly radio program, "Critic's Choice," since 1965.

BOURGEOIS, LOUISE (Sculptor)
c/o Robert Miller Gallery, 724 Fifth Ave., New York NY 10019

Born: 1911 *Awards:* Honorable D.F.A., Yale University; Outstanding Achievement in Arts Award, Women's Caucus *Collections:* Museum of Modern Art; Whitney Museum of American Art *Exhibitions:* Museum of Modern Art; Whitney Museum Biennial *Education:* Ecole de Louvre; Academie des Beaux-Arts *Dealer:* Daniel Weinberg Gallery, San Francisco; Robert Miller Gallery, NYC

Wood constructions, painted in black or white, gained her recognition in the early 1950s. She had experimented with tall, thin figures in groups, meant to interact with the observer. Later she arranged the painted wood forms into constructions resembling landscape or architecture. Since the 1960s Bourgeois has left wooden constructions behind, and has turned to modeling plaster forms meant for metal casting.

BOWLER, JOSEPH JR. (Painter)
9 Baynard Cove Rd., Hilton Head Island, SC 29928

Born: 1928 *Awards:* Artist of the Year, Artists' Guild *Collections:* Sleepy Hollow Country Club, Scarborough-on-Hudson, NY; Dr. & Mrs. William Hayden, Paris, TX *Exhibitions:* Joe Demers Gallery, Hilton Head Island, SC *Education:* Art Students League *Dealer:* Marilyn C. Bowler, Hilton Head Island, SC

His first story illustration for a national magazine was published in *Cosmopolitan* when he was only nine-

M. Booth-Owen, *Lavender's Blue,* 30 x 40, translucent watercolor.

Aaron Bohrod, *Clowns* (1982), 24 x 36, oil on gesso panel.

teen. Three years later he was elected to the Society of Illustrators. His work appeared regularly as illustrations or covers for national magazines. In 1972 he moved with his family to Hilton Head Island, S.C., and has since made a transition to portrait painting. Photographs are a key element in the portrait process. He works from photographs to prepare small studies, which can be mailed to clients for their review before he begins the final portrait. He draws inspiration for his style both from the European and American Impressionists.

BOWLES, MARIANNE VON RECKLINGHAUSEN (Painter, Sculptor)
5 Sage Ct., White Plains, NY 10605

Born: 1929 *Awards:* William Henry Lowman Award; Award, Annual Show, Westchester Art Society *Collections:* Smithsonian Institution; Silvermine Center of the Arts *Exhibitions:* Hudson River Museum; Renwick Gallery, Washington, DC *Education:* Self-taught

The acrylic paintings and mixed-media assemblages of her early work, reflect an America seen through the eyes of an immigrant. The representational, hard-edged painting style was used to depict idiosyncratic narratives and myths. In her current and on-going work, the *Paradise Series*, the painted, mixed-media constructions take the physical form of medieval triptychs. The precision of the painting is reminiscent of the Renaissance and the Flemish masters, but the images are familiar and contemporary ones set in unexpected juxtapositions. The mythic landscapes and universal symbols in her work reveal paradoxes and present the viewer with puzzles on the nature of life and art.

BOWMAN, DON (Painter)
1308 Factory Place, Los Angeles, CA 90013

Born: 1934 *Collections:* Fluor Corporation, Irvine, CA; General Electric Corporation, NYC *Exhibitions:* Art Expo 1982, New York City; The Broadway, Sherman Oaks, CA *Education:* Lincoln University, St. Louis; Pasadena (CA) City College *Dealer:* Art Hall, First Street Gallery, Cathedral City, CA; Irving Novick, Designers Contemporary Gallery, Beverly Hills, CA; The James Gallery, Studio City, CA

His early works in oil were painted in the style of Abstract Expressionism. The pouring of oil paints onto paper was an initial technique used to capture the soft movement of flowing color. The translucent, opaque colors enabled him to manipulate space and form from the confines of the two-dimensional surface to the richness of full-bodied constructions. This concept is still evident in his newest works. Through the formal use of sculpted paper, these current works focus on the striking juxtaposition of sensuous line against the severity of hard-edged compositions. He maintains the use of flowing color found in the earlier paintings. The palette ranges from subtle, refined pastels to vibrant primary colors.

BOWMAN, DOROTHY LOUISE (Painter, Printmaker)
Star Route #1, Ste. Genevieve, MO 63670

Born: 1927 *Awards:* Purchase Award, Brooklyn Museum; Purchase Award, Library of Congress *Collections:* Los Angeles County Museum of Art; Boston Public Library *Exhibitions:* Brooklyn Museum National Print Show; Museum Arte Moderne *Education:* Chouinard Art Institute; Otis Art Institute *Dealer:* Oskar Salzer, Los Angeles

An abstract expressionist and realist expressionist painter and printmaker, her early work was strongly influenced by the structure of plants, growing edges, shapes of limited space, mirrored glass, and woven fantasies. Seascapes, landscapes, and historical settings painted on the California coast and in the Missouri Ozark's are subjects of her current works as a realist expressionist. Recently, she executed architectural concept renderings designed with the city planning department of Saint Genevieve, Missouri. The design for the City Hall facade was engineered to blend with early century architectural forms, a park design, an outdoor theater, and city parking.

BOXER, STANLEY ROBERT (Painter)
37 E. Eighteenth St., New York NY 10002

Born: 1926 *Awards:* Fellowship, John Simon Guggenheim Memorial Foundation *Collections:* Museum of Modern Art; Solomon R. Guggenheim Museum *Exhibitions:* Museum of Fine Arts, Boston; Pennsylvania Academy of the Fine Arts *Education:* Art Students League *Dealer:* Andre Emmerich Gallery, NYC

Paintings record ''sky-light'' in a particular moment, unified by ''nuances of color and line, the sum total of which culminates in a new reality of object-concept.'' The titles of the works are deliberately ambiguous, ''informational instead of educational,'' such as *Weepingsunportrait* (oil on linen). The painted surfaces are textured, almost like sculptures, with run-on titles that are attempts at verbal equivalents of the painted gesture. He rejects the current interest in figurative expressionism.

BOYD, MICHAEL (Painter)
78 Greene St., New York, NY 10012

Born: 1936 *Collections:* Albright-Knox Gallery, Buffalo, NY; Baltimore Museum of Art *Exhibitions:* Andre Zarre Gallery, NYC; Ana Sklar Gallery, Miami, FL *Education:* University of Northern Iowa *Dealer:* Andre Zarre Gallery, NYC

His early work was strongly influenced by abstract expressionism, but geometric elements of shape and structure gradually began to replace a loose gestural approach. By the early 1970s, he was using a severely restricted geometric vocabulary. He has since developed a more complex compositional process that combines systematic and intuitive elements in a grid-based format. His interest in structure lies in its value as a vehicle for complex color experiences. His paintings are often large in size, consisting of several attached panels. Areas may be smooth or loosely brushed, opaque or thinly glazed, with earlier layers of color still visible.

BRADLEY, DAVID P. (Painter)
P.O. Box 5692, Santa Fe, NM 87502

Born: 1954 *Awards:* Artist of the Year Award, Santa Fean Magazine *Collections:* Atlantic Richfield, Denver; Museum of Fine Arts, Santa Fe, NM *Exhibitions:* Elaine Horwitch Galleries, Santa Fe, NM; Heard Museum *Education:* Institute of American Indian Arts, Santa Fe, NM; University of Arizona *Dealer:* Elaine Horwitch Galleries, Santa Fe, NM and Scottsdale, AZ

A member of the Minnesota Chippewa Tribe, he considers himself a folk painter who uses modern techniques. He expresses his philosophical ideas through painting and sculpture, in a style that might be termed ''neo-primitivism.'' In his interiors and landscapes he is particularly interested in showing the details of daily

Michael Boyd, *Powesiek Series #4*, 30 x 22, graphite on paper. Courtesy: Andre Zarre Gallery (New York NY)

Vonnie Brenno, *Fifth Avenue 10:28 AM*, 46 x 40, oil on canvas.

Marianne von Recklinghausen Bowles, *Rites of Passage*, 25 x 14 x 4, acrylic.

human experience. The work shows influences of Fernando Botero, Henry Rousseau, Diego Rivera, and many Indian painters.

BRALDS, BRALDT (Illustrator, Painter)
455 West 23rd St., New York, NY 10011

Born: 1951 *Awards:* Silver Medals, Society of Illustrators; Hamilton King Award *Exhibitions:* Society of Illustrators Annual Show; American Illustrators, Japan *Education:* Self-taught *Dealer:* Milton Newborn, NYC

His meticulously crafted and colorful illustrations in oil on Masonite have appeared in *Time, Redbook, Penthouse,* and *Atlantic Monthly.* Works are small, usually measuring no more than fourteen by twenty inches in size, and display highly detailed draftsmanship and incorporation of figurative elements. Images are often times whimsical juxtapositions that create surrealistic visions. Subject matter varies from animals and portraiture to fantasy settings and historical interpretations. Influenced by Roy Caruthers, Dick Hess, and Wilson McLean, he has a natural bent toward realism but is not photo-realistic in his execution of detail. In terms of style he changes and rearranges reality which together with a strong use of color creates a kind of naive realism.

BRAMLETT, BETTY JANE (Painter)
502 Perrin Dr., Spartanburg SC 29302

Born: 1925 *Awards:* Appalachian Corridors Exhibition II Award; Best in Show, Spartanburg Fall Festival *Collections:* South Carolina Arts Commission; Greenville City Hall Collection, Greenville, SC. *Exhibitions:* The 25th Annual South Carolina Artists Exhibition, Charleston, SC. *Education:* Columbia University; University of South Carolina.

A strict, academic style characterized the early oil and acrylic paintings. More abstract works followed, with forms and color areas blocked out in a manner reminiscent of the late works of Mondrian. In her mixed media paintings, rice paper is collaged onto heavier paper which then serves as a ground for the addition of watercolor. Color, abstractions derived from nature, and the interplay of the materials themselves, are primary concerns. Travels in the Far East have stimulated her interest in papermaking techniques. In present work, hand-made papers are combined with watercolors in free, gestural collage compositions.

BRAMSON, PHYLLIS HALPERIN (Painter)
300 Flora Ave., Glenview IL 60025

Born: 1941 *Awards:* National Endowment for the Arts Craft Grant; Louis C. Tiffany Grant *Collections:* Art Institute of Chicago; Museum of Contemporary Art, Chicago *Exhibitions:* Art Institute of Chicago; Smithsonian Institution *Education:* University of Illinois; University of Wisconsin; School of the Art Institute of Chicago *Dealer:* Monique Knowlton Gallery, NYC; Dart Gallery, Chicago

Seeking to depict a "private mythology" that is "fraught with magical and mystical powers," she expresses "philosophical views about life and one's role as an artist/observer." A quasi-representational artist influenced by Oriental philosophy, she employs mixed media on paper to depict a new kind of surrealism which deals with personal narrative and lush decorative motifs. During the late 1970s the study of mime and theater proved influential in later work. Recent drawings and paintings feature voluptuous women in theatrical roles such as artist, actress, acrobat or magician.

P.G. and the Holy Sparks (1982) is a rectangular space divided into four diagonal sections, each containing fragments of figures and unknown objects engaged in strange dramas.

BRENNO, VONNIE (Painter)
3960 Laurel Canyon Blvd. #389, Studio City, CA 91604

Born: 1950 *Collections:* Continental National Bank, Fort Worth *Exhibitions:* Butler Institute of American Art; Ps Galleries, Dallas *Education:* University of Hawaii; University of Southern California; Art Center College of Design

Her early figurative oil paintings were created with a painstaking process of underpainting and glazing in the tradition of the Venetian masters. Recent work displays her technical ability and discipline in the sure, deft handling of the pigment while the actual method of application has become more spontaneous. Her large canvases are modern genre paintings, depicting people in such familiar urban settings as a crowded sidewalk, a bus stop, or a performance of street musicians. Elements of photo-realism and touches of surrealism are present in her paintings which capture an "ordinary" and transient image with a startling clarity and focus.

BREWER, BILL (Cartoonist)
4013 Country Place, Plano, TX 75023 *Awards:* Award of Merit, Art Directors Club of Kansas City; Citation for Merit, Society of Illustrators *Collections:* Museum of Cartoon Art; Smithsonian Institution *Exhibitions:* Festival of Cartoon Art, Ohio State University; World Cartoon Exhibition, Belgium *Education:* University of California, Berkeley; Chouinard Art Institute

Past work has been in both illustrations and cartoons created for Hallmark Cards as well as various major books, periodicals and newspapers. *Parade Magazine, Saturday Evening Post,* the *Los Angeles Times,* and the *San Francisco Examiner* and *San Francisco Chronicle* have all published his cartoons and illustrations. Cartoons often depict animals as characters with which both men and women can identify. Currently working at Argus communications in Dallas as a creative director and cartoonist in charge of the development of greeting cards, posters, post cards, and calendars, he is trying to incorporate new and innovative concepts into the design of products for the greeting card industry.

BRISTOW, WILLIAM ARTHUR (Painter)
344 Wildrose Ave., San Antonio, TX 78209

Born: 1937 *Awards:* Artist of the Year, San Antonio Art League; Piper Foundation Grant *Collections:* Dallas Museum of Art; Houston Museum of Fine Art *Exhibitions:* Witte Museum; Circle Gallery, NYC *Education:* University of Texas; University of Florida *Dealer:* Sol de Rio, San Antonio

From early experiments with post-cubist figurative imagery, he moved towards abstract expressionism, evolving a non-objective image of palette knife parallel bands and ribbons of color derived from the conceptual base of Clyfford Still and Ernest Briggs. A transition through collage and construction, led to Pop imagery, and the adoption of the tree as a familiar icon. Once the background became a sky he was back into the world of nature and the landscape. The earlier vertical parallels became trees and the horizontal bands and ribbons of paint were adapted to ground planes and furrowed fields, integrating painted images with the artist's native environment of the plains of Texas. In large oil canvases the artist has developed walk-in environments

that explore the interfacing of earth and sky with trees as transitional elements.

BRODERSON, MORRIS (Painter)
657 N, La Cienega Blvd., Los Angeles, CA 90069

Born: 1928 *Awards:* New Talent USA, Art in America; First Prize and Purchase, Los Angeles County Museum *Collections:* Whitney Museum of American Art; Hirshhorn Museum *Exhibitions:* M.H. De Young Museum; University of Arizona *Education:* University of Southern California *Dealer:* Ankrum Gallery, Los Angeles

His work in oil, watercolor, and pastels is primarily realistic still lifes, rich with the color and pattern of the objects he assembles. Humanistic and passionate, these paintings reveal his concern with man's emotional response to the world around him. In his early paintings allegorical themes such as the Crucifixion, Garcia Lorca, and Kabuki legends predominate. Current work depicts both exotic and common subjects, flowers, embellished vases, textiles, and some portraiture. His use of intense color and complex, careful composition unifies seemingly disparate material. The images are embued with a multitude of associations and allusions sometimes approaching fantasy.

BRODHEAD, QUITA (Painter)
211 Atlee Rd., Wayne, PA 19087 *Awards:* Gold Medal, Pennsylvania Academy of Fine Arts; Caroline Granger Award *Collections:* Westerdahl Museum of Widener College, Philadelphia; Huan Kim Collection, Washington, DC *Exhibitions:* Pennsylvania Academy of Fine Arts; Appunto Gallery, Rome *Education:* Pennsylvania Academy of Fine Arts; Grande Chaumiere, Paris

Her painting has evolved from the figurative to the abstract. Her works are characterized by an orchestration of brilliant, contrasting colors and a concern with spatial balance. Her most recent canvases are concerned with weightlessness involving the balance of volumes. These works have a somewhat luminous quality.

BRODSKY, STAN (Painter)
7 Glen-A-Little-Trail, Huntington, NY 11743

Born: 1925 *Awards:* First Prize; Delaware Art Center; Fellowship, MacDowell Colony *Collections:* Parrish Museum; New York University *Exhibitions:* Heckscher Museum; Nassau Community College *Education:* University of Missouri; University of Iowa

His abstracted landscapes are executed in a variety of media including oil, pastel, casein, charcoal, ink, and watercolor. He works both from the immediate observation of nature and from the "inner landscapes" of his imagination while in the studio. His exploration of the possibilities of color and its application has resulted in a lyrical abstract style. The use of mineral spirits with the pigments allow color to flow, collide, infiltrate or slide over preceding passages uncovering unexpected visual possibilities and allusions to nature.

BROER, ROGER L. (Painter)
10819 SE 231st, Kent, WA 98031

Born: 1945 *Awards:* Trail of Tears Art Show; Gold medal, American Indian & Cowboy Artists *Collections:* United States Department of Interior; Pierre Cardin *Exhibitions:* American Indian Art in Paris; Indian Market *Education:* Eastern Montana College; Central Washington University

His work is thoroughly modern and at the same time, distinctly traditional in subject matter. His realistic rendering of representational imagery is executed in a style that spans both impressionism and surrealism. Images are often taken from the American West, both modern landscapes and historical scenes. His use of color is vivid, and by leaving traces of the drawing stage in his completed paintings, we are always reminded of the process of the work.

BROMMER, GERALD F. (Painter)
11252 Valley Spring Ln., North Hollywood, CA 91602

Born: 1927 *Awards:* Purchase Award, National Watercolor Society; Award, American Watercolor Society *Collections:* Glendale Federal Collection; State of California Collection *Exhibitions:* Watercolor U.S.A.; National Academy of Design *Education:* Otis Art Institute; University of California at Los Angeles *Dealer:* Louise Newman Gallery, Beverly Hills; Esther Wells Collection, Laguna Beach; Fireside Gallery, Carmel

Although he began his painting career with traditional watercolor techniques, he is currently involved in a wide range of watermedia expression. His work has developed out of a unique way of working with watercolor and collage employing Oriental rice papers. His current work is mostly representational, but relies heavily on solidly designed structure. Basically he is a landscape painter, working both on location and in his studio to render landscapes and urban interpretations in a transparent watercolor style.

BROOKINS, JACOB BODEN (Sculptor)
431 Cosino Rd., Flagstaff, AZ 86001

Born: 1935 *Awards:* National Endowment for the Arts; Resident Artist, Museum of Northern Arizona *Collections:* Museum of Northern Arizona; University of Oregon *Exhibitions:* State of Arizona; Cosnino Center for the Arts *Education:* Oregon School of Art

His recent sculptural works have departed from the earlier descriptive pieces in steel, terra cotta, or stone. The newer works are multiple unit mixed media "settings," involving hundreds of individual sculptural elements combined and articulated to give dimensional images. His studio complex gives him the technical flexibility to develop an idea through various possibilities and then bring the concept to fruition in one of a number of media.

BROTHERS, BARRY (Illustrator, Painter)
1922 E. 18th St., Brooklyn, NY 11229

Born: 1955 *Awards:* Certificate of Distinction, Art Direction Magazine; Charles G. Shaw Memorial Award in Painting *Collections:* Brooklyn College; Herbert F. Johnson Museum of Art, Cornell University *Exhibitions:* Brooklyn Museum; Museum of the Borough of Brooklyn *Education:* Brooklyn College

His paintings and illustrations of urban landscapes are derived from his black and white photographs. In his paintings, the clutter and dirt of the photographs has been excised. The pavement is clean, architectural details have been simplified, and all signs of human presence are eliminated. Basic geometric order and rhythm, simplified lines and planes, and colors for the most part muted give a sense of idealistic vision to his paintings.

BROWN, ALICE DALTON (Painter)
c/o A.M. Sachs Gallery, 29 West 57th St., New York, NY 10019

Born: 1939 *Awards:* Award Exhibition, New York State Council on the Arts *Collections:* Metropolitan Life In-

surance Company; Western Electric Company, NYC *Exhibitions:* A.M. Sachs Gallery, NYC; McNay Art Institute *Education:* Oberlin College *Dealer:* A.M. Sachs Gallery, NYC

Architecture and architectural details are the subject of most of her realistic oil paintings. Portions of Victorian houses are studied in close-ups which emphasize the abstract configurations of light, shadow, and reflections. Space, foliage, and landscape add richness and contrast to the more elaborate elements. The paintings deal with time, place, and season. The unfamiliar shapes and odd tonalities themselves seem to become the subject. There is a mood of disquietude, a subtle but pervasive pessimism in these apparently serene domestic orders.

BROWN, BRUCE ROBERT (Painter, Sculptor)
17 Sedgwick St., Honeoye, NY 14771

Born: 1938 *Awards:* Award, Ford Foundation; Award, Steubenville Art Association *Collections:* Museum of Fine Arts, Savannah; West Virginia Arts and Humanities Council Collection *Exhibitions:* Pennsylvania Academy of Fine Arts; Bertrand Russel Peace Foundation Show, London *Education:* Tyler School of Fine Arts, Temple University

Primarily an oil painter, he has worked in a wide variety of media. Figure drawing, printmaking, ceramics and sculpture have contributed lessons in line, composition, texture, and form which are incorporated into the continually evolving body of work. His abstract imagery is personal and symbolic; his content subjective and introspective—questioning the "dark areas of human thought." He is an eclectic artist for whom the central concept, the content, of the piece is of primary importance. It is the idea which dictates both the material and the technique.

BROWN, FREDERICK J. (Painter)
120 Wooster St., New York, NY 10012

Born: 1945 *Awards:* Award, New York State Council on the Arts *Collections:* Metropolitan Museum of Art; The Aldrich Museum of Contemporary Art *Exhibitions:* Marlborough Gallery, NYC; Aldrich Museum of Contemporary Art *Education:* Southern Illinois University *Dealer:* Marlborough Gallery, NYC

Older works are in an abstract expressionist vein, with the artist citing the strong influence of Pollock and de Kooning. Though many such works use current brush techniques they often employ "pour and splash" techniques as well to relate perspective in the spirit of New York School action painting. Current works have been exclusively representational. Religious themes dominate the figurative realism painted on large scale canvases. Perspective now takes the form of spiritual levels, not easily recognizable due to their conceptual nature.

BROWN, GARY H. (Painter)
Art Department, University of California, Santa Barbara, CA 93106

Born: 1941 *Awards:* Greenshields Foundation Grant for European Travel *Collections:* Elvehjem Art Center, Madison, WI; Atlantic Richfield Corporation *Exhibitions:* ART/LIFE Gallery, Santa Barbara, CA; Source Gallery, San Francisco *Education:* University of Wisconsin-Madison

He is a painter, designer, and teacher. He considers his work in art to be autobiographical research, deriving from the complexity and variety of daily life. His training and vision guides him in his goal to explore a meaningful life in the context of the larger society. His love of drawing has led to experimentation in design, typography, papermaking, and book design. Presently he is painting in oil and has become involved in glazing and varnish formulas. He is a professor of painting and drawing at the University of California in Santa Barbara.

BROWN, JAMES (Painter)
117 54 219th St., Cambria Heights, NY 11411

Born: 1926 *Awards:* Best in Show, Festival in the Park, Union, NJ; First Prize, Gallery North Juried Show, Setauket, NY *Collections:* Corpus Christi (TX) Museum; Municipal Building, Union, NJ *Exhibitions:* Windermere Art Gallery, FL; Atelier Galerie Fontaine, Quebec City *Education:* Long Island University; Brooklyn College *Dealer:* Dorsey's Art Gallery, Brooklyn

His earlier works were in an impressionistic mode. He then gravitated into surrealism. These works were in oil and were characterized by the dominant use of the palette knife as the method of paint application. Currently, his images are exclusively figurative and/or realistic in style. He has concentrated on carbon pencil renderings of individuals and group urban and rural scenes. This group of drawings has been strongly influenced by the art of Charles White and Francisco Zuniga.

BROWN, JOAN (Painter)
c/o Allan Frumkin Gallery, 50 W. 57th St., New York NY 10019

Born: 1938 *Exhibitions:* University Art Museum, Berkeley (CA) *Education:* California School of Fine Arts *Dealer:* Fuller Goldeen Gallery, San Francisco; Allan Frumkin Gallery, NYC

Early work employed the impasto technique, influenced by the Expressionists, the Impressionists, and the Old Masters. She later studied with Elmer Bischoff and became interested in dynamic interactions between forms. Mysticism and Eastern thought also have affected her work. She deals with introspection, she says, regardless of the subject matter: "The form or image varies, but the content is the same." A California Bay Area artist, she travels in order to study belief systems and cultures. Impressions and images gathered from extensive travels in Europe, Egypt, South America, China and India have inspired recent paintings of shiny enamels.

BROWN, ROGER (Painter)
c/o Phyllis Kind Gallery, 313 W. Superior St., Chicago, IL 60610

Born: 1941 *Collections:* Museum of Modern Art; Whitney Museum of American Art *Exhibitions:* Museum of Contemporary Art, Chicago; Whitney Museum Biennial *Education:* American Academy of Art; School of the Art Institute of Chicago *Dealer:* Styria Studio, NYC; Asher/Faure, Los Angeles; Phyllis Kind Gallery, Chicago

Paintings are both puzzling and whimsical depictions of rural landscapes and cityscapes. A Chicago Imagist, he creates tension between the composition and subject of the scenes, shifting scale and perspective. For example, in *Home on the Range*, patterning is used in a unique way to create a disorienting surface which simultaneously draws the viewer inside the picture's space. Skies are full of stylized clouds illuminated from an unknown

Barry Brothers, *Upstairs 171 SSE (13 Tanks MJW),* 9 x 10, oil on masonite.

Jan Bruggeman, *Chicago,* 24 x 48, textile.

source, which dwarf tiny silhouetted figures on the landscape, also included in *Land of Lincoln* and *Buttermilk Sky*, and figures are engaged in mysterious encounters which the viewer can watch as if from above.

BRUCKER, EDMUND (Painter)
545 King Dr., Indianapolis, IN 46260

Born: 1912 *Awards:* Milliken Award, Art Association of Indianapolis *Collections:* Indianapolis Motor Speedway Hall of Fame Museum; Cleveland Museum of Art *Exhibitions:* Metropolitan Museum of Art; Carnegie Institute *Education:* Cleveland Institute of Art *Dealer:* Lyman & Snodgrass, Indianapolis; Hoosier Salon Art Gallery, Indianapolis

He specializes in portrait painting in oil, pastel, and charcoal. The portraits are naturally representational and marked with a strong feeling for character and expressive drawing. He has painted business and professional people of Indiana and other states. His other works are in various art media, including acrylic, watercolor, etching, and lithography.

BRUGGEMAN, JAN (Fiber artist)
2237 175th St. #1A, Lansing, IL 60438

Born: 1945 *Collections:* American Telephone and Telegraph Technologies Collection; General Accident Insurance Collection *Exhibitions:* American Bar Foundation; Chesterton Art Gallery, Chesterton, IN *Education:* Self-taught *Dealer:* Contempo Art/Design, Lansing, IL

Early work in painting was in acrylics with a hard-edge style. In 1982 he began experimenting with the time honored tradition of fiber applique. Non-woven textile pieces, hand-cut into a variety of shapes, were then combined into landscapes, skylines, and other traditional representations. Works commissioned by large corporations often include corporate logos as part of the design element.

BRUSCA, JACK (Painter)
109 W. 26th St., New York, NY 10001

Born: 1939 *Collections:* Whitney Museum of American Art; Aldrich Museum of Contemporary Art *Exhibitions:* Merrill Chase Galleries, Chicago; Fischbach Gallery, NYC *Education:* School of Visual Arts *Dealer:* Fischbach Gallery, NYC

Early in his career, he freed himself from the conventional devices of illusionistic representation to concentrate upon the act of painting itself. He has used the airbrush to render forms that appear three-dimensional and machine-crafted. Metallic bands, spheres, and coils float within undifferentiated space. The works portray a confrontation between imagery and geometry. In both his past and current works, he insists upon impossible physicalities and the placing of images in an undefined space.

BRYCELEA, CLIFFORD (Painter, Printmaker)
P.O. Box 122, Dulce, NM 87528-0122

Born: 1953 *Awards:* Gold Medal, American Indian and Cowboy Association Show; Purchase Award, New Mexico Watercolor Society *Collections:* Louis L'Amour Collection; The Indian Center, Durango, CO *Exhibitions:* Navajo Tribal Museum; Santa Fe Indian Market *Education:* Fort Lewis College

A leading Navajo artist working in a representational and contemporary style, his paintings in both oil and acrylic, and his prints, stone lithographs and photo prints, picture the various cultures, tell the stories, and recall the legends of the American Indians. The costumes, the life styles, and the mysticism of the native American tribes are depicted in these rich and magical compositions. Often a single figure in elaborate ceremonial garb fills the relatively shallow depth of the picture plane while the background swirls with abstractions that suggest the surreal and ethereal.

BUCKNALL, MALCOLM RODERICK (Painter)
808 West Ave., Austin, Texas 78701

Born: 1935 *Awards:* Best in Oil, Sun Carnival, El Paso Museum of Art; Award, Butler Institute of American Art *Collections:* University of Virginia Museum; Oklahoma Art Center *Exhibitions:* Stephan F. Austin State University; Betty Moody Gallery, Houston *Education:* University of Texas; University of Washingtion

His expressionistic oil paintings, and pen and ink drawings of the 1960s were strongly influenced by his study of primitive art objects. He has retained in his images a disturbing sense of presence of the "other." In current work his sources and style have become more complex and eclectic. Figures with historical art references and fantastic anthropomorphic creatures populate his compositions. The scenes range from a magical land of make-believe to views of the grotesque. Despite the meticulous detail and realism of his oils, watercolors, and pen and ink drawings, the overriding sense is not of realism but of a fantastic search in the dark for mystery itself.

BUENO, JOSE (JOE GOODE) (Sculptor, Painter)
1153 E. 71st, Los Angeles CA 90001

Born: 1937 *Awards:* Cassandra Foundation Grant; American Federation Arts Award *Collections:* Museum of Modern Art; Los Angeles County Museum of Art *Exhibitions:* Whitney Museum of American Art; Art Institute of Chicago *Education:* Chouinard Art Institute *Dealer:* Charles Cowles Gallery, NYC

In the early 1960s milk bottles were placed at the base of his paintings, calling attention to the disparity between the objects and the canvas, between the commonplace and the aesthetic experience. Later a staircase was displayed leading up the wall of a Los Angeles gallery, a presentation called *Untitled Construction*. In the 1970s he turned to printmaking, depicting clouds and sky in a painterly network of color. Recent prints, paintings and drawings use color to present variations on the theme of forest fires.

BUONAGURIO, TOBY LEE (Sculptor)
2104 E. 177th St., Bronx, NY 10472

Born: 1947 *Awards:* Creative Artists Public Service Fellowship for Drawing *Collections:* Everson Museum of Art; K & B Corporation, New Orleans *Exhibitions:* Everson Museum of Art; Contemporary Arts Center, New Orleans *Education:* City College of New York *Dealer:* Gallery Yves Arman, NYC

Since the early 1970s she has been involved with a highly personalized approach to ceramic sculpture. Her exotic "hybrid" images feature flamboyant glazed, lustered, glittered, flocked, painted, and rhinestone-studded surfaces. Her footwear fantasies combine improbable elements, such as flamingo and foliage accouterments, pistol stilettos bedecked with dice, and robot shoes covered with mock-ceramic snakeskin. Her repertoire of works also includes "souped-up" hot rods. Most recently her shrines, bionics, robots, and totems appear to be images in a state of metamorphosis. They juxtapose the hard-edged, metal-

Richard Campbell, *Christmas,* 40 x 50, oil. Courtesy: Susan Catto (Los Angeles CA)

Edmund Brucker, *Reflection,* 36 x 30, oil.

Anthony Cardoso, *Young Circus Performer.*

lic, mechanistic-looking structures of science fiction with magical, mythological creatures.

BURDEN, CHRIS (Conceptual Artist, Performance Artist)
c/o Ronald Feldman Fine Arts, 33 E. 74th St., New York NY 10021

Born: 1946 *Collections:* Long Beach Arts Museum; Museum of Modern Art *Exhibitions:* Riko Mizuno Gallery, Los Angeles; 112 Green St., NYC *Education:* Pomona College; University of California, Irvine *Dealer:* Ronald Feldman Fine Arts, NYC

In Chicago's Museum of Contemporary Art he lay under an angled sheet of glass for forty-five hours, a conceptual piece he called *Doomed.* Primarily known for putting himself in violent and threatening situations, he once had himself "crucified" to the hood of a Volkswagen. He has been shot in the arm with a rifle during a performance as well as being arrested by the Los Angeles Police Dept. for yet another sensational piece. Often recording these performances on film, he has been featured live on American public television and European television stations. He uses experiences like this, from elements found in American culture, to test his own "illusions or fantasies about what happens." He insists that the performances are art, not theater, both because he creates a visual image, and because he actually experiences what is performed.

BURNS, JEROME (Painter)
248 Garfield Place, Brooklyn, NY 11215

Born: 1919 *Awards:* National Academy of Design; Director's Award, National Society of Painters in Casein *Collections:* Metropolitan Museum of Art; Oklahoma Museum *Exhibitions:* Alonzo Gallery, NYC; Long Island University *Education:* Art Students League, Hans Hofmann School *Dealer:* Weyhe Gallery, NYC

In his early work, he was involved with mood, areas of light and dark, and introspection. He used simplified shapes and a generalized surface with little or no detail. During the 1950s, he began painting in casein, working mostly from landscapes. The color in these paintings was low key, in closely related tones. In the 1960s he started using acrylics and worked toward a brighter palette. More recently he has become interested in trompe l'oeil subjects, and has explored this genre for several years. He continues to draw in pencil, exploring the broad interplay of shapes and forms and the changing density of tones. He also draws outdoors with pens in colored inks in an attempt to find a maximum transparency by maintaining the spaces behind and through the colors.

BURNS, JOSEPHINE (Painter)
248 Garfield Pl., Brooklyn, NY 11215

Born: 1917 *Awards:* Fellowship, MacDowell Colony; Fellowship, Yaddo Foundation *Collections:* Bristol City Art Gallery; Whitworth Gallery, Manchester, U.K. *Exhibitions:* Alonzo Gallery, NYC; Long Island University *Education:* Cooper Union Art School *Dealer:* Lillian Kornbluth Gallery, Fair Lawn, NJ

In the past she was influenced by Braque, and worked in a cubist style. Presently she is more interested in the expressiveness of color, as well as structure. She works in oil and pastel, using still life and interior motifs. Many of the interiors include exterior views through windows. The color works as shapes, patterns, and objects, integrating the interiors and exteriors in a com-

position. The entire painting functions on an abstract level with patterns of density and transparency.

BURPEE, JAMES STANLEY (Painter)
3208 Aldrick Ave. South, Minneapolis, MN 55408

Born: 1938 *Awards:* Fellowship, MacDowell Colony; Grant, Minnesota State Arts Council *Collections:* Federal Reserve Bank; Fordham University Collection *Exhibitions:* Sheldon Memorial Gallery, Lincoln, Nebraska; Macalaster College *Education:* California College of Arts and Crafts

Figurative painting on both canvas and paper continues as the primary focus of his work. His figures and representational images deal with personal experiences and the concerns of life and art, captured in domestic and nature scenes. Max Beckmann was a primary influence in addition to Matisse, Morandi, and the artist's teacher, James Weeks. His recent compositions are reduced, simple, and painted in a direct manner. The translucent colors are fitting to subject matter which has become more allegorical using visual metaphors to approach personal, social, and ecological issues.

BUTCHKES, SYDNEY (Painter)
Sagg Main St., Sagaponack, NY 11962

Born: 1922 *Collections:* Metropolitan Museum of Art, Smithsonian Institution *Exhibitions:* Museum of Modern Art *Education:* Art Students League; New School, NYC *Dealer:* Touchstone Gallery, NYC

In the late 1960s and early 1970s, he produced three-dimensional abstract geometric works in acrylic over wooden supports. His next development was color field painting, influenced by living in eastern Long Island. In these works he dealt with landscape references, employing thin washes of acrylic paint. The technique of his most recent work refers back to his early work of the 1960s, but now he uses readily recognizable botanical forms. The works employ a spray technique with both enamels and acrylics.

BUTTERFIELD, DEBORAH KAY (Sculptor)
11229 Cottonwood Rd., Bozeman MT 59715

Born: 1949 *Awards:* National Endowment for the Arts Grants; Grant, John Simon Guggenheim Foundation *Collections:* Whitney Museum of American Art; San Francisco Museum of Modern Art *Exhibitions:* Whitney Museum Biennial; Albright-Knox Art Gallery *Education:* University of California, Davis *Dealer:* O.K. Harris Works of Art, NYC

Training in ceramics and sculpture increased interests in crafts, ethnography and archaeology. These impulses inspired horse images that recall tribal art. She began portraying horses as substitute self-portraits, large, gentle mares made of plaster. The next several series of horses were of mud and sticks, materials used to suggest that the horses were both figure and ground, connecting the external world with the subject. Later horses look as if they consist of branches and dirt, but they actually include such materials as plaster, tar, fiberglass, steel, and papier-mache, each horse representing "a framework or presence that defines a specific energy at a precise moment."

BYE, RANULPH (Painter)
P.O. Box 362, Mechanicsville, PA 18934

Born: 1916 *Awards:* Goldsmith Award, American Watercolor Society; Eastman Prize for Watercolor *Collections:* Museum of Fine Arts, Boston; Smithsonian Institution *Exhibitions:* Allied Artists of America Annual; Salamagundi Club *Education:* Philadelphia College of

Art; Art Students League *Dealer:* Newman Galleries, Philadelphia.

He is a traditional painter of the American impressionist, realist school, who has painted professionally for over thirty five years in both watercolor and oil. His subject matter consists of landscapes, seascapes, village scenes, old mill bridges, Victorian houses, and old farms. The works are subtle in color and strong in contrast, with a sensitivity to texture, light, and mood. He does not tamper with the visual appearance of things, but is always very selective in how he interprets his subjects. A collection of his works of early American railroad stations, *The Vanishing Depot*, was published in 1973.

BYRD, JERRY (Painter)
c/o Hunsaker-Schlesinger, 812 N. La Cienega Blvd., Los Angeles CA 90069

Born: 1947 *Collections:* Newport Harbor Art Museum; Museum of Modern Art, Melbourne, Australia *Exhibitions:* Hunsaker-schlesinge; Ivory/Kimpton Gallery *Education:* University of California, Irvine *Dealer:* Hunsaker-Schlesinger, Los Angeles; Ivory/Kimpton Gallery, San Francisco

Part of a new generation of geometric abstract painters, lyrical abstraction is the aesthetic rule in geometrical compositions with a strong constructivist feeling. Precise symmetrical geometric studies of line and rich color show a great interest in the process of painting. Planar grounds contrast with subtly textured patterned surfaces in highly ordered depictions which fluctuate between two-dimensionality and illusionary space. Formalist works such as *Zinko No. 2* (oil on rag paper) often use a central focus such as a circle to draw the viewer's attention, and geometrical designs are mirror images on either side, emphasizing order within the faceted space.

CADMUS, PAUL (Painter, Printmaker)
P.O. Box 1255, Weston, CT 06883

Born: 1904 *Awards:* Grant, American Institute of Arts & Letters *Collections:* Metropolitan Museum of Art; Whitney Museum of American Art *Exhibitions:* Midtown Galleries, NYC *Education:* National Academy of Design; Art Students League *Dealer:* Midtown Galleries, NYC

A painter, draftsman, photographer, and printmaker, he first exhibited his prints and paintings in the 1920s and 30s. His style includes elements of the surreal and the satirical. The subject matter is almost exclusively people and the human figure, depicted in a representational manner. In 1940 he began working in egg yolk tempera, the medium he has preferred ever since. His works are almost always small in scale.

CALCAGNO, LAWRENCE (Painter)
215 Bowery, New York, NY 10002

Born: 1913 *Awards:* Grant, Ford Foundation *Collections:* Museum of Modern Art; National Gallery, Washington, DC *Exhibitions:* Smithsonian Institution; Museum of Fine Arts, Houston *Education:* California School of Fine Arts; Academy Grande Chaumiere, Paris *Dealer:* New Gallery, Taos

A "second generation" abstract expressionist painter in New York City in the 1950s, his oil paintings of the 1960s became increasingly more minimal. Forms were simplified and reduced while the compositions retained the horizontal banded elements which had been so characteristic of his earlier work. Later work remains quite

abstract yet evokes a sense of mythic landscape. Horizontal bands of color range from deep, "brooding" hues to pale, airy colors that dissolve toward the upper and lower borders of the painting. As in vistas of landscape or sky, the presence of vastness touches the emotional and spiritual.

CALLAHAN, HARRY M. (Photographer)
c/o Light Gallery, 724 Fifth Ave., New York NY 10019

Born: 1912 *Awards:* Photography Award, Rhode Island Arts Festival; Fellowship, John Simon Guggenheim Memorial Foundation *Collections:* Museum of Modern Art; Art Institute of Chicago *Education:* Self-taught *Dealer:* Light Gallery, NYC

He studied engineering briefly, but developed a photography hobby into a career by teaching himself with a Rolleicord in 1938. Six years later he left a job in a photography laboratory to devote himself to his art. His medium, until recently, was almost exclusively black-and-white, focusing on cityscapes, landscapes, and portraiture. Recent color photographs follow earlier themes in rigorously structured compositions which exalt the commonplace, brilliant dye transfer prints of cityscapes. Passers-by in close-up, their faces indifferent or sad, characterize series of photographs taken in such cities as New York, Chicago, Cairo and Providence. Other color series include dreary views of Ireland that are almost monochromatic, as well as brilliantly colored Moroccan scenes.

CAMPBELL, RICHARD HORTON (Painter, Printmaker)
643 Baylor St., Pacific Palisades, CA 90272

Born: 1921 *Awards:* Prize, Los Angeles 7th Festival of the Arts; Prize, Cleveland May Show *Collections:* Theater Guild of America, NYC; Hilton Hotel, Denver *Exhibitions:* H.M. De Young Museum; Butler Institute of American Art *Education:* Cleveland School of Art; University of California, Los Angeles

His early work in oil was figurative and dealt with socio-political subjects. Smooth, flat brushstrokes and a somber palette depicted a dark view of a world peopled with characters embroiled in fear and anxiety. He also produced a series of etchings with anguished figures and grotesqueries. His most recent oils evidence a radical transformation. They are spiritual works and celebrations. Brilliant color and joyous, sensual images abound in compositions that are inspired by dreams, visions, and meditation. These are the metaphysical opposites of the previous figures also from the unconscious. He calls his current images "a new language, a gift."

CAPONIGRO, PAUL (Photographer)
Rt. 3, Box 96D, Santa Fe NM 87501

Born: 1932 *Awards:* Fellowship, John Simon Guggenheim Memorial Foundation; National Endowment for the Arts Grant *Collections:* Art Institute of Chicago; Metropolitan Museum of Art *Exhibitions:* Museum of Modern Art; Art Institute of Chicago *Education:* Boston University *Dealer:* Weston Gallery, Carmel, CA; Photography Gallery, La Jolla, CA; Ledel Gallery, NYC

Originally studying music in the 1950s he later turned to photography and studied with Minor White and Benjamin Chin. Images from nature on a large scale, often in close-up, are abstract renderings of flowers, foliage, water, and landscapes. "Through the use of the cam-

era, I must try to express and make visible the forces moving in and through naturethe landscape behind the landscape.'' A founding member of the Association of Heliographers in New York City, he has taught at Minor White's Creative Photography Workshop, at Yale University and other universities.

CARDOSO, ANTHONY (Painter)
3208 Nassau St., Tampa, FL 33607

Born: 1930 *Awards:* Prix de Paris Award, Raymond Duncan Galleries, Paris; Gold Medal, Accademia Italia, Italy *Collections:* Minneapolis Museum of Art; Ringling Archives *Exhibitions:* Raymond Duncan Galleries, Paris; Rotunda Gallery, London *Education:* University of Tampa; University of South Florida *Dealer:* Warren Gallery, Tampa, Florida

He paints in oil, acrylic, and watercolor as well as creating graphics and sculpture. His early works experimented widely with style and technique. Subjects ranged from abstracted geometric forms to figurative and religious images. His works are often characterized by hard-edged renditions of representative images simplified into high contrast compositions with strong design. In current figurative paintings the perspective shifts and twists into surrealistic visions.

CARLBERG, NORMAN KENNETH (Sculptor, Graphic Artist)
120 West Lanvale St., Baltimore, MD 21217

Born: 1928 *Awards:* Fulbright Teaching Grant; Purchase Award, Ford Foundation *Collections:* Whitney Museum of American Art; Pennsylvania Academy of Fine Arts *Exhibitions:* Museum of Modern Art; Schenectady Museum *Education:* Minneapolis School of Art; Yale University

The designing and silk screen printing of posters while in the United States Air Force, stimulated his interest in multiple images and forms. His later formal study with Josef Albers, Robert Engman, and Erwin Hauer at Yale University's School of Design focused his concern with ordered structures. His subsequent and current sculpture, as well as his graphics, are characteristically modular. The images used in the assemblages are often suggested by the natural world and are always a result of an order necessitated by the unit. The reasoned relationships are complimented by the smooth and sensuous surfaces of the forms.

CARPENTER, EARL L. (Painter)
Box C, Pinewood Studio, Munds Park, AZ 86017

Born: 1931 *Awards:* Stacey Scholarship Fund Award; Purchase Award, Valley National Bank *Collections:* Sen. Barry Goldwater; Valley National Bank *Exhibitions:* Husberg Gallery, Phoenix Biltmore Hotel; Wild Wings Gallery, Santa Rosa, CA *Education:* Art Center, Los Angeles *Dealer:* Wadle Gallery, Santa Fe, NM; Husberg Gallery, Sedona, AZ; Wild Wings Gallery, Santa Rosa, CA; Moran Gallery, Tulsa, OK

Prior to the time he decided to make a living as a fine artist he worked as a technical illustrator and art instructor. He tries to capture nature's changing moods and forms first-hand on canvas, board, or watercolor paper. He uses oil media and applies it as a watercolor technique. His subjects may be the Grand Canyon, which is close to where he lives, or a ''quiet'' close-up on an abstracted part of nature.

CARRINGTON, OMAR (Painter)
3705 Taylor St., Chevy Chase, MD 20815

Born: 1904 *Awards:* Gold Medal, Society of Washington Artists; First Prize, Baltimore Museum of Art *Collections:* Dallas Museum of Art; The Mint Museum *Exhibitions:* Metropolitan Museum of Art; Baltimore Museum of Art *Education:* University of Maryland; Corcoran School of Art; Pennsylvania Academy of Fine Arts

His highly emotional and expressionistic content has been expressed in a variety of painting styles spanning his long career. Early work was impressionistic in nature, then shifted to deal with surrealistic content of memory and fantasy. The paintings that followed were strongly influenced by the abstract expressionist movement. Currently, he cites as his major influences expressionists such as Braque, Miro, Kuniyoshi, and Pittman. Canvases are dark in tonality; moonscapes form the subject matter of many of them. His work deals heavily in fantasy and reflects his emotional and spiritual reactions to the locale and substance of his subject matter.

CARTER, DUDLEY CHRISTOPHER (Sculptor)
3075 Bellevue Redmond Rd., Bellevue, WA 98008

Born: 1891 *Awards:* Hall of Honor, Washington State Historical Society; Music and Art Foundation *Collections:* Seattle Art Museum; Evergreen East, Bellevue *Exhibitions:* Golden Gate International Exposition; D. L. Vaughan, Vancouver, B.C.

His monumental wood sculpture ranges from the fairly realistic to the abstract. All his work retains the creative character produced by his use of the double bit axe, a tool used in trail blazing by the pioneers. The broad planes of his spontaneous creations bring his work in line with contemporary design. In addition to monumental sculpture, he creates cedar and redwood handmade materials and carved primitive buildings. Currently he is working on two monumental projects in British Columbia, two at Bellevue, WA, and one in California. Much of his recent work is designed to conform to the natural shape of the wood or tree, such as his ''Legend of the Moon,'' a commission for the Washington State Arts Commission.

CARTER, JERRY WILLIAMS (Sculptor)
10602 Bucknell Dr., Silver Spring MD 20902

Born: 1941 *Awards:* Fulbright Italiana; American First Place, A Sign of Peace, UNESCO *Collections:* Phillips Collection; Pinacoteca Comunale, Ravenna, Italy *Exhibitions:* National Museum of American Art *Education:* Antioch College; Suomen Taideakatemian Koulu, Helsinki, Finland; Ecole des Beaux Arts, Paris

Early influences included Paul Cezanne as well as the Russian Constructivists. Experimental ceramic sculptural pieces and glass mosaics expressed a radical individualism, reflecting his purpose: ''to evoke higher levels of perception and intellectual and spiritual involvement in the participant-observer.'' Recent architectonic sculptures reflect the influence of contemporary field painters. These large pieces explore the relationship between mankind and the universe. *Second Genesis* is a working painting for a monument which will be constructed from cast concrete and Venetian glass, a commission from the Italian government and the European Parliament. It will be America's contribution to *The Sign of Peace and Friendship,* a permanent monument to world peace and understanding in Ravenna, Italy.

CARULLA, RAMON (Painter)
4735 NW 184th Terrace, Miami, FL 33055

Omar R. Carrington, *Still Life with Flowers,* 30 x 36, oil.

Dudley C. Carter, *Synthesis of Organic Forms, 14'*
High, cedar.

Martin Charlot, *Ko Ke Hanau Hou* (1980), 72 x 48,
oil. Center Art Galleries (Honolulu HI)

Born: 1938 *Awards:* Prize, Metropolitan Museum, Miami; Prize, VI Biennial International of Graphic Art, Puerto Rico *Collections:* Detroit Institute of Art; Cincinnati Art Museum *Exhibitions:* Schweger Gold Galleries, Birmingham, Michigan; Atelier Lukacs, Montreal *Education:* Self-taught *Dealer:* Schweger Gold Galleries, Birmingham, Michigan

His paintings in both oil and acrylic are figurative and expressionistic. In some compositions he uses mixed-media collage elements to build texture and heighten visual contrasts. Plastic elements are extended over large areas of the paper or canvas, suggesting cryptic elements from an exotic, undiscovered culture. Textures are rich and personal. He incorporates mysterious effects, achieved with everyday objects transformed by the stroke of the brush. Work today has evolved into peculiar and characteristic treatments of the human figure. This figurative expressionism captures the human figure full of emotion and feeling. The face is often distorted and is delicately colored to establish a tension between the beautiful and the grotesque.

CASAS, FERNANDO RODRIGUEZ (Painter)
5222 Woodlawn, Houston, TX 77401

Born: 1946 *Awards:* First National Painting and Drawing Awards, Bolivia *Collections:* Museo de Arte Moderno, da Paz, Bolivia; Barbara Duncan Collection *Exhibitions:* Harriet Griffin Gallery *Education:* Rice University *Dealer:* Toni Jones Gallery, Houston, TX

In the late 1960s, he abandoned the minimalistic style that he practiced earlier and began investigating new possibilities in visual representation. During the early 1970s he produced a series of drawings and paintings that dwelled upon human visual perception. The phenomena of binocularity, focus, and peripheral vision were explored in these works. In the late 1970s, his attention focused on the issue of how space-time is represented illusionistically in an image. He developed "flat-sphere perspective" and "polar perspective." With the aid of these systems, he has been producing large paintings and drawings that depict the entire surrounding visual world and also perspective images of more than three dimensions.

CASTLE, WENDLE KIETH (Designer, Sculptor)
18 Maple St., Scottsville NY 14546

Born: 1932 *Awards:* Louis C. Tiffany Grant; National Endowment for the Arts Grant *Collections:* Museum of Modern Art; Metropolitan Museum of Art *Exhibitions:* Smithsonian Institution; Museum of Contemporary Crafts, NYC *Education:* University of Kansas *Dealer:* Alexander Milliken Gallery, NYC

During the late 1960s and early 1970s he experimented with laminated plastic, making flowing organic forms. However, he is primarily known for his decorative furniture pieces in laminated fine woods such as mahogany and maple, ornamented with inlays of ivory or silver leaf. Recent work includes life-size furniture pieces which appear to have articles of clothing casually left there, although upon a closer examination one discovers that these apparently soft objects are actually made of wood, as in *Hat and Scarf on a Chest* and *Shearling Coat* (a coat hanging on a coat rack).

CELMINS, VIJA (Painter, Graphic Artist)
c/o Gemini G.E.L., 8365 Melrose Ave., Los Angeles CA 90069

Born: 1939 *Collections:* Whitney Museum of American Art; Museum of Modern Art *Exhibitions:* Whitney Museum of American Art; Los Angeles County Museum of Art *Education:* John Herron School of Art; University of California, Los Angeles *Dealer:* David McKee Gallery, NYC; Gemini G.E.L., Los Angeles

Born in Latvia, she came to Indiana as a child, eventually studied there, and later moved to California. Images in wood and enamel sculpture as well as her drawings come from her perception of the California landscape. As she seeks to recapture "some remembered light or feeling" from the past, graphite drawings of seas, galaxies and deserts reflect a long-time preoccupation with the tension between surface and depth, motion and stillness. These unified surfaces of graphite on acrylic ground simultaneously depict abstract designs and illusionistic deep space, resulting in a balance between abstraction and the recognizable image.

CHAMBERLAIN, JOHN ANGUS (Sculptor)
222 Bowery, New York NY 10013

Born: 1927 *Awards:* Fellowship, John Simon Guggenheim Memorial Foundation *Collections:* Solomon R. Guggenheim Museum; Museum of Modern Art *Exhibitions:* Solomon R. Guggenheim Museum; Whitney Museum of American Art *Education:* School of the Art Institute of Chicago *Dealer:* Xavier Fourcade, New York City; James Corcoran Gallery, Los Angeles; Daniel Weinberg Gallery, Los Angeles

Crushed motor body parts were his media in the 1950s. Welded tubular sheet forms were linear and open, influenced by David Smith. However, unlike Smith, he did not seek irony or underlying symbolic meanings, but used wrecked automobile parts simply for their color and abstract formal possibilities. Out of his interest in the potential of commonplace materials in creating individual works, after 1963 he began to work with automobile lacquer as his main medium. More recently he has assembled arrangements of discarded metals, foam rubber, plexiglass, and coated paper, in works that are similar to action painting.

CHAN, PHILLIP PAANG (Painter)
5225 Edgeworth, San Diego, CA 92109

Born: 1946 *Awards:* National Endowment for the Arts *Exhibitions:* Third World Painting and Sculpture Exhibition, San Francisco Museum of Modern Art *Education:* University of California, Berkeley

From 1971 to 1973 his paintings and drawings were influenced by Bay Area figurative painters. An interest in the abstract expressionists, especially de Kooning, followed, and in 1975 he moved through a minimalist phase resulting in the rejection of painting entirely. Faced with the dual loyalty to painting and the idea of the "avante-garde" he proceeded through a post-minimal phase of anti-painting lasting until 1981. The paintings of this period utilized constructivism and the assertion of the physicality of paint to create a painted irony of the state of modernist painting. Current work is concerned with the dialectic between structure and anti-structure. It is his attempt to reconcile the circle between the conjunctive mind and the disjunctive experimental world. He is deeply concerned with the metaphysics, and is not interested in rendering things.

CHAPPELL, DOYLE W. (Painter)
4552 Westminster Pl, St. Louis MO 63108

Born: 1938 *Awards:* Goldstein Award; Laguna Gloria Invitational *Collections:* Lynda Byrd Johnson Robb; Sen. Warren Magnuson *Exhibitions:* United States

Phillip P. Chan, untitled, 22 x 28, oilsticks.

Doyle Chappell, *Lisa,* 36 x 48, acrylic.

Capitol; Longview Museum and Arts Center *Education:* University of Texas

Working mainly in a personal style of portraiture, he has sought to create images that are a vehicle for reflecting the changing moods of his subjects. He employs large jars of acrylic paints, celebrating the sensuous flow and feel of the paint with the spontaneous energy of the action painters. Influenced by the work of Robert Rauschenberg he often utilizes a collage approach in his portraits, using bits and pieces of the subject's memorabilia and sometimes even hair and fingernails to create a "mindscape" that helps to convey the person's essence.

CHARLOT, MARTIN DAY (Painter, Illustrator)
P.O. Box 161, Kaneohe, HI 96744

Born: 1944 *Collections:* State of Hawaii Collection; Bishop Museum *Exhibitions:* De Mena Gallery, New York City; Contemporary Arts Center, Honolulu *Education:* Study with Jean Charlot *Dealer:* Bernard Lum, Beverly Hills, CA

Known primarily as an oil painter and a muralist working in the fresco technique, his figurative compositions express an electic spiritualism and humanist concern. The multi-racial people of present day Hawaii are often pictured in re-statements of Christian stories and Polynesian myths to serve as commentary on current social and political issues. In a recent mural scale painting, entitled, *Fruits of the Spirit,* children, fruit, fish and other symbols of fertility and plenty soar through the air amid a lush Hawaiian valley. A careful draftsman and adept colorist, his rich botanical details take on mystical, surrealist connotations and colors glow with the luminous light of the tropics.

CHASE, JEANNE NORMAN (Painter)
1602 Bay Rd., Sarasota, FL 33579

Awards: Award, Florida Artist Group; Award, La-Grange College *Collections:* La Grange College *Exhibitions:* Henry Flagler Museum; Fort Lauderdale Museum of Art *Education:* California State at Northridge *Dealer:* Tatem Gallery, Fort Lauderdale

Her representational paintings and drawings of objects feature the unusual and curious as subject matter. Store windows and their contents, "collectibles," antique dolls, circus events, as well as interesting human faces appear in her compositions. The study of light on form—the interplay of sun, and shadow—is a primary focus in her work. The central image is frequently dappled by the sunlight which filters through straw hats, blinds, and windows—to pattern the surface with delicate designs.

CHAVEZ, EDWARD ARCENIO (Painter, Sculptor)
370 John Joy Road, Woodstock, NY 12498

Born: 1917 *Awards:* Fulbright Grant; Award, Louis Comfort Tiffany Foundation *Collections:* Museum of Modern Art; Hirshhorn Museum and Sculpture Garden *Exhibitions:* Denver Art Museum; Whitney Museum of American Art *Education:* Colorado Springs Fine Arts Center Largely a self-taught painter and sculptor, he sites the masters of the Italian Renaissance and the painters of the Mexican mural school as major influences on his work. Sculpting in bronze and steel, and painting in oil and acrylic, he is interested in the manipulation of materials, allowing the medium to suggest the direction of the work. Both his sculpture and painting are abstract in subject matter. His compositional concerns are the dynamics of space, line, and mass.

Conceptually, he sees the work as metaphysical expressions of personal myth and a part of a universal whole.

CHEMECHE, GEORGE (Painter)
222 W. 23rd St., New York, NY 10011

Born: 1934 *Awards:* American and Israel Culture Foundation *Collections:* Solomon R. Guggenheim Museum; Denver Art Museum *Exhibitions:* Lillian Heidenberg Gallery, NYC *Education:* Ecole des Beaux Arts, Paris *Dealer:* Lillian Heidenberg Gallery, NYC

The source of his work over the past decade has been the elegant calligraphy and highly stylized decorative arts of near-Eastern cultures. An Iraqi Jew who immigrated to Israel at the age of 15, he was raised with these Semitic traditions. His art reflects his immersion in the fluid lines of pan-Islamic script, the rhythms of Kufic writing and illumination, the mosaics of mosques and synagogues, and the embellishments of Hebraic calligraphy. The work generally adheres to a scheme of relatively simple individual form engaged in optically spectacular arrangements.

CHEN CHI (Painter)
23 Washington Sq. North, New York NY 10011

Born: 1912 *Awards:* National Institute of Arts and Letters Grant; Saltus Gold Medal of Merit, National Academy of Design *Collections:* Metropolitan Museum of Art; Pennsylvania Academy of the Fine Arts *Exhibitions:* Metropolitan Museum of Art; Whitney Museum Annual *Dealer:* Grand Central Art Galleries, NYC

Born in Wu-sih, China, he studied and taught in China and then came to the United States in the mid-1940s. He has blended his Oriental background with a Western experience to produce watercolors and oils which combine the philosophies of both worlds. Bustling cityscapes of America are rendered in the gentle lines and subtle color modulations of Chinese art, giving a new vitality to the rugged urban views. Since the 1950s he has published sketchbooks illustrated with watercolors and drawings. In 1978 he returned to the People's Republic of China for a visit and purchased large sheets of Chinese paper for a series of watercolors which were then sent to the Shanghai Museum for mounting on traditional hand scrolls.

CHEN, HILO (Painter)
302 Bowery, Floor 3, New York NY 10012

Born: 1942 *Collections:* Solomon R. Guggenheim Museum; Byer Museum *Exhibitions:* Indianapolis Museum of Art; Wadsworth Atheneum *Education:* Chong Yen College *Dealer:* Louis K. Meisel Gallery, NYC

Born in Taiwan, his formal education there was in architecture. As a U.S. citizen he did not have his first exhibition in painting until 1973. Considered a second-generation Photo-realist, his subject matter is the figure, specifically the female nude. He is now well known for super-real depictions of svelte women set in high contrast lighting, such as *City III*, a large-scale oil painting in which two bikini-clad sunbathers casually lounge in the blazing sun. Additional media include watercolor on paper.

CHERNOW, ANN (Painter)
2 Gorham Ave., Westport, CT 06880

Born: 1936 *Awards:* Painting Fellowship, State of Connecticut *Collections:* Neuberger Museum, Purchase, NY; Housatonic Museum of Art, Bridgeport, CT *Exhibitions:* Alex Rosenberg Gallery, NYC; Queens College *Education:* New York University;

Syracuse University *Dealer:* Alex Rosenberg Gallery, New York City

The images in her work are based on stopped action and reinterpretation of film from the 1930s and 1940s. After a brief period of semi-abstract work, she turned to images of women as subject matter. Her concerns included women as seen on theatre marquees, as paradoxical portraits of "stars," and on actual billboards commissioned by the State of Connecticut. Presently, she is developing multi-figure compositions focusing on women in film. She works in oils, graphic media including pencil erasers, and lithography. Her methods of "erasing" in both drawings and paintings evoke the shimmering, fleeting moment of a screen image about to change.

CHICAGO, JUDY (Painter, Sculptor)
P.O. Box 834, Benicia CA 94510

Born: 1939 *Collections:* Brooklyn Museum; San Francisco Museum of Modern Art *Exhibitions:* Whitney Museum of American Art; San Francisco Museum of Modern Art *Education:* University of California, Los Angeles *Dealer:* A.C.A. Galleries, NYC

Minimalism and color fields characterized this feminist artist's style when she studied in Los Angeles in the early 1960s. All of her work had a woman's perspective, bringing new light on the subject. She is best known for her mixed media presentation *The Dinner Party*, a triangular table, each side forty-eight feet long and each displaying thirteen place settings, that addresses the subject of women in society. Upon each plate was painted a flower in a style derived from Georgia O'Keefe. Each plate was set for a particular woman, and because of the resemblance of the flowers to vaginas, the work proved to be a highly controversial and political statement. "I am trying to make art that relates to the deepest and most mythic concerns of humankind. I believe that . . . feminism is humanism."

CHIHULY, DALE PATRICK (Glass Artist)
4301 N. 33rd, Tacoma WA 98407

Born: 1941 *Awards:* Louis C. Tiffany Foundation Award; Fulbright Fellowship, Murano, Italy *Collections:* Metropolitan Museum of Art; Philadelphia Museum of Art *Exhibitions:* Seattle Art Museum; St. Louis (MO) Art Museum *Education:* University of Washington; University of Wisconsin; Rhode Island School of Design *Dealer:* Walter/White Fine Arts, Carmel, CA; Charles Cowles Gallery, NYC; Carson-Sapiro Gallery and Art Consultants, Denver

The blown studio glass of this decorative artist is well-known. Work of the 1960s trapped the illuminating action of gases like neon and argon to produce an element of movement. Utility was subordinated by lyrical imagery. Later, radiant laminated colors in liquid and flowery shapes that looked molten and alive were often fused together in "clusters." Many of the recent small pieces with fluted rims have been both functional or sculptural, resembling sea urchins, shells and other natural forms from the Pacific coast where he now lives. Tradition and innovation blend in bowl-like objects with fluid irregularities, often with contrasting colors inside and outside. Glowing milky hues, starfish red, jewelweed yellow and other colors from the sea adorn his blown glass forms.

CHRISTENSEN, DAN (Painter)
16 Waverly Pl., New York, NY 10003

Born: 1942 *Awards:* Fellowship, John Simon Guggenheim Memorial Foundation; Theodoran Award *Collections:* Metropolitan Museum of Art; Museum of Modern Art *Exhibitions:* Andre Emmerich Gallery, NYC; Meredith Long Galleries, Houston *Education:* Kansas City Art Institute *Dealer:* Salander-O'Reilly Galleries, NYC

Primarily an abstract painter, he has varied his style over the past seventeen years, always attempting to paint "what he doesn't know." His painting has employed a variety of tools, including spray guns, trowels, and squeegies. The constant in his art is the importance of color, and his work shows a continual exploration of the possibilities of color. Although he formerly painted mostly large canvases, more recent work has been divided between large canvases and smaller paperworks. In his newest work, he uses a pearlescent pigment which allows for subtle manipulation of color. He inscribes the pigment to reveal washes of color previously applied to the canvas or paper, and sometimes paints onto the pigment.

CHRISTENSEN, TED (Painter, Printmaker)
573 3rd St. E, Sonoma, CA 95476

Born: 1911 *Awards:* First Prize, Oregon Society of Arts *Collections:* Sausalito Historical Museum; Bank of America *Exhibitions:* Westview Gallery, San Jose, CA *Education:* Art Center School; Otis Art Institute of Los Angeles

His paintings and prints have always been impressionistic. His forte is the landscape. He painted in oil until 1969, and then switched to acrylics on canvas. This past year he has turned to watercolor on paper to gain the use of white areas, leaving some bare and applying only a transparent glaze to others. At present he is using acrylics in this manner to achieve more strength and brilliance in his work.

CHRISTO (Environmental Artist, Sculptor)
48 Howard St., New York NY 10013

Born: 1935 *Exhibitions:* Wrapped Coast, Little Bay, Australia; Running Fence, Sonoma and Marin Counties, CA *Education:* Fine Arts Academy, Sofia; Burian Theatre, Prague; Vienna Fine Arts Academy *Dealer:* Jeanne-Claude Christo, NYC

Born in Bulgaria, he came to Paris in 1958 and began to wrap objects and packages. In the early 1960s he gained recognition with huge assemblages of oil casks, and in 1964, upon moving to New York City, completed a series of *Store Fronts*, much like stage sets. Subsequently many monuments and buildings all over the world such as the Kunsthalle Berne, have been wrapped in plastic sheeting, redefining the meaning and scope of art. He is best known for *Running Fence* (1972), an eighteen foot high, twenty four mile long fabric fence that ran across the California countryside. Like most of the projects it was time-consuming and controversial; people from all walks of life were brought together to execute the project, and it was later intentionally dismantled and distributed for practical use. His most recently finished work was *Surrounded Islands, Biscayne Bay, Greater Miami, Florida*, (1980-1983) using six and-one-half million square feet of pink woven polypropylene fabric. Five wrapped monuments or buildings, such as *Wrapped Reichstag, Project for Berlin*, are still in progress.

CIVITELLO, JOHN PATRICK (Painter)
733 N. Kings Rd. #232, Los Angeles, CA 90069

Born: 1939 *Awards:* Prix de Rome; Childe Hassam Purchase *Collections:* Minnesota Mining and Manufacturing Co.; Monterey Museum *Exhibitions:* A.M. Sachs Gallery, NYC; Dubins Gallery, Los Angeles *Education:* New York University; American Academy in Rome *Dealer:* Dubins Gallery, Los Angeles

Tinted and toned acrylic colors on a range of subject matter from bold industrial forms to architectural, still-life, and landscape motives make up his early work. The subject content acts as a vehicle for the symbolic implication. The feeling of floating, and the mysterious atmospheric stillness infused with light present in the paintings divulges his strong surrealistic influences. The painter is currently exploring Mediterranean-like subjects of the California coast where the vibrancy of light, atmosphere and color heighten the everchanging landscape.

CLIFFORD, JUDY (Illustrator)
24 W. 90th St., New York, NY 10024

Born: 1946 *Awards:* Women in Design International Competition; Illustrators 23 Award of Merit *Collections:* Museum of American Illustration; Del Monte Corporation *Exhibitions:* 200 Years of American Illustration; International Exhibition of Botanical Drawings *Education:* University of Washington; San Francisco Academy of Art

Illustrations, and oil and acrylic paintings are done in a realistic style that mixes photo-realism with the fantastic in a slick stylized juxtaposition of the real and the imagined. Working as a free lance illustrator in San Francisco and New York, her clients have included American Express, *Cosmopolitan, Good Housekeeping, Reader's Digest, Redbook Magazine* and Almay cosmetics. A recent series of paintings entitled the *Food and Architecture* series, divides the vertical canvases into a play between the skyscrapers of New York City and over-sized scenes of sumptuously prepared deserts.

CLOSE, CHUCK (Painter)
271 Central Park West, New York NY 10024

Born: 1940 *Awards:* Fulbright Fellowship; National Endowment for the Arts Grant *Collections:* Museum of Modern Art; Whitney Museum of American Art *Exhibitions:* Museum of Modern Art; Whitney Museum of American Art *Education:* University of Washington School of Art; Yale University School of Art; Academy of Fine Arts, Vienna *Dealer:* Pace Gallery, NYC

Large-scale photo-realist portraits of faces in black-and-white gained him recognition in 1967. A grid system was used to transfer the photographic image as accurately as possible to the canvas. Similar giant faces were also painted in color, employing layers of the three primary colors much like the color-printing process of photography, as in *Mark.* Since 1972 grid systems have often been left on the finished product in order to emphasize the artistic process. A large variety of media have been employed in the execution of these works, including pastels, watercolors, oil, "fingerprint drawings," printmaking and collage, as well as varying techniques including the use of a highly intricate grid system which creates the look of a computer-generated drawing. These innovative experiments have turned portraits into icons, expanding the concept of portraiture.

CLOVER, SUSAN (Painter)
14553 Ventura Blvd., Sherman Oaks, CA 91403 *Collections:* Laguna Beach Museum of Art; Santa Monica

College *Exhibitions:* Los Angeles Institute of Contemporary Art; Butler Institute of American Art *Education:* Art Center School, Los Angeles; Center for Creative Study, Detroit *Dealer:* Orlando Gallery, Sherman Oaks, CA

A realist painter, she portrays family and friends in her paintings and pastels. The figures in her early works are placed in idyllic settings and appear to be enjoying life and each other's company. In the recent paintings, the figures are at swimming pools, playing and just "hanging out." Fluid paint is applied with dexterity. All areas are given equal status in her compositions. Painterly relationships and subtle color harmonies characterize these works.

CLYMER, ALBERT ANDERSON (Painter)
P.O. Box 2278, Yountville, CA 95499

Born: 1942 *Awards:* First Prize, Vintage 1870 International Exhibition; First Prize, Santa Rosa Statewide Annual Exhibition *Collections:* Newport (CA) Museum of Modern Art; Oakland Museum *Exhibitions:* Dallas Museum of Art; Newport Museum of Modern Art *Education:* Texas A&M University *Dealer:* Arlene Lind Gallery, San Francisco; Shorebird Gallery, Belvedere, CA

He began painting in 1962 while studying with Joseph Donaldson at Texas A&M University. His style ranges from photorealism to abstract expressionism. The technique is acrylic washes used to develop a layering of visual textures. He always has attempted to push his medium and the materials he uses beyond traditional confines. In his recent work, some grasp of instinctual feeling is emerging. A feeling of isolation and independence are recurring themes in all his paintings.

COBER, ALAN E. (Illustrator)
Croton Dam Rd., Ossining, NY 10562

Born: 1935 *Awards:* Gold Medal, Society of Illustrators; Gold Medal, New York Art Directors Club *Collections:* Minnesota Museum of Art; Smithsonian Institution *Exhibitions:* "200 Years of American Illustrators" *Education:* School of the Visual Arts; University of Vermont

He uses a "dip-in" pen and ink to draw his illustrations. His assignments for books, newspapers, and magazines sometimes involve on-the-spot reportage. More often, he creates the visual impact of a scene by using symbolism and graphic references associated with the subject, as in the case of drawings of the Martin Luther King assassination for *Skeptic* magazine. His drawings are mostly expressionistic, but also include texture, shading, emphasis, and color.

COLWAY, JAMES R. (Painter)
101 The Vineyard, Oneida, NY 13421

Born: 1920 *Awards:* Kashiwa Award, Adirondacks National Exhibition of American Watercolors *Collections:* Lyman Allyn Museum; Butler Institute of American Art *Exhibitions:* Chase Gallery, NYC; Arvest Gallery, Boston *Education:* Syracuse University School of Art; University College of Syracuse University *Dealer:* Orleans Art Gallery, Orleans, MA

Early works were heavily textured abstract paintings employing collage and mixed media techniques on large panels and canvases. Recent works are of mixed media on both watercolor paper and canvas, and employ a spontaneous realism, relying heavily on textures derived from his earlier works. The current watercolor and acrylic paintings emphasize strong design themes that suggest changing weather moods with sky and

Ted Christensen, *Mendocino Watertowers,* 24 x 30, oil. Courtesy: Westview Gallery (San Jose CA)

James Colway, *Weathervane & Sparrow,* 24 x 18, watercolor. Courtesy: Aaron Ashley (New York NY)

George Chemeche, *Multi-Figure #4,* 40 x 50, oil on canvas. Courtesy: Grey Art Gallery (New York NY)

cloud themes. Richness of color and a keen sense of composition are characteristics of his work, many of which depict the countryside of upstate New York and the coastline of Cape Cod.

CONGER, WILLIAM (Painter)
3014 W. Hollywood Ave., Chicago, IL 60659

Born: 1937 *Awards:* Bartels Award, Art Institute of Chicago; Cluseman Award, Art Institute of Chicago *Collections:* Museum of Contemporary Art, Chicago; Art Institute of Chicago *Exhibitions:* Douglas Kenyon Gallery, Chicago; Zaks Gallery, Chicago *Education:* University of New Mexico; University of Chicago His paintings, drawings, and other works are abstract, though their formal pictorialism evokes references to everyday environments and experience. His work has developed from abstract expressionist and surrealist traditions, and reflects his study of artistic anatomy. He works with oil on carefully prepared linen and cotton, employing a technique of painting thin layers of opaque and translucent colors over an underpainting. This process gives the work a highly luminous and illusionist appearance. His newer paintings remain abstract, but they are more insistently allusive in reference to an urban landscape of tall buildings, floral growth, wind, and water.

CONNER, BRUCE (Painter, Assemblage Artist)
45 Sussex St., San Francisco CA 94131

Born: 1933 *Awards:* Fellowship, John Simon Guggenheim Memorial Foundation; Gold Medal Award, Milan Biennale *Collections:* Whitney Museum of American Art; Solomon R. Guggenheim Museum *Exhibitions:* Museum of Modern Art; Whitney Museum Annual *Education:* Brooklyn Museum Art School *Dealer:* University Art Museum, Berkeley, CA Early assemblages were made of photographs, feathers, fur, and veils of fabric—silk, lace and chiffon. These surrealist works concerned humor, eroticism, fetishism, horror, and death, most memorably in a figure of a baby doll in a high chair, scorched black as if destroyed at Hiroshima. Recently he has been more direct and formal, working in black and white drawings and paintings which seem to come from drug-induced visions. Many of these intricate designs are mounted on scrolls and framed in silk, a reminder of the earlier fetishistic works.

CONOVER, CLAUDE (Sculptor, Ceramicist)
1860 Oakmont Rd., Cleveland, OH 44121

Born: 1907 *Awards:* Drakenfeld Award, Everson Museum of Art; Governor's Award, Columbus Museum of Art *Collections:* Cleveland Museum of Art; Everson Museum of Art *Exhibitions:* Everson Museum of Art; Butler Institute of American Art *Education:* Cleveland Institute of Art

The artist's early training as a sculptor and painter, has heavily influenced his more recent work in stoneware sculpture. His stoneware pottery forms have their roots in primitive sculpture, and recall the appearance of ancient vessels. His interest in and influence by Mayan culture is evident in the Mayan names, taken from Mayan excavation sites and the Mayan language, that he gives to his pieces. The continuum of clay, and human use of it, is inherent in the artist's work in hand built pottery forms in high fired techniques.

CONOVER, ROBERT FREMONT (Painter)
162 E. 33rd St., New York, NY 10016

Born: 1920 *Awards:* Vera List Award; Creative Artist Public Service New York State Fellowship *Collections:* Whitney Museum of American Art; Museum of Modern Art *Exhibitions:* Brooklyn Museum; Whitney Museum of American Art *Education:* Philadelphia College of Art; Art Students League *Dealer:* Associated American Artists, NYC

Early works during the 1950s were geometric abstract paintings, with limited color. His style changed and became freer in the 1960s, strongly influenced by the Abstract Expressionists, and employing a fuller range of color. At this time he also made abstract and realistic woodcuts. During the 1970s, his work shifted to large colorful cardboard relief prints. These compositions were geometric and abstract, with an emphasis on strong diagonal movements. Presently he is concentrating on etching. The etchings are more realistic than his previous works, with cityscapes as the subject matter.

COOK, LIA (Fiber Artist)
c/o Allrich Gallery, 251 Post St., San Francisco, CA 94610 *Awards:* Fellowships, National Endowment for the Arts *Collections:* American Craft Museum; University of Texas, Austin *Exhibitions:* San Francisco Museum of Modern Art; San Jose (CA) Museum of Art *Education:* University of California, Berkeley *Dealer:* Allrich Gallery, San Francisco

Her large scale woven hangings employed a variety of materials including cotton, wool, and polyurethane fibers. Working with an air brush, space dyeing, and photographic transfers, she was able to give the impression of an underweave. In the late 1970s she paused from these ribbed constructions and dye techniques to develop a series of small studies that she called "pressed weaves". These works employed post-weaving dyes and finishing processes to create shimmering low reliefs. More recent hangings in industrial rayon gain a three dimensional quality from wads of foam inserted horizontally as the works are woven. The fabric is washed and hammered into shining relief before dotting on translucent dyes and opaque prints.

COPLEY, WILLIAM NELSON (Painter)
c/o Phyllis Kind Gallery, 139 Spring St., New York NY 10012

Born: 1919 *Collections:* Museum of Modern Art; Whitney Museum of American Art *Exhibitions:* Whitney Museum of American Art; Centre Georges Pompidou, Paris *Education:* Self-taught *Dealer:* Phyllis Kind Gallery, NYC

Self-taught, he did not start painting until 1946. From 1951 to 1964 he lived in Paris and associated with Max Ernst, Man Ray and Marcel Duchamp. In New York City in 1964, he began describing the ordinary world with humorous comic-strip sketchy figures and blots of color. His media is mixed, and often features materials used as camouflage—such as curtains, veils, and masks. He has shown work in exhibitions of Surrealism, Pop Art, assemblages, and erotica.

COST, SHELLEY ANNE (Painter)
P.O. Box 3638, Carmel, CA 93921

Born: 1953 *Awards:* Feature article, Southwest Art *Collections:* West Point Military Academy *Exhibitions:* James Peter Cost Gallery, Carmel *Education:* University of California, Los Angeles *Dealer:* James Peter Cost Gallery, Carmel

Her technique combines the academic instruction of her artist father, James Peter Cost, with her own style of realism in transparent watercolors, gouache, acrylic, and oil. Her work is characterized by a traditional

approach to detailed landscape and portraiture painting with subject matter predominately the landscape and people of Northern California. Her paintings portray Victorian homes and working ranches in her native Monterey Bay area as well as recognizable golf course scenes from the Monterey Peninsula. The figure holds equal fascination for her in her paintings. Current work includes landscapes of Salinas and Carmel Valley ranches and ranch animals.

COTTINGHAM, ROBERT (Painter)
16 Blackman Road, Newtown CT 06470

Born: 1935 *Awards:* National Endowment for the Arts Grant *Collections:* Whitney Museum of American Art; Museum of Modern Art *Exhibitions:* Brooklyn Museum; Whitney Museum of American Art *Education:* Pratt Institute *Dealer:* Fendrick Gallery, Washington, DC

He gained recognition as a New Realist in the late 1960s and the 1970s with paintings which were Photorealistic close-ups of the shining surfaces of polished steel, glass and electric signs on building facades, spelling out words and parts of words, as in *Flagg Bros., Toys, Broadway*, and *Roxy*. Annual trips on a bus take him to areas of urban decay, where he takes photographs with a Hasselblad of the signs and facades, and produces slides that are later projected and used as models for his work. The resulting paintings are gradually modified, so that they do not exactly replicate subject, color and tone as the photograph was able to do, for his subject is painting. "If the final work can be read . . . as a formal painting, taut and succinct, and at the same time as a depiction of a sign—I feel the work approaches success."

CRABTREE, JAN FRENCH (Painter)
311 Old La Honda Road, Woodside, CA 94062

Born: 1943 *Collections:* Blackman Garlock and Flyn & Company; Mr. and Mrs. James Flood *Exhibitions:* Oakland Museum, Art Division; San Jose Museum of Art *Education:* San Jose State College *Dealer:* Crabtree and Associates, Palo Alto, and Woodside, CA

Employing the media of paint, wood, metallic thread, and silver and gold plate, she describes a love for the horse. Her aim is to capture "the live and vital emotions I feel from riding horses." The paintings become metaphors for the riding experience itself: "architectural lines next to unconfined paint, weighted silver next to delicate thread, fresh cloth stained with blood, all represent the rider's graceful discipline combined with the horse's powerful forward movement." Recently her work was part of an exhibition entitled *Sport on Horseback*, sponsored by the Wells Fargo Bank to celebrate the equestrian events of the 1984 Olympic Games.

CRESPIN, LESLIE (Painter)
Box 357, Taos, NM 87571

Born: 1947

Her work consists of paintings and assemblages. She uses found objects and a variety of media, including woodblock, oil, acrylic, pastels, and natural pigments. The layering of textures and surfaces in her work adds a paradoxical complexity to her subjects, which are portrayed in simple abstraction. She produces her dyes and paints from substances found in the area of New Mexico where she lives. These materials further communicate her awareness of the earth and nature. In all her work she combines emo-

tion with technique and material to form a rich, strong statement about reality.

CRISPO, DICK (Painter)
412 W. Curtis, Salinas, CA 93906

Born: 1945 *Awards:* First Place, California State Fair; Gold Medal, Italian Academy of Art *Collections:* Museum of Western Art; Bibliotheque National, Paris *Education:* Carmel Art Institute; Arizona School of Art

Work has been primarily as a muralist, completing over sixty murals in the United States, the most famous being the world's longest indoor mural, over a half mile long, on the main line of the central facility at Soledad Correctional Facility in Soledad, Ca. The piece is entitled, *America the Outside*. Currently he is developing abstract paintings on rhythmic patterns in nature and in the mind, but his first love is the mural, as it encompasses both a wide audience for its appreciation and a sense of community participation in its completion.

CROZIER, RICHARD LEWIS (Painter)
624 Preston Pl., Charlottesville VA 22903

Born: 1944 *Awards:* Purchase Award, Southeastern Center for Contemporary Art *Collections:* American Embassy, Zaire *Exhibitions:* Pennsylvania Academy of the Fine Arts; Virginia Museum of Fine Arts *Education:* University of Washington; University of California, Davis *Dealer:* Tatistcheff, NYC

He studied with Wayne Thiebaud in California in 1974, and has since been concerned with the accurate depiction of reality in landscape paintings which highlight the Albemare County of Virginia, the Blue Ridge Mountains. Small oil studies are painted directly from nature, and large-scale studio works are composites based on the studies. Picturesque landscapes have been criticized for being merely "scenic," but without pretense he continues to capture landscapes in a moment in time, with an overriding theme of precise weather and light.

CROZIER, WILLIAM (Sculptor)
c/o Xavier Fourcade, 36 E. 75th St., New York NY 10021

Born: 1942 *Collections:* Metropolitan Museum of Art; The Patrick Lannan Foundation *Exhibitions:* Whitney Museum Biennial; Metropolitan Museum of Art *Dealer:* Xavier Fourcade, NYC

Representational bronze cast sculptures are traditional in technique and scale. Erotic male and female nudes of anatomical frankness are modern-day figures placed in their own environments also made of bronze. The figures are often horizontal, lying on a bed with disheveled sheets and pillows. Women alone, or couples engaged in sexual intercourse are common subjects, treated with honesty and erotic energy. Bronze is employed in a traditional way to effectively display the medium itself and the art of sculpture, imbuing contemporary realistic figures with dignity and permanence without the encumbrances of social commentary, irony or sarcasm.

CUNNINGHAM, JOHN (Sculptor)
Dept. of Art, Skidmore College, Saratoga Springs, NY 12866

Born: 1940 *Collections:* Museum of Modern Art, Basil; Hirshhorn Museum and Sculpture Garden *Exhibitions:* Betty Parsons Gallery, NYC; Oklahoma Art Center *Education:* Kenyon College; Yale School of Art and Architecture

His sculpture is primarily abstract, large-scale floor pieces. Works are singular light-gathering, acrylic forms to composite structures, unique juxtapositions of abstract and geometric shapes consisting of old and new materials—wood, plastic, and steel. Translucent acrylic is combined with the notable opaque density of geometric slices of black steel, cut, welded, drilled, ground to smoothness, painted and bolted to monolith 6″ x 6″ polished pine posts. In the recent piece *Dance of Three*, three huge wood posts are joined together at their apex with black steel caps and welded pipe, to appear balanced upon their black steel footings.

CURTISS, GEORGE CURT (Painter)
832, NE 124th St., North Miami, FL 33161

Born: 1911 *Awards:* Metal, Academy of Fine Arts, Munich; Medal, Galeria Del Sagratto, Milan *Collections:* Museum of Modern Art, Munich; Museum of Art, Vienna *Exhibitions:* Museum of Science and Natural History; Montmartre Art Galleries; Palm Beach *Education:* Academy of Art, Milan; Academy of Fine Arts, Berlin *Dealer:* The "R" Gallery of Art, Miami, FL

While working in many media including graphics and sculpture, he is known primarily as a painter. His oil paintings are representational, displaying a stylized realism and exploring a wide range of modern art movements. Portraits and landscapes were favorite early subjects. An active participant in the peace movement, the horror of war and the threat of nuclear holocaust are the themes of much of his recent work. Consistent with his view of art as an instrument for social and political education, his current painting is evangelistic and expresses Christian themes.

CUSACK, MARGARET (Fiber Artist)
124 Hoyt Street, Brooklyn NY 11217

Born: 1945 *Awards:* Society of Illustrators; Emmy Award *Collections:* Kettering Foundation; Aid to Lutheran Association *Exhibitions:* Renwick Gallery, Washington, DC; Art Directors Club, NYC *Education:* Pratt Institute

In addition to her work as an artist/illustrator in appliqued collage, soft sculpture, and woodcuts, her early work as a graphic and set designer, has garnered her considerable notoriety and even won her an Emmy Award. Her fabric work began in 1972 with explorations of portraits and landscapes in applique. Since that time she has been creating a series of "skyscapes"—large hangings that are realistic, yet abstract, sky-land compositions—that are padded, and sometimes mounted on canvas stretchers. The surfaces are highly textured, and dyed to create rich imagery of many moods. Her current work includes illustrations in fabric and woodcuts, portraits, soft sculpture, banner, hangings, and pillows.

DAHILL, THOMAS HENRY, JR. (Painter)
223 Broadway, Arlington, MA 02174

Born: 1925 *Awards:* Fellow, American Academy in Rome *Collections:* Fogg Art Museum, Cambridge, MA *Exhibitions:* Downtown Gallery, NYC; Carl Siembab Gallery, Boston *Education:* Boston Museum School; Skowhegan School

His compositions of the late 1950s were large canvases characterized by strong color and hard-edged flat shapes. The decorative textures changed to expressionistic brushwork in the early 1960s. The outer shape of the work began to reflect the organic content in 1962, leading to shaped canvases dependent on and derived from inner structure. In recent years the subject matter has become less expressionistic and more clearly defined. Paralleling the production of the large compositions have been the development of small pen drawings of similar subject matter and pen and watercolor drawings of locales visited by the artist. The latter are characterized by a precision and freedom of pen lines and washes, used to render light, color, and atmosphere. The most recent works depict places in Madagascar.

DAILY, EVELYNNE MESS (Painter)
6237 Central Ave., Indianapolis, IN 46220

Born: 1903 *Awards:* J. I. Holcomb Award, Heron Museum of Art *Collections:* Pennsylvania Academy of Fine Arts; Library of Congress *Exhibitions:* National Academy of Design; Art Institute of Chicago *Education:* Ecole des Beaux Arts, France; School of the Art Institute of Chicago *Dealer* Central Art Studio, Indianapolis, IN

Her early paintings and etchings were of subjects sketched while traveling in Europe. Later her concentration turned to the aquatint etching process. Presently she is painting landscapes and personalities in Southern Indiana, using diverse techniques. She also does still lifes in her studio. In a complete departure, she also is developing abstract designs using an air brush technique.

DALY, TOM (Illustrator, Painter)
47 East Edsel Ave., Palisades Park, NJ 07650

Born: 1938 *Awards:* Award of Excellence, Society of Illustrators *Collections:* Smithsonian Institution Collection of American Poster Art *Exhibitions:* Youngstown Museum; Smithsonian Institution *Education:* Art Students League

He has worked in the business of art for reproduction since 1961. His work has appeared on record albums covers, posters, magazine covers, and animated television commercials in a variety of techniques including gouache and watercolor paintings. Works are both in black and white illustrations as well as paintings. A light and airy illustrative style, with lots of color in stylized realism is characteristic of his paintings. His sometimes whimsical, playful nature, is almost always present.

DAPHNIS, NASSOS (Painter)
362 W. Broadway, New York, NY 10013

Born: 1914 *Awards:* National Foundation of Arts; Fellowship, John Simon Guggenheim Memorial Foundation *Collections:* Museum of Modern Art; Solomon R. Guggenheim Museum *Exhibitions:* Leo Castelli Gallery, NYC; Albright-Knox Gallery, Buffalo, NY *Education:* Art Students League; Academie Frochot, Paris *Dealer* Leo Castelli Gallery, NYC; Andre Zarre Gallery, NYC

During a long and successful artistic career, the artist's work has undergone several major changes. In the 1930s work was in the modern primitive style. Then, in the 1940s, a change toward more imaginative, surrealistic, organic, and amorphic abstractions took place. In the 1950s the artist began to explore the geometric shapes and lines that have remained the characteristic element of the work ever since. In the most recent work there is an attempt to capture the energies that exist in outer space. The visual images in the current paintings represent transmitted radio waves and magnetic fields.

Stephen De Santo, *Ocean City Hotel Awning,* 24 x 36, acrylic.

Tom Dahill, *Forum—Rome. From House of Vestals,* 9 x 13, pen & wash.

DAUGHTERS, ROBERT A. (Painter)
702 San Antonio, P.O. Box 1745, Taos, NM 87571

Born: 1929 *Awards:* Best of Show and Governor's Purchase Award, New Mexico State Fair *Collections:* Valley National Bank, Phoenix; Maytag Foundation, NYC *Exhibitions:* New Mexico State Fair; Philbrook Museum *Education:* Kansas City Art Institute *Dealer* Taos Art Gallery, Taos, NM; Linda McAdoo Gallery, Santa Fe, NM.

His earlier works were in a realistic, academic vein, and dealt mostly with Southwestern Indians and landscapes.His present works are a result of a period of experimentation with composition, color, and paint. He strives for a strong composition in every painting as a foundation of the work. He also concentrates on proper color balance, "bending" his colors to enhance the composition. The artist is influenced by the impressionistic painters. However, he believes his work is an expression of the subject he is painting and not necessarily the true nature of that subject.

DAVIDOVICH, JAMIE (Video artist)
152 Wooster St., New York, NY 10012

Born: 1936 *Awards:* Video 81, San Francisco Video Festival; Fellowship, National Endowment for the Arts *Collections:* Everson Museum of Art; Dayton Art Institute *Exhibitions:* Sao Paulo Biennal; Center for Media Arts, Paris *Education:* School of Fine Arts, Buenos Aires; School of Visual Arts, NYC

Early work was in large scale environmental projects and paintings, but since 1972 the artist has worked primarily in video. The video work was a natural development of earlier work allowing the use of time in conjunction with the investigation of space. Three video tapes from this period, *3 Mercer Street*, *Surveillance*, and *Two Windows* explored the artist's New York City surroundings. More recent work explores the possibilities of interactive live television in addition to the production of video tapes. Currently, as president of the Artists Television Network, he is developing cable television as an art media.

DAVIDSON, HERBERT LAURENCE (Painter)
406 W. Webster Ave., Chicago, Il. 60614

Born: 1930 *Awards:* Raymond Foreign Traveling Fellowship *Collections:* Signode Corporation; Kemper Insurance *Exhibitions:* Rahr-West Museum; Royal College of Art *Education:* The School of the Art Institute of Chicago *Dealer* Merill Chase Galleries, Chicago

Representational figurative painting in oil as well as lithography are his primary media. His pictures are the records of the things he sees, of the people he knows and meets, of the experiences he has. Whether it is a child off in the woods lost in thought, or an old woman poised with a searching, inward look, or as in the case of his illustrations of celebrities, his paintings provide penetrating glimpses into the lives of his subjects. Lately he has been spending time in the Southwest and as a consequence has become involved in painting the Indians of the area amid the designs and textures of their lives. This current work responds to the images provided by the landscape and it's people.

DAVIS, DOUGLAS MATTHEW (Video Artist)
80 Wooster St., New York NY 10012

Born: 1933 *Awards:* National Endowment for the Arts Grants; New York State Council on the Arts Grant for Creative Work in Mixed Media *Collections:* Metropolitan Museum of Art; Venice Biennale Archive *Exhibitions:* Whitney Museum of American Art; Centre Georges Pompidou, Paris *Education:* Abbott Art School; The American University; Rutgers University *Dealer* Ronald Feldman Fine Arts, NYC

Whether the medium is printmaking, drawing, painting, performance or video, his aim is to create an art which is a "two-way process" of communication, between himself and the world. In 1969 he began to concentrate almost entirely on video art in order to expand Marcel Duchamp's idea that art is completed by the observer: he wanted to communicate on "a very intense, private and personal level" using the public medium of television broadcasts. Early programs were attempts to introduce two-way metaphors to the viewers' ways of thinking. Interests in interactive video have continued, but he is actually against video "in the sense that I am assaulting what the medium *is* and *has been*. Video is simply the latest step in a process that is destroying the spectator ritual in art."

DAVIS, GENE (Painter)
4120 Harrison St. N.W., Washington DC 20015

Born: 1920 *Awards:* American Painting Biennial Award, Corcoran Gallery; Fellowship, John Simon Guggenheim Memorial Foundation *Collections:* Museum of Modern Art; Whitney Museum of American Art *Exhibitions:* Whitney Museum Annual; Corcoran Gallery of Art *Education:* Self-taught *Dealer* Charles Cowles Gallery, NYC

Self-taught, he began painting in the 1950s, experimenting with abstract expressionist, neo-dada, and pop styles. His first painting employing the vertical stripes that would later become his characteristic mark was completed in 1958. Subsequent works eliminated all signs of painterliness as stripes were rendered in various intensities, hues and widths onto unprimed canvas. Choosing various widths for color sequences, he arranges compositions of emotion, tension or balance, giving them such titles as *Moon Dog* and *Black Popcorn*. He is associated with the Washington, D.C. Color Painters.

DAWSON, BESS PHIPPS (Painter)
P.O. Box 32, Summit, MS 39666

Born: 1914 *Awards:* Mississippi Art Association; Alabama Watercolor Society *Collections:* U.S. State Department; Cotton Landia Museum, Greenwood, MS *Exhibitions:* International Trade Mart, New Orleans; Brooks Museum, Memphis, TN *Education:* Belhaven College, Jackson, MS; Mississippi Art Colony, Utica, MS *Dealer* Gulf/South Gallery, McComb, MS Though she received earlier formal training, her serious painting did not begin until the 1950s when she was influenced by de Kooning, Kline, and others. Her paintings of that time were large, abstract, and forceful. Though these qualities are still present in her paintings today, the work has become more objective. One series started several years ago was concerned with "light patterns." An ongoing involvement is with the figure in a very loosely structured way. Often umbrellas are used in the compositions.

DAWSON, DOUG (Painter)
8622 W. 44th Pl., Wheat Ridge, CO 80033

Born: 1944 *Awards:* Silver Medal, National Academy of Western Art, Oklahoma City, OK *Collections:* Exxon Corporation, Denver; Mountain Bell, CO *Exhibitions:* Knickerbocker Artist Exhibition, NYC; Allied Artists, NYC *Dealer* Gallery of the Southwest, Taos, NM

Pat Denton, *Cactus of Fire*.

B. Dogançay, *Walls V,* 23 x 19, lithograph. Courtesy: Tamarind Workshop (Los Angeles CA)

Robert Daughters, *Fall Aspens,* 24 x 18.

His past and present work are of a style he calls "expressionist-impressionist." It is impressionist in that it is built up of loose strokes of color. However, unlike the French impressionists, his emphasis is not on light but rather on the emotional content of the subject. The work is evenly divided between landscapes and character studies. He also does about six portraits a year. Nearly all of the work is in pastel, though many of the early works were in watercolor.

DE ANDREA, JOHN LOUIS (Sculptor)
c/o O.K. Harris Works of Art, 383 W. Broadway, New York NY 10012

Born: 1941 Collections: Neue Galerie, Aachen, Germany; Susanna Ratazzi Collection, NYC Exhibitions: Whitney Museum of American Art; Documenta 5, Kassel, Germany Education: University of Colorado Dealer O.K. Harris Works of Art, NYC

Polyvinyl and fiberglass figures, often nude, are super realistic and life-size, painted to meticulously replicate skin tone, complete with goose flesh and veins. Made from direct casts of the human body, glass eyes and real hair are added to complete the illusion of reality. The difference between art and life seems to vanish, but these are visual counterfeits. It is common to mistake the figures for real people, but they are people who aren't there, isolated, vacant. "I set up my own world, and it is a very peaceful world—at least my sculptures are."

DE FOREST, ROY DEAN (Painter, Sculptor)
P.O. Box 47, Port Costa CA 94569

Born: 1930 Awards: National Endowment for the Arts Grant; Purchase Prize, La Jolla (CA) Art Museum Collections: Art Institute of Chicago; Whitney Museum of American Art Exhibitions: Whitney Museum of American Art; Albright-Knox Art Gallery Education: California School of Fine Arts Dealer Hansen-Fuller Gallery, San Francisco; Allan Frumkin Gallery, NYC

Several series of drawings in marker or pastel on large paper were early works depicting the development of themes such as romance or friendship. After these he turned to painting on large canvases, series full of allusions to pulp westerns or works of philosophy he had read. Whimsical, naive interpretations of the figure in landscape have gained him recognition in the California Bay Area. He calls himself an "obscure visual constructor of mechanical delights" who seeks to depict the "phantasmagoric micro-world" in which he travels. Media have recently included ceramics, painted clay and wood mounted on canvas stretcher frames. He also worked with Robert Arneson in a cooperative effort to create fifty ceramic items such as cups, dishes and lamps, a project called The Bob and Roys.

DE KOONING, WILLEM (Painter)
c/o Fourcade Droll Inc., 36 E. 75th St., New York NY 10021

Born: 1904 Awards: President's Medal; Andrew W. Mellon Prize Collections: Metropolitan Museum of Art; Museum of Modern Art Exhibitions: Museum of Modern Art; Whitney Museum of American Art Education: Academie voor Beeldende Kunsten en Technische Wetenschappen, Amsterdam Dealer Xavier Fourcade, NYC

While training in his native land of Holland for eight years, he was influenced not only by the strict academic training, but also by the abstract art of the De Stijl group. Early works of the 1930s were untitled

abstract works influenced by Arshile Gorky, with whom he shared a studio. Since the mid-1940s, he has rendered distorted figures, usually of women, in fragmented confusion. Bold brush strokes in vibrant colors, pastel tints and black areas outlined in white typify this Abstract Expressionist's work. Because he has never fully rejected the earlier influences, his work shows a passionate mixture of abstract expressionistic leanings and of the bold colorations of the C.O.B.R.A. School. Recently he has painted nearly abstract renderings of landscapes.

DE LA VEGA, ANTONIO (Painter)
2500 Johnson Ave., Riverdale, NY 10463

Born: 1927 Awards: Who's Who in American Art Collections: Museo del Barrio, NYC Exhibitions: Pintores Nuevos, Galeria Ciga, Buenos Aires; Galeria Fuentes, Mexico City Education: New York University; Art Students League, NYC

Paintings are in a variety of realistic and impressionistic styles in "the painterly tradition of Sorolla and Velasquez". His work is rich in mood and color, encompassing oil, acrylics, and watercolors painting. Subject matter is derived from his interest in all people and historical subjects. Current works display a strong concern with sunlight and luminescent color in his still-lifes, landscapes, and portraiture.

DE LA VEGA, ENRIQUE MIGUEL (Sculptor)
4507 Atoll Ave., Sherman Oaks, CA 91403

Born: 1935 Awards: National Design Award, St. Francis of Assisi Church, South Windsor, CT Collections: Air Force Village, San Antonio, TX Exhibitions: Simon Patrich Gallery, Los Angeles; Galeria Teatro Casa de la Paz, Mexico City Education: Los Angeles County Art Institute Employing traditional and contemporary materials, his sculpture is monumental both in size and concept. Thematically his work is of a religious and spiritual nature. His commissioned public works have been more formal and liturgically oriented, and have been installed in numerous places in California and throughout the United States. The current works are more personal. They evolve into semi-abstract compositions with airy, fluid lines, symbolically concerned with the transcendental spiritual vision of man. He draws his influence and inspiration from the renaissance masters as well as contemporary masters such as Moore, Miles, Epstien, and Barlach.

DE SANTO, STEPHEN (Painter)
1325 Kensington Blvd., Fort Wayne, IN 46805

Born: 1951 Awards: John Young-Hunter Memorial Award, American Watercolor Society; Award for Realism, Allied Artists of America Collections: The Wichita Art Museum; Alford House Anderson Fine Arts Center Exhibitions: Pennsylvania State University; Fort Wayne Museum of Art Education: Ball State University; Huntington College Dealer Andrew Crispo Gallery, NYC

His large-scale acrylic paintings typically range from highly detailed depictions of common objects and portions of architectural landscapes to much more romantically distilled visions of pure landscape. While the majority of his works are executed in acrylic on Masonite with a thin coat of paint that dries flat and smooth to the touch, others are done on watercolor paper employing a combination of watercolor techiniques. Design is geometrically simple, striving towards neo-classical formalism, but with an overall detail resembling photo-realism. Great pains are taken to capture the

Richard Campbell, *Catalina Duo,* 40 x 50, oil. Courtesy: Susan Catto (Los Angeles CA)

Jerry W. Carter, *Second Genesis,* 9½ x 13½ feet, painting for Venetian glass mosaic.

Omar R. Carrington, *Summer Things*, 30 x 36, oil.

Phillip P. Chan, *Untitled*, 22 x 28, oilsticks.

Doyle Chappell, *Jon Arnold,* 36 x 48, acrylic.

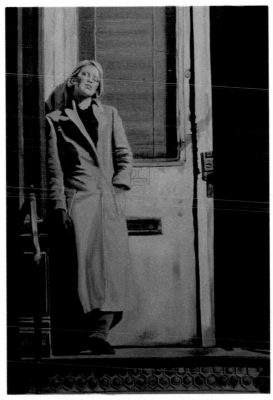

Jeanne Norman Chase, *Greenwich Village Doorway,* 30 x 40, oil.
Courtesy: Tatem Gallery (Fort Lauderdale, FL)

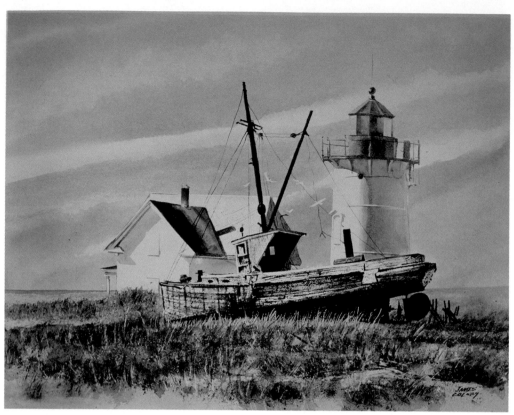

James Colway, *High and Dry,* 22 x 28, watercolor. Courtesy: Aaron Ashley (New York NY)

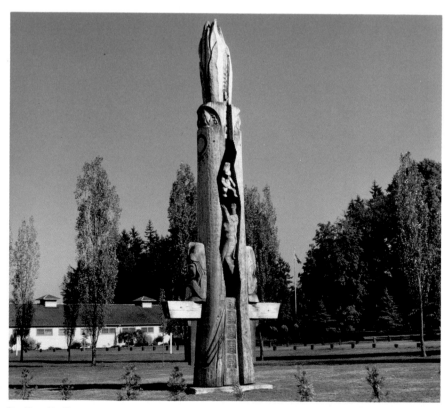

Dudley C. Carter, *Legend of the Moon,* 11 x 35 ft., cedar. Courtesy: New Bellevue Art Museum (Bellevue WA)

Hilo Chen, Beach 100, 38 x 56, oil on canvas. Courtesy: Louis K. Meisel Gallery (New York NY)

George Chemeche, *Multi-Figure 14*, 60 x 72, oil on canvas. Courtesy: Dr. & Mrs. Leon J. Weiner

Ted Christensen, *Waldo,* 18 x 24, acrylic on paper. Courtesy: Westview Gallery (San Jose CA)

Martin Charlot, *Fruit of the Spirit,* 10 x 13, oil on canvas. Courtesy: Lewin Galleries (Beverly Hills)

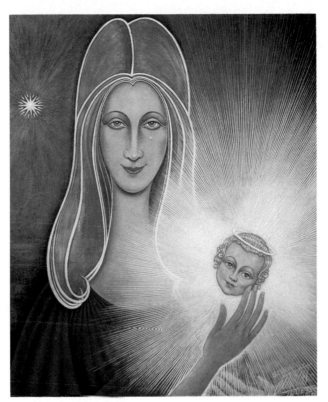

George C. Curtiss-Truetsch, *Madonna and Child,* 15 x 18, oil. Courtesy: R Gallery of Art (Miami FL)

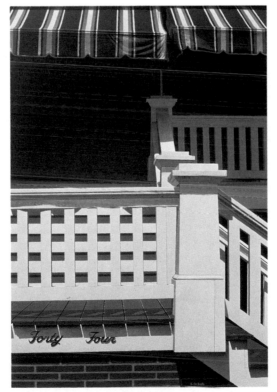

Stephen De Santo, *Forty Four in Ocean City,* 36 x 24, acrylic.

Tom Dahill, *Dance Lesson,* 52 x 58, polymer.

Pat Denton, *Sleighbells*.

Robert Daughters, *Chamisa,* 38 x 34, oil. Courtesy: Taos Art
Gallery (Taos NM)

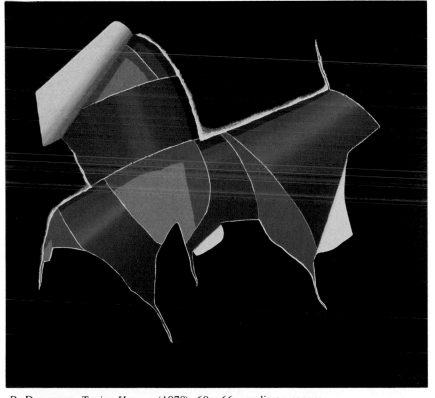

B. Dogançay, *Trojan Hoorse* (1978), 60 x 66, acrylic on canvas.

George Dergalis, *Venus Adorned* (1983), 82 x 129, mixed media.

Michael Engel, *The City,* 32 x 45, acrylic. Courtesy: Clayton-Liberatore (Bridgehampton NY)

Vincent Dzierski, *The Old Kitchen on Greeley Street,* 13 x
17, tempera.

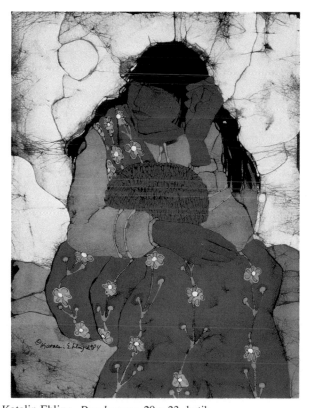

Katalin Ehling, *Daydreams,* 20 x 23, batik.

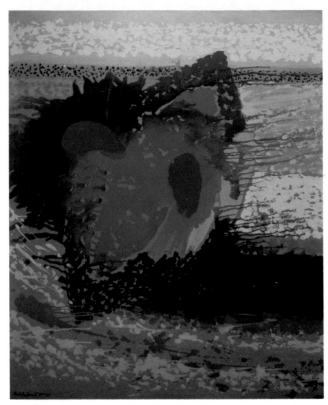

Paul England, *Africa,* 50 x 60, oil on linen.

Stanley Dean Edwards, *Night Passage,* 76 x 90, oil.

Wayne Ensrud, *Olympia,* 50 x 60, mixed media.

Barbara Erdman, *Trapezium II,* 56 x 71, oil on canvas.

Estelle Fedelle, *Patricia,* 28 x 32, oil.

Emily Farnham, *Diptych: States of Mind 1 . . . ,* 40 x 40, Kem-tone on wood.
Courtesy: Gray Gallery (Greenville NC)

Mel Fillerup, *Autumn Glory,* 24 x 30, oil.

Barclay Ferguson, *Three Tin Mice,* 52 x 71, acrylic. Courtesy: Louis Newman Galleries (Carmel CA)

Alexander Farnham, *Centers of New Jersey Culture,* 40 x 56, oil.

Astrid Fitzgerald, *Golden Section XXIX,* 30 x 44, pastel. Courtesy: Steiger Jones Gallery (New York NY)

proper image composition with a single snapshot. Then, using a slide projector, the basic outline of the subject is traced from a projected slide onto the Masonite and the design further simplified to arrive at its final form. In the last few years subject matter for paintings has been taken almost exclusively from architectural details in the seaside resort town of Ocean City, New Jersey.

DEAN, NAT (Painter)
3435 Army St. Suite 214, San Francisco, Ca. 94110

Born: 1956 *Awards:* Best of Show, San Francisco Museum of Modern Art; Merit Award, California Institute of Arts *Collections:* San Francisco Museum of Modern Art; Fukuoa Cultural Center *Exhibitions:* Artworks, Los Angeles; Pratt Institute Gallery *Education:* San Francisco Art Institute; California Institute of the Arts

Her work is concerned with an exploration of the complexities which occur between one's inner private world, and the external world which we travel through on a daily basis. In the early seventies her work consisted of abstract paintings on canvas and paper, and through the later seventies evolved into more representational painted paper fans, envelopes and booklets. Eventually she built book-like constructions which incorporated traditional hand book-binding techniques and figurative images. This led to duo and trifold boxes containing painted acrylic panels and acid etched glass panes. She is currently working on large scale screens made of mirrored panels with sandblasted images. She uses black covered book-like boxes which must be opened, and three part screens which must be opened if small or walked through if life size, demanding the viewer to either involve themselves with the work or pass it by completely.

DEHNER, DOROTHY (Sculptor)
33 Fifth Ave., New York, NY 10003

Born: 1901 *Awards:* Honorary Ph.D., Skidmore College *Collections:* Metropolitan Museum of Art; Museum of Modern Art *Exhibitions:* Willard Gallery, NYC; A. M. Sachs Gallery, NYC *Education:* Art Students League; University of California, Los Angeles *Dealer* A. M. Sachs Gallery, NYC; Marian Locks Gallery, Philadelphia

Her work ranges from bronze and silver miniatures to large-scale cor-ten steel structures. She has exhibited extensively since the 1930s throughout the U.S. as well as abroad in England, Holland, France, Italy, Greece and South America. In sculptures that are powerful without being monumental she compresses ancient legends, even abstract landscapes of gardens, avenues, and skyscrapers in forms that are organic and evocative yet convey the rhythm and movement of the city. Her bronze sculptures are curious but immensely imaginative constructions that suggest ancient totems or icons. Recent sculptures have been primarily medium scale, free standing cor-ten steel structures.

DELAP, TONY (Sculptor)
225 Jasmine St., Corona Del Mar CA 92625

Born: 1927 *Awards:* National Endowment for the Arts *Collections:* Museum of Modern Art; Los Angeles County Museum of Art *Exhibitions:* Whitney Museum of American Art; Museum of Modern Art *Education:* California College of Arts and Crafts; Claremont Graduate School *Dealer* Janus Gallery, Los Angeles; Robert Elkon Gallery, NYC

Beginning as a painter, in the early 1960s he turned to

sculpture. After ten years of working exclusively in sculpture he combined sculpture with painting to create "wall-hanging paintings." His media included wood, canvas and acrylics. A primary concern was the edge: "I developed a hyperbolic paraboloid wooden edge that changed course as it continued around the canvas, much like a Mobius strip." In this way the wall became an integral part of each work. The wall was also integrated into the work through experiments with different geometrical shapes and negative space, as in *Jaipur Jinnee.*

DELLA-VOLPE, RALPH EUGENE (Painter)
RR2 Box 51 South Rd., Millbrook, NY 12545

Born: 1923 *Awards:* Witchita Art Association Purchase Award; Library of Congress Purchase Award *Collections:* Chase Manhattan Bank Collection; U.S. Treasury Building *Exhibitions:* Columbia Art Museum; Berkshire Museum *Education:* National Academy of Design; Art Students League

His paintings during the 1950s concentrated on coastal and beach subject matter, and were executed in a semi-abstract manner. The human figure in broad shapes and muted colors, dominated his work in the 1960s, which showed people in their environment and at work; for example—flag makers, flower arrangers, and a figure entering the library. The early 70s saw more intense use of color employed with the figure in beach subject matter executed in simplified compositions and with a concentration on light. These paintings showed wide, open beaches and frequently emphasized sand dunes, sand patterns and atmospheric effects. His current works are landscapes painted in and around his home in rural and suburban New York.

DEMATTIES, NICK (Painter)
2337 N. 10th St., Phoenix, AZ 85006

Born: 1939 *Awards:* Western States Arts Foundation Award *Collections:* Brooklyn Museum of Art; Los Angeles County Museum of Art *Exhibitions:* Biennial, Phoenix Art Museum; Laguna Gloria Museum *Education:* Institute of Design; Illinois Institute of Technology *Dealer* Leo Castelli Gallery, NYC

The self-referential is important in his paintings. He finds organic forms that relate to his own personal history and relationships and transforms them into metaphors for isolation and alienation. His paintings reveal a search for his inner self with various figures and personal symbols. His somewhat visionary, and poetic style, expresses the dichotomy between the emotions and the mind, between feelings and intellect.

DENES, AGNES CECILIA (Conceptual Artist)
595 Broadway, New York NY 10012

Born: 1938 *Awards:* Creative Artists Public Service Grants; National Endowment for the Arts Grant *Collections:* Museum of Modern Art; Whitney Museum of American Art *Exhibitions:* Whitney Museum of American Art; Venice Biennale *Education:* New School for Social Research; Columbia University *Dealer* Elise Meyer Gallery, NYC; Germans Van Eck, NYC; Works of Art for Public Spaces, NYC

Using science and philosophy in the service of her art, she explores the structure of matter and idea, and the mysteries of human existence. Fascinated by Einsteinian physics, she employs science in order to expand artistic possibilities. Mathematical diagrams and projected maps, often on graph paper and annotated, such as the *Study of Distortion Series: Isometric Systems in*

Isotropic Space: The Snail or the *Pyramid Series,* reflect this goal. "We must create a new language, consider a transitory state of new illusions and layers of validity and accept the possibility that there may be no language to describe ultimate reality, beyond the language of visions." Recently she has completed a series of extremely close-up photographs which continue her quest to make the invisible visible.

DENNIS, DON W. (Painter)
731 Brooks Ave., Wyoming, Ohio 45215

Born: 1923 *Awards:* Emily Lowe Award, American Watercolor Society; Walser Greathouse Medal, American Watercolor Society *Collections:* Phillips Petroleum, Norway; Reading Museum and Art Gallery *Exhibitions:* Cincinnati Art Museum; Museum Bahamas *Education:* Kutztown University; Pratt Institute

His watercolors emphasize color and pattern and the use of design elements. Early paintings were concerned with realistic depiction and the versatile surfaces of the watercolor medium. He also worked in the field of commercial art as a designer, illustrator, and art director until 1973 when he turned to teaching and painting full-time. In present watercolor paintings he exaggerates color and shape seeking an individual interpretation of the objects and scenes he studies. Rather than a pictorial representation he is interested in expression of the internal "essence" or "spirit" of his subjects.

DENNIS, DONNA (Painter, Sculptor)
131 Duane St., New York, NY 10013

Born: 1942 *Awards:* Fellowship, John Simon Guggenheim Memorial Foundation; Award, American Academy and Institute of Arts and Letters *Collections:* Walker Art Center; Ludwig Collection, Aachen, Germany *Exhibitions:* Venice Bienale; Whitney Museum of American Art *Education:* Carleton College; Art Students League *Dealer* Holly Solomon Gallery, NYC

Having started as a painter, she began in the early 1970s to show free-standing painted constructions she called "false-front hotels." By the mid-1970s she was making fully three-dimensional work based on American vernacular architecture. Her subway stations, tourist cabins, and rooming houses are endowed with a mood that recalls Hopper, Burchfield, Walker Evans, and Atget. At present the sculptures are increasing in size and complexity. By condensing space and carefully observing details, she arrives at a kind of architecture that is altered to house dreams or reveries.

DENTON, PAT (Painter)
2948 Pierson Way, Lakewood CO 80215

Born: 1943 *Awards:* Best of Show, Wind River National, Dubois WY; Catherine Lorillard Wolfe Art Club, Ida Becker Memorial Award *Collections:* Art Museum of West Texas Tech University; McCleery-Cumming Company, Inc. *Exhibitions:* Foothills Arts Center; West Nebraska Arts Center *Education:* University of Denver; *Dealer:* J. Barrett Gallery, Toledo OH; La Porta, Denver; Maxims, Greeley CO; Robison's, Wichita Falls TX; White Oak Gallery; Minneapolis

Prior to 1972, her work was almost entirely in oil and pastel mediums with subject matter almost invariably derived from nature. But, in the last ten years she developed a love for watercolors that has lead to her current work being almost exclusively in water media. Her paintings display a strong sense of color, dimension, and texture as well as an exquisite use of light and

composition. The highly impressionistic and often times experimental backgrounds of her paintings provide a base that allows the viewers attention to be drawn to the "tight realistic renderings" that serve as the focus of her work. Subject matters vary from floral, still life and landscape studies to portraiture and figurative representation.

DERGALIS, GEORGE (Painter)
72 Oxbow Rd., Wayland, MA 01778

Born: 1928 *Awards:* Prix de Rome; Civilian Merit Award, United States Army Historical Society *Collections:* Museuo de Zea y Camara de Comercio, Medellin, Columbia *Exhibitions:* Tampa Museum; Landmark Center, St. Paul *Education:* Accademia delle Bella Arte; Museum School of Fine Arts *Dealer* George Degalis Studio, Wayland, MA

He has painted in a wide range of mediums from oil, acrylic, and egg tempera to watercolor and mixed media. In addition he has worked both as a sculptor and printmaker. His style encompasses realism and surrealism as well as elements of abstraction. He has been influenced by his stay in Southeast Asia as a combat artist during the Vietnam war, and additionally as an artist-in-residence in Columbia for Partners of Americas.

DI CERBO, MICHAEL (Painter, Printmaker)
33 Howard St., New York, NY 10013

Born: 1947 *Awards:* Purchase Award, National Print Exhibition *Collections:* The Victoria & Albert Museum; Brooklyn Museum *Exhibitions:* 21st Annual National Print Exhibition; "Architectural Images", The World Print Council *Education:* Pratt Institute *Dealer* Weyhe Gallery, NYC

Urban landscapes are the subject matter of his acrylic paintings and etched prints. The concrete, steel, and glass of the American city are the source of inspiration for him. He has turned his sense of urban grandeur into a geometry of forms, patterns of intense light, and saturated colors that allude to the soaring architecture of skyscrapers. One sees the city from the perspective of both an ant and an eagle in his prints and paintings; buildings reach endlessly upward or fall away to chasms below. The imagery becomes a vision of pure energies and raw forces.

DI SUVERO, MARK (Sculptor)
c/o Richard Bellamy, 333 Park Ave. S., New York NY 10010

Born: 1933 *Awards:* Longview Foundation Grant; Art Institute of Chicago Award *Collections:* Whitney Museum of American Art; Art Institute of Chicago *Exhibitions:* Art Institute of Chicago; Whitney Museum of American Art *Education:* University of California *Dealer* Oil and Steel Gallery, NYC

After study in California he moved to New York and helped to set up a cooperative gallery there called Park Place. Constructions have been called "three-dimensional equivalents of paintings by Willem de Kooning," and feature old wooden beams, rope, wire, and other found objects such as tires and rusty chains. These often large-scale flamboyant pieces have moving parts. In 1966 he built *Tower of Peace* as a protest against the Viet Nam War. During the 1960s he employed "clean," rather than discarded materials. In the following decade his sculpture was made of fewer and larger elements—primarily steel I-beams—that he used to create monumental public sculpture. Recently cut steel has been used to create small, convoluted table-top pieces.

George Dergalis, *The Juggler,* 22 x 30, pencil & graphite.

Vincent Dzierski, *Chair with Fruit,* 19 x 23, oil.

Stanley Dean Edwards, *The Unkept Promise,* 78 x 66, oil.

DICKINSON, ELEANOR CREEKMORE (Painter)
2125 Broderick St., San Francisco, CA 94115

Born: 1931 *Awards:* National Society of Arts & Letters; Distinguished Alumni, San Francisco Art Institute *Collections:* National Museum of American Art; San Francisco Museum of Modern Art *Exhibitions:* Corcoran Gallery of Art; Smithsonian Institution *Education:* University of Tennessee; San Francisco Art Institute; California College of Arts and Crafts *Dealer* Poindexter Gallery, NYC; William Sawyer Gallery, San Francisco

She is essentially a draftsman. Though she works in a variety of media, they are usually linear and color is employed for its value, not its hue. To her, the act of drawing is most important, along with the excitement of unplanned composition and discovery. Her subject is always figurative, and her style is expressionistic realism. Among the subjects of her major series are old and young lovers, animals, revival meetings, models, and illness and death. Her most recent show at the Tennessee State Museum was titled *Revival!*. The essence of the exhibition was the 2,000 objects interacting with each other in paintings, drawings, photographs, slides, holograms, artifacts, and videotapes.

DIEBENKORN, RICHARD (Painter)
c/o M. Knoedler, 19 E. 70th St., New York NY 10021

Born: 1922 *Awards:* Gold Medal, Pennsylvania Academy of Fine Arts; National Institute of Arts and Letters *Collections:* Metropolitan Museum of Art; San Francisco Museum of Modern Art *Exhibitions:* Whitney Museum Annual; Venice Biennale *Education:* California School of Fine Arts; University of New Mexico *Dealer* M. Knoedler, NYC

Early still life, and interior and figurative paintings during World War II were influenced by modern French painters such as Matisse and Bonnard. Contact with artists in California and New York changed his work to a more non-objective, energetic style which moved quickly from geometric abstraction to a more expressionistic mode. In his large, expressionist canvases, such as in his *Ocean Park* series, he tends to use areas of color rather than line, arranging pictorial space asymmetrically into large open areas with smaller active areas, abstracting specific elements from the landscape as a whole. In recent years, he has become increasingly independent from Abstract Expressionism, and has shown greater concern for more literal subject matter. He recently completed a set of prints at Crown Point Press.

DIEHL, GUY LOUIS (Painter)
c/o Hank Baum Gallery, 2140 Bush St., San Francisco CA 94115

Born: 1949 *Awards:* Purchase Award, Alameda County Art Commission *Collections:* City Hall Building, Oakland (CA); Alameda County Art Commission, Oakland (CA) *Exhibitions:* Hank Baum Gallery; Shepard Art Gallery, University of Nevada *Education:* California St. College at Hayward; San Francisco St. University *Dealer* Hank Baum Gallery, San Francisco

Acrylics and watercolors on canvas are realistic renderings of contemporary leisure activities, such as *Edge of Pool with Mondrian Towel*. Formal symmetrical compositions are full of the intense sunlight of summer, deep shadows, and brilliant colors. Although figures are not present, personal belongings indicate their presence.

DILL, GUY GIRARD (Sculptor)
819 Milwood Ave., Venice CA 90291

Born: 1946 *Awards:* Theodoron Award, Solomon R. Guggenheim Museum; Fellowship, National Endowment for the Arts *Collections:* Museum of Modern Art; Whitney Museum of American Art *Exhibitions:* Whitney Museum Biennial; Solomon R. Guggenheim Museum *Education:* Chouinard Art Institute *Dealer* Flow Ace Gallery, Los Angeles

He constructs architectonic structures in scale, out of such materials as metal, marble, concrete and wood. Beginning in 1971, the circle was a fulcrum for the compositions. Later the column was added as a "connection and icon." He preserved the natural colors and surfaces of the media in order to provide his works with "real-energy." Now more interested in the combination of planes, surfaces and shapes and in working with space and scale to create works of visual harmony, he seeks to unify his chosen forms—the circle, the beam, and other elements—in order to create "an integrated icon or shape."

DILL, LADDIE JOHN (Painter, Sculptor)
1625 Electric Ave., Venice CA 90291

Born: 1943 *Awards:* Fellowship, John Simon Guggenheim Foundation; National Endowment for the Arts *Collections:* Los Angeles County Museum; San Francisco Museum of Modern Art *Exhibitions:* Corcoran Gallery Biennial; Smithsonian Institution *Education:* Chouinard Art Institute *Dealer* James Corcoran Gallery, Los Angeles; Fuller Goldeen Gallery, San Francisco; Charles Cowles Gallery, NYC

An early influence upon his work was the environmental art of Robert Irwin. In 1968 he created light and sand pieces in a horizontal format, installations made of glass, neon and sand which appeared to be aerial views of landscape. Experiments with painting led to a rectilinear format with the addition of architectonic shapes to the landscape imagery. In 1975 the format was vertical, suggesting "a figurative reference achieved by a more formal architectural structuring," and two years later he produced a vertical *Door* series. Paintings now reflect both landscape and architectural imagery. His media are cement polymer, glass, silicone, and oil on canvas; he has also made drawings in pastel, oil and graphite on rag paper.

DINE, JIM (Sculptor, Painter)
c/o The Pace Gallery, 32 E. 57th St., New York, NY 10022

Born: 1935 *Collections:* Centre Pompidou; Metropolitan Museum of Art *Exhibitions:* Denver Art Museum; Walker Art Center *Education:* University of Cincinnati; Ohio University *Dealer* The Pace Gallery, NYC

For him, the distinctions between sculpture and painting have always seemed arbitrary. His paintings have repeatedly incorporated three-dimensional objects, and his sculptures have employed painterly gesture and rich surface coloration. His recent cast bronze sculptures re-create in three-dimensional terms many of the images that have been associated with him throughout his career—hearts, tools, shells, the Crommelynck Gate. Among the new subjects in these works is a group of life-sized and smaller Venus figures, inspired by a plaster replica of the *Venus de Milo* that he found in an art store. In a group of recent paintings, the dominant image is the heart, reflecting his continuing preoccupation with personal expression and the capacity of paint to convey feeling.

DIXON, WILLARD (Painter)
5 Belloreid, San Rafael, CA 94901

Born: 1942 *Awards:* Purchase Prize, San Francisco Art Festival *Collections:* Oakland Museum; San Francisco International Exposition *Exhibitions:* William Sawyer Gallery, San Francisco; Tortue Gallery, Los Angeles *Dealer* William Sawyer Gallery, San Francisco; Fischbach Gallery, NYC; Harris Gallery, Houston

There has been a general progression in his work from surrealist oriented drawings, constructions, and collages, to a Magritte influenced realist painting. Later work was in a style of photo-realism. Recently his work has been more painterly, and less photographic. He has been concentrating on large-scale landscape painting.

DOGANÇAY, BURHAN C. (Painter)
220 E. 54th St., New York, NY 10022

Born: 1929 *Awards:* Certificate of Appreciation, City of New York *Collections:* Solomon R. Guggenheim Museum; Museum of Modern Art *Exhibitions:* Centre Georges Pompidou, Paris; Musee d'Art Contempmorain, Montreal *Education:* Academie de la Grande Chaumiere, Paris *Dealer* Galerie Swidbert, Dusseldorf, W. Germany

For over twenty years his artistic expression has concentrated on the theme of walls. His obsessive interest in walls can be attributed to the fact that the literature and art we find on walls are part of our daily environment. During his early period he reproduced walls in a realistic manner, on canvas, utilizing old, dirty posters and other objects found on walls. He has continued to refine the wall concept, and his latest paintings are more abstract. They depict in a three-dimensional way layers of torn papers and the shadows they cast. In addition to painting, he has also portrayed walls through photography and shadow sculpture.

DOLL, CATHERINE (Painter)
928 Park Ave., Racine, WI 53403

Born: 1950 *Collections:* United Auto Workers Local 72; United Autoworkers Region 10 *Exhibitions:* "Products of Society", NAB Gallery, Chicago; ARC Gallery, Chicago *Education:* San Jose City College; University of Wisconsin at Parkside *Dealer* ARC Gallery, Chicago

Reflecting a social conscience attuned to the heritage and current reality of American labor, her mixed-media paintings forcefully depict the themes of unemployment, "marginal" populations, and ordinary people's struggles for better lives. Her autobiographical acrylic painting, *Final Assembly A-28*, shows her at her job on the American Motors Company assembly line. She works from sketches and photographs taken in factories and auto plants and then, using airbrush, colored pencil, pieces of cut paper and even a fragment or two of furnace filter—to give the effect of chain link fence—she builds her three dimensional collages into a unified statement of hope, fear, rejection, and frustration.

DOMJAN, JOSEPH SPIRI (Printmaker)
West Lake Rd., Tuxedo Park, NY 10987

Born: 1907 *Awards:* Grant, Rockefeller Foundation *Collections:* Metropolitan Museum of Art; Smithsonian Institution *Exhibitions:* Cincinnati Art Museum; New Jersey State Museum *Education:* Hungarian Royal Academy of Fine Arts

He "paints" with color wood-blocks and designs tapes-tries. His technique consists of pulverizing dry pigment by hand and grinding it to a fine power before mixing it with oil and turpentine. He applies an even film of this mixture to the carved woodblock by brush, and then uses his thumb as a "printing press," varying the pressure to obtain different color tones and depth. As many as twenty one different colors and eight woodblocks may be used for one image, printed in small editions of about fifteen prints.

DOOLEY, HELEN BERTHA (Painter)
Box 5577, Dooley Gallery, Carmel, CA 93921

Born: 1907 *Awards:* First Place, Watercolor, Society of Western Artists; First Award, Monterey Peninsula Museum of Art *Collections:* University of the Pacific; Merifex Corporation *Exhibitions:* Lord & Taylor Galleries, NYC; Haggin Museum and Art Gallery, Stockton, CA *Education:* San Jose State College; Claremont Graduate School *Dealer* Carmel Art Association Galleries, Carmel, CA

She paints fairly realistic, broadly painted watercolors and oils. The oils may be abstract and can include figures, symbolism, and still-life subjects in imaginative compositions. The watercolors pertain to boats and flowers, and they are more realistic. The oils are mostly large-sized canvases, painted in flat color. The subjects relate to the outside world but much is left to the imagination, leaving room for the observer's interpretation. Strong color with an emphasis on pure unmixed color dominates her oil paintings.

DOUKE, DANIEL W. (Painter)
5151 State University Dr., Los Angeles, CA 90032

Born: 1943 *Awards:* James D. Phelan Award, San Francisco Foundation *Collections:* Israel Museum, Jerusalem; Art Museum of California State University at Long Beach *Exhibitions:* Oakland Museum of Art; The Museum of Modern Art *Education:* California State University at Los Angeles *Dealer* O.K. Harris, NYC; Torture Gallery, Santa Monica, CA

Work is characterized by super realist acrylic paintings of common objects. His early paintings of California swimming pools are characterized by a detached airbrush look. The image reflected and recorded in candid fashion the Southern California environment. The artist's current direction has pushed him towards dealing with the haziness surrounding "reality and truth". Constructed stretched canvases are transmuted through various painting techniques into what seem to be mundane, used cardboard cartons or, in his more recent works, thick plates of painted cold rolled steel.

DOWNES, RACKSTRAW (Painter)
536 W. 111th St., New York NY 10025

Born: 1939 *Awards:* Creative Artists Public Service Award; National Endowment for the Arts Grant *Collections:* Whitney Museum of American Art; Hirshhorn Museum and Sculpture Garden *Exhibitions:* Whitney Museum of American Art Biennial; Pennsylvania Academy of the Fine Arts *Education:* Cambridge University, England; Yale University School of Art *Dealer* Hirschl and Adler Modern, NYC

Born in England, this American realist painter was first influenced by Fairfield Porter. He worked for many years as an art critic until devoting himself to painting. Highly detailed landscapes and cityscapes of the northern East Coast in oil or watercolor explore the effects of light and atmosphere much like the tradition of John Constable, but the canvases are long horizontal panora-

mas of usually unromanticized scenes, split seconds of stopped action in modern America. He finds beauty in the industrialized rural landscape and in modern urban scenes. In recent years his palette has brightened from the earlier subdued tones.

DOWNING, THOMAS (Painter)
c/o Pyramid Art Galleries, 2121 P St. N.W., Washington DC 20037

Born: 1928 *Awards:* V.M.F.A. Travel-Study Grant *Collections:* Corcoran Gallery of Art; Whitney Museum of American Art *Exhibitions:* Corcoran Gallery of Art; Museum of Modern Art *Education:* Randolph-Macon College; Pratt Institute *Dealer* Pyramid Art Galleries, Washington, DC

He first gained recognition in 1965 with an exhibition in Washington, D.C. with the Washington Color Painters, a Minimalist group which included Morris Louis and Kenneth Noland. The optical effects of color were explored, often in acrylic on unprimed canvas. Geometric forms, especially small circles, were repeated in grid-like arrangements in series of paintings so that the constancy of the shapes helped to demonstrate the color variations. Recently his media have also included gouache and watercolor.

DRYFOOS, NANCY (Sculptor)
45 East 89th St., New York, NY 10028

Awards: Gold Medal, Allied Artists of America; Constance K. Livingston Award, American Society of Contemporary Artists *Collections:* Brandeis University; Evanston Museum of Fine Arts *Exhibitions:* Pennsylvania Academy of Fine Arts Biennale; Collectors Gallery, Washington, DC *Education:* Sarah Lawrence College; Columbia University

Her representational sculpture is carved in a semi-realistic style, displaying an expressionistic influence. Marble, alabaster, and terra cotta are her primary sculptural media. The content of her work is derived from moods, emotions, and concepts. Often the work contains an embedded narrative and references to mythology. Both the human and animals figures which populate her work and are executed in a personal, free style rather than a strict realism.

DUCA, ALFRED MILTON (Painter, Sculptor)
Annisquam, Gloucester, MA 01930

Born: 1920 *Awards:* grant, Rockefeller Foundation; grant, Ford Foundation *Collections:* National Gallery of American Art; Fogg Art Museum *Exhibitions:* Downtown Gallery, NYC; DeCordova Museum, Lincoln, MA *Education:* Pratt Institute; Boston Museum School

He is a painter/sculptor/inventor who is acknowledged to be a pioneer in the development of the Polymer Tempera process for painters and the foam vaporization process for sculptors. He is a contemporary of the "Boston School" of the 1940s and 1950s. His sculptural works range in scale from small, figurative "lost wax" bronze castings to massive four- and eight-ton commissioned iron castings. He recently returned to painting, after spending a decade developing community programs for young people nationwide. He is involved with the paint surface in his current works, bringing to them his lifelong concern for ideas and their creative interpretation.

DUKE, CHRIS (Illustrator)
E. Maple Ave. P.O. Box 471, Millbrook, NY 12545

Born: 1951 *Awards:* Award, Society of Illustrators *Collections:* General Electric; Borg-Warner Corporation *Exhibitions:* Society of Illustrators Annual Show *Education:* Parsons School of Design *Dealer* Frank & Jeff, NYC

Working as a commercial illustrator her clients have included American Express Co., CBS, General Electric, and American Airlines. Since becoming a mother she has attempted in her work and her portraits of her children to portray their sense of discovery and the mysterious significance they find with everyday objects. The elements of the picture, though rooted in reality, are transformed by her own memories from childhood images, dreamy and vague.

DUNLAP, LOREN (Painter)
Box 332 Sagg Road, Sagaponack, NY 11962

Born: 1932 *Awards:* Louis Comfort Tiffany Grant; William P. Hapgood Traveling Grant *Collections:* Addison Gallery of American Art; Nortre Dame University Museum *Exhibitions:* Purdue University; Santa Barbara Museum *Education:* Tulane University; The American Academy in Rome *Dealer:* James R. Borynack, NYC
In his early abstract work, he sought images of nature among the forms. His paintings of imaginary landscapes and trees during the late 1950s, led him into direct studies and representations of elements of nature. His current oil paintings, measuring approximately forty-five by fifty inches, are intricate, realistic still lifes. Arranged on a table top, flowers, fruit, china, textiles—the traditional still life objects—are displayed in elegant profusion with the tools of the painter's trade—paints, brushes, and artists' reproductions. The works of Matisse are often represented in the painting as if to underscore the influence obvious in the simple, brilliant colors and the careful design.

DYYON, FRAZIER (Painter)
155 W. 73rd St., New York, NY 10023

Born: 1946 *Awards:* Scholarship, Printmakers Workshop *Collections:* Museum of Modern Art; The Whitney Museum of American Art *Exhibitions:* Mather Gallery, Cleveland; Whitney Museum of American Art *Education:* Self-taught

His early career was marked by an Abstract Expressionist style, influenced by the works of Pollack and de Kooning. These works were mainly landscape images painted with a bright palette. He later created an extensive series of collages and experimented with small plaster sculptures. His paintings developed into the *Mohican Series*, works painted on a darker canvas with a flowing brush on a vertical format. His latest works are characterized by colorful, highly textural compositions using such materials as towels, napkins, and stockings. The materials are "painted," held together with paint and glue application. A relationship is created of ideas and forms that exceeds the substances used, setting up planes of energy, pattern, contrast, depth, and motion.

DZIERSKI, VINCENT (Illustrator, Painter)
1577 Hastings Mill Rd., Pittsburgh, PA 15241

Born: 1930 *Awards:* Award, Society of Illustrators; Art Directors Society of Pittsburgh *Education:* Armando Del Cimutto

Although the majority of his work is executed in tempera, he also works in oils, prints, drawings and sculpture. Subject matter is often taken from simple ordinary things that he is attracted to for their sense of character. Abstract images as well as representational imagery are

mixed freely in all his work. Sculpture consists primarily of free standing lacquered wood forms. Prints and drawings tend toward more realistic renderings with subject matter inspired from wilderness scenes and natural environments.

EDDY, DON (Painter)
c/o Nancy Hoffman Gallery, 429 W. Broadway, New York NY 10012

Born: 1944 *Collections:* Neue Galerie, Aachen, Germany; Cleveland Museum of Art *Exhibitions:* Baltimore Museum of Art; Tokyo Biennial *Education:* University of Hawaii; University of California, Santa Barbara *Dealer:* Nancy Hoffman Gallery, NYC

With a background in professional photography and a knowledge of art history based primarily on reproductions, he first gained recognition as a New Realist painter in the early 1970s with Photo-realistic works which explored the reflective qualities of automobile surfaces. Views of shop windows included both transparency and window reflection, depicting several depths of focus on a single level. He is best known for depictions in acrylic of fine silver objects as seen through store windows or glass cases in which multiple reflections abound, such as *Silverware for S.F.* The paintings ''are about the development and maintenance of spatial tensions: the tension that results from the creation of a space that is both logical and illogical, a space that simultaneously strains toward illusionary depth and flatness.''

EDWARDS, STANLEY (Painter)
731 W. 18th St., Chicago, IL 60616

Born: 1941 *Awards:* Prize, Art Institute of Chicago; Prize, Corcoran Gallery of Art *Collections:* National Museum of American Art, Smithsonian Institution; Corcoran Gallery of Art *Exhibitions:* ''Art Across America'', Mead Corporation; Art Institute of Chicago *Education:* School of the Art Institute of Chicago; University of Chicago

His early paintings are large scale oil and acrylic works that combined surrealist and constructivist imagery in a hard-edged, brightly colored style. Works were in portraiture, color field, and animal—specifically ''dogs''—imagery. Figures with no faces were set on brightly colored fields of color. He referred to his work as ''pop art without the pop'' or contemporary portraits without trademarks. Later works were scenes of Chicago with strong simplified design elements. Working from photographs of the Chicago industrial cityscape he assembled straight line forms from various locales and perspectives to synthesize the composition of each painting. More recent work continues his hard-edged, structured style combining realistic cityscape and animal imagery with strong design elements to produce fascinating juxtapositions.

EHLING, KATALIN (Painter, Printmaker)
30835 N. Rancho Tierra Dr., Cave Creek, AZ 85331

Born: 1941 *Dealer:* Suzanne Brown Gallery, Scottsdale, AZ; Hobar Gallery, Santa Barbara, CA; Adagio Galleries, Palm Springs, CA

She first began working in batik a decade ago, exploring and experimenting with the medium to express traditional Southwestern themes. The focus of her work still is on batik, but she has expanded into lithography and serigraphy. She has established her own serigraph workshop, Dorcas Arts on Paper, and continues to explore printing possibilities, especially serigraphy on

hand-made paper. In the future she expects to re-explore acrylic and watercolor. She hopes to return to her native country, Hungary, to depict its folklore and life-style, both past and present.

EICHEL, EDWARD V. (Painter)
Studio A 1106, 463 West St., New York, NY 10014

Born: 1932 *Awards:* Louis Comfort Tiffany Foundation Grant *Collections:* Lyman Allyn Museum, New London, CN; New York Drawing Society *Exhibitions:* Federation of Modern Painters and Sculptors, City Gallery, NYC; National Academy of Design *Education:* Oskar Kokoschka Academy, Salzburg, Austria; School of the Art Institute of Chicago *Dealer:* Allan Stone Gallery, NYC

Although rooted in Cubism, his work has evolved from a geometrized structuring of subject matter to a fluid painterly technique. The artist's development has been influenced by his studies with Oskar Kokoschka in Salzburg and with Isobel Steele MacKinnon. He has synthesized elements of his aesthetic approach from diverse techniques, including those of de Kooning and Matisse. In his larger-than-life portraits, he builds the figure with structural planes and strokes of pulsating color, creating spatial relationships specific to the subject.His recent works retain the basic character of personages and landscapes. He attempts to attain an image of historical figures that reflects their individual spirit and destiny.

EINO (Sculptor)
32926 Mulholland Hwy., Malibu, CA 90265

Born: 1940 *Collections:* Library of Congress; Sculpture Garden, Osaka, Japan *Exhibitions:* Pepperdine University; California Institute of Technology

From his early modern figurative works in 1962, he has created many series in marble. These include *Epistles*, *Vitalistic*, and *Space in Marble*. He is also continuously engaged in creating a series of portraits of sports figures in bronze. Currently he is working on an Olympic commemorative piece in bronze. He is also carving an architectural-sized piece in Carrara marble as part of the series, *Light and Shadow*.

ELLISON, NANCY (Painter)
68 Malibu Colony, Malibu, CA 90265

Born: 1936 *Awards:* Leon Kroll Award; Texas Invitational Drawing Exhibition *Collections:* Allen Museum, Oberlin, OH *Exhibitions:* Zabriskie Gallery, NYC *Education:* Finch College, NYC

Her oils fuse abstraction and a sensual paint quality and palette with precise realism. Her motifs consist of fruit in cross-section and flowers open in full bloom. Her large-scale format and loose brush technique owe much to the Abstract Expressionist and Expressionist figure painters of the 1950s. Since she began working in California, her palette has bleached considerably from the darker, firmer New York paintings. As her colors have lightened, her brush stroke has become more vigorous. Most recently she began work on a series of paintings that take as their theme various images of hotel bedrooms.

ENGEL, MICHAEL MARTIN II (Painter)
22 Lee St., Huntington, NY 11743

Born: 1919 *Awards:* National Arts Club Award. *Collections:* Parrish Art Museum, Southampton, NY; U.S. Navy Combat Art Collection.*Exhibitions:* Audubon Artists Annual; National Arts Club, New York City

Education: Art Students League, New York City
Dealer: Clayton-Liberatore, Bridgehampton, NY

His early seascape and landscape paintings utilize the aqueous mediums of acrylic, watercolor, and casein. The expanses of sky, ocean, and land become secondary to a sense of the ethereal contained in these paintings. His careful use of color as well as his distinctive brushwork, heighten the sensuous quality of his style. Recent pieces combine serigraphy (silkscreen printing) with his work in water media. The clean, clear application of inks possible with this printing technique furthers Engel's work toward increasing spareness of composition and simplification of color, line, and form.

ENGLAND, PAUL GRADY (Painter)
359 Soundview Dr., Rocky Point, NY 11778

Born: 1918 *Awards:* Grand Award, Philbrook Art Center; Award, Smithtown Arts Council, Long Island *Collections:* Fitzwilliam Museum; Heckscher Museum *Exhibitions:* Galerie Creuze, Paris; Grand Central Moderns, NYC *Education:* Art Students League; Zadkine Studio, Paris

Identifying himself as an expressionist with impressionist and cubist influences, his early paintings were representational. The human figure and portraits, still-life, landscapes, seascapes, and many paintings of carrousels compose these works. A student of George Grosz and Rufino Tamayo, he nevertheless feels his inspiration comes from his own life experience and extensive world travels. After a period of semi-geometric, soft-edged paintings with much experimentation in method and application, he has now returned primarily to his early themes. This content is considered with more emphasis on formal values and enhanced with techniques developed during the period of abstract work.

ENSRUD, E. WAYNE (Painter, Printmaker)
65 Central Park West, New York, NY 10023

Born: 1934 *Awards:* Rothschild Design Award; Lever House Award *Collections:* New England Center for Contemporary Art; Bristol Museum of Art *Exhibitions:* Minneapolis Institute of Art; National Arts Club, NYC *Education:* Minneapolis School of Fine Art *Dealer:* Virginia Lynch, Tiverton, RI

Working in a contemporary style his landscapes, seascapes and portraits are abstracted with the emphasis on the manipulation of intense and luminous color. He explores his concerns with color in a variety of media—oil, watercolor, etching and lithography. He calls his color "expressionistic" and revels in the explosive tensions the chromatic relationships produce. The color is applied to the canvas in daubs and splashes—the pigments raw and thick. There is uninhibited energy, emotion, and a sense of the spiritual in the flow and synthesis of line, form, and color.

ERDMAN, BARBARA (Painter, Photographer)
2006 Conejo Drive, Santa Fe, NM 87501

Born: 1936 *Education:* Art Students League; Cornell University; Chinese Institute

Originally an abstract expressionist painter starting in 1958, she soon began to incorporate representational and surrealist aspects into her work. Recently she has returned to abstract expressionism and is particularly involved in the painting of odd-shaped canvases, panel paintings and "jigsaw puzzle" paintings that interlock to create larger tableaus. In her odd-shaped canvases, the angles and lengths of the various sides, and not just the edges, are integral parts of each painting. In her

panel paintings, she strives to make each panel work separately as well as with each other. Her present work represents a continuation of her concern with spatial problems both in terms of the canvas and as an embodiment of the concept of infinity. She believes that abstract expressionism is the most direct way to deal with the problems of painting.

ERES, EUGENIA (Painter)
86 10 109th St., Apt. Cc2, Richmond Hill, NY 11418

Born: 1928 *Awards:* Gold Metal, National Art League; Gold Metal, Accademia Italia *Collections:* American Russian Museum; Grauebar Corporation *Exhibitions:* American Artists Professional League Grand National; Le Salon des Nations, Paris *Education:* Escola Das Belas Artes, Brazil *Dealer:* Fine Arts Gallery, Ardmore, PA

An oil painter and lithographer, she is known for her romantic landscapes and seascapes. In her paintings, the "real," external world is transformed into a dream-like, ideal world. Autumn, winter, spring dawn, summer sunset and other idealized themes are represented in her work. Painted with a subdued palette, her landscapes are unpopulated, quiet, and remote. The trees and ponds are enveloped in soft, pastel mists heightening the sense of isolation. She describes her work as "research for a transfiguration of the concrete."

ERLEBACHER, MARTHA MAYER (Painter)
c/o Dart Gallery, 212 W. Superior, No. 203, Chicago IL 60610

Born: 1937 *Collections:* Art Institute of Chicago; Philadelphia Museum of Art *Exhibitions:* Art Institute of Chicago; Dart Gallery *Education:* School of the Art Institute of Chicago *Dealer:* Robert Schoelkopf Gallery, NYC; Dart Gallery, Chicago

Paintings during the 1970s were realistic depictions of series and patterns of fruit, eggs, and other objects. Since 1978 works have been figurative, in a neo-Renaissance vein, primarily portraits and studies of the female nude. The oil paintings are rendered in warm erotic colors; the graphite drawings in subtle grey modulations. Women are often placed in ornamental interiors of checkered marble floors and walls, much like those depicted in Renaissance Florence, as in *Woman with Chaos, Time and Death*. This painting in particular presents traditional symbolic images and employs an arrangement of figures which recalls the "sacra conversazione": a partially clad woman is surrounded by Chaos, a masked figure; Father Time; and Death, a skeleton in a cape.

ESAKI, YASUHIRO (Printmaker)
11 San Antonio Ct., Walnut Creek, CA 94598

Born: 1941 *Awards:* First Prize, 3rd Miami International Graphic Biennial *Collections:* Boston Museum of Fine Arts; Brooklyn Museum *Exhibitions:* San Francisco Museum of Modern Art; Brooklyn Museum *Education:* Lone Mountain College

Drawing and painting are the main media she's explored in her art. Her older works featured isolated objects, portrayed in a still-life manner. She drew ropes, leaves, towels, and brown paper bags without any trace of time or place in them. In her present works she uses colored pencils over a layer of acrylic. She is drawing sheets, variously creased, folded over, flattened out, or bunched up. With the sheet as a starting point, she freely modifies its shape in the drawing for compositional emphasis.

Wayne Ensrud, *Young girl with a Pink,* 36 x 44, oil on canvas.

Katalin Ehling, *Afternoon Delight,* 23 x 26, batik.

Paul England, *Carousel,* 96 x 108, oil.

ESTES, RICHARD (Painter)
300 Central Park West, New York NY 10028

Born: 1936 *Collections:* Whitney Museum of American Art; Art Institute of Chicago *Exhibitions:* Venice Biennale; Whitney Museum Annual *Education:* Art Institute of Chicago *Dealer:* Freidenrich Contemporary Art, Newport Beach (CA); Graphics 1 and Graphics 2, Boston; Martina Hamilton Gallery, NYC; Fingerhut Gallery, Minneapolis

A city dweller, he paints realistic urban scenes. Early work of the 1960s featured earth tones to depict people in the generalized backgrounds of buildings in medium focus. In 1967 his colors brightened, the images came into sharp focus, and the figure was abandoned entirely. He has been called a photo-realist although his approach is painterly and does not ignore composition, color, line and form. Photographing a subject before beginning to paint, he employs several views and combines elements from each to create complex three-dimensional images. He often works in acrylic, and then, for depth and clarity of focus, he finishes in oil. *Central Savings* (1975) and *Ansonia* (1977) are examples of the use of reflections in glass to create complex readings of depth; multiple imagery is used to include the space outside the picture.

EVANS, JOHN (Painter)
P.O. Box 1004, New York, NY 10009

Born: 1932 *Awards:* Competition Award, Buecker & Harpsichords Gallery, NYC *Collections:* James Garrett Faulkner, Chicago; Sam and Rosetta Miller, Newark, NJ *Exhibitions:* Cordier and Ekstrom Gallery, NYC; Arts Club of Chicago *Education:* School of the Art Institute of Chicago *Dealer:* Luise Ross Gallery, NYC

Since he graduated from art school and moved to New York he has kept a daily collage/diary, using colored inks, watercolor, and pen and ink to create a series of works. These collages are composed of odd juxtapositions of both strange and familiar things. Along with his collages, he has produced a series of abstract paintings, first in oil on canvas and later in acrylic. In recent years he has concentrated on the collages and on correspondence art. He has been involved with Mail Art since the early 1960s.

EVERSLEY, FREDERICK JOHN (Sculptor)
1110 W. Washington Blvd., Venice, CA 90291

Born: 1941 *Awards:* Artist in residence, Smithsonian Institution *Collections:* Solomon R. Guggenheim Museum; National Museum of American Art, Smithsonian Institution *Exhibitions:* Whitney Museum of American Art; Santa Barbara Museum of Art *Education:* Carnegie-Mellon University

The early works, for which he became known, are cast, multi-colored, multi-layered resin sculptures. Work was primarily transparent, although later pieces were translucent or opaque. Shapes were geometric, and explored properties of the parabola; Many consisted of large parabolic lenses. Several of these same shapes were executed in large (up to 35 feet high) outdoor pieces constructed of stainless steel. Current work consists of multiple triangular elements arranged to form large curvilinear arcs in space. The indoor pieces utilize alternating layers of metal triangles, alternating with clear, plastic triangles. All of his work, past and present, deals with energy concepts, particularly solar energy. He has also created and is presently involved working on a series of large architectural scale transparent oil flowing fountains.

FACEY, MARTIN (Painter)
c/o Ivory/Kimpton Gallery, 55 Grant Ave., San Francisco CA 94108

Born: 1948 *Collections:* Wally Goodman; McDonald's Corporation Collection *Exhibitions:* Los Angeles Municipal Art Gallery *Education:* University of California, Los Angeles *Dealer:* Fingerhut Gallery, Minneapolis; Tortue Gallery, Santa Monica, CA; Ivory/Kimpton Gallery, San Francisco

Early influences range from Paul Cezanne and Henri Matisse to such mentors as Charles Garabedian and Richard Diebenkorn. A young abstract Southern California painter, like the New Imagists he combines figuration and abstraction, but unlike them his canvases are completely full of elements rather than a few isolated figures in an abstract background. Concrete objects are combined with personal experiences, juxtaposing random elements from California life such as lush foliage, bright sunlight, Hollywood and violence, in rectilinear arrangements. Colorful oils are "tablescapes"—flattened spacial planes in which objects such as shoes, palm trees, flowers, brick walls, chairs and stone paths hint at narrative, as in *Dog, Pool and Palms. Drawings in oil stick on rag paper feature boxed figures, a series of crypts which began when his father began to suffer from a terminal disease. The paintings, with their enigmatic interactions convey a psychological tension between life and death.*

FACTOR, YALE (Painter, Illustrator)
411 Gayle Ave., DeKalb, IL 60115

Born: 1951 *Awards:* Residency, "Cite de Arts", Paris *Collections:* Field Museum of Natural History; Hollister Corporation *Exhibitions:* Triton Museum; Mitchell Museum *Education:* East Texas State; Southern Illinois University *Dealer:* Neville/Sargent, Evanston, IL; Art Institute of Chicago Sales and Rental Gallery

Photo-realist pencil portraits and acrylic landscapes of the the Southwest are the two subjects of everyday life that occur repeatedly in his works. The portraits, displaying incredible facial detail in closely cropped compositions, strive to capture the subjects' hidden realities, the essence of the mysteries he constantly searches for in nature and his fellow human beings. The rendering is careful and the execution is exact. Results often border on the photographic. Recognizable objects and visages are often subtly altered, evoking uniquely constructed worlds. The sharp contrast of intimate detail against subdued shadows brings to life unexpected aspects of a subject. The acrylic paintings of Southwest landscapes are painted employing a chiaroscuro technique. The canyon landscapes contain the same elements of line and perspective that comprise the facial portraits.

FARNHAM, ALEXANDER (Painter)
Rd. 2, Box 365, Stockton, NJ 08559

Born: 1926 *Awards:* Purchase Award, Newark Museum; Fellowship, New Jersey State Council on the Arts *Collections:* Morgan Guaranty Trust Co, NY; National Arts Club, NY *Exhibitions:* National Academy of Design; New Jersey State Museum, Trenton, NJ *Education:* Art Students League *Dealer:* The Coryell Gallery, Lambertville, NJ; Dumont-Landis Fine Art, New Brunswick, NJ

From the late 1930s, when he first started painting in oils, to the present, he has been fascinated by architectural subject matter. As an art student, and later as an artist in the U.S. Navy during the mid-1940s, he incor-

Alexander Farnham, *Abandoned Farm*, 20 x 40, oil.

Barbara Erdman, *Grand Canyon Suite III*, 64 x 48, oil on canvas.

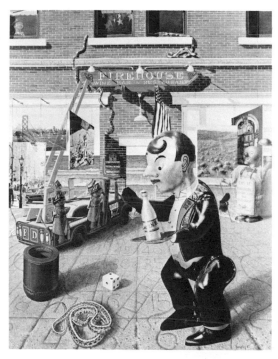

Barclay Ferguson, *Snakes & Ladders* (1982), 30 x 24, acrylic on linen. Courtesy: Louis Newman Galleries (Carmel CA)

porated architecture into his paintings. Though the canvases are extremely realistic, their compositions are based on abstract designs. Composition is the most important ingredient of his work. He works slowly on fine linen canvas, building up his paintings with many layers of pigment. He has painted canvases as large as five by seven feet, but usually he maps out his preliminary compositions on small canvases.

FARNHAM, EMILY (Painter)
616 Commercial St., #10, Provincetown, MA 02657

Born: 1912 *Collections:* Gray Gallery; East Carolina University *Exhibitions:* Louisburg College, Louisburg, NC; Outermost Gallery, Provincetown, MA *Education:* Kent State University; Ohio State University

Her early work was in the form of realistic watercolor still lifes, watercolor landscapes, and portraits in oil. Following studies with Hans Hofmanan in the early 1950s, she began producing primarily abstract and non-objective works. During the period 1975-82 she produced a series of mixed media works developed from monoprints, using pen and ink with collage. Among her recent works is a series of acrylic paintings entitled the *Golden Ball* series, showing a strong influence from her study of De Chirico. Currently she is producing non-objective acrylic works employing a semi-transparent watercolor technique.

FEBLAND, HARRIET (Sculptor)
245 E. 63rd St. Apt. 408, New York, NY 10021

Born: NYC *Awards:* film, Agnes K. Haverly Foundation *Collections:* Cincinnati Art Museum; Metromedia *Exhibitions:* Hudson River Museum; Museum de Arte Moderne, Paris *Education:* Pratt Institute; Art Students League

Constructivist, geometric abstractions in relief and free standing forms combine color on wood, with plexiglass, marble, aluminum and steel. Some are nearly architectural, emerging from the very flatness of the wall as I-beams richly wrapped with ribbons of color like a school of tropical fish. They are the makings of a sanctuary studded with colorful inlaid wall reliefs, totemic shrines, and brilliant coffers. Size ranges from her monumental architectural sculptures and wall reliefs to intimate box constructions and hand held pieces. Outdoor sculptures are produced in fiberglass, steel and painted aluminum. Her early fascination with totemic shapes continues to appear in current works.

FEDELLE, ESTELLE (Painter)
1500 S. Cumberland, Park Ridge, IL 60068 *Awards:* Margaret Remington Dingle Award *Collections:* People's Church, Chicago; Lutheran General Hospital, Chicago *Exhibitions:* Illinois State Fair; Chicago Public Library *Education:* The School of the Art Institute of Chicago; Northwestern University

Her mainstay is the commissioned portrait. She paints in a style that could be described as an individualistic version of impressionism, though her portraits usually are rendered realistically. She has traveled widely, and many of her works reflect her impressions of foreign lands. She is the author of an instruction book for teachers in art, *How to Begin Painting for Fun.* She also has written a weekly column about art since 1974, *Art and You,* a Leader Newspaper feature.

FEIGIN, MARSHA (Printmaker)
200 E. 84th St., New York, NY 10028

Born: 1948 *Awards:* Grant, National Endowment for the Arts; Grant, New York State Council on the Arts

Collections: Brooklyn Museum; National Art Museum of Sports *Exhibitions:* Brooklyn Museum; Whitney Museum of American Art *Education:* University of Hawaii; City College of New York

She is a graphic artist whose primary interest is giving expression to sports imagery. Her past work has focused on creating large-scale, black-and-white, airbrushed aquatint etchings. Her current work gives more emphasis to drawings, collages, and other unique works on paper. This shift has resulted from a desire to capture a more immediate, hands-on quality in image-making. She presently is concerned with a series on boxing, kick-boxing, and other martial arts.

FEININGER, ANDREAS B.L. (Photographer)
18 Elizabeth Lane, New Milford CT 06776

Born: 1906 *Awards:* Robert Leavitt Award; Gold Medal, Art Directors Club of Metropolitan Washington *Collections:* Metropolitan Museum of Art; Museum of Modern Art *Education:* The Bauhaus, Weimar, Germany *Dealer:* Daniel Wolf, NYC

Son of painter Lyonel Feininger, he graduated with high honors from the Bauhaus in 1925 and worked as an architect in Germany until 1931. In Sweden two years later he became a photographer and after arriving in America in the 1940s became a staff photographer for *Life* magazine. Careful depictions of architectural forms and street scenes are documentary in their approach. He has done a great deal of work in telephoto and close-up photography, including intricate nature studies. Of greatest importance to him is "clarity of presentation." His works shows a strong connection to Bauhaus though it is often proclaimed as warm and intimate, very European in style and sensibility.

FELLOWS, FRED (Painter, Sculptor)
Box 464, Bigfork, MT 59911

Born: 1934 *Awards:* Gold, Silver Medals, Cowboy Artists of America Exhibition *Collections:* Whitney Cody, WY; Phoenix Art Museum *Exhibitions:* Grand Palace, Paris; First American Art Exhibition, Mainland, China *Dealer:* Trailside Galleries, Scottsdale, AZ

His paintings and sculptures feature Western themes; He was strongly influenced by Western and Indian traditions as he grew up in northern Oklahoma. He worked as a saddle-maker, cowboy, and commercial artist before he began focusing on fine art. He recently was selected by the Hesson Corporation to be their National Finals Rodeo Artist. He will do a series of paintings, sculptures, and belt buckles relating to the rodeo. He is past president and current director of the Cowboy Artists of America.

FELTUS, ALAN EVAN (Painter)
Rt. 1 Box 344, Hughesville, MD 20637

Born: 1943 *Awards:* Rome Prize, Fellowship in Painting; Fellowship, National Endowment for the Arts *Collections:* Hirshhorn Museum and Sculpture Garden; Bayley Museum *Exhibitions:* Forum Gallery, NYC; Dayton Art Institute *Education:* Yale University; Cooper Union *Dealer:* Forum Gallery, NYC

Since 1970 he has been painting images containing one to four female figures, nude and clothed, in interior spaces. These life sized figures are organized in compositions in which the formal structure becomes controlled and visually meaningful. Yet, there is no narrative content and interpretation of figures or their gestures is made difficult because of ambiguity. Current works continue the series, working as before without

models, on large canvases up to about five by six feet in size. Influences are many ranging from ancient Roman painting to Giotto, Pierro Della Francesca, Pontormo, Balthus, Gorky, and DeKooning.

FENICHEL, LILLY R. (Painter)
Box 2474, Taos, NM 87571

Awards: Grand Prize, Taos Open Award Show; Laguna Beach Museum *Collections:* AAMOCO Corporation; ARCO Corporation *Exhibitions:* Santa Barbara Museum of Art; Otis Art Institute *Dealer:* New Gallery, Taos, NM

With her roots in the Bay Area abstract expressionist of the 1950s and 60s, her early paintings reflected a strong interest in the expressive capabilities of painting. Color continued to be the underlying inspiration and structural aspect of her paintings although her imagery evolved over the years. In the past year and a half her work has moved away from conventional oil canvases to works that incorporate three dimensional fiberglass surfaces with a strong painterly expressiveness. Current concerns are the interplay of shadow and color and the illusions that result.

FERBER, HERBERT (Sculptor)
44 MacDougal St., New York NY 10012

Born: 1906 *Awards:* Paris Prize, Beaux-Arts Institute; Tiffany Grant *Collections:* Metropolitan Museum of Art; Museum of Modern Art *Exhibitions:* Whitney Museum of American Art; Museum of Modern Art *Education:* Beaux-Arts Institute of Design; City College of New York *Dealer:* M. Knoedler, NYC

Early media of the 1930s were stone and wood, carved on a massive scale. Throughout the next decade he was influenced by Henry Moore and Ossip Zadkine, creating open wood pieces by gluing and dowelling. He moved from open, graceful human figures to abstract organic forms when he began to experiment with soldering and welding. Experimenting with space in the 1950s, he created "roofed sculpture," wherein parts were raised from a flat base and hung from an attached ceiling. By 1958 the pieces had become architectonic. Recently he has done abstract painting.

FERGUSON, BARCLAY
(LORD OF LAMOND) (Painter)
Box 1552, Carmel CA 93921

Born: 1924 *Awards:* Best of Show, California State Fair *Collections:* Monterey Peninsula Museum of Art; Pacific Grove Art Center *Exhibitions:* Monterey Peninsula Museum of Art; M.H. de Young Memorial Museum *Education:* Glasgow School of Art; Instituto Allende, Universidad Guanajuato *Dealer:* Louis Newman Galleries, Beverly Hills, CA

A super-realist, this Canadian artist's aim is to depict the textures created by light and space. Early paintings featured precise renderings of New York City buildings. "Cardboard box paintings," like the more recent works, placed objects in unusual or unnatural settings. Games and tin toys are the objects presented in a recent period of paintings using two- and three-point perspective. The most recent examples from this period are more simplified, in one-point perspective, with the repetition of one toy rather than many different toys. He calls these images "symbols of fables and foibles of mankind."

FERNANDEZ, RUDY M. (Painter, Sculptor)
4211 N. Marshall Way, Scottsdale, AZ 85251

Born: 1948 *Awards:* Visual Arts Award, Arizona Community Arts *Collections:* University of Arizona Art Museum; Smithsonian Institution *Exhibitions:* Denver Metropolitan Museum; And/Or Gallery, Seattle *Education:* Washington State University; University of Colorado *Dealer:* Elaine Horwitch Gallery, Santa Fe

He works in mixed media, painting, drawing, printmaking and sculptural techniques to depict an imagery that incorporates Southwest scenes with cultural commentary. Apart from his strong attachment to the Southwest landscape, the artist employs a contemporary and personal symbolism derived from long experience with the Hispanic folk tradition. Many of his works draw upon Spanish religious folk art, striving to create an art form that emulates the naive innocence of a lost tradition. He displays a strong sensitivity to color and use of materials. His works also speak about perception and the nature of visual illusions; what is reality and what is artifice.

FERRARI, VIRGINIO (Sculptor)
5429 S. East View Park, Chicago, IL 60615

Born: 1937 *Awards:* Award, Illinois Council of the American Institute of Architects *Collections:* University of Chicago; Collection of the City of Chicago *Exhibitions:* Zaks Gallery, Chicago; University of Parma, Italy *Education:* Scuola d'Arte & Academi Cignaroli *Dealer:* Zaks Gallery, Chicago

Lyrical abstract sculpture in bronze, and marble is highly expressive with a minimum of means. His austere, but intensely alive compositions express a search for essence, reminiscent of Brancussi's images or architectural statements by Mies van der Rohe or Aldo Rossi.More recent pieces in stainless steel, vary from the monumental *Being Born* on the State Street Mall in downtown Chicago, to the smaller lyrical piece *Nine Elements* done for a private residence where the bizarre concoction of non-symmetrical cubes and planar shapes free fall and melt into the clapboard surface of the suburban house.

FILLERUP, MEL (Painter)
P.O. Box 938, Cody, WY 82414

Born: 1924 *Awards:* Gold Medal, American Indian and Cowboy Artists *Collections:* Cowboy Hall of Fame *Dealer:* Trailside Galleries, Jackson, WY, Scottsdale, AZ; Big Horn Gallery, Cody, WY; Tivoli Gallery, Salt Lake City; Gallery 85, Billings, MT

His subjects are the landscape, wild and domestic animals, and people. He paints in an impressionistic style, usually on location. In all his work he strives for the mood of the landscape or the interesting attitude of animals or people. Occasionally his works use historic themes. He worked as a lawyer for many years, but then decided to paint full time. Among the influences on his mature work are Conrad Schwiering, Paul Bransom, Bob Meyers, and Robert Longheed.

FINE, JUD (Sculptor, Conceptual Artist)
110 Center St., Los Angeles CA 90012

Born: 1944 *Awards:* Laura Slobe Memorial Award, Art Institute of Chicago; Contemporary Art Council New Talent Grant, Los Angeles County Museum of Art *Collections:* Art Institute of Chicago; Los Angeles County Museum of Art *Exhibitions:* Art Institute of Chicago; Documenta 5, Kassel, Germany *Education:* Cornell University *Dealer:* Ronald Feldman Fine Arts, New York City

During the 1960s he earned undergraduate and doctoral degrees in history, and did not receive a degree in sculpture until 1970. In experimental mixed-media

pieces art and language were parodied, often with fragments of text or photographs in combination with stenciled images and colored shapes. *Discourse,* for example, was a booklet which hung at the end of a chain on the wall containing a convoluted argument that ended where it began. More recent sculptures continue an interest in history and language, including architectonic pieces which are both geometric and organic, such as *Horizontal Pillar*, a one-hundred-and-sixty-foot long horizontal steel pillar with elements of straw and wood attached by string and wire. Drawings accompanying works such as this depict monolithic structures along with written explanations of mankind's existence and his relationship throughout history to the structures he has built.

FIRFIRES, NICHOLAS SAMUEL (Painter)
1330 Pepper Ln., Santa Barbara, CA 93108

Born: 1917 *Collections:* Harmsen's Western Americana; University of Wyoming Museum *Exhibitions:* C.M. Russell Museum; Arizona Museum of Art *Education:* Otis Art Institute

A realistic impressionist in oil and watercolor, his paintings are of sea and landscapes, nudes, animals, still life, and, most importantly, the western ranch life he knows and loves so well. His painting style is direct; bold, broad, and colorful. Masculine sensitivity and a truly aesthetic concept of his subject mark his work. Honest and competent, in his dramatic paintings authenticity goes far beyond correctness of costume and saddle, even beyond knowledge of cowboy types and of horse and cattle breeds and their anatomies. He brings to life the crisp morning on the rangeland, sunny lazy afternoons in the pastures, or warm quiet evenings on the trail camp.

FISCHL, ERIC (Painter, Printmaker)
c/o Mary Boone Gallery, 417 W. Broadway New York NY 10012

Born: 1948 *Collections:* Metropolitan Museum of Art; Dominique DeMenil *Exhibitions:* Kunsthalle Basel; Mary Boone Gallery *Dealer:* Mary Boone Gallery, NYC;

In paintings and drawings, the psychosocial self is explored through the use of taboo subject matter such as themes of sexuality, often capturing figures in self-conscious and awkward moments. The prints, too, contain a narrative sensitivity without telling an actual story, for the figures are always about to take action and the scenes are full of possibilities, as in a recent group of six etchings which can be viewed in any sequence entitled *Year of the Drowned Dog*.

FISH, JANET I. (Painter)
101 Prince St., New York NY 10012

Born: 1938 *Awards:* Harris Award, Chicago Biennale; MacDowell Fellowship *Collections:* Whitney Museum of American Art; Metropolitan Museum of Art *Exhibitions:* Whitney Museum of American Art; Art Institute of Chicago *Education:* Smith College; Yale University School of Art *Dealer:* Robert Miller Gallery, NYC

First trained by Leonard Baskin in sculpture and printmaking, in the early 1960s she turned to Abstract Expressionist painting and then quickly to a more realistic style, painting still lifes. The effects of light upon surfaces became a primary concern. Photo-realistic still lifes are large-scale depictions of common objects, most notably of glass, such as *Berrio Olive Oil* bottles and *Wine and Cheese Glasses*. Glass objects placed on

mirrors or filled with water create a complicated interplay of surfaces and their reflections, and a rainbow of sparkling colors. Unlike most other photo-realists, her approach is painterly: "I get more out of the marks—out of a very active surface."

FITZGERALD, ASTRID (Painter)
650 West End Ave., New York, NY 10025

Born: 1938 *Awards:* Juror's Award, 4th Annual Smallworks Competition; Charles Levitt Award, National Academy Galleries *Collections:* Aldrich Museum; Rockefeller Center Collection *Exhibitions:* Atlantic Gallery, NYC; Galerie Steinfels, Zurich *Education:* Pratt Institute; Art Students League, NYC *Dealer:* Heidi Jones Gallery, NYC; Swanston, Foster, and Hanchey, Atlanta

Color interaction evolved into geometric illusionism, as the artist sought various ways to express the indefinite nature of an image or structure in media ranging from serigraphs and watercolors to constructions and shaped canvases. Older works explored primary relationships of unity, order and law through geometry in an effort to reconcile the differences in the philosophies of science and art—the material and the numismatic. Recent work explores harmonic proportions of the Golden section, or the Divine proportion. Works are in pastel on paper or acrylic on canvas in a tectonic manner. Gestural strokes infuse the work with movement and light. The imagery is often suggestive of landscapes or at times architectural forms, but space is always modeled within the laws of the Golden section.

FIX, JOHN ROBERT (Sculptor)
Box 167, Groton Long Point, CT 06340

Born: 1934 *Awards:* First Place, Crafts, Associated Artists of Pittsburgh; Mrs. Roy Arthur Hunt Prize *Exhibitions:* World's Fair; DeCordova, Lincoln, MA *Education:* School for American Craftsmen; Connecticut College

For twenty seven years he has been teaching and working as a jeweler, silversmith, and sculptor. His work is organic and relates to the sea. The sculpture is done in pewter, surface cast, and relates to natural sea life. In jewelry he has experimented with a number of techniques, including fabrication, casting, and water casting. The work tends to develop from hard edge to organic and a combination of both. Originally he began to do his sculpture in a vY.free, organic way to escape the hard edge results of silversmithing and jewelry. Eventually he has come to use both techniques in all his work.

FLACK, AUDREY L. (Painter)
110 Riverside Dr., New York NY 10024

Born: 1931 *Awards:* The Cooper Union Citation; Second Prize, National Exhibition of Paintings, Butler Institute of American Art *Collections:* Metropolitan Museum of Art; Museum of Modern Art *Exhibitions:* Whitney Museum of American Art; Metropolitan Museum of Art *Education:* Cooper Union; Cranbrook Academy of Art; Yale University *Dealer:* Louis K. Meisel Gallery, NYC

Still life paintings from the early 1960s consist of perfume bottles, jewelry, and other dressing table accessories. Personal objects such as these are the subjects of her work. *Royal Flush,* for example, a screen print, and other highly realistic representations of objects refer to her own family's preoccupation with gambling. The air brush technique creates brilliant colors

Emily Farnham, *Golden Ball Series #5 : Whitecaps,* 30 x 40, acrylics. Courtesy: Gray Gallery (Greenville NC)

Mel Fillerup, *Ranch Business,* 12 x 24, oil.

and light. Thinking in terms of light rather than color, she is fascinated with color and its individual wave lengths. "Color is not stable, it changes as light changes. . . . Color does not exist in actuality. It is only a sensation in our consciousness."

FLAVIN, DAN (Installation Artist, Sculptor)
P.O. Box 248, Garrison NY 10524

Born: 1933 *Awards:* William and Noma Copley Foundation Grant; National Foundation Arts and Humanities Award *Collections:* Museum of Modern Art; Whitney Museum of American Art *Exhibitions:* Art Institute of Chicago; Whitney Museum of American Art *Education:* Self-educated *Dealer:* Leo Castelli Gallery, NYC

A series of Minimalist structures which he called "blank, almost featureless square-fronted constructions with obvious electric lights" was begun in 1961. Later works employed fluorescent lights exclusively, without "constructions," sometimes rendering the light fixtures invisible.He now seeks to dissolve flat surfaces and to restructure space. Artificial "installations" emphasize the characteristics of the rooms in which he creates.

FLEMING, FRANK (Sculptor)
1309 Saulter Road., Birmingham, AL 35209

Born: 1940 *Awards:* Purchase Award, 22nd National Drawing/Sculpture Exhibition, Ball State University, Muncie, IN; Award, Birmingham (AL) Museum of Art Juried Exhibition *Collections:* National Museum of American Art, Smithsonian Institution; Utah Museum of Fine Arts *Exhibitions:* Hunter Museum of Art, Chattanooga, TN; Birmingham (AL) Museum of Art *Education:* University of Alabama *Dealer:* Woody Gallery, Houston; Milliken Gallery, NYC; Heath Gallery, Atlanta, GA; Garth Clark Gallery, Los Angeles

He creates his ceramic sculpture in porcelain, not casting the material in molds, but instead building it up by hand. This technique reinforces a sculptural attitude, and the immediacy of the artist's hand is always evident. He has developed a style of precise and minute detailing of his subjects—feathers of birds, scales of fish, bark and leaves of trees. His inspiration comes from a highly personal mythological imagery, rooted in his Southern heritage but also having classical associations.

FOGEL, SEYMOUR (Painter)
Torandor 339 Georgetown Rd., Weston, CT 06883

Born: 1911 *Awards:* Silver medal, Architectural League of New York; First Prize, Gulf Caribbean International *Collections:* Whitney Museum of American Art; Joseph H. Hirshhorn Collection *Exhibitions:* M. Knoedler & Co., NYC; Houston Museum of Fine Arts *Education:* National Academy of Design *Dealer:* Graham Modern, NYC

Works have evolved from the social realism of the thirties to his present direction of structured painting and three dimensional constructions. The artist's evolution has encompassed a period of hard-edged painting, abstract expressionism and a vast amount of self-described "unusual work". He has done mosaic murals for the US Customs Courts Building and several high schools in New York, and a sand sculpture wall for the Hoffman-La Roche Residential Tower in Nutley, New Jersey. His art work combines a multitude of dualities, involving complex combinations of pride and humility, searching and finding, freedom and rigidity, and form and meaning.

FOOLERY, TOM (Painter, Assemblage Artist)
186 Clara, San Francisco, CA 94107

Born: 1949 *Collections:* St. Francis Memorial Hospital, San Francisco *Exhibitions:* Velick Gallery, San Francisco; Anhalt Gallery, Los Angeles *Education:* Oregon State University; University of Washington *Dealer:* Bruce Velick Gallery, San Francisco

Formerly, he painted in oils on canvas, synthesizing abstraction and surrealism. He has since made a transition into assemblage, and the fascination with surrealism continues. His box constructions, while indebted to the Joseph Cornell tradition, are characterized by their range in tone, from the humorous to the very serious. Recurring themes include male/female relations, world predicaments, and military satires. Other pieces are more intuitive, allowing viewers to interject themselves into the works.

FORMAN, ALICE (Painter)
8 Croft Rd., Poughkepsie, NY 12603

Born: 1931 *Exhibitions:* Kornblee Gallery, NYC; Museum of Fine Arts, Houston *Education:* Cornell University *Dealer:* Kornblee Gallery, NYC

The original theme of her paintings was based on the Hudson Valley landscape. Her early paintings were abstract and made heavy use of impasto techniques. The work gradually became figurative and patterned, depicting still lifes and figures. Recently her paintings have become larger in scale and show a more expressionistic quality of color and paint surface. She prefers still lifes as subjects, viewing them as freer and more metaphorical than literal. She also is interested in exploring the iconography and historical traditions of still lifes of other eras to find expressive equivalences in a contemporary genre.

FORRESTER, PATRICIA TOBACCO (Painter, Printmaker)
2220 Twentieth St. N.W., Washington DC 20009

Born: 1940 *Awards:* Fellowship, John Simon Guggenheim Foundation, Printmaking; MacDowell Colony Fellowship *Collections:* Brooklyn Museum; Oakland Museum, Art Division *Exhibitions:* San Francisco Museum of Art; Corcoran Gallery of Art *Education:* Smith College; Yale University School of Art *Dealer:* Kornblee Gallery, NYC; Fendrick Gallery, Washington, DC

Early work under Leonard Baskin was derivative, but in 1961 after contact with Neil Welliver and Philip Pearlstein she developed a realistic style. Detailed watercolors of nature are sensuous images of foliage, trees and flowers painted from life. Contrasting elements from the imagination are common in the paintings, such as a fragile blossom on a winter tree branch. Unlike the work of many realists, her works are fantasies, more conscious of the beautiful. Extensive travels, especially to tropical areas, provide her with plenty of exotic flowers and trees from which to work. Working outdoors, watercolors are executed on large sheets of paper, later attached together to make multi-paneled images such as *The Blue Pool.* Recently some of the multi-paneled works were mounted in Oriental fashion on folding screens.

FOULKES, LLYN (Painter, Assemblage Artist)
6010 Eucalyptus Lane, Los Angeles CA 90806

Born: 1934 *Awards:* Fellowship, John Simon Guggenheim Foundation; New Talent Purchase Grant, Los Angeles County Museum of Art *Collections:* Whitney Museum of American Art; Museum of Modern Art *Exhibitions:* Whitney Museum of American Art; Art Institute of Chicago *Education:* Chouinard Art Institute *Dealer:* Asher/Faure, Los Angeles

Astrid Fitzgerald, *Golden Section LVI,* 30 x 44, pastel. Courtesy: Steiger Jones Gallery (New York NY)

Audrey Flack, *Fruits of the Earth* (1983), 54 x 74, acrylic on canvas. Courtesy: Louis K. Meisel Gallery (New York NY)

Believing in the most direct approach to art, he wants to give art validity "in an over-stimulated world." Because he refuses to become "a product for art's sake," he is difficult to categorize. His media have included assemblages of such materials as polyethylene, wood, paper and enamel, and paintings in oil and acrylic. A humorist, in the 1970s he founded a group called Llyn Foulkes and the Rubber Band. He stands on the fringes of Pop Art with repeated monochrome images of eroded rocks, to which he applies labels, such as postcards.

FOWLER, ERIC (Illustrator, Painter)
268 E. 7th St., New York, NY 10009

Born: 1954 *Awards:* Award, 1977 Illustrators Workshop; Certificates of Merit, Society of Illustrators *Exhibitions:* Graphis Annual; Society of Illustrators *Education:* Pratt Institute; Syracuse University

A free lance illustrator working in the Manhattan area, his illustration clients have included *Sports Illustrated*, *Penthouse*, American Express, IBM, Pacific Bell, *Redbook*, E.P. Dutton, St. Martins Press, and RCA. Recent work in illustration has included designing and illustrating maps for *Cityscapes*, as well as editorial and advertising work. Recent paintings were exhibited at a group show at Diaz-Marcial Gallery, NYC

FOWLER, MARY JEAN (Fiber Artist)
1415 Hamlin Valley, Houston, TX 77090

Born: 1934 *Collections:* Prudential Bache; First City Bank *Exhibitions:* Archway Gallery, Houston; "Five Fiber Artists", Baylor University *Education:* Iowa State University *Dealer:* Archway Gallery, Houston

Her work is involved in simple direct approaches toward tapestries and wall hangings executed in subtle designs and expressed in muted colors. She concentrates on overall patterns of landscapes displaying strong design elements and simple, concise shapes. In each piece she tries to create a quiet place, an interval of calm and peace in an effort to balance the serenity lacking in our contemporary lives. Current work is almost exclusively in fiber. The artist believes this to be a warm, expressive medium—familiar because of our common involvement with fiber in our everyday lives and at the same time reflective of a long tradition as an art form in tapestries and rugs. She uses fiber's tactile qualities to enhance the visual qualities of the strong Texas landscapes she depicts.

FOWLER, MEL (Painter, Sculptor)
Studio G 224 Westbeth, 463 West St., New York, NY 10014

Born: 1922 *Awards:* Scholarship, Minneapolis Institute of Fine Arts *Collections:* Walker Art Center; The British Museum *Exhibitions:* Museum of Modern Art; Traveling Exhibition, New York State Council on the Arts *Education:* Minneapolis Institute of Fine Arts; California School of Fine Art *Dealer:* Multiple Impressions, NYC; Wenniger Gallery, Boston

An accomplished artist in both painting and sculpture, his works are in both figurative and abstract styles. Previous work in oil consisted mainly of large scale murals and sculpture in bronze and steel. For the last ten years he has been primarily concerned with woodcut and etched printmaking. His emphasis in these works has been the use of the figure in tandem with folk proverbs to comment on the human condition in an illustrative manner. He has illustrated fourteen poetry and children's books.

FOX, TERRY (Conceptual Artist, Video Artist)
Box 84, Canal Street Station, New York, NY 10013

Born: 1943 *Collections:* Museum of Modern Art *Exhibitions:* Museum of Conceptual Art; University Art Museum, University of California, Berkeley *Education:* Cornish Institute; Accademia di Belli Arti, Rome

A conceptually oriented artist working both in video and performance, his video tapes *The Children's Tapes*, executed using simple props and a single black and white camera, remain an early landmark in the history of video. His sometimes controversial performances have included pieces performed at the Museum of Conceptual Art and a near legendary performance at the University Museum at the University of California at Berkeley where he burned the museum's rare plants with a flame-thrower as part of a performance that was a protest to the Vietnam war. Current work in video, performance, and installations continues in a conceptually oriented direction.

FRANCIS, SAM (Painter)
345 W. Channel Dr., Santa Monica Canyon, Los Angeles CA 90402

Born: 1923 *Awards:* Tamarind Fellowship; Dunn International Prize, Tate Gallery *Collections:* Solomon R. Guggenheim Museum; Museum of Modern Art *Exhibitions:* San Francisco Museum of Art; Albright-Knox Art Gallery *Education:* University of California, Berkeley; Atelier Fernand Leger *Dealer:* Galerie Smith-Anderson, Palo Alto, CA

After prolonged formal study, he had his first solo show in 1952 in Paris. This early work consisted of abstract paintings with large areas of color light in tone. Soon the tones became more vivid, with areas of color bleeding into each other. A trip around the world in 1957 perhaps influenced his artistic career most. Cool colors, thinly applied and arranged in asymmetrical segments on the canvas, seem to recall the Japanese tradition. During the 1960s he became increasingly occupied with lithography. Currently his Oriental tendencies continue, with the clarity and starkness of form and composition related to the Minimalists.

FRANKENTHALER, HELEN (Painter)
173 E. 94th St., New York NY 10028

Born: 1928 *Awards:* First Prize, Biennale de Paris; Garrett Award, Art Institute of Chicago *Collections:* Whitney Museum of American Art; Metropolitan Museum of Art *Exhibitions:* Metropolitan Museum of Art; Solomon R. Guggenheim Museum *Education:* Bennington College; Art Students League *Dealer:* Andre Emmerich Gallery, NYC

After formal training in Cubism she developed an individual abstract expressionistic style influenced by the work of Arshile Gorky and Vassily Kandinsky. In 1951 she became interested in Jackson Pollock and the transformation of the unconscious into concrete artistic creations. She began to explore color-field combinations and the ways in which their accidental combinations are controlled. Progressing from small areas of color in oil to large areas in acrylic, she has painted on unsized, unprimed canvas, a technique developed from Pollock's method of dripping and staining the paints onto raw canvas. Paint actually soaks into the canvas to create a purely optical image, rather than a three-dimensional form.

FRANKLIN, JONATHAN (Painter)
565 W. 18th St., Chicago, IL 60616

Michael Frary, *Coast Town,* 72 x 96, diptych acrylic.

Robert Freiman, *Granary in Nantucket,* 30 x 40, oil. Courtesy: Caravan House Gallery (New York NY)

Born: 1953 *Awards:* American School Artist Scholarship *Collections:* The Art Institute of Chicago *Exhibitions:* DEO Fine Arts, Chicago *Education:* University of Michigan *Dealer:* DEO Fine Arts, Chicago

A figurative painter, his settings in paintings are simple yet ambiguous with figures casually oriented in undefined space. By contrasting tight positioning of the figures with looser treatment of the surrounding space, he tries to capture a moment of dramatic tension in which the viewer becomes involved. Currently, he is completing a volume of work on which the figure is increasingly involved with the surrounding space. Whereas in earlier work, in order not to distract from the figure, descriptive details such as a specific landscape or a still life were played down, the more recent paintings exhibit background elements that have begun to play more significant roles in the work as a whole.

FRARY, MICHAEL (Painter)
3409 Spanish Oak Dr., Austin, TX 78731

Born: 1918 *Awards:* Prize, Annual Mid-Year Show, Butler Institute of American Art *Collections:* National Museum of American Art; Dallas Museum of Fine Arts *Exhibitions:* McNay Art Institute, San Antonio, TX; Springfield (MO) Museum of Art *Education:* University of Southern California; School of the Art Institute of Chicago *Dealer:* Soho Gallery, Austin, TX

He works in watercolor, acrylic on canvas, and acrylic on canvas as large tapestry designs. The Department of Interior commissioned him to paint a series of reclamation sites in four states. His watercolor, *Antelope Country*, was selected by the National Gallery for presentation by President Lyndon Johnson to the New Zealand Minister at the Manila Conference. Currently he is a professor of art at the University of Texas in Austin.

FRECKLETON, SONDRA (Painter)
67 Vestry St., New York NY 10013

Born: 1936 *Awards:* Ingram Merrill Grant; Bradford Print Prize *Collections:* Prudential Insurance, Newark; Sara Roby Foundation, NYC *Exhibitions:* Whitney Museum Annual; Springfield (MO) Art Museum *Education:* School of the Art Institute of Chicago *Dealer:* Brooke Alexander, NYC

She began as an abstract sculptor using her married name, Sondra Beal, working in woods and plastics. Soon after, watercolor became her primary medium for depictions of still life often taken from scenes in her home. An interest in music guides the compositions, integrating "a mixture of complicated quick passages, simple rest areas, major thrusts . . . and theme." Sitting before the actual objects, preliminary drawings and studies in oil or pastel are developed and redefined into a final composition to be used for the watercolor. Photographs are sometimes used in order to record a perishable item, but she works primarily from life. The large, realistic still lifes which result often have a narrative flavor, as in *The Garden Plan*.

FREIMAN, ROBERT J. (Painter)
360 W. 55th St., Apt. 6E, New York NY 10019

Born: 1917 *Awards:* First Prize, French Republic, Ecole des Beaux Arts *Collections:* Museum of Fine Arts, Boston; Musee Municipal de St. Paul-de-Vence *Exhibitions:* Galerie Cardo Matignon; Galerie Marcel Bernheem *Education:* Art Students League; National Academy of Design; Parsons School of Design; Pratt Institute; Ecole des Beaux Arts *Dealer:* Caravan House Gallery, NYC

Deaf since birth, he has been able to portray without distraction the history of painting, moving from portrait to still life, then to landscape, later influenced by Impressionism and Expressionism. Extensive travels to France, Greece, northern Africa and the American West have inspired his work. Many drawings and paintings have depicted objects and people in motion: trains, cyclists, acrobats, ballet dancers and other athletes. Among the recent paintings are mannerist and post-modernist visions of the cosmos, reminiscent of Giorgio de Chirico, wherein architectural elements are placed in metaphysical landscapes. Arches, towers, pyramids, facades and castles seem to float in a dark void. "I have seen this world in my dreams when I was a child."

FREIMARK, ROBERT (Painter, Printmaker)
Rt. 2, Box 539a, Morgan Hill, CA 95037

Born: 1922 *Awards:* Artist in Residence, Ford Foundation *Collections:* British Museum; Smithsonian Institution *Exhibitions:* Art Institute of Chicago; Brooklyn Museum *Education:* Cranbrook Academy *Dealer:* Moos Art International, Miami, FL; Percival Galleries, Ltd., Des Moines, IA

He is probably most widely known for his experimentation with the new Czech media Art Protis, and his attempts to liberate tapestry from its conventional crafts limitations. From 1960 to 1968 he executed a suite of color serigraphs depicting each of the 50 states of the Union, which has been widely exhibited. During the 1970s he created tapestry installations for museums and corporations. He regularly returns to Czechoslovakia to complete works. Currently he is working on a suite of 500 watercolor paintings of pristine California, portraying isolated locations that have not been "improved" by modern man.

FRIDGE, ROY (Sculptor)
Box 1311, Port Aransas, TX 78373

Born: 1927 *Awards:* Standard Oil Teaching Award *Collections:* Museum of Modern Art; Menil Foundation, Houston, TX *Exhibitions:* Moody Gallery, Houston, TX *Education:* University of Texas; Baylor University *Dealer:* Moody Gallery, Houston, TX

During the mid-1950s, he designed theater sets, made 16mm films, and created wood sculpture. In 1962 he "retreated" to the Texas coast and concentrated on wood sculpture. Using driftwood and found objects, in combination with carved wood, he created iconographic "heroes," totems, boxes, reliquaries, and fetishes. He taught at Rice University and the University of Oklahoma from 1968 to 1973. Then he again returned to the Texas coasts, creeks, and woods to continue his autobiographical "mythologies." The voyages and journeys of his inner search are described by his narrative sculpture and photo/drawings.

FRIED, HOWARD LEE (Video Artist, Installation Artist)
16 Rose St., San Francisco, Ca. 94102

Born: 1946 *Awards:* Fellowship, National Endowment for the Arts *Collections:* Stedelijk Museum; San Francisco Museum of Modern Art *Exhibitions:* University Art Museum, University of California, Berkeley; Museum of Modern Art *Education:* Syracuse University; San Francisco Art Institute; University of California at Davis *Dealer:* Paule Anglim, San Francisco

A seminal figure in the overlapping fields of video, performance and installation art, he has earned an inter-

Henry Fukuhara, *Untitled,* 18 x 24, mixed media.

Bob Freimark, *Border Town,* 30 x 22, lithograph.
Courtesy: Moosart Gallery (Miami FL)

Max Ginsburg, *Holding an Orange Section,*
12 x 9, oil.

national reputation particularly in video. However because of their structural nature, all his works are best discussed as sculpture. Generally, his method involves the objectification of social or psychological process. He accomplishes this by constructing metaphors which in some sense equate physical structures with psychological phenomena. Earlier works tend to be autobiographical and to focus on the complexities of decision making and the process of learning. The more recent pieces are concerned with group dynamics and external societal issues.

FUERST, SHIRLEY MILLER (Sculptor)
266 Marlborough Rd., Brooklyn, NY 11226

Born: 1928 *Awards:* Award, National Association of Watercolor Artists *Collections:* James Michener Foundation, Collection of 20th Century American Art; Exxon Corporation *Exhibitions:* College of New Rochelle; Hudson River Museum *Education:* Hunter College; Brooklyn Museum Art School

She constructs luminous translucent hangings in which brilliantly colored forms seem to float, balance, or move. She began as a landscape painter and later worked as a printmaker, developing a unique method of coloring and shaping transparent plastic. She soon realized that this new medium was ideal for sculpture. Her current works consist of wall-sized, free-hanging constructions and smaller works encased in acrylic boxes. In these pieces, several layers of translucent shapes are attached to a transparent support. Light passes through the colored layers to cast duplicate color images on the wall beyond. The forms are organic, reminiscent of those found in water environments or forest interiors.

FUKUHARA, HENRY (Painter)
400 Half Hollow Rd., Deer Park L.I., NY 11729

Born: 1913 *Awards:* Purchase Award, Nassau Community college; Elise Brown Memorial Award, Mamaroneck Art Guild, NY *Collections:* Hekscher Museum, Huntington, NY; Palm Springs Desert Museum *Exhibitions:* American Watercolor Society, NYC; Elaine Benson Gallery, Bridgehampton, NY

He concentrates on watercolor in both large and miniature formats. He uses the environment as the source of his imagery, but does not limit himself to literal translations of his subject matter. His style reflects the calligraphic strength, sparsity, and abstraction of Japanese art. He treats landscape primarily in terms of abstract form and color. Most of his works fall into two categories: one emphasizes the translucency of the watercolor medium, and the other uses more opaque color to suggest emotional rather than natural landscapes.

GALLES, ARIE ALEXANDER (Painter)
81 Ridgedale Ave., Madison, NJ 07940

Born: 1944 *Collections:* Charles Allen, NYC *Exhibitions:* OK Harris, NYC; Zolla Lieberman, Chicago *Education:* Tyler School of Art; University of Wisconsin *Dealer:* OK Harris, NYC; Zolla Lieberman, Chicago

He works on extruded aluminum rods mounted on a white backing. The sides of the rods are painted in fluorescent paint, causing a reflected color glow to bridge the spaces between them—a sort of "anti-shadow" of pastel-reflected light. The works take on an intense coloration as the viewer changes vantage points to look at the painted sides. The images usually are abstract. Organic shapes characterized the earlier works, while highly geometric systems are

suggested in the later series. The current series of reflected light paintings, *Aras* and *Heartland*, are representational in their imagery.

GALLO,FRANK (Sculptor)
Dept. of Art, University of Illinois, Urbana IL 61801

Born: 1933 *Awards:* Prize, Interior Valley Competition, Cincinnati; Guggenheim Fellowship *Collections:* Museum of Modern Art; Whitney Museum *Exhibitions:* Whitney Museum Annual; Venice Biennale *Education:* Toledo Museum School of Art; Cranbrook Academy of Art; Iowa St. University *Dealer:* Circle Gallery, Chicago; Fingerhut Gallery, Minneapolis; Jack Gallery, New York City

Works of the 1950s and 1960s were in the media of polyester resin and fiberglass, giving the pieces a glutinous texture. He gained recognition with elongated, often subtly erotic studies of elegant women reclining in attitudes of indifference or self-absorption. He has also composed sculptures of men. Similar figures have been case in papoer relief and epoxy-resin. Recently he has also made lithographs depicting the same sorts of figures.

GARABEDIAN, CHARLES (Painter)
c/o Ruth S. Schaffner Gallery, 128 W. Ortega St., Santa Barbara CA 93101

Born: 1924 *Awards:* Fellowship, National Endowment for the Arts; Fellowship, John Simon Guggenheim Memorial Foundation *Collections:* David H. Vena; Michael Elias *Exhibitions:* Whitney Museum of American Art; Rose Art Museum *Education:* University of California, Santa Barbara; University of Southern California *Dealer:* Ruth S. Schaffner Gallery, Santa Barbara, CA; L.A. Louver Galleries, Venice, CA; Hirschl and Adler Modern, NYC

Unswayed by current styles, he has employed a variety of media in innovative ways including combinations of paper collage, watercolor, drawing and even colored resins poured and hardened directly on the surface. The narrative works often suggest scenes of violence or eroticism, heightened with a melodramatic flavor. Although his approach has gone through many changes, he has always dealt in some way with the figure and with the theme of freedom: the struggle to obtain it, what it means to possess it, and the limitations upon it. In 1978 he began a series lasting several years called *Prehistoric Figures*, characterized by primitive-looking figures in enigmatic landscapes, as in *Islands No. 2*.

GARDNER, JOAN A. (Painter)
10 Silver Sands Rd., East Haven, CT 06512

Born: 1933 *Awards:* Connecticut Commission on the Arts *Collections:* Art Institute of Chicago, Museum of Modern Art *Exhibitions:* 55 Mercer Gallery, NYC *Education:* University of Illinois *Dealer:* 55 Mercer Gallery, NYC

Faces, figures, animals, and masks in ambiguous narrative situations comprise her subjects. Faces are fascinating to her, and are her most common subject matter. She also finds sensual pleasure in working with the paint itself. Her past work includes intaglios, lithographs, animated films, and artist's books.

GAREL, LEO (Painter)
c/o Image Gallery, Stockbridge, MA 01262

Born: 1917 *Awards:* First Prize, Watercolor, Albany Institute of Art *Collections:* Norfolk Museum of Arts

Joan Gardner, *The Baltic Princess,* 65 x 76, oil. Courtesy: 55 Mercer (New York NY)

Leo Garel, *Evening,* 18 x 24, watercolor. Courtesy: Image Gallery (Stockbridge MA)

and Sciences; Chase Manhattan Bank *Exhibitions:* Berkshire Museum; Zabriskie Gallery, NYC *Education:* Parsons School of Art; Art Students League *Dealer:* Image Gallery, Stockbridge, MA

His early works in oil on canvas, featured nighttime scenes of New York City. The play of the artificial lights of the city added mysterious, magical qualities to the buildings, bridges, rivers, streets, and the bay. His present compositions in watercolor and gouache are broadly painted views of the Hudson River Valley, the Catskills, and Berkshires. The landscapes are specific depictions of exact locations, time of day, season, and weather, yet they are imbued with a particularly personal interpretation. The colors of nature take on subtle expressionistic alterations as these paintings make reference to other, interior landscapes.

GARET, JEDD (Painter)
c/o Robert Miller Gallery, 724 Fifth Ave., New York NY 10019

Born: 1955 *Collections:* Whitney Museum of American Art; Paine-Webber Collection *Exhibitions:* Robert Miller Gallery; Michael H. Lord Gallery *Dealer:* Robert Miller Gallery, NYC; Texas Gallery, Houston; Michael H. Lord Gallery, Milwaukee

A part of the "new painting" movement, he combines figuration and abstraction in evocative works which suggest narrative. Ambiguous unrelated images are like visions in metaphysical landscapes of Classical architectural fragments and gaseous forms, as in *Wonderland of Forms,* in which columns and a spiral are floating in illusionistic space. Influenced by Giorgio de Chirico, the forms he uses are either biomorphic or geometric; garish colors in jarring contrasts express moods, exploring relationships between nature, man and art. In recent work, figures, trees and other more recognizable objects have been added to the minimalist flat ground in order to create tension between it and the illusionistic space.

GAVALAS, ALEXANDER BEARY (Painter)
2578 34th St. Astoria, Long Island City, NY 11103

Born: 1945 *Awards:* Citation, U.S. 88th Congress; Who's Who in American Art *Collections:* Tweed Museum of Art *Exhibitions:* Tweed Museum of Art; Fort Wayne Museum of Art *Education:* School of Art and Design; Manhattanville College

Known primarily as a landscape painter he works in the classical realist style. The Hudson River countryside and the old villages portrayed by the American masters of the 19th Century are the subject of his new paintings. His paintings in oil on canvas are executed in a variety of scales as are his pen and ink drawings on rag paper. He works with a strict, near photographic accuracy of representation and yet the compositions contain an elusive subjective quality.

GECHTOFF, SONIA (Painter)
421 Hudson St., New York, NY 10024

Born: 1926 *Awards:* Fellowship, Ford Foundation *Collections:* Museum of Modern Art; Metropolitan Museum of Art *Exhibitions:* Whitney Museum of American Art, Museum of Modern Art *Education:* Philadelphia Museum School of Art *Dealer:* Gruenebaum Gallery, NYC

His past works, spanning the period 1952-65, are similar to the approach of Bay Area expressionist working in the 1950s. These Abstract Expressionist oils use impasto and knife work. Since 1966, his works have been in acrylic and pencil on paper. The images relate to landscapes, seascapes, and architecture, and are more abstract than representational. The recent works employ more thematic imagery than earlier pieces. Movement, while always present, has become more important.

GERARDIA, HELEN (Painter)
490 West End Ave., apt. 4C, New York, NY 10024

Born: 1925 *Awards:* Medal of Honor, National Association of Women Artists; 8th New England Regional Exhibition *Collections:* Metropolitan Museum of Art; National Collection, Washington, DC *Exhibitions:* Albany Institute of History and Art; Abilene Fine Arts Museum *Education:* Art Students League; Hans Hofmann *Dealer:* Rudolph Galleries, Woodstock, NY and Coral Gables, FL

In her early work, she used realistic subjects in perspective. She broke up areas into triangles and squares so that at first viewing the painting appeared to be a puzzle, and then came into focus. After the first space flight in the 1960s, she became obsessed with the vastness of the invisible world. She placed a grid upon the canvas, and "made space visible" using controlled lines in sharp pristine colors and black and white. Her work employs sharp geometric patterns, showing the influences of Cubism, Malevich, and Mondrian.

GIANAKOS, CRISTOS (Sculptor)
93 Mercer St., New York, NY 10012

Born: 1934 *Awards:* National Endowment for the Arts; Creative Artists Public Service New York State Fellowship *Collections:* Museum of Modern Art; Moderna Museet, Stockholm *Exhibitions:* Nassau County Museum of Fine Art; Hal Bromm Gallery, NYC *Education:* School of Visual Arts *Dealer:* Galerie Nordenhake, Malmo, Sweden

The main body of his work consists of large ramp-like structures built specifically for particular sites. The materials used are wood and steel, and the pieces could be described as architectural in scale and structure. The earlier sculptural works (1968-72) were cast geometrical forms of polyester resin with a rough surface texture and muted hues. Currently he is working on a series of large acrylic drawings on heavy-gauge mylar. A group of large stone sculptures, to be created in Sweden, is also planned.

GIBBS, TOM (Sculptor)
1333 Kaufman, Dubuque IA 52001

Born: 1942 *Awards:* National Community Art Competition, H.U.D. *Collections:* Western Electric Corporation; Mayor Byrne's Mile of Sculpture, Navy Pier, Chicago *Exhibitions:* One Illinois Center Plaza, Chicago; Zaks Gallery *Education:* Loras College; University of Iowa *Dealer:* Zaks Gallery, Chicago; Anton Gallery, Washington, DC

After studying with Walter Arno in Germany he began to construct free-standing sculptures and wall-reliefs from his own foundry in Dubuque, Iowa. Twisted intertwinings of soldered metal are machinery scraps of industrial steel and bronze, the soldering exposed as lumps and knots to reveal the artist's progress as he builds. The pieces are often coated with a brown sealer with parts of the metal left visible. This smooth brown contrasts with the violently broken ends and crude bonds of the shiny metal to create unified objects full of energy.

GILLIAM, SAM (Painter)
c/o Middendorf/Lane Gallery, 2009 Columbia Rd.
N.W., Washington DC 20010

Born: 1933 *Awards:* Guggenheim Fellowshipl; Norman
Walt Harris Prize, Art Institute of Chicago *Collections:*
Museum of African Art, Washington (DC); Corcoran
Gallery *Exhibitions:* Museum of Modern Art; Walker
Art Center *Education:* University of Lousiville *Dealer:*
Middendorf Gallery, Washington (DC)

Originally from Mississippi, he came to Washington,
D.C. in 1962 to join the second generation of Washington Color Painters. Like the first generation of the
group which included such men as Morris Louis and
Kenneth Noland, he has an interest in the qualities of
color, applying the medium of acrylic paints onto unprimed canvas. From the mid-1960s acrylics were
poured over the canvases to make abstract works. Later
canvases were without frames, and some canvases were
even folded in 1968. Bold colors on draped canvases
are sometimes displayed as environmental pieces,
sometimes as wall pieces. For the past ten years he has
made collages as well as paintings.

GINSBURG, MAX (Painter)
40 W. 77th St. New York, NY 10024

Born: 1931 *Awards:* Gold medal, Society of Illustrators; Award, Allied Artists of America *Collections:*
New York Cultural Center; Martin Luther King, Jr.
Labor Center *Exhibitions:* Harbor Gallery, NYC; Reyn
Gallery, NYC *Education:* Syracuse University; National Academy of Design, City College of New York

New York City's people and places make up the subject matter of his medium-scale, realist oil paintings.
Figure composition remains the main thrust of his work
encompassing portraits, figures, landscapes, still-lifes
and interior settings. Heavily influenced by the humanist painters, and especially his father, a portrait painter,
his canvases give us a look at a rush hour crowd
hurrying to a subway stop, boys playing ball against a
grafitti decorated wall, hot dog vendors, and news
stand operators. Although his paintings are humanistic
and at times reminiscent of Hopper, Sloan, or Soyer,
there is, above all, a formal sense of design in his
canvases. In *Leafleteers* for instance, the figures are
grouped on the right and offset by the space on the left,
cut through by a single vertical line. Front to rear depth
and movement is gained through the figure placement
and the careful control of light as it plays on the faces,
hands and leaflets in this New York City street scene.

GINZEL, ROLAND (Painter, Printmaker)
412 N. Clark St , Chicago IL 60610

Born: 1921 *Awards:* Fulbright Fellowship, Rome, Italy;
Campana Prize, Art Institute of Chicago *Collections:*
Art Institute of Chicago; U.S. Embassy, Warsaw, Poland *Exhibitions:* Art Institute of Chicago; Whitney Museum of American Art Biennial *Education:* School of
the Art Institute of Chicago; St. University of Iowa;
Slade School, London, England *Dealer:* Phyllis Kind
Gallery, Chicago

Multi-colored chevrons, bars and other geometric forms
were featured in early stencilled formal works. A lyrical, formal and colorful abstract artist, he paints in a
larger format than most of his fellow Chicago artists.
Although he is the eldest of these artists, he continues
lively experiments with paint. Recent work has become
more painterly, less hard-edged, irregular shapes in a
textured surface of many layers of paint. Triangles,
rounded rectangles and half-moons appear to have been
made without stencils, in contrasting colors and surfaces. He has also experimented with collage, adding
colored plastics to the painted canvases.

GLANCY, MICHAEL (Glass Artist)
c/o David Bernstein Gallery, 36 Newbury St., Boston
MA 02116

Born: 1950 *Collections:* Metropolitan Museum of Art;
Corning Museum of Glass *Exhibitions:* American
Craft Museum; Tuscon Museum of Art *Education:*
Penland School of Crafts; Rhode Island School of
Design; University of Denver *Dealer:* Mindscape Collection, Chicago; David Bernstein Gallery, Boston;
Heller Gallery, NYC

During the 1970s he studied with glass artist Dale Chihuly and also learned how to work with light and heavy
metals from jewelry makers Louis Mueller and Rodney
Nakomoto. In 1979 Glancy used an electroforming technique to apply copper to glass surfaces. Soda lime cullet
is his medium, scrap glass from the Corning Glass factory which is melted down and blown while coatings of
colored glass or materials such as metallic oxide powders and sand are added. Grid patterns are transferred
onto the blown glass with a self-adhesive rubber stencil
in a sandblasting technique which he calls "carving."
The piece is then polished with hydrofluoric acid, and
copper is added by electroforming to produce faceted
and crenelated jewel-like sculptures. Sometimes electroplated silver is added, as in *Lapis Star X,* and in recent
years he has experimented with other kinds of metal and
glass. Because his pieces are encased in metal, unlike
most glass pieces their appearance changes rapidly
through oxidation and handling, subdued and aged in
only a few years.

GLASER, MILTON (Graphic Designer)
207 E. 32nd St., New York, NY 10016

Born: 1929 *Awards:* Fulbright Fellowship; St. Gauden's Medal, Cooper Union *Collections:* The Museum
of Modern Art; The Smithsonian Institution *Exhibitions:* The Museum of Modern Art; Centre George
Pompidou *Education:* Cooper Union Art School

Book jackets, record album covers, posters, magazines,
restaurants, a toy store, and even a 600 foot mural for
the Federal Office Building in Indianapolis are all his
creations, but his best known design is undoubtedly his
insignia for the "I Love New York" campaign. He
founded Push Pin Studios in 1954 and New York
magazine in 1968. His 1966 poster of Bob Dylan,
regarded by some of its admirers as distinctly American
in style yet deriving its effect through a careful combination of various influences, was distributed in over six
million record albums. His posters often times employ
the surrealistic device perfected by Rene Margritte of
juxtaposing incongruous objects: a red poppy emerges
from a stone monolith in a poster for Poppy Records,
and in another, a poppy grows out of a foot. He has
most recently been engaged in the redesign of a principal American supermarket chain and the *Washington
Post* newspaper, and *Parade* magazine.

GLOVER, ROBERT LEON (Ceramic Sculptor)
6015 Santa Monica Blvd., Los Angeles, CA 90036

Born: 1936 *Awards:* Grant, Ford Foundation *Collections:* First Federal Savings, South Pasadena; Southern
California Container Corporation Exhibition: San Francisco Museum of Fine Arts; Space Gallery, Los Angeles *Education:* Chouinard Art Institute; Los Angeles
County Art Institute *Dealer:* Corporate Arts Consultants, Los Angeles

His ceramic sculpture is formal and abstract dealing with the natural attributes of clay as both medium and metaphor. Early upright forms were rounded, closed, and engraved with designs suggestive of bricks or stonework. These made references to standing stones and conceptually linked the man-made object with the natural. His current work is modular and composed of units which are placed in natural settings or arranged within an interior space to create a "site." The curving stoneware slabs of his piece entitled, *Dial O*, are arranged in a circle ten feet in diameter. Connotations of prehistoric earthworks, archeological sites and techniques, as well as the natural landscape are activated by these pieces.

GOELL, ABBY JANE (Painter, Printmaker)
37 Washington Square, New York, NY 10011 *Awards:* Yaddo Fellowship; Fellowship, Virginia Center for the Creative Arts *Collections:* Museum of Modern Art; Chase Manhattan Bank *Exhibitions:* Brooklyn Museum; Hudson River Museum *Education:* Art Students League of New York; Columbia University

Largely "romantic" abstract oil paintings were among her early work, often using glazes and visible brushwork. Lithographs and serigraphs followed the canvas/paint compositions. In 1974 she began a "serpentine" series, large-scale oil on canvas paintings, where the major shape is a single or double serpent meandering across a field. Colors in subsequent paintings became increasingly subdued and flattened. The series following, entitled *Faux Jeux,* consisted of box assemblages, each with a moving element encased in a glass-fronted frame, employing historic references, "playful" notions, and 19th century imagery. Her most recent work includes a paper-and-cloth collage series of abstract fan compositions.

GOINGS, RALPH LADELL (Painter)
c/o O.K. Harris Works of Art, 383 W. Broadway, New York NY 10012

Born: 1928 *Collections:* Museum of Modern Art; Museum of Contemporary Art, Chicago *Exhibitions:* Museum of Modern Art; Documenta 5, Kassel, Germany *Education:* California College of Arts and Crafts; California St. University, Sacramento *Dealer:* O.K. Harris Works of Art, New York City

Avoiding the cliches of the 1950s and early 1960s, he rejected the notion that art had to be about art rather than about subject matter. As a Photo-Realist he is concerned with the perception of things, not their underlying structure. Particular, objective things and places from everyday life, replicated with a photographic accuracy, characterize his work, such as *Garage Interior*. He wants his depictions of what is perceived to lead to discovery. "Looking supersedes formal contrivance, depiction becomes an extention of seeing."

GOLDBERG, LENORE (Photographer)
210 Park Ave., Glencoe, IL 60022

Born: 1923 *Collections:* Museum of Modern Art; Milwaukee Art Institute *Exhibitions:* 4th Street Gallery, NYC; Art Institute of Chicago *Education:* Institute of Design with Moholy-Nagy

The play of light on unadorned objects from our everyday environment forms the subject matter of many of her photographs. Rather than arranging or manipulating the objects in a scene she utilizes their random arrangement and feeling of motion at a given moment to create forms of interest. Color too is a vital factor in her

photographs. Night scenes, moving subjects, and camera movement are among the areas of her explorations. Although, she uses a 35mm camera with a tripod at times, most of the imagery comes from hand held photographs. In 1982 her one person show at 4th Street Gallery, "A Woman's Journal", displayed a pictorial history of her house and family, photographed during the winter and summer activity of the previous four years.

GOLDBERG, MICHAEL (Painter)
222 Bowery, New York NY 10012

Born: 1924 *Collections:* Art Institute of Chicago; National Gallery of Art *Exhibitions:* Museum of Modern Art; Smithsonian Institution *Education:* Art Students League; City College of New York; Hans Hofmann School of Art *Dealer:* Paley and Lowe, NYC

His studies with sculptor Jose de Creeft perhaps influenced his method of collage in which parts of oil paintings are cut up and then combined with cut paper. The paintings are executed upon a table, in "flat-bed" style. Metallic paints reflect light, splashing in different directions; the cutouts are taped loosely onto the canvas, so that they appear to float above the surface. Recent works use examples of architectural elements like the post-and-lintel as models for rationally assembling the picture surface, exploring such architectural properties as weight, tensile stress and counterpoint.

GOLDEN, EUNICE (Painter)
463 West St., Apt. 332b, New York, NY 10014 *Awards:* Purchase Award, Hudson River Museum; Fellowship, MacDowell Colony *Collections:* Hudson River Museum; New York City Department of Parks and Recreation *Exhibitions:* Whitney Museum of American Art; Gemeentemuseum, The Hague *Education:* University of Wisconsin; Brooklyn College; Art Students League

In much of her work she has explored a singular image of the male figure, identifiable in terms of a "landscape" metaphor. From the early 1960s she painted the full figure of the male nude with energetic brushwork and strong vibrant color in an expressionistic mode. In the 1970s, she utilized the head and torso as revealing vehicles for sensual human processes, restructuring the relationship between artist and audience on both an emotional and intellectual basis. More recently her portraits have evidenced new social and psychological awareness. In the current works the immediacy of primal concerns is manifested in original images based on animal configurations.

GOLUB, LEON ALBERT (Painter)
530 La Guardia Pl., New York NY 10012

Born: 1922 *Awards:* Ford Foundation Grant; Guggenheim Foundation Grant *Collections:* Museum of Modern Art; Art Institute of Chicago *Exhibitions:* Museum of Modern Art; Museum of Contemporary Art, Chicago *Education:* University of Chicago; Art Institute of Chicago *Dealer:* Susan Caldwell, New York City; Portland (OR) Center for the Visual Arts

In the 1940s he earned degrees in the art history as well as in studio art. In the following decade he criticized the popular Abstract Expressionists for destroying "the individualist of the Renaissance." Golub's subsequent paintings featured images of sphinxes and other figures from Non-Western culture, and later of man's birth and struggle. Depictions of man took on mythological proportions in representations of man versus the environment, created with tumultuous mixtures of thickly ap-

Joe Ruiz Grandee, *Uncertain Welcome,* 31 x 48, oil on canvas. Courtesy: Joe Grandee Gallery (Arlington TX)

Alexander Beary Gavalas, *Road Ft. Tryon,*
15 x 12, oil.

Donald B. Gooch, *Age of Aquarius,* 40 x 30, oil on canvas.

plied garnish colors. This method gave the huge figures a sculptured effect, and heightened the conflicts depicted. In 1965 he began a series which lasted for the next five years, very large canvases called "Gigantomachies," showing male nudes in combat. This series and a large-scale series of "Assasins" in the 1970s violence and disorder." He has since painted portraits of contemporary figures.

GONSKE, WALT (Painter)
c/o Trailside Galleries, 7330 Scottsdale Mall, Scottsdale AZ 85251

Awards: First Prize, Southwestern Watercolor Society; Silver Medal, Second Place in Oil, National Academy of Western Art, Cowboy Hall of Fame *Collections:* Thomas Gilcrease Institute of American History and Art; The Eiteljorg Collection *Exhibitions:* National Academy of Western Art; Beijing Exhibition Center, People's Republic of China *Dealer:* Trailside Galleries, Scottsdale, AZ; Jones Gallery, La Jolla, CA; Wichita Gallery of Fine Art, Wichita, KS; Stables Art Center, Taos, NM

After studying in New York City with Frank Reilly, he worked as an illustrator until he decided to devote himself to painting and moved to Taos, New Mexico in 1972. Oils and watercolors depict the Southwestern landscape in an impressionist style. He travels on back roads across the United States and Mexico in search of subjects, then paints in the open air. "I try to explain with paint, my emotional response, the impression that the landscape has made upon me." Canvases such as *Taos Summer* are filled with dazzling light. A member of the National Cowboy Hall of Fame, he is a prolific painter and has been exhibiting steadily since he first came to New Mexico.

GOOCH, DONALD BURNETTE (Painter, Illustrator)
1633 Leaird Dr., Ann Arbor MI 48105

Born: 1907 *Awards:* Alumni Prize, Collaborative Competition, American Academy in Rome; Art Founder's Prize, Detroit Institute of Arts *Collections:* Detroit Institute of Arts; Ford Motor Company *Exhibitions:* Pennsylvania Academy of the Fine Arts; Pepsi-Cola's Paintings of the Year *Education:* University of Michigan; Detroit Art Academy; Fontainebleau School of Fine Arts

As a young man he was a sign and poster painter, and in the 1930s he studied education and design. During the 1950s he created numerous illustrations for advertisements, book covers, film strips and children's books, as well as for such magazines as the *New Yorker, Holiday, and Sports Illustrated.* Media have included watercolor, tempera, oil and acrylic. After over forty years of teaching at the high school and university level, in 1973 he became professor emeritus at the University of Michigan.

GOODACRE, GLENNA (Painter, Sculptor)
313 Foxtail Circle, Boulder CO 80303

Born: 1939 *Awards:* National Sculpture Society; Allied Arts of America Award *Collections:* Texas Technical University Art Dept. Teaching Gallery; Diamond M. Museum *Exhibitions:* National Academy of Design; Allied Artists of America, NYC *Education:* Colorado College; Art Students League *Dealer:* Driscol Gallery, Denver; Fenn Galleries, Santa Fe NM; Meinhard Galleries, Houston

Early work consisted of still lifes and landscapes in oil,

but she is best known for realistic cast bronze sculptures of busts and small-scale figures. Her subject is the American Old West with a female viewpoint: single figures or groups of children and women, often dancing, are common themes. She has made some bas-reliefs, such as *Buffalo Dance*, and has also illustrated several book jackets in silver or bronze relief. A variety of techniques is employed in the paintings, including direct application as well as underpainting. Pastels have also been combined with dry brush or with washes.

GOODNOUGH, ROBERT ARTHUR (Painter)
38 W. Ninth St., New York NY 10011

Born: 1917 *Awards:* Garrett Award, Art Institute of Chicago; Purchase Prize, Ford Foundation *Collections:* Guggenheim Museum; Metropolitan Museum *Exhibitions:* Museum of Modern Art; Venice Biennial *Education:* Ozenfant School of Art; Hofmann School of Art *Dealer:* Andre Emmerich Gallery, New York City; Tibor de Nagy Gallery, New York City

An artist who can not be categorized, he began as early as grade school with abstract drawings which, without their titles, were indiscernible. He did not pursue an art career seriously until after serving in World War II. Art instruction in New York under Amedee Ozenfant and Hans Hofmann influenced his abstract style. He began to make collages in 1953 and the next year constructed dinosaurs, birds and human figures. Continuing with painting, he adopted a cubist mode in an attempt "to create a space which is neither recessive nor advancing, but just special relationships on a single plane." In the 1960s and 1970s large forms with smooth edges, or small clusters of hard-edged shapes were painted on vast backgrounds of light colors.

GORMAN, R.C. (Painter)
Navajo Gallery, P.O. Box 1756, Taos NM 87571

Born: 1933 *Awards:* Grand Award, American Indian Art Exhibition, Oakland; First Award, Scottsdale National Indian Exhibition *Collections:* Santa Fe Fine Arts Museum; Heard Museum *Exhibitions:* Muirhead Gallery, Costa Mesa, CA *Education:* Northern Arizona University; Mexico City College *Dealer:* Jamison Galleries, Santa Fe; Mary Livingston, c/o Gallery II, Santa Ana, CA

The son of Navajo painter Carl Gorman, this internationally known Navajo's figurative paintings were influenced by Mexican mural painters Jose Orozco and Diego Rivera. Simplified representations of women with classic grace are his trademark in paintings, sculptural ceramics, lithographs and serigraphs which capture the tradition of Indian culture while using a contemporary style. Indian traditionalists say his precise and linear approach is too modern, others say his sketchiness is too primitive; but he continues his work, lives on a Navajo reservation and also owns a gallery, representing Southwestern artists and modern Indian painters.

GRAESE, JUDY (Printmaker, Sculptor)
2055 S. Franklin, Denver, CO 80210

Born: 1940 *Awards:* Scholastic Arts Award *Collections:* City Library, Enid, OK; Cutcher, Las Cruces, NM *Exhibitions:* May Company, Denver; Western Federal Savings, Denver *Education:* Augustana College, Sioux Falls, SD *Dealer:* Bishop Gallery, Scottsdale, AZ

She works in etching in weathered wood and ink painting on native stone. Her subjects are mythical figures,

inspired by the legends and folklore of the Grimm Brothers and Hans Christian Andersen. As the figure emerges, the natural grain of the wood and the curve of the stone dictate the final design. She also creates bronze sculptures, serigraphs, and watercolors.

GRAHAM, DAN (Video Artist, Installation Artist)
Box 380, Knickerbocker Station, New York, NY 10002

Born: 1942 *Awards: Collections:* Tate Gallery, London; Allen Art Museum, Oberlin, OH *Exhibitions:* Nova Scotia College of Art and Design; Documenta VII, Kassel *Dealer:* Lisson Gallery, London

His installations and video environments continually deal with the relationship between the viewer and their perception of both time and space in illusionary and contradictory architectural environments that he creates especially for each piece. In his *Present Continuous Past* he used mirrors to relate the "instantaneous time without duration" to the viewer while a video monitor related the same actions eight seconds later. Current work is split between video installations and environments, and a video tape dealing with the history of rock and roll and religion.

GRAJALES, ELIZABETH (Pastel Artist)
667 Carroll St., Brooklyn, NY 11215

Born: 1952 *Awards:* Artist-in-Residence, Gulf & Western, Altos De Chavon *Collections:* Gulf & Western; Smithsonian Institution *Exhibitions:* The Brooklyn Museum; The Hudson River Museum *Education:* Arizona State University; Pratt Institute

For the last eight years she has concentrated on works executed in pastel chalk on paper. The brilliancy of color and most of all the sensual surface texture on paper has attracted her to this medium. Works express elements of figurative representation but are abstracted and combine strong decorative and design elements as well. Pattern becomes a strong aspect in some of her works with a hard edged line quality, outlined in black, that sets off the brilliant colors. Works have always been in series; Images and textures develop over a period of time. She feels that the images and shapes she picks have an emotional impetus and through gesture she can direct an idea or attitude.

GRANDEE, JOE RUIZ (Painter, Illustrator)
Joe Grandee Gallery and Museum of the Old West, 606 Center St., Arlington TX 76010

Born: 1929 *Awards:* First Official Artist of Texas; Franklin Mint Gold Medal, Western Art for Pursuit and Attack *Collections:* White House, Washington, DC; Marine Corps Museum *Exhibitions:* Amon Carter Museum; El Paso Museum of Art *Education:* Aunspaugh Art School *Dealer:* Gene McDaniel, Midland (TX); Bob Hoff, Houston

This historical western artist puts factual scenes to canvas, depicting battles between "cowboys and Indians" of the Old West. The costumes and accouterments of mountain men, Indians and cowboys are represented with as much authenticity as possible. He has illustrated several books about the history of the American West, and was a contributor to Time-Life's *Cowboy Series*. In his gallery and museum, genuine American artifacts are displayed along with his oil paintings, ink drawings and, occasionally, sculptural pieces. This versatile artist has also painted portraits of celebrities, including Johnny Carson and Robert Taylor.

GRAVES, NANCY STEVENSON (Painter, Sculptor)
69 Wooster St., New York NY 10012

Born: 1940 *Awards:* Paris Biennale Grant; National Endowment for the Arts Grant *Collections:* Museum of Modern Art; Whitney Museum *Exhibitions:* Museum of Modern KArt; Venice Biennale *Education:* Vassar College; Yale University *Dealer:* M. Knoedler, New York City

She moved to Florence, Italy in 1966, after studying art in America. A few years later she moved to New York City where she made hyperrealistic sculptures of camels, camel bones and camel skeletons. She started making films in 1969, and often depicted camels, as in "Izy Boukir," a short color film. In addition to sculptures and films, she has done many abstract paintings in acrylic and oil, some of which feature sketches of camel bones as part of the composition (*Three by Eight*, 1977), and others which do not contain any references to camels.

GREEN, ARTHUR (Painter)
5 Elizabeth St., Stratford, ON, N5A 421, Canada

Born: 1941 *Awards:* Cassandra Foundation, Chicago; Canada Council for the Arts Bursary *Collections:* Art Institute of Chicago; New Orleans Art Museum *Exhibitions:* Pennsylvania Academy of the Fine Arts; Whitney Museum *Education:* Art Institute of Chicago *Dealer:* Phyllis Kind Gallery, New York City

Visual ambiguities characterize the boldly colored paintings of this Chicago Imagist. Each work depicts layer upon layer of objects, reflections and spatial representations which do not completely connect, creating illusionistic puzzles. Work of the 1970s often represented frames, windows and metal-looking latticework, motifs inviting a voyeuristic view into several levels of perception, as in *Difficult Decisions*. Recent work continues an interest in equivocal images and also suggests collage as he articulates the questions of vision and their interpretation.

GREEN, DENISE G. (Painter)
c/o Max Protetch Gallery, 37 W. 57th St., New York NY 10019

Born: 1946 *Awards:* Visual Arts Board Grant, Australian Council on the Arts; Ingram Merrill Foundation Grants *Exhibitions:* Solomon R. Guggenheim Museum; Museum of Modern Art *Education:* Sorbonne University; Hunter College *Dealer:* Max Protetch Gallery, NYC

After studying architecture in Paris, building facades were her subject until 1975, when centralized images in a single color were used to symbolize isolation. These New Imagist paintings featured images scraped or built out of an overall coating of paint. Other themes included "transition, obstacles, security, growth, inwardness, and openness." Recent paintings are "configurations," consisting of several forms as well as elements of line, as in *Looking Back on the Other*. She says, "I feel that the work cannot be interpreted in terms of its subject matter," preferring to eliminate any anecdotal connotations and often using underlying grids to emphasize structure.

GREEN, MARTIN LEONARD (Painter, Printmaker)
322 N. Beverly Dr., Beverly Hills, CA 90210

Born: 1936 *Collections:* Fogg Museum, Harvard University; Los Angeles County Museum of Art *Exhibitions:* Santa Barbara Museum of Art; Smithsonian Insti-

tution *Education:* Pomona College; Scripps College *Dealer:* Louis Newman Galleries, Beverly Hills, CA

Living atop a mountain near Idyllwild, Calif., he creates oil paintings, intaglio and lithographic prints, monotypes, and, most recently, cliche-verre. In his oils he has attempted to synthesize oriental and occidental themes. He has experimented with new methods in printmaking, and his monotypes in particular have attracted attention. His work was included in the traveling exhibition "New American Monotypes", sponsored by the Smithsonian Institution.

GREENE, STEPHEN (Painter)
408A Storms Rd., Valley Cottage NY 10989

Born: 1918 *Awards:* Prix de Rome, American Academy, Rome;l Institute of Arts and Letters Award *Collections:* Metropolitan Museum; Whitney Museum *Exhibitions:* Guggenheim Museum; Whitney Museum *Education:* Art Students League; Iowa St. University *Dealer:* Marilyn Pearl Gallery, New York City

During the late 1930s and the 1940s, realistic paintings were carefully rendered depictions of psychological states. Suffering and alienation were represented by often disfigured or starved bodies in unknown settings, as in *The Burial* (1947). In 1954, after spending a year in Rome, he turned to abstraction. Where there had once been highly detailed forms, now there were only hints of their presence. During the 1960s the works contained abstracted rather than direct references to isolation and hopelessness. More recent paintings have become much freer and abstract.

GREENLY, COLIN (Painter)
RD 1, Box 545, Campbell Hall, NY 10916

Born: 1928 *Awards:* Grant, National Endowment for the Arts; Fellowship, Creative Artists Public Service *Collections:* Museum of Modern Art; Everson Museum of Art *Exhibitions:* Andrew Dickson White Museum, Cornell University; Corcoran Gallery of Art *Education:* Harvard College; Columbia University

His work has included woodcuts, large-scale drawings and paintings, white paintings, multi-level white relief drawings, and time/light sculpture constructions. In 1964 he showed drawings and sculpture relating to his intuitive discovery of the "primary transitional symbol," or supercircle. He also has shown, in drawings and photo emulsion, technologically impossible images located in specific landscapes. In his present work, categorized as "intangible sculptures, all previous experience is assimilated into a single distilled image, incorporated in and used as a foil to photographed sites and activities.

GREER, A.D. (Painter)
610 Plymouth Park S/C, Irving, TX 75061

Born: 1904 *Awards:* Gold Award, Texas Ranger Hall of Fame *Collections:* Everett Bohls Co., John Byrum Corporation *Exhibitions:* American Fine Arts Gallery, Irving, TX *Education:* Self-taught *Dealer:* American Fine Arts Gallery, Irving, TX

A self-taught painter, he has worked in oils painting realistic scenes of florals, still lifes, figures, westerns, portraits, animals, and landscapes. He is strongly influenced by landscape painters of both the 19th and 20th centuries. His medium scale oil works depicting mountain and canyon scenes of the American West are his most famous works. He has explored the West on foot and horseback and has painted the scenes he has discovered for more than fifty years.

GREGOR, HAROLD LAURENCE (Painter)
107 W. Market St., Bloomington, IL 61701

Born: 1929 *Awards:* Grant, National Endowment for the Arts; Best of Show, Evansville Museum *Collections:* Rose Art Museum, Brandeis University; Commodities Corporation *Exhibitions:* Tibor de Nagy, NYC; Richard Gray, Chicago *Education:* Ohio State University; Michigan State University; Wayne State University *Dealer:* Tibor de Nagy, NYC; Richard Gray, Chicago; Nancy Lurie, Chicago

Early work was in full color gestural/figurative abstraction, but since 1965 his art has been devoted to large scale oil and acrylic paintings derived from the prairie country of the Midwest. Realistic architectural imagery in oil, colorful aerial views in acrylic and environmental sculptural floor pieces now comprise his work. Two different spatial formats are employed in his paintings. Illusionary space—photo inspired illusion—and color formed space—pictorial space made coherent primarily by the demands of orchestrated color—are the two formats he employs. The second format, color-formed aerial views, attempts to take advantage of a flat, geometrically sectioned farm image to achieve a compatible union of a recognizable subject with color understood space.

GRIMM, LUCILLE DAVIS (Painter)
Box 554, 5 Oak Ridge Dr., Clinton, CT 06413

Born: 1929 *Awards:* Grumbacher Award, Watercolor USA; Glendining Company Award, New England Annual *Collections:* Fairfield University; H.E.B. Hospital, Euliss, Texas *Exhibitions:* National Academy Galleries, New York City; University of New Hampshire *Education:* Vanderbilt University *Dealer:* Munson Gallery, New Haven; Shippee Gallery, NYC

Her paintings in watercolor and acrylic are executed in a range of styles with matching technical versatility. She has painted in a contemporary abstract, semi-abstract, and even a super-realist style. In non-objective paintings her brush work varies from the control of wet pools of pigment—as in her large, flowing watercolors —to the careful arrangement of hard edged objects in space. Representational work includes such subjects as landscapes and still lifes of flowers or knotted fabric. The landscapes are often painted on lengths of paper taken from a roll, while floral compositions are allowed to extend across panels to create a diptych or triptych.

GRIPPI, SALVATORE (Painter)
423 Seneca St., Ithaca, NY 14850

Born: 1921 *Awards:* Fulbright Fellowship *Collections:* Whitney Museum of American Art; Hirshhorn Museum and Sculpture Garden *Exhibitions:* Whitney Museum of American Art; Museum of Modern Art *Education:* Art Students League

From the 1950s through the 1970s he concentrated primarily on the figure and the still life as subjects. Still lifes increasingly dominated his work; The objects that he painted included bottles, cake boxes, milk cartons, and beer cans. The earlier works were characterized by impetuous, emotionally charged movement, vibrations of dark and light, and the dissolution of mass. The more recent work is contemplative in mood. The use of color and the treatment of space enhances the unreality as well as the real presence of things.

GROOMS, RED (Assemblage Artist, Painter)
c/o Marlborough Gallery, 40 W. 57th St., New York NY 10019

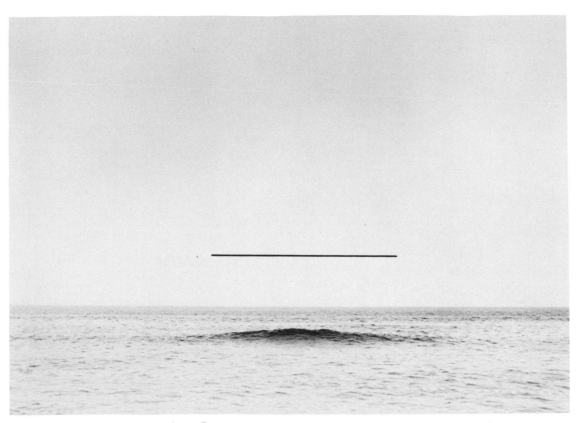

Colin Greenly, *P/CS*, 40 x 60, Intangible sculpture.

Werner Groshans, *Winter Landscape*, 40 x 60, oil. Courtesy: Babcock Galleries (New York NY)

Born: 1937 *Awards:* Lower Manhattan Cultural Council Award *Collections:* Museum of Modern Art; Art Institute of Chicago *Exhibitions:* Solomon R. Guggenheim Museum; Museum of Modern Art *Education:* New School for Social Research; School of the Art Institute of Chicago; Hans Hofmann School *Dealer:* Marlborough Gallery, NYC

In the late 1950s and early 1960s he created Happenings such as *Burning Building,* a melodrama which included performances by him and others. In 1963 he founded a multi-media performance and construction company, Ruckus Productions. Employing mixed media to create an entire environment, assemblages were presented using wood, plaster, cardboard, paper and real objects. A desire for the enjoyment and celebration of life inspires the work with "a proletarian feeling," as this "type of energy and subject matter" is what excites him most; his creations are often filled with colorful amusing figures in whimsical settings. He also has made short films, paintings and graphics.

GROSHANS, WERNER (Painter)
R.D. 1, Box #57, Catskill, NY 12414

Born: 1913 *Awards:* Hassam & Speicher Fund Purchase Award, American Academy & Institute of Arts & Letters; Fellowship, New Jersey State Council on the Arts *Exhibitions:* Whitney Museum Annual Exhibition of Contemporary American Paintings; Retrospective, Monclair Art Museum *Education:* Newark School of Fine and Industrial Art *Dealer:* Babcock Galleries, NYC

Since youth he has been interested in realistic painting. The High Renaissance, the later realism of Vermeer, Velazques, Ingres and the Americans of the Hudson River School, including the Luminists, have had a lasting influence on his style. His work in oil and pastel includes figurative and landscape subjects rich with the ambient mystery of nature. While avoiding photo-realism or an illustrative style, he works from the convictions that realism is a continuing process in the development of art.

GROSS, CHAIM (Painter, Sculptor)
526 La Guardia Place, New York, NY 10012

Born: 1904 *Awards:* Fellowship, Louis Comfort Tiffany Foundation; Award, National Institute of Arts and Letters *Collections:* Chicago Art Institute; Philadelphia Museum of Fine Art *Exhibitions:* National Collection of American Arts, Smithsonian Institution; Museum of Modern Art *Education:* Beaux-Arts Institute of Design; Art Students League

His early work consisted of sculpture carved directly from African and South American hard woods. He later turned to modeling in clay and chose as his subjects the abstracted forms of acrobats, and playful figures arrested in motion. The energy of the human figure appears again in his watercolors, and charcoal and pencil drawings. These fantasy-like compositions are alive with surrealistic and anthropomorphic figures celebrating the wonder of human love and sensuality while teetering on the edge of danger and violence. The conscious and unconscious imagery build an iconography of anxiety, guilt, joy, and hope with graceful line, vivid color, and haunting design.

GRUBER, AARONEL DEROY (Sculptor, Kinetic Artist)
2409 Marbury Road, Pittsburgh, PA 15221

Awards: Papercraft Prize, Society of Sculptors; John Elliott Memorial Prize, Newport, RI *Collections:* Smithsonian Institution; Aldrich Museum of Contemporary Art *Exhibitions:* Jewish Museum, NYC; Vancouver Art Gallery *Education:* Carnegie Mellon University *Dealer:* Concept Art Gallery, Pittsburg; Arbitrage Gallery, NYC

She began her career in art with nature oriented paintings in a semi-abstract style. She later turned to work in three dimensions using steel, aluminum, and plastics. Today she is known best for her lucite and plexiglass sculpture, both kinetic and stable pieces. In current work, geometric shapes are combined into complex and elegant sculpture that make use of vacuum formed, laminated, and constructed plastic elements often reinforced with metal. The highly polished surfaces and fluorescent colors of the material itself are heightened by lights and motors concealed in the bases of the sculpture. The transparency emphasizes the intersecting of curving lines of color and the mysteriously glowing edges.

HAACKE, HANS CHRISTOPH (Sculptor, Conceptual Artist)
463 West St., New York NY 10014

Born: 1936 *Awards:* Fellowship, John Simon Guggenheim Memorial Foundation; Fulbright Fellowship *Collections:* Museum of Modern Art; National Gallery of Canada, Ottawa *Exhibitions:* Museum of Modern Art; Venice Biennale *Education:* Staatl Werkakademie; Atelier 17; Tyler School of Art *Dealer:* John Weber Gallery, NYC

His highly conceptual and often times political artworks have taken many forms over the years. In one of his works he traced the ownership of a particular painting to catalogue the rise in value of the work of art and to bring into question the motives and function of buying art. In his *Mobilization* (1975) he created "advertisements" that mocked the major oil company's position on political issues and the role that art played in their public relations promotions. He has continued to produce highly political conceptual pieces that continually prove to be both conceptually unique and politically provocative.

HAAS, ERNST (Photographer)
853 Seventh Ave., New York NY 10019

Born: 1921 *Awards:* Newhouse Award, Syracuse University; Kultur Preis Award, German Government. *Collections:* Museum of Modern Art; George Eastman House, International Museum of Photography *Exhibitions:* Museum of Modern Art; Museum of the Twentieth Century, Vienna *Education:* Graphischen Lehr- und Versuchsanstalt, Vienna *Dealer:* Artspace/Virginia Miller Galleries, Coral Gables, FL

Born in Vienna, he studied medicine for a year before deciding on a career in photography instead. Although influenced by the work of Henri Cartier-Bresson and Edward Weston, both photographers who worked almost exclusively in black-and-white, he has worked primarily in color photography. During the 1950s he did photo essays for *Life* magazine, *Esquire, Paris-Match* and *Holiday*. He worked in a small format, then took an interest in motion pictures. He was a still photographer for such films as *Moby Dick*, *Little Big Man*, *West Side Story*, and *Hello Dolly*. He now concentrates on audio-visual presentations, in which music and photography are combined. He is also an advisor for the magazines *Stern* and *Geo*.

Charles Garabedian, *Green Man,* 48 x 60, acrylic on panel. Courtesy: Hirschl & Adler Modern (New York NY)

Max Ginsburg, *79th and Broadway,* 38 x 62, oil.

Bob Freimark, *Yosemite Falls IV*, 30 x 22, watercolor.
Courtesy: Moosart Gallery (Miami FL)

Henry Fukuhara, *Brooklyn Bridge*, 36 x 24, mixed media.

Joan Gardner, *The Supervisor,* 70 x 57, oil. Courtesy: 55
Mercer (New York NY)

Robert Freiman, *Bonne Femme au Soliel,* 28 x 36, oil.
Courtesy: Caravan House Gallery (New York NY)

Alexander Beary Gavalas, *Afternoon in Cold Spring N. Y.*, 16 x 20, oil.

Leo Garel, *After Snowfall*, 18 x 24, gouache. Courtesy: Image Gallery (Stockbridge MA)

Michael Frary, *Caernarvon,* 22 x 30, watercolor.

Joe Ruiz Grandee, *An Angry Clash of Steel,* 37 x 51, oil on canvas.

Keiko Hara, *Verse I.I.I.I.,* 48 x 24, oil.

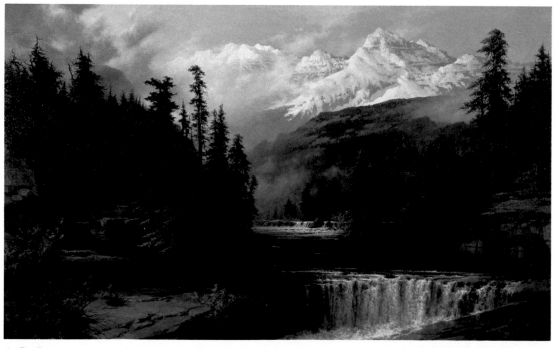

A. D. Greer, *Sunrise in the Cascades,* 45 x 73, oil.

Donald B. Gooch, *Scarecrow,* 30 x 36, oil on canvas.

Colin Greenly, *Yellow Prediction at the Hulse Barn: . . . ,* photograph.

Beverly Hallam, *Emperors* (1983), 50 x 50, acrylic on canvas.

Werner Groshans, *Jeannine,* 22 x 18, oil. Courtesy: Babcock
Galleries (New York NY)

Lloyd Manford Herfindahl, *Sleeping City,* 54 x 96, oil.

Mary Hatch, *The Candidate,* 28 x 36, oil on linen.

Orval Hempler, *Ecce Homo,* 30 x 36, sculptured painting.
Courtesy: Mary Browne

Donald Hatfield, *Reaction,* 36 x 48, oil/collage.

Jackson Hensley, *The Hay Wagon*, 4 x 9 ft., oil on canvas. Courtesy: Gallery of the Southwest (Taos NM)

William Hoffman, *Primavera*, 3 x 9 ft., glazed ceramic.

Paul Hertz, *Domain,* 36 x 60, acrylic.

Emil J. Hess, *Circus at the Garden 4,* 24 x 36, oil on canvas. Courtesy: Jack Tilton
(New York NY)

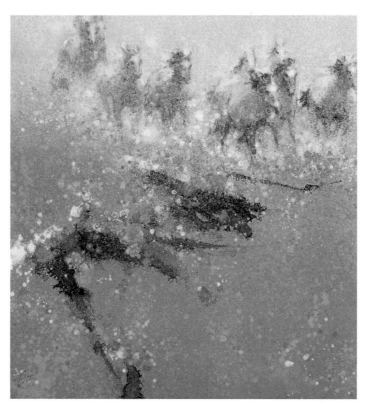

Chi Chung Hu, *Flight*, 50 x 46, oil.

Mark Hess, *Mystic Warrior*, 12 x 15, oil on canvas.

Lani Irwin, *Balthazar's Room* (1982), 43 x 43, oil on linen.

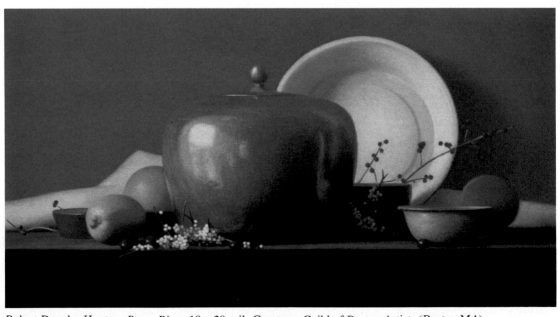

Robert Douglas Hunter, *Brass Blue,* 18 x 28, oil. Courtesy: Guild of Boston Artists (Boston MA)

Tom Huffman, *Garden View*, 14 x 17, watercolor.

Michael Florian Jilg, *Keri*, 80 x 60, oil.

Giancarlo Impiglia, *Night Gathering*, 52 x 40, acrylic on canvas. Courtesy: Alex Rosenberg Gallery (New York NY)

Cathy Hull, *Porn Martyr*, 11 x 6, watercolor and pencil.

HAAS, RICHARD JOHN (Painter)
81 Greene St., New York NY 10012

Born: 1936 *Awards:* Fellowship, John Simon Guggenheim Memorial Foundation; National Endowment for the Arts Printmaking Grant *Collections:* Museum of Modern Art; Metropolitan Museum of Art *Exhibitions:* Whitney Museum of American Art; Brooklyn Museum *Education:* University of Wisconsin; University of Minnesota *Dealer:* Brooke Alexander, NYC; Young Hoffman Gallery, Chicago

Realistic murals on the outside walls of buildings in large cities such as New York, Chicago and Boston, turn blank walls into amazing trompes l'oeil of architectural facades. He has also painted interior walls of offices and hotels in recent years, such as *Venetian Facade* at the Hyatt Regency Hotel Cambridge. A printmaker as well as a muralist, his medium is intaglio. Oils and watercolors also depict architectural scenes, small versions of the subjects of his murals.

HALABY, SAMIA ASAAD (Painter)
103 Franklin St. New York, NY 10013

Born: 1936 *Awards:* grant, Creative Artists Public Service Program; Tamarind Lithography Workshop *Collections:* Solomon R. Guggenheim Museum; The Art Institute of Chicago *Exhibitions:* Housatonic Museum; Marilyn Pearl Gallery, NYC *Education:* Indian University; Michigan State University

His artistic output is spread equally between works of oil on canvas and drawing media on paper. His oil canvases have been analytically abstract compositions that reflect the cacophony of present day reality. The work developed in isolation along complex geometric lines. Afterwards international traditions such as cubism and constructivism as well as American painters such as Mark Tobey and Stewart Davis asserted a strong influence on the artist. For example, in his painting entitled, *One Yard Past the Shingle Factory* he alludes to the danger of the city and the tangled web of modern manufacturing while at the same time paying homage to Duchamp's *Nude Descending a Staircase.* Recent pieces have been extremely large, 6' x 24', works on paper.

HALBACH, DAVID ALLEN (Painter)
2722 Lema Dr., Mesa, AZ 85205

Born: 1931 *Awards:* National Academy of Western Art; Silver Medal, Watercolor *Collections:* The Arizona Bank; Favell Museum of Western Art *Exhibitions:* Western Heritage Show; Biltmore Celebrity Show *Education:* Chouinard Art Institute *Dealer:* Overland Trails, Scottsdale, AZ

His expressive watercolors are colorful paintings capturing sunlight and shadows, in beautiful settings. Realistic details are balanced along with the impressions of what one feels. People, land, streets, seascape, and wildlife are common subjects of his paintings. He spends summer traveling between the pine country of northern California, the Midwest and Europe collecting history and sketching on location. With delicacy he evokes nostalgia and narrative through his interpretations of subject matter.

HALKIN, THEODORE (Painter, Sculptor)
c/o Jan Cicero Gallery, 221 W. Erie St., Chicago IL 60610

Born: 1924 *Awards:* Cassandra Award; First Prize for Sculpture, Chicago and Vicinity Show, Art Institute of Chicago *Collections:* Art Institute of Chicago *Exhibitions:* Corcoran Gallery of Art; Pennsylvania Academy of the Fine Arts *Education:* School of the Art Institute of Chicago; Southern Illinois University *Dealer:* Jan Cicero Gallery, Chicago

Early sculpture of the late 1940s featured decorative stylized figures influenced by Paul Klee. During the next decade contact with expressionistically inclined fellow student painters changed his work to include fantastic animals and hieratic figures in heavy patination. Also at this time low reliefs in plaster were made. By the mid-1960s, surrealistic, nearly abstract sculpture consisted of anthropomorphic "furniture" pieces. During the late 1960s found objects were added to the sculptures, as in *A Case of Gloves* (1970); he also executed bright paintings similar in style to the Chicago Hairy Who group. Whatever the medium or style, there has always been an element of fantasy. He does not hesitate to change methods, because it is important to him to constantly "renew" his style.

HALLAM, BEVERLY (Painter, Printmaker)
R.R. #2, Box 381, York, ME 03909

Born: 1923 *Awards:* Blanche E. Colman Foundation Award; Edwin T. Webster First Prize, New England Watercolor Society *Collections:* Harvard University Art Museums; The Corcoran Gallery of Art *Exhibitions:* Addison Gallery of American Art; Witte Memorial Museum *Education:* Massachusetts College of Art; Syracuse University *Dealer:* Hobe Sound Galleries, Portland, ME

From 1945 to 1951 she painted figures and landscapes in oil, black oil, and encaustic. Work in acrylic of flowers, and ocean and rock formations soon followed. Thereafter, she formulated a lightweight, flexible medium capable of high relief on large stretched linen and through the 1960s she continued her work in painting and in the 1970s concentrated on monotypes in oil, printed by hand using gelatin rollers. More recent work since 1981 has been executed in acrylic using an airbrush on large canvases. She has concentrated on enlarged flower arrangements with mirrored images and dramatic lighting. Colors are vivid, highlighted with stunning shadow effects, and the paintings executed from photographs.

HALLIDAY, NANCY RUTH (Illustrator)
629 NE 11th Ave., Gainesville, FA 32601

Born: 1936 *Awards:* First prize, Guild of Natural Science Illustrators Exhibition; Second Prize, National Wildlife Federation *Collections:* Visual Arts Gallery, Pensacola; Hunt Institute for Botanical Documentation *Exhibitions:* Thomas Center for the Arts; Leigh Yawkey Woodson Art Museum *Education:* University of Oklahoma; Art School of the Society of Arts and Crafts

Although she has worked in other media as well, notably pen and ink, she is known primarily for her technical art work in watercolor in the style of English fine book illustrators. A professional natural history museum illustrator since 1957, her early work, necessarily representational, was characterized by extraordinary detail. In her more recent work she is developing a more wholistic approach with greater attention to the elements of graphic design. Her work past and present reflects her consuming interest in the natural world and she prefers to illustrate species of animals and plants that are often overlooked.

HAMMOND, PHYLLIS BAKER (Sculptor, Ceramicist)
285 Scarborough Road, Briarcliff Manor, NY 10510

Born: 1936 *Awards:* Grant, National Endowment for the Arts; Traveling Scholarship, Museum of Fine Arts, Boston *Collections:* Connecticut State College; Connecticut Commission for the Arts *Exhibitions:* Noyes Museum; Cummings Art Center, Connecticut College *Education:* School of the Museum of Fine Arts, Boston; Tufts University *Dealer:* Pindar Gallery, NYC

Working in clay she produces sculpture ranging in size from small wall pieces to free standing work as much as eight feet tall. Trained in the traditional clay techniques, her early work consisted of vessel forms with surface embellishments. Her current work makes allusions to the art and architecture of Classical Greece. Tall standing columns sprout leaves of clay beneath which are human faces—as if interior figures are struggling to emerge. Wall reliefs with applied textures also carry classical elements and Greek faces. The high fire, stoneware clay produces multi-toned, earthen colors which are enhanced with oxide stains.

HANEY, WILLIAM L. (Painter)
181 Mott St., New York, NY 10012

Born: 1939 *Collections:* Metropolitan Museum of Art; Solomon R. Guggenheim Museum *Exhibitions:* Solomon R. Guggenheim Museum *Education:* Indiana University *Dealer:* Sherry French Gallery, NYC

In the early 1960s, he rejected the academic modernism he was taught and began to paint representational images. His present painting is an attempt to re-create a synthetic representation of particular images: the narrative possibilities of staged events in artificial lights. To this end, he uses many kinds of sources, such as drawings, photographs (his own and others), and invention. A single source could not serve the composite image. His subjects most often are social controversies with multiple readings. The realist surfaces of the paintings are directed against the questionable reality of the event. Modernism's quality of collage is preserved in the works.

HANNAY, JANN (Painter)
15 Gerard Ct., New Providence, NJ

Born: 1933 *Awards:* Sommerset Art Association; Summit Art Center *Exhibitions:* Viridian Space, NYC *Education:* Miami University; Art Students League

His giant canvases emphasize transparent color-field abstraction, stained effects, and rich surface textures that recall the work of Helen Frankenthaler. Early paintings were characterized by earth-toned washes, scratchings, and high color marks. His most recent works are large, abstract paintings of moving, exploding forms of dark rich color in the background, with smaller forms of red, white, or deep purple on the surface. These works convey the feeling of thunder clouds crashing on some subconscious terrain.

HANSEN, STEPHEN (Sculptor)
c/o St. Joseph Art Association, Krasl Art Center, 707 Lake Blvd., St. Joseph MI 49085

Born: 1950 *Collections:* Herman Miller Furniture Company *Exhibitions:* Dobrick Gallery, Chicago; St. Joseph Art Association *Dealer:* St. Joseph Art Association, St. Joseph, MI; Mac Gilman Galleries, Chicago

Whimsical three-dimensional comic-strip-like papier-mache figures range in size from miniature to almost life-size. After greatly detailed wooden armatures are constructed, the papier-mache is applied and later painted. The rotund, rather pear-shaped characters "are figures that exude real life instead of being replicas."

In 1984 he was commissioned by Herman Miller's furniture manufacturer to make twenty-two nearly life-size figures engaged in the activities of work, including a window washer, a carpenter, a wall painter, and a foreman. They were placed throughout the offices on realistic scaffolds and ladders.

HANSON, DUANE (Sculptor)
6109 S.W. 55 Ct., Davie FL 33314

Born: 1925 *Awards:* Blair Award, Art Institute of Chicago; German Academy Exchange Services Grant, W. Berlin *Collections:* Whitney Museum; Milwaukee Art Museum *Exhibitions:* Whitney Museum Biennial; Corcoran Gallery *Education:* Macalester College; University of Minnesota; Cranbrook Academy of Art *Dealer:* O.K. Harris Works of Art, NYC

After graduate work he lived from 1953 until 1961 in Germany, where he met George Grygo. Back in America during the 1960s, he began working with polyester resin and fiberglass, the media of Grygo. From live models, negative molds were made of dental plaster bandages into which was poured a mixture of polyester resin and fiberglass. Figures were painted in oil, and real hair, clothes and objects were added. The figures illustrated themes of war, crime or violence. By 1970, instead of being ideographic, the pieces were satirical, such as *Tourists*. For a short time he tried to present figures in movement, such as football players, but it proved unsuccessful. Super-realistic portrayals of lower- and middle-class Americans are disconcertingly lifelike, and it is common for an observer to mistake them for their living, breathing equivalents. He is interested not in human form but in capturing the "idiosyncrasies of our time."

HANSON, PHILIP HOLTON (Painter)
5008 N. Hermitage, Chicago IL 60640

Born: 1943 *Awards:* Cassandra Grant; National Endowment for the Arts Grants *Collections:* Museum of Contemporary Art, Chicago; Museum of the Twentieth Century, Vienna *Exhibitions:* Whitney Museum of American Art; Madison Art Center *Education:* University of Chicago; School of the Art Institute of Chicago *Dealer:* Phyllis Kind Gallery, Chicago

Flowers and florid designs typify this Chicago Imagist's work. In glowing colors women are portrayed in designs of undulating flower petals or convoluted shells, as in *The Shell Robe*. Other works display imaginative realms of floral splendor and other ornate imagery, as in *Dappled Pleasure Dress* and *Chambers of the Shell*. These richly composed designs often include philosophical themes and allusions referring to the nature of creative and artistic identity and purpose.

HARA, KEIKO (Painter, Printmaker)
c/o Fine Arts Dept., U of Wisconsin, River Falls, WI 54022

Born: 1942 *Awards:* First Prize, Michigan Prints and Drawings, Detroit Institute of Art *Collections:* Art Institute of Chicago; Detroit Institute of Art *Exhibitions:* Perimeter Gallery, Chicago; Brooklyn Museum of Art *Education:* Cranbrook Academy of Art *Dealer:* Perimeter Gallery, Chicago; Bradley Gallery, Milwaukee

Her lithographs and oil and acrylic paintings contain abstractions executed in vibrant color. The subtle references to water, fire, midnight skies and fertile grasslands offer rich metaphorical images. Her current work incorporates real light into pieces already aglow with color. A series of "banners" are printed on sheer handmade paper and attached back to back, allowing

Beverly Hallam, *Goldenrod* (1984), 64 x 96, acrylic on canvas.

Kciko Hara, *Topophilia*, 24 x 36, lithograph.

sunlight to layer the images. Recent paintings also leave the walls and are mounted in free-standing screens. The abstract compositions emphasize flickering light, radiant colors, aactive forms.

HARDY, JOHN (Painter, Printmaker)
130 West 26th St., New York, NY 10001 *Collections:* Brooklyn Museum; National Museum of American Art *Exhibitions:* Armstrong Gallery, NYC; Brooklyn Museum *Education:* Ringling School of Art; Georgia State University *Dealer:* Armstrong Gallery, NYC

His expressionistic paintings are primarily figurative. He uses the female form as a metaphor to convey transition, passage, and conflict. Some works contain a sense of narrative produced by simultaneous, multiple views of a single figure. The collected gestures symbolize the brief, fragmented passages of time which enclose all human thought and activity. He seeks the perfect balance of tension between elements, the right balance of contrasts in his compositions. In his portrayal of women he sees a symbolic "state of survival," the regenerative, life force of nature which stands in opposition to the temporal, destructive forces.

HARI, KENNETH (Painter)
228 Sherman St., Perth Amboy, NJ 08861

Born: 1947 *Awards:* Feice Award; Pulaski Award *Collections:* Vatican; Museum of Modern Art, Barcelona, Spain *Exhibitions:* Baron Museum *Education:* Maryland Institute of Art *Dealer:* Afonso Gallery, NYC

He painted poet W. H. Auden, cellist Pablo Casals, and novelist Irving Stone by the time he was 24. His approach is realistic and direct; he objectively renders his subjects in a straightforward manner. The resulting portraits comprise detailed statement's of the subject's personality. He also does pencil drawings that have a textural quality. His early celebrity portraits often were done on speculation, writing his subjects for permission to paint or sketch them. Presently, he may see a subject once or ten times, each sitting lasting several hours. After preliminary sketching, he usually takes a week to paint the portrait, working seventeen hours a day. Frequently he creates multiple oil paintings of a subject, which allows to explore the many facets of the subject's personality.

HARKER, LEE (Painter)
5240 N. Sheridan, Chicago, IL 60640

Born: 1954 *Awards:* award, Spoon River Art Festival *Collections:* Mid-States Concrete; Equitable Life Insurance *Exhibitions:* Kansas City Art Festival; Venice Area Art League *Education:* Ringling School of Art; Montserrat School of Visual Art; School of the Art Institute of Chicago

Early paintings were in an "abstract realist" style combining realistically rendered images in a variety of juxtapositions. The painter was strongly influenced by Matisse, Avery, Manet, Vermeer, and Rembrandt. More recent work has been inspired by Christianity and she is exploring joyful, exciting color interactions in paintings with luminescent qualities.

HARMON, ELOISE NORSTAD (Ceramicist, Sculptor)
35 Bedford Road, Pleasantville, NY 10570

Awards: International Award, American Institute of Decorators; *Collections:* Redeemer Lutheran Church, NYC; Park Sheraton Collection, NYC *Exhibitions:* Silvermine Guild, New Canaan, CT; Contemporary Christian Art, NYC *Education:* Hunter College; Art Students League *Dealer:* Kendall Gallery, Wellfleet, MA; Main Street Gallery, Nantucket, MA

Her clay wall reliefs and free standing sculpture range in scale from small to as much as six feet in height. She works directly with the clay—hand building the forms and embellishing the surface with lavish carvings, impressed textures, or additive elements. Images from nature, the human figure, as well as letters and numerals are simplified into her decorative motifs. One body of work addresses Christian themes and symbols—the Madonna, the Mother and Child, crosses, and shrines. An interest in the durability of the clay medium has led her to experiment with outdoor sculpture and architectural uses for her work. She has produced several series of interior/exterior wall tiles in low relief.

HARRISON, CHARLES (Photographer, Fiber Artist)
28 West 38th St. Apt. 4W, New York, NY 10018

Born: 1949 *Collections:* Museum of New Mexico; Addison Gallery of American Art *Exhibitions:* Marcuse Pfeifer Gallery, NYC; David Dawson Fine Arts, London *Education:* Harvard College *Dealer:* Marcuse Pfiefer Gallery, NYC

Work has been divided equally between photography and textile arts. For the past decade he has employed knitting as a means to address painterly questions. In addition to the formal and emotional issues of painting he has been engaged by the scientific and cognitive issues raised by photography, specifically information organization and artificial intelligence questions raised by the transmission of computer images. A series of work done in the mid 1970s was based on photographs beamed back by NASA from the moon and Mars. Recently he has returned to a fascination with the human face in his work and is exploring how forms are revealed by the play of light.

HARRITON, ABRAHAM (Painter)
66 W. Ninth St., New York, NY 10011

Born: 1893 *Awards:* Marjorie Peabody Waite Award, National Institute of Arts and Letters; Grant, Mark Rothko Foundation *Collections:* Whitney Museum; Hirshhorn Museum and Sculpture Garden *Exhibitions:* Metropolitan Museum of Art; Brooklyn Museum *Education:* National Academy of Design

A painter for eight decades, his work has gone through many phases, including an idyllic phase a la Ryder, social realism during the Depression of the 1930s, and a classical phase that encompassed landscapes, portraits, figure compositions, marine paintings, and allegories.He now considers himself to be a symbolical painter. He is the author of a book on the underpainting and glazing techniques of the Renaissance masters, and he continues to draw and paint works that are modern but steeped in tradition.

HART, ALLEN M. (Painter)
34 Jackson Rd., Valley Stream, NY 11581

Born: 1925 *Collections:* University of Massachusetts; Butler Institute of American Art *Exhibitions:* Lerner-Heller Gallery, NYC *Education:* Art Students League, NYC

His influences in the past have been expressionist from Bosch to Munch, and his imagery surveys the grotesque as well as embedding itself with the naturalistic. Some of his work consists of elements of collage and mixed media, where rice papers are mounted upon the painted surface of the canvas, then made transparent by application of oils and varnishes to allow the imagery

underneath to reveal itself. By employing thin glazes, color structures are developed. Other works display bold, broad brushstrokes of brilliant colors and crisp textures. Current themes include volumes of self-portraits, landscapes, animal mythologies and the fantastic. His work is upon canvases of heavy cotton duck, and are moderate in size.

HASELTINE, MAURY (Painter)
3820 Sunset Beach Dr. NW, Olympia, WA 98502

Born: 1925 *Awards:* Tacoma Art Museum; Museum of New Mexico *Collections:* Museum of Art, Eugene; Salt Lake Art Center *Exhibitions:* Expo 74, Spokane *Education:* Reed College; Northwest College of Art *Dealer:* Phillips Gallery, Salt Lake City; Marianne Partlow, Olympia

Her paintings are inspired by the landscape and seascape of the Pacific Northwest, and her canvases often display a vigorous application of painted surfaces and patterning of color. The *Rembrance Series,* combining painting and collage incorporated mirrors, velvet, photographs and found objects were executed in a bold, abstract style. The *Wheatland Series,* 1970-1980, were oil on canvas and explored the deep space and striped patterns of plowed fields. In her current work since 1980, entitled the *Bay Series,* the artist has explored light on water with acrylic on canvas. The surfaces are flat and the combination of deep space, folding shapes and strong patterns suggest peeling landscapes and sea edges.

HATCH, MARY (Painter)
6917 Willson, Kalamazoo, MI 49009

Born: 1935 *Awards:* Susan Kahn Prize, National Association of Women Artists; Award, 1978 Area Show, Battle Creek Art Center *Collections:* Kalamazoo Institute of Arts; Upjohn Co. *Exhibitions:* Kouros Gallery, NYC; Marie Pellicone Gallery, NYC *Education:* Western Michigan University; Kalamazoo Institute of Arts *Dealer:* Marie Pellicone Gallery, NYC; Alter Associates, Highland Park, IL; Rubiner Gallery, West Bloomfield, MI

As figurative painter working in oil, she is preoccupied with the human psyche, the emotional and psychological. Vivid colors on a flat picture plane are characteristic of early works which usually included a single figure. In a series of portraits of women, a mysterious inner reality was suggested by the inexplicable presence of large and solemn birds. In recent paintings, the colors have softened and the picture plane has deepened to include layers of movement and activity, paralleling the complexity and flux of the human personality. Contemporary, middle class men and women appear together in surreal environments and incongruous situations. In *Levitation,* a man with a a hand on one hip and a bag on his head, casually and magically levitates a reclining woman.

HATFIELD, DONALD GENE (Painter)
550 Forest Park Circle, Auburn, AL 36830

Born: 1932 *Awards:* Award, Montgomery Museum of Art; Purchase Award, Jacksonville State University *Collections:* Montgomery Museum of Art; Tuskegee Institute *Exhibitions:* Columbia College; Del Mar College *Education:* Michigan State University; University of Wisconsin

His early watercolor paintings exhibit fluid brush work and a strong, structurally arranged composition. The vitality of these "action paintings" testify to the physi-cal, emotional, and intellectual involvement of the artist. In recent imaginary landscape pieces, he works with a more realistic style. Without loss of structure or order, the application of pigment continues to testify to the physical and emotional nature of painting. Negative spaces are emphasized in the composition of newer works.

HAVARD, JAMES PINKNEY (Painter)
c/o Louis K. Meisel Gallery, 141 Prince St., New York NY 10012

Born: 1937 *Awards:* Purchase Prize, Philadelphia Museum of Art; Mabel Wilson Woodrow Award, Pennsylvania Academy of the Fine Arts *Collections:* Philadelphia Museum of Art *Exhibitions:* Pennsylvania Academy of the Fine Arts; Philadelphia Museum of Art *Education:* Pennsylvania Academy of the Fine Arts *Dealer:* Louis K. Meisel Gallery, NYC

Part of a new generation of painters to come out of the Abstract Expressionist movement, he borrowed their ideas and combined them with trompe l'oeil to help develop what gallery director Louis Meisel has called Abstract Illusionism. His boldly colored acrylic paintings have such titles as *Brahama Night Ride, Radwor Green,* and *Chippewa.* The images transform the rectangle of the canvas into a shallow niche, creating an illusion of depth by overlapping abstract shapes which seem to cast shadows.

HAYDON, HAROLD (Painter)
5009 Greenwood Ave., Chicago, IL 60615

Born: 1909 *Collections:* Pickering College, Newmarket, Ontario; Sonia Shenkman Orthogenetic School, University of Chicago *Exhibitions:* Art Institute of Chicago; University of Illinois *Education:* School of the Art Institute of Chicago; University of Chicago

From the early 1930s he was interested in visual problems in art. This took the form of painting what one sees with two equally balanced eyes, yielding a field of vision in which all images are double except in the plane of focus. He continues to explore this perception, both for its complexities of composition and the sensation of deep space it engenders. Since 1958, he has executed major mural commissions for churches, temples and schools. His materials include wool tapestry, stained glass, polychrome brick mosaic, Byzantine glass mosaic, and porcelain enamel on steel. He has served as an art critic for the *Chicago Sun-Times* since 1963.

HEALY, JULIA SCHMITT (Painter)
22 Marion Ave., Staten Island, NY 10304

Born: 1947 *Awards:* Canada Council Grant; First Place, Purchase Award, "Graphics Atlantic" *Collections:* National Gallery of Canada; Canadian Art Bank, Ottawa *Exhibitions:* Art Institute of Chicago; Dalhousie University *Education:* School of the Art Institute of Chicago *Dealer:* Phyllis Kind Gallery; Susan Whitney Gallery

Images in oil and acrylic and drawings in crayon compose her mixed media paintings. Humor and social commentary have always figured in her work. Earlier art work included "send-ups" of musclemen, weddings, and housewives. Her painting style shows her Chicago imagist roots yet incorporates a myriad of influences from around the world. Her present series have concerned themselves with post-nuclear landscapes and other timely themes, the latest of which is her large paintings of modern day martyrs.

HEE, HON-CHEW (Painter, Printmaker)
45-650 Kapunahala Road, Kaneohe, HI 96744

Born: 1906 *Awards:* Artist of Hawaii Freedom Award, Sertoma Club; Award, National Art Committee of Taiwan *Collections:* State of Hawaii Foundation on Culture and the Arts; Honolulu Academy of Arts *Exhibitions:* National Academy of Design; Seattle Art Museum *Education:* California School of Fine Arts; Art Students League

A painter, printmaker, graphic artist, and muralist, he works in a variety of media and styles. In early paintings he concentrated on figure drawings and renderings of houses accompanied by calligraphic scripts. These revealed a strong Cubist influence from his teachers, Andre Lhote and Fernand Leger. From the 1950s until 1970 he painted primarily nature subjects using watercolors and a "wet on wet" technique. Eastern and Western sensibilities blend in his work. Recent compositions utilize abstracted images and symbols that present opposition and deliberate contrasts as in the Yin-Yang theory. The serigraphs, oil paintings, and several large murals in baked enamel on metal all exhibit bold, warm colors and strong figuration.

HEINICKE, JANET (Painter, Printmaker)
1302 W. Boston, Indianola, IA 50125

Born: 1930 *Collections:* Caterpiller Corporation Permanent Collection; Richmond Art Association Permanent Collection *Exhibitions:* "Three Chicago Artists", Mitchell Museum; Kanakee Community College *Education:* Northern Illinois University; University of Wisconsin at Madison; Cleveland Institute of Art

Her work in medium-to-large scale watercolors, serigraphy, and acrylic stains is often concerned with the simplification of things, and a concentration of certain themes derived from nature. In general each work examines some aspect of the natural world, magnifying aspects that seem curious, unusual or forceful, and frequently the single aspect being studied turns out to be color, shape or texture. Objects that are frequently overlooked or ignored because of their commonplace nature, like sticks, stones, and little bones, were common subjects of her early paintings. Early watercolor landscapes evolved into broad sweeps of color, melting into gray and cloudless skies. Strongly influenced by philosophies of the American Indian and the Far East, she has sought to paint the spiritual essence in natural phenomena. In late 1981 she began to look at things of the spirit as pictorial subject matter themselves, and has begun to employ Biblical scriptures as sources for her metaphorical imagery.

HEIZER, MICHAEL (Sculptor, Environmental Artist)
c/o Xavier Fourcade, 36 E. 75th St., NYC NY 10021

Born: 1944 *Collections:* Kunstmuseum, Basel; Museum of Modern Art *Exhibitions:* Solomon R. Guggenheim Museum; Whitney Museum Annual *Education:* San Francisco Art Institute *Dealer:* Xavier Fourcade, NYC; Gemini G.E.L., Los Angeles

First an Abstract Expressionist painter, in 1967 he turned to Earth Art with an excavation project in Reno, Nevada. During 1969 and 1970, 240,000 tons of rhyolite and sandstone were displaced at Virgin River Mesa, Nevada, for a project called *Double Negative*. A main concern was the physical property of things: density, volume, mass and scale. Other works included cantilevered rock pieces. Although he has not constructed earthworks in recent years, he has continued to produce works that address his earlier concerns in the form of lithographs, serigraphs and drawings as well as both monumental and small sculpture in metal and stone.

HELD, AL (Painter)
c/o Andre Emmerich Gallery, 41 E. 57th St., New York NY 10022

Born: 1928 *Awards:* Logan Medal, Art Institute of Chicago; Fellowship, John Simon Guggenheim Memorial Foundation *Collections:* Museum of Modern Art; Hirshhorn Museum and Sculpture Garden *Exhibitions:* Whitney Museum of American Art; Solomon R. Guggenheim Museum *Education:* Art Students League; Academie Grande Chaumiere, Paris *Dealer:* Donald Morris Gallery, Detroit

Early work in New York was social-realist, but after studying sculpture with Ossip Zadkine in Paris in 1949 and meeting Jackson Pollock, he developed a style which he said would synthesize the subjectivity of Pollock and the objectivity of Piet Mondrian. Two years later pigment was thickly applied to the canvases in horizontal ribbons of color. Once again in New York in the 1950s, heavily pigmented canvases were influenced by the painters of the New York School. In 1959 forms had become geometrical, with sharp edges and bold colors. Subsequent paintings of the 1960s tended to be massive in scale. Black and white paintings beginning in 1967 overlapped the geometrical shapes for the first time, presenting elements that appeared to recede or advance in multi-layered space, as in *South Southwest* (1973).

HEMPLER, ORVAL F. (Painter)
2302 Second St., Santa Monica, CA 90405

Born: 1915 *Awards:* Frank and Alva Parsons Fellowship *Collections:* Los Angeles County Museum, University of Kansas Museum *Exhibitions:* New York Watercolor Society *Education:* University of Colorado, University of Iowa *Dealer:* Mary Browne, Norton, KS

His works in watercolor have been compared to those of Raoul Dufy. His use of color is characterized by a splashy, calligraphic style. Working as a designer-artist for a California ceramics firm allowed him to experiment with materials. Using clays, paints, and glazes, with high-firing kilns, he created "sculptured paintings." In these works, he deals with spiritual, celestial, and abstract subjects.

HENSLEY, JACKSON M. (Painter)
Box 1442, Taos NM 87571

Born: 1941 *Awards:* National Academy Scholarship, Arthur T. Hill Memorial *Collections:* New Mexico St. Museum; IBM, Inc. *Exhibitions:* National Arts Club; Salmagundi Club *Dealer:* Gallery of the Southwest, Taos, NM; O'Meara Gallery, Santa Fe, NM

A traditional painter, he makes a number of studies before rendering the final painting. Subjects from life are executed outdoors or in the studio, employing oil, watercolor, and/or tempera on small-scale and large-scale canvases of various sizes. When working in oil, glazing is often used, and some paintings have taken three years or more to complete.

HERA (Sculptor)
32 W. 20th St., New York, NY 10011

Born: 1940 *Awards:* National Endowment for the Arts; New York State Council on the Arts *Collections:* New Orleans Museum; Rose Art Museum *Exhibitions:* Art

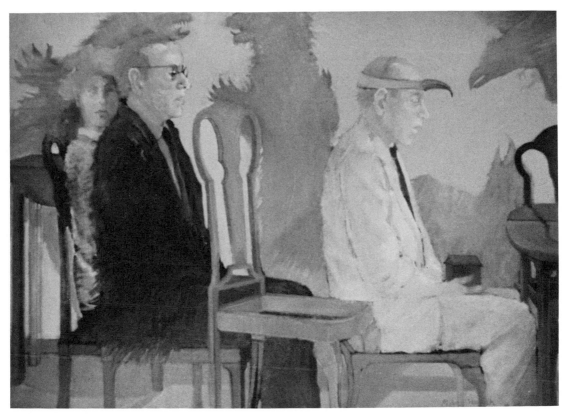

Mary Hatch, *Monster Movies,* 26 x 36, oil on linen.

Donald Hatfield, *River Bank,* 18 x 24, charcoal.

Park; Institute of Contemporary Art, Boston *Education:* School of the Art Institute of Chicago; Mt. Holyoke College

The environments that the artist builds are arenas for human response. The work is provocative and affects the viewer/participant on multiple levels. Work is always large enough to surround the viewer. For example, the *Niagara-Knossos-Carranza Connector* was a 101-foot-diameter compass with an eighteen foot by sixty-five foot constructed walk-in compass arrow that contained a film loop of the imaginary orbit northeast from Niagara to Knossos. Recent commissions for large sculptural arbors in New York City will offer meditative, flowering green spaces for pressured city dwellers. The focus of the work is positive, with perceptual expansion its aim.

HERFINDAHL, LLOYD MANFORD (Painter)
809 John Farry Place, Albert Lea, MN 56007

Born: 1922 *Awards:* Silver Medal, Societe D'Encouragement au Progres, Paris; Gold Medal, Grand Prix de Humanitaire de France, Paris *Collections:* Holyland Museum; Minnesota Historical Museum *Exhibitions:* Salon des Independents, Grand Palais, Paris *Education:* Minneapolis College of Art and Design

He has experimented with representational, expressionistic, and abstract styles, both in watercolor and oil media. His compositions include satirical subjects, multiple images, historical murals, and portraits. Some of his portrait subjects have included King Olav V of Norway, former Governor and Ambassador, Karl Rolvaag, and pianist-composer, Percy Grainger. His current paintings depict scenes and subjects of social realism. In 1983 he completed a series, *The 1980s,* which captures the frustration and suffering experienced by Midwesterners during the Nation's economic recession.

HERNANDEZ, JOHN A. (Painter)
2823 Live Oak, Dallas, TX 75204

Born: 1952 *Awards:* Voertman Purchase Award, North Texas State University *Collections:* Atlantic Richfield Corporation *Exhibitions:* Corpus Christi Museum of Art; Laguna Florida Art Museum *Education:* North Texas State University *Dealer:* DW Gallery, Dallas; Moody Gallery, Houston

Early works were both collages and hard-edge paintings inspired by Pop art and the Chicago Imagists. These were later combined with drawings as the artist explored three dimensional aspects of the work. Presently, he employs a variety of media, including oils, acrylic, airbrush, pencil, and both found and constructed objects, to extend the surface of the "canvas" away from the wall sometimes as much as a foot. Paintings are often the combination of seemingly disparate images from cartoons, and fantasy to naturalistic settings, the figure, and abstraction.

HERTZ, PAUL B. (Painter)
3323 N. Seeley, Chicago IL 60618

Born: 1949 *Awards:* Mellon Fellowship, Center for Advanced Studies in Art and Technology; SAIC, Chicago (1984-85) *Exhibitions:* Universitat Nova, Barcelona; Sitges XIII (Spain) *Education:* Brown University, B.A; Art Institute of Chicago, MFA

The relation between visual and musical, and the possibility of persons other than the artist entering into the creative process through "compositional games" are the primary interests of this artist. Earliest exhibited work was painting in geometric abstract style, and alternately in a painterly figurative style. After several years playing piano in local nightspots in Spain, he developed a systematic approach to relating visual and musical composition through mathematical structures. Subsequent works have included painting, music, performance and installation, often oriented towards the participation of others. Currently working with computer programming as a tool for generating and realizing compositions. Recent works have been less concerned with "systems" and more oriented towards the social function of a work, its content and the occasion of its realization.

HESS, EMIL JOHN (Painter, Sculptor)
130 W. Tenth St., New York NY 10014

Born: 1913 *Collections:* Museum of Modern Art *Exhibitions:* Museum of Modern Art; Metropolitan Museum of Art *Education:* Art Students League; Brooklyn Museum School *Dealer:* Jack Tilton Gallery, NYC

As a young man he worked as a watercolor renderer for an industrial company. While serving in the army during World War II, he spent three years as an artist for training films and slides, followed by a term in Korea as an illustrator of street scenes and war camps for the *Korea Graphic* newspaper. Upon returning to the United States, he pursued graduate studies in art, studying painting and sculpture. Representational paintings depict circus life and performance. For the past several years he has concentrated on abstract sculpture of wood and plastic sheets, with "adjustable shapes and forms."

HESS, MARK (Painter, Illustrator)
88 Quicks Lane, Katonah NY 10536

Born: 1954 *Awards:* Art Directors' Clubs Awards *Collections:* Museum of Natural History, Hayden Planetarium *Exhibitions:* Society of Illustration; Georges Pompidou Museum *Education:* University of Colorado

After studying art academically, he dropped out of school and chose to pursue an apprenticeship instead. After one year he became a free-lance illustrator, creating art works for advertising campaigns as well as for record album covers and for magazine covers such as *Time.* Presently he works as a portrait painter for about four months per year, and for the remainder of the year works as a free-lance illustrator, teacher and traveling lecturer.

HIBEL, EDNA (Painter, Sculptor)
Box 9967, Riviera Beach, FL 33404

Born: 1917 *Awards:* Medal of Honor, Pope John Paul II *Collections:* Ethelbelle and Clayton Bion Criag Collection, Palm Beach, FL; Hibel Museum of Art, Palm Beach, FL *Exhibitions:* U.N. Gallery, NYC; Edna Hibel Gallery, Palm Beach, FL *Education:* Boston Museum School of Fine Art *Dealer:* Edna Hibel Gallery, Palm Beach, FL

Her body of work consists of paintings on canvas, frescoes, lithography, sculpture in bronze, and porcelain sculpture. Her subjects include mothers and children, farmers working their fields, and oriental themes, portrayed in delicate brushstrokes and a vividly colored palette. Her older works, 1939-60, are more classically and Renaissance oriented. The current works feature glazes and gold leaf on canvas and board and charcoals on silk, and are more impressionistic.

HICKENS, WALTER H. (Sculptor, Graphic Artist)
130 E. 24th St. New York, NY 10010

Orval Hempler, *Spirit of Kansas,* 22 x 30, watercolor.

Jackson Hensley, *Running Free,* 36 x 52, oil on canvas. Courtesy: Gallery of the Southwest (Taos NM)

Born: 1936 *Awards:* Anna Hyatt Huntington Award; Best Bronze in Show, Salmagundi Club *Collections:* McKinsey & Co.; Celenese Corporation *Exhibitions:* Metropolitan Museum of Art; New York Public Library *Education:* City College of New York; Columbia University *Dealer:* Marcoleo, Ltd., NYC

His work in sculpture is in a variety of stone as well as metal media. Metal sculptures are mostly highly polished bronzes exhibiting elegant, smooth, curved lines in abstract motifs derived from nature. Leaf-like lines, wings of birds and the outlines of fish are the inspiration for his forms. His bas-reliefs allow a play of light against dark, high polish and dark patinas. In contrast, his graphic works achieve a quick spontaneous brush stroke effect through the use of sugar lift aquatint. The sudden quick movement in abstract forms is completely unlike his sculpture.

HILDEBRANDT, WILLIAM ALBERT (Painter)
417 Turner Rd., Media, PA 19063

Born: 1917 *Awards:* Medal, Philadelphia Sketch Club; Best in Show, Philadelphia Art Teachers Association *Collections:* Philadelphia Board of Education; Glen-Croft Baptist Church, Fulcroft, PA *Exhibitions:* Minnesota Museum of Art, Philadelphia Art Alliance *Education:* Tyler School of Art; Philadelphia College of Art

His past works mainly consist of oil paintings, watercolors, and drawings rendered in pencil or ink. They were done in a number of styles, ranging from the non-objective to detailed realism. His body of work also includes some sculpture, collage, and collagraphs. Motivation in his work stems from an observation of the elemental, abstract qualities present in human activities, and mood frequently is injected into the works. A religious orientation in recent years has provided a principal source of motivation and thematic substance. His recent works also include large constructions that combine realistic painting and sculptural forms with junk materials such as hub caps, plastic packing materials, and other found objects.

HILL, CLINTON J. (Painter)
178 Prince St., New York, NY 10012

Born: 1922 *Awards:* National Endowment for the Arts *Collections:* Museum of Modern Art; Metropolitan Museum of Art *Exhibitions:* Marilyn Pearl Gallery, NYC; Galleria Blu, Milan, Italy *Education:* University of Oregon; Brooklyn Museum Art School *Dealer:* Marilyn Pearl Gallery, NYC

He works in hand-made paper as well as acrylic paint on fiberglass-covered canvas. The paintings and paperworks reflect his long-time interest in the openness of light and space of the West, where he was born. This concern translates into the translucency and color that is enhanced by the materiality of the different media used. The tracks built into the canvases and paperworks generate a sense of momentum and speed. They are visual plans or routes for getting from one side to the other. These tracks not only divide the canvas or paper with the cadence of jazz, but also allow the viewer to read the path in ways other than the formal.

HIMMELFARB, JOHN DAVID (Painter)
908 W. 19th St., Chicago IL 60608

Born: 1946 *Collections:* Art Institute of Chicago; Brooklyn Museum *Exhibitions:* Art Institute of Chicago; Walker Art Center *Education:* Harvard University *Dealer:* Terry Dintenfass, NYC

Intuitive visualizations in paintings, ink drawings and prints are networks of tiny lines, topsy-turvy worlds with buildings, humanoids, animal-plant creatures and vehicles piled on top of one another. Compositional strategies include open format "topographies" in which forms are jumbled; grid frameworks; or row structures. The "topographies" usually begin in one corner and branch out to cover the entire surface. In the grid and row formats, the surface is covered quickly with horizontal or vertical rows in a method similar to pictographic or calligraphic writing. "Sometimes there are immediate subliminal influences. Images of a house, an animal with legs, a building or a car will pass through my mind and they come out in the drawings as an elaboration on a basic block form to which appendages are added to make it go in one direction or another." Recent works employ brilliant colors in sometimes unsettling visions such as *Riding High,* a large-scale acrylic painting which depicts a boat full of debris in a sea full of people caught in the waves.

HIRSCHFELD, AL (Graphic Artist, Cartoonist)
122 East 95th Street, New York, NY 10028

Born: 1903 *Awards:* Specialist Grant, U.S. State Department *Collections:* Museum of Modern Art; Metropolitan Museum of Art *Exhibitions:* William Hayes Fogg Museum; Museum of Performing Art *Education:* National Academy of Design; Julien's, Paris; Art Students League *Dealer:* Margo Feiden Gallery, NYC

Working primarily in pen and ink, while also producing lithographs and etchings, he is renowned as the major cartoonist of Broadway theatre. Since 1925 he has been the theatre cartoonist for the *New York Times* capturing such unforgettable personalities as Basil Rathbone in *The Command to Love*, Mary Martin in *South Pacific*, and Carol Channing in *Hello, Dolly*. He has also chosen noted musicians, movie stars, and dancers as his subjects. His images contain an energy and vitality reminiscent of the Japanese woodcut artists of the 18th and 19th Centuries. The drawings are black, rarely employing tone, and never using shadows. While the drawn design and the grace of the flowing lines themselves are a prime concern, it is his ability to distill personality into line that has become the hallmark of his art.

HOARE, TYLER JAMES (Sculptor, Printmaker)
30 Menlo Place, Berkeley, CA 94707

Born: 1940 *Awards:* Diploma of Merit, Universita Delle Arti; Master of Painting Honoris Causa, Accademia Italia *Collections:* The Oakland Museum; The State University of New York at Albany *Exhibitions:* The University of Lancaster, Bailrigg, Lancaster, England; Camberwell School of Art, England *Education:* University of Kansas; Sculpture Center, NYC *Dealer:* Atherton Gallery, Menlo Park, CA

Work ranges from mixed media sculpture to prints employing 3M and Xerox color copies. Earlier sculptures and assemblages were representational, sometimes whimsical constructions of mixed media and found objects. More recent color copies combine text with graphics, and often times mirrored effects to create interesting superimpositions and juxtapositions of images. One process whereby eight prints are made from a 35mm slide, every other one reversed, and then segments of the prints pasted together, creates a kaleidoscopic pattern of juxtaposed images. The advantage offered by the color copier process is that it allows him to control quite precisely the varying color of each copy and makes each copy as original as a drawing.

Lloyd Manford Herfindahl, *Tunnel of Time*, 18 x 24, oil. Courtesy: Collection of Montbard Museum (France)

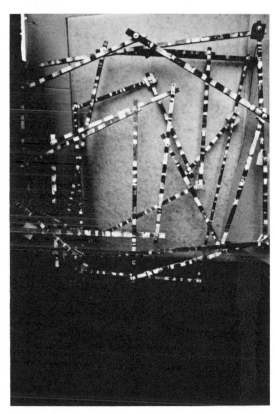

Emil J. Hess, *A Version of Zetetics*, 36 x 36 x 4, wood. Courtesy: Jack Tilton Gallery (New York NY)

Mark Hess, *Pennsylvania People*, 28 x 18, oil on canvas.

HOBBIE, LUCILLE (Painter)
Talmadge Rd., Mendham, NJ 07945

Born: 1915 *Awards:* Silver Medal of Honor, New Jersey Watercolor Society *Collections:* Montclair (NJ) Art Museum; Newark Public Library *Exhibitions:* National Academy of Design; National Arts Club *Dealer:* Vokes Gallery, Morristown, NJ

She is mainly a realistic landscape painter who uses watercolor and acrylics. She has produced realistic lithographs as well. Presently she is doing commissioned work, including a current project of a series of twelve drawings celebrating historic sites for the New Jersey Bicentennial. The drawings are of homes and public buildings throughout the state. She has recently designed a poster of Cape May that is also being reproduced.

HOCKNEY, DAVID (Painter, Set Designer)
c/o Andre Emmerich Gallery, 41 E. 57th St., New York NY 10022

Born: 1937 *Awards:* Graphic Prize, Biennial, Paris; Guinness Award, London *Collections:* Museum of Modern Art; Victoria and Albert Museum *Exhibitions:* Museum of Modern Art; Arts Council of Great Britain *Education:* Bradford College of Art; Royal College of Art, London *Dealer:* Richard Gray Gallery, Chicago; Andre Emmerich Gallery, NYC; Gemini G.E.L., Los Angeles

Although this British artist was first identified with late Pop Art, his stylistic tendencies came from Abstract Expressionism. Often autobiographical works are known for their irony and humor, and a basic theme is the figure, in designs and surroundings which explain character. Acrylic paintings are bright and naturalistic but flattened, with a strong sense of pattern. A versatile artist, he has made photographic collages in which fragments are overlapped to create one image, such as *Desk, London, June 1984*. Other accomplishments include drawings (and book illustrations), gouaches, lithographs, etchings and aquatints. An interest in the effects produced by moving water and in reflections in glass were evident in a series of paintings and in an autobiographical film, *A Bigger Splash*. *Hockney Paints the Stage* is a recent showing of paintings, drawings and displays depicting the various costume and stage designs he has executed for the theater.

HOFFMAN, WILLIAM (Ceramicist)
1925 N.Hudson, Chicago, Il. 60614

Born: 1920 *Collections:* St. Mary's College; Roswell Museum *Exhibitions:* Art Institute of Chicago; Ceramic Arts U.S.A. *Education:* School of the Art Institute of Chicago; State University of New York at Alfred *Dealer:* Fairweather-Hardin Gallery, Chicago

His current abstract style of clay sculpture developed about eight years ago as a result of working directly with students at the School of the Art Institute of Chicago and Loyola University. The set aside, discarded pressed forms, coiled pots, and trimmings of his students, although incomplete and fragmented, provide him with the initial forms that develop into his finished pieces. The discarded material is laid out on table tops, suggesting yet other forms, and taking on new meaning. Now and then a new piece is made when called for by the resultant combinations, and the final work is the culmination of diverse influences and a skillful eye for composition.

HOFFMAN, WILLIAM MCKINLEY (Painter)
167 Elm Ave., Woodlynne, NJ 08107

Born: 1934 *Awards:* Visual Arts Fellowship, National Endowment for the Arts; Governor's Purchase Award, New Jersey State Museum *Collections:* New Jersey State Museum; City of Camden *Exhibitions:* Peale House, Pennsylvania Academy of Fine Arts; Pavilion Gallery, Mt. Holly, NJ *Education:* Tyler School of Art; Pennsylvania Academy of the Fine Arts

Early work was largely figurative with an important part of it being large portraits and narrative figure compositions. His major interests were in light, color, structure and space. The paintings which developed from these interest, although naturalistic in appearance, were non-photographic in concept. In these early works, light and color dominate, the paint handling is less loose and space less deep. There were also a number of still life paintings in which the texture of objects was brought out by the use of strong light sources. Recently, the work has been mostly pure landscapes or the painting of urban scenes in which the recording of historically important buildings before they are destroyed is a major concern. In these paintings the color and paint handling tends to be juicy and more loose.

HOLABIRD, JEAN (Painter)
81 Warren St., New York, NY 10007

Born: 1946 *Awards:* Certificate of Merit, Vermont Arts Council *Collections:* Metropolitan Museum of Art; Staatmuseum, West Berlin *Exhibitions:* Bennington College; Sarah Y. Rentschler Gallery, NYC *Education:* Bennington College; Art Students League *Dealer:* Sarah Y. Rentschler Gallery, NYC

Watercolor has been, and continues to be, her main medium, executed from life, drawings, or her own photographs. Though not strictly figurative, her work is representational. The colors are flat and distinct; she uses the white of the paper as a major color to sharpen the effect. She also continues to produce collaborative etchings with poet Tony Towle. They employ a postcard motif, with hand-colored etching on the left and text on the right. The semi-humorous themes include summer vacations, famous battles, and New York City doorways.

HOLLAND, TOM (Painter)
227 Tunnel Rd., Berkeley CA 94705

Born: 1936 *Awards:* National Endowment for the Arts Sculpture Grant; Fulbright Grant, Santiago, Chile *Collections:* Museum of Modern Art; Whitney Museum of American Art *Exhibitions:* Museum of Modern Art; Whitney Museum of American Art *Education:* University of California *Dealer:* James Corcoran Gallery, Los Angeles; Charles Cowles Gallery, NYC

The son of a painter, he was also influenced by David Park. Paintings and sculptures are three-dimensional, bright, geometric works often in day-glo colors, on and off the wall. *Helli*, epoxy on aluminum, is one of the larger examples of what he calls a painting, even though it is two-sided and free-standing. Layer upon layer is painted and worked, each one referring to the structure of what is underneath, so that these "standup" paintings at times take on an organic quality. The substance of what exists below the surface of matter is explored through this medium. His media have also included fiberglass.

HOLMAN, ARTHUR S. (Painter)
Box 72, Lagunitas, CA 94938

Born: 1926 *Awards:* Purchase Award, Stanford Univer-

Paul Hertz, *Manifestation*, 24 x 14, acrylic.

sity *Collections:* Fine Arts Museums of San Francisco; Eureka College, IL *Exhibitions:* W. M. Sawyer Gallery, San Francisco; Smithsonian Institution *Education:* University of New Mexico; Hans Hofmann School; California School of Fine Arts

The marriage between realism and abstraction is the synthesis he has sought in his painting for forty years. Landscapes in oil always have remained his mainstay, influenced by both the Venetians and the Impressionists. He now lives in the country—the influence of nature on his work unmistakable—but he still explores an underlying abstraction. At this point, the constructivist elements he has tried to incorporate in his work to give it skeleton and muscle are far less evident, allowing the viewer a more visceral experience than before. This is particularly true in his recent series of oils of outer space.

HOLSTE, TOM (Painter)
Star Rt. Box 796, Orange, CA 92667

Born: 1943 *Awards:* National Endowment for the Arts *Collections:* Solomon R. Guggenheim Museum, Chase Manhattan Bank *Exhibitions:* S.U.N.Y. College at Purchase, New York; Solomon R. Guggenheim Museum *Education:* California State College at Fullerton; University of California, Irvine; Claremont College *Dealer:* Newspace Gallery, Los Angeles, CA

During the early 1970s he was noted for his large-scale, meditative "field paintings." In these works, strokes of sprayed acrylic were allowed to accrue on a prepared ground, resulting in a highly sensual spatial image. In 1974, he took a radical step: he began explorations of a painting-sculpture synthesis, characterized by geometric arrangements and frequent shifts in low relief. These multi-segmented painting-sculptures, constructed of cast rhoplex on wood, became larger through 1977 until they started to fragment and became multi-part wallworks. Now quite sizable, his works refer to both the dynamic geometric paintings of the Russian Suprematists and the kachina icons of desert Indian cultures. There is a strongly implied sense of movement in the current works, characterized by an overall sense of spiraling and an ambiguous state of motion.

HOLT, NANCY LOUISE (Sculptor)
799 Greenwich St., New York, NY 10014

Born: 1938 *Awards:* Grant, National Endowment for the Arts; Fellowship, John Simon Guggenheim Memorial Foundation *Collections:* Laguna Gloria Museum; Miami University Art Museum *Exhibitions:* John Weber Gallery, NYC; Bykert Gallery, NYC *Education:* Tufts University *Dealer:* John Weber Gallery, NYC

Her sculpture of concrete, brick, stone masonry, earth, and steel are intimately connected to their outdoor sites. The structure draws the viewer inside forming an enclosure while creating a sense of expansiveness with layers of openings and tunnels. Perception and space are key concerns in the pieces, additionally manipulated by changes in scale from various perspectives. Patterns of sunlight and moonlight, astronomical alignments, and/or water reflections connect the natural elements with the piece while astrally fixing each work in its site. Her most recent sculpture includes function and invites use. Basic systems of technology such as plumbing, electricity, drainage, and heating, are used to make labyrinthian structures that can be entered and operated by the viewer.

HONIG, MERVIN (Painter)
64 Jane Ct., Westbury, NY 11590

Born: 1920 *Awards:* Gold Medal, American Veterans Society of Artists *Collections:* Metropolitan Museum of Art; William Benton Museum of Art *Exhibitions:* Whitney Museum of American Art; Bergen Museum of Art and Science *Education:* Hans Hofmann School

His work reflects two main trends. The first period of his paintings was concerned with a depiction of life in America, as he observed it while traveling in the Air Corps. These paintings were narrative, and were associated with both the regionalism of American art of the 1940s and the humanism of the Italian Renaissance. The second phase of painting is directed away from a narrative treatment of subject matter, and shows his search for a deeper, more personal expression. The result is a realism imbued with an emotional power. In a current group of paintings, *Portrait of an Island,* the deeper involvement with moods of nature produce paintings with exciting visual abstract elements that enhance the subject.

HOPPER, FRANK J. (Painter)
P.O. Box 1806, Sarasota, FL 33578

Born: 1924 *Awards:* Gold Medal, Accademia Italia della Arti e del Lavoro *Collections:* Muer Corporation; Historic Museum, Washington, DC *Education:* Indiana University; School of the Art Institute of Chicago; American Academy of Art

His career has emphasized portraiture, including two Presidential portraits—Nixon and Reagan—and a *Famous American* series commissioned by President Kennedy. Two hundred paintings on the New Liturgy were done for the Archdiocese of Chicago. He has also painted murals on Western themes, as well as a mural and fourteen stations of the cross in *St. Mary Star of the Sea.* A tour of Israel resulted in a *Hope of Israel* series of paintings that depicted his impressions of that country and its people.

HOPTNER, RICHARD (Sculptor)
5000 Knox St., Philadelphia, PA 19144

Born: 1921 *Awards:* Scholarship, Cranbrook Academy of Art; Louis C. Tiffany Award *Collections:* Philadelphia Civic Center Museum *Exhibitions:* American Institute of Architects, Greenville (SC); Allentown Museum of Fine Art *Education:* University of Pennsylvania; Cranbrook Academy of Art *Dealer:* J. A. Munroe, Lansdale, PA

A sculptor who carves directly in wood, his work owes much to Medieval and African sculpture, with other influences including Barlach, Kollwitz, and the German expressionists. His vision is tragic. In the surface treatment of his works, he compels the viewer to respond on a sensual and intellectual level. He conveys his sense of tragedy by employing a trio of interrelated motifs in all his works: the erotic, the demonic, and the mythic. He confronts the tragic dilemma directly and systematically, believing that we must confront our demons if we are to exorcise them.

HOUGH, JENNINE (Painter)
4012 Peachtree Dunwoody Road NE, Atlanta, GA 30342

Born: 1948 *Awards:* Grant, National Endowment for the Arts and Southeastern Center for Contemporary Arts; MacDowell Colony *Collections:* Mississippi Museum of Art; Equitable Life Association Co. Collection *Exhibitions:* Monique Knowlton Gallery, NYC; Wilhelm Gallery, Houston *Education:* University of North Carolina *Dealer:* Morehead Gallery, Greensboro; Wilhelm Gallery, Houston; Fay Gold Gallery, Atlanta

David Hockney, *Terrace—Pool & Living Room* (1984), 36 x 60, oil on canvas. Courtesy: Andre Emmerich Gallery (New York NY)

William Hoffman, *Fossilized Chirping Bird,* 14 high, engobe on clay.

Tom Huffman, *Artists Disguised in his Work,* mixed media on paper board.

She calls her compositions in oils and watercolors, "imagined landscapes." The medium to large paintings are painted spontaneously each day from still life objects at hand in her studio and home. Rendered in a realistic, representational style the compositions assume an aura of fantasy. The arrangements of potted plants, miscellaneous items of clothing and house pets are compressed and crowded into the picture plane creating an illusion of landscape. Personal items and possessions as innocuous as sunglasses and left-over picnic items, become unfamiliar and alien within the context of this distorted geography.

HU, CHI CHUNG (Painter)
P.O. Box 1039, Carmel CA 93921

Born: 1927 *Awards:* First Prize, First Armed Forces Art Exhibit *Collections:* City Hall Art Museum, Hong Kong, China; National Museum of History, Taipei, Taiwan *Exhibitions:* Carnegie Institute *Education:* Self-taught *Dealer:* Zantman Art Galleries, Carmel, CA

Early works often depicted landscapes and dramatic mountain peaks in an impressionistic style which tended towards abstraction. Although the medium was oil, the technique was influenced by Oriental watercolor techniques, combining the tradition of Oriental brushwork with a Western impressionistic style.[5] Current works in oil are shimmering, diffused images. Subject matter has expanded to include the best of both East and West: pandas, flowering trees and fields, and ethereal renderings of female figures. "Fascination with motion and fluidity" has led him to the frequent depiction of horses.

HUFFMAN, TOM (Sculptor, Illustrator)
130 West 47th Street, Apt. 6A, New York, NY 10036

Born: 1935 *Collections:* Hudson River Museum; Gallery Association of New York State *Exhibitions:* Allan Stone Gallery, NYC; Sarah Rentschler Gallery, Bridgehampton, Long Island *Education:* University of Kentucky

His work ranges from satirical drawings, fanciful book illustrations and posters to mixed-media sculptural pieces. His drawings for many years have interpreted the human face, underscoring the relationship of the private and psychological to the external world. Most recent work has been the creation of cut and folded paper masks using fine grade paper which is then finished with an acrylic varnish. The "faces" are often left stark and unadorned although some are painted and ornamented. The masks are frequently combined in wooden "cages." Each piece captures a facet of the human psyche, exhibiting irony, fantasy, anthropomorphism or the grotesque.

HULL, CATHY (Illustrator)
236 E. 36th St., New York, NY 10016

Born: 1946 *Awards:* Text Book Cover Award, The Printing Industries of America Show; Silver award, The Society of Publication Designers *Exhibitions:* Contemporary American Graphic Design & Illustration, Butler Institute of American Art; Women in Design, Pacific Design Center *Education:* Connecticut College; The School of Visual Arts

The elements of her drawings are realistic—almost to the point of looking like photographs—for the attention to detail is impeccable. But, the meaning is transmitted by the strange juxtapositions of images that result in a pseudo-surrealistic satire. Most of her work is done in pencil. Minute detail, control, color, and the combination of collage with drawing, are all characteristics of her style. Similar images and symbols occur frequently in her work, repeated from drawing to drawing. She seems to enjoy psychological topics, and the belief in fantasy as a form of insight. There is a willing suspension of disbelief on the part of the viewer, and one accepts familiar objects in unfamiliar situations. Her drawings have appeared in most national publications, and her cover illustrations have graced the books of almost every major publishing house.

HULL, GREGORY STEWART (Painter)
2114 N. Deer Crossing Rd., Flagstaff, AZ 86001

Born: 1950 *Awards:* Best of Show, Utah Painting and Sculpture; First Prize, Davis County *Collections:* Utah State Institute of Fine Arts *Exhibitions:* Los Angeles Municipal Art Gallery; Butler Institute of American Art *Education:* Utah State University; University of Utah *Dealer:* Wally Findlay Galleries, Chicago

Taking his inspiration from such 17th and 19th century masters as Vermeer, Velazquez, Degas, and Sargent, his realistic oil paintings express a rich neo-realism that transcends time and place. He illuminates his subjects with a vibrancy and vitality that is strongly sensual. His subjects include figure, landscape, still life and portraits done in a traditional, academic technique. The artists has a fascination with objects and their surface textures and emphasizes light and how it falls on the subject, working directly from life to achieve a three-dimensional illusion with bold accuracy in drawing.

HUMPHREY, NENE (Sculptor)
325 West 37th St., New York, NY 10018

Born: 1947 *Awards:* Grant, National Endowment for the Arts; Fellowship, MacDowell Colony *Collections:* St. Mary's College, Notre Dame; Morris Museum *Exhibitions:* Alternative Museum, NYC; University of Wisconsin, Priebe Gallery *Education:* York University *Dealer:* Touchstone Gallery, NYC

She is an environmental sculptor creating both indoor and outdoor works. Her pieces, constructed from an assemblage of diverse materials, make references to both nature and autobiography. In a recent gallery installation, miniature mountains constructed from wax-covered mesh dot the floor and walls, while cotton-clad clouds balance on spindly legs, and a "road" made from dressmaker's paper cuts across the room. The idiosyncratic character of her pieces, the changes in materials, texture, and scale imply personal narratives. Her outdoor pieces are concerned with "enclosure." In these works, pyramid or mountain forms surround and "protect" selected elements of nature from others.

HUNT, RICHARD HOWARD (Sculptor)
1017 W. Lill Ave., Chicago IL 60614

Born: 1935 *Collections:* Museum of Modern Art; Metropolitan Museum of Art *Exhibitions:* Museum of Modern Art; Art Institute of Chicago *Education:* School of the Art Institute of Chicago *Dealer:* B.C. Holland Gallery, Chicago

Although his medium was welded sculpture during study in Chicago, he also made lithographs. By 1960 he included found objects and car parts and assembled them into plant-like and insect-like pieces with textured linear extensions. In the late 1960s he constructed "hybrid figures," combining open and closed forms. He cast sculpture in aluminum in addition to the welded

Cathy Hull, *Starring,* 10 x 4, deep pencil.

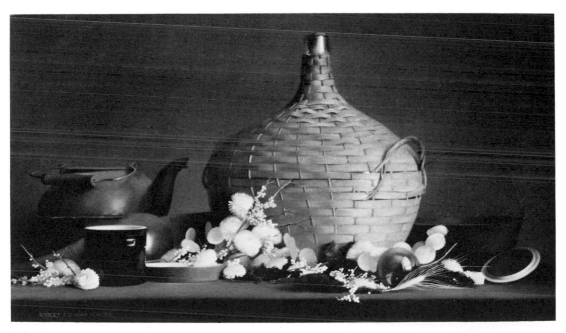

Robert Douglas Hunter, *The Demi-John,* 24 x 40, oil. Courtesy: Guild of Boston Artists (Boston MA)

pieces. Since the 1970s flourishes have been added to the constructions, so that they simultaneously magnify and are magnified by space.

HUNTER, ROBERT DOUGLAS (Painter)
250 Beacon St., Boston, MA 02116

Born: 1928 *Awards:* 14 Richard Mitton Gold Medals, Annual Show of New England Artists; Award, Grand National Exhibition, American Artists Professional League *Collections:* Northeastern University; Massachusetts Institute of Technology *Exhibitions:* New England Artists Exhibition; American Artists Professional League Show *Education:* Cape Cod School of Art *Dealer:* Grand Central Art Gallery, NYC; Blair Gallery, Santa Fe

Careful studies of landscapes, still lifes, and portraiture have occupied his work in oil painting. His early years were given to an intense study of drawing and painting and the close, honest observation of nature and objects. His current painting is the distillation of these observations. Varied compositions of his own invention are rendered with a subdued palette and even brushstrokes. In the still life arrangements of platters, jugs, baskets, fruit, bowls, and other items of rural domesticity, there is simple, spare beauty and a confident serenity.

HURD, PETER (Painter)
Sentinel Ranch, San Patricio NM 88348

Born: 1904 *Awards:* Pennsylvania Academy of the Fine Arts Medal; Isaac Maynard Prize, National Academy of Design *Collections:* Metropolitan Museum of Art; National Gallery, Edinburgh, Scotland *Exhibitions:* Amon Carter Museum of Art; California Palace of the Legion of Honor *Education:* Pennsylvania Academy of the Fine Arts *Dealer:* Wadle Galleries, Santa Fe; Carlin Galleries, Fort Worth

A painter of the Southwest, he studied with N.C. Wyeth in the 1920s. In 1929 experiments with oil wash and tempera on gesso-prepared panels brought him to his medium of egg tempera. These paintings, and the watercolors and lithographs depict the vastness and dryness of the Southwestern landscape. In the 1930s several federally funded projects included a mural for the Dallas post office. A fresco series was completed at Texas Technical University in 1950. His body of work is not a nostalgic look at the Old West but a recording of scenes from modern Southwestern rural life.

IMPIGLIA, GIANCARLO (Painter)
182 Grand St., New York, NY 10013

Born: 1940 *Collections:* Museum of the City of New York; Museo Italo-Americano *Exhibitions:* Alex Rosenberg Gallery; Goldman-Kraft Gallery *Education:* Accademia di Belle Arti, Rome; Liceo Artistico, Rome *Dealer:* Alex Rosenberg Gallery, NYC

He has worked in a variety of media, including assemblages, acrylics and oils on canvas, cut-out wood sculptures, and silkscreens. His education and training in Rome gave him a classical foundation, from which he has developed his own, highly personal imagery. His early pieces consisted of assemblages of clothes, canvas, and uniforms upon which the artist painted his images. The work was based on the conviction that clothes are costumes that reflect cultural values. In his current work, he still is questioning artistic and societal values. In these figurative works, the figures are faceless, suggesting the anonymity of urban life. There is a pronounced sense of isolation in his depictions of sumptuous interiors, where people supposedly gather to interact. Costume and posture are epitomized to the exclusion of content, communication, and emotion. These witty and humorous works satirically comment on the human condition.

INDIANA, ROBERT (Painter, Sculptor)
c/o Star of Hope, Vinalhaven ME 04863

Born: 1928 *Collections:* Museum of Modern Art; Whitney Museum of American Art *Exhibitions:* Museum of Modern Art; Art Institute of Chicago *Education:* John Herron School of Art; Munson-Williams-Proctor Institute; School of the Art Institute of Chicago *Dealer:* Marian Goodman Gallery, NYC

Early work featured a ginkgo leaf motif and bold lettering. Hard-edged geometric shapes and stencilled slogans in bright billboard colors characterized work of the 1950s. The circle was applied frequently in the paintings and constructions, often with words arranged in concentric circles. The first solo show came in 1962 with the debut of Pop. Two years later he made the film *EAT* in collaboration with Andy Warhol, and during the next several years he created the work for which he is best known: large-scale paintings and sculptures of *LOVE*. He also combined letters with numbers. A hanging over fifty feet long which vertically displayed ten *Cardinal Numbers* at Montreal's "Expo '67," and *The Demuth American Dream No. 5* were both strongly influenced by Charles Demuth's 1928 work, *I Saw the Figure Five in Gold*. He continues an interest in American popular culture, including the historical and the literary manifestations of the American Dream. An uninvolved style precludes any direct social commentary.

INGHAM, THOMAS (Painter, Illustrator)
9830 Overlook Dr. NW, Olympia, WA 98502

Born: 1942 *Awards:* Gold medal, Society of Illustrators *Collections:* Ball State University; University of Puget Sound *Exhibitions:* American Institute of Graphic Arts; Society of Illustrators *Education:* Self-taught

Symbolic representation and self-expression were the keystones of earlier work. The image of great, enormous fat people, instead of the heroic figures of the renaissance, became associated with the mind and aspirations of modern man. Drawings and oil paintings depicted man as the perfect destructive force. Recent years have witnessed a change in the artist's attitude from attacking the negative to accentuating the positive. Still-lifes of natural objects—flowers, leaves, barnacles, and bugs—now play a greater role in his work. Mythological references have become the vehicle for symbolic representation and self-expression. In current work the fantastic imagery of Northwest Coast American Indian art and myths are combined with still-lifes and nature studies.

INGLE, JOHN STUART (Painter)
c/o Tatistcheff, 50 W. 57th St., Eighth Floor, New York NY 10019

Born: 1933 *Collections:* Metropolitan Museum of Art; St. Louis Art Museum *Exhibitions:* Pennsylvania Academy of the Fine Arts; University of Virginia Art Museum *Education:* University of Arizona *Dealer:* Tatistcheff Gallery, NYC

Formal still lifes in watercolor are painted in a realistic style from arrangements made of fruit, crystal-ware and flowers. The objects are chosen with great care and their placement and background are chosen because of a series of mathematical relationships. Many photographs are taken of the still life in black-and-white,

Giancarlo Impiglia, *Urbanscape*, 60 x 46, acrylic on canvas. Courtesy: Alex Rosenberg Gallery (New York NY)

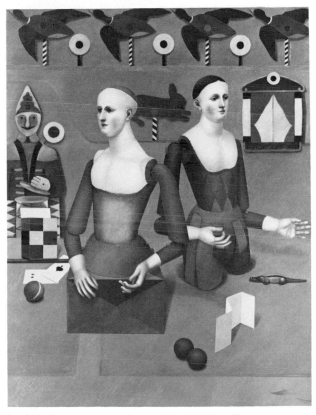

Lani Irwin, *Carnival I* (1983), 48 x 36, oil on linen.

color transparencies and color prints, all in various exposures so that many aspects of the subject can be documented as models for the final painting. Miniature studies are made before the final watercolors are executed on very large sheets of paper. While he is "building a well-coordinated spatial event . . . with movement suggested by the flow of occupied and unoccupied space" he is also concerned with the spiritual aspects of reality. The "still life is, for me, metaphysical, and my still lifes are about my relationships with the physical world."

INUKAI, KYOHEI (Painter, Printmaker)
884 West End Ave., New York, NY 10025

Born: 1913 *Collections:* Albright-Knox Art Gallery, Rose Art Museum, Waltham, MA *Exhibitions:* Carnegie Institute, Brooklyn Museum, Corcoran Biennial *Education:* School of the Art Institute of Chicago; Art Students League

Primarily a painter, he is also a printmaker and sculptor. His sculpture of large curving prism shapes have been installed at sites in Chicago, Knoxville, Tenn., and Eatontown, N.J. His early paintings were in a romantic expressionistic style. He developed through phases of constructivism and hard-edged abstraction to finally return to expressionism. The recent paintings of landscapes and figures are bold and vigorous, employing his characteristic palette of rich and sonorous colors. These works have the aura of stained glass and patterns. Both his past and present works have a direct relationship to architectural settings.

IPSEN, KENT FORREST (Glass Artist)
11761 Bollingbrook Dr., Richmond VA 23235

Born: 1933 *Awards:* National Endowment for the Arts Grants *Collections:* Art Institute of Chicago; Corning Museum of Glass *Exhibitions:* Corning Museum of Glass; Vatican Museum *Education:* University of Wisconsin *Dealer:* Habatat Galleries, Lathrup Village, MI; Heller Gallery, NYC

After formal education he also studied with Harvey K. Littleton. Known for free-blown glass works, his lyrical presentations are objects both functional and decorative such as bowls and vases, as well as abstract sculptural pieces. He works from a workshop and kilns next to his home, making pieces of all sizes, shapes and surfaces. These usually untitled pieces are often marbled like colorful stones, in a great variety of colors. He has been teaching the art of glassworking since 1965.

IRELAND, PATRICK (Sculptor)
c/o Charles Cowles Gallery, 420 W. Broadway, New York NY 10012

Born: 1935 *Awards:* Nuffield Grant, Cambridge University; Gold Medal, Eire Society *Collections:* Metropolitan Museum of Art; Museum of Modern Art *Exhibitions:* Los Angeles County Museum of Art; Corcoran Gallery of Art *Dealer:* Charles Cowles Gallery, NYC

Born Brian O'Doherty in Ireland, he now lives in America and uses a pseudonym. Early work featured reflections and labyrinths which created the illusion of infinite interior spaces. Later "rope drawings" employed the two-dimensional element of line in three-dimensional installations which transformed space as the observer moved. In 1976 large planes of color were added to the networks of lines, modifying corners and walls. A recent installation for example, *String Quartet*, featured twine spanning a grey room, crisscrossing

it at different angles, while also invisibly attaching large planes of subdued colors to the room's corners so that they appeared to float there. Three-dimensional space was flattened as the hanging quadrilaterals seemed to collapse into the corners, and as the observer moved, so did the string designs on the planes.

IRWIN, LANI HELENA (Painter)
Route 1, Box 344, Hughesville, MD

Born: 1947 *Collections:* Bayly Museum; Watkins College *Exhibitions:* Gallery K, Washington, DC; Graham Gallery, New York City *Education:* American University

Early oil paintings were still life compositions of such disparate objects as antique mannequins, animal bones, balls, boxes, and reproductions of the paintings of the masters. Complex spatial relationships were created with objects rendered in meticulous detail. In later paintings the compositions evolved into less formal arrangements of elements. Her most recent works include representations of human figures painted from life to join or replace the mannequins that appear in the earlier canvases. The elements of the still life arrangements are personal and decidedly modern, while exhibiting the influence of Italian art.

IRWIN, ROBERT (Installation Artist, Sculptor)
10966 Strathmore Dr., Los Angeles CA 90024

Born: 1928 *Collections:* Museum of Modern Art; Whitney Museum of American Art *Exhibitions:* Museum of Modern Art; Whitney Museum of American Art *Education:* Otis Art Institute; Jepson Art Institute; Chouinard Art Institute *Dealer:* Pace Gallery, NYC

An Abstract Expressionist painter during the 1950s, he later abandoned personal expression and became a Minimalist by 1960. He questioned the meaning of image and object in a series of dot paintings, followed by a series of spray-painted discs. In 1968 aluminum convex discs protruded from the wall and were illuminated by floodlights, creating interior and exterior shapes in a composition of shapes and shadows. Installations during the 1970s explored varying arrangements of interior light and space, as in *Portal*. Recent work includes site/architectural sculpture in public spaces. A conceptual approach to art incorporates inquiries in philosophy, natural science and social science.

ITO, MIYOKO (Painter)
c/o Phyllis Kind Gallery, 313 W. Superior St., Chicago IL 60610

Born: 1918 *Awards:* Whitney Fellowship; MacDowell Fellowships *Collections:* Art Institute of Chicago; Smithsonian Institution *Exhibitions:* Phyllis Kind Gallery, Chicago; Museum of Contemporary Art, Chicago *Education:* School of the Art Institute of Chicago *Dealer:* Phyllis Kind Gallery, NYC and Chicago

Early watercolors were influenced by training in the Bay Area. In the late 1940s her medium became primarily oil as she executed cubist still lifes in a subdued palette. Organic and tubular forms, as well as abstracted landscapes of California and Chicago characterized work of the following decade. In 1962 *Step by Step* introduced bright red tones to her palette as the work became more abstract. Six years later the colors quieted again to earth tones and subdued primaries, while biomorphic elements suggestive of surrealism were placed in illusionistic space. In the 1970s the forms in the foreground were geometrized and flattened, and in recent years they have become more

hard-edged and are often situated in architectural settings. Currently a Chicago artist, her evocative metaphorical imagery has been called "Maximalist," but she calls herself, along with Frank Piatek, William Conger, and Richard Loving a member of the "Allusive Abstractionists."

JACKSON, HARRY ANDREW (Painter, Sculptor)
P.O. Box 2836, Cody WY 82414

Born: 1924 *Awards:* Silver Medal, National Cowboy Hall of Fame; Samuel Finley Breese Morse Gold Medal, National Academy of Design *Collections:* Whitney Gallery of Western Art, Cody (WY); Vatican Museum *Exhibitions:* National Academy of Design; National Cowboy Hall of Fame *Education:* School of the Art Institute of Chicago; Brooklyn Museum of Art School *Dealer:* Smith Gallery, NYC; Robertson Gallery, Riverside, CA

After leaving his native Chicago as a teenager, from 1938 to 1942 he studied with Ed Grigware in Cody, Wyoming and several years later with Hans Hoffman. After serving in World War II, a life-long interest in horses developed into his work in sculpture, carefully documenting horses and riders of the American West. He experimented with an expressionistic mode and eventually adopted the lost wax process to cast small realistic bronze sculptures of the horses and riders. He has a foundry and studio in Italy, but returns often to Wyoming.

JACKSON, HERB (Painter)
Box 2495, Davidson, NC 28036

Born: 1945 *Awards:* Southeastern Fellowship, National Endowment for the Arts *Collections:* Boston Museum of Fine Arts; Mint Museum of Art *Exhibitions:* National Academy of Sciences, Washington, DC; Edmonton Art Gallery, Edmonton, Canada *Dealer:* Phyllis Weil Gallery, NYC

For him, painting is an act of meditation. He considers his work to be a part of nature, rather than a statement about nature. He builds up paint in many coats, alternating between transparent and opaque layers. His process of application becomes a kind of archaeology. The process of viewing also is related to archaeology as the viewer decodes the information of the painting. As the painting develops, signs, symbols, and marks appear and disappear. Some remain to participate in the surface of the finished work, but their relationships are not immediately discernible.

JACKSON, PRESTON (Sculptor)
c/o Gilman Gallery, 277 E. Ontario St., Chicago IL 60611

Born: 1944 *Collections:* Purdue University; University of Illinois at Champaign-Urbana *Exhibitions:* Springfield State Museum; Purdue University *Education:* Milikin University; University of Illinois *Dealer:* Gilman Gallery, Chicago

Representational sculpture in bronze and other metals display a strong interest in the figure and manifestations of the duality between passivity and aggression. Works in resin are mixed with steel and other ingredients to give a cold yet beautiful appearance to the figures. The combination of warm plastic and cold steel further combines the ever changing dualities present in his work. Female figures are not seen as cheap sexual images, but, the artist says, "as strong and powerful shapes of beauty". Their strength lies inward, their stances signifying both protection and love.

JACOBS, JIM (Painter)
26 W. 20th St., New York, NY 10011

Born: 1945 *Awards:* Creative Artists Public Service Fellowship Recipient *Collections:* Chase Manhattan Bank; Rose Art Museum *Exhibitions:* National Gallery, Smithsonian Institution; South Miami Dade Community College *Education:* Boston University; Harvard University

Early lacquer paintings, in monochromes, gave way to color field paintings that explored the limits of color delineation. A series of "folded paintings" followed that further explored the idea of color delineation and line. In more recent work, the natural landscape has made a strong impact upon the artist. Several paintings that relate to the Grand Canyon, where the artist has spent the last several summers, employ folded surfaces and large color fields to convey the feeling of a river winding its way around a bend. A new interest in the textural differences in the surfaces has lead to a juxtaposition of smooth lacquer with rough grouted surfaces that are then drawn upon with sculptural tools.

JAEGER, BRENDA KAY (Painter, Papermaker)
P.O. Box 2152, Longview, WA 98632

Born: 1950 *Awards:* First place, All Alaska Annual Watercolor Exhibition *Collections:* Dean Witter Reynolds; Alyeska Pipeline Service Co. *Exhibitions:* Anchorage Historical and Fine Arts Museum; International Hand Papermakers Conference *Education:* Eastern Washington University, Whitworth College *Dealer:* Antique, Ltd., Anchorage; Gallery West, Portland

Work is in both watercolor and oil paintings and plant and rag papermaking. Her representational watercolors are characterized by free movement and color, overlapping washes, and the incorporation of calligraphy into the composition. Additional work is in large oil paintings and ink drawings. The artist has studied nagashizuki papermaking in Japan and now works in a traditional Japanese papermaking studio. She also uses techniques of momigami and collage combined with her watercolors to produce landscape and figurative works of great imagination and power. She currently divides her time between Washington and Alaska.

JAFFEE, FERN (Sculptor)
1040 Sheridan Road, Glencoe, IL 60022

Born: 1924 *Awards:* Purchase Award, MacDonalds Corporation *Collections:* Carol Block, Ltd.; MacDonalds Corporation Collection *Exhibitions:* Arbitrage Gallery, NYC; Co-op Gallery, Evanston, IL *Education:* School of the Art Institute of Chicago *Dealer:* Art Institute of Chicago Sales and Rental Gallery

Earliest sculpture was carved directly in both stone and clay creating representational and yet abstracted forms. The major portion of her work is the rendition of the female figure. Her women are aloof, enigmatic, and overtly fertile forms, exhibiting a greater kinship to the mysteries of the Venus of Willendorf figure than to a Renaissance ideal. In later sculpture using the fiberglass medium, color and even dime store bric-a-brac were embedded directly into the surfaces. Most recent fiberglass figures are worked with smooth surfaces to emphasize the planes, the curves, and the angles. The pieces are both free-standing forms and three-dimensional wall-pieces.

JAMES, BILL (Illustrator)
15840 SW 79 Ct., Miami, FL 33157

Born: 1943 *Awards:* M. Grumbacher Award; Members

Award *Exhibitions:* Pastel Society of America; American Watercolor Society *Education:* Syracuse University *Dealer:* Palm Beach Art Galleries, Palm Beach, FL

As an illustrator in pastel, pencil, conte crayon, watercolor, and brush and ink he has worked for numerous advertising agencies in the Miami area. His style is loose and fluid but always firmly based in representational imagery. Portraits and figurative scenes from everyday life are common subject matter. Fine art work is almost exclusively in pastel, and he cites Edgar Degas and Mary Cassatt as influences in this medium. He works from photographs of subjects only as a reference, highlighting color and simplifying the design of the composition as the subject matter dictates.

JENKINS, PAUL (Painter)
831 Broadway, New York NY 10003

Born: 1923 *Awards:* Officier des Arts et Lettres Award, France; Commandeur Arts et Lettres, France *Collections:* Museum of Modern Art; Whitney Museum of American Art *Exhibitions:* Art Institute of Chicago; Whitney Museum of American Art *Education:* Kansas City Art Institute; Art Students League *Dealer:* Gimpel and Weitzenhoffer Gallery, NYC; Karl Flinker Gallery, Paris

Work of the late 1940s and early 1950s was influenced by Yasuo Kuniyoshi. However, in 1955, he destroyed all previous work and began anew, determined not to be swayed by the Abstract Expressionists; he wanted to portray a spiritual, rather than a kinetic abstraction. An interest in mysticism and in Symbolist painters such as Gustav Moreau and Odilon Redon brought him to the understanding, as he states it: "I paint what God is to me." Acrylics, oils and other synthetic paints were poured onto the canvas in different thicknesses, laced with thin linear spills. During the 1960s work became increasingly rich in texture, affected by mood and time. Recent large canvases are moved in order to guide the flow of the pigments, leaving the paths of their ebb and flow, as in *Phenomena Track the Wind.* The addition of vivid watercolors has brought a spectrum-like quality to his work.

JENSEN, CLAY (Sculptor)
951-62nd St. #F, Oakland, CA 94618

Born: 1952 *Awards:* SECA Award, San Francisco Museum of Modern Art; Eisner Award, University of California, Berkeley *Collections:* Federal Reserve Bank, San Francisco *Exhibitions:* San Francisco Museum of Modern Art; Oakland Museum *Education:* University of Utah; University of California, Berkeley *Dealer:* Fuller Golden Gallery, San Francisco; Morgan Gallery, Kansas City, MO

Born in Salt Lake City, he expressed his appreciation of the open spaces of the West in his early sculpture. These works primarily used natural materials, such as wood. When he moved to Oakland in 1977 he was struck by the contrast between the natural and the urban environments, and his sculpture reflected this awareness. He juxtaposed bronze casts of tree limbs with I-beams, using dark metals. The more recent work uses cut and welded steel plates and beams to suggest the abstract patterns of freeways, alleys, and warehouses. He combines sculptural and painterly concerns in these works. He applies oil paints to the sculpture, and also marks the works with graffiti and mechanically embossed patterns.

JILG, MICHAEL FLORIAN (Painter)
317 W. 20th, Hays, KS 67601

Born: 1947 *Awards:* Joslyn Art Museum, Omaha; Junior League of Omaha *Collections:* Wichita (KS) Art Museum; Kansas Arts Commission *Exhibitions:* Springfield (MO) Art Museum; St. Louis Art Museum *Education:* Wichita State University; Studio Camnitzer, Valdottavo, Italy; Kent State University; Kansas State University *Dealer:* Reuben Saunders, Wichita, KS

His early work demonstrated a willingness to experiment. He used spray guns, drips, splatters, and wrinkles, combined with traditional brush painting methods, to develop a large technical vocabulary and a strong sense of composition. Drawings of this same period reveal more expression than was evident in the paintings' controlled textural compositions. Since 1972, he has painted in isolation, uniting his technical vocabulary with the personal reality expressed in his drawings. His recent works employ recognizable 20th century icons as reference points.

JOHANSON, PATRICIA (Sculptor)
RFD 1, Buskirk, NY 12028

Born: 1940 *Awards:* Fellowship, John Simon Guggenheim Memorial Foundation; Fellowship, National Endowment for the Arts *Collections:* Museum of Modern Art; Metropolitan Museum of Art *Exhibitions:* Dallas Museum of Art; Philippe Bonnafont Gallery, San Francisco *Education:* Brooklyn Museum Art School; Art Students League; Bennington College *Dealer:* Rosa Esman Gallery, NYC

Her art incorporates sculpture, architecture, and painting into such environmental works as gardens, pools, parks, and dwellings. These structures, built in the setting of nature, are inspired in their form by other natural orders. The designs are based primarily on plants and insects and are executed in such large scale as to become abstracted. Her works are most often unobtrusive when set in the environment—physically allied with the forms and functions of nature. Occasionally bright, garish colors—shocking as the colors of insects themselves—are used in such works as the *Butterfly Parks and Gardens,* Her work strives to bring art, man, and nature into an aesthetic/ecological whole.

JOHNS, JASPER (Painter)
225 E. Houston St., New York NY 10002

Born: 1930 *Collections:* Museum of Modern Art; Whitney Museum of American Art *Exhibitions:* Museum of Modern Art; Art Institute of Chicago *Education:* University of South Carolina *Dealer:* Leo Castelli Gallery, NYC

He reacted against Abstract Expressionism with a first solo show in 1958 which included paintings of targets, flags, numerals and alphabets. Everyday objects were the subjects, focusing attention not on the objects themselves but on the act of painting. An encaustic painting method turned ordinary images into thought-provoking works which pointed to the ambiguity between object and image. A constant questioning of the nature of art brought him to the utilization of actual common objects. Cast in bronze were the likenesses of beer cans, flashlights, and light bulbs and real objects were affixed directly to the paintings as well. Known for visual puns and contradictions, he has logically been compared to Marcel Duchamp. Unlike Duchamp, he has not renounced painting, but has continued to question the ways of seeing, maintaining the unique ambivalence of his creations.

JOHNSON, D'ELAINE (Painter)
16122 72nd Ave. W., Edmonds, WA 98020

Patricia Johanson, *Flower Fountain*, 50 x 32 x 7, stoneware & fiberglass.

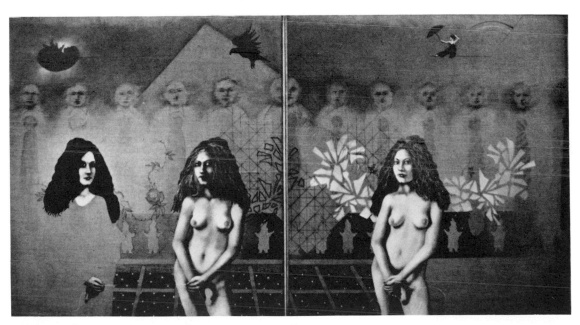

Michael Florian Jilg, *Judy and the Elders*, 48 x 104, acrylic.

Born: 1932 *Collections:* Nova Scotia Art Museum; Vancouver Maritime Museum *Exhibitions:* Seattle Art Museum; Edmonds Art Museum *Education:* University of Washington; Central Washington University

Her paintings are inspired by the sea cultures of the past, placed in a current context. Through the use of universal imagery, the works portray a collective sea history and heritage. The inner spirits of the sea, as mythological currents, are her point of departure. The paintings can be described as a "visual mosaic," enlivened through historic documentation. Her seascapes depict the tides, the sea-bed, shores, currents, headlands, reefs, islands, and storms.

JOHNSON, DOUGLAS WALTER (Painter)
General Delivery, Coyote, NM 87012

Born: 1946 *Awards:* 2nd Prize, New Mexico Biennial Exhibition; Cash Award, New Mexico Watercolor Society *Collections:* Museum of New Mexico; American National Insurance Co. *Exhibitions:* Colorado Springs Fine Arts Center; Elaine Horwitch Gallery, Santa Fe, NM *Dealer:* Elaine Horwitch Galleries, Santa Fe, NM; Scottsdale, AZ

His meticulously executed miniature casein paintings are done in rich colors, in an ultra-realistic style bordering on surrealism. His style is directly influenced by Southwestern American Indian art. The paintings and lithographs utilize the design motifs of ancient Pueblo cultures. He also creates constructions in painted matboard, decorated with turquoise and feathers, making fetishes similar to Hopi prayer wands. He recently traveled throughout Mexico and Peru, and his current work is influenced by pre-Columbian art. Many new works depict scenes from Oaxaca and Cuzco.

JOHNSON, JOYCE (Sculptor)
Box 201, Truro, MA 02666

Born: 1929 *Collections:* Cushing Academy; Cape Cod Conservatory of Music and Art *Exhibitions:* "Art In Transition", Boston Museum of Fine Arts; Tanzer Gallery, NYC *Education:* The Boston Museum School of Fine Arts; Escuela de Artes, Madrid *Dealer:* Original Print Gallery, Orleans, MA; Schoolhouse Gallery, Truro, MA

Principally a woodcarver in the traditional sense of mallet and chisel techniques, she was strongly influenced by her years living in Spain. Her early series was dominated by *Figures in Hat and Cape with Birds,* sculpture with a strong mystical sense and totemic imagery. Her later works include abstractions from plant life, culminating in a series of twelve foot totems portraying growth and bud formations. Recently, she has also returned to the figure, making studies from life and developing them into sculpture. The theme of cloaked figures with hats and birds continues to hold a fascination for her with mystical overtones of uncertain origin.

JOHNSON, LESTER L. (Painter)
c/o Center for Creative Studies / College of Art and Design, 245 E. Kirby St., Detroit MI 48202

Born: 1937 *Awards:* John S. Newberry Purchase Prize, 54th Exhibition of Michigan Artists, Detroit Institute of Arts; Gallery Purchase Award, Harlem Gallery Square *Collections:* Detroit Institute of Arts; Osaka University of Arts, Japan *Exhibitions:* Whitney Museum of American Art; Cranbrook Academy of Art Museum *Education:* Wayne St. University; University of Michigan *Dealer:* Donald Morris Gallery, Birmingham, MI; London Arts, Detroit; Gimpel and Weitzenhoffer Gallery, New York, NY

Work in 1951 was characterized by geometric abstractions in an expressionist style. In the next few years the abstractions were replaced by geometric human figures, expressively portrayed with free and thick applications of a limited number of pigments. In 1956 he had become, in his own words, an "action painter" but with "content." He said, "My painting doesn't start or stop. . . . It just moves across—like time." Canvases convey the evidence of the painting process, with layer upon layer of applications which finally result in figures symbolizing the human condition. Recently his palette has expanded to produce more colorful compositions.

JOHNSTON, BARRY (Sculptor)
1622 Que St., NW, Washington, DC 20009

Born: 1941 *Awards:* Stewardson Award, Pennsylvania Academy of Fine Arts; Second Prize for Figurative Sculpture, Georgia Marble Festival *Collections:* Vatican Museum; Martin Luther King Library *Exhibitions:* Martin Luther King Library; The National Sculpture Society Annual Exhibition *Education:* Pennsylvania Academy of Fine Arts; National Academy of Fine Arts

Whether in bronze or marble there is a startling energy and lightness about his figurative sculpture. His early influences came from Michaelangelo and Rodin as well as Art Nouveau whose fluid linearity is reflected in his organic and flowing compositions of interlocking forms. He often takes themes from biblical and mythological references which offer a fertile field for symbolism, expression and personal interpretation. Current work focuses on larger-scale figure groupings and fountain designs for architectural spaces, gardens, and parks. Representational works combine human forms with organic ones in compositions strongly based on classic Greek sculpture.

JOHNSTON, THOMAS ALIX (Printmaker, Painter)
1514 Bellevue Ave. #711, Seattle, WA 98122

Born: 1941 *Awards:* Purchase Award, West New Mexico University; Purchase Award, University of Texas at El Paso *Collections:* Seattle Art Museum; Portland Art Museum *Exhibitions:* Whatcom Museum; Library of Congress *Education:* University of California at Santa Barbara; Atelier 17, Paris

He is known primarily for his intaglio prints although he works in drawing, painting, painted constructions, and photography as well. His early work emphasized subtle coloration in figurative and constructivist compositions yet revealed an underlying geometric organization. His current work combines bold gestural marks, expressive lines, and complex textures in non-objective compositions. Color, line, form, and texture seem to interact spontaneously. A foundation of order remains suggesting an organic geometry.

JOHNSTON, YNES (Painter, Printmaker)
579 Crane Blvd., Los Angeles, CA 90065

Born: 1920 *Awards:* Grant, National Endowment for the Arts; Grant, Guggenheim Memorial Foundation Fellowship *Collections:* Museum of Modern Art; Metropolitan Museum of Art *Exhibitions:* San Francisco Museum of Art; Mitsukoshi, Tokyo *Education:* University of California, Berkeley *Dealer:* Mekler Gallery, Los Angeles

Influenced by her travels in Mexico and Europe, her watercolors, oils, and etchings of the 1950s and 1960s were rich with complex imagery, and displayed a disciplined and somewhat restrained use of color. In re-

Kwan Yee Jung, *Panda in a Tree,* 8 x 12, watercolor.

Barry W. Johnston, *Wedlock* (1980), 19½' H,
bronze. Courtesy: Lafayette Centre (Washington DC)

Mary Frances Judge, *Pandora* (1982), 50 x 72, mixed
media on linen. Courtesy: Dolly Fiterman Gallery
(Minneapolis MN)

cent mixed-media pieces she examines the tactile qualities of the surface. The paintings involve the combination and occasional lamination of diverse materials— oil, acrylic, dyes, encaustic on cloth, canvas, and raw silk. The colors are vibrant and the images are composite forms suggesting ambiguous architectural, human, animal, and plant shapes. She sites Persian and Indian art as influences along with such artists as Matisse, Miro, Klee, and Picasso.

JOLLEY, DONAL CLARK (Painter)
26375 Apache Trail, Rimforest, CA 92378

Born: 1933 *Awards:* Award, National Watercolor Society *Collections:* Church of the Latter Day Saints; Smithsonian Institution *Exhibitions:* University of Nevada; San Bernadino County Museum *Education:* Brigham Young University *Dealer:* Esther Wells Collection Gallery, Calabasas, CA

Drawing on his environmental experience and memories growing up in Zion National Park in southern Utah, his colorful watercolor and acrylic paintings executed in a semi-representational to traditional rendering of realistic subject matter are primarily landscapes of the Southwest and still life on American Western themes. Works in human and animal portraiture, landscapes, and still life of Old Western memorabilia are predominantly medium scale paintings. His impressions are abstracted elements so much a part of the isolation of the Western landscape. His latest honor includes his selection as one of the artists to paint one of the Easter eggs to be displayed at the annual White House Easter display.

JONES, LOUIS MAILOU (Painter)
4706 17th St. NW., Washington, DC 20011

Born: 1905 *Awards:* Robert Woods Bliss Painting Award *Collections:* Boston Museum of Fine Arts; Metropolitan Museum of Art *Exhibitions:* Boston Museum of Fine Arts; Philllips College *Education:* Boston Museum School of Fine Arts; Academie Julian, Paris

While still a student in Paris, she began painting in an impressionistic style. Oil, handled with a palette knife, and watercolor were her principal media. She did many street scenes, still lifes, and figure compositions during her Paris period. Travels to Africa and Haiti brightened her palette. The current works involve hard-edge and mixed-media techniques. Symbolism is evident in many of the paintings, and design and structure are always basic to the work.

JORGENSEN, SANDRA (Painter)
245 Elm Park, Elmhurst, IL 60126

Born: 1934 *Awards:* Eisendrath Prize, Art Institute of Chicago *Collections:* Chicago Public Library; Elmhurst (IL) Art Museum *Exhibitions:* Richard Gray Gallery, Chicago *Education:* Lake Forest College; School of the Art Institute of Chicago *Dealer:* Richard Gray Gallery, Chicago

Her paintings often employ figures grouped in landscape settings. Early work fluctuated between romanticism and expressionism, showing the influence of Edward Hopper in her work. She also made life-sized, full-length, figure drawings in pencil. Further influences included DeChirico, and Mondrian. Her present works are oil paintings and pastel drawings of landscapes, or small figures in generally large landscapes. These works are in high-value contrast, intense color, and are somewhat hard-edged. They are often described as metaphysical or spiritual.

JU, IX HSIUNG (Painter)
Washington and Lee University, Lexington, VA 24450

Born: 1923 *Awards:* Second prize, SouthEast Asia Art Contest; First prize, Philippine Art Association Annual Show *Collections:* Philippine Art Center; National Museum of History, Tapei *Exhibitions:* Philippine and Japan Joint Art Show *Education:* University of Amoy; University of Santo Tomas *Dealer:* E. & J. Frankel, New York, NY

Illustrations and paintings, in ink, watercolor, and acrylic, are executed with Chinese brush and traditional oriental techniques. Subject matter is also traditional and consists of landscapes, seascapes, flowers, and village settings. Illustrations appear in the book, *The Children of Light*, published in 1956, and the more recent works *Book of Bamboo*, *Book of Orchids*, and *A Collection of Recent Landscape Paintings*, all published by the National Museum of History in Taipei.

JUDD, DONALD CLARENCE (Sculptor)
101 Spring St., New York NY 10012

Born: 1928 *Awards:* Fellowship, John Simon Guggenheim Memorial Foundation; U.S. Government. Grants *Collections:* Museum of Modern Art; Whitney Museum of American Art *Exhibitions:* Whitney Museum of American Art; Kunstmuseum Basel, Switzerland *Education:* Art Students League; Columbia University *Dealer:* Leo Castelli Gallery, NYC

A painter in the 1950s, he turned to Minimalist sculpture in 1963. Wood and metal were used to assemble unadorned symmetrical forms without bases, creating a sense of order within each piece. These large sculptures were placed on the floor, not reaching above eye-level, carrying no meaning other than their own unified presence. Opposed to the subjectivism of the Abstract Expressionists, as well as to any figurative illusionism, the goal was spatial unity in three dimensions, namely in solid geometric forms like the cube. Fabricated cubes and boxes made of stainless steel or plexiglass, painted in metallic monochromes and placed in repetitive and symmetrical arrangements are his best known works. The properties of mass, volume, gravity and space are explored in these often untitled presentations.

JUDGE, MARY FRANCES (Painter)
265 E. 162nd St., Bronx, NY 10451

Born: 1935 *Awards:* Bixby Portrait First Award; Strathmore Scholastic Art Award *Collections:* Carnegie Institute; Nobles County Art Center, Worthington, MN *Exhibitions:* Museum of Contemporary Art, Sao Paulo; "Great American Artists Series", Hansen Galleries, NYC *Education:* University of Notre Dame *Dealer:* Dolly Fiterman Gallery, Minneapolis

In her *Great American Artists Series* (1970-1976)—a collection of paintings, sculptures, and works on paper—a view of the world as seen through the eyes of the "mini-society of the art-world" unfolds in a mixed media pop art style. Her more recent big, shimmering paintings are concerned with mystical aspects and psychological allegories. In lyrical bursts of color she portrays the emergence of the soul of women from the unconscious realm of the collective human psyche. What at first appear to be abstract paintings reveal themselves to the viewer as as a variety of figurative imagery and scenes from classical mythology.

JUDSON, JEANETTE ALEXANDER (Painter)
1130 Park Ave., New York, NY 10128

Born: 1912 *Awards:* National Association of Watercolor Artists *Collections:* Brooklyn Museum; Joseph H. Hirshhorn Collection *Exhibitions:* Key Gallery, NYC; New York University *Education:* National Academy of Design; Art Students League *Dealer:* Key Gallery, New York, NY

Her abstract paintings display color harmonies that are both subtle and striking. A joyful lyricism unifies the body of her work with the earlier work primarily geometric abstractions. She is also a collage artist. Her collages are composed of paper, canvas, linen, string, paint, and bits of found objects. The torn edges give the work vibration and movement. It is the odd juxtapositions and combinations of various materials that infuse the works with their power.

JUNG, KWAN YEE (Painter)
5468 Bloch St., San Diego, CA 92122

Born: 1932 *Awards:* American Watercolor Society, National Watercolor Society *Collections:* Springville Museum of Art; Utah State University *Exhibitions:* Edward-Dean Museum, Hong Kong City Hall *Education:* New Asia College, Hong Kong; San Diego State University *Dealer:* A. Huncy Gallery, San Diego

Earlier works are in the style of "Su Ma Qua," which calls for a very direct, spontaneous manner of painting. Using this method, the artist applied clean-cut brush strokes directly to the paper without previous planning or penciled layout. In current paintings there is an essence of landscape. The artist begins by flooding color on paper in what he considers to be pleasing forms. Then, when these shapes come to suggest a recognizable subject, he uses his brush like a pen to draw enough detail to suggest the subject he has in mind. Tiny figures are placed in the environmental scene as "accent spots." His paintings philosophically suggest the role humans play in the environment.

JUSZCZYK, JAMES JOSEPH (Painter)
130 W. 17th St., New York, NY 10011

Born: 1943 *Awards:* grant, Ford Foundation *Collections:* Art Institute of Chicago; Chase Manhattan Bank *Exhibitions:* Gimpel Hanover & Emmerich, Zurich; Galerie Konstructiv Tendens, Stockholm *Education:* Cleveland Institute of Art; University of Pennsylvania *Dealer:* Jan Cicero Gallery, Chicago; Storrer Gallery, Zurich

Since graduation from art school, he has maintained a deep interest in and commitment to the principles of non-objective geometric painting. Among his influences are Mondrian and Rothko. He believes strongly in a meaningful synthesis of the clear and concise nature of geometry, merged with the mysterious and sensuous energy generated by color. His sensitive, controlled canvases, past and present, focus on the richness and depth of color. In his current work he continues to investigate the possibilities of the merger of line and plane, combined with an eloquent system of color, to point toward the essence of a "spiritual geometry."

KACERE, JOHN C. (Painter)
152 Wooster St., New York NY 10012

Born: 1920 *Collections:* Stedelijk Museum, Amsterdam; Yale University School of Art *Exhibitions:* Museum of Modern Art; Art Institute of Chicago *Education:* Mizen Academy of Art; Iowa St. University *Dealer:* O.K. Harris Works of Art, NYC

Known for super-realistic paintings of the female anatomy exclusively from the mid-thigh to the midriff, this Photo-realist was first associated with late Pop. Oil paintings are technically accurate renderings of skin and lace, silk lingerie and transparent undergarments. He can not be called a figurative painter, for his interest lies in the formalism of the composition and in the subtle modulations of color. The women are young, perfectly proportioned beauties without identities, although the paintings are given names such as *Lauren* and *Maude*. His depiction of buttocks, thighs and bellies has been called "mechanical Eros."

KALB, MARTY JOEL (Painter)
165 Griswold St., Delaware, OH 43015

Born: 1941 *Awards:* Grant, Ohio Arts Council *Collections:* J. B. Speed Art Museum, Louisville, KY; University of Massachusetts *Exhibitions:* Canton (OH) Art Institute; Allan Stone Gallery, NYC *Education:* Yale University; University of California, Berkeley *Dealer:* Allan Stone Gallery, NYC

His paintings confront the viewer with energetic paint handling and decisive composition. He uses abstract imagery, but the paintings consistently evoke a naturalistic presence. The early work included an exploration into various ways of using the figure in both expressionistic and geometric settings. Over the last decade, he has concentrated on developing a visual dialogue between pure abstraction and a formalist analysis of the basic elements in his paintings. The techniques used include richly impastoed surfaces, airy stained passages, geometric linear elements, and aggressively applied brushwork.

KANOVITZ, HOWARD (Painter)
237 E. Eighteenth St., New York NY 10003

Born: 1929 *Awards:* Berlin Deutscher Akademischer Austauschdienst Fellowship *Collections:* Whitney Museum of American Art; Hirshhorn Museum & Sculpture Garden *Exhibitions:* Whitney Museum of American Art; Documenta 6, Kassel, Germany *Education:* Providence College; Rhode Island School of Design; Institute of Fine Arts, New York University *Dealer:* Alex Rosenberg Gallery/Transworld Art, NYC

After studying privately with Franz Kline in 1951 and 1952 he was an Abstract Expressionist painter, but in 1963 he turned to the figure and began painting ironic depictions of American urban dwellers in a new Photorealistic style. Works of the late 1970s were experiments with illusionistic space and trompe l'oeil using photographic images, as in *Projected Man* and *Grosses Kleinbild*. The themes of his works are the artistic process and self-reflection. Realistic pastels and paintings are among the most recent work.

KARWELIS, DONALD CHARLES (Painter)
202-K East Stevens, Santa Ana, CA 92707

Born: 1934 *Awards:* Grant, National Endowment for the Arts; Grant, National Defense Education Act, U.S. Government *Collections:* Los Angeles County Museum; Long Beach Museum of Art *Exhibitions:* Kirk de Gooyer Gallery, Los Angeles; Sidney Janis Gallery, NYC *Education:* University of California, Irvine *Dealer:* Kirk de Gooyer Gallery, Los Angeles

He is known for paintings and collages which exhibit bold, colorful images emphasized by heavily textured surfaces. A more lyrical approach to abstraction in his early acrylic on paper works, developed from an interest in Ancient Japanese art. His current work includes large scale acrylic on canvas paintings, mixed-media collage on paper, and lithographs. Dramatic color,

striking contrasts of value, invented textures, as well as provocative forms and content continue to be distinctive characteristics of his style.

KARWOSKI, RICHARD CHARLES (Painter, Sculptor)
28 E. Fourth St., New York NY 10003

Born: 1938 *Awards:* Second Prize, Watercolor, Lubow Publishing; Purchase Prize, Prints USA *Collections:* Newark Museum; Guild Hall Museum *Exhibitions:* American Crafts Museum; Heckscher Museum *Education:* Pratt Institute; Columbia Teacher's College *Dealer:* Gallery East, East Hampton, NY

Early paintings, sculptures, drawings and prints described the "painful preoccupation with the anxiety of human relations." In 1972 he began to use shoes in a variety of ways as symbols of "the footprints, horrible or amusing, that humanity seems to leave everywhere." The depictions of shoes multiplied; they huddled in large, shadowy heaps across expansive canvases. Eventually only the footprints were shown, formed into flower-like patterns of concentric circles. From the patterns of shoes came his most recent paintings, such as *Peppers No.3* and depictions of enormous blossoming flowers. "The calm beauty at their center becomes the theme" of related landscapes and still lifes.

KASSOY, BERNARD (Painter)
130 Gale Pl., Bronx, NY 10463

Born: 1914 *Awards:* Pastel Society of America; Art Directors Club *Collections:* Butler Institute of American Art, Youngstown, OH; Slater Memorial Museum, Norwich, CT *Exhibitions:* Mid-Hudson Art and Science Center, Poughkeepsie, NY; National Academy of Design *Education:* Cooper Union Art School; Columbia University; Brooklyn Museum School *Dealer:* Ward-Nasse Gallery, NYC

His paintings, prints, and sculptures are primarily expressionist, with strong roots in the traditions of Western art. He has worked in diverse media, including stage design, illustration, and photography. His work in painting is figurative, with strong color and rhythmic structure. Often his work has social content, as in the anti-war series of the Viet Nam period, and in the current *Holocaust* series. Recently he turned to completely abstract color drawings which carry the evocative lyricism which runs through his work. He plans to return to figurative work in the near future.

KASSOY, HORTENSE (Sculptor)
130 Gale Pl., Bronx, NY 10463

Born: 1917 *Awards:* Erlanger Award in Sculpture; Rizzoli Award *Collections:* Slater Memorial Museum *Exhibitions:* "Sculpture Today", Toledo Museum of Art; "28 Contemporaries", Bronx Museum Inaugural *Education:* Pratt Institute; Columbia University

Her sculptures, in a variety of traditional media including wood, stone, and clay, range in size from small table pieces to free standing sculptures. Treatment of the materials remains lyrical—subject matter is almost always derived from the figure with elements of abstraction. The artist cites Flanagan, Rodin, and Brancussi as major influences on her work. Recent work has also involved fabric and batik. Flowers, faces, and figures dominate her brightly colored imagery.

KASTEN, KARL ALBERT (Painter, Printmaker)
1884 San Lorenzo Ave., Berkeley, CA 94707

Born: 1916 *Awards:* Humanities Research Fellowship; Tamarind Lithography Fellowship *Collections:* Victoria & Albert Museum; Achenbach Collection *Exhibitions:* Sao Paulo Bicentennial; World Print III Traveling Show *Education:* University of California at Berkeley; University of Iowa *Dealer:* Rorick Gallery, San Francisco; Sansiao, Tokyo

Early works were paintings and pastels, but in the early 1950s he began to devote equal attention to printmaking techniques. His paintings on canvas are highly abstract, almost totally non-referential, and employ flat geometric forms and textural elements with themes frequently taken from landscape. His collagraph prints are particularly noteworthy for a procedure he developed that allows the printing of a multiple-colored image on a single run through the etching press.

KATZ, ALEX (Painter)
c/o Marlborough Gallery, 40 W. 57th St., New York NY 10019

Born: 1927 *Awards:* Fellowship, John Simon Guggenheim Memorial Foundation; Professional Achievement Citation, New York *Collections:* Museum of Modern Art; Whitney Museum of American Art *Exhibitions:* Corcoran Gallery Biennial; Museum of Modern Art *Education:* Cooper Union; Skowhegan School of Painting and Sculpture *Dealer:* Marlborough Gallery, NYC

In the 1950s large simple figures were depicted in unspecified surroundings, as in Ada Ada (1959). The figures were also cut out and mounted on plywood to create striking likenesses. Still isolated from their settings, the figures of the 1960s became upper bodies only, as in *Red Smile*. Additional work made during this decade portrayed flowers and figural groups which recalled the earlier cutouts. Clean edges and underdrawing serve to flatten and simplify the figures. But because the subjects are so large in relation to the canvas, like the face coming up out of the water in *Swimmer No. 2,* they seem to rise from the picture plane towards the observer.

KATZEN, LILA (Sculptor)
345 W. Broadway, New York NY 10013

Born: 1932 *Awards:* National Endowment for the Arts Grant; Goodyear Fellowship *Collections:* Smithsonian Institution; National Gallery of Art *Exhibitions:* Whitney Museum of American Art Biennial; Baltimore Museum of Art *Education:* Art Students League; Cooper Union *Dealer:* Alex Rosenberg Gallery/Transworld Art, NYC

In addition to formal study she also worked with Hans Hofmann in New York City and in Provincetown, Massachusetts. First known as an Abstract Expressionist painter, she gained recognition in the 1960s with assemblages and environmental sculptures made of such materials as mirrors, aluminum, plastic, fluorescent liquid and ultraviolet light. During the next decade her media became more austere and heavy, including concrete and various metals obtained from industrial steel rolling mills. These monumental pieces were often displayed in public places. Recent abstract sculptures incorporate curves in a combination of metals for indoor and outdoor spaces.

KAUFFMAN, ROBERT CRAIG (Painter, Sculptor)
31-33 Mercer St., 5B, New York NY 10013

Born: 1932 *Awards:* First Prize, 69th American Exhibit, Art Institute of Chicago; U.S. Government. Fellowship for the Arts *Collections:* Whitney Museum of

Richard C. Karwoski, *All Apples,* 22 x 30, lithograph. Courtesy: Gallery East (East Hampton NY)

Richard Kemble, *Whispering Pines,* 37 x 74, woodcut. Courtesy: A.A.A. (New York NY)

173

American Art; Art Institute of Chicago *Exhibitions:* Museum of Modern Art; Whitney Museum of American Art *Education:* University of Southern California School of Architecture; University of California, Los Angeles *Dealer:* Pace Gallery, NYC

Early paintings of the 1950s on the West Coast were Abstract Expressionist, rendered in thickly applied paint. After two years in Europe in the early 1960s, large drawings in enamel and watercolors heightened an interest in line, and led to pictures on glass in paint and later in plastic. Subsequent low reliefs in plastic and molded plastic sculptures were sprayed with bright acrylic lacquers. An interest in mass production led him to make many series in molded plastic, including *Bubbles* and *Loops.* Later wall pieces were made for exhibitions and destroyed afterwards. He also returned to painting, applying paint directly to the wall. Recently he has renewed an interest in two-dimensional works, as in *Leg with Garden Element* in tempera, oil stick, and acrylic on paper and silk (1980-1981).

KAWABATA, MINORU (Painter)
463 West St., New York, NY 10014

Born: 1911 *Awards:* Guggenheim International; San Paolo Biennial *Collections:* Solomon R. Guggenheim Museum; Museum of Modern Art, Kamakura, Japan *Exhibitions:* Museum of Modern Art, Kamakura, Japan; Venice Bienale *Education:* Academy of Fine Arts, Tokyo *Dealer:* Jack Tilton Gallery, NYC

He paints large abstract canvases with a rich sense of color and tone. His work is meditative and carefully considered. In the past, the paintings were related to Abstract Expressionism, and then to hard edge painting. Now his work contains elements of both, yet it is unique in also showing the influence of traditional Japanese screen painting. Recent paintings employ broad areas of color in polygonal shapes that evoke the folded paper forms of origami. These abstract works are characterized by an individual sense of composition.

KEARNEY, JOHN (Sculptor)
830 Castlewood Terrace, Chicago, IL 60640

Born: 1924 *Awards:* Fulbright Fellowship; Italian Government Award *Collections:* Park District, City of Chicago; Museum of Science and Industry, Chicago *Exhibitions:* Ulrich Museum, Wichita, KS; ACA Galleries, NYC *Education:* Cranbrook Academy of Art *Dealer:* ACA Galleries, NYC; Contemporary Art Workshop, Chicago

He is known for his large sculpture incorporating car bumpers to create a fantastic menagerie. He also sculpts in bronze, developing the technique while studying in Italy on a Fulbright. Early in his career he worked with silver and gold as well as bronze, and developed a fascination with animals, the human condition, and statements on war. His sculpture is figurative and often contains visual puns. The current work is concerned with the impact of the automobile on our culture. Small bronze boxes in the form of animals and automobiles, with unexpected hinged compartments, express his sense of humor and tragedy.

KELLY, ELLSWORTH (Painter, Sculptor)
R.D.P.O. Box 170B, Chatham NY 12037

Born: 1923 *Awards:* Carnegie International Prizes; Flora Mayer Witowsky Prize, Art Institute of Chicago *Collections:* Metropolitan Museum of Art; Museum of Modern Art *Exhibitions:* Museum of Modern Art; Venice Biennale *Education:* Pratt Institute; Boston Museum School; Ecole des Beaux-Arts, Paris *Dealer:* Leo Castelli Galleries, NYC; Gemini G.E.L., Los Angeles

Unconcerned with the spontaneity of Abstract Expressionism in the 1950s, he painted preconceived, hardedged silhouettes of shapes from nature in the manner of Henri Matisse's cutouts. The large-scale simplified forms were often in two planes of black and white, so that it was difficult to distinguish figure from ground. The concern was with an observed object, its mass and shadow, distilled to its "telling shape." In 1955, convinced that "a shape can stand alone," he added sculpture to his media, free-standing polychromed works that echoed the paintings, often consisting of connected planes, as in *Pony.* Wall reliefs and segmented pictures of the 1950s and 1960s portrayed effects of shadows upon fields of color. Some paintings resembled color charts, repeated rows of solid colors. Later works explore color-shape relationships as in *Chatham XI: Blue Yellow.* Additional drawings are precisely outlined plants.

KEMBLE, RICHARD (Printmaker)
Forager House Studio, Box 82, Washington Crossing, PA 18977

Born: 1932 *Awards:* Printmakers Fellowship, National Endowment for the Arts *Collections:* Newark Museum; New Jersey State Museum *Exhibitions:* Allentown Museum; Philadelphia Museum of Art *Education:* Trenton State College; Pratt Institute *Dealer:* Associated American Artists, NYC

He primarily is a woodcut printmaker. His prints are unique in that after they are pulled from the plate, the image is sprayed with mineral spirits which causes the ink to "bleed" through the paper. This creates soft edges, with each print showing unique features of color saturation. He prefers subjects inspired by nature. He sets off his images from more realistic portrayals by choosing colors not found in nature, such as deep red for pine trees or purple for the ocean.

KERSWILL, J. W. ROY (Painter)
Box 2440, Jackson Hole, WY 83001

Born: 1925 *Collections:* Wyoming State Art Gallery; U.S. Dept. of Interior National Collection *Exhibitions:* American Artists Professional League Annual *Education:* Plymouth College of Art, England

After spending twenty years in the aerospace industry as a concept illustrator, in the mid-1960s he turned to his first love, painting. He specializes in portraying the mountains and the history of the exploration of the West, in both oils and watercolors. The scenes depict trappers and contemporary packers in rugged mountain settings. *Colter's Hell,* showing the historic trek made by John Colter into Yellowstone Park, is part of the artist's series on the mountain man.

KERZIE, TED L. (Painter)
320 Oleander, Bakersfield, CA 93304

Born: 1943 *Awards:* Honors, Claremont College *Collections:* Gelco Collection *Exhibitions:* Cirrus Gallery, Los Angeles *Education:* Claremont College *Dealer:* Cirrus Gallery, Los Angeles

Paintings are executed through a unique process whereby he paints on large canvases through a small aperture with a taped, dripping border. Canvases are layered to create a multi-dimensional tableau that looks rather like window views of flowers and lush foliage as if seen through a screen. His work recalls impressionist

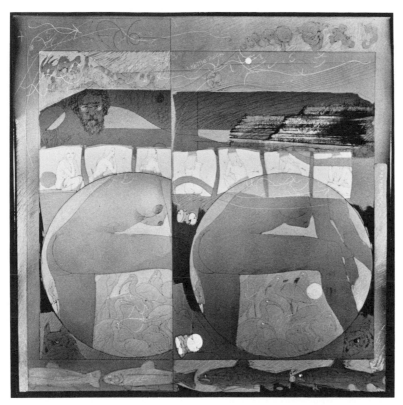

John Killmaster, *Kettle Rock,* 22 x 22, porcelain enamel on steel. Courtesy: Ochi Gallery (Boise ID)

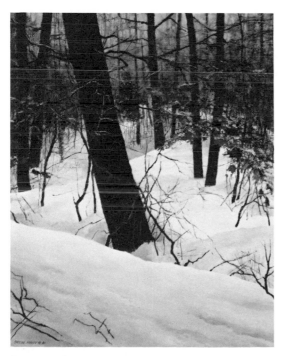

Lorene Kohut, *Winter Afternoon,* 30 x 24, alkyd. Courtesy: Extra Touch of Class (Alexandria VA)

Ted Kerzie, untitled. Courtesy: Cirus Gallery (Los Angeles CA)

and pointillist landscapes but remains positively contemporary. A further exploration of color, pointillism, and illusion characterizes current work.

KILLMASTER, JOHN H. (Painter)
220 Cotterell Dr., Boise, ID 83709

Born: 1934 *Awards:* Juror Award, "Mainstreams '68 International," Marietta, OH; Award, 42nd Annual Northwest Watercolor Exhibition, Bellevue, WA *Collections:* Boise (ID) Gallery of Art; Morridon-Knudsen Corporation *Exhibitions:* Smithsonian Institution; American Watercolor Society *Education:* Cranbrook Academy of Art; Hope College *Dealer:* Ochi Gallery, Boise, ID; Gallery West, Portland, OR; Spring St. Enamel Gallery, NYC

His earlier works in acrylic oil and gouache dealt with realistic, expressive, and abstract concepts usually derived from the surrounding land forms. Central to these works was an exploration of color. During the past decade, much of his work has been an ongoing exploration of porcelain, enamel-fired on large steel panels. The permanence of color and the free-form possibilities of porcelain enamel have resulted in large-scale mural and wall-relief applications. His current work consists of several free-standing public art sculptures and modular relief wall pieces. He also continues to work in gouache and acrylic, exploring the imagery of the Northwest.

KIM, PO (Painter)
417 Lafayette St., New York, NY 10003

Born: *Collections:* Solomon R. Guggenheim Museum; The Art Institute of Chicago *Exhibitions:* Indianapolis Museum of Art; Brooklyn Museum of Art *Education:* University of Illinois *Dealer:* Fairweather Hardin Gallery, Chicago

Large oil paintings in an abstract expressionist style characterize his early work. The addition to the canvases of colored pencil and, sometimes, pastel on paper lead to several years of work in a meditative representational still-life approach. Common subjects were flowers, fruit and vegetables. Current work is in oil and acrylics on large canvases. Representational imagery ranges from landscapes to interior settings.

KIPNESS, ROBERT (Painter, Printmaker)
26 E. 33rd St., New York NY 10016

Born: 1931 *Awards:* Medal of Honor, Audubon Artists; Prize, National Academy of Design *Collections:* Whitney Museum of American Art; Art Institute of Chicago *Exhibitions:* Whitney Museum of American Art; Hirschl and Adler Galleries *Education:* Art Students League; Wittenberg University; University of Iowa *Dealer:* Merrill Chase Galleries, Chicago; Weisberg Payson, NYC

In still lifes and landscapes of the early 1950s forms were geometrical, but the depictions were more representational by the end of the decade. Mist-covered rural landscapes which spoke of dream and reality were rendered in combinations of gentle colors in a style recalling the pointillism of Georges Seurat. Current work is characterized by a variety of quick brushstrokes. Realistic oils and lithographs use strong light and subtle color to depict nature in a tranquil mood, thus revealing an inner landscape. "My *Inner Landscapes* are a projection of inner feelings and moods—an expression of all our internal views."

KITTREDGE, NANCY (Painter)
13646 Mira Montana Dr., Del Mar, CA 92014

Born: 1938 *Collections:* University of Maine; Household Corporation Collection *Exhibitions:* San Diego Museum of Art; Laguna Beach Museum of Art *Education:* Vesper George School of Art; University of Maine; University of Miami *Dealer:* Joy Horwich Gallery

As a figurative oil painter, she is known for her rich, vivid use of color in the portrayal of subconscious images and imaginary characters. The compositions create a distinctly theatrical mood. The figures stand in "stage light," their facial colors heightened and somewhat exaggerated. The clothing is reminiscent of the costuming for the theater. Bold, impasto brush strokes, a lighter palette, and enlarged faces filling the canvas are typical of her current work. While the figures interact within the composition, a new emphasis is placed on drawing the viewer into the scenario with these larger than life-sized paintings.

KLEEMANN, RON (Painter)
c/o Louis K. Meisel Gallery, 141 Prince St., New York NY 10012

Born: 1937 *Collections:* Museum of Modern Art; Solomon R. Guggenheim Museum *Exhibitions:* Museum of Contemporary Art, Chicago; Museum of Modern Art *Education:* University of Michigan *Dealer:* Louis K. Meisel Gallery, NYC

In 1967 he turned from abstract sculpture to painting. Relating to sculptural concerns, early paintings used shaped canvases and abstracted hard-edged forms. The next year photographs served as models. Several different views were combined to create surrealistic presentations of contemporary subjects such as cars, fire engines and trucks, with super-impositions of human anatomical parts. Subsequent photo-realist works depict racing machines—cars, boats, planes, and motorcycles—as icons. The brush stroke is loose when seen closely, but at a greater distance the images take on the look of sharp photographs. He is interested in the "formal graffiti" of decals, pin stripes and insignia on racing machines because they symbolize for him the marks men leave to declare their masculinity. Conceptual Art plays a part in his work: for example, he became a taxicab driver while working on *Scull's Angels*, a proposal for a taxicab racing team; in 1977 he created *Team Kleemann—Conceptual Art Racing Team* for the Indianapolis 500. Since then he has been that race's official artist.

KLEINHOLZ, FRANK (Painter)
21 Second Ave., Port Washington, NY 11050

Born: 1901 *Awards:* Purchase Prize, Hearn Fund, The Metropolitan Museum of Art; First Annual American Artist Award, Art Department, Nassau Community College *Collections:* The Metropolitan Museum of Art; Fine Arts Museum, Moscow *Exhibitions:* Carnegie Institute; Association of American Artists *Education:* Fordam Law School; American Art School *Dealer:* ACA Galleries, NYC

His expressionistic oil paintings depict the lovely, tender, vulnerable images of life. Representations of children, flowers, birds, city crowds, and pastoral scenes carry a subtle and sometimes disquieting undertone of social commentary. His lyrical reality is one in which joy and humanistic values combat the ugly and the tragic. He simplifies drastically, restricting the elements to the essential. The forms themselves can be three-dimensional, flat, outlined, or roughly indicated and the proportions, perspectives and anatomies are

Richard C. Karwoski, *Peppers No. 3,* 22 x 30, watercolor. Courtesy: Gallery East (East Hampton NY)

Patricia Johanson, *Pyrameis Myrinna (Color Garden)* (1981), 36 x 48, acrylic/ink/pastel.

Barry W. Johnston, *Communitty,* 44 high, bonded bronze.
Courtesy: Lafayette Centre (Washington DC)

Kwan Yee Jung, *Midnight Stroll,* 31 x 22, watercolor.

Mary Frances Judge, *Exile*, 72 x 72, mixed media on linen. Courtesy: Dolly Fiterman Gallery (Minneapolis MN)

Ted Kerzie, untitled, 8 x 8 ft., Courtesy: Cirus Gallery (Los Angeles CA)

John Killmaster, *Third Heaven,* 4 x 6 ft., porcelain enamel on steel. Courtesy: Ochi Gallery (Boise ID)

Dominick Labino, *Icosahedron,* 4 x 4 ft., hot-cast glass on steel. Courtesy: Bowling Green State University

Po Kim, *Midday*, 7 x 17 ft., oil

Richard Kemble, *Sheltered Inlet*, 37 x 74, woodcut. Courtesy: Associated American Artists (New York)

Lorene Kohut, *Summer Clouds,* 20 x 36, acrylic pastel. Courtesy: Extra Touch of Class (Alexandria VA)

Ellen Lampert, *Gideon & His Parents (again)* (1984), 30 x 80, watercolor. Courtesy: Daniel Gouro Associates

Nancy Kitteredge, *The Dance*, 45 x 48, oil on masonite. Courtesy: Joy Horwich Gallery (Chicago IL)

Eleanore Berman Lazarof, *Garden with Hedge*, 74 x 76, oil on canvas. Courtesy: Kirk De Gooyer (Los Angeles CA)

Harold M. LeRoy, *At the Regina,* 16 x 12, oil. Courtesy: Belanthi Gallery (Brooklyn NY)

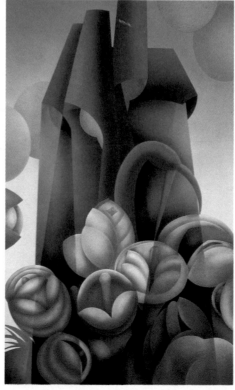

Alice Lauffer, *Spring Phantasy,* 66 x 40, acrylic.

Anthony J. Manzo, *The Last Roundup,* 34 x 24, oil. Courtesy: The Collectors Gallery (Taos NM)

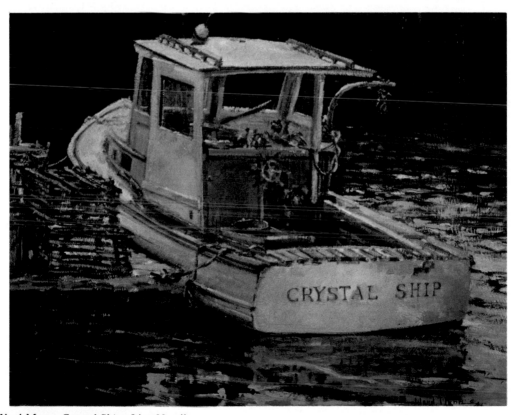

Ward Mann, *Crystal Ship,* 24 x 30, oil.

Leza Lidow, *Paris—1920*, 96 x 72, oil. Courtesy: Ankrum
Gallery (Los Angeles CA)

Joan Michaels-Paque, *Curves*, 53' dia., flexible sculpture.
Courtesy: JMP Atelier (Milwaukee WI)

Mortimer Laughlin, *The Dining Room,* 26 x 37, oil. Courtesy: Bartholet Gallery (New York NY)

Martha Margulis, *By the Brook II,* 47 x 74, acrylic on canvas. Courtesy: Payson-Weisberg Gallery (New York NY)

Melvin O. Miller, *Hyde Street Pier,* 24 x 40, oil on canvas. Courtesy: John Pence Gallery (San Francisco CA)

Tom McClure, *Queen of Chances,* 27 x 13 x 9, bronze and polyester. Courtesy: Ankrum Gallery (Los Angeles CA)

Joyce Prindiville Lopez, *Phoenix-103-Noir*, 83 x 53, acrylic on canvas.

Marianne, *The Awakening*, 24 x 48, oil. Courtesy: The Home Gallery (Austin TX)

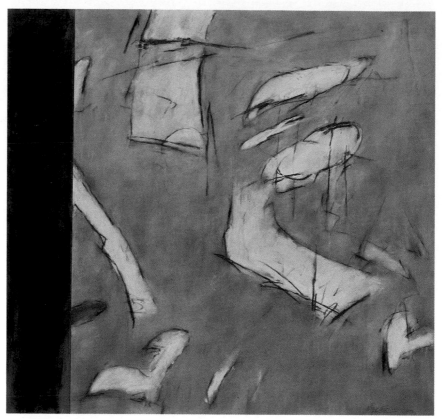

Tony Magar, untitled, 54 x 54, oil on canvas, New Gallery (Taos NM).

Pat Musick, *Laura Negotiating,* 80 x 80, oil on canvas. Courtesy: Economos Works of Art (Houston TX)

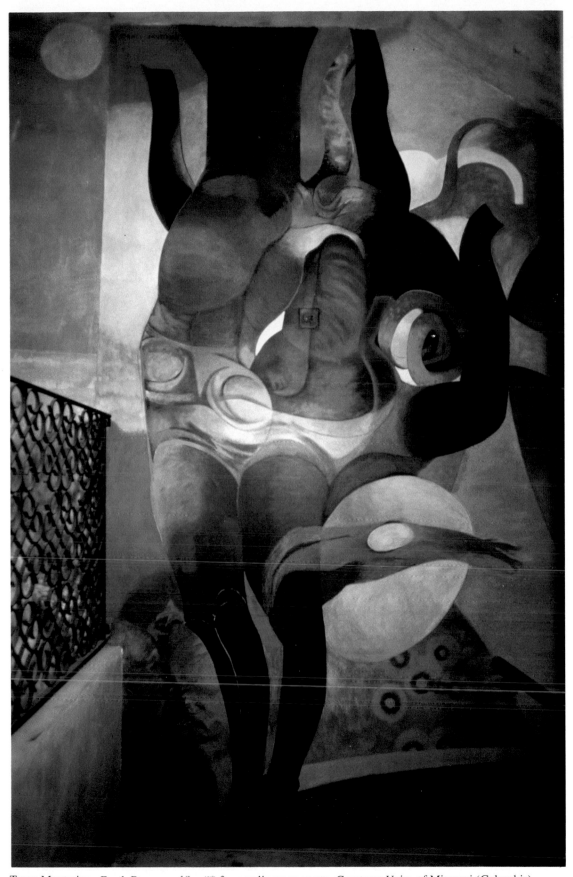

Tracy Montminy, *Earth Dancers*, 13 x 20 ft., acrylic on concrete. Courtesy: Univ. of Missouri (Columbia)

Marilyn Levine, *Spots Suitcase,* 29 x 18 x 8, ceramic and mixed media. Courtesy: Fuller Goldeen (San Francisco CA)

Anna Maria Muccioli, *Watercolor Texture Collage,* 4 x 8 ft., watercolor. Courtesy: Muccioli Studio Gallery (Detroit MI)

altered and abstracted. His colors have been described as "Byzantine" in their splendor, and add a primitive power to the compositions.

KLEMENT, VERA (Painter)
727 S. Dearborn, Chicago, IL 60605

Born: 1929 *Awards:* Fellowship, John Simon Guggenheim Memorial Foundation; Louis Comfort Tiffany Award *Collections:* Museum of Modern Art; Philadelphia Museum of Art *Exhibitions:* Jewish Museum; Walker Art Center *Education:* Cooper Union *Dealer:* CDS, NYC; Roy Boyd Gallery, Chicago

For three decades she has worked in the tradition of Abstract Expressionism. Her new paintings use the technique of encaustic to enhance the clarity of her colors. In these works, she continues a previous exploration of what she calls a "two-part connection." The total picture plane is one "part," the other a plane made from a square or rectangle of canvas that is affixed to the canvas ground.

KLIROS, THEA (Illustrator)
313 E. 18th St., New York, NY 10003

Born: 1935 *Awards:* award, Society of Illustrators *Exhibitions:* Society of Illustrators; American Illustration Today *Education:* Yale School of Fine Arts

Early work was as a painter and illustrator, greatly inspired by her three year residence on the Spanish island of Mallorca. Work in free lance illustration since has been primarily advertisements for the manufacturer of the fiber Trevira and other fashion firms and fiber accounts in the New York area. Illustrations are detailed, lifelike renderings, often based upon the figure. Pencil drawings are most often her chosen medium.

KLOPFENSTEIN, PHILIP ARTHUR (Painter)
2155 Kingsbury Dr., Montgomery, AL 36106

Born: 1937 *Exhibitions:* Arkansas Watercolor Society; El Dorado Art Center, AK *Education:* Michigan State University; Western Michigan University

He is a painter and art historian with a working knowledge of both historical and contemporary techniques. His work has become a blend of concepts reflecting French Impressionists, the Orient, and the intense color use of South American artists—along with the regionalism of the southern United States. Landscape paintings in watercolor and acrylic dominate his limited production of works.

KLUNK, ROBERT EDWARD (Printmaker)
731 W. 18th St., 2nd Floor, Chicago, IL 60616

Awards: Purchase Award, Illinois Regional Print Show; Merit Award, Oakland Park Art Festival *Collections:* Elliot Museum; Northwestern University *Exhibitions:* Elliot Museum; International Print Exhibit, Taipei *Education:* Loyola University; University of Illinois, Chicago *Dealer:* B. Altman & Co., NYC; Clemmons Gallery, Houston; Center for the Print, Chicago

Nature is the primary source of his imagery and inspiration for his copper etchings and drawings. Living creatures, figurative and animal forms, endowed with attributes derived from his own imagination are the subject matter of many of his drawings and etchings. Intricate, fanciful images derived from mythology, symbolism, and dreams, as well as emblematic designs displaying strong design elements and embellished patterns also comprise the subject matter for much of his work. Many drawings are done before the image attains the state when it is finally ready to be etched. Prints are made on a variety of papers including cypress paper and rice paper.

KNAPP, TOM (Sculptor)
Box 510, Ruidoso Downs, NM 88346

Born: 1925 *Collections:* Indianapolis Museum of Art; Museum of Native American Cultures, Spokane, WA *Exhibitions:* Cowboy Hall of Fame, Oklahoma City, OK; Maxwell Gallery, San Francisco *Education:* Art Center, Los Angeles; California College of Arts And Crafts, Oakland, CA

His career includes work as a designer and animator, professional photographer, and commercial artist before he devoted himself full-time to his bronze sculpture. He creates, manipulates, casts, grinds, and personally supervises every step in the execution of his works. His most recent achievement has been the completion of his Indian ceremonial dancer series, produced in a limited edition of forty. He has researched the dances to insure the historical accuracy of the body positions and the cultural authenticity of the costumes.

KNAUB, RAYMOND L. (Painter)
859 S. Miller Ct., Lakewood, CO 80226

Born: 1940 *Awards:* Award, 61st Annual Allied Artists of America; Award, Watercolor U.S.A. *Collections:* Petro-Lewis Corporation; Denver Art Museum *Exhibitions:* Denver Art Museum Biennial; Rocky Mountain National Watermedia Exhibition *Education:* Baylor University; University of Nebraska *Dealer:* Bakers Gallery of Fine Art, Lubbock, TX; Hayden Hayes, Colorado Springs; Mongerson Gallery, Chicago; Savageau's Fine Art, Denver

Previous works in oil and watercolor, were realistic renderings of landscapes and historical scenes taken from the southwest and great plains region. Subject matter varied from landscapes with figures, and character studies, to historic railroad depictions, on medium to very large canvases. Works now are solely in oil which lend themselves to a more "meditative" approach that allows the artist to play with light and layering of the paint to produce rich, lustrous surfaces. Strongly influenced by Vermeer, he remains a realistic painter who has also done extensive research into Colorado history, Indians of the Southwest, railroads, and wheat farming from an historical perspective.

KNOEDEL, GERHARDT (Fiber Artist)
c/o Cranbrook Acadamey of Art, 500 Lone Pine Rd., Box 801, Bloomfield Hills, MI 48103

Born: 1940 *Awards:* Grant, National Endowment for the Arts *Collections:* University of Houston; Xerox Corporation *Exhibitions:* Cleveland Museum of Art; Detroit Institute of Arts *Education:* California State University, Long Beach; University of California, Los Angeles

One of the first artist to exploit the potentials of cloth as a compositional element, his early experiments were glades of suspended, free-hanging cloth panels dyed in pastel color ranges. Layered panels, that reflected and transmitted light, and could be rearranged and recomposed followed soon after, and lead to a series of large commissions including the enormous *Free Fall* in the Detroit Plaza Hotel & Renaissance Center lobby and *Gulf Stream* in the University of Houston library. Cloth is hand woven on production looms from mylar fibers, and the shiny, vividly colored sheets of fabric suspended in the air to create giant kite-like shapes that interact with the architectural space.

KNOWLTON, GRACE FARRAR (Sculptor)
Snedens Landing, Palisades, NY 10964

Born: 1932 *Collections:* Metropolitan Museum of Art; Corcoran Gallery of Art *Exhibitions:* Metropolitan Museum of Art; San Francisco Museum of Modern Art *Education:* Columbia University; Smith College *Dealer:* Susan Harder Gallery, NYC

She has been a sculptor since 1960, building group pieces consisting of five to seven large abstract forms, primeval in feeling and boulder-like in structure. The forms can be rearranged, changing relationships to each other and their surroundings. The early works were originally conceived in clay. A shift to reinforced concrete as the building material made possible an increase in the sizes of the forms. For a time she worked in welded steel, but then returned to the more primitive and rock-like substance of concrete. Presently she is making photographic studies of the interior white corners of rooms that are sculptural in feeling and abstract, though realistic in detail. The platinum and palladium prints are white-on-white, with a matte surface, and have more the feeling of watercolors or drawings than photographs.

KOCAR, GEORGE (Painter)
24213 Lake Rd., Bay Village, OH 44140

Born: 1948 *Awards:* Special Mention, May show, Cleveland Museum of Art *Collections:* The Art Studio, Cleveland Metropolitan General Hospital; University President's Collection, Cleveland State University *Exhibitions:* Butler Institute of American Art; Cleveland State University Gallery *Education:* Cleveland State University; Syracuse University *Dealer:* Bonfoey's, Cleveland

Work is medium-scale oil on canvas paintings executed with a brightly colored palette and applied with exuberant brush strokes in a neo-expressionist fashion. His work is almost always American social satire, exploring the excesses, the false dreams, the twisted aspirations of a society seeking its share of a mythical "American apple pie". His subjects, which range from cowboys and hunters to "urban guerrillas" often disguised in masks or fake noses-and-glasses, usually wear large grins on their faces. The weapons in the paintings look ominous but harmless; The hunter's bow has rubber tipped arrows, and the firearms they carry are mere pop guns and water pistols. He tempers satire with humor in outrageous caricatures of people mixed up with bananas and fruit in a frenzied joy ride superimposed upon a camouflage background.

KOCH, PHILIP FREDERICK (Painter)
4823 Hawksbury Rd., Baltimore, MD 21208

Born: 1948 *Awards:* grant, Ford Foundation *Collections:* Minnesota Museum of Art; Indiana Museum of Art *Exhibitions:* Meredith Long Gallery, Houston, TX; C. Grimaldis Gallery, Baltimore *Education:* Indiana University; Oberlin College *Dealer:* Meredith Long Gallery, Houston, TX; C. Grimaldis Gallery, Baltimore

His early paintings may be seen as a contemporary re-examination of Hudson River School painting and as a source and framework for personal experimentation. The subjects include natural foliage and maritime situations. Recent works have evolved toward a more impressionist sensibility, with lighter tones predominating. Architectural views that recall Edward Hopper are described with a free-flowing brush. Naturalistic light and shadow and an increasingly intense color sense characterize the recent oils. Coastal shorelines, especially those of Cape Cod, have become an important theme. He is particularly interested in painting the reflective surfaces of water.

KODAMA, MARIE (Ceramic Sculptor)
99-142 Pooholua Drive, Aiea, HI 96701

Born: 1949 *Awards:* Artist in Residence, Waikiki School, Honolulu *Collections:* State Foundation on Culture and the Arts; Contemporary Arts Center of Hawaii *Exhibitions:* Artists of Hawaii, Honolulu Academy of Arts; Following Sea Gallery, Honolulu *Education:* University of Hawaii

Her ceramic sculpture has used primarily high fire porcelain or low fire clays. Her pieces have been noted for their embellished surfaces—rich with a personal and whimsical iconography. Early work used hand formed and slip-cast elements juxtaposed and recombined into surreal relationships. Work of the late 70s consisted of enclosures reminiscent of doll houses or dioramas, the drawings and imprints on the surface of the slabs suggested mysteries and fragments of memory. More recent work includes wire, paper, and plastic fragments and is suggestive of shrines, icons, or reliquaries. Her works have a strong symbolic presence without a specific message or meaning. Many elements hark back to childhood images and fascinations—cows, dolls, imprints of letters and numbers; "little things to create little mysteries."

KOHLMEYER, IDA R. (Painter)
11 Pelham Ave., Metairie, LA 70005

Born: 1912 *Awards:* Annual Achievement award, National Women's Caucus for Art; Mayor's Art Award, New Orleans *Collections:* Smithsonian Institution; Brooklyn Museum *Exhibitions:* Mint Museum; Oklahoma Art Center *Education:* Newcomb College *Dealer:* Gimpel & Wietzenhoffer, NYC; Arthur Roger, New Orleans

Her painting depends on tensions achieved through the positioning of shapes, shape sizes, directional axes, and color. The architectural grid plan holds the expressive, spontaneous brushwork in check. Through this visual concept and spare means of applying paint to canvas, she attempts to formulate a visual experience that is tantalizing and surprising.

KOHUT, LORENE (Painter)
Route 3 Andrews Lake, Felton, DE 19943

Born: 1929 *Awards:* Gold Medal Award, Hudson Valley Art Association; Gold Medal, watercolor, Catharine Lorillard Wolfe National *Collections:* Court of General Sessions, Washington, DC; Dupont Corporation *Exhibitions:* National Academy of Design; American Artist Prof. League Grand National *Education:* Self-taught *Dealer:* Extra Touch of Class, Alexanderia, VA

Mixed media, acrylic, and oil paintings of landscapes and pastoral scenes executed in a representational realistic vein characterize the work of this painter. Early works were done in oil using knife and brush techniques but over the years she has developed a unique mixed media technique utilizing acrylic and pastels. Although, this technique suits her well for her subject matter of woodlands, fields, flowers and the sea, recently, she has begun to use alkaline pigments for larger scale landscape works.

KOONS, DARELL J. (Painter)
6 Yancy Dr., Greenville, SC 29615

Nancy Kittredge, *First Date*, 46 x 48, oil on masonite. Courtesy: Joy Horwich Gallery (Chicago IL)

Po Kim, *King's Necklace*, 18 x 23, oil on paper

Born: 1924 *Awards:* Purchase Award, Guild of South Carolina Artists; Purchase Award, Wake Forest University Gallery of Contemporary Art *Collections:* Butler Institute of American Art; Mint Museum *Exhibitions:* Chico State College Invitational; Springfield Museum of Art National *Education:* Western Michigan University *Dealer:* Hampton III Gallery, SC

His early art consisted of experiments in technique and a search for a successful approach to painting. He now works in a realistic manner, using acrylic and watercolor. His primary subject matter is old weathered buildings of early Americana. The paintings convey the basic shapes of these buildings and the surrounding landscape. The emphasis is the subject matter, but he attempts to play up the composition to create unity and harmony. Currently, he teaches art at Bob Jones University, and travels considerably, seeking subject matter for painting ideas. He avoids preliminary sketching in his approach to painting, preferring the freshness of an idea to the over-working of it.

KOPPELMAN, CHAIM (Printmaker)
498 Broome St., New York, NY 10012

Born: 1920 *Awards:* Grants, Louis Comfort Tiffany; Grant, New York State Creative Artists *Collections:* Metropolitan Museum of Art; Museum of Modern Art *Exhibitions:* Associated American Artists Gallery, NYC; Warwick Gallery, England *Education:* American Artists School; Art Students League *Dealer:* Terrain Gallery, NYC

Before the mid 1970s she was known primarily as a printmaker working in black and white intaglio prints. The work dealt with the individual and the internal struggle of good and evil. She credits her teacher, Eli Siegel, with strengthening and clarifying her philosophical concepts and art. The earlier body of work has been followed by color prints and still lifes which explore the presence of opposites in inanimate objects. Her recent pastel compositions have combined the new, rich colors with the incisive drawing notable in her prints.

KOPRIVA, SHARON (Painter)
5611 Arncliffe, Houston, TX 77088

Born: 1948 *Awards:* Award, Brazosport Fine Arts Center; Award, Art League of Houston *Collections:* Monsanto Chemical Co. and United Energy Resources *Exhibitions:* Midtown Art Center, Houston; Blaffer Gallery, University of Houston *Education:* University of Houston; Texas Tech University; Art Students League *Dealer:* Bill Graham, Houston

Using oil and pencil on canvas, she dealt primarily with religious imagery in her early works. The contradictions she perceived between God as nature and the deity described by structured religions is a reoccurring theme. Formal symbolism and religious iconography are combined with landscape and human figures in these compositions. In current work, she depicts both human and animal images on large, pierced, multi-panel canvases and in small sculptures. These figurative works question the nature of mortality and present death as a new awakening.

KOSTECKA, GLORIA (Painter)
23 Elmwood Dr., Clifton, NJ 07013

Awards: Travel Award, National Society of Painters in Casein & Acrylic; Travel Award, Washington Square Outdoor Art Exhibit *Exhibitions:* National Academy Galleries, NYC *Education:* American Art School, NYC; Traphagen School of Fashion, NYC

She specializes in painting portraits. Her sociological studies are portrayed with emotion and sensitivity, expressed freely in both her paintings and drawings. The earlier paintings, though realistic, were done using vivid colors and vertical brushstrokes. The drawings also were done with vertical strokes. Her current paintings, through still realistic, are done in softer and more delicate tones. The drawings now are executed with many fine lines and are no longer dominated by vertical strokes.

KOURSAROS, HARRY G. (Painter)
362 West Broadway, New York, NY 10013

Born: 1928 *Awards:* Fulbright Fellowship; Fulbright Grant Award *Collections:* Newark Museum; Birmingham Museum of Art *Exhibitions:* University of Alabama; Albright College Art Gallery *Education:* The American University; Albright College *Dealer:* UHaber-Theodore Gallery, NYC

Painting in both oil and acrylic he has used the grid to explore pictorial relationships. In the early 1970s he worked within the tradition of geometric abstract painters. The later introduction of etched pictographic figuration and abstract decorative motifs, drawn from Greek and Byzantine architectural embellishments, associated his work with pattern painting. More recently he has peopled the colorful spaces of his grids with athletes, hunters, and Amazons, who function as decorative design elements as well as characters in narrative action. The figures and narratives from antique art are given a witty twist, as he brings myth down to earth and pokes fun at current polemics about sexual roles.

KOWALSKI, DENNIS ALLEN (Sculptor)
4134 N. Damen Ave., Chicago, IL 60618

Born: 1938 *Awards:* Fellowship, National Endowment for the Arts; Fellow, Illinois Arts Council *Collections:* Art Institute of Chicago; Museum of Contemporary Art *Exhibitions:* Art Park, Lewiston, NY; Marianne Deson Gallery, Chicago *Education:* School of the Art Institute of Chicago; University of Illinois *Dealer:* Marianne Deson Gallery, Chicago

His sculpture of the past was architectural in nature, consisting mostly of large interior and exterior installations and smaller wall pieces made of easily accessible and common building materials. His interest was in the social aspects of architecture and the failure of contemporary architecture to deal effectively with these aspects. More recently he has found the architectural reference in itself inadequate to deal with social and political concerns. He now combines domestic objects—such as fireplaces, shelves, shutters, and bowls—with airplanes, submarines, and helicopters. These works suggest that the world situation is interconnected and inseparable from the domestic realm.

KRAMER, LINDA (Ceramic Sculptor)
370 Glendake, Winnetka, IL 60093 *Awards:* Grant, Illinois Arts Council *Exhibitions:* The Art Institute of Chicago; Museum of Contemporary Art, Chicago *Education:* Scripps College; School of the Art Institute of Chicago

Her ceramic sculpture and installations are brightly colored abstract compositions that combine a myriad of separate pieces into tableaus that sometimes encompass an entire room. The component parts are often times painted with a single color and only through their com-

Ron Kleemann, *On Xmas,* 15 x 20, oil on canvas. Courtesy: Louis K. Meisel Gallery (New York NY)

Ellen Lampert, *When Shooting Indoors Always Use a Flash,* 60 x 120, watercolor. Courtesy: Daniel Gouro Associates

bination with the rest do they take on the vibrancy that the final piece transmits. Colors tend to be primary tones or soft "post-modern" pinks and greens. The forms have a playful, sometimes whimsical, quality about them, alluding to tree-forms and electric currents.

KRASNER, LEE (Painter)
The Springs, East Hampton NY 11937

Born: 1908 *Awards:* Augustus St. Gaudens Medal, Cooper Union Alumni Association; Lowe Fellowship of Distinction, Barnard College *Collections:* Whitney Museum of American Art; Philadelphia Museum of Art *Exhibitions:* Museum of Modern Art; Whitney Museum of American Art *Education:* Women's Art School, Cooper Union; National Academy of Design *Dealer:* Robert Miller Gallery, NYC; Jason McCoy, NYC; Janie C. Lee, Houston

Work of the 1930s was realistic, but after studying with Hans Hofmann from 1937 to 1940, she exhibited with the Abstract Expressionists in the 1940s. At the time she married the painter Jackson Pollock in 1945, her improvisational methods were applied to a cubist style to create heavily painted canvases like the *Hieroglyph* series in black and white wherein hieroglyphic forms were enclosed within rectangles. From 1950 on, mostly vertical shapes seemed to float on color fields, as in *Shooting Gold*, while others included biomorphic forms suggesting the influence of Henri Matisse's cutouts. Linear elements wind through energetic images often cropped by the frame in the 1960s and 1970s. Recent work includes collage.

KRENTZIN, EARL (Sculptor, Silversmith)
412 Hillcrest, Grosse Pointe, MI 48236

Born: 1929 *Awards:* Fulbright Fellowship; Louis Comfort Tiffany Award *Collections:* Detroit Institute of Art; Cranbrook Academy of Art *Exhibitions:* Ultimate Cookie Jar; Jewelry U.S.A. *Education:* Wayne State University; Cranbrook Academy of Art; Royal College of Art *Dealer:* Donna Jacobs Gallery Ltd., Birmingham, MI

A silver sculptor utilizing precious metals to create whimsical figures in real and fanciful settings, his easily recognizable work, fabricated from sterling silver is combined with natural materials, semi-precious stones, wood, minerals and ivory. Functional objects such as chests are appropriately designed with exquisite decorative details in locks, keys, and hinges all made by the artist. Influenced by such diverse sources as his antique toy collection, contemporary toys, and more traditional silversmith craft, his current work includes cookie jars, jewelry, and robots. Jewelry is humorous, miniature creatures depicted knitting, skating, hammering, weaving, painting or golfing.

KRIEGER, RUTH M. (Painter, Printmaker)
33 Winding Way, West Orange, NJ 07052

Born: 1922 *Awards:* Clyde L. Carnahan Award; Award, National Academy, New York *Collections:* State Museum, Trenton; Burndy Engineering Co. *Exhibitions:* Audubon Artists, National Academy Gallery, New York; Boston Museum of Fine Arts *Education:* Pratt Graphics Center; Kean College *Dealer:* Gallery 9, Chatham, NJ

She works in an impressionistic style using oil and acrylic as well as all the printmaking media. Early paintings and prints concentrated on studies of the human figure and the use of rich and vibrant colors. She sites the paintings of Bonnard and Vuillard as major influences. Later work has turned to the landscape with the figure as a subordinate element in the composition. Her paintings depict peaceful, pleasant scenes which offer a much needed emotional, visual respite to the viewer.

KRIGSTEIN, BERNARD (Painter)
4 West 18th St., New York, NY 10011

Born: 1919 *Awards:* 40th Anniversary Award, Audubon Artists; Ralph Mayer Award, American Society of Contemporary Artists *Exhibitions:* Adirondack Center Museum; Fashion Institute of Technology *Education:* Brooklyn College

A landscape artist particularly noted for his paintings of the Adirondack Mountains and other wilderness areas of New York State, he is also an avid sketcher. The pencil drawings capture the broken rock forms of the mountain valleys in natural still-life compositions, displaying quick, sure lines and variety in mark-making techniques. Working directly from nature, primarily in oil and watercolor, his paintings are views into the rough beauty of the unpopulated areas of the Northeast. The compositions achieve harmony through the play of color and the balancing of the larger shapes against the finer details of the foreground.

KRUSHENICK, NICHOLAS (Painter)
140 Grand St., New York NY 10013

Born: 1929 *Awards:* Tamarind Lithography Workshop Grant; Fellowship, John Simon Guggenheim Memorial Foundation *Collections:* Metropolitan Museum of Art; Museum of Modern Art *Exhibitions:* Whitney Museum Annual; Documenta 4, Kassel, Germany *Education:* Art Students League; Hans Hofmann School *Dealer:* American State of the Arts Gallery Exchange, NYC; River Gallery, Westport, CT

After formal study, in 1951 figurative forms were replaced by abstract expressionist works done with a soft brush stroke. In the early 1960s his language became hard-edged, using bold colors and black stripes or outlines to portray rich overlapping patterns in acrylic. These Pop-related works had such titles as *Moon Maid, King Kong,* and *Malibu.* Shaped and sculptured canvases have created relief-like pieces. Additional media include cutouts and graphics, as well as designs for some of the sets and costumes of the Center Opera Company.

KRUSKAMP, JANET (Painter)
1627 Hyde Drive, Los Gatos, CA 95030

Born: 1934 *Awards:* First Grand Prize, Grand Galleria National Art Competition, Seattle, WA; Grand Prix, Humanitaire De France, International Festival of the Arts *Collections:* Rosicrucian Egyptian Museum, San Jose, CA; Triton Museum of Art *Exhibitions:* Charles & Emma Frye Art Museum, Seattle, WA; San Jose (CA) Museum of Art *Dealer:* Marjorie M. Cahn Fine Arts, Los Gatos, CA; Galleria La Costa, Rancho La Costa, CA; Center Art Gallery, Honolulu, HI

She is a romantic realist who paints American scenes in oil and egg tempera. The white gesso surface of her paintings reflects through the pigment, giving a luminous quality to the finished works. Her subjects may be children, back yards, railroad ties, or crumbling walls. To coincide with the American Bicentennial, she traveled more than 30,000 miles by car to study and sketch most of the states of the Union. The paintings based on these studies depict rural and urban life-styles in contemporary America.

KURZ, DIANA (Painter)
152 Wooster St., New York, NY 10012

Born: 1936 *Awards:* Grant, Creative Artists Public Service; Fulbright Fellowship *Collections:* Corcoran Gallery of Art; Columbia University *Exhibitions:* Alex Rosenberg Gallery, NYC; Green Mountain Gallery, NYC *Education:* Columbia University; Brandeis University *Dealer:* Alex Rosenberg Gallery, NYC

She paints from direct observation of her subject in large-scale expressionist oil on canvas paintings characterized by larger-than-life size images, vivid color and painterly techniques. She works in pastels and watercolors as well as oils. In the 1970s she worked primarily from the nude model in a studio setting, singly or in pairs, as well as portraits and landscapes. In the 1980s she began to paint clothed figures in interior settings and still life. Her recent figure and still life paintings display unexpected juxtapositions of disparate elements resulting in complex combinations of bright colors and multiple textures and patterns. Still lifes of American pottery of the 1930s through 50s are carefully composed paintings mixing multiple patterns, forms, and background to arrive at compositions that appear to be randomly arranged.

KUVSHINOFF, BERTHA HORNE (Painter, Sculptor)
121 1/2 Yale Ave. North, Seattle, WA 98109 *Awards:* Gold Medal, Academy Int Tommasso Companelia, Rome *Collections:* Seattle Art Museum; Miami Museum of Modern Art *Exhibitions:* State Capitol Museum, Olympia, Washington; Seattle Russian Center

Her oil paintings describe a reality of the imagination, landscapes of another world inhabited by phantoms. The medium to large canvases exhibit carefully muted colors. Figures are elongated, stretched into the graceful poses of dancers and angels. Landscapes, obscured and softened by mist and swirling clouds, often contain domed temples, palaces, arches, and spired alien structures stacked into the shallow vertical depth of the canvas. Her vision extends to three dimensions in the small bronzes which depict robed and hooded, androgynous figures. A sense of the spiritual imbues all the work to present a view of a fantastic environment, both mysterious and hospitable.

LABINO, DOMINICK (Glass Artist, Sculptor)
23271 Kellogg Rd., Grand Rapids OH 43522

Born: 1910 *Awards:* Glass Award, American Ceramic Society; Distinguished Life Member, Ohio Senior Citizen's Hall of Fame *Collections:* Metropolitan Museum of Art; Smithsonian Institution *Exhibitions:* Victoria and Albert Museum, England; Corning Museum of Glass *Education:* Carnegie Institute; Toledo Museum School of Design

For thirty years he worked in industry developing glass fibers and compositions. Some of his fibers were used in the Mercury, Gemini, and Apollo space shots, and a silica fiber which he developed was recently used to make the tiles for the U.S. Space Shuttle. In 1962 he helped to found the Studio Glass Movement, and has since then pursued an artistic career in glass. Techniques employed include blown glass, hot glass sculpture, hot cast panels and hot cast profiles in relief (including a relief of Harry S. Truman). The hot cast polychrome panels have been used as architectural or sculptural elements in public buildings.

LADERMAN, GABRIEL (Painter)
760 West End Ave., New York NY 10025

Born: 1929 *Awards:* National Endowment for the Arts Fellowship; Ingram Merrill Foundation *Collections:* Cleveland Museum of Art; Museum of Fine Arts, Boston *Exhibitions:* Whitney Museum of American Art; Corcoran Gallery of Art *Education:* Brooklyn Museum School; Hans Hofmann School of Fine Arts; Cornell University; Atelier 17 *Dealer:* Schoelkopf Gallery, NYC; Harkus Gallery, Boston

In addition to formal study he worked under Willem de Kooning from 1949 to 1950 and was an Abstract Expressionist painter until the late 1950s, when he turned to the figure in experiments with printmaking. During the next few years he painted landscapes outdoors, as well as still lifes and interiors. The clothed models sit in unassuming contemplative poses, and the still lifes, too, are objects of contemplation, sitting in bright light crossed by deep shadows. Compositions are arranged in shallow depth and often at oblique angles, tendencies the artist admits have come from Balthus and Louis Le Nain. He continues to work to revive genre painting and even history painting, and recent paintings continue to be figurative.

LAGUNA, MARIELLA (Painter)
324 Christopher St., Oceanside NY 11572

Born: 1935 *Awards:* National Academy of Women Artists, Medal of Honor; American Society of Contemporary Artists, Annual Award; *Collections:* Rockefeller Collection; Brooklyn College. *Exhibitions:* The National Academy of Fine Arts Annual, NYC; The Pennsylvania Academy of Fine Arts *Education:* New York University; The New School

Primarily an oil and acrylic painter—although she has produced some work in watercolors, drawings, pastels, and etchings—her work has been continually influenced by the landscape around her. Her earlier abstract and textural paintings were inspired by what she refers to as "the inconsequential aspects of nature"; the cracks in sidewalks, or plaster peeling off the walls. She often incorporated sand and other materials from her New York City surroundings into her paintings. Recent work employs more conventional landscape aspects and a more colorful palette inspired by the countryside of California, New Mexico, Virginia, and New England.

LAMPERT, ELLEN (Painter)
c/o Daniel Gouro Associates, 800 W. First St., Suite 2210, Los Angeles CA 90012

Born: 1948 *Collections:* Skirball Museum; Sheptow Publishing *Exhibitions:* Chouinard Institute; Frauen-Museum, Bonn, W. Germany *Education:* Chouinard Institute; University of California, Berkeley *Dealer:* Daniel Gouro Associates, Los Angeles

After living in the Republic of the Ivory Coast and witnessing the results of political violence there, she returned to this country with a new awareness of America as a land of "personal violence." She abandoned abstract painting and commercial work to depict the lives of women. A series of paintings of tribal African women in the marketplace was well received in Africa. In America she is known for cartoon-like depictions of average housewives in American households of disarray. Women are home alone, grappling with children and kitchen gadgets, or painting their nails, with eyes on the television screen or listening to headsets. Through the windows can be seen the male world, made manifest in great machines: airplanes, helicopters, rockets, and tanks. In addition to ironically

depicting the drudgery and isolation of the lives of housewives, incidents of violence against women are also described, as in *Point Blank*. ''I'm narrating what happens around me at any given time. The kitchen paintings are me in my kitchen. The gun paintings are happening on my block.''

LANDIFELD, RONNIE (Painter)
31 Desbrosses St., New York, NY 10013

Born: 1947 *Collections:* Metropolitan Museum of Art; Museum of Modern Art *Exhibitions:* Cowles Gallery, NYC *Education:* San Francisco Art Institute, Kansas City Art Institute *Dealer:* Charles Cowles, NYC

He began exhibiting his work in New York City at age 19. At age 20, he became the youngest exhibitor in the history of the Whitney Museum, and by 1972 a number of museums had acquired major works by him. His roots as a painter are the Abstract Expressionists, whose works he saw while growing up in New York. He is known as a colorist, and his paintings seem to be a blend of abstraction and landscape.

LANE, LOIS (Painter, Printmaker)
c/o Willard Gallery, 29 E. 72nd St., New York NY 10021

Born: 1948 *Awards:* Fellowship in Painting, National Endowment for the Arts; New York State Council on the Arts Creative Artist Public Services Program Grant *Collections:* Whitney Museum of American Art; Museum of Modern Art *Exhibitions:* Whitney Museum of American Art; Museum of Modern Art *Education:* Philadelphia College of Art; Yale University School of Art *Dealer:* Willard Gallery, NYC

A New Image Painter, her oil paintings depict isolated images, with the goal that it leave "some sense of isolation," that it be "not entirely clear," and that it be "a shared experience." The images come from drawings she makes after photographs from magazines, and are rendered in close-valued colors. The canvases are "split" in earlier white paintings by shapes placed in a row down the center. A painting such as *Mardi Gras* is an example of the later "split" canvases, in which two dominant plant-like forms, one on either side, balance the composition so that the viewer cannot focus on both at once.

LANYON, ELLEN (Painter, Printmaker)
412 N. Clark St., Chicago IL 60610

Born: 1926 *Awards:* National Endowment for the Arts Award; Yaddo Fellowship *Collections:* Metropolitan Museum of Art; Art Institute of Chicago *Exhibitions:* Metropolitan Museum of Art; Museum of Modern Art *Education:* School of the Art Institute of Chicago; Iowa State University; Courtauld Institute, University of London *Dealer:* Richard Gray, Chicago; Susan Caldwell, NYC

Early depictions of her native Chicago landscape were rendered in egg tempera. In 1951 a series of monochromatic interiors were painted from old photographs of relatives. Ten years later an interest in magic led to a series of fantastic paintings dealing with table magic. She is known for the many surrealistic works of the 1970s such as *Spoolbox—Thread Web Construction* or *Super Die-Box*, primarily acrylic paintings on canvas which depict boxes which open like Pandora's to reveal insects, lizards, snakes and other creatures. Recent paintings and drawings do not feature boxes, but are instead delicate and sensitive depictions of birds, flowers and fans in a magic realist style.

LASUCHIN, MICHAEL (Painter)
120 E. Cliveden St., Philadelphia, PA 19119

Born: 1923 *Awards:* Medal of Honor, Audubon Artists; Gold Medal, National Watercolor Society *Collections:* Brooklyn Museum; Museum of Modern Art, Barcelona, Spain *Exhibitions:* 10th International Print Biennial, Cracow, Poland; Cabo Frio International, Brazil *Education:* Philadelphia College of Art; Tyler School of Art

His geometric paintings are metaphoric, with somewhat metaphysical inferences. The works convey a vibrant, positive life. Areas of interaction relate to a declared space within configurations. Scale and the absence of romantic gestures are important issues in establishing the personality of his work. All his paintings are characterized by harmonic resolution, and upbeat character, and an often otherworldly presence.

LAUFFER, ALICE (Painter)
123 N. Jefferson St. Chicago, IL 60606

Born: 1919 *Awards:* James Broadus Clarke Award, Art Institute of Chicago *Collections:* Art Institute of Chicago; Minnesota Museum of Art *Exhibitions:* Art Institute of Chicago; Artemisia Gallery, Chicago *Education:* The School of the Art Institute of Chicago

A painter of smooth, sensual, subtly modeled surfaces, her work with curvilinear shapes and modified elliptical forms results in original, easily recognizable imagery. In the late 1960s and early 1970s, the subjects of her drawings and prints were related to science and space. Her art evolved through geometric constructions to a more complex, amorphous subject matter. Currently her work is figurative but not realistic. The subjects often are mythic female figures in a landscape of flora and fauna intertwined in a surrealistic metaphor. The references relate to her "earth mother" and ecological views of the world.

LAUGHLIN, MORTIMER (Painter)
Rd. 1, Box 8, Susquehanna PA 18847

Born: 1918 *Collections:* Linn Selby; Ronald Coons *Exhibitions:* Museum of Modern Art; San Francisco Museum of Modern Art *Education:* Hollywood Art Center; Abbott Art School; Art Students League *Dealer:* Bartholet Gallery, NYC

Tranquil, visionary scenes in a palette dominated by cool blues and whites characterized his earlier work. Wild white horses, exotic birds and fish, glistening trees and mountain peaks were bathed in a soft moonlight. Occasionally objects were arranged in magical settings, as in *The Dining Room* (also called *Life is a Series of Musical Chairs*). From a studio isolated in the mountains of Pennsylvania, he continues to portray a dream-like imaginary world, but with a warmer palette, so that his magical visions are now bathed in a warm golden glow.

LAWRENCE, JACOB (Painter, Printmaker)
4316 37th Ave. NE, Seattle, WA 98105

Born: 1917 *Awards:* Grant, National Institute of Arts and Letters; Fellowship, John Simon Guggenheim Memorial Foundation *Collections:* Museum of Modern Art; Whitney Museum of American Art *Exhibitions:* Brooklyn Museum; Whitney Museum of American Art *Education:* Harlem Art Center; Pratt Institute *Dealer:* Terry Dintenfass Gallery, NYC

A painter in oils, acrylics, gouache and casein, as well as a printmaker, his early work in the 1930s consisted

Alice Lauffer, *Phantastic Garden*, 40 x 40, acrylic.

Dominick Labino, *Faceted Fountain*, 5 x 8, hot glass sculpture.

of scenes from the Harlem community; bars, churches, street orators, dance halls, vaudeville, people at work and play, and the interiors of tenements. For the past decade, and in various ways throughout his career, he has concentrated on scenes depicting people at work. As a result, he has concentrated in content on the builders theme. In formalistic terms, he attempts to achieve the rhythm, shape and color of tools, and the atmosphere in which people use them in a highly stylized and colorful style.

LAXSON, RUTH (Painter)
P.O. Box 9731, Atlanta, GA 30319

Born: 1924 *Awards:* Exhibition Grant, National Endowment for the Arts *Collections:* Museum of Modern Art; Sackner Collection, Miami, FL *Exhibitions:* University of Wisconsin-Madison; Center for Book Art, NYC *Education:* Atlanta College of Art *Dealer:* Heath Gallery, Atlanta; Artworks, Los Angeles

The past work consisted of etchings, woodcuts, and oil paintings, containing some organic imagery but dealing also with human communication and its lexicon of markings. More recently her handmade paper pieces have led to artists' books, a vehicle for nurturing and shaping language-related art. These works contain drawing, printmaking, collage, and embossing. While the artists' books are still a strong concern, her present work is a series of ink drawings, with music/physics imagery. These are to function as scores or notation for performance by visual artists and musicians.

LAZAROF, ELEANORE BERMAN (Painter)
718 N. Maple Dr., Beverly Hills, CA 90210

Born: 1928 *Collections:* Brooklyn Museum, Los Angeles County Museum of Art *Education:* University of California, Los Angeles; Leger Atelier, Paris *Dealer:* DeGooyer, Los Angeles

Her work of the 1970s was mostly abstract, referring to the organic world of earth and stone shapes. From this grew another body of work of a painterly color field style, with brushed and scratched diagonal strokes evoking the flowing energy of air and water. In her current work these diagonal strokes are shorter, and evoke the dappled light and shade of gardens and tree forms. There is some figuration in the overall energized surface. Her medium is largely oil on canvas, with some smaller works of pastel and oil on paper and editions of large-format color etchings.

LEDERMAN, SHEYA NEWMAN (Painter)
44 Jayson Ave., Great Neck, NY 11021

Born: 1921 *Awards:* Wanamaker Medal, National League of American Penwomen *Collections:* Educational Association; Hunter College *Exhibitions:* Lever House, NYC; Smithsonian Institution *Education:* Hunter College; Wayne State University

Her past works are strongly expressionistic, with the watercolors influenced by Winslow Homer and the oils by Dali, Whistler, and Manet. Her landscapes and seascapes are done directly from nature, "on location," as are her still lifes and portraiture. Currently she works in a strictly figurative manner. She works mostly in the early morning or the late afternoon when the light evokes a subtle range of colors and tones.

LEON, DENNIS (Sculptor, Painter)
2501 14th Ave., Oakland, CA 94606

Born: 1933 *Awards:* Fellowship, John Simon Guggenheim Memorial Foundation; National Institute of Arts

and Letters *Collections:* Storm King Art Center, NY; San Francisco Museum of Modern Art *Exhibitions:* Kraushaar Galleries, NYC; Fuller Goldeen Gallery, San Francisco *Education:* Tyler School of Art, Temple University *Dealer:* Fuller Goldeen Gallery, San Francisco

His works prior to 1975 were studio sculptures, using materials very directly. These works ranged in scale from the very small to twenty feet, and always were accompanied by drawing. At present his work involves landscape. He is creating very large works done outdoors with local materials. The scale may reach 100 feet in these pieces. His new oil paintings and pastels use the same landscape themes. A very recent development is the placing of figures in the landscapes.

LERNER, SANDRA (Painter)
10 East 18th Street, New York, NY 10003

Awards: Anne Eisner Putnam Prize, National Association of Women Artists; Benjamin Altman Prize, National Academy of Design *Collections:* Aldrich Museum of Contemporary Art; Kampo Museum, Japan *Exhibitions:* Museum of Fine Arts, Houston; Kauffman Gallery, Houston *Education:* Brooklyn College; Pratt Graphic Institute *Dealer:* Betty Parsons Gallery, NYC; Kauffman Gallery, Houston

Large abstract oil canvases—some up to ten by seven and a half feet in size—making use of collage, impasto, stains and semi-calligraphic squiggles characterize this artist's work. Eastern philosophy is as much a part of painting as technique for her. Influenced by the the the writings of 6th century thinker and poet, Lao Tsu, she strives throughout her work to reveal how the divergent parts of the universe combine to form a oneness of all things. Her recent work has included the *Inland Sea Series.* Inspired by a recent trip to Japan, these large gestural abstract canvases executed on beige-toned backgrounds, incorporate both painting and collage, and multiple transparent layers of delicate, soft poetic images, with deft calligraphic elements. Gestural content, drips and splashes in black, charcoal gray and mixed violet and green create the pulse of the painting. She succeeds in combining the spirit of Eastern culture with contemporary Western sensibilities.

LERNER, SANDY R. (Painter, Lithographer)
71 W. 23rd St., New York, NY 10010

Born: 1918 *Awards:* Lyle Award, Salmagundi Club *Collections:* Smithsonian Institution; Navy Museum *Exhibitions:* National Arts Club; Audubon Artists *Education:* Pratt Institute; Art Students League, NYC; Washington University *Dealer:* Schuster Gallery, NYC

The beauty of the sky, the clouds, or the earth as seen from space compose the imagery of his paintings. Although a major influence on his work was his first teacher, Henry J. Soulens, whose visits to the Orient and Palestine gave him the tools later used in painting the deserts of Arizona and New Mexico, without a doubt the strongest influence on his paintings was his many years as a pilot in the United State Air Force. Each of his many landscapes gives the feeling of being painted from above or perhaps while landing. Newer work continues in a similar style but whereas previous work gave us a feeling of flying, the new paintings are now cosmic, giving us the feeling of space. The color—or lack of it—of the heavens and the earth as seen from the stratosphere, and the texture of the paintings, add a dimension and subtlety, as well as great beauty.

LE ROY, HAROLD M. (Painter)
1916 Ave. K., Brooklyn, NY 11230

Mortimer Laughlin, *The Vision,* 30 x 40, oil. Courtesy: Bartholet Gallery (New York NY)

Harold M. LeRoy, *French Landscape,* 20 x 16, oil.
Courtesy: Belanthi Gallery (Brooklyn NY)

Eleanore Berman Lazarof, *Canto Variation,* 40 x 30,
Intaglio. Courtesy: Kirk De Gooyer (Los Angeles CA)

Born: 1905 *Awards:* American Society of Contemporary Artists; American Veterans Society of Artists *Collections:* Princess Grace Collection; Butler Institute of American Art *Exhibitions:* Belanthi Gallery, Brooklyn, NY; Randall Gallery, NYC *Education:* Brooklyn Museum School; Art Students League *Dealer:* Belanthi Gallery, Brooklyn, NY; Randall Gallery, NYC

His work can be recognized by his unusual use of color. He is influenced by Van Gogh, but his contrasts reflect the push and pull of Hans Hofmann, with whom he studied. He has gone through periods of abstract expressionism and hard-edge painting, and now is back to representational work. The recent paintings include canvases portraying unusual scenes of Paris and Provence, France. Among these works are scenes which were painted by the Cubists and Impressionists originally—such as Mount Saint Victoire—but done in his own unique style of vivid colors.

LESHER, MARIE PALMISANO (Sculptor)
10130 Shady River Rd., Houston, TX 77042

Born: 1919 *Awards:* International Women's Art Festival; Prix de Paris *Collections:* U.S. Embassy, London; Smithsonian Institution *Exhibitions:* Beaumount (TX) Art Museum; Hooks-epstein Galleries, Houston *Education:* Berte Studio, Philadelphia; University of Houston *Dealer:* Sol Del Rio, San Antonio, TX

She works in bronze, portraying human, animal, bird, and abstract forms. The current bronze sculptures continue her focus on the female form. The new works offer challenging interpretations. More stylized than her earlier designs, the undisclosed details suppressed by abstraction provoke intimate response from the viewer.

LESLIE, ALFRED (Painter)
c/o University of Arkansas Fine Arts Center Gallery, Fayetteville AR 72701

Born: 1927 *Awards: Collections:* Whitney Museum of American Art; Albright-Knox Gallery *Exhibitions:* Fifth Sao Paulo Bienale; Museum of Modern Art *Education:* New York University *Dealer:* University of Arkansas Fine Arts Center Gallery, Fayetteville

A second-generation New York Painter, he studied with Tony Smith, William Baziotes, John McPherson, and Hale Woodruff in the mid-1950s. Large canvases were Action Paintings done in a limited palette, containing shapes, sometimes with additional vertical stripes, as in *The Minx*. For a few years realistic collage was added to the abstract geometrical forms, but in 1964 the work became realistic and figurative. Figures were monumental, vigorously drawn in an exacting manner. In the 1970s baroque paintings evocative of Caravaggio portrayed current events. Recent realistic figural works are dramatic character studies, some depicting Biblical themes.

LEVIN, ELI (Painter)
445 Don Miguel, Santa Fe, NM 87501

Born: 1938 *Collections:* Museum of New Mexico; Roswell Museum *Exhibitions:* Phoenix Museum; New Mexico Governor's Gallery *Dealer:* Ernesto Mayans Gallery, Sante Fe

He first gained prominence as a painter with his *Bar Room* series. In the tradition of the social realists, these oil paintings depicted crowded bar room scenes with satirical under-tones. There are affinities in his style and subject matter with the works of Sloan, Marsh, Cadmus, and Rivera. In current work he continues to paint crowd scenes while a larger number of his compositions are devoted to still life subjects executed in the rich, luminous hues of the egg tempera medium. Interior scenes, landscapes, and nudes comprise the remainder of his recent paintings.

LEVINE, JACK (Painter)
68 Morton St., New York NY 10014

Born: 1915 *Awards:* Fellowship, John Simon Guggenheim Memorial Foundation; Corcoran Gallery Medals *Collections:* Metropolitan Museum of Art; Museum of Modern Art *Exhibitions:* Whitney Museum of American Art; Art Institute of Chicago *Dealer:* Kennedy Galleries, NYC

Originally from a poor Jewish section of Boston, he studied with Harold Zimmerman at the Jewish Welfare Center while still in high school. He was given a studio at Harvard University when he studied privately with Denman Ross from 1929 to 1931. Early influences came from Rembrandt and Honore Daumier during his moralistic works in 1935 for the W.P.A. Federal Arts Project. Complex arrangements of distorted figures in dramatic lighting were characteristic of subsequent satirical paintings, reflecting the themes of corruption and dehumanization, as in the well-known *Gangster's Funeral* (1952-1953). Political and social commentaries of the 1940s and 1950s were anti-capitalist and anti-military. Later works have continued to depict group scenes, including circuses and fairs. More recently he has turned to Biblical and other subjects related to Judaism.

LEVINE, LES (Sculptor)
20 E. 20th St., New York, NY 10003

Born: 1935 *Awards:* First Prize, Art Gallery of Ontario; National Endowment for the Arts *Collections:* Museum of Modern Art; Metropolitan Museum of Art *Exhibitions:* Documenta, Kassel, West Germany; Finch College Museum *Education:* Central School of Arts and Crafts, London *Dealer:* Ronald Feldman Fine Arts, New York, NY

A founder of media art, his first videotapes were produced in 1964. Since then he has produced environments, installations, sculptures, and mass media campaigns. He also produces plasticine models for these media projects. His large-scale drawings on canvas are usually 6' x 8' in size and are done with oil stick. He also has produced many wax-on-paper drawings. Generally his work consists of an image of an object, such as a building, combined with a word. A recent drawing, his largest ever, is entitled *Taking A Position*.

LEVINE, MARILYN (Sculptor)
950 61st Street, Oakland, CA 94608

Born: 1935 *Awards:* Arts Award, Canada Council; Fellowship, National Endowment for the Arts *Collections:* National Museum of Modern Art, Kyoto and Tokyo; Australian National Gallery *Exhibitions:* Institute of Contemporary Art, Boston; O.K. Harris Gallery; NYC *Education:* University of Regina; University of California at Berkeley *Dealer:* O.K. Harris, NYC; Fuller Goldeen Gallery, San Francisco

She is best known for her realistic illusionist ceramic sculpture. Her early work however, was in painting, functional pottery, and hard edge ceramic sculpture. The most recent pieces are illusionistic simulations in clay of three dimensional leather objects. She is astonishingly adept at the transformation of stoneware into

convincing replicas of worn leather bags, satchels, and garments. There is an emphasis on a sense of human history as told by wear, use, and their associations.

LEVINSON, MON (Painter, Sculptor)
309 W. Broadway, New York NY 10013

Born: 1926 *Awards:* National Endowment for the Arts Fellowship; Creative Artists Public Services Program Award, New York State Council on the Arts *Collections:* Whitney Museum of American Art; Albright-Knox Art Gallery *Exhibitions:* Whitney Museum of American Art Sculpture Annual; Hirshhorn Museum & Sculpture Garden *Education:* Self-taught

He did not begin exhibiting until 1960, with "knife drawings" such as the *Tondo* series. During the next several years constructions were made of such materials as plexiglass, ink, paper and acetate. In the late 1970s he became concerned with process as well as product. The works involved conceptual, serial and process art found in hand-dyed paper and cotton duck executed with inks and acrylics, often cleverly mounted in plexiglass boxes which created a mysterious and evocative aura.

LEW, WEYMAN (Painter, Printmaker)
2810 Pacific Ave., San Francisco, CA 94115

Born: 1935 *Awards:* Merit Award, San Franciso Art Festival *Collections:* San Francisco Museum of Art; Brooklyn Museum *Exhibitions:* M. H. De Young Memorial Museum; Santa Barbara Museum *Education:* University of California, Berkeley; San Francisco Art Institute

His pen and ink drawings, watercolors, serigraphs, and etchings translate the human figure into volumes of flesh and rhythmic lines which seem to float effortlessly across the paper. Early black and white compositions used an economy of line in contrast with space, producing ambiguous and often humorous forms. Recent work has added color as well as flora and fauna to the figurative elements. The lines twist and cavort with a seemingly independent vitality and the imagination is encouraged to complete the spare, evocative images.

LEWITT, SOL (Sculptor, Conceptual Artist)
c/o John Weber Gallery, 1452 Greene St., New York NY 10012

Born: 1928 *Collections:* Museum of Modern Art; Albright-Knox Gallery *Exhibitions:* Whitney Museum Annual; Museum of Modern Art *Education:* Syracuse University *Dealer:* John Weber Gallery, NYC

After working for architect I.M. Pei in the mid-1950s, he began making wall reliefs and then three-dimensional sculptures. With the open modular cubical structures of 1964 he was recognized as a Minimalist. Wall drawings three years later were deliberately painted over after their exhibition, emphasizing their impermanence. A spokesman for Conceptual Art, he published several articles in the late 1960s describing the artist's concept and formulation of an idea as more important than its execution. Wood or metal open cubes in various arrangements are often painted white in order to draw attention away from the display itself. Thus the titles are significant because they bring meaning to the work by describing its premise, so that abstractions of mathematics, philosophy and linguistics are made visible.

LEWTON, VAL EDWIN (Painter)
404 Tenth St. SE, Washington, DC 20003

Born: 1937 *Collections:* National Museum of American Art; Corcoran Gallery of Art *Exhibitions:* Studio Gallery, Washington, DC; Plum Gallery, Kensington, MD *Education:* Claremont College *Dealer:* Plum Gallery, Washington, DC

In early abstract, figurative paintings he dealt with subjects of social commentary. This led to his large acrylic paintings on canvas depicting areas of economic and social transition within a neighborhood—such as car lots and gas stations. His objective renderings of urban and suburban scenes are taken largely from sites in and around Washington, D.C. Working currently in both acrylic and watercolor, he studies the changing neighborhood around an old downtown Washington synagogue. Gradually the surrounding structures have been ripped away leaving the cityscape stark and chaotic.

LIBERMAN, ALEXANDER (Sculptor)
173 E. 70th St., New York NY 10021

Born: 1912 *Awards:* Chevalier, Legion Honor, France; Gold Medal for Design, Paris International Exhibition *Collections:* Museum of Modern Art; Art Institute of Chicago *Exhibitions:* Museum of Modern Art; Corcoran Gallery of Art *Education:* L'Ecole des Beaux-Arts, Paris; Ecole Special d'Architecture *Dealer:* Andre Emmerich Gallery, NYC; Janie C. Lee Gallery, Houston

Born in Kiev, Russia, he studied painting in Paris with Andre Lhote, then architecture with August Peret. He came to America in 1940 and began painting geometric shapes, like the circle in *Minimum*. The circles later seemed to be placed in illusionistic space as the transition to sculpture was made. Votives and icons were planar geometric shapes often constructed from aluminum. Experiments with assemblage in the 1960s led to a series of painted outdoor pieces made of cut boiler-tanks and pipes, such as *Realms*. In 1970 huge hollow columns of steel were sliced at an angle to reveal ellipses, as in *Firmament*. Also a photographer, he often records the steps taken during construction of outdoor pieces as they are rearranged and re-worked. He has published photographic essays, and has been the editorial director of Conde Nast Publications magazines—including *Vogue* and *Glamour*—for over twenty years.

LICHTENSTEIN, ROY (Painter)
P.O. Box 1369, Southampton NY 11968

Born: 1923 *Collections:* Whitney Museum of American Art; Museum of Modern Art *Exhibitions:* Solomon R. Guggenheim Museum; Whitney Museum Annual *Education:* The Ohio St. University; Art Students League *Dealer:* Leo Castelli Gallery, NYC

As a young painter his style was abstract expressionist, but in 1957 cartoon images from bubble-gum wrappers were his motifs, and during the early 1960s he became increasingly concerned with making art from mass-produced merchandize. Huge reproductions of single frames from comic-strips using Ben Day dots (a simulation of the typographic technique) were contributions to the Pop movement. In later years media included sculpture, reliefs which were representations of images borrowed from comic-strips and art deco. Reproductions of advertising fragments, travel posters, romance characters, or stylized landscapes, make insipid what is already trite. He avoids definition by continuing to make derivatives. Using an anonymous language, the sources are transformed, presenting new terms for understanding art.

LIDOW, LEZA (Painter)
454 Cuesta Way, Los Angeles, CA 90077

Born: 1924 *Collections:* International Rectifier Corp. *Exhibitions:* Los Angeles County Art Museum; Security Pacific Bank *Dealer:* Ankrum Gallery, Los Angeles

7,13/She is a realist painter working in the oil and acrylic media. The "old masters" are her primary technical influence and she continues to use their classic formulas for color. She paints with a harmonious, subdued palette using a flat brush stroke. Her current work is concerned with the problems of men and women living in the contemporary world while yearning for the past. In her paintings, often of interiors, there are objects of beauty, vases, plants, perhaps a cat, yet there is an undertone of surrealism and an almost tangible nostalgia.

LIEBERMAN, LOUIS (Sculptor)
16 Greene St., New York, NY 10013

Born: 1944 *Awards:* Fellowship, National Endowment for the Arts; Grant, Creative Artists Public Service *Collections:* Metropolitan Museum of Art; Philadelphia Museum of Art *Exhibitions:* Columbus Museum of Art; Aldrich Museum of Contemporary Art *Education:* Rhode Island School of Design; Brooklyn College *Dealer:* Ellen Price, NYC

Earlier works were relief sculptures derived from simple biomorphic forms built directly on to the wall and painted flat white. These earlier pieces led to paper reliefs, also pure white, which in turn led to larger scale graphite drawings, both on paper and on gesso/fiberglass castings that emerged from the wall in the same manner. Current work incorporates the essential features of previous wall pieces but has additional use of color, usually pastel chalk and plasticine clay, applied to the surface.

LIGAMARI, TONY (Painter)
190 Duane St., New York, NY 10013

Born: 1952 *Awards:* Scholarship, Skowhegan School, ME *Collections:* Rene Dirosa, Napa, CA; Roselyn Swig, San Franciso *Exhibitions:* San Francisco Museum of Modern Art, Rental Gallery; Fuller Goldeen Gallery, San Francisco *Education:* School of Visual Arts, NYC; San Francisco Art Institute *Dealer:* Fuller Goldeen Gallery, San Francisco

He studied and worked in video for six years, and his earlier canvases show his interest in the idea of lines creating images as in television. He worked with individual lines that connected and overlapped to form geometric shapes. His focus switched to surface and space. He wanted to show the illusion of deep space while confined to a two-dimensional surface. His present work continues to deal with projecting deep space, but the shapes are no longer static. There is a lot of new movement with fragments and shapes exploding from the canvas.

LIGARE, DAVID (Painter)
19518 Creekside Ct., Salinas CA 93908

Born: 1945 *Collections:* Museum of Modern Art; Thyssen-Bornemisza Collection *Exhibitions:* Phoenix Art Museum; Andrew Crispo Gallery, NYC *Education:* Art Center College of Design *Dealer:* Robert Schoelkopf Gallery, NYC; Koplin Gallery, Los Angeles

His early work in middle-to-large scale oil paintings is best typified by his concern with forms derived from classic Greek sculpture combining still life and landscape aspects. In later work, he employed photo realist techniques to achieve carefully structured scenes that had the appearance of casual snapshots. Working from photographs of draperies thrown into the air, he often set the floating cloth forms against coastal landscapes to create scenes of tilted horizons and sunlit cloth. Paintings were named after Greek islands and referred metaphorically to classical sculpture. He has referred to this attention to the past in his pieces as "anachronistic painting". His current large-scale figurative paintings represent a further incorporation of Greek mythology into his work. Traditional themes present in the paintings are interpreted in a contemporary manner through the use of a painterly realism derived from photographs.

LIND, JENNIFER (Painter)
Rt. 2, Box 226, La Cienega, Santa Fe, NM 87501

Born: 1942

A glaze painter and production potter, perhaps best known for her porcelain sketches, the body of her work to date reflects her belief that function is as important as form and drawing. The basis of her work is functional ceramics. She decorates her work with drawings that are both realistic and expressionistic. Her primary medium is high-temperature porcelain. Recently her work has become larger in scale, and more painterly. It is brightly decorated with China paints and underglaze stains. Among the latest pieces are a series of non-functional, standing slabs.

LIPOFSKY, MARVIN B. (Sculptor)
1012 Pardee, Berkeley, CA 94710

Born: 1938 *Awards:* Fellowship, National Endowment for the Arts *Collections:* National Museum of Modern Art, Kyoto, Japan; Museum of Contemporary Crafts, NYC *Exhibitions:* San Francisco Museum of Art; Greenwood Gallery, Washington, DC *Education:* University of Wisconsin-Madison *Dealer:* Betsy Rosenfield, Chicago

Since 1970 he has worked in glass factories throughout Europe, Australia, Japan, and New Zealand. His interest has been to combine the culture and environment of the factory with his aesthetic judgment, and to absorb the intensity of the factory's daily routine. Each series has been produced by collaborating with factory workers and individual masters. In 1982 he initiated a series of work at the California College of Arts and Crafts. He blew large forms, trying to reveal the glass through color and structure. After studying the results he finished the work in his studio, cutting open the forms to reveal the inner and outer forms and colors. This process resulted in *The California Storm Series.*

LIPPINCOTT, JANET (Painter)
P.O. Box 2970, Santa Fe, NM 87504

Born: 1918 *Awards:* El Paso Museum Prize; New Mexico Museum of Fine Arts *Collections:* Utah Fine Arts Museum; Denver Art Museum *Exhibitions:* Albuquerque Museum of Art; Muse d'Art Moderne, Paris *Education:* Art Students League, NYC; San Francisco Art Institute; Colorado Springs Fine Arts Center

A versatile painter in a variety of media including oils, acrylic and watercolors, current work has been almost exclusively in oil and acrylic. She has been deeply influenced by both the color sense and numismatic qualities present in the work of the late Mark Rothko as well as the expansive landscape of the Southwestern

Robert Longo, *We Want God* (1984), 96 x 115, mixed media. Courtesy: Metro Pictures (New York NY)

Marilyn Levine, *John's Jacket,* 36 x 23 x 7, ceramic & mixed media. Fuller Goldeen (San Francisco CA)

Joyce Prindiville Lopez, *The Bishop Enters Through Red Door,* 37 x 16 x 28, wood & cotton thread.

United States, especially New Mexico. Regional influences are also apparent in her interest in and exploration of American Indian sand painting.

LITTLECHIEF, BARTHELL (Painter, Sculptor)
Rt. 3, Box 109A, Anadarko OK 73005

Born: 1941 *Awards:* First Place, American Indian Exhibition, Anadarko (OK); First Place, Trail of Tears Art Show, Talequah (OK) *Collections:* U.S. Dept. of Interior; Southwestern Museum, Los Angeles *Exhibitions:* American Contemporary Paintings, Traveling Exhibit of South America; Native American Center of Living Arts, Niagra Falls *Dealer:* The Galleria, Norman, OK; Oklahoma Indian Art Gallery, Oklahoma City

A Kiowa-Comanche Indian, early work reflected a traditional Native American heritage, in a flattened figurative style rendered in watercolor. He was influenced then by friend James Auchiah, one of the original Five Kiowa Artists. After formal study, unlike his Indian contemporaries, he broke from the traditional style and began painting abstractly in acrylic. Later influences were the expressionistic works of Mark Rothko and Frank Stella. Primary media are tempera and gouache; in sculpture they are terra cotta and bronze casting. Recently he has returned to the figure. "I owe a duty not only to create something appealing to the eye but also to preserve my people's traditions."

LIVINGSTONE, JOAN (Sculptor, Fiber Artist)
1443 West Jarvis, Chicago, IL 60626

Born: 1948 *Awards:* Fellowship, National Endowment for the Arts; Founders Award, Portland Shakespeare Company *Collections:* Cranbrook Academy of Art Museum; The Robert Pfannebecker Collection, Lancaster *Exhibitions:* Ferris State College; Hadler-Rodriguez Gallery, NYC *Education:* Portland State University; Cranbrook Academy of Art

She creates fabric that is more like architecture than cloth, standing walls of felted fabric which present surface images akin to paintings without frames. The planes are formed as sculptural entities, and steel structures are used to present the massive surfaces of felted fibers giving them support and posture in space. The hand-made felt that forms the cloth plane is responsive and fluid, implying flexibility and change, yet rigorous enough to give stable form and gesture. An earlier work, *Dante's First Curtain* was a large scale felted fabric "curtain" that incorporated abstract gestural markings and graffiti derived iconography. Her work for the past year and a half has lead her to explore a group of "figures"—forms which are referential to certain animal shapes, and which use fabric more sparingly than prior work in an attempt to integrate structural and linear elements, such as wood, with a fluid cloth plane.

LONG, FRANK WEATHERS (Painter, Printmaker)
1836 Florida NE, Albuquerque, NM 87110

Born: 1906 *Awards:* First Prize, New Mexico Biennial, Santa Fe, NM; First Prize, National Arts and Crafts Benefit Show, Albuquerque *Collections:* Albuquerque Museum; University of Kentucky Art Museum *Exhibitions:* Museum of International Folk Art, Santa Fe, NM; New Mexico Western University, Silver City, NM *Education:* School of the Art Institute of Chicago; Pennsylvania Academy of Fine Arts *Dealer:* Mariposa Gallery, Albuquerque

A painter, muralist, and printmaker from 1930 to 1942, his career was interrupted by military service during World War II. Since then he has devoted his talents to the field of contemporary crafts. He directed programs for the Indian Arts & Crafts Board in Alaska, Florida, and the Southwest, developing arts and crafts projects for Eskimos and Indians. Since resigning from the board in 1969 he has devoted his time to his own work as jeweler, metal smith, and lapidary carver. His pieces are unique in the combining of metals and lapidary materials in original and creative techniques.

LONGO, ROBERT (Sculptor, Painter)
c/o Metro Pictures, 150 Greene St., New York NY 10012

Born: 1953 *Collections:* Tate Gallery, London; Museum of Modern Art *Exhibitions:* Leo Castelli Gallery; Akron Art Museum *Dealer:* Texas Gallery, Houston; Editions Schellmann and Kluser, NYC; Middendorf Gallery, Washington, DC

A versatile artist, he has done performances which combine dance, sculpture, film and theatre, such as *Empire*. Large-scale black and white drawings depict figures in urban attire and animated postures. Sculpted reliefs in bronze depict figures or imposing buildings. He has also made prints and paintings and has employed such media as ink, acrylic, and charcoal on a variety of surfaces such as aluminum, wood and Masonite. Interests in the power of fascism, nostalgia and melodrama wield a strong influence upon his diverse creations. All of the work is concerned with the surface of things, with a super-real simulation, and has been called "sheer style."

LOPEZ, JOYCE PRINDIVILLE (Painter, Sculptor)
927 Noyes St., Evanston IL 60201

Born: 1941 *Awards:* Illinois Arts Council Grant *Collections:* City of Chicago; Bank of America *Exhibitions:* Ukranian Institute of Modern Art; Art-Expo, Chicago *Education:* School of the Art Institute of Chicago

A constructivist, she seeks in her paintings and sculptures "to reconcile inner human conflicts through creative use of form and space." Wooden sculptures contrast strong forms with "profiled edge detailing," to unify seemingly unrelated elements. A recent series of paintings, *Phoenix,* depict the illusions of depth and texture, juxtaposing a layered ground with active hard-edged shapes. "Like the mystical regeneration of the phoenix bird, the paintings are a synthesis of the renewal of energy."

LOPINA, LOUISE CAROL (Painter)
3 Weatherstone Way, Smithtown, NY 11787

Born: 1936 *Awards:* Best in Show, Bruckner Memorial Award, National Nature Exhibition; Best in Show, Purdue University *Collections:* The Cincinnati Club; Miami Bank of Ohio *Exhibitions:* Garden of the Gods, Colorado Springs; Air University Library *Education:* School of the Art Institute of Chicago *Dealer:* G & R Gallery of Wildlife Art, Buffalo

Her early paintings, as well as current pieces, invariably have animals as their subject matter. Her animal portraiture allows each one of the animals or birds depicted in her oil and watercolor paintings to have a personality of its own; Even in a heard of Buffalo no two will look the same. Her oils are rich and full colored earth tones, her watercolors transparent and fluid. Design elements in her paintings are inspired by the abstract artist Franz Kline yet she works in a painterly fashion in the spirit of Bruno Liljefors and Arthur Tate whose paintings the artist cites as being important

for their depiction of "feelings and behavior of animals more than detail for detail's sake"

LOSTUTTER, ROBERT (Painter)
c/o Dart Gallery, 212 W. Superior, No. 203, Chicago IL 60610

Born: 1939 *Collections:* Art Institute of Chicago; Museum of Contemporary Art, Chicago *Exhibitions:* Renaissance Society, University of Chicago; Dart Gallery *Education:* School of the Art Institute of Chicago *Dealer:* Monique Knowlton Gallery, NYC; Dart Gallery, Chicago

In the late 1950s he was influenced not by Abstract Expressionism but by John Rogers Cox, an academic painter who spoke of the importance of preliminary drawings and glazing methods. Richard Lindner also influenced Lostutter's development of a personal iconography. Unlike many of his fellow Chicago Imagists he is very concerned with technique, and spends many hours working on preparatory sketches and watercolors before painstakingly painting, glazing and repainting. Early imagery centered upon masked figures in some type of bondage with ropes. During the mid-1970s bird-like heads or masks were added to the figures, and more recently flowers were tied to a figure's chest or head, as in *Hummingbird and Two Orchids*. These quasi-erotic paintings also seem to express the pleasure and pain of man's co-existence with nature.

LUNDIN, NORMAN K. (Painter)
c/o Francine Seders Gallery, 6701 Greenwood Ave. North, Seattle WA 98103

Born: 1938 *Awards:* National Endowment for the Arts Grant; Ford Foundation Grant *Collections:* Whitney Museum of American Art; Museum of Modern Art *Exhibitions:* Seattle Art Museum; Los Angeles Municipal Museum *Education:* School of the Art Institute of Chicago; University of Chicago; University of Cincinnati *Dealer:* Allan Stone Gallery, NYC; Jack Rasmussen Gallery, Washington, DC

Early work is predominantly figure drawings and paintings, though he has also dealt with landscape subjects. The figures in his works often are placed in interior settings with strong directed light. He organizes his compositions around the shapes of light and dark, not around the shapes of the objects or figures depicted. In his more recent work, the figures have disappeared from the composition and sunlit, atmosphere filled interior spaces are all that remain. These works are executed in pastel and dry pigment, suggesting an atmospheric luminosity that differs from the air-filled spaces of his earlier paintings. The color effects are subtle, with large neutral areas enlivened by strategically placed patches of intense color. In all his works, he is interested in using color to control space.

LUTZ, MARJORIE BRUNHOFF (Sculptor)
203 E. 72nd St., New York, NY 10021

Awards: Doris Kreindler Memorial Award, American Society of Contemporary Artists *Collections:* Joyce and Daniel Cowen Collection *Exhibitions:* Southern Vermont Art Center, Manchester, VT *Education:* Art Students League

She is a sculptor whose work is primarily figurative and humanist, but incorporates abstracted thoughts. Her style ranges from minimal to representational. She works mostly in bronze in recent years, but she also has worked in stone, wood carving, and welded steel. Among her early influences were de Brunhoff draw-

ings, Rodin sculpture, and Toulouse-Lautrec posters. While living in Rome and North Africa she was impressed by the influences of ancient Rome and Renaissance Europe. Strong recent influences include Degas, Henry Moore, Elizabeth Frink, and Mary Frank.

LYNCH, MARY BRITTEN (Painter)
1505 Woodnymph Trail, Lookout Mountain, TN 37350

Born: 1934 *Awards:* Medal of Honor, National Association of Women Artists; Drawing Award, Tennessee State Museum *Collections:* University of Tennessee, Chattanooga; Anchorage (AK) Museum *Exhibitions:* USA Works on Paper (traveling show); Anchorage (AK) Museum *Education:* University of Tennessee, Chattanooga; Provincetown (MA) Workshop *Dealer:* Art South, Montgomery, AL; Norman Worrell, Nashville; The Gallery, Chattanooga, TN; Muse Arts Gallery, Springfield, MO

Up until a few years ago her works were largely representational, but always striving for an original vision. Presently she does highly personal watercolor collages that incorporate a surrealistic, humorous tone. Periodically she also paints large acrylic canvases. She calls these "soft expressionism," and views them as a break between ideas for more constructions.

LYTLE, RICHARD (Painter)
Sperry Rd., Woodbridge, CT 06525

Born: 1935 *Awards:* Fulbright Fellowship *Collections:* Museum of Modern Art; National Collection of Art, Washington, DC *Exhibitions:* Whitney Museum of American Art; Marilyn Pearl Gallery, NYC *Education:* Cooper Union; Yale University *Dealer:* Marilyn Pearl Gallery, NYC

His paintings have been strongly inspired by the Baroque. They are large in scale with vigorous spatial activity. In his earlier work, shapes surge across the canvas and often react when they meet by extending and then fusing, somewhat like Arshile Gorky. The current images are evolved from the close observation of botanical forms. Vivid colors inspired by floral shapes are orchestrated to convey epic movements in a timeless landscape. Water and its reflections depict a still yet active surface where light dances and catches our eye.

McCAFFERTY, JAY DAVID (Painter, Video Artist)
1017 Beacon St., San Pedro, CA 90731

Born: 1948 *Awards:* grant, National Endowment for the Arts; New Talent Award, Los Angeles County Museum *Collections:* Los Angeles County Museum of Art *Exhibitions:* Long Beach Museum of Art; Cirrus Gallery, Los Angeles *Education:* University of California at Irvine *Dealer:* Cirrus Gallery, Los Angeles; Grapestake Gallery, Los Angeles

Although primarily known for his "solar burn" paintings, his work encompasses a variety of fields including video, photography and painting. "Solar burn" paintings are perforated wall pieces created by focusing points of sunlight on paper through a magnifying glass until the spot ignites and singes a hole in the material. He devised the process in the mid 70s lining up row upon row of charred holes in gridded abstractions. Within these narrow parameters he has found a surprising variety of visual effects and expressive possibilities. The holes range from tiny pinpricks and slots to smokey-whiskered mouths and gaping fissures. More recent work is brightly painted, but still tightly regulated like his earlier work, blending the opposites of

freedom and structure. Also, recently he has begun to explore the possibilities of video as a creative medium.

McCARTHY, FRANK C. (Painter)
c/o Mongerson Gallery, 620 N. Michigan Ave., Chicago IL 60611

Born: 1924 *Awards:* Most Popular Show, Cowboy Artists' Exhibition *Collections:* Thomas Gilcrease Institute of American History and Art; Favell Museum, Klamath Falls, OR *Exhibitions:* Husberg's Fine Arts Gallery, Sedona, AZ; McCulley Fine Arts Gallery, Dallas *Education:* Art Students League; Pratt Institute *Dealer:* Mongerson Gallery, Chicago

In 1949 he toured the American and Canadian West, sketching and photographing his impressions. Illustrations for paperback books, magazines and movie promotions followed. He became a gallery artist in 1969 and gave up commercial illustration two years later. In many of his works casein is applied to a gesso-coated Masonite panel before the application of oil paints. Painting in order ''to achieve visual impact,'' the works are dramatic, meticulously researched depictions of historical Western scenes from the life of the Plains and Southwestern Indians.

McCHESNEY, CLIFTON (Painter)
Kresge Center, Michigan State University, East Lansing, MI 48824

Born: 1929 *Awards:* Merit Award, South Bend Art Center; Purchase Award, Detroit Institute of Art *Collections:* Cranbrook Museum; Detroit Institute of Art *Exhibitions:* Ginza Nova Gallery, Tokyo; The Art Institute of Chicago *Education:* University of Indiana; Cranbrook Academy of Art *Dealer:* Dimensions in Art, Lansing, MI; Designers Gallery, Detroit

Early abstract polyptych paintings and permutable walls in thin washes of oil overlays were strongly influenced by the idea of floating form in the work of Tiepolo and the painting of traditional Japanese screens. He arranged narrow panels in series to create large scale compositions that could be rearranged as each panel worked individually. Departing from his previous format and painting in acrylics he became more involved with textured surfaces that are a direct extension of the staining of earlier pieces. Combining the opacities and the transparencies of floating colors with textured marks and surfaces, he has produced more variable elements to work with in his current series of painting.

McCLURE, TOM (Painter, Sculptor)
2406 Pine Cove Rd., Prescott, AZ 86301

Born: 1920 *Awards:* Founders Prize, Sculpture, Detroit Institute of Art; Rackham grant *Collections:* Seattle Art Museum; Detroit Institute of Art *Exhibitions:* Pennsylvania Academy Annual, Philadelphia; Ravinia Festival International, Chicago *Education:* University of Nebraska; Cranbrook Academy of Art *Dealer:* Ankrum Gallery, Los Angeles; Elaine Horwitch Gallery, Scottsdale

His work in the past in both sculpture and painting was fundamentally expressionist in character based to a certain degree on the abstraction of the human figure. More recent pieces in bronze cast relief and free standing metal sculptures have centered upon the relationship of humans to technology, computers, and medical experiments and the psychological implications of these developments. Man and machine are merged in his work. Parts of the human figure and recognizable objects of technology are combined in startling and unfa-miliar juxtapositions to pose questions about the direction and intention of contemporary life.

McCRACKEN, PHILIP (Sculptor)
Guemes Island, Anacortes, WA 98221

Born: 1928 *Awards:* Washington State Artist of the Year 1964; Norman Davis Award *Collections:* Whitney Museum of American Art; St. Louis Art Museum *Exhibitions:* Phillips Gallery, Washington, DC; National Museum of Art, Osaka, Japan *Education:* University of Washington *Dealer:* Kennedy Gallery, NYC

He works with an array of new and traditional materials to fashion figural and abstract forms. He favors woods of all kinds, especially cedar, yew, redwood, and juniper. He creates animal and bird shapes, using a variety of materials in addition to wood, among them plaster, pigment, stone, steel, fiberglass, electrical fixtures, pewter, leather, and shell. His techniques include carving, welding, brushwork, and modeling. In addition to these diverse materials and techniques, he also works with bronze. His pieces are characterized by both abstract and realistic motifs. He has been influenced by Henry Moore, whom he assisted in England in 1954, as well as Pacific Northwest artists Mark Tobey and Morris Graves.

McFARREN, GRACE (Painter)
3 Winterbury Circle, Wilmington, DE 19808

Born: 1914 *Awards:* American Watercolor Society *Collections:* Nelson Rockefeller; University of Delaware *Exhibitions:* American Watercolor Society; National Academy of Design *Education:* School of Design for Women, Philadelphia

She has progressed through various styles in painting, influenced by trends in locations where she lived. She began with realism in Philadelphia, experimented with abstractions and non-objective art while living in the Cleveland area, and then returned to realism in the Wyeth-influenced area of Wilmington, Delaware. She believes the subject or content of a painting dictates the method and medium used. She works mainly in watercolor and acrylics, sometimes using collage. Her flower paintings are colorful and impressionistic, usually using over-sized Masonite or watercolor paper.

McKIM, WILLIAM WIND (Painter, Lithographer)
8704 E 32nd St., Kansas City, MO 64129

Born: 1916 *Awards:* D.M. Lighton Award, Midwestern Exhibit *Collections:* Nelson-Atkins Museum; Samuel Sosland Collection *Exhibitions:* New York World's Fair 1939, 1964 *Education:* Kansas City Art Institute

A childhood interest in the human figure, and animal subjects, both domestic and wild, has persisted in his paintings. A personal and intimate acquaintance with Thomas Hart Benton and Grant Wood, as well as inspiration from the fifteenth and sixteenth century Gothic realists of Flemish and German origin lead to his current technique of painting almost exclusively in tempera and acrylic. His paintings display a concern for the details of natural forms along with the elementary concerns of the traditions he admires.

McLEAN, RICHARD (Painter)
5840 Heron Dr., Oakland CA 94618

Born: 1934 *Collections:* Solomon R. Guggenheim Museum; Whitney Museum of American Art *Exhibitions:* Whitney Museum of American Art; Smithsonian Institution *Education:* California College of Arts and Crafts;

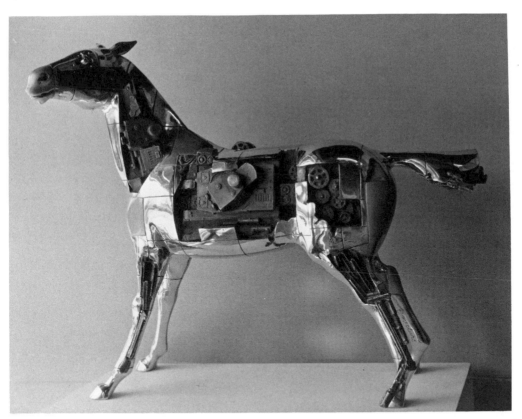

Tom McClure, *Trojan Horse*, 21 x 25 x 8, bronze and polyester. Courtesy: Ankrum Gallery (Los Angeles CA)

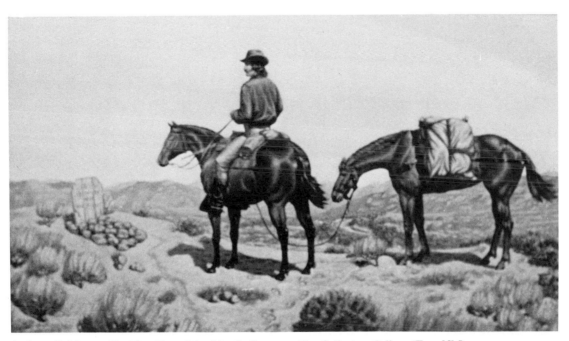

Anthony J. Manzo, *The Way West*, 14 x 24, oil. Courtesy: The Collectors Gallery (Taos NM)

Mills College *Dealer:* O.K. Harris Works of Art, NYC

Early work was influenced by Richard Diebenkorn and Nathan Oliveira, but in the mid-1960s he began painting in oil from photographs in horse magazines, posing racing horses with people, equipages, trophies, and ribbons. Since 1973, when he began to use his own photographs, the paintings have been less postured, more informal. Invisible brushwork renders with great accuracy the light reflected from the horse's coat in paintings that are classically composed. "I've always liked formal, aggressive imagery where the structure and organization are immediately apparent—easy access, no mysteries." Cows, donkeys and other rural scenes have also been included in his subject matter. Recent work includes still life watercolors of horse equipment.

McREYNOLDS, JOE CLIFF (Painter)
6311 Dowling Dr., La Jolla, CA 92037

Born: 1933 *Awards:* First Prize, California-Hawaii Biennial *Collections:* Art Institute of Chicago; United Artists *Exhibitions:* Gallery Rebecca Cooper, NYC; Museum of Contemporary Art, Chicago *Education:* San Diego State University

Early paintings from 1957 to 1970 were in various styles including abstract expressionism. In 1970 his work changed dramatically and he began painting highly detailed representational paintings with a Christian spiritual orientation. He refers to his work as "revelation art".Current work combines the technique of the early Flemish painters with universal symbolism to magnify God, which he believes is the proper purpose of art.

MACARAY, LAWRENCE RICHARD (Painter, Printmaker,Collage Artist)
628 Buttonwood St., Anaheim, CA 92805

Born: 1921 *Awards:* Award, Downey Museum of Art; Award, All-California Exhibition, Del Mar *Collections:* Bowers Museum; San Bernardino County Museum of Art *Exhibitions:* Los Angeles County Museum of Art; Long Beach Museum of Art *Education:* Whittier College; Long Beach State College *Dealer:* Ruskin Fine Arts, Culver City, CA

He takes a multi-media approach to his art by using direct oil painting, photography, etching, drawing, and collage techniques. The different media are so carefully tailored into the finished piece, that only the closest scrutiny reveals where one medium ends and another begins. The work juxtaposes representational images—often from several cultural sources and in varying styles—to create personal, eclectic visions and narratives. Tricks of perspective, visual puns, surprising repetitions of motifs, and other examples of the humor and playfulness of the artist abound in his compositions.

MADSEN, LOREN WAKEFIELD (Sculptor)
428 Broome St., New York NY 10013

Born: 1943 *Awards:* New Talent Award, Modern and Contemporary Art Council, Los Angeles County Museum of Art; National Endowment for the Arts Fellowship *Collections:* Museum of Modern Art; Hirshhorn Museum & Sculpture Garden *Exhibitions:* Museum of Modern Art; Los Angeles County Museum of Art *Education:* University of California, Los Angeles *Dealer:* L.A. Louver Galleries, Venice (CA); Zolla/Lieberman Gallery, Chicago; David McKee Gallery, NYC

Gallery installations incorporate lines, spaces, and the suspension of weight in a seemingly impossible fashion. Heavy materials such as brick, granite and lumber are suspended on steel cables or wires; the light plays on the metal, and the whole gives the appearance of threat and imbalance, simultaneously defining and defying space. Earlier works in the 1970s provided the observer with many vantage points from which to experience the installation. In more recent works he has dominated the space so completely that one can no longer choose varying viewpoints, as in *Slight Slippage (Tectonic Travel)*, one of his largest pieces installed in one of his smallest areas. Many pieces for public places are uniquely adapted to their architectural environments, so that the sculptural piece and its site create an integrated whole.

MADSEN, STEVEN R. (Painter)
511 12th St. S.W., Albuquerque, NM 87102

Born: 1947 *Dealer:* Snyderman Gallery, Philadelphia, PA

A sculptor and carver who works primarily in wood, fashioning furniture and other pieces, much of his work has been deeply rooted in the art deco tradition. The design and construction of his small-scale containers bring art deco architecture and 1930s settings to mind. Presently his work is being affected by his exposure to Russian Constructivism and Suprematism. His recent, larger pieces of furniture attempt to capture the sculptural and visual excitement of that period.

MAGAR, TONY (Painter)
Box 210, Taos, NM 87571

Born: 1936 *Dealer:* New Gallery, Taos, NM

Influenced early on by Mark DiSuvero, John Chamberlain, and Gorky, and more recently by the work of Cy Twombly, his medium to large scale oil on canvas paintings display a lyrical, gestural style that reflects the strong influence of the abstract expressionists. Imagery is representational yet abstracted from its ordinary surroundings and painted with a colorful palette and expressionist, painterly application of paint. Paintings sometimes have whimsical titles such as *Surfers Disciple*. More recent work combines the early influence of the abstract expressionist with representational references from the southwest landscape. A strong quality of line and color sense is present in all his works.

MALONE, ROBERT R. (Painter, Printmaker)
600 Chapman St., Edwardsville, IL 62025

Born: 1933 *Awards:* Purchase Award, University of Wisconsin; Purchase Award, Colorprint U.S.A. *Collections:* The Art Institute of Chicago; The Smithsonian Institution *Exhibitions:* Biennale Internationale de l'Estampe, Paris; "New Talent in Printmaking", NYC *Education:* University of North Carolina; University of Chicago *Dealer:* Lakeside Studio, Lakeside, MI

Earlier works of the 1960s and 70s were in a figurative style influenced by the simple design and hard-edged style of Pop Art painting. Today his drawings, etchings, lithographs, monoprints, and large oil canvases deal specifically with the human figure in contemporary society. The rectangle of the canvas takes on a symbolic reference to the world's population, and his figures are composed in such a way that they tend to crowd one another, as well as the limits of the canvas. The figures seem to be choreographed in their movements at implied different speeds. Their acts are simple; standing, walking, running, and waiting. The variety of figures—athletes, politicians, musicians, soldiers, and models—as well as a contrast of body types, races, and sexes, compel the viewer to invent their own

narrative out of the contrasts in his works. Above all, his paintings display a keen sense of humor about the contemporary human condition.

MANDEL, HOWARD (Painter, Set Designer)
285 Central Park West, New York, NY 10024

Born: 1917 *Awards:* Louis Comfort Tiffany Fellowship; Fulbright Fellowship *Collections:* Whitney Museum of American Art; Butler Institute of American Art *Exhibitions:* Metropolitan Museum of Art; Whitney Museum of American Art *Education:* Pratt Institute; Art Students League, NYC; Atelier Fernand Leger, Paris

His paintings have progressed from the muted colors and somber subject matter of the early post war period to highly colorful paintings with a touch of humor and whimsey. Work is in a variety of media including oil, acrylic, watercolor, and casein. Subject matter is depicted in a representational manner and embraces figure, landscape, and architectural studies. Work is always painted from memory and imagination and displays the artist's intellectual and emotional response to the world as well as surrealistic overtones.

MANGOLD, ROBERT PETER (Painter)
90 Eldridge St., New York NY 10002

Born: 1937 *Awards:* National Council on the Arts Award; Fellowship, John Simon Guggenheim Memorial Foundation *Collections:* Museum of Modern Art; Whitney Museum of American Art *Exhibitions:* Whitney Museum of American Art; Solomon R. Guggenheim Museum *Education:* Cleveland Institute of Art; Yale University School of Art *Dealer:* John Weber Gallery, NYC

Early Minimalist works were matte-surfaced pastel wall slabs such as *Pink Area,* oil on Masonite piece from 1965. In the 1970s geometric shapes on plain backgrounds were Minimalist paintings which encouraged controversial discussions on the nature of art, as in *Incomplete Circle No. 2.* Recent work continues an interest in formal problems and their self-referential answers. Color-suffused shaped canvases, sometimes in several panels, emanate tension geometrically controlled by line.

MANN, KATINKA (Sculptor, Painter)
294 Pidgeon Hill Rd., Huntington Station, NY 11746

Born: 1925 *Collections:* Polaroid Corporation; Williamsburg Savings Bank, Brooklyn *Exhibitions:* Heckscher Museum, Huntington, NY; Central Hall Gallery, NYC *Education:* University of Hartford *Dealer:* Central Hall Gallery, NYC

Her interest in form developed after ten years of easel painting. The first body of work was geometric, dimensional, and symmetrical. This concept broadened to embossed, dimensional etchings. In 1974 her shaped paintings evolved into larger, irregular shapes with bright colors. A few years later the shaped paintings were sculptural, unpainted bas reliefs. She continued to work in sculpture, fashioned of highly polished stainless steel, aluminum, and wood, sometimes painted. In 1982 she developed a unique technique of photo/construction, where the geometrical scene is manipulated so that shadows create perceptual ambiguities. The results celebrate aspects long associated with trompe l'oeil.

MANN, WARD PALMER (Painter)
163 Stony Point Trail, Webster, NY 14580

Born: 1921 *Awards:* Salmagundi Club; Hudson Valley Art Association *Collections:* Smithsonian Institution; U.S. Coast Guard *Exhibitions:* National Arts Club; Salmagundi Club *Education:* University of Michigan; Detroit Institute of Arts *Dealer:* King's Leg Gallery, Pittsford, NY

He had an earlier engineering career before devoting himself primarily to painting, and his experience in planning and decision making applies to his art. He works both in oil and transparent watercolor. The traditional landscapes and seascapes stress design, value, and color. He uses a technique of knife painting on a panel with random brush-stroke texture. The result is a looseness and structure that gives the effect of suffused light to the subject.

MANZO, ANTHONY JOSEPH (Painter)
Box 2708, Taos, NM 87571

Born: 1928 *Awards:* Ray A. Jones Award; Award, American Artist Prof. League *Collections:* Losurdo Foods Collection; Rocky Graziano *Exhibitions:* American Artists Professional League; Hudson Valley Art Association *Education:* National Academy of Design *Dealer:* Collectors Gallery, Taos, NM

Although primarily an oil painter he has also worked in watercolor, charcoal, pastel, pencil, pen and ink, dry point and sculpture. A narrative realist painter, his technique is derived from classic realism but has developed from a purely realistic approach to rendering to a more painterly technique. His main theme is the American West, landscapes, figures and animal themes, but he has also created works with other varied subject matter, as well as portraits.

MAPPLETHORPE, ROBERT (Photographer)
24 Bond St., New York NY 10012

Born: 1946 *Awards:* Creative Artists Public Service Program *Collections:* Metropolitan Museum of Art; Museum of Modern Art *Exhibitions:* Whitney Museum Biennial; Museum of Modern Art *Education:* Pratt Institute *Dealer:* Robert Miller Gallery, NYC

His work explores the erotic, by creating, what some consider, pornographic images and photographic pieces. Pictures of flowers and portraits contain undertones of eroticism. Sadistic and violent images are also used to create disturbing compositions. A well-known and notable example is *Portrait of Frank Diaz,* which shows a muscular man holding a dagger above his head ready to strike; a mirror hangs beside the photograph, so that the viewer becomes the man's potential victim. Recent subjects have been derived from sensationalized or staged scenes of New York City's homosexual community. A view he sees as "trying to sort of be on the edge."

MARCA-RELLI, CONRAD (Painter, Collage Artist)
7337 Point of Rocks Rd., Sarasota FL 33581

Born: 1913 *Awards:* Kohnstamm Prize; Purchase Prize, Art Institute of Chicago *Collections:* Museum of Modern Art; Metropolitan Museum of Art *Exhibitions:* Whitney Museum of American Art; Museum of Modern Art *Education:* Cooper Union *Dealer:* Marisa del Re Gallery, NYC; Galeria Joan Prats, NYC; F.A.M.E. Gallery, Houston

After World War II, surrealistic paintings of circus life and Italian Renaissance architectural motifs were suggestive of Giorgio de Chirico. In 1951, biomorphic hard-edged shapes seemed to float in undefined spacial planes. The next year unprimed canvas was used in

experiments with collage techniques in order to capture the textures of Classical architectural structures. After contact with Abstract Expressionists, a unique method of collage, wherein forms were stretched on raw canvas, cut out and then applied to another canvas with pigment—produced two series of abstract figurative works followed by large-scale collages which combined paint with such materials as metal and vinyl. Aluminum reliefs and interlocking metal sculptures, as well as collages in which shapes were attached to the canvas with real or painted rivets characterize subsequent work.

MARDEN, BRICE (Painter)
54 Bond St., New York NY 10012

Born: 1938 *Collections:* Museum of Modern Art; Whitney Museum of American Art *Exhibitions:* Whitney Museum of American Art; Solomon R. Guggenheim Museum *Education:* Boston University; Yale University School of Art *Dealer:* Pace Gallery, NYC

After formal education under Alex Katz and others, from 1963 to 1968 he painted monochromatic panels in oil paint and beeswax, leaving bare a thin margin along the lower edge which revealed paint drips. Subsequent works were multi-paneled works joined horizontally, each panel covered entirely with paint. Vertical joinings such as *Red, Yellow, Blue* characterized series of the 1970s. Because the oil paint was mixed with wax, colors almost equal in tone were difficult to define. Paintings were often accompanied by drawings. In 1981 a series of oil paintings were executed on marble fragments, horizontal and vertical lines emphasizing the qualities of surface. Other recent work includes prints.

MARGULIS, MARTHA BOYER (Painter)
Valley Ridge Rd., Harrison, NY 10528

Born: 1938 *Awards:* International Women's Year Award; Art of the Northeast Award *Collections:* Smithsonian Museum; Everson Museum of Art *Exhibitions:* Payson-Weisberg Gallery, NYC; Pindar Gallery, NYC *Education:* Syracuse University; Columbia University *Dealer:* Payson-Weisberg Gallery, NYC

Her past works used line and luminous color to create abstract biomorphic shapes which floated in space and crashed one against another to create a sense of movement on the canvas. The current works are abstract landscapes, which are as much about the act of painting as they are representations of identifiable forms. As color abstractions, these works are concerned with warm and cool, emerging and recessive color. Usually large in scale, the paintings sometimes form diptychs, triptychs, or quadritychs, though each part of the series functions independently as well. An illusionistic space from deep inside the picture plane makes the viewer feel enveloped by the paintings, especially in the larger works.

MARIANNE (MARIANNE MILES) (Painter, Printmaker)
P.O. Box 6083, Austin TX 78762

Born: 1941 *Awards:* Honorable Mention, Atlanta University *Collections:* Fisk University; First National Bank, Nashville, TN *Exhibitions:* East Texas State College; Schoener Gallery *Education:* Fisk University; University of Washington; New York University *Dealer:* Home Gallery, Austin, TX

Early canvases were densely covered by heavy brushstrokes in blues, greys and earth tones. A new expressionist who depicts "the inquisitive relations of the kingdoms of plants and animals," her media are oil, watercolor, casein, acrylic, and pastels as well as graphics. Current works feature many other colors: bold, bright greens, reds and blues in two-dimensional compositions full of energy and emotion. The many aspects of existence are explored, symbolically conveying "the existentialistic and apocalyptic."

MARIL, HERMAN (Painter)
5602 Roxbury Place, Baltimore, MD 21209

Born: 1908 *Collections:* Wichita Art Museum *Exhibitions:* Wichita Art Museum; Howard University *Education:* Baltimore Polytechnic Institute; Maryland Institute *Dealer:* Forum Gallery, NYC; Louis Newman, Los Angeles; Franz Bader Gallery, Washington, DC

His early work was influenced by both contemporary European painting—Cezanne and the synthetic cubism of Braque—and the old masters Giotto and Piero della Francesco. His subject matter at that time was reduced to simple stark forms and clearly discernible abstract organization. In almost every instance his forms adhered to a frontal plane and conventional illusionism was avoided. During the depression, work produced while employed for the Public Works of Art Project reflected a social realism that still maintained a simplified formal structure. His work after World War II has become more and more simplified. While realistic, he does not strive toward naturalism. Interlocking forms built of broad flat planes of color with largely inarticulated surfaces combine to form the abstract organization of his oil paintings on canvas or board. An attention to subtle color and tonal variation, strong dark contour lines, and often an emphasis on black as one of the basic components of design are characteristics of his paintings.

MARK, PHYLLIS (Sculptor, Painter)
803 Greenwich St., New York, NY 10014

Born: NYC *Collections:* Corcoran Gallery; Orlando Florida Convention and Civic Center *Exhibitions:* Institute of Contemporary Art; Brooklyn Museum *Education:* Ohio State University

She started out as a painter, and through her concern with the plane of the canvas, gradually moved off the wall and into sculpture. Working in factory fabricated motorized or wind moved sculpture, composed of metal structures and painted sails, motion adds the element of time to her works. She thinks of her current work as a series of interactions. Light interacts with a polished surface to create shadows and reflections. Motion sets the reflections gliding across the surfaces. Wind causes sails to move. Sails as they billow and flap make wind force visible. These are all interactions. If no one turns on a light or motor, or if there is no breeze, the work does not exist as she intended.

MARKER, MARISKA PUGSLEY (Painter)
300 Queen St., Alexandria, VA 22314

Awards: Alexandria (VA) Art League *Collections:* National Museum of Fine Arts, Valletta, Malta; The White House Artists Easter Collection, Washington, DC *Exhibitions:* Virginia Beach (VA) Art Center; Fine Arts America Gallery, Richmond, VA *Education:* Kansas City (MO) Art Institute; Art League, Alexandria, VA

She produced hard-edged and poured abstract paintings until 1979. Presently she is an abstract painter experimenting with color and its perception, concerned primarily with the effects of light and shadow on a variety

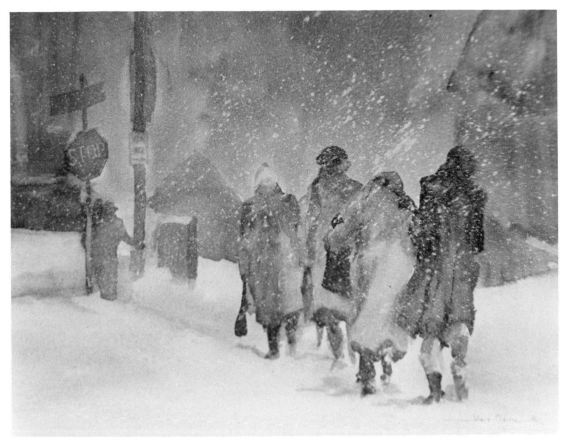

Ward Mann, *Winter,* 18 x 24, watercolor.

Tracy Montminy, *The Shipwreck,* 45 x 36, oil on canvas.

Martha Margulis, *Waterfall by the Pond,* 67 x 60, acrylic on canvas. Courtesy: Payson-Weisberg Gallery (New York NY)

of shaped and painted surfaces. The majority of her pieces are free-hanging, sculpted paper. Though the abstract works are her primary statement, she produces another body of work on canvas and in pastel. These compositions are representational, studying the visual effects of light and shadow in the sky and on the water.

MARKS, ROBERTA BARBARA (Ceramicist)
816 Eaton Street, Key West, FL 33040

Born: 1936 *Awards:* Sculpture Award, Hollywood Museum of Art; Purchase Award, American Banker's Insurance Company *Collections:* Smithsonian Institution; Rochester Institute of Technology *Exhibitions:* Everson Museum of Art, Syracuse, NY; Nelson-Atkins Museum of Art, Kansas City, MO *Education:* University of Miami; University of South Florida *Dealer:* Garth Clark Gallery, Los Angeles

Her painted pots are containers in the broader metaphysical sense—they contain feelings, issues, and ideas. On her recent vessels, she has deliberately scratched away part of the paint, leaving a ghost-like undersurface that recalls pre-Columbian polychrome vessels. The pots are similar to those that she has made for most of her career, but they have a renewed contemporary relevance.

MARQUIS, RICHARD (Glass Artist)
c/o Walter/White Fine Arts, Seventh and San Carlos, Carmel CA 93921

Born: 1945 *Awards:* Fulbright-Hays Fellowship, Venice, Italy *Collections:* Smithsonian Institution *Exhibitions:* Walter/White Fine Arts; Craft and Folk Art Museum *Education:* University of California, Berkeley *Dealer:* Walter/White Fine Arts, Carmel, CA; Gallery Eight, La Jolla, CA; David Bernstein Gallery, Boston

In the 1960s he gained recognition with delicate and innovative glass objects of function and beauty, blown glass in iridescent and transluscent colors such as *Tall Bottle.* Teachers Peter Voulkos and Marvin Lipofsky influenced the early Funk Art pieces. After working for a year with glass blowers in Venice, Italy, he applied the technique of millefiori, in which thin rods of different colored glass were fused together and then embedded within the walls of the blown glass to make decorative filigree patterns. The *Fabricated Weird Series,* begun in 1974 consisted of assemblages of decorative blown glass and found objects such as toys and curios. Cups also made during this period contained American flag motifs embedded in the glass to create the illusion of three-dimensional depth, as did the *Crazy Quilt/ Star/Adventurin Teapot,* a recent mold-blown decorative piece. He has also made ceramic pieces with James Melchert and Ron Nagle.

MARTIN, AGNES BERNICE (Painter)
Lamy, NM 87540

Born: 1912 *Collections:* Museum of Modern Art; Whitney Museum of American Art *Exhibitions:* Museum of Modern Art; Stedlelijk Museum, Amsterdam *Education:* Columbia University; University of New Mexico *Dealer:* Pace Gallery, NYC

Born in Canada, she came to the United States in 1932 and became an artist in the 1940s. Early abstract work featured biomorphic shapes, but in 1958 after living for several years in New Mexico the forms had become hard-edged and were repeated in systematic compositions. The next year grids were painted on plain brown canvas in the pale colors of Southwestern landscapes. In 1967 she left New York City to settle permanently in New Mexico, and for a brief time did not paint. The new paintings which soon emerged were rendered in radiant colors, followed in the mid-1970s by canvases of two colors applied in wide horizontal bars with intermittent stripes showing the white gessoed surface. Small-scale watercolors of the late 1970s continued her ongoing concerns with geometry, light and color. Recent large canvases of horizontal bands against a grey background show a new painterliness, exploring variations on a theme—"the theme is devotion, nuances on devotion."

MARTIN, BILL (WILLIAM HENRY) (Painter)
c/o Joseph Chowning Gallery, 1717 Seventeenth St., San Francisco CA 94103

Born: 1943 *Awards:* Louis C. Tiffany Grant *Collections:* Capital Research and Management, Los Angeles; McDermott Will and Emery, NYC *Exhibitions:* San Francisco Museum of Modern Art; Museum of Contemporary Art *Education:* San Francisco Art Institute *Dealer:* Joseph Chowning Gallery, San Francisco

A California visionary, his early work reflected an imaginative and fantastic concept of life in the future. In the mid-1970s he began to balance the earlier fantastic views with pure and incisive interpretations of the landscapes of West Marin County, California, where he now lives. Canvases are often circular, framed in wood, so that the viewer has the sensation of looking through a telescope or peephole. *Autumn* was a circular view in oil, fifty-five inches in diameter, of a group of trees with people lounging in the grass next to a winding brook. *Sunbeams* is a more recent circular canvas smaller in diameter depicting convincing shafts of light through trees.

MARTIN, LARRY KENNETH (Painter)
Wren's Nest Gallery, 507B N. Church St., Jacksonville, AL 36265

Born: 1939 *Awards:* Best of Show, Southern Wildfowl Festival *Collections:* U.S. Dept. of Interior *Exhibitions:* Southeastern Wildlife Exposition; Oklahoma Wildlife Art Festival *Education:* Tulane University *Dealer:* Wren's Nest Gallery, Jacksonville, AL

Throughout his artistic career, he has concentrated on painting both wildlife and human subjects. He worked in several other professions, including tropical medicine and museum curating, before devoting himself to painting. Among his works is an ongoing series of portraits of American characters, eccentrics, and individualists. He also has painted a series of wildlife. More than forty of his subjects have been introduced in print editions. The 1985 Alabama Waterfowl Stamp features his "bi-level" design of a pair of wood ducks.

MARX, NICKI D. (Painter, Photographer)
417 Cliff St., Santa Cruz, Ca. 95060

Born: 1943 *Awards:* Fellow, MacDowell Colony *Collections:* Stanford University; Bank of America *Exhibitions:* Weston Gallery, Carmel; Phoenix Art Museum *Education:* University of California at Riverside; University of California, Santa Cruz *Dealer:* Weston Gallery, Carmel

She works in a painterly and sculptural fashion with non-traditional materials, and objects from nature including earth, bones, bark, and feathers. Past works have incorporated fetish-like constructions, as well as a series comprised of staffs, baskets, Xboxes. Current work involves studies of over seventy different earth colors and a series called *Aftermath,* referring to the

Marianne, *A Wisp of Wind*, 18 x 24, pencil. Courtesy: The Home Gallery (Austin TX)

Joan Michaels-Paque, *Reversals*, 13 x 4 x 1, flexible sculpture. Courtesy: JMP Atelier (Milwaukee WI)

wonder of life and the threat of nuclear war. These are highly textured, dimensional paintings of chalk-white earth, with fetish objects attached and then wrapped in gauze.

MASON, ALDEN (Painter)
3131 Western Ave. #503, Seattle, Wa. 98121

Born: 1919 *Awards:* Purchase Award, Seattle Art Museum *Collections:* Denver Art Museum; San Francisco Museum of Modern Art *Exhibitions:* Portland Center for the Visual Arts; Charles Cowles Gallery, NYC *Education:* University of Washington *Dealer:* Greg Kucera Gallery, Seattle; Torture Gallery, Santa Monica, CA

Large scale acrylic on canvas paintings with the paint applied directly from the tube to the canvas in squiggly lines to form a wealth of stylized imagery has been the characteristic signature of this Northwest artist. Although influenced by Bonnard, Matisse, El Greco, and Gorky, he shares more affinity with the Chicago Imagists in his free combination of color and his sometimes cartoon-like iconography and shapes that emerge from the highly textured, densely applied paint of his canvases.

MATLICK, GERALD ALLEN (Painter, Printmaker)
127 W. 17th St., Owensboro, KY 42301

Born: 1947 *Awards:* Purchase Award, Potpourri of the Arts; Outstanding Painting, Toledo Art Museum *Collections:* Owensboro Museum of Fine Art; Bowling Green State University *Exhibitions:* Mid-States Art Exhibition; Evansville Museum of Arts and Science *Education:* Bowling Green State University; Western Kentucky University *Dealer:* Swearingen Gallery, Louisville

Although he works in a variety of media including drawing, printmaking, photography, and mixed media, he has selected watercolor as the medium for the majority of his works since 1979. His earlier works are representational and capitalize on three dimensional illusion. More recent works are concerned with visual effects of surface texture and color, and in many of the works the actual subject matter is not readily identifiable. While he periodically uses the human figure for interpretive work, his watercolors are abstractions and semi-abstractions based on isolated sections of eroded, decayed or discarded items such as wrecked automobiles, demolished buildings, and urban landscapes. He uses the subjects merely as points of departure for experimentation in design, texture, color and composition.

MATTERNES, JAY HOWARD (Painter)
4328 Ashford Ln., Fairfax, VA 22032

Born: 1933 *Awards:* Merit Award, Society of Animal Artists *Collections:* Cleveland Museum of Art; Kenya National Museum *Exhibitions:* Leigh Yawkey Woodson Art Museum, "First Western Art Classic", Minneapolis-St. Paul *Education:* Carnegie Mellon University

He has always specialized in landscape painting, as well as paintings of birds and animals. He places emphasis on depiction of habitat, not as much for scenic value as for the fact that the habitat is the stage upon which the subject is developed. He designs his paintings to enhance the subjects. All his work is exclusively representational, and heavily influenced by Rembrandt, Caravaggio, Russell, and Remington. Recent works, in oil and acrylic, are paintings on linen which employ Western themes.

MAURICE, ELANOR INGERSOLL (Painter)
215 S. Mountain Ave., Montclair, NJ 07042

Born: 1904 *Awards:* National Academy; Ranger Fund *Collections:* A.T.&T.; Dodge Foundation *Exhibitions:* Audubon Artists Annual; Butler Institute of American Art Annual *Education:* Art Students League *Dealer:* The Chimes Art Gallery, Summit, NJ

Her work includes florals and landscapes in watercolor and figurative oil paintings. For many years she painted exclusively in watercolor without adding white or acrylics. Later she began adding India ink and using acrylics on rice paper. In the past ten years she has changed to oils, finding this more compatible with subjects and interests. Her current paintings are more colorful, lighter, and simpler. Impressionist paintings of children at play, boating scenes, horse races, and landscapes are representative of her recent works.

MAURO, GARY (Fiber artist)
P.O. Box 82, Santa Fe, NM 87504

Born: 1944 *Collections:* Denver Art Museum; New Mexico Museum of Fine Art *Exhibitions:* Barbara Mack Gallery, Seattle; Albuquerque Museum of Fine Arts *Education:* University of Colorado Art School; Southern Colorado State College *Dealer:* Ventana Gallery, Santa Fe, NM

His work is part of an art fabric movement that comes out of the climate of experimentation of the 1960s, encompassing a freedom in choice of materials, size, and technique. His recent work has been drawing on three-dimensional or irregular sewn canvases. The drawings are done with colored chalks, pencils, sewing machines, and sprayed pigments. He is interested in the unity of sculpture and drawing in these works. At times his subject matter is the figure, including animal forms and the male and female figure; at other times the subject is the drawing itself.

MAX, PETER (Painter, Printmaker)
Peter Max Enterprises, 118 Riverside Dr., New York NY 10024

Born: 1937 *Awards:* American Institute of Graphic Arts Award; Award, International Poster Competition, Poland *Collections:* U.S. postage stamp, World's Fair, Spokane (WA); World's Fair, Knoxville (TN) *Exhibitions:* Smithsonian Institution; Corcoran Gallery of Art *Education:* Art Students League; Pratt Institute; School of Visual Arts *Dealer:* Peter Max Enterprises, NYC; Martin Lawrence Galleries, Los Angeles

Born in Berlin, he spent his early years in China and Israel before coming to America in 1953. During the mid-1960s he gained wide attention when he became the primary protagonist of psychedelic art. Combining random and improvisational imagery he painted posters for airlines, television, libraries, musicians and moon shots, eventually branching out to design such products as clocks, pillows, sheets and dinnerware. The exotic and eclectic images were referred to by some as composites of Art Nouveau, Pop and Op. Beginning in the 1970s he wanted to portray an art that was "super-optimistic, looking with great foresight towards a super-civilization, highly technologically oriented." Adhering to the principles of Yoga, he is committed to "producing lots of beautiful things for everybody and turning everybody on to beautiful things." The official artist of the 1982 World's Fair, he produced the *Statue of Liberty* series. He has also published his work in books.

MAXWELL, WILLIAM C. (Painter, Printmaker)
307-9 Canal St., New York, NY 10013

Born: 1941 *Awards:* Purchase award, University of Dallas; President's award, National Arts Club *Collections:* Continental Group, Inc.; TRW, Inc. *Exhibitions:* Bernice Steinbaum Gallery, NYC; Pratt Manhattan Center Gallery *Education:* Columbia University; Wagner College *Dealer:* Bernice Steinbaum Gallery, NYC

A painter and printmaker, he works in a variety of media including acrylics, watercolor, pastels, intaglio and lithography. Older work utilizes a recognizable grid and creates a non-objective format of continuous motifs and layered color in very large formats. The underlying spacial grid utilizes process as motifs, with superimposed linear, curvilinear and geometric shapes in transposition lithographs and multi-method intaglio prints.Current work continues his concerns with abstraction but introduces hints of recognizable imagery into the form of geometry that plays on the relationships of opposites. These new works include the use of neon and argon illumination, to engage the viewer problematically with the contrast between the ideal of affected response versus effect.

MAZUR, MICHAEL B. (Painter, Printmaker)
5 Walnut Ave., Cambridge MA 02140

Born: 1935 *Awards:* Louis C. Tiffany Grant; Fellowship, John Simon Guggenheim Foundation *Collections:* Museum of Modern Art; Art Institute of Chicago *Exhibitions:* Museum of Modern Art; Whitney Museum of American Art *Education:* Amherst College; Yale University School of Art *Dealer:* Barbara Krakan Gallery, Boston; Barbar Maches Gallery, NYC

He studied with Leonard Baskin, Gabor Peterdi and Bernard Chaet in the late 1950s and early 1960s, and became well known as a printmaker, depicting figurative images, anatomical forms and household objects. During the late 1960s and early 1970s he experimented with painting, using an airbrush to apply blacks, greys and whites in multi-paneled depictions of studio spaces and objects now absent of figural elements, concentrating on a personal vision of pictorial space. For the past fifteen years he has worked in monotype. Recent work includes a pair of large triptychs in monotype with pastel, *Wakeby Day/Wakeby Night,* a mural commissioned by the Massachusetts Institute of Technology.

MEADER, JONATHAN (Printmaker)
P.O. Box 21146, Washington, DC 20009

Born: 1943 *Awards:* National Endowment for the Arts; Wurlitzer Foundation Grant *Collections:* Whitney Museum of American Art; National Collection, Washington, DC *Exhibitions:* Washington Project for the Arts; Zenith Gallery, Washington, DC

In the mid-1960s he began to produce tightly drawn pen-and-ink works, notable because of their intensity and painstaking technique. His images were composed of thousands of lines laid side-by-side to create texture and density. In the early 1970s he turned his attention to serigraphy—an interest which continues up to the present as his major means of artistic expression. His images have always tended toward the magical, depicting transparent doors in solid walls, animals with human thoughts, and men with wings.

MEEKER, BARBARA MILLER (Painter)
8314 Greenwood Ave., Munster, IN 46321

Born: 1930 *Awards:* Artists Guild of Chicago; Hoosier Salon, Indianapolis *Collections:* DePauw University, Greencastle, IN; Purdue University *Exhibitions:* Midwest Watercolor Society; DePauw University *Dealer:* Trachtenberg Gallery, Merrillville, IN

She has been an art educator for thirty years as well as a painter. She uses her creative methods of instruction in her own painting, constantly experimenting with various water media. Her compositions vary from the representational to the non-objective. The early works primarily were oils, acrylics, collages, and abstracted realism. Based on extensive study in watercolor, her recent works are mostly expressionistic landscapes, florals, and imaginative idea concepts. She also enjoys drawing and painting architecture and specializes in recording local buildings.

MEJER, ROBERT LEE (Printmaker, Painter)
Fine Arts Dept., Quincy College, Quincy, IL 62301

Born: 1944 *Awards:* Grants, Illinois Arts Council; Fellowship, Virginia Center for the Creative Arts *Collections:* Continental Illinois National Bank and Trust; Bank of America *Exhibitions:* "New American Monotypes", Traveling Exhibition; Pensacola National Watermedia Exhibition *Education:* Notre Dame University; Washington University *Dealer:* Eagle's Nest Gallery, Austin, TX; Peter David Art Gallery, Minneapolis

His works in watercolors show a wealth of resources combining abstract painting and an unusual blend of linear and coloristic styles. Compact, well-divided windows to which the viewer is drawn, contain a large variety of shapes and patterns—crosses, checks, diamonds, rows of circles, lines of separations, blocks, squiggles, spirals, flags, and dots. Placed in relationship to each other, they swim over or sink under the big colorful pools that divide the surface into unpredictable, geometrically conceived portions. Some are horizontal, others vertical, triangular or even circular. The effect from a distance is quadrants of natural but controlled northern lighting, and up close of tight, primitive emblems and forms caught in a moment of dance.

MELL, EDMUND PAUL, JR. (Painter, Printmaker)
c/o Suzanne Brown Gallery, 7160 Main St., Scottsdale AZ 85251

Born: 1942 *Collections:* Scottsdale Center for the Arts *Exhibitions:* Long Beach Museum of Art; Scottsdale Center for the Arts *Education:* Art Center College of Design *Dealer:* Suzanne Brown Gallery, Scottsdale, AZ; Dewey-Kofron Gallery, Santa Fe; Harris Gallery, Houston

Training and early work in advertising and illustration in the 1960s and early 1970s has influenced his landscapes structured with flat planes. Southwestern canyons and valleys are dramatically rendered, as rock and cloud formations are reduced to geometric abstractions that vibrate with the hot and cool reds, oranges, blues, and purples of the desert, as in *Desert Distance.* "The suggestion of curves or modeling is achieved exclusively through tones, color relationships, or shading. . . . The landscape of the American West is a particular challenge. The variety of color combinations and stark contrasts is endless." First a sketch is made, then a larger pastel, and then the image is transferred to a gessoed panel. Lines are drawn with straight edges and layers of wash are applied, followed by the application of brilliant oils. Before painting these panoramic views, much of his material comes from observations during frequent helicopter rides.

MENDELSON, HAIM (Painter)
234 W. 21st St., New York, NY 10011

Born: 1923 *Awards:* Purchase Award, Drawings USA; Graphics Award, Painters and Sculptors Society of New Jersey *Collections:* New York Public Library Print Collection; Edward Uhlrich Museum, Wichita, KS *Exhibitions:* Museum of Modern Art, Pratt Graphics Center *Education:* American Artists School; Educational Alliance Art School

His early still lifes explored color in tones and atmosphere. Subsequently, as a printmaker, he freely developed line and drawing in intaglio prints. In 1975, he evolved a direction which integrated his feeling for color-tone with the articulation of his drawing. Working with acrylics, he developed a technique in which subtle collage elements define the drawing, allowing the brush full freedom for the tonal qualities. This method extended the expressive possibilities in his work. Recurrent themes in his art are growth as the affirmation of renewal, and death as the ultimate loss. In such works as *The Artist and His Dead, Threnody for Matthew,* and *Michael's Earth,* perspective emphasizes the dramatic aspect of the subjects.

MENDENHALL, JACK (Painter)
5824 Florence Terrace, Oakland, CA 94611

Born: 1937 *Awards:* Purchase Award, Butler Institute of American Art *Collections:* Oakland Museum; University Art Museum, University of California, Berkeley *Exhibitions:* "Realism since 1960", Traveling Exhibition; Tokyo Biennial *Education:* California College of Arts and Crafts *Dealer:* O.K. Harris Gallery, NYC

A photo-realist painter working in both oil and watercolor, he utilizes a refined brush technique to capture the world of the contemporary nouveau riche that comprises the subject matter of his paintings. Using images from popular magazines, and occasionally professional models, he paints the opulent interiors that are the trademark of his work. The result is a reflection of the American fantasy rendered in meticulously realistic style. Paintings of mirror clad interiors tend toward the abstract as the complexities of reflected realities become blurred upon the canvas. In these works, formal concerns are perceived under the rubric of realism. Influences include seventeenth century genre paintings, pop art, and minimalism.

MENDES, BARBARA (Painter)
870 S. Acacia Ave., Rialto, CA 92376

Born: 1948 *Awards:* First Prize, Staten Island Museum Show *Collections:* Matthew Kaufman, Berkeley, CA; Phyllis Needleman, Chicago *Exhibitions:* Factory Place Gallery, Los Angeles; Phyllis Needleman Gallery, Chicago *Education:* University of California, Riverside; Hunter College *Dealer:* Milou de Reiset, Los Angeles

Her paintings teem with myriad images, expressing the multiplicity of the human mind in vibrant colors. Her early large acrylic paintings combined Eastern religious themes with landscapes and patterns of pure color. The more recent large paintings in oil abound with African imagery, California scenes, and figures of personal and universal significance. Large women with intricate scenes in their dresses and other spatial devices recur often in an attempt to show the bewildering and infinitely complex mental order of imagery.

MESCHES, ARNOLD (Painter)
4727 W. Washington Blvd., Los Angeles, CA 90016

Born: 1923 *Awards:* Ford Foundation Faculty Grant; National Endowment for the Arts *Collections:* Philadelphia Museum of Art; San Francisco Museum of Modern Art *Exhibitions:* Los Angeles Municipal Art Gallery; Newport Harbor Art Museum *Education:* Chouinard Art Institute; Jepson's Art Institute *Dealer:* Karl Bornstein Gallery, Santa Monica, CA; Civilian Warfare, NYC; Nina Freudenheim Gallery, Buffalo, NY

Early acrylic, expressionist paintings addressed social and political issues of the twentieth century; the newly revealed horrors of World War II death camps, the social aspirations of postwar America and the displaced, open ended mood at that time were all evident in his paintings. His triptychs revealed his admiration for the work of Siquieros, Goya, and Picasso but they also declared his own desire for ambitious scale and a range of subjects. Massive portrait heads became the subject of his assertive, large paintings of the 1960s and 70s, painted in a free expressionistic style and broad brushstrokes. In the last few years his work has recalled the multi-paneled complex narratives of his first decade as a painter. Now, however individual panels have a remarkable completeness of their own. Wide, vibrant colors and simplified design, combine the figure with abstractions from nature in the large, expressively executed paintings. They are are concise yet evocative, sparse yet fluid.

METZ, FRANK ROBERT (Painter)
800 West End Ave., New York, NY 10025

Born: 1925 *Awards:* Purchase Award, Ball State Teachers College *Collections:* Philadelphia Museum of Art; Olsen Foundation, Guilford, CT *Exhibitions:* Haber Theodore Gallery, NYC; Alonzo Gallery, NYC *Education:* Philadelphia Museum School; Art Students League

Working in oil and watercolor, he has devoted years to observing and depicting the coast lines of Maine, Long Island, Scotland, and Ireland. His realist-impressionistic style uses a low-keyed palette of color in the landscapes and seascapes to achieve a lush, painterly view of nature. His paintings focus on a balance between land and sky and the sometimes unexpected placement of rock and vegetation to further that balance. By concentrating on low tide scenes, revealing rock formations, he is able to organize forms otherwise overwhelmed by the horizon or water line. His paintings invariably seek to capture that ephemeral moment of light between cloudy skies and the clear light of day.

MEW, TOMMY (Painter)
Box 580 Art, Mt. Berry, GA 30149

Born: 1943 l *Awards:* Gellhorn Award, Newsweek Magazine; Grant, Cowperthwaite Corporation *Collections:* American Telephone and Telegraph; Meridian Museum of Art *Exhibitions:* Rockefeller Arts Center; Montgomery Museum of Fine Arts *Education:* University of Houston; Florida State University; New York University *Dealer:* Marianne Lambert, Atlanta

His early paintings and drawings were concerned with a sense of fantasy, a kind of visual day-dreaming always rich in color and rife with multiple layers of meaning. The content was philosophical, focused on the search for The Self. Current work using islands as the visual metaphor continues his attempt to depict another world in which the subconscious, the emotional, and the spiritual are manifested. With mixed-media drawings and paintings he strives to meld the sense of time and space and mix memory and desire. He welcomes the personal vulnerability encountered through his work. The artist

admits, "I realize that my work is about me—I have become my work."

MEYEROWITZ, JOEL (Photographer)
817 West End Ave., New York NY 10025

Born: 1938 *Awards:* Fellowship, John Simon Guggenheim Memorial Foundation; Fellowship, National Endowment for the Arts *Collections:* Museum of Modern Art; Art Institute of Chicago *Exhibitions:* Museum of Modern Art; George Eastman House, International Museum of Photography *Education:* Ohio State University *Dealer:* Witkin Gallery, NYC

In the Leica tradition, he seeks out scenes from urban and rural life, capturing in an instant the spectacles of human activity. The photographs seem contrived because his specialty is coincidences. The mobile and social situations depicted could not have been arranged, yet since an early series of black-and-white pictures taken from a moving car, he has been able to seek them out, and they continue to be his trademark. He claims not to be making social commentary, but instead to ask the viewer to explore the ways of seeing. Asymmetrical images display contrasts between colors, between space and activity, light and dark. Carefully composed work often employs a flash to create sharp profiles, deep shadows or glaring surfaces, and to reveal hidden information which the observer would normally not notice. Recently his style has shifted to include highly detailed landscapes of Cape Cod in the manner of Walker Evans.

MICHAEL, GARY (Painter)
1440 Columbine, Denver, CO 80206

Born: 1937 *Awards:* Popular Vote Award, Pastel Society of America Annual Exhibition; Merit Award, Colorado State Fair *Collections:* Harmsen Western Art; Denver Public Library *Exhibitions:* Farraginous V, Denver; Pastel Society of America Annual Exhibition *Education:* Art Students League

Traditional, representational paintings of people and places in oil and pastel characterizes his work. A romantic by temperament and a classicist by training he prefers no single recognizable style, but rather paints in a variety of genre. He is strongly influenced by the people and landscape around him. Design remains the most important element in his work. Large canvases of imaginary water lillies recall the famous paintings of Monet. Other works are executed with a more reserved brush.

MICHAELS-PAQUE, JOAN (Fiber artist)
4455 N. Frederick Ave., Milwaukee, WI 53211
Awards: Grant, Bush Foundation; Lily Mills Award *Collections:* National Museum of American Art, Washington, DC; Southampton Art Gallery, London *Exhibitions:* Ariel Gallery, Chicago, IL; Craft Alliance Gallery, St. Louis, MO *Dealer:* Garver Gallery, Madison, WI

Her work is a search for equilibrium between art, architecture, nature, technology, and self. This pursuit emanates from her interest in topology, the phenomenon of the warped flexible surface. Her medium may be any pliable linear element that lends itself to these topological principles. Most recently she has created large-scale flexible structures whose geometric compositions are tectonic in scale and incremental in theme.

MICHOD, SUSAN A. (Painter)
2242 N. Dayton St., Chicago, IL 60614

Born: 1945 *Awards:* Grant, Illinois Arts Council *Col-*

lections: Museum of Contemporary Art; Illinois State Museum *Exhibitions:* Bronx Museum; Susan Caldwell Gallery, NYC *Education:* Pratt Institute; University of Michigan *Dealer:* Jan Cicero Gallery, Chicago

She became interested in combining chairs with her paintings by way of ideas of decoration. The paintings were soon transformed into landscape "sets" or environments for the objects, which became "characters" in an open-ended narrative. Camouflage is a dominant element in these works, and philosophically has become for her a symbol of painting's ambiguity. The painting process vies with the imagery as subject matter. The dripping, brushing, glowing colors are also the content. Her new cupboards are about process and paint fluidity, and what painting is about. Ideas of myth and archetypal knowledge, as well as formal changes such as thicker paint and collage, are leading her work in new directions.

MIDDAUGH, ROBERT BURTON (Painter)
1318 W. Cornelia, Chicago IL 60657

Born: 1935 *Awards:* Purchase Award, American Academy of Arts and Letters; Purchase Award, Portsmouth Community Arts Center *Collections:* Los Angeles County Museum; Art Institute of Chicago *Exhibitions:* Art Institute of Chicago; Pennsylvania Academy of the Fine Arts *Education:* School of the Art Institute of Chicago *Dealer:* Fairweather Hardin Gallery, Chicago

There were no human beings in his past paintings depicting disquieting worlds of futuristic buildings and enigmatic machines. Sources for these images are similar to those of the Chicago Imagists although they are exploited differently. They come from intuition, memory, and an interest in hand-operated machinery. "I like the idea of anthropomorphic machines." In more recent work the bleak scenes are sometimes populated with anonymous distorted figures resembling computer cards or slithering snakes. An unknown light source blazes down upon the menacing machines, making sharp shadows in distorted perspective. His technique involves a preliminary sketch executed on black board with pencil; then small acrylic studies are made before the subject for the large oil painting is chosen. He has also made small monochromatic constructions.

MIHAESCO, EUGENE (Illustrator)
c/o Galerie St. Etienne, 24 West 57th St., New York, NY 10019

Born: 1937 *Awards:* Best Illustration, American Institute of Graphic Artists; Best Cover, Newspaper Guild *Exhibitions:* "Art of the Times," Musee des Arts Decoratifs; "The Statue of Liberty," Centre Pompidou, Paris *Education:* Academy of Fine Arts, Bucharest, Rumania *Dealer:* Galerie St. Etienne, NYC

When he first emigrated to the United States in the early 1970s, he developed an extremely meticulous pen-and-ink technique so fine that his drawings were often mistaken for 19-century engravings. His surrealistic commentaries on contemporary political situations were often seen in the early days of the *New York Times* Op-Ed pages. He also did more lyrical pastel renderings of New York scenes that frequently appeared on the cover of *New York* magazine. In recent years his style has loosened considerably.

MILLER, DONALD RICHARD (Sculpture)
52 Feagles Rd., Warwick, NY 10990

Born: 1925 *Awards:* Mrs. Louis Bennett Prize, National Sculpture Society; Miriam B. Beline Memorial

Award, Allied Artists of America *Collections:* Dayton Art Institute; William Farnsworth Art Museum *Exhibitions:* National Sculpture Society; National Academy of Design *Education:* Dayton Art Institute; Art Students League *Dealer:* The Fisher Gallery, Washington, DC

Interpretive sculpture executed in a variety of media and scales comprises the body of the artist's work. Past work includes a number of architectural projects completed with Marshall Fredericks, Oronzio Maldarelli, Carl Schmitz, and Joseph Kiselewski. However, an early interest in animal sculpture and fascination with animals particularly has proven to be the most influential factor on his current work. After several years of sculpting other subject matter in a variety of styles, the execution of two animal gargoyles for the Washington Cathedral, renewed the artist's interest to work almost exclusively in animal sculpture. He finds excitement in the beauty and rhythmical grace of other creatures. The swirl of a fish, the flow of a snake as it glides silently through the grass, or the ponderous magnificence of a charging rhino are the sources for his artistic inspiration.

MILLER, GUSTAF (Sculptor, Painter)
c/o Lange Miller Gallery, 416 Main St, Chatham, MA 02633

Born: 1940 *Collections:* Addison Museum *Exhibitions:* Andover Gallery, Andover; Thomas Segal Gallery, Boston *Education:* Syracuse University *Dealer:* Thomas Segal Gallery, Boston

Architecture had been a persistent element in his previous paintings, watercolors, and box constructions. In his "buildings"—human-size constructions of urban architecture and skyscrapers—the four vertical surfaces of each sculpture offer individual painting and/or collage surfaces. Each facade is a painting reference to a building wall, thus, as in a real building, there is a facade and a back with two anonymous side walls. The earlier pieces favored nostalgia and were somewhat model-like in their appearance. Whereas the earlier "buildings" had a painterly tenderness and mood that evoked comparisons to the paintings of Hopper, the more recent work is oriented toward a more singular formal integration of the whole.

MILLER, MELVIN O. JR. (Painter)
2001 Alto Vista Ave., Baltimore, MD 21207

Born: 1937 *Awards:* Second Prize, John F. & Anna Lee Stacey Scholarship Fund *Collections:* Equitable Trust Co. *Exhibitions:* Butler Institute of American Artists; American Marine Artists *Education:* Maryland Institute of Art *Dealer:* John Pence Gallery, San Francisco

His work consists of representational paintings of landscapes, cityscapes, and maritime subjects. The influence of Francesco Guardi, Ruisdael, and Piranesi can be seen in his work. As a student of Jacques Maroger and Earl F. Hofmann, he became interested in the media and techniques of the Flemish and Italian masters of the 15th through 18th centuries, and he continues his research into these media to this day. His marine paintings in particular have been exhibited in places as far afield as Brazil, Greece, Pakistan, and Haiti.

MILLER, RICHARD KIDWELL (Painter)
222 W. 83rd St. Apt 8c, New York, NY 10024

Born: 1930 *Awards:* Fulbright Fellowship; Gertrude Vanderbilt Whitney Fellowship *Collections:* Phillips

Collection; Hirshhorn Museum and Sculpture Garden *Exhibitions:* Carnegie International; Tokyo International *Education:* American University; Columbia University *Dealer:* Adron Berman Gallery, NYC

His strong expressionistic, figurative work during his teens and twenties gave way to his abstract paintings from 1955 to 1970. Slashing, expressionistic strokes, characterized by intense color and strongly structured forms were typical of his paintings from this period. His recent work in oil and acrylic is a synthesis of both abstract and figurative painting. Convoluted forms of inventive personal images derived from primitive art combine with textured surfaces and rich color to form original abstract paintings of highly emotional and structural content. Current work combines painted surfaces with recessed wood construction and collage.

MILLER, RICHARD McDERMOTT (Sculptor)
53 Mercer St., New York, NY 10013

Born: 1922 *Awards:* Sculpture Award, American Academy and Institute of Arts and Letters; Gold Medal, National Academy of Design *Collections:* Hirshhorn Museum and Sculpture Garden; Whitney Museum of American Art *Exhibitions:* Pennsylvania Academy of Fine Arts; Alwin Gallery, London *Education:* Cleveland Institute of Art

A figure sculptor who models in wax and casts in bronze, his early themes were depictions of the figure in motion at slightly different moments of time, as in a Muybridge photograph, and female figures in natural and relaxed poses; many of these quite large in scale. Many of his figures were larger than life size scale. In recent years he has composed interactive groups of figures, male and female, within the space of a square frame, under the title of the *Metope Series*. His approach to the figure remains firmly based in classical tradition.

MILLIKEN, GIBBS (Painter, Photographer)
Dept. of Art, University of Texas, Austin, TX 78712

Born: 1935 *Awards:* Texas Fine Arts Association; Chataqua National Juried Exhibition *Collections:* Butler Institute of American Art; University of Texas *Exhibitions:* Witte Memorial Museum; Cranbrook Academy of Art *Education:* Trinity University; University of Colorado; Cranbrook Academy of Art *Dealer:* Patrick Gallery, Austin, TX

His early paintings, drawings, and color photographs showed his concerns with fragments of plants, bits of stone, and scattered debris. Very few traditional brush strokes are evident, and paints are applied to imitate natural forms, surfaces, light, and shadow. In the 1970s he worked as an artist-aquanaut with an underseas research project in the U.S. Virgin Islands, creating works of the sea floor and marine life. He also worked on the Apollo 14 moon mission, becoming the first artist to draw and paint directly from moonstones. Since the mid-1970s he has exhibited large format color photographs, incorporating subjects such as wall sites and constructions, urban plantings, and Indian ritual sites. His background as a biologist has led him to work and travel in Latin America. The influence of these experiences has caused a major shift in his photographs, from nature images to documentation of indigenous peoples and their religious practices.

MILLS, LEV TIMOTHY (Printmaker)
3378 Ardley Road SW, Atlanta, GA 30311

Born: 1940 *Awards:* European Fellowship, Ford Foun-

Pat Musick, *One Dozen Valleys II,* 48 x 48 x 2, oil on paper on plywood.
Courtesy: Economos Works of Art (Houston TX)

Anna Maria Muccioli, *Sculpture Woman,* 30 x 13, bronze.
Courtesy: Muccioli Studio Gallery (Detroit MI)

dation *Collections:* Museum of Modern Art; British Museum *Exhibitions:* Victoria and Albert Museum; High Museum of Art *Education:* University of Wisconsin; Slade School of Fine Art *Dealer:* Associated American Gallery, NYC; Ann Jacob Gallery, Atlanta

Etchings, lithographs, collagraphs, serigraphs, and mixed media prints comprised his early work. The representational subject matter documented historic events and the illustrious personalities of the decade from approximately 1965 to 1975. These intimate, black and white impressions on paper led to work in higher relief using color and photographic imagery. Present work combines non-traditional materials—plastic, metals, and glass—with the traditional printmaker's papers and inks in more colorful, mixed media pieces. Humanistic concerns continue to generate the subject matter, while the content has become less specific and more universal, with bold, simplified images.

MITCHELL, JOAN (Painter)
c/o Xavier Fourcade, 35 E. 75th St., New York NY 10021

Born: 1926 *Awards:* Brandeis Creative Arts Award Medal; Honorary D.F.A., Ohio Wesleyan University *Collections:* Museum of Modern Art; Art Institute of Chicago *Exhibitions:* Museum of Modern Art; Whitney Museum of American Art *Education:* Smith College; School of the Art Institute of Chicago; New York University *Dealer:* Xavier Fourcade, NYC

Early work was figurative and influenced by training in Cubism, but after contact with Willem de Kooning and other Abstract Expressionists in New York City, she developed a gestural approach, interlacing sketchy twisting brush strokes on white ground. Emotional impressions from the past of landscapes and seascapes were translated into paint, as in *George Swimming at Barnes Hole, but It Got Too Cold.* She has spent much of her artistic career in Paris, and so has ignored subsequent American art movements. Works remain lyrical, lavishly layered colors applied with an energetic brush stroke. Recent work includes a number of multi-paneled paintings that seem to refer to the passage of time.

MODEL, ELISABETH D. (Sculptor)
340 W. 72nd St., New York, NY 10023

Awards: Gold Medal of Honor, National Association of Women Artists *Collections:* Cass Canfield; Rose Collection, Brandeis University *Exhibitions:* Corcoran Gallery of Art; Jewish Museum, NYC *Education:* Ryksacademy, Amsterdam

At the beginning of her career, she was strongly influenced by Moissi Kogan, the Russian sculptor. Maillol and Henry Moore also have inspired her work. She has fashioned her sculpture in a variety of media, including clay, terra cotta, wax, wood, and stone. In particular she favors hard woods, such as ebony and rosewood. Presently she is drawing and working in watercolor.

MONTANO, LINDA (Performance Artist, Video Artist)
111 Hudson St., New York, NY 10013

Born: 1942 *Awards:* Grants, National Endowment for the Arts; Women's Studio Workshop Grants *Collections:* Museum of Modern Art *Exhibitions:* University of California, San Diego; Museum of Modern Art *Education:* Villa Schifonoia, Florence; University of Wisconsin, Madison

Originally a sculptor, for the last decade she has con-centrated on video and performance work that has explored our common perceptions about life, death and spiritual matters. Her performances have included the emotionally charged *Mitchell's Death,* a chanted performance about the tragic death of her ex-husband, and numerous palm-readings at galleries and universities throughout the United States. Her most recent work was the year long performance with performance artist Teching Hsieh in which the two were tied together at the waist by an eight foot rope but not allowed to touch each other.

MONTMINY, TRACY (Painter)
1506 Paris Rd., Columbia, MO 65201

Born: 1911 *Awards:* Fellowship, John Simon Guggenheim Memorial Foundation *Collections:* Selden Rodman, Oakland, NJ *Exhibitions:* Addison Gallery, Andover, MA; California Palace, Legion of Honor, San Francisco *Education:* Radcliffe College; Art Students League

She is primarily a draughtsman and mural painter. Five of her early murals are located in public buildings in Maine, Massachusetts, and Illinois. Italian Renaissance drawing is the major influence underlying a recent metamorphic approach, in which human figures borrow certain structural elements from banyan trees. Among her influences are Indian, Palmyrene, and Romanesque sculpture and the color harmonies of Tamayo and Matisse. Several murals done since 1978 are installed in three academic buildings in Columbia, MO.

MOON, JIM (Painter)
Rt. 3, Box 410 A, Lexington, NC 27292

Born: 1928 *Collections:* Museum of Modern Art; North Carolina Museum of Art *Exhibitions:* Spaghetti Gallery, London; Norlyst Gallery, NYC *Education:* Cooper Union; Universita Italiana Per Stranieri *Dealer:* The Calvert Collection, Washington, DC

His paintings might be described as neo-surrealistic. He found his own style early in his career and since then has remained true to his personal expression. He juxtaposes animals, insects, and sea creatures with humans in improbable settings and situations. His work recalls the geometry of Paolo Uccello and Piero della Francesca, as well as influences of Cubism and the surrealists. He disregards conventional coloring and uses whimsical, fresh hues in harmony with the mood he wishes to express. His paintings often employ images from the various cultures he has observed while traveling in Europe and Mexico.

MOQUIN, RICHARD ATTILIO (Sculptor)
3 Herbing Ln., Kentfield, CA 94904

Born: 1934 *Awards:* Oakland Museum *Collections:* Oakland Museum *Exhibitions:* Quay Gallery, San Francisco; Gallery Paule Anglim, San Francisco *Education:* San Francisco State University *Dealer:* Gallery Paule Anglim, San Francisco

His ceramic constructions deal with hard-edged geometric forms relative to abstracted landscapes and still lifes. The subject matter changes continuously in response to Moquin's experiences and travels. In all his work, his methods of working with minimal form remains constant. The Abstract Expressionist movement of the late 1950s is basic to his philosophy of art. His present works use materials such as marble for figurative life-sized constructions. His interests include translating classical forms—both architectural and figurative—into simplified, geometric contemporary sculpture.

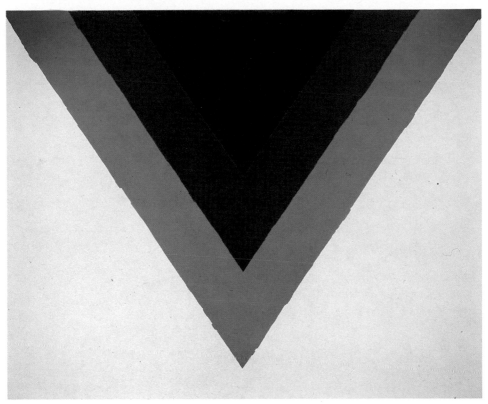

Kenneth Noland, *Across,* 97 x 126, acrylic resin paint on canvas. Courtesy: Andre Emmerich Gallery (New York NY)

Mary Nash, *Pink Skull,* 50 x 50, oil and alkyd on canvas. Courtesy: Reynolds/Minor Gallery (Richmond VA)

William Nagengast, *Pinata,* 36 x 48, acrylic.

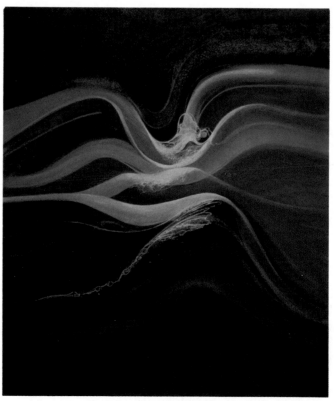

Stephanie Nadloski, *Passage #10* (1984), 19 x 24, acrylic on
paper. Courtesy: Archway Gallery (Houston TX)

Marilyn Newmark, *The Broken Leather,* 22 x 31, bronze.

Richard Pantell, *Subterrania,* 54 x 52, oil. Courtesy: Bernard
& S. Dean Levy (New York NY)

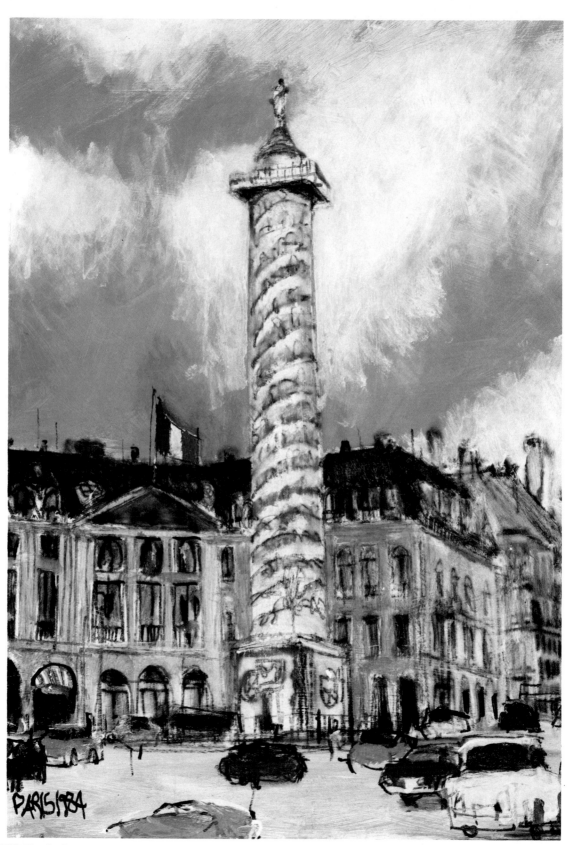

Bill Olendorf, *Paris* (1983), 18 x 24, oil on canvas.

Amado Maurilio Pena, *Paseo de Ocho,* 22 x 36, serigraph. Courtesy: El Taller Gallery (Austin TX)

Alice Marie Plaster, *The Shop Window* (1982), 33 x 42, oil on canvas.

Mr.Alex Preiss,*Master & Margareta,* 9 x 12, mixed media on paper.

Lester Rebbeck, *Marsh Wind,* 28 x 38, oil on canvas.

Stephen Quiller, *The Ravine*, 29 x 36, acrylic and casein.

Henry C. Ransom, *Earthscape: Happy Valley*, 34 x 45, oil on linen. Courtesy: Arras Gallery (New York NY)

Stephen Rybka, *Transition,* 31 x 50, oil and acrylic.

Joseph Shepperd Rogers (Nevia), *Montpelier Dinner 1,*
32 x 40, collage.

Genevieve Reckling, untitled, oil on canvas.

Marco Sassone, *San Francisco Studio Vista,* 40 x 44, oil. Courtesy: Bernard Galleries (Laguna Beach CA)

August J. Propersi, *The Future,* 27 x 35, oils.

Chyrl L. Savoy, *Portrait of the Doucet Children,* 44 x 52, acrylic.

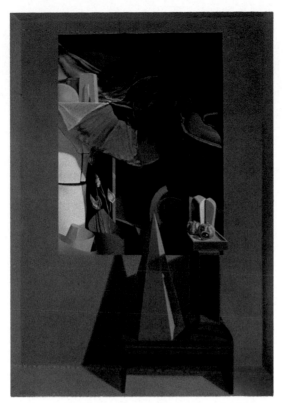

Anthony Schepis, *In the Interim,* 58 x 80, oil. Courtesy:
Robert L. Kidd Assoc. (Birmingham MI)

Lolo Sarnoff, *The Flame,* 10 x 2 ft., fiber optics and
plexiglas. Courtesy: Gallery K (Washington DC)

William Grant Sherry, *Emmet Kelly,* 24 x 30, oil.

Ben Shute, *Spring in the Quarry,* 26 x 40, watercolor. Courtesy: Frances Aronson Gallery (Atlanta GA)

Clifford Singer, *Phthalo* (1984), 32 x 32, acrylic on plexiglas.

Antonia F. Mastrocristino Sirena, *The Poor Soul with Richness of Music* (1970), 24 x 36, oil.

Philip Lawrence Sherrod, *Ode to Fertility* (1975), 70 x 57,
oil. Courtesy: Allan Stone (New York NY)

Adolf Sehring, *Thistles and Queen Anns Lace,* 20 x 30, oil.

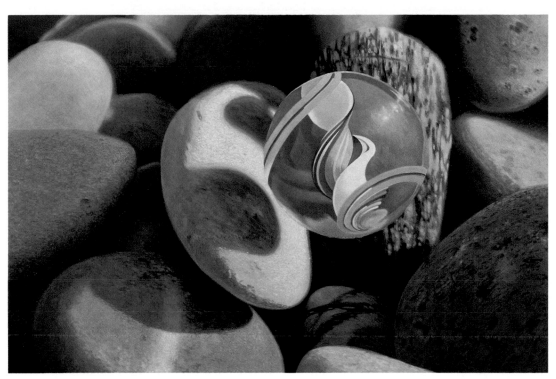

Bill Shepherd, *Vortex*, 40 x 60, oil on canvas.

Jean Shadrach, *Daisies*, 24 x 30, acrylic. Courtesy: Artique, Ltd. (Anchorage AK)

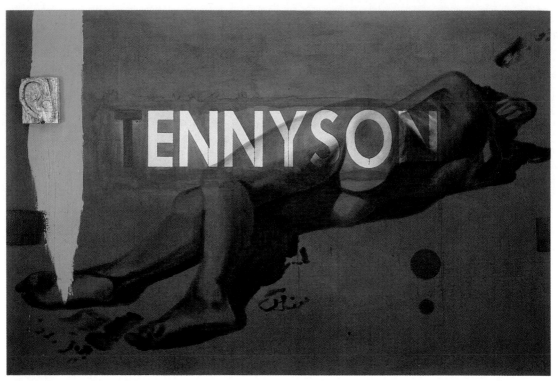

David Salle, *Tennyson* (1983), 78 x 117, oil on canvas. Courtesy: Mary Boone Gallery (New York NY)

Carl E. Schwartz, *Tropical Lushness,* 36 x 54, acrylic.

MOREHOUSE, WILLIAM PAUL (Painter, Sculptor)
P.O. Box 210, Bodega, CA 94922

Born: 1929 *Collections:* Whitney Museum; San Francisco Museum of Modern Art *Exhibitions:* California Palace Legion of Honor; Richmond Art Museum *Education:* San Francisco Art Institute; San Francisco State University *Dealer:* Paule Anglim, San Francisco

His abstract oil paintings of the 1950s reflected the strong influence of his teachers, Clyfford Still, and Mark Rothko. During the next decade his attention turned to abstracted landscapes in which the relationships between the physical and the psychological were explored. While painting remains the primary media, the present body of work includes drawing, printmaking, sculpture, and installation pieces as well. Symbolic and literal forms are paired in the compositions to acknowledge the presence of "duality."

MORGAN, JIM (Painter)
P.O. Box 1331, Mendon, UT 84325

Awards: Best of Show, National Wildlife Art Show; Best of Show, Oklahoma Wildlife Art Festival *Collections:* Texaco, Inc. *Exhibitions:* Easton Waterfowl Festival; 1983 Bird Art Exhibition *Education:* Utah State University

His paintings portray his impressions of the endless colors, ever changing moods, the play of light and the timeless beauty found in nature. He lives in a rural area of northern Utah, where he derives much of the inspiration for his paintings from the mountains, marshes and abundant wildlife that surround him. Through his art work he strives to show others the importance of saving our wild and scenic areas and wildlife, and he donates many of his paintings to various conservation groups to further this cause. He emphasizes the importance of the background in his compositions and has been commissioned to do a series of wildlife paintings for the 1984 and 1985 Texaco calendars.

MORLEY, MALCOLM (Painter)
2 Spring St., New York NY 10012

Born: 1931 *Collections:* Whitney Museum of American Art; Museum of Modern Art *Exhibitions:* Solomon R. Guggenheim Museum; Whitney Museum of American Art *Education:* Royal College of Art, London *Dealer:* Bonnier Gallery, NYC; Xavier Fourcade, NYC

Born and raised in England, his work of the late 1950s and early 1960s was abstract, but he first gained recognition as a late Pop painter when he coined the word "Superrealist" to describe his work. Unlike earlier Pop painters he was interested in the abstract qualities of the subjects and emphasized the painting process, concentrating on close-up and detailed analyses. For Photo-realistic work, a photograph was enlarged and divided into grids in order to reproduce as accurately as possible such subjects as ocean liners and dinner parties. The paintings which resulted were framed with a white border. During the 1970s exotic locales became backgrounds for the explorations of personal psychological subjects, as in *Christmas Tree (The Lonely Ranger Lost in the Jungle of Erotic Desires)*. Recent landscapes are painterly and full of enigmatic symbolic images, as in *The Cradle of American Civilization*.

MORRIS, ROBERT (Sculptor)
c/o Castelli Gallery, 4 E. 77th St., New York NY 10021

Born: 1931 *Awards:* Prize, Solomon R. Guggenheim Museum; Fellowship, John Simon Guggenheim Memorial Foundation *Collections:* Whitney Museum of American Art; Tate Gallery *Exhibitions:* Museum of Modern Art; Whitney Museum of American Art *Education:* Kansas City (MO) Art Institute; California School of Fine Arts, San Francisco *Dealer:* Leo Castelli Gallery, NYC

Minimalist works of the early 1960s ranged from constructions of painted rope and wood to aluminum to molded fiberglass. Each object was based on a single, plastic idea. *Box with the Sound* was a nine-inch cube with a recording inside of the sounds of the object being made. In *Earthwork*, a 1968 temporary object, dirt, peat, steel, aluminum, copper, brass, grease, felt and brick were randomly arranged in a pile. Since the 1970s he has continued an interest in the relationships between objects, their environment, and sounds. One piece gave an electric shock when touched. He raises questions about the perception of the work rather than about the work itself.

MORRISON, FRITZI MOHRENSTECHER (Painter)
1845 Jersey St., Quincy, IL 62301

Awards: St. Louis Art Museum; Quincy (IL) Art Center *Collections:* St. Louis Art Museum; Whatcom Museum of History and Art, Bellingham, WA *Exhibitions:* Pennsylvania Academy of Fine Arts; American Watercolor Society *Education:* School of the Art Institute of Chicago; Eliot O'Hara Watercolor School, Goose Rocks Beach, ME

Primarily a mood painter, she relies upon her "color eye" and sensitivity to abstract qualities in her variety of subjects. She concentrates on watercolor. Her early, broadly painted papers were mainly objective in focus. The recent work is more imaginative, with an emphasis on color and textural detail. She has painted in the United States, Great Britain, Europe, and the Middle East. Beyond literal depiction of her subjects, she seeks to explore the intangible feel of place, time, and season.

MORTELLITO, DOMENICO (Painter, Sculptor)
716 W. Matson Run Pkwy, Wilmington, DE 19802

Born: 1906 *Awards:* Creative Printing Award; Graphic Arts Review *Collections:* Newark Museum; The Museum of Modern Art *Exhibitions:* National Sculpture Society; The Bicentennial Exhibition, Philadelphia Memorial Hall *Education:* The Pratt Institute

As a painter, sculptor, and architectural and industrial designer, his work has graced numerous public buildings, luxury liners, and world's fairs. His work encompasses architectural decorations, genre pieces, and representational and abstract forms. Early works were executed in a process he developed employing rigid polyurethane as a sculptural medium. He has also worked closely with industry, both as a designer of the DuPont pavilion for the 1969 world's fair and as a color consultant for the graphic arts and paper industries. Current work is in sculpture, painting, murals, and graphic design.

MOSCATT, PAUL N. (Painter)
Md. College of Art, 1300 Mt. Royal Ave., Baltimore, MD 21217

Born: 1931 *Awards:* Faculty Grant *Collections:* Cincinnati Museum of Art; Peale Museum *Exhibitions:* Maryland Institute of Art; Grimaldis Gallery, Baltimore

Education: Cooper Union; Yale University

Primarily a portrait painter, his works include comparatively small, single portraits, large portraits and multiple portraits. He has followed a theme of self portraiture into complex iconography so that works become autobiographical, episodic and somewhat abstract. Work is in both oil and acrylic with loose, form oriented brushwork consistent throughout the body of his work. He has also completed a series of representational scenes depicting merchant vessels. Currently, he is continuing his self-portrait series—at the present time numbering some 200 self portraits—in different forms and themes. Additionally, he has begun another series depicting the everyday activities of life executed in a more abstract conceptual orchestration.

MOSES, EDWARD (Painter)
c/o Andre Emmerich Gallery, 41 E. 57th St., New York NY 10022

Born: 1926 *Awards:* National Endowment for the Arts Grant; Fellowship, John Simon Guggenheim Memorial Foundation *Collections:* Art Institute of Chicago; Corcoran Gallery *Exhibitions:* Museum of Modern Art; Art Institute of Chicago *Education:* University of California, Los Angeles *Dealer:* Andre Emmerich Gallery, New York, NY

As a color and field abstract painter he held his first major New York show in 1969. In the 1970s diagonal and near-horizontal stripes were a recurring motif in various media including acrylic and plastic resin (*Hagamatama*, for example), pigment or rhoplex, on diverse surfaces ranging from canvas to laminated tissue paper. In 1979 he left recognizable images behind as the canvases became large monochromatic expanses. He has also made lithographs.

MOTHERWELL, ROBERT (Painter)
909 North St., Greenwich CT 06830

Born: 1915 *Awards:* Belgian Art Critics Prize, Brussels; Gold Medal, Pennsylvania Academy of the Fine Arts *Collections:* Museum of Modern Art; Metropolitan Museum of Art *Exhibitions:* Museum of Modern Art; Whitney Museum of American Art *Education:* Stanford University; Columbia University *Dealer:* M. Knoedler, NYC; Andre Emmerich Gallery, NYC

Combining interests in art, philosophy and psychoanalysis while doing graduate work in the 1930s, he traveled to Europe and became fascinated with the exiled Surrealists and with French Symbolist poetry. He exhibited with the Surrealists in New York in 1939, but in the next decade joined the New York Abstract Expressionist movement. His medium changed from painting to collage, later a combination of the two. Committed to an abstract vocabulary of stick figures and arbitrary symbols, he wanted to convey meaning from the artist's unconscious mind, guided not by reason but by instinct. He is known for paintings which cover entire walls such as *Elegy for the Spanish Republic, No. 34*, characterized by passionate brush strokes.

MUCCIOLI, ANNA MARIA (Painter)
Muccioli Gallery, 511 Beaubien, Detroit, MI 48266

Born: 1922 *Awards:* Second Place, Ford Motor Company Exhibition *Collections:* Stuart Dingman; George Michaels *Exhibitions:* Butler Institute of American Art, Youngstown, OH; American Watercolor Society, National Academy Galleries, NYC *Education:* Center for Creative Studies, College of Art and Design *Dealer:* Muccioli Studio Gallery, Detroit

Her earlier paintings were of figures, but recently she has moved toward use of silhouettes and the breaking up of space. She works in oil, charcoal, pen and ink, acrylics, and watercolors. She also does sculpture in plaster, bronze, and clay. Recent travels to China and India have stimulated her *Oriental Series,* which are fluid, unique designs. She is interested in the conceptual changes induced by the interaction of various materials.

MURRAY, ELIZABETH (Painter)
c/o Paula Cooper Gallery, 155 Wooster, New York NY 10012

Born: 1940 *Collections:* Solomon R. Guggenheim Museum; Hirshhorn Museum & Sculpture Garden *Exhibitions:* Whitney Museum of American Art; Solomon R. Guggenheim Museum *Education:* School of the Art Institute of Chicago; Mills College *Dealer:* Paula Cooper Gallery, NYC Work of the early 1970s was characterized by small geometrical figures in large areas of color, surrounded by tiny textured scrapings. Later in the decade she employed biomorphic and anthropomorphic shapes in experimental shaped canvases which only suggested their titles, such as *Children's Meeting* and *Traveler's Dream*. Also in recent work the large areas of color are biting and brilliant, opposing each other, yet unified by flowing outlines. A varied brushstroke produces both glossy and dull effects within the same composition, in thickly textured applications or in thin layers. Shape, color and line are combined in an enigmatic style to emphasize surface texture, as in *Just in Time* (1981).

MUSICK, PAT (Painter)
2138 Colquitt, Houston, TX 77098

Born: 1926 *Awards:* Gold Metal, Premio Pizzo, Pizzo Calbro, Italy; Prize, JCC National *Collections:* University of Houston; Dartmouth College *Exhibitions:* Cornell University; Everson Museum *Education:* Dartmouth; Cornell University; Syracuse University *Dealer:* Economos Works of Art, Houston Painted in oil on canvas or on her own handmade paper mounted on wood, the scale of the pieces range from small to pieces of ten to fifteen feet. The content is concerned with personal perceptions of the human experience, such as childhood, adolescence, old-age, love, death, and grief. Her work is figurative and expressionistic, bearing historical ties to Kollwitz and Munch and contemporary relationship to Neel, Jimeniz and Balthus. While in the past the figures were clearly demarcated from the grounds, recently the figural arrangements have become ambiguous, setting the composition even more empathetically in the psychological realm. In newest works, the figures have been taken from the rectangular picture plane altogether. The "pieces" are mounted in four to five different spatial planes away from the wall, creating a bas relief type visual puzzle.

NADOLSKI, STEPHANIE L. (Painter, Collage Artist)
8250 Magnolia Glen, Atascocita, TX 77346

Born: 1945 *Awards:* Grumbacher Award, XV Annual Exhibition, Baytown, TX; *Collections:* University of Mississippi; Texas Commerce Bank Collection, Houston *Exhibitions:* Brazosport Center for Arts and Science; Archway Gallery, Houston *Education:* San Jose State College *Dealer:* Gallery Greenspoint, Houston; Archway Gallery, Houston

Her early work was primarily representational oil and watercolor landscapes. Experiments with a wide variety of media and techniques, led to her series of watercolor

Melvin O. Miller, *Judy Moran*, 18 x 24, oil on canvas. Courtesy: Foxhall Gallery (Washington DC)

Stephanie Nadloski, *Passage #10*, 22 x 30, acrylic on paper. Courtesy: Archway Gallery (Houston TX)

on rice paper collages. Current work continues her exploration of media. Handmade paper pieces have found objects embedded into the ground itself, while her monotypes, collographs, and acrylics on paper are more abstract with found objects providing the initial images. Her facility with color, sensitivity to texture, and interest in the representation of motion run consistently through her work in all media.

NAFTULIN, ROSE (Painter)
1301 Stotesbury Ave., Wyndmoor, PA 19118

Born: 1925 *Awards:* Award, National Academy of Design; Prize, Woodmere Art Museum *Collections:* Fidelity Bank, Philadelphia; Johnson and Johnson *Exhibitions:* National Academy of Design; Philadelphia Museum of Art *Education:* Philadelphia College of Art; Barnes Foundation *Dealer:* Gross-McCleaf Gallery, Philadelphia

She paints in a representational and expressionistic style using both oils and watercolors. The bold, turbulent colors of her early work changed to a paler, more tranquil palette and then back again, reflecting the influence of Matisse, Cezanne, and Bonnard, whose work she studied. Predominately landscapes, the paintings retained a distinctive romantic quality. Her current body of work in oil concentrates on the nature and application of the paint itself. Layer after layer of pure pigment is built upon a ground of transparent washes to create a dense and active surface. In contrast, her watercolor still lifes remain lighter, serene, and realistic.

NAGENGAST, WILLIAM JOSEPH (Painter, Designer)
159 Park Place, Irvington, NJ 07111

Born: 1934 *Awards:* Grand Prize, Atlantic City National Art Show; Grand Prize, South Orange National Art Show *Collections:* City of Irvington Collection, NJ; Office Unlimited *Exhibitions:* Kean College; Ocean City Museum *Education:* Newark School of Fine and Industrial Arts

He began his painting career with a realistic technique, and moved toward his present impressionistic abstract style. He works in an evolutionary manner, with each concept first explored in pastel sketches, furthered developed in watercolor, before a final rendition in acrylic. The futuristic imagery gathers complexity and conceptual layers with each of at least three steps of enlargement, from square inches of the first studies to the square feet of the acrylic paintings. His evolutionary process of painting builds a richness of subliminal associations and allusions into his compositions. His present work incorporates the strengths of his line work with the subtle beauty of his colors. The work is futuristic with lyrical overtones, uniting the continuity of color and design.

NAKIAN, REUBEN (Sculptor)
810 Bedford, Stamford CT 06901

Born: 1897 *Awards:* Skowhegan School Sculpture Award; National Endowment for the Arts Grant *Collections:* Museum of Modern Art; Whitney Museum of American Art *Exhibitions:* Museum of Modern Art; Solomon R. Guggenheim Museum *Education:* Robert Henri School; Art Students League *Dealer:* Marlborough Gallery, NYC; Benjamin Mangel Gallery, Philadelphia

As a young man he was an apprentice to Paul Manship, who influenced his stylized, smooth forms. In 1932 the series beginning with busts of political and bureaucratic figures ended with the famous monumental plaster statue of Babe Ruth. Due to contact with Arshile Gorky and Stuart Davis his sculptures of the 1930s and 1940s became increasingly abstract, with rough, improvised surfaces, like three-dimensional equivalents of Abstract Expressionist paintings. Drawings were also added to his media at this time. Small terra cotta pieces represented mythological themes, as did large bronze and welded steel constructions. These expressive, often erotic monumental sculptures are best presented in open spaces, as is *Voyage to Crete*, installed at New York City's Lincoln Center.

NARANJO, MICHAEL ALFRED (Sculptor)
P.O. Box 747, Espanola, NM 87532

Born: 1944 *Awards:* First Prize, Sculpture, Celebration '81, Atlanta, GA; Governor's Award for Sculpture, 1976 *Collections:* Heard Museum; Museum of the Horse, Patagonia, AZ *Exhibitions:* Heard Museum; Smithsonian Institution *Education:* Highland University

Though blinded in Vietnam in 1968, he continues to do what others told him was impossible—to succeed as a sculptor. His bronzes reflect man's ability to believe in himself. The older works deal mainly with Indian and nature subjects. More recently he has become known for his fluidity and fine lines, reflecting intense emotion. His newer pieces, many of which are nudes, demonstrate a new concentration and maturity. He currently is experimenting in stone and wood as well as continuing to work in bronze.

NASH, MARY (Painter)
8536 Aponi Rd., Vienna, VA 22180

Born: 1951 *Awards:* MacDowell Colony Fellowship *Collections:* Washington State Arts Commission; San Antonio Museum *Exhibitions:* Osuna Gallery, Washington, DC; Southeastern Center for Contemporary Art *Education:* George Washington University; Washington State University *Dealer:* Reynolds Minor Gallery, Richmond, VA

The body of her work consists of her paintings and drawings, whose hallmark is her use of personal symbolism. Her style shows a conscious disregard of anatomical rules and a use of narrative, expressing a primitive energy. The characters in her tableau act in scenarios that suggest Nash's own personalized mythology. The symbolic relationships are heightened by her rejection of the rules of perspective and proportion in the presentation of the human form.

NATKIN, ROBERT (Painter)
24 Mark Twain Lane, West Redding CT 06896

Born: 1930 *Collections:* Museum of Modern Art; Whitney Museum of American Art *Exhibitions:* Whitney Museum of American Art; San Francisco Museum of Modern Art *Education:* School of the Art Institute of Chicago *Dealer:* Gimpel and Weitzenhoffer Gallery, NYC; Andre Emmerich Gallery, NYC; Meridian Gallery, Chicago

During the 1950s he was an Abstract Expressionist, and early influences included not only Willem de Kooning but also Mark Rothko, Henri Matisse and Paul Klee. Later the *Apollo* series presented translucent bands of color which seemed to hover over the canvases. The surface of the canvas is emphasized in most of his paintings, in which multi-colored compositions are rendered in a pointillist and crosshatch style, while at the same time an illusion of depth is created so that the images seem to float in undefined planes, as in the

Mary Nash, *Judgement,* 50 x 60. Courtesy: Reynolds/Minor Gallery (Richmond VA)

William Nagenghst, *No Title*, 38 x 38, acrylic.

Intimate Lighting series. Biomorphic and anthropomorphic shapes are evident in the recent *Bern Series*, large colorful works in translucent acrylics on paper.

NAUMAN, BRUCE (Sculptor)
c/o Leo Castelli Gallery, 420 W. Broadway, New York NY 10012

Born: 1941 *Awards:* National Endowment for the Arts Grant; Aspen Institute for Humanistic Studies Grant *Collections:* Whitney Museum of American Art; Los Angeles County Museum of Art *Exhibitions:* Museum of Modern Art; Whitney Museum of American Art *Education:* University of Wisconsin; University of California, Davis *Dealer:* Leo Castelli Gallery, NYC

In the late 1960s he gained recognition as a post-Pop artist, with multimedia presentations in such media as neon, rubber, fiberglass, sound, video, and even holography. Slogans in neon played with language, and mocked advertising gimmicks. Pieces made of rubber and fiberglass were bent, folded and hung, emphasizing the objects' properties rather than the objects themselves. He has made casts of his own body in fiberglass, clay and neon, during taped or live performances in an attempt to probe self-awareness. At times the audience members were asked to participate in video performances in order to expand their own self-awareness. Language, inner meaning and experience continue to be important in the sculptures and various other presentations.

NEIMAN, LE ROY (Painter)
1 W. 67th St., New York, NY 10023

Born: 1927 *Awards:* Clark Award, Chicago Show *Collections:* Art Institute of Chicago; Minneapolis Institute of Art *Exhibitions:* Carnegie Institute; Hammer Galleries, NYC *Education:* School of the Art Institute of Chicago *Dealer:* Hammer Galleries, NYC; Knoedler Publishing, NYC

He is a sports artist and chronicler of contemporary life-styles, and a creator of the subject of action. His work has been influenced by the art of Lautrec, Dufy, and the Social Realists such as Hopper, Bellows, and Sloane. The colors are brilliant and raw, and their spontaneous application also reflects the influence of the abstract expressionists on his work. He applies his color with a technique that may start with a version of impressionism and continue with a process that resembles the action paintings of abstract expressionism.

NERI, MANUEL (Sculptor)
c/o Anne Kohs and Associates, 251 Post St., Suite 300, San Francisco CA 94108

Born: 1930 *Awards:* Fellowship, John Simon Guggenheim Memorial Foundation; National Endowment for the Arts Grant *Collections:* Seattle Art Museum; Oakland Museum *Exhibitions:* Oakland Museum; Seattle Art Museum *Education:* California College of Arts and Crafts; California School of Fine Arts *Dealer:* John Berggruen Gallery, San Francisco; Charles Cowles Gallery, NYC

A class with ceramicist Peter Voulkos turned him away from the study of engineering to a serious pursuit of an artistic career. After a number of Abstract Expressionist paintings and Funk Art pieces, he turned to the figure. Bright enamel paint was applied to these early figural plaster sculptures in order to enhance texture and contrast; most of each figure was left white. Later an interest in the effects of light and shadow made him discontinue the use of color in favor of the plain white plaster. In 1977 color was again added to a series of plaster figures which experimented with depictions of gestural movement. Bronze casts have been made of some of the plaster pieces, the bronze reworked and then painted. Recent marble sculptures are treated similarly to earlier works in plaster. He works with the stone in his studio in Carrara, Italy.

NESBITT, LOWELL (BLAIR) (Painter)
c/o Andrew Crispo Gallery, 41 W. 57th St., New York NY 10022

Born: 1933 *Awards:* Purchase Awards for Oils and Prints, Baltimore Museum of Art; Drawing, Baker Brush Co. *Collections:* Museum of Modern Art; Smithsonian Institution *Exhibitions:* Whitney Museum Annual; Corcoran Gallery of Art *Education:* Tyler School of Fine Arts, Temple University; Royal College of Art, London *Dealer:* Andrew Crispo Gallery, NYC

After studying stained-glass-making and etching, he turned instead to Photo-realist painting in 1963. Early works were based upon x-rays, followed by large-scale depictions of flowers. He eventually began to execute work in series: cityscapes, building facades, studio interiors and windows, bridges, and close-ups of shoes. Photographs served as models, but they were not copied exactly; often monochrome oils were used to flatten the space, making the paintings look like depictions of photographs, rather than representations of the subjects themselves. Unlike the work of most Photo-realists, a thick brushstroke visibly emphasizes the illusory quality of the painting.

NEUSTEIN, JOSHUA (Painter, Printmaker)
7 Mercer St., New York, NY 10013

Born: 1940 *Awards:* Jerusalem Prize; Sandberg Prize *Collections:* Museum of Modern Art; Solomon R. Guggenheim Museum *Exhibitions:* Mary Boone, NYC; Johnson Museum *Education:* The Pratt Institute; City College of New York

Work is comprised of torn, cut, folded, removed and replaced papers covered with acrylic paint and combined in collages on a monumental scale. Influences from cubism, fauvism, and the paintings of Matisse and Mondrian combine in a contemporary manner to express his strong concern with pictorial narrative in his paintings. Further, the artist cites his concern with the dualities of drawing versus color, forms versus words, brain versus body, and the nostalgia for old values in relationship to the epigones of modern society as major influences on his current work.

NEVELSON, LOUISE (Sculptor)
29 Spring St., New York NY 10012

Born: 1900 *Awards:* MacDowell Colony Medal; Creative Arts Award, Brandeis University *Collections:* Whitney Museum of American Art; Museum of Modern Art *Exhibitions:* Art Institute of Chicago; Whitney Museum of American Art *Education:* Art Students League; Hans Hofmann School; Smith College *Dealer:* Pace Gallery, NYC

Born in Kiev, Russia, she came to America as a child. After studying in New York and Munich, in 1932 she and Ben Shahn helped Diego Rivera with his mural for the New Workers' School. Work of the 1930s and 1940s reflected the influences of his primitivism, as well as of Umberto Boccioni's Futurism and Constantin Brancusi's pure forms. Angular shapes were hollowed out in solid areas of wood, and in 1942 experiments with assemblage led her to a series of environmental

Circus sculptures. In the 1950s she gained recognition with intricate arrangements of geometric forms painted in a single color. These were found objects and carved wood mounted on platforms or in boxes and, by 1958 stacked into wall-like reliefs, painted black. The next year these constructions were painted white in order to emphasize more strongly her main interests, "shadow and space." In later years monumental formations of geometric shapes and elements in less compact configurations have employed such materials as plexiglass, plastic, and steel.

NEVIA (Painter, Assemblage Artist)
Bealls Pleasure, P.O. Box 1268, Landover, MD 20785

Born: 1943 *Awards:* Jamieson Award, 49th Annual Miniature Society *Collections:* University of Maryland; Bishop O'Connell *Exhibitions:* Koln, West Germany; Rotunda Gallery, Pan America *Education:* Greensboro College *Dealer:* Galerie Geilsdorfer, Cologne, West Germany

His early work was in interpolated and applied papiermache assemblages, drawn work and picture images, and "boxed images." In painting, his early palette was primary within an untraditional format. His work in "dimorphic collage" is a direct outgrowth of his earlier work. Emphatically ambiguous images present obscure pretensions in abundance, rushing from the Renaissance to the Victorian in an imperial sweep. In the newer works, the one-dimensional ratio of the specified quality to the total magnitude of contingent relationships is achieved through a limited palette and traditional format. The cumulative references are based on the artist's inner responses.

NEWMAN, ELIAS (Painter)
215 Park Row, New York, NY 10038

Born: 1903 *Awards:* Grumbacher Art Award, American Society of Contemporary Artists; Stanley Grumbacher Memorial Medal, Audubon Artists *Collections:* National Museum of American Art, Smithsonian Institution; Boston Museum of Fine Arts *Exhibitions:* Babcock Galleries, NYC; Doll and Richards Galleries, Boston *Education:* Educational Alliance Art School, NYC

His early works included watercolors, with his subjects primarily derived from nature. During the 1960s he began working in encaustic and caseins. In his experiments with encaustic he used an electrically heated palette and a blow-torch to keep the colors in a fluid state. The encaustics have an impressionist quality. His subjects are varied and include landscapes, seascapes, and street scenes. He also has focused on biblical subjects and ancient Jewish customs.

NEWMARK, MARILYN (Sculptor)
Woodhollow Road, East Hills, NY 11577

Born: 1928 *Awards:* Gold Medal, Allied Artists of America; Award, National Academy *Collections:* National Museum of Racing; International Museum of the Horse *Exhibitions:* Hammond Museum; James Ford Bell Museum of Natural History *Education:* Adelphi College; Alfred University *Dealer:* Arthur Ackermann and Son, Inc., NYC

She works in the tradition of the 19th Century animal sculpting, modeling primarily horses as well as hounds, foxes, and equestrian figures in exacting realism. The figures are executed in clay, cast into bronze, and mounted on pedestals. The finished work ranges from about four inches to fourteen inches in height. These are animal portraits, frequently of famous horses and their riders, which capture a specific animal in mid-stride—running, jumping, or playing. Often several horses are grouped together or horses and dogs interact and the piece assumes a good-natured, narrative quality echoed by such titles as *The Mischief Maker,* or *The Pensioners.*

NICE, DONALD (Painter)
c/o Nancy Hoffman Gallery, 429 W. Broadway, New York NY 10012

Born: 1932 *Awards:* Ford Foundation Purchase Award *Collections:* Museum of Modern Art; Whitney Museum of American Art *Exhibitions:* Museum of Modern Art; Pennsylvania Academy of the Fine Arts *Education:* University of Southern California; Yale University School of Art *Dealer:* Nancy Hoffman Gallery, NYC

He gained recognition as a New Realist painter in the early 1960s. Realistic renderings of packaged and processed items were very large, detailed studies of the optical image. Close-ups of light reflections on plastic wrap or glass revealed a beauty even in commercial objects. Foods and grocery items or synthetic objects such as tennis shoes were collected in artificial arrangements to create illusionistic still lifes. Later work continued the depiction of single items, also combining media and including new subjects. *Bear, Hudson River Series, American Predella No. 3,* for example, is a large picture of a bear in acrylic, over four framed smaller watercolors of lollipops, a gym shoe, a bag of opened marshmallows, and a seascape.

NICHOLAS, THOMAS ANDREW (Painter)
7 Wildon Heights, Rockport MA 01966

Born: 1934 *Awards:* Gold Medal, Allied Artists of America; Elizabeth T. Greenshields Memorial Foundation Grants *Collections:* Greenshields Museum, Montreal; Butler Institute of American Art *Exhibitions:* I.F.A. Galleries, Washington (DC) *Education:* School of Visual Arts *Dealer:* Tom Nicholas Gallery, Rockport, MA; Huney Gallery, San Diego

Oils, gouaches and watercolors depict his native New England landscapes as well as views from extensive travels in Mexico and Europe. Painting from sketches and color notes, compositions are carefully designed in the studio and include abstract patterns and textured areas, as in *Mykonos, Greece.* "I feel the finished work painted from the visual world should tell us more about the artist who painted it than to demonstrate its facsimile to nature." Recent work has included multi-colored lithographs.

NICHOLS, WARD H. (Painter)
318 Elm St., Wilkesboro, NC 28659

Born: 1930 *Awards:* Grumbacher Award of Merit; Award, Mississippi Art League *Collections:* R.J. Reynolds Co.; Gutenburg Museum *Exhibitions:* Allied Artists of America; Museum of Fine Arts, Springfield *Education:* Western Virginia University *Dealer:* Top Drawer Gallery, Winston-Salem, NC

The contemporary treatment of traditional subjects, executed in an extremely realistic wet on wet oil technique was characteristic of his earlier paintings. Although the rural landscape had been almost the exclusive subject of his past work, he now addresses a variety of subjects in several different medium. Currently he is involved in a renewed effort of painting still life subjects and concentrating on the abstract qualities, and chance patterns of ordinary objects as subject mat-

ter. His fascination with rural subjects continues as well with his studies of older barns, homes, and other buildings in an effort to document a passing life style. The artist prefers to paint in oil because of its expressive qualities and adaptability for detail work.

NICHOLSON, LAURA FOSTER (Fiber Artist)
2036 Cortlandt Street, Houston, TX 77008

Born: 1954 *Collections:* University of Illinois Medical Center; Chicago Board of Trade *Exhibitions:* Elements Gallery, New York City; Ruth Volid Gallery, Chicago *Education:* Kansas City Art Institute; Cranbrook Academy of Art *Dealer:* Hadler-Rodriquez Gallery, NYC; Ruth Volid Gallery, Chicago

The source of her woven cloth images is the notion of the place where one dwells—the home. House, garden, courtyard, doors and windows, all take on symbolic meaning in her compositions. That the images are made of cloth is not incidental, considering the function of both cloth and the home as the lining between people and their surrounding environment. The sense of building the images makes a logical connection with architecture, but the work does not speak of architecture so much as it uses buildings to point to the life within.

NIIZUMA, MINORU (Sculptor)
463 West St., New York, NY 10014

Born: 1930 *Collections:* Hirshhorn Museum and Sculpture Garden; Solomon R. Guggenheim Museum *Exhibitions:* Gimpel & Weitzenhoffer Ltd., NYC; Whitney Museum of American Art *Education:* Tokyo University of Arts *Dealer:* Gimpel & Weitzenhoffer Ltd., NYC

Work is abstract sculpture in marble and granite. Works vary from small table pieces to larger free standing sculpture. The duality of nature is represented through the contrasts evident in his sculpture. Highly polished, and finished surfaces are contrasted against the uncut, rough black marble and granite faces. The harmony within nature and man with nature is symbolized in this duality.

NILSSON, GLADYS (Painter)
1035 Greenwood Ave., Wilmette IL 60091

Born: 1940 *Collections:* Museum of Modern Art; Whitney Museum of American Art *Exhibitions:* Museum of Contemporary Art, Chicago; Whitney Museum of American Art *Education:* School of the Art Institute of Chicago *Dealer:* Phyllis Kind Gallery, Chicago and NYC

This Chicago Imagist first gained recognition as part of The Hairy Who group in the late 1960s. Her colorful watercolors depict often innumerable fanciful figures in complex arrangements, overlapping and twisting with activity across the canvas. Crowded elongated figures engage in odd encounters, puzzles for the viewer. Because the main concern is the transformation of form, these lyrical images are made to be observed again and again, each sequence of vision lending a new interpretation to the intertwined incidents. Most works are on a small scale, but some large-scale canvases have been made as well. Although her primary medium is watercolor, she has also employed acrylic.

NISBET, P. A. (Painter)
1201 W. Meade Lane, Flagstaff, AZ 86001

Born: 1948 *Awards:* First Prize, Glendale (AZ) Festival of the Arts *Exhibitions:* O'Brien's Art Emporium, Scottsdale, AZ *Dealer:* O'Brien's Art Emporium, Scottsdale, AZ; The Jamison Galleries, Santa Fe, NM

Over two decades of painting, his work has followed a representational path with an emphasis on landscape, particularly the American Southwest. In the past his work has dealt objectively with natural phenomena, often expressed with exaggerated compositions and colors. Presently he works exclusively in oils, usually on canvas. His materials are obtained outdoors from remote locations throughout Arizona and New Mexico. His oil studies lead to more finished paintings, which may range from twelve to eighty inches in length. His style has been changing to a more fluid realism where description gives way to a direct pursuit of the "emotional" character of a landscape.

NOBLE, HELEN (Printmaker, Painter)
1702 Cliff Dr., Santa Barbara, CA 93109

Born: 1922 *Awards:* 3rd Place, 41st Annual Exhibition of Miniature Art, Washington, DC; Honorable Mention, 7th Annual Exhibition, Miniature Art Society of New Jersey *Exhibitions:* Small Works National Exhibition, Rochester, NY; 24th Annual Exhibition of Prints and Drawings, Oklahoma City, OK *Education:* Wayne State University; Santa Barbara Art Institute *Dealer:* Gallery 932, Ventura, CA; Byck Gallery, Louisville, KY

She has always used themes that evolve from nature's moods, colors, and shapes. She began with a small image that combined printmaking methods, including woodblock, stencil, and offset roller. Later she moved to a larger format, using plywood blocks, dampened Japanese paper, and watercolor. The editions were small and often contained variations. While she continues to work in the print medium to express mood and subtlety, she has also turned to oil painting to delineate landscape as seen in travels across Western terrain. She observes and paints in semi-abstract shapes, and is strongly influenced by color. The latest work introduces man-made objects combined with broad sweeps of landscape, such as brightly lit signs against an evening sky.

NOGUCHI, ISAMU (Sculptor, Designer)
32-37 Tenth, Long Island City NY 11106

Born: 1904 *Awards:* Fellowship, John Simon Guggenheim Memorial Foundation; Bollingen Fellowship *Collections:* Metropolitan Museum of Art; Museum of Modern Art *Exhibitions:* Whitney Museum of American Art; Museum of Modern Art *Education:* Columbia University *Dealer:* Pace Gallery, NYC

An apprentice to Constantin Brancusi from 1927 to 1929 in Paris, he then studied brush drawing in Peking and pottery in Japan. In 1935 he created set designs for Martha Graham's dance company, as well as a high-relief mural in Mexico City, Mexico. In 1942 he made one of the first illuminated sculptures, and three years later a series of *Gunas* consisted of marble slabs placed on tripods. Experiments with media continued, including the employment of stainless steel, stone, ceramics, aluminum and bronze. Designs for lamps, furniture, gardens, and playgrounds aimed at a Western commercial market also retained an Oriental flavor with forms like three-dimensional equivalents of calligraphy. In the 1960s simple sculptural pieces with roughened surfaces of bronze or marble were often placed in gardens in order to emphasize relationships between the object and the environment. During the next decade stainless steel sculptures explored the properties of surface density and reflected light. Recent works in stone bring a sensual and spiritual refinement to the medium.

Richard Pantell, *Centre Spring*, 51 x 68, oil. Courtesy: Bernard & S. Dean Levy (New York NY)

Marilyn Newmark, *Day's End*, 17 x 23, bronze.

NOLAND, KENNETH C. (Painter)
South Salem NY 10590

Born: 1924 *Collections:* Museum of Modern Art; Metropolitan Museum of Art *Exhibitions:* Solomon R. Guggenheim Museum; Metropolitan Museum of Art *Education:* Black Mountain College; Zadkine School of Sculpture, Paris *Dealer:* Andre Emmerich Gallery, NYC

In the early 1950s he was introduced to Helen Frankenthaler's method of staining unprimed canvases with acrylic, and with this technique he developed a geometric coloristic style. Motifs such as circular or ellipsoid rings and later chevrons and targets were presented in works of the next decade. He first exhibited with the Minimalist group called The Washington Color Painters in 1965. Colors were sometimes juxtaposed with areas of raw canvas, or with other colored forms, creating an ambiguity between image and ground. His work moved from symmetry to asymmetry, from motifs to mere bands of color. Later experiments with shaped canvases and vertical and horizontal stripes ("plaids") lead to the use of diagonals to create irregular compositions involving the space outside of the paintings.

NONAS, RICHARD (Sculptor)
c/o Oil and Steel Gallery, 157 Chambers St., New York NY 10007

Collections: Walker Art Center; Count Panza di Biumo, Italy *Exhibitions:* Oil and Steel Gallery; Jack Tilton Gallery *Dealer:* Hoshour Gallery, Albuquerque; Oil and Steel Gallery, NYC; Jack Tilton Gallery, NYC

He was an anthropologist before choosing an art career in the 1960s. Large minimalist installations in unfinished steel and lumber often consist of groups of floor pieces which fill whole rooms. The flat pieces sometimes appear to be artifacts, seeming out of place in irregular arrangements of cement, wood and metal in created interior sites, as in the 1980 installation at the Oil and Steel Gallery, in which squared columns broke up the large spaces between the rectilinear floor pieces. The *Willow Line* series of 1981 featured much smaller pieces—many short willow sticks placed in sections, each section twenty-seven feet long and six-and-a-half feet wide, in patterned arrangements across the floor. The room had tall windows, each one allowing light to shine upon a separate section of sticks.

NOVOTNY, ELMER LADISLAW (Painter)
7317 Westview Rd., Kent, OH 44240

Born: 1909 *Awards:* Purchase Award, Butler Institute of American Art; First Prize, Cleveland Museum of Art *Collections:* Butler Institute of American Art; Akron Museum of Art *Exhibitions:* Carnegie Museum; Milwaukee Art Museum *Education:* Cleveland Institute of Art; Slade School *Dealer:* Vixseboxse Gallery, Cleveland

He paints in all media—oils, acrylics, gouache and watercolor—in a realistic style with a variety of subject matter. Although fine draftsmanship is extremely important in his work, it does not interfere with his strong sense of formal order and color composition. Color and simulated texture play important roles in the overall aesthetic of his paintings. Never however is any one element stronger than the pictorial structure. Common subject matter is landscape, figurative and portraiture work.

NUTT, JAMES TUREMAN (Painter)
1035 Greenwood Ave., Wilmette IL 60091

Born: 1938 *Collections:* Museum of Contemporary Art, Chicago; Whitney Museum of American Art *Exhibitions:* Art Institute of Chicago; Venice Biennale *Education:* School of the Art Institute of Chicago *Dealer:* Phyllis Kind Gallery, Chicago

This Chicago Imagist first gained recognition in the late 1960s as part of The Hairy Who group of painters. Meticulously executed drawings and paintings depict fantastic characters engaged in ironic dramatic scenes. Distorted figures recall those of Cubism in that they often possess several faces at once, perhaps representing different states of feeling. The dramas are erotic and mysteriously threatening, and although (or perhaps because) Nutt adds oddly placed captions and gives the works cryptic titles, the situations remain inexplicable, and therefore engaging.

NUTZLE, FUTZIE (Cartoonist, Illustrator)
P.O. Box 325, Aromas, CA 95004

Born: 1942 *Awards:* College Journalism Awards *Collections:* Oakland Museum; Santa Cruz City Museum *Exhibitions:* Santa Barbara Museum of Art; Pacific Grove Art Center *Education:* Cleveland Institute of Art; Cooper School of Art; Ohio State University

His sparsely executed yet poignant cartoons have appeared in numerous magazines and newspapers throughout the United States, including *Rolling Stone* magazine and the *San Francisco Chronicle*. Although the artist has worked in oils, acrylics, pastels, etchings, and lithographs, the primary medium of the cartoons has been the pen and ink drawing. He has illustrated a variety of books, posters and catalogs, and has authored and illustrated three books of cartoons, most recently *The Modern Loafer*.

O'BANION, NANCE (Fiber Artist)
c/o Allrich Gallery 251 Post St., San Francisco, CA 94610

Born: 1949 *Awards:* Fellowship, National Endowment for the Arts; Designer Craftsman Award *Collections:* Seattle Art Museum; San Francisco International Airport *Exhibitions:* San Francisco Museum of Modern Art; Oakland Museum *Education:* University of California, Berkeley *Dealer:* Allrich Gallery, San Francisco

She works with paper, starting with liquid pulp and building up successive layers of colored watermarked sheets on a grid of painted and hand-tied bamboo. For a large complex composition, long paper strips with deckle edges are made, then plaited over and under a bamboo grid and finally spray painted after the plaiting is completed. Paper is often crumpled and spray-painted, spread out and crumpled and painted again to create shimmering layers. Sometimes the works are lacquered, and in her more recent larger works, several layers of bamboo and paper are tied together with brightly colored string to make free-standing works. In a recent suspended work, installed at the San Francisco International Airport, her four part paper and bamboo piece, changes as the viewer approaches it.

OBLINSKI, RAFAL (Graphic Artist)
470 W. 23rd St., New York, NY 10011

Born: 1943 *Awards:* First Prize, Poster Competition, Human Rights Institute; First Prize, Trademark Competition, International Jazz Federation *Collections:* Carnegie Foundation, NYC *Exhibitions:* Society of Illustrators Traveling Exhibition; Jersey City State College *Education:* Warsaw Polytechnical School *Dealer:* Tania Kimche, NYC

Ostensibly self-taught, he turned from architecture to illustration while still a resident of his native Poland. As part of his educational process he fed on the works of other practitioners for inspiration: Heinz Edelmann, Holger Matthies, Brad Holland, Marshall Arisman and Milton Glaser. Ideas, not design and technique, were and remain his primary concern. His illustrations and cover art for publications such as the *New York Times Magazine, Time,* and *Business Week* combine a stylized realistic technique with surrealistic juxtapositions of images to convey his message.

OFFNER, ELLIOT (Sculptor)
74 Washington Ave., Northampton, MA 01060

Born: 1931 *Awards:* Grant, Tiffany Foundation; Award, National Institute of Arts and Letters *Collections:* Hirshhorn Museum and Sculpture Garden; Brooklyn Museum *Exhibitions:* Springfield Museum of Fine Arts; Forum Gallery, NYC *Education:* Yale University; Cooper Union *Dealer:* Forum Gallery, NYC

His life size, realistic sculpture in both bronze and wood, are primarily figurative and address religious themes. A series of bronzes entitled *Holocaust* represent a major concern in his work—the tragic human suffering caused by war. A recent full scale woodcarving of St. Francis as a youth continues his Christian, figurative work. Other nature images—fish, birds, skulls—are studied and meticulously rendered for both their symbolic associations and their visual beauty.

O'KEEFE, GEORGIA (Painter)
Abiquiu NM 87510

Born: 1887 *Awards:* Gold Medal for Painting, National Institute of Arts and Letters; Edward MacDowell Medal *Collections:* Metropolitan Museum; Museum of Modern Art *Exhibitions:* Art Institute of Chicago; Museum of Modern Art *Education:* School of the Art Institute of Chicago; Art Students League

An early Precisionist, she began in her twenties with close-ups of flowers and plants. As a member of Alfred Stieglitz's 291 Gallery she had her first show there in 1916. Semi-abstract paintings of New York City were examples of a preoccupation with simplification, stylized shadows, and areas of hard-edged color. Monumental flowers, looked at so closely, become worlds in themselves. Sun-bleached bones and skulls, and landscapes of the American Southwest are charged with mystery through a surreal sensibility. Her love for the dazzling light and big open spaces of the American Southwest is reflected in visions of skulls and flowers as icons, hills and clouds as undulating bodies.

OKUMURA, LYDIA (Painter, Sculptor)
114 Franklin St., New York, NY 10013

Born: 1948 *Awards:* Award, XII International Sao Paulo Biennial; Graphic Grant, Creative Artists Public Service Program *Collections:* Metropolitan Museum of Art; Modern Art Museum, Sao Paulo, Brazil *Exhibitions:* Modern Art Museum, Sao Paulo, Brazil; Cranbrook Academy of Art *Education:* Fac Plastic Arts, Armando Alvares Penteado Foundation, Sao Paulo, Brazil; Pratt Graphics Center, NYC *Dealer:* Condeso and Lawler Gallery, NYC

She creates conceptual and perceptual environments using mixed-media materials in both two and three dimensional works. She calls herself "an architect of the space" and is concerned with perspective and illusion. Her recent work produces optical illusions of other spaces within real spaces. She combines large

paintings on canvas in brilliant, strong colors with sculpture made from such diverse materials as wire screening, string, fabric, metal, wood, and paper. The titles *Metamorphosis, Energy, Synchronization,* and *Reflections/Refractions,* are introductions to carefully altered environments.

OLDENBURG, CLAUS THURE (Sculptor)
556 Broome St., New York NY 10013

Born: 1929 *Collections:* Museum of Modern Art; Whitney Museum of American Art *Exhibitions:* Metropolitan Museum of Art; Museum of Modern Art *Education:* Yale University School of Art; School of the Art Institute of Chicago

Born in Sweden, his early life was spent shuttling between America and Scandinavia. By the time he moved to New York in 1956, figurative works were rendered with a loose brush stroke. Four years later he was involved with a group of artists including Jim Dine, who started a new kind of participatory art called "happenings." During the next decade he composed numerous happenings using crude costumes, cardboard props, a proliferation of found objects, and audience participation. He is perhaps best known for his work in monumental sculpture and stitched pieces in soft vinyl or canvas. The latter, such as *Soft Toilet,* are stuffed with kapok and rely on gravity and chance for their ultimate shape. The similarity of these pieces to human forms serves to lessen their potential irony, for this artist's main goal is to delight the senses.

OLENDORF, BILL (Painter, Printmaker)
9 E. Ontario, Chicago, IL 60610

Born: 1924 *Awards:* Grant, Rockefeller Foundation *Collections:* Tiffany & Co.; First National Bank of Chicago *Exhibitions:* The Art Institute of Chicago; Galerie Bernhgim, Paris *Education:* Harvard University; School of the Art Institute of Chicago

Oil paintings and prints of European and American urban landscapes make up the majority of the subject matter of his work. Paris rooftops, Spanish villages, and urban America are all depicted in his medium to large scale oil on canvas paintings and in both his color and black and white prints. These representational landscapes are executed in a painterly impressionism; It is realism without being naturalistic. His prints of La Salle Street in Chicago and Wall Street in New York have been distributed among the financial community with great success.

OLITSKI, JULES (Painter, Sculptor)
R.F.D. 1, Bear Island, Lovejoy Sands Rd., Meredith NH 03253

Born: 1922 *Awards:* First Prize for Painting, Corcoran Gallery; Second Prize for Painting, Pittsburgh International, Painting and Sculpture *Collections:* Museum of Modern Art; Art Institute of Chicago *Exhibitions:* Whitney Museum of American Art; Los Angeles County Museum of Art *Education:* Beaux-Arts Institute, New York; Academie Grande Chaumiere, Paris; National Academy of Design; New York University *Dealer:* M. Knoedler, NYC; Andre Emmerich Gallery, NYC

Work of the 1940s was influenced by the Fauves and by works of artists such as Rembrandt who dealt with color and texture. During study abroad he shed these influences and, instead, employed bright colors in an abstract mode. Upon return to America a renewed interest in texture led to monochrome quasi-abstract im-

pastoed works on drawing boards. In 1960 experiments with canvas staining changed his style to emphasize color rather than drawing, featuring biomorphic and geometric forms in rich colors. Paint was later sprayed onto unprimed canvas to saturate it with bars of brilliant color bleeding into each other. Recent monochromes point to color as an actual element of a painting, rather than as a mere covering for a canvas.

OLUGEBEFOLA, ADEMOLA (Painter, Printmaker)
800 Riverside Dr., Std 5e East, New York, NY l0032

Born: 1941 *Awards:* Award, Carnegie Institute *Collections:* Museum of Northern Illinois University; Virgin Islands Council on the Arts *Exhibitions:* Museum of African American Culture; Birmingham Museum of Art *Education:* Fashion Institute of Technology; Wevsi Academy of Arts and Sciences *Dealer:* Grinnell Galleries, NYC; Capitol East Graphics, Washington, D.C.

His work in a wide variety of media—woodcuts, prints, watercolor, drawing, and sculpture—has brought him recognition as an important artist in the new Black American aesthetic. He is best known for his two dimensional compositions which are dense with images recalling the supernatural ,the metaphysical and the traditions of African Art. The primarily figurative elements are executed in a stark linear style, well- suited to his woodcut prints. The totemic personalities cavort within the shallow picture plane along with stylized animals and motifs which convey a spirit of movement, dance and primeval energy.

O'MEALLIE, KITTY (Painter, Printmaker)
211 Fairway Dr., New Orleans, LA 70124

Born: 1916 *Awards:* Award of Merit, Barnwell Center *Collections:* New Orleans Museum of Art; Meridian Museum of Art *Exhibitions:* Masur Museum of Art; Meridian Museum of Art *Education:* Newcomb Art School

She is a lyrical painter, printmaker, and draftsman who in the past has concentrated principally on nature subjects, with particular emphasis on trees. Flowing line and positive/negative space relationships are two of the most notable elements in her semi-abstract works, rendered in oil, acrylic, mixed media, charcoal, and silkscreen. In recent years she has presented environmental installations using actual tree branches, leafless and painted, as sculptural elements in conjunction with her paintings. Currently she is continuing to produce tree-branch compositions and also is working with the nude figure in mixed-media drawings and paintings.

O'NEIL, JOHN (Painter)
2224 Wroxton Rd., Houston, TX 77005

Born: 1915 *Awards:* Denver Art Museum; American Color Print Society *Collections:* Dallas Museum of Art; Library of Congress, Washington, DC *Exhibitions:* Art Institute of Chicago; Kyoto Museum, Japan *Education:* University of Oklahoma *Dealer:* Kauffman Galleries, Houston

From the mid-1930s to the early 1950s, his work used the single figure as portrait, and occasionally a figure in a landscape or cityscape. There were forays into partial, and eventually total, abstraction, strongly influenced by Kandinsky. Freely constructed lyric abstractions emerged beginning in the 1950s. These had underlying suggestions of imagined landscapes. Currently he is engaged in disciplined, geometric, small scale works on paper, employing acrylic or transparent watercolor media. These works are characterized by complex color modulation within airy, floating forms.

OPPENHEIM, DENNIS A. (Conceptual Artist, Sculptor)
54 Franklin St., New York NY 10013

Born: 1938 *Awards:* Newhouse Foundation Grant, Stanford University; Fellowship, John Simon Guggenheim Memorial Foundation *Collections:* Museum of Modern Art; Centre Georges Pompideau, Paris *Exhibitions:* Museum of Modern Art; Whitney Museum of American Art *Education:* California College of Arts and Crafts; University of Hawaii; Stanford University *Dealer:* Sonnabend Gallery, NYC

Earth art of the 1960s included the excavation of a mountain, a presentation in a frozen lake, and crop seeding. Theoretical ideas were applied to a physical situation, then models or photographs were made in order to document the project for gallery exhibits. Works of the 1970s included *Poison*, which consisted of red magnesium flares spelling out the word on a thousand-foot-long strip of land, and other similar monumental works with flares. More conceptual pieces, often outdoors, incorporate himself or other participants; an indoor example is *Energy Displacement—Approaching Theatricality*, a free-style swim meet after which competitors were awarded theatre tickets and seated according to how they finished in the race.

PADOVANO, ANTHONY JOHN (Sculptor)
Rt. 1, Box 64, Putnam Valley, NY 10579

Born: 1933 *Awards:* Prix de Rome; Fellowship, John Simon Guggenheim Memorial Foundation *Collections:* Whitney Museum of American Art; Walker Art Center *Exhibitions:* Museum of Modern Art; Whitney Museum of American Art *Education:* Pratt Institute; Columbia University; Hunter College *Dealer:* Graham Gallery, NYC

He was traditionally trained in figure modeling and carving, but showed an early interest in Rodin, Michaelangelo, Picasso, and Lipschitz. His early pieces exhibit strength and power through volume and planes. Later he began welding while working for Theodore Roszak and his works became large and abstract, fashioned in a variety of media, to convey his interest in volumes that recall geometric forms. The content usually is earthy and graceful, in the tradition of Egyptian and Classical art. A more recent interest is portraiture. He has modelled over one hundred portrait heads in clay, plaster, bronze, and stone. His aesthetic philosophy is one of growth and change, and he abhors repetition for either stylistic or economic reasons.

PAIK, NAM JUNE (Video Artist)
c/o Galerie Bonino Ltd., 48 Great Jones St., New York, NY 10012

Born: 1932 *Awards:* National Endowment for the Arts *Collections:* Museum of Modern Art; Louisiana Museum, Denmark *Exhibitions:* Museum of Modern Art; The Kitchen *Education:* University of Tokyo *Dealer:* Galerie Bonino Ltd., NYC

A seminal figure in avante-garde art, he is often identified as the father of video art. Originally a composer, this Korean born artist, was soon influenced by the American composer and writer John Cage and began to explore "happenings" and, subsequently, video art. His works have included numerous video tapes, installations, and performances, most notably his *Video*

Cello and *TV Bra for Living Sculpture* both for Charlotte Moorman, and the installations *TV Buddha*, and *TV Garden*, the latter at the Georges Pompidou Centre in Paris. Recently, he was responsible for the simultaneous live broadcast from San Francisco, New York, and Paris of a program of numerous performing artists entitled *Good Morning Mr. Orwell* on New Year's Day of 1984.

PALMER, MICHAEL ANDREW (Painter)
P.O. Box 2381, Ogunquit, ME 03907

Born: 1942 *Collections:* DeCordova Museum, Lincoln, MA; Museum of Art of Ogunquit, Ogunquit, ME *Exhibitions:* Hobe Sound Gallery, Hobe Sound, FL; PS Galleries, Dallas, TX *Education:* University of New Hampshire *Dealer:* PS Galleries, Dallas

He received his formal training in an academic studio; mastering drawing before even approaching the use of paint. Even now, his work is as much drawing as painting. His subject matter is derived from loosely painted amorphous shapes. He refines and reworks his canvases, and as he does, the subject—figure or landscape—becomes more defined. Areas are drawn in greater or lesser detail, creating areas of tight concentration opposing less developed areas of spatial planes. The finished work could be described as a tight drawing over the loose painting.

PALMER, WILLIAM C. (Painter)
Box 263, Clinton, NY 13323

Born: 1906 *Awards:* American Institute of Arts and Letters Grant; Benjamin Altman Prize, National Academy of Design *Collections:* Metropolitan Museum of Art; The White House *Exhibitions:* Corcoran Gallery of Art; Whitney Museum of American Art *Education:* Art Students League; Ecole des Beaux Artes *Dealer:* Midtown Galleries, NYC

His early works are recognizable by their realistic, regional themes characteristic of the 1930s. In 1939 he completed several murals under the Works Project Administration Fine Arts Project. Later work in landscapes exhibit small flat planes of color traversed by areas of light. The landscapes and changing seasons of the upper New York State region dominate his paintings.

PANTELL, RICHARD (Painter)
Coopers Lake Road, Bearsville, NY 12409

Born: 1951 *Awards:* Julius Hallgarten First Prize, National Academy of Design *Collections:* Woodstock Historical Society *Exhibitions:* Butler Institute of American Art *Education:* Art Students League *Dealer:* Bernard & S. Dean Levy, NYC

His early works concentrated on urban comedy and tragedy, at a point where they became inseparable. He aimed toward luminosity in his use of bright colors. His colors became subtle when he began to work with the technique of glazing. In his present manner of working, he makes on-the-spot sketches of subject matter. From there he explores the subject's possibilities in an etching, and then goes on to the painting. His works depict a sense of the past, often in a deteriorated state with signs of the new emerging. In one of these paintings, a subway station's turn-of-the-century mosaics are covered with modern-day grafitti. On the subway platform, various types of people are shown caught between the two different worlds.

PAONE, PETER (Painter, Printmaker)
1027 Westview St., Philadelphia, PA 19119

Born: 1936 *Awards:* Fellowship, John Simon Guggenheim Memorial Foundation; Grant, Tiffany Foundation *Collections:* Museum of Modern Art; Victoria and Albert Museum *Exhibitions:* Pennsylvania Academy of the Fine Arts; Contemporary Arts Museum, Houston *Education:* Philadelphia College of Art; Barnes Foundation *Dealer:* Hooks-Epstein Galleries, Houston

He finds the iconography for his representational paintings and drawings in the realm of dreams, subconscious visions, and chance. Between the world of realism and surrealism is his world of the reality of imagination. Objects that have no real relationship to each other in familiar experience come together with an unassailable confidence of their own in these private visions. The assemblage seems to be a reconstruction of reality rather than a fantasy. It is articulate, precise, and unsettling.

PARKS, GORDON (ALEXANDER BUCHANAN) (Photographer, Filmmaker)
860 United Nations Plaza, Apt. 10B, New York NY 10017

Born: 1912 *Awards:* Spingarn Medal, N.A.A.C.P.; Carr Van Adna Journalism Award *Collections:* Museum of Modern Art; George Eastman House, International Museum of Photography *Exhibitions:* Art Institute of Chicago; Museum of Modern Art *Education:* Self-taught *Dealer:* Stephen Rosenberg Gallery, NYC

Self-taught in photography, he first worked as a fashion photographer. From 1948 to 1972 he was a staff photographer for *Life* magazine, during which time he produced powerful and candid photo-essays on a variety of subjects ranging from Harlem street gangs and the civil rights movement to Paris fashions. Black-and-white and color portraits are narrative, dramatic and documentary without being polemical, yet they reveal a personal concern for the events and subjects, such as those of Malcolm X and Duke Ellington. A versatile artist, he also worked a few years as editorial director for *Essence* magazine, and has published poetry, novels and music. He has also been a film director for the past sixteen years, with credits such as *Shaft, Super Cops,* and *The Learning Tree,* a dramatization of his autobiographical novel.

PASCHKE, EDWARD F. (Painter)
1927 E. Estes, Chicago IL 60626

Born: 1939 *Awards:* Logan Medal, Art Institute of Chicago; Cassandra Grant, Cassandra Foundation *Collections:* Art Institute of Chicago; Museum of Contemporary Art, Chicago *Exhibitions:* Art Institute of Chicago; Whitney Museum Annual *Education:* School of the Art Institute of Chicago *Dealer:* Phyllis Kind Gallery, Chicago

In a biting style aided by acid colors, this Chicago Imagist presents disturbing events and enigmatic people from real life in order to provoke "emotive responses" from the viewer. He began as part of the Pop movement, and is well-known for sometimes grotesque figures which question sexual identity such as *Nueva Yorka* and *Tropicale*. Current work includes figures which look as if they have been electronically produced in a "high-tech" surrealism of neon colors. A recent collaboration with Lyn Blumenthal and Carole Ann Klonarides resulted in the video *Arcade*.

PEAK, ROBERT (Illustrator, Painter)
c/o Harvey Kahn Associates, 50 E. 50th St., New York NY 10022

Awards: Gold Medals, Society of Illustrators; Artist of the Year, Artists Guild of New York *Collections:* Smithsonian Institution *Exhibitions:* Jack O'Grady Galleries, Chicago *Education:* Wichita St. University; Art Center College of Design *Dealer:* Harvey Kahn, NYC

In 1953 he went to New York City to become a commercial illustrator, and eventually gained recognition with illustrations for Old Hickory Whiskey. Since then he has had advertising clients such as Coca-Cola, Puritan Sportswear, *Time* magazine and *Sports Illustrated.* Movie promotions to his credit are extensive, including *West Side Story, Camelot, Apocalypse Now,* and *Superman.* Within the last several years he began to show his work in galleries. Charcoal is often used for preliminary sketches. His primary medium is watercolor; other media include acrylic, gouache, oil and pastels.

PEARLSTEIN, PHILIP (Painter)
163 W. 88th St., New York NY 10024

Born: 1924 *Awards:* National Endowment for the Arts Grant; Fellowship, John Simon Guggenheim Memorial Foundation *Collections:* Whitney Museum of American Art; Museum of Modern Art *Exhibitions:* Whitney Museum Biennial; Carnegie Mellon University *Education:* Carnegie Institute; Institute of Fine Arts, New York University *Dealer:* Allan Frumkin Gallery, NYC

A realist figurative painter, he presents human bodies as forms arranged in the compositional limits of a rectangle. He works on specific parts of a figure, one at a time, so that even he is not sure about the final outcome of a painting. Thus, because his progress is not structured in accordance with the canvas edges, cropping is characteristic of the work. He calls the configurations of nude figures "a sort of stilled-action choreography." The directional movement of the figures structures the paintings and expresses the innate dignity of the human body.

PEART, JERRY LINN (Sculptor)
1544 North Sedgwick St., Chicago, IL 60610

Born: 1948 *Awards:* Jeanette Sacks Art Achievement Metal, Arizona State University; Award, Chicago Art Association *Collections:* Museum of Contemporary Art, Chicago; Nathan Manilow Sculpture Park *Exhibitions:* Illinois Collection for the State of Illinois Center; E. B. Crocker Art Gallery,Sacramento *Education:* Southern Illinois University; Arizona State University *Dealer:* Richard Gray Gallery, Chicago

Working in a constructivist manner, he fabricates large scale sculpture by welding together aluminum or steel components. Organic forms are often assembled onto more strictly geometric forms, giving the finished piece a sense of animation and life. Volumes and space are manipulated and balanced to build a formal harmony within the piece. Applied color is a distinctive feature in his work. Some works are monochrome with a single surface color, while others are polychrome, the multiple surface colors vitalizing the metal volumes. He has executed a variety of large public sculptures across the United States.

PELLICONE, WILLIAM (Painter)
47 Bond St., New York, NY 10012

Born: 1915 *Awards:* Scholarship, Pennsylvania Academy; Scholarship, Barnes Foundation *Collections:* Smithsonian Institution; Boston Museum of Fine Arts *Exhibitions:* Allan Stone Gallery, NYC; Baltimore Museum *Education:* Pennsylvania Academy *Dealer:* Allan Stone Gallery, NYC

He began painting figuratively, showing influences of the color relationships of Titian and Renoir. He experimented during the 1950s with burnt wood panels combined with pigment. Presently he concentrates on landscapes, nudes, and nudes on horses in a colorful combination of Renaissance and German Expressionist elements. In his still lifes he has invented a "third" light, which he calls his "split light series." He usually uses pears for these paintings, concentrating on the various light areas between the fruit and before and after the light recedes from the pears.

PELS, ALBERT (Painter)
2109 Broadway, New York, NY 10023

Born: 1910 *Awards:* First Prize, Southern Florida Museum; Gold Medal, Beaux Art *Collections:* Smithsonian Institution; Butler Institute of American Art *Exhibitions:* Carnegie Institute, Museum of Art; Whitney Museum of American Art *Education:* Art Students League; Cincinnati Art Academy *Dealer:* Raimone Art Galleries, Dallas and Arlington, TX

Primarily an oil painter working in figurative compositions, he studied and copied the old masters, using the knowledge he gained from their work. His subject matter is contemporary life in America, especially New York. The handling of the subjects is mostly in a dramatic fashion, hemmed in with a painted frame. Many of the scenes date from the 1930s, and the political innuendo is significant. His use of colors is dramatic and dynamic. The paintings are started on different colored grounds, each color giving a different final effect.

PENA, AMADO MAURILIO, JR. (Printmaker, Painter)
11511 Catalonia, Austin TX 78759

Born: 1943 *Awards:* Citation Award, Laguna Gloria Art Museum; Corpus Christi Art Foundation Award *Collections:* Los Pinos, Presidential Palace, Mexico; University of Texas *Exhibitions:* Chicano Artists of the Southwest, Institute of Mexican Culture, San Antonio; Museo Nuevo Santander, Laredo (TX) *Education:* Texas A. & M. University *Dealer:* El Taller Gallery, Austin, TX; Gallery Mack, Seattle

This Texas native makes serigraphs, lithographs and etchings depicting scenes from his Chicano heritage in bold graphic design using warm colors. Figures of Mestizo and Indian women and scenes of traditional family life, such as *Tejedora*, are rendered with a flowing line and a strong dedication to form. He has also been commissioned to paint murals for public buildings such as the City Hall in Crystal City, Texas, and he has worked as an illustrator. Recent mixed media paintings employ oil, acrylic, pencil, ink, pastel and watercolor.

PENN, IRVING (Photographer)
Irving Penn Studios, Box 934, F.D.R. Station, New York NY 10150

Born: 1917 *Collections:* George Eastman House, International Museum of Photography; Museum of Modern Art *Exhibitions:* Metropolitan Museum of Art; Museum of Modern Art *Education:* Philadelphia Museum School of Industrial Art *Dealer:* Marlborough Gallery, NYC

First a part of revolutionary fashion photographer Alexey Brodovitch's famed "design laboratories" in Philadelphia in the late 1930s, he then painted for a year in Mexico before coming to New York City in

Amado Maurilio Pena, *Antepasados*, serigraph. Courtesy: El Taller Gallery (Austin TX)

1943 to accept a job as cover designer for *Vogue* magazine. He gained recognition when he photographed the covers himself, and for over forty years he has remained an editorial contributor to the magazine. His clients are in industry and advertising throughout America and Europe.

PENNEY, BRUCE BARTON (Painter)
27 West St., Portland, ME 04102

Born: 1929 *Collections:* Mr. and Mrs. Laurence Rockefeller; Ivan Albright *Exhibitions:* Weiner Gallery, NYC; Center Street Gallery, Winter Park, FL *Dealer:* Hobe Sound, Woodstock, VT

Growing up in Cape Cod, he was influenced by the dramatic light, the deep and sharp contrasts of the landscape. Later he worked with the late Ivan Albright and was influenced by his close observance of textures and surface. His work shows a mystical understanding of the Vermont scene and its people. He draws with a spare line and understates his wash. Burchfield, Hopper, and John Whorf are among his life-long influences. He appreciates their use of subjects they knew to create an honest mood and an atmosphere that is identifiable, yet not slick or photographic.

PEREZ, VINCENT (Painter, Printmaker)
1279 Weber St., Alameda, CA 94501

Born: 1938 *Awards:* grant, American Institute of Graphic Artists; Gold award, 4th Annual Gertrude B. Murphy *Collections:* San Francisco Museum of Modern Art; Time/Life, Inc. *Exhibitions:* World's Fair, Osaka; Oakland Art Museum *Education:* Pratt Institute; California College of Arts and Crafts

Illustrative science fiction and fantasy work is in a variety of media including woodcuts, drawings, and acrylic and oil paintings. His science fiction paintings have been reproduced in published calendars for 1984 and 1985. He has done covers for *Time* magazine and other national publications, as well as completing post-production art for George Lucas' *Indiana Jones and the Temple of Doom* and the Disney studio's *The Scheme of Things.* He is currently completing a series of woodcut prints for Potlatch Corporation and doing anatomical drawings for publication in textbooks and advertising purposes.

PERLMAN, BENNARD BLOCH (Painter)
6603 Baythorne Road, Baltimore, MD 21209

Born: 1928 *Awards:* First Prize and Museum Purchase, Peale Museum; First Prize and Purchase Award, Easton Academy of the Arts *Collections:* Library of Congress; Baltimore Museum of Art *Exhibitions:* Vanderlitz Gallery, Boston; Lyford Key Gallery, Bahama Islands *Education:* Carnegie-Mellon University; University of Pittsburgh

Working primarily in oil, his earliest styles were based in realism and impressionism. His work evolved into a near-abstract expressionist statement by the late 1960s and since then there has been a gradual return to realism. Early paintings were almost exclusively landscapes, many inspired by European subject matter. After a visit to France in 1983, there was an abrupt change toward fauve-like colors applied in an impasto manner. In the last year he has begun to focus on the figure and even still-life. Scale of the paintings seldom exceeds four by five feet, however, he often tailors their shapes to conform to his concept of his subject.

PERSHAN, MARION (Painter)
20925 18th Ave., Bayside, NY 11360

Born: 1916 *Awards:* Top Watercolor Award, Hudson Valley Art Association; Gold Medal of Honor, National Academy of Design *Collections:* Dow Chemical Corporation; Associates of Westport *Exhibitions:* Metropolitan Museum of Art; Brooklyn Museum *Education:* National Academy of Fine Arts; Art Students League

She is a versatile watercolorist. Her earlier oils were painted in the Rembrandt manner, capturing the mood and character of the subject. Now a realist, she paints exclusively in the watercolor medium. A bold approach and use of strong contrasts are evident in her work. She chooses from an array of themes, including old houses, boats, flowers, or portraits. Among the influences that inspire her are John Singer Sargent and Winslow Homer.

PETERSON, LARRY D. (Painter)
4 Seminole Ln., Kearney, NE 68847

Born: 1935 *Awards:* The Governor's Award; Who's Who in America *Collections:* University of Minnesota *Exhibitions:* 26th National Watercolor Exhibition; 5th Annual American National Miniature Exhibition *Education:* Kearney State College; Northern Colorado University; Kansas University *Dealer:* Vintage Prints, Kearney, NE

Impressionistic landscape paintings and studies of the prairie countryside where the artist has lived and worked comprise the majority of his artistic output. Paintings are executed in acrylic and watercolor with an instinctual action that mirrors the expanses of the Midwestern plains. He has also produced and exhibited prints and is an active teacher and advocate of art education in the Midwest region.

PETERSON, ROGER TORY (Illustrator, Painter)
Neck Rd., Old Lyme, CT 06371

Born: 1908 *Awards:* Presidential Medal of Freedom; Smithson Medal *Collections:* Metropolitan Museum of Art; Minneapolis Institute of Art *Exhibitions:* California Academy of Sciences; Smithsonian Institution *Education:* National Academy of Design; Art Students League, NYC *Dealer:* Mill Pond Press, Venice, CA

Work has consisted of illustrations and bird portraiture for numerous books and magazines. He is best known for his *Field Guide to the Birds* which in the aggregate has sold more than 6,000,000 copies. These are illustrated in a schematic style. Limited edition prints are mainly in the Audubon tradition. Present direction is more "painterly" and environmental; his medium is acrylics on Masonite, mixed acrylics and oils, and oil on canvas. Approach is basically academic with emphasis on natural realism.

PFEIFFER, WERNER (Sculptor)
Flat Rock Rd., Cornwall Bridge, CT 06754

Born: 1937 *Awards:* Segerman Award; Purchase Prize, Silvermine Guild Center for the Arts *Collections:* Museum of Modern Art; Museum of Modern Art, Stockholm *Exhibitions:* Bienale Santiago, Chile; Galerie Brusberg, Berlin and Hannover *Education:* Akademie of Fine Arts, Stuttgart; Pratt Institute *Dealer:* F.A.M.E. Gallery, Houston; AAA Gallery, NYC; Gallery of Graphic Arts, NYC; Neville Sargent Gallery, Evanston, IL

Strong colors and clearly defined shapes and forms, with a noticeable current of surrealism, are trademarks of his earlier works. Initially he did mostly works on

Alice Marie Plaster, *Packard* (1978), 45 x 60, oil on canvas.

Alexandru Preiss, *Drawing From Memory*, 20 x 30, pencil pastel.

paper, collages, and drawings, which eventually evolved into manipulative forms on canvas and in wood. He has experimented with "System Kunst"— systems art. His current works are large outdoor sculptural pieces in steel and concrete.. He also does smaller relief constructions in wood and paper, which have a strong identification with surrealism and neo-Dadaism.

PHELPS, NAN DEE (Painter)
1721 Green Wood Ave., Hamilton, OH 45011

Born: 1904 *Collections:* Cincinnati Art Museum; Galerie St. Etienne, New York City; Copley Society of Boston *Dealer:* Galerie St. Etienne, NYC

Working within the tradition of the American folk artist, her paintings capture scenes of family and community life as well as compositions purely from the imagination. The work is personal and often humorous. Since the early 1920s, she has painted murals for schools, churches, private homes, and other sites. Many of her subjects are religious, such as the last supper, the crucifixion, and Jesus walking on the water. She uses oil, watercolor, acrylic, tempera, and spray enamel. In the portrait of her young granddaughter, the child wears a pointed "Happy Birthday" hat and smiles at the viewer, her face smeared with chocolate cake. Another whimsical painting of a girl struggling to hang out the wash in a landscape of bending trees is titled, *Can't Hold on to All of Your Possesions in a Wind Storm Like This.* The compositions are crowded with colorful details painted in the flat, honest style of the "naive" artist.

PINCHBECK, PETER (Painter)
69 Greene St., New York, NY 10012

Born: 1940 *Awards:* Fellowship, National Endowment for the Arts *Collections:* Corcoran Gallery of Art *Exhibitions:* "American Painting: The Eighties", Grey Art Gallery, NYC; Jewish Museum *Education:* Twickenham Art School

Non-objective oil paintings in a constructivist tradition made up the body of his early work. In the sixties he experimented with making three dimensional works exploring the same concepts which were later exhibited in the "Primary Structures" show in 1971. Since then, he has returned to painting on canvas and creates imagery of squares and rectangles, in different configurations, that convert the surface into colored space. Current paintings show a concern with surface incidence and texture, although the basic imagery is the same. He works with oil paint, applying it either with a brush or palette knife, to build up dense, layered surfaces. The result combines the painterliness of Abstract Expressionism with the vocabulary of geometric abstraction.

PINTO, JODY (Sculptor)
124 Chambers St., New York, NY 10007

Born: 1942 *Awards:* Fellowship, National Endowment for the Arts *Collections:* The Whitney Museum of American Art; The Philadelphia Museum of Art *Exhibitions:* 1979 Whitney Biennial; 1980 Venice Bienniale *Education:* Pennsylvania Academy of Fine Arts; Philadelphia College of Art *Dealer:* Hal Bromm Gallery, NYC

Instead of following the traditional process of creating work in a studio situation and then exhibiting it publicly, she works directly with specific sites to construct site-specific outdoor sculptures and earthworks, and indoor installations. The structures she makes combine the characteristics of architecture and sculpture and merge personal experience with public expression to transform common materials such as straw, seed, soil, cement blocks, and rough timber into metaphors which depend on and demand a high level of active participation.

PINZARRONE, PAUL (Painter)
103 Paris Ave., Rockford, IL 61107

Born: 1951 *Awards:* Juried Cash Award, Art Institute of Chicago *Collections:* Illinois State Museum; Butler Institute of American Art *Exhibitions:* Milikan University; Horwich Gallery, Chicago *Education:* University of Illinois at Champaign-Urbana *Dealer:* Horwich Gallery, Chicago; Art Independent, Geneva, WI

His paintings are highly colorful abstract landscapes that seem to suggest other worlds, body surfaces, and the sensuous textures of satin or velvet. The works are acrylic on plexiglass in medium-to-large scale size. His richly colored paintings are created by a technique that involves spraying lacquer pigments and bronze powders on the back side of clear acrylic sheets. Since the paintings are "built down" from the surface instead of "up" from a ground, each work is begun by spraying the top transparent layers of pigment first.

PLASTER, ALICE MARIE (Painter)
3925 Winchester Ln., Bowie, MD 20715

Born: 1955 *Awards:* National Society of Arts and Letters Drawing Scholarship *Collections:* George Washington House Museum, Bladensburg, MD; J. Boehls, W. Germany *Exhibitions:* Gallery II/RSVP, Charlottesville, VA; Middleton Gallery of International Art *Education:* Maryland Institute

Her oil canvases use recognizable objects and scenes, with the degree of realism dependent on the impact desired and the statement to be conveyed. The projected imagery varies from the bold and detailed to the more subtle and suggestive. Her earlier works echo the imagery and philosophy of the Impressionists. In her recent work she has become increasingly interested in abstractions within realism. This has resulted in imagery that is more graphic than naturalism. The influences of surrealism and photorealism may be found in her current works. Reflective surfaces, such as the glass and metal textures of storefronts and cars, have been recent elements of her compositions.

PLETKA, PAUL (Painter)
c/o A.C.A. Galleries, 21 W. 67th St., New York NY 10021

Born: 1946 *Awards:* National Watercolor Society Award, Watercolor U.S.A.; Certificate of Excellence, Chicago *Collections:* Minneapolis Institute of Art; St. Louis Art Museum *Exhibitions:* Indianapolis Museum of Art; Four Corners Biennial, Phoenix Art Museum *Education:* Arizona St. University; Colorado St. University *Dealer:* A.C.A. Galleries, NYC; Frameworks, Grand Junction, CO; Gallery 10, NYC

In the early 1970s he gained recognition in the Southwest with dramatic portrayals of Plains Indians of the nineteenth century rendered in acrylic and watercolor. The figures are "conjured," he says, for he rarely uses live models. His technique involves a preliminary sketch from memory applied in charcoal to a gessoed canvas; then with matte medium and pigment the form is developed using a hog bristle brush before the painting begins. It has been said that he "bares Indian souls

on canvas'' through the depiction of rituals and symbols of the past, as in *Nothing Lives Forever But the Rock*. ''I want to make people slow down and look carefully at what has gone on. Maybe that's why I put so many ironies into my paintings.'' Recent subject matter includes the Penitentes, an Hispanic-Indian lay order of Franciscans.

PLOSSU, BERNARD (Photographer)
c/o Ernesto Mayans Gallery, Santa Fe, NM 87501

Born: 1945 *Collections:* Amon Carter Museum; Tucson Center for Photography *Dealer:* Ernesto Mayans Gallery, Santa Fe, NM; Eaton-Shoen Gallery, San Francisco

He moved to New Mexico from Paris in 1977. He has been editorial photographer for several major European magazines, and has photographed the Lacandon Maya Indians of Mexico and the Fulani nomads of the African savannah. He has traveled widely, but he is a permanent resident of the Southwest, where he photographs with a passion. His color photographs are printed by the Fresson process, and he also takes black-and-white pictures.

PONCE DE LEON, MICHAEL (Printmaker)
463 West St., New York, NY 10014

Born: 1922 *Awards:* Fellowship, Guggenheim Foundation; Fulbright Fellow *Collections:* Metropolitan Museum of Art; Museum of Modern Art *Exhibitions:* Corcoran Gallery of Art; National Gallery of American Art, Washington, DC *Education:* National Academy, NYC; Art Students League *Dealer:* Associated American Artists Gallery, NYC

He is part of a growing movement of artists who use the resources of other media in printmaking. Dualism is the key to his work, in which two ideas struggle against each other, and from the clash a new metaphor is born. His work is biographical in feeling, not in description. By wedding his opposing worlds—emotion and reason, conscious and subconscious, chaos and order—the child and the man in the artist merge.

POND, CLAYTON (Painter, Printmaker)
130 Greene St., New York NY 10012

Born: 1941 *Awards:* Boston Museum Purchase Award, Boston Printmakers Twentieth Annual; Color Print U.S.A. Purchase Award, W. Texas Museum *Collections:* Museum of Modern Art; Art Institute of Chicago *Exhibitions:* Whitney Museum of American Art; Smithsonian Institution *Education:* Carnegie Institute of Technology; Pratt Institute *Dealer:* Martha Jackson Gallery, NYC

Early work featured bathroom and kitchen scenes, full of household objects painted in bold colors. During the mid-1960s he experimented with screen-printing, making colorful serigraphs of commonplace objects from American culture in a cartoon-like style, realistically and with humor. Series were produced, using the same print in a variety of color combinations to create a new picture each time. During the 1970s the printing method became more complex, sometimes requiring as many as twenty-five different stencils for one print. Recent work includes the *American Leisure Time Obsessions* series, a *Television* series, and a series on space travel. ''I'm trying to record Americans, their possessions and their obsessions.''

POONS, LARRY (Painter)
831 Broadway, New York NY 10003

Born: 1937 *Collections:* Museum of Modern Art; Albright-Knox Art Gallery *Exhibitions:* Art Institute of Chicago; Whitney Museum Biennial *Education:* Boston Museum of Fine Arts School *Dealer:* Andre Emmerich Gallery, NYC

A musician before he became a painter, early influences came from the random compositions of John Cage and the rhythmic geometric forms of Piet Mondrian. In the early 1960s bright color fields were covered with grids of small circles or ovals of color, usually complementary, so that the dots seemed to project or recede due to the sharp color contrasts, sometimes creating after-images, as in *Nixes' Mate*. In 1965 his work was exhibited with the Op Artists. The next year the compositions were freer, less grid-like and used colors similar in value; small colored shapes seemed to float in space. Concentration on Op Art has given way to an expressionist mode, and colorful impastoed abstract paintings are included in recent work.

PORTER, ELIOT FURNESS (Photographer)
R. 4, Box 33, Santa Fe NM 87501

Born: 1901 *Awards:* American Academy of Arts and Sciences Fellowship; Conservation Service Award, Dept. of the Interior *Collections:* Metropolitan Museum of Art; George Eastman House, International Museum of Photography *Exhibitions:* Museum of Modern Art; George Eastman House, International Museum of Photography *Education:* Harvard University *Dealer:* Daniel Wolf Gallery, NYC

He earned degrees in engineering and medicine and taught at Harvard Medical School before deciding to become a freelance photographer in 1944. A member of several ornithological and environmental societies, he brought to photography a great interest in wildlife, especially birds. He is known for black-and-white and color photographs of wildlife in natural biological and geological settings. A life member of the Sierra Club, in 1962 he was commissioned by them to take photographs for the publication entitled *In Wildness is the Preservation of the World*. He has also published archaeological and architectural photographs taken during travels in Mexico, Egypt and Greece.

PORTER, LILIANA (Painter, Printmaker)
178 Franklin St., New York, NY 10013

Born: 1941 *Awards:* Fellowship, John Simon Guggenheim Memorial Foundation *Collections:* Museum of Modern Art; Biblioteque National, Paris *Exhibitions:* Museum of Modern Art; Barbara Toll Fine Arts, NYC *Education:* School of Fine Arts, Buenos Aires, Argentina; Iberoamerican University, Mexico City *Dealer:* Barbara Toll Fine Arts, NYC

For over a decade she has created paintings and drawings concerned with the relationship of art, real objects, and illusion. This project has grown increasingly complex and specific through the years. She is an accomplished printmaker who handles various printing and photographic techniques for emotive ends. In her latest work she brings together a group of disparate, whimsical images culled from both high art and popular sources. Real objects are juxtaposed with images of the same, drawn, painted, collaged, or silkscreened onto the canvas. The motifs are rich in narrative overtones.

PORTER, SHIRLEY (Painter)
14315 Woodcrest Dr., Rockville, MD 20853

Born: 1940 *Awards:* Gold medal, Allied Artists of America; Silver medal, Georgia Watercolor Society

Collections: Tweed Museum; Utah State University *Exhibitions:* American Watercolor Society; National Academy *Education:* Self-taught

Soft-edged representational close-ups, still-life, and plants or animals with an emphasis on personality of subject are the characteristics of her watercolor paintings. Works are at once representational and interpretative, even in paintings of inanimate objects, rather than an accurate rendering of their physical reality. Subjects are most often taken from nature. Soft or lost edges are played against clearly defined ones, and suggested passages set against more carefully detailed studies, with colors flowing and blending within the composition to create movement. The environment into which subjects are placed are often imagined areas of color and shape. She works almost entirely in transparent, overlapping watercolors, occasionally incorporating line drawn in pencil or ink.

POUSETTE-DART, RICHARD (Painting)
286 Haverstraw Rd., Suffern NY 10901

Born: 1916 *Awards:* Comstock Prize, Art Institute of Chicago; National Arts Council Award *Collections:* Museum of Modern Art; Whitney Museum of American Art *Exhibitions:* Museum of Modern Art; Whitney Museum of American Art *Education:* Bard College *Dealer:* Marisa del Re Gallery, NYC

The son of a painter and a poet, he painted in an abstract style, the early works combining cubist space with surrealistic forms. Throughout the 1940s calligraphic lines flourished among biomorphic shapes, crowding the canvas. During the next decade paint was thickly applied in brilliant color clusters to create the look and feel of tapestry, with additions of circular motifs by 1960. He has been called a Transcendental Expressionist.

PRECHTEL, DON (Painter)
83647 N. Pacific Hwy, Creswell, OR 97426

Born: 1936 *Awards:* Merit Award, Western Heritage Show *Collections:* Virginia Military Institute; Museum of Native American Cultures *Exhibitions:* Trailside Galleries, Scottsdale, AZ; Golden Gate University *Education:* Eugene School of Commercial Art *Dealer:* Trailside Galleries, Scottsdale; Mongerson Gallery, Chicago

His admiration of early American illustrators and impressionist painters, shows in his oil paintings. Splashes of brightness are there along with the muted blues and lavenders from the mountains that surround his home. He paints with a textured palette, but allows the personality of his subjects to emerge from his paintings. Scenes of the American West, cowboys, Indians, and wildlife dominate his paintings.

PREISS, ALEXANDRU (Illustrator, Painter)
2515 Burnet Ave. #701, Cincinnati, OH 45219

Born: 1952 *Awards:* Silver Medal, International Exhibition of Illustration and Editorial Art; Award of Excellence, Indiana Art Directors Club *Collections:* Greater Lafayette Museum of Art; Bioanalytical Systems, Lafayette *Exhibitions:* American Drawing IV, Portsmouth Community Arts Center; Smithsonian Institution Traveling Exhibition *Education:* Purdue University; N. Grigorescu Fine Arts Institute, Bucharest

Although the style of drawing and the media may change, color is always a very strong element throughout all his work. The technique varies according to the message: color, texture, and contrast all convey subtle meanings. Early work was in colored pencils and pastels almost exclusively. The drawings served as interpretations of various events surrounding our quotidian existence. More recent work uses mixed-media including transfer images, tempera, and collage. His inspiration comes from the social structure in which we live. Interpersonal relationships between individuals and the relationship between individuals and the whole of society comprise the majority of his subject matter.

PREUSS, ROGER (Painter)
2224 Grand Ave., Minneapolis, MN 55405

Born: 1922 *Awards:* Mead Graphics Award; Federal Duck Stamp Award *Collections:* National Wildlife Art Gallery; Demarest Memorial Museum *Exhibitions:* Minneapolis Institute of Arts; Montana State Historical Museum *Education:* Minneapolis College of Art *Dealer:* Wildlife of America; Norby Gallery of Fine American Art

He is a wildlife artist who works in a style of traditional realism, with an emphasis on anatomical accuracy, correct animal behavior, and authentic habitat. His media include oil, watercolor, and gouache. His versatility in the use of various styles and techniques is dictated by the media choice and subject.

PRICE, KENNETH (Printmaker, Ceramicist)
Box 1356, Taos NM 87571

Born: 1935 *Awards:* Tamarind Fellowship *Collections:* Los Angeles County Museum of Art *Exhibitions:* Whitney Museum of American Art; Museum of Modern Art *Education:* Otis Art Institute; Chouinard Art Institute; University of Southern California; St. University of New York *Dealer:* Willard Gallery, NYC

In a reaction to the large-scale art of the 1950s and 1960s, he has been a principal figure in the "renaissance of clay" in fine art, making small-scale ceramic sculptures. Early ceramic cups were often decorated with animals and other motifs, defying artistic interpretation because of their seeming simplicity and blandness. The cups were followed by biomorphic shapes in earth tones. Recent miniature work in polychrome glaze and paint is abstract, utilizing geometric forms.

PRINDIVILLE, JIM (Painter)
6425 E. Mockingbird Lane, Paradise Valley AZ 85253

Awards: Purchase Prizes, Artist's Guild of Chicago; First Prize, Mixed Media, Plaza del Lago Show *Collections:* Illinois State Museum; University of Wyoming *Exhibitions:* Art Institute of Chicago; Northwestern University *Education:* American Academy of Art, Chicago; School of the Art Institute of Chicago; Illinois Institute of Design *Dealer:* Gallery A, Taos, NM; El Presidio Gallery, Tucson

After a trip through New Mexico and Arizona in 1968, a great interest in Pueblo Indian culture led him to numerous depictions of the Indians in the desert landscapes of the American Southwest. Extensive travels throughout the United States, Mexico, Central America and Europe give him the subject matter for paintings which he later executes from sketches and notes in the studio, employing bright colors and strong images. He strives to recreate the physicality as well as the mood of a locale. His media for these well-researched portraits and landscapes have included watercolor, acrylic and graphics, as well as combinations of collage, painting and airbrush.

PROPERSI, AUGUST J. (Painter)
225 Magnolia Ave., Mt. Vernon, NY 10552

Born: 1926 *Awards:* Prix d' Paris, Raymond Duncan Galleries, Paris; Award, 50 States Competition, Duncan Galleries, Paris *Collections:* Veterans Hospital, Montrose,NY; Connecticut School of Art *Exhibitions:* Bohman Galleries, Stockholm; Duncan Galleries, Paris *Education:* School for Art Studies, NYC; School of Visual Arts

The representational subject matter is executed in a variety of media—pen and ink, water colors, oils, and pastels. Early landscapes and figures display impressionistic and expressionistic influences in color and brush techniques while the strong design approaches the concerns of the cubists. Later work exhibits thicker brush strokes and exaggerated color in the bold images. Reality and fantasy blend in surrealistic content that addresses questions of psychology, philosophy and religion.

PROVDER, CARL (Painter)
1416 Elva Terrace, Encinitas, CA 92024

Born: 1933 *Awards:* Southern California Exposition; San Diego Art Institute *Collections:* St. Joseph's Hospital and Medical Center, Phoenix, AZ; Delson & Gordon Law Office, NYC *Exhibitions:* National Academy of Design; Brooklyn Museum *Education:* Pratt Institute; Columbia University

His interest in Zen and other Eastern philosophies led him to develop his unique form of "lyrical abstraction." He develops his images in oils, watercolors, and mixed media. His older works were very structured and well balanced, and were characterized by a sensuous use of color and painterly technique. In his current work he relies on his intuitive powers to lead him into new, unpremeditated experiences of both a personal and spontaneous nature.

PURYEAR, MARTIN (Sculptor, Printmaker)
c/o Donald Young Gallery, 212 W. Superior St., Chicago IL 60610

Born: 1941 *Collections:* Solomon R. Guggenheim Museum; Corcoran Gallery of Art *Exhibitions:* Whitney Museum Biennial; Solomon R. Guggenheim Museum *Education:* Royal Academy of Art, Stockholm; Yale University School of Art *Dealer:* McIntosh/Drysdale Gallery, Houston; Donald Young Gallery, Chicago; Landfall Press, Chicago

Although his work does not follow a single style, he has always shown a great interest in the surface qualities of his medium, wood. Many kinds of unusual woods such as hemlock or African blackwood are used, along with other exotic materials, as in *M. Bastion Bouleverse,* an installation made of hickory, Alaskan cedar and deerskin. Branch-like shapes often emerge from the wood's natural state as well as from careful workings of the materials, creating a sort of "natural artificiality," in simplified gestural pieces. Linear forms are often suggestive of functional objects such as tools and farm implements, as in the installation entitled *Some Tales, Bask, Self.* Wall pieces, architectural presentations and outdoor projects are also linear but have also featured geometrical solids such as cones and cubes. Recently he has added printmaking to his repertoire.

QUAYTMAN, HARVEY (Painter)
c/o David McKee Inc., 41 E. 57th St., New York NY 10021

Born: 1937 *Awards:* Creative Artists Public Services Program Awards; Fellowship, John Simon Guggenheim Memorial Foundation *Collections:* Museum of Modern Art; Whitney Museum of American Art *Exhibitions:* Whitney Museum of American Art; Institute of Contemporary Art *Education:* Boston Museum of Fine Arts School *Dealer:* David McKee, NYC

During the 1960s and early 1970s shaped canvases were often assembled together to create free-standing paintings with highly textured surfaces of muted organic pigments. Eventually the impasto technique was replaced by purist depictions of pictorial subjects. In later work color and light were integrated in greater contrasts than before, within a tightly controlled, sometimes eccentrically shaped canvas.

QUILLER, STEPHEN FREDERICK (Painter)
P.O. Box 307, Creede, CO 81130

Born: 1946 *Awards:* Colorado Governor's Award; Rocky Mountain National Honor Award *Collections:* Colorado Art Council Collection; City of Medford, OR *Exhibitions:* Montalvo Center for the Arts, Saratoga, CA; Foothills Art Center, Denver, CO *Education:* Colorado State University

He has concentrated on the various water media throughout his years as a painter. He started working with transparent watercolor in a representational manner but has since become increasingly experimental, combining transparent watercolor, acrylic, casein, and gouache to achieve various visual qualities. He has studied the impressionists and post-impressionists and is especially interested in their use of color. His present work is concerned with the interaction of color through the various combinations of water media. His subjects include the Colorado San Juan Mountains, the Northern New Mexico terrain, and the southern Oregon coast.

QUINN, WILLIAM (Painter)
School of Fine Arts, Washington University, St. Louis, MO 63130

Born: 1929 *Awards:* Regional and national exhibitions *Collections:* Butler Institute of American Art; St. Louis Art Museum *Education:* Washington University; University of Illinois *Dealer:* Schweig Gallery, St. Louis, MO; Galerie Karree, Dusseldorf, W. Germany

He "grew up" as an artist during the high tide of Abstract Expressionism. During the 1950s, he was taught by two painters of that era, Paul Burlin and Carl Holty. These artists' influences have remained with him, and continue to influence his present work. Primarily a painter, he has also worked in silk screen printing. Now, more than ever, he is challenged by the ideas of the Abstract Expressionists, and continues to expand on them in his work.

RABINOWITCH, DAVID (Sculptor)
49 E. First St., New York NY 10003

Born: 1943 *Awards:* Fellowship, John Simon Guggenheim Memorial Foundation; Lynch Staunton Award, Canadian Council *Collections:* St. Louis Art Museum; National Gallery, Berlin *Exhibitions:* Museum of Modern Art; Art Gallery Ontario *Education:* Self-taught *Dealer:* Oil and Steel Gallery, NYC

Massive steel floor-planes encourage an interiorized perception in architectonic settings exploring space, mass and light. Each part of an installation functions independently, and it is the observer who participates in the space who must recognize the relationships, mentally unify the elements, and integrate them into a cohesive whole. Recent *Construction of Vision Drawings* in charcoal are approached much as the

sculpture was, concentrating on mass and surface rather than volume.

RAFFAEL, JOSEPH (Painter, Printmaker)
P.O. Box 210, San Geronimo CA 94963

Born: 1933 *Awards:* Tiffany Foundation Fellowship; Fulbright Award *Collections:* Metropolitan Museum of Art; Smithsonian Institution *Exhibitions:* Whitney Museum of American Art; San Francisco Museum of Modern Art *Education:* Cooper Union; Yale University School of Art *Dealer:* Nancy Hoffman Gallery, NYC

Early Photo-realistic paintings of the 1960s were depictions of nature taken from photographs: animals, ponds and foliage. Large-scale close-ups of animal faces, such as *Lizard's Head*, and human faces such as *African Lady* were sensuous replications reflecting a deep concern for nature, for "observing fertile and fantastic things that have within them the power to erupt, like Vesuvius." This interest in nature's mystical qualities made his approach quite different from that of other Photo-realists. His media changed from oil to watercolor, pastel and lithography as renditions of natural phenomena became less photographic and more impressionistic—for example, as in the watercolor entitled *Luxembourg Gardens: Memory*. He says, "I like to think I paint feeling. I am interested in spirit as expressed in nature, the invisible made visible."

RAFFEL, ALVIN ROBERT (Painter)
6720 Mad River Rd., Dayton, OH 45459

Born: 1905 *Awards:* Purchase Award, Dayton Art Institute *Collections:* Dayton Art Institute; Youngstown Art Association *Exhibitions:* Carnegie International; Cincinnati Art Museum *Education:* School of the Art Institute of Chicago

American representational oil paintings using brush and palette knife techniques, along with watercolors make up the body of his work. Early works exhibited a meticulous attention to detail in still life scenes and landscape studies. From a truly representational approach to painting he progressed to an interpretive and conceptual type of expression in his landscape works. Works are at times semi-abstract but never non-objective.

RAGLAND, JACK WHITNEY (Painter, Printmaker)
5490 Rainbow Heights Rd., Fallbrook CA 92028

Born: 1938 *Awards:* Grand Purchase Prize, Arizona Annual Exhibition; First Prize, Southern California Exhibition *Collections:* Albertina Museum, Vienna; Los Angeles County Museum of Art *Exhibitions:* Southern California Exhibition *Education:* Arizona St. University; University of California, Los Angeles; Akademie Angewandte Kunst; Akademie Bildenden Kunste; Graphische Bundes-Lehrund Versuchsanstalt *Dealer:* Marilee J. Ragland

Since an early age he has shown his versatility, experimenting with many media including oil, pastel and watercolor and working in impressionistic, expressionistic and surrealistic styles. After formal education he worked almost exclusively in serigraphy, prints characterized by overlapping forms in solid bold colors. Recent prints on canvas and Masonite are representational still lifes, landscapes, and figurative works emphasizing structure and color. He seeks to validate "both the self of the artist and the self of each observer."

RAKOCY, WILLIAM (Painter)
4210 Emory Way, El Paso, TX 79925

Born: 1924 *Awards:* Watercolor Award, Butler Institute of American Art *Exhibitions:* Cooper School of Art, Cleveland, OH; Juarez Art and History Museum *Education:* Kansas City University; Kansas City Art Institute

He concentrates on watercolor, and also works in template and spray, enamel, pastel, and spray enamel. He began by painting the mountains, wilderness, and ghost towns of Colorado, New Mexico, and Arizona. The early works are more abstract than the later works, in which the artist "rediscovered" realism. Among his influences are Peter Hurd, Ross Braught, John Meigs, and Bruce Mitchell.

RAMBERG, CHRISTINA (Painter)
3454 N. Damen, Chicago IL 60618

Born: 1946 *Awards:* National Endowment for the Humanities Grants *Collections:* Whitney Museum of American Art; Art Institute of Chicago *Exhibitions:* Whitney Museum Annual; Sao Paulo Biennial *Education:* School of the Art Institute of Chicago *Dealer:* Phyllis Kind Gallery, Chicago

This Chicago Imagist paints upon Masonite the wrapped torsos of sinister figures, a combination of flesh and clothing expressing an enigmatic tension. Paintings of the early 1970s suggested a woman in lingerie, bound by silk and lace. Subsequent works became less discernible, such as *Sedimentary Disturbance,* which is collage-like in its depiction of various textured garments and undefined surfaces. The female figures are usually headless; if the head is included, the face is obstructed by hair, as in *Layered Disorder.* Aggressively surrealistic and hallucinatory imagery gives the works an iconic weight symbolizing victimization and fetishism.

RAMIREZ, DANIEL P. (Painter)
c/o Roy Boyd Gallery, 215 W. Superior St., Chicago IL 60610

Born: 1941 *Collections:* Art Institute of Chicago; Museum of Contemporary Art, Chicago *Exhibitions:* Art Institute of Chicago; Renaissance Society, University of Chicago *Education:* School of the Art Institute of Chicago *Dealer:* Roy Boyd Gallery, Chicago and Los Angeles

Geometrical elements in muted tones characterized early Minimalist works. More recent works continue a Minimalist approach in geometrical figures of greater intricacy placed on backgrounds of less subdued colors. Triptychs and polyptychs explore mystical, philosophical and musical concepts, often symbolized by geometrical forms placed upon five-line arrangements, like the musical staff, on a shining celestial background. Collages and drawings have also resembled musical notations. A preoccupation with theological issues is apparent in works of the past several years, with titles such as *Where Are the Angels Now?* and *The Conversion of Longinus.*

RAMOS, MELVIN JOHN (Painter)
5941 Ocean View Dr., Oakland CA 94618

Born: 1935 *Collections:* Museum of Modern Art; Neue Galerie, Aachen, Germany *Exhibitions:* Whitney Museum of American Art; Hayward Gallery, London *Education:* San Jose State College; Sacramento State College *Dealer:* Louis K. Meisel Gallery, NYC; Calle Moragrega, San Juan, Spain

In the early 1960s Pop paintings of comic-strip heroes were influenced by his teacher, Wayne Thiebaud. He

Lester Rebbeck, *Hostages,* 40 x 50, oil on canvas.

Stephen Quiller, *Ice Flow,* 29 x 21, acrylic & casein.

Mel Ramos, *I Still Get A Thrill . . . #3,* 30 x 22, watercolor. Courtesy: Louis K. Meisel Gallery (New York NY)

invented other characters and dealt with the images of mass-media culture in energetic distorted compositions. Later he became known for figurative works, "pin-up girls," accompanied by exotic animals, as in *Aardvark*, or with consumer products. *Unzip a Banana* was a picture of a peeled banana with a woman inside. Recent work is no longer figurative but "referential, and for many of the same reasons as with the figure, deals with the landscape."

RAND, ARCHIE (Painter)
326-55th St., Brooklyn, NY 11220

Born: 1949 *Collections:* Art Institute of Chicago; Brooklyn Museum *Exhibitions:* Carnegie Institute Museum; Hudson River Museum *Education:* Pratt Institute; Art Students League *Dealer:* Tibor de Nagy Gallery, NYC

His earliest works were abstract expressionist paintings. However, while painting a mural for the Congregation B'nai Yousef Temple in Brooklyn, he began incorporating figurative elements, playing them against the abstract passages in his work. These experiments led him to a synergistic combination of the figure and abstract elements. The recent canvases are activated by surfaces of gel and often thickly applied and vigorously manipulated acrylic paint. He strives to achieve a compositional unity in the wide-ranging motifs and textural variations of his canvases.

RANSOM, HENRY CLEVELAND JR. (Painter)
P.O. Box 25, Good Hope, GA 30641

Born: 1942 *Awards:* Julius Hailgarten Prize, National Academy of Design; Atwater Kent Award, Society of the Four Arts *Collections:* Columbus Museum of Art; Mint Museum of Art *Exhibitions:* Hunter Museum of Art; FAR Gallery, NYC *Education:* University of Georgia *Dealer:* Arras Gallery, NYC; Schenck Gallery, Atlanta

His personal aesthetic goal in both his oil paintings and drawings is the absolutely accurate recording of visual perceptions. In this he is set apart from other realist painters who are concerned with the creation of convincing illusions. Preconceived solutions are rejected as intellectual notions rather than direct, personal, and immediate visual observations. This approach is his own re-definition of the representation of realism in art.

RAPOPORT, SONYA (Painter)
6 Hillcrest Ct., Berkeley, CA 94705 *Awards:* Vera Adams Memorial Prize; Rhea Keller Memorial Prize collections: Stedelijk Museum; San Francisco Museum of Modern Art *Exhibitions:* Peabody Museum, Harvard University; Truman Gallery, NYC *Education:* New York University; University of California, Berkeley

Her art is characterized by its search for new genres. In the mid-1960s she combined canvases of different media and styles and pattern-painted on fabric—practices now accepted as current art forms. By 1972 she had evolved her own visual language code, superimposed on antique geological survey charts. For the past ten years her artworks have been a response to contemporary cultural behavior patterns. The source is biographical or social interplay derived from audience participation performances that she produces. Video and audio tapes, computer graphics, and copy machines are used for implementing the presentation of her art concepts.

RAUSCHENBERG, ROBERT (Painter)
c/o Leo Castelli Gallery, 420 W. Broadway, New York NY 10012

Born: 1925 *Awards:* Grand Prix D'Honneur, Thirteenth International Exhibition of Graphic Art, Ljubljana, Yugoslavia; Venice Biennale *Collections:* Whitney Museum; Museum of Modern Art *Exhibitions:* Whitney Museum of American Art; Museum of Modern Art *Education:* Kansas City Art Institute; Art Students League, *Dealer:* Leo Castelli Gallery, New York, NY

After working with de Kooning, in 1955 he exhibited his "mixed media" paintings that combined painted elements with found objects in an effort to break down the boundaries between art and life. He also participated at Black Mountain College with composer John Cage and dancer Merce Cunningham in some of the first performances that later came to be called "happenings". His new methods opened the way for Pop Art. Combinations of disparate images through photo-transfer, silkscreen, incorporation of found objects, and painted forms resulted in striking juxtapositions. Since 1966 he has experimented with disks, motors, plexiglass, sound, and variations in technique such as the transfer of photographs to silk-screen in the manner of Andy Warhol. Recent work includes a silk-screen-like collage of photographic images on the surface of the Talking Heads' plastic record album, *Speaking in Tongues.*

REBBECK, LESTER JAMES JR. (Painter)
2041 Vermont St., Rolling Meadows, IL 60008

Born: 1929 *Awards:* Best of Show, McHenry Art Fair *Collections:* Mr. William Fisher; Dr. Mellach *Exhibitions:* Peace Museum; Illinois State Museum *Education:* School of the Art Institute of Chicago

He has worked independently of various schools and philosophies to develop a style of painting that is truly his own and yet is definitely American in background and origins. His work shows a development based on the teaching of Hans Hofmann. While he is not a photorealist, the work is subject oriented. He attempts to strike a balance between realism and the emotional impact of abstract expressionism. Recently he has concentrated on landscape painting as part of his *America the Beautiful* series. The scenes depict the Midwest, sometimes indicating man's intrusion upon the natural landscape.

RECKLING, GENEVIEVE (Painter)
c/o C.G. Rein Galleries, 4235 N. Marshall Way, Scottsdale AZ 85251

Awards: City-wide Art Award, Houston *Collections:* Phoenix Art Museum; Arizona St. University *Exhibitions:* Art Club of Washington (DC); Elaine Starkman Gallery *Education:* University of Texas; Arizona St. University *Dealer:* C.G. Rein Galleries, Santa Fe, Houston, and Denver

First known for oil paintings of still lifes and landscapes in the 1960s, she focused on realistic depictions of flowers and cactus. During the 1970s she worked on drawings and monotypes and turned away from purely representational images. Recent landscape paintings are begun with thin washes, then pigments are thickly applied, and glazes enrich the surface. Figuration defines physicality, while abstract elements capture mood, movement and light. Water has been a recurring image, flowing over rocks in shimmering brooks or pools recalling Joseph Raffael, as in the series entitled *Pool of Siloe.*

REDDY, KRISHNA N. (Printmaker, Sculptor)
80 Wooster St., New York, NY 10012

Genevieve Reckling, *Ceremony of Stones,* 46 x 60, oil on canvas.

Henry C. Ransom, *Earthscape: Inland Shore,* 26 x 18, colored pencil drawing. Courtesy: Arras Gallery (New York NY)

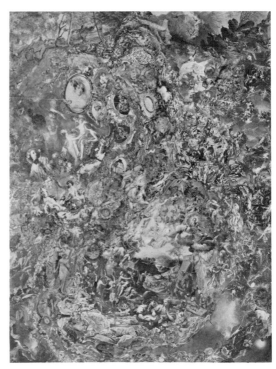

Joseph Shepperd Rogers (Nevia), *Religious and Profane or Whatever Became of,* 40 x 32, collage. Galerie Geilsdorfer (Koln W. Germany)

Born: 1925 *Awards:* Padma Shree Award; Abani-Gagan Award *Collections:* Museum of Modern Art; The Library of Congress *Exhibitions:* Bronx Museum of the Arts; Academy of Fine Arts, New Delhi *Education:* International University at Santiniketan; University of London *Dealer:* Associated American Artists Gallery, NYC; Weintraub Gallery, NYC

Special methods developed by the artist for sculpture in stone, wood and bronze platemaking allowed him to produce powerful, energetic images in his prints. Trained as a sculptor, he works the plate like a sculpture, carving contours of relief with tools in addition to etching with acid. His discovery that numerous colors can be printed at one time on a single plate by controlling the viscosity of inks, virtually revolutionized the field of intaglio printmaking. He is also renowned as a teacher of workshops and lectures.

RED STAR, KEVIN (Painter, Printmaker)
2705 Camino Chueco, Santa Fe NM 87501

Born: 1943 *Awards:* Governor's Trophy, Scottsdale National Indian Art Exhibition; First Place, Central Washington State College Art Exhibition *Collections:* Institute of American Indian Arts Museum; Heard Museum *Exhibitions:* New Mexico Museum of Fine Art Indian Art Show; Oklahoma Museum of Art *Education:* Institute of American Indian Arts; San Francisco Art Institute *Dealer:* Good Company Gallery, NYC; Louis Newman Galleries, Beverly Hills, CA

Born on a Crow Indian reservation in Montana, he brings a primitive style to portrayals of the Crow people, in acrylics on canvas or in multi-colored serigraphs. Ritual scenes and portraits of Indians posed in their full regalia are glorified and stylized in bold dramatic colors. A few action scenes show Indians hunting, but most are posed, as in *Resting Indian,* in which an Indian in traditional dress on horseback smokes a cigarette. Pictures such as this one are perhaps subtle social commentaries on life on the reservation.

REEP, EDWARD ARNOLD (Painter)
201 Poplar Dr., Greenville, NC 27834

Born: 1918 *Awards:* Fellowship, John Simon Guggenheim Memorial Foundation; First Purchase Prize, Los Angeles County Museum of Art Annual *Collections:* National Museum of American Art, United States Military History Collection *Exhibitions:* Whitney Museum Annual; Corcoran Biennial *Education:* Art Center College of Design *Dealer:* Annex Gallery II, Charlotte, NC

As an official war artist/correspondent during World War II, he was able to begin his art career painting oil and watercolor scenes from real life subjects and landscapes. Current paintings are either representational or nonobjective—it is of "little consequence" to the artist. Works sometimes contain sociological or philosophical messages, but not always. Recently, humor and satire have entered his canvases.

REGINATO, PETER (Sculptor)
60 Green St., New York, NY 10012

Born: 1945 *Awards:* Fellowship, John Simon Guggenheim Memorial Foundation; Allen Center Commission *Collections:* Metropolitan Museum of Art; Hirshhorn Museum and Sculpture Garden *Exhibitions:* Whitney Museum of American Art; Hayward Gallery, London *Education:* San Francisco Art Institute *Dealer:* Salander-O'Reilly Galleries, NYC

His sculpture strives for a balance between drawing and structure. From the earliest works, he has been developing a personal vocabulary of shapes. The pieces use a minimum of tacking and welding, so the forms touch lightly and easily. The sculpture has a sense of energy and animation, with looping and curling strands of steel twisting around the forms. His recent works have been noted for the activity of forms contained within a cohesive structure.

REILLY, JACK (Painter)
443 S. San Pedro St., 5th Floor, Los Angeles, CA 90013

Born: 1950 *Awards:* Grant, National Endowment for the Arts; Best of Show, Bellair National Exhibition *Collections:* Oakland Museum, CA; ARCO Center for the Arts, Los Angeles *Exhibitions:* Stella Polaris Gallery, Los Angeles; Aaron Berman Gallery, New York City *Education:* Florida State University *Dealer:* Stella Polaris Gallery, Los Angeles

His painting thrives on extremes—control/losing control, have/have not. His work has always demonstrated a responsibility to art history. He chooses particular issues in art to explore for himself in his own way. Definition of the picture plane and pictorial space has always been an issue of importance in his work. By the use of artistic options such as movement/stillness, thin/thick, color/neutrality, and edge/amorphic, he explores issues of extreme aesthetic forces in action.

REMINGTON, DEBORAH WILLIAMS (Painter)
309 W. Broadway, New York, NY 10013

Born: 1935 *Awards:* Fellowship, John Simon Guggenheim Foundation; Grant, National Endowment for the Arts *Collections:* Whitney Museum; National Collection of American Art, Washington, DC *Exhibitions:* Newport Harbor Art Museum, CA; Oakland Museum of Art, CA *Education:* San Francisco Art Institute *Dealer:* Gallery Paule Anglim, San Francisco

Since the mid-1960s Remington has been producing heraldic but totally abstract paintings. They are machine-like, and yet they are organic. She was a student of Clyfford Still and an admirer of Franz Kline. Their abstract expressionist influences survive in the automatism of the preliminary drawing that underlies her highly finished paintings, which are otherwise anything but abstract expressionist. The most recent works, dating from 1984, are considerably more expressive than the earlier work. Their gestural qualities, grainy textures, and spiky components convey an almost primitive aura.

REMSING, GARY (Painter, Sculptor)
1418 Oakwood Dr., Modesto, CA 95350

Born: 1946 *Awards:* Sculpture Commission, State of California *Collections:* University of Santa Clara, CA *Exhibitions:* University of Santa Clara, CA; William Sawyer Gallery, San Francisco *Education:* San Jose State University

His sculpture and painting are concerned with natural phenomena. The works of the 1960s and early 1970s use light and reflection as the main visual element. These works were constructed primarily of clear acrylic plastic, with aluminum coatings applied in a vacuum chamber. His first vacuum-coated works, entitled *Achromatic Series,* were constructed in 1965. In the mid-1970s and into the 1980s he has used various materials such as bronze, stainless steel, and glass in his works.

RENNER, ERIC (Photographer)
Star Route 15, Box 1655, San Lorenzo, NM 88057

Born: 1941 *Awards:* Fellowship, National Endowment for the Arts *Collections:* Museum of Modern Art; National Gallery of Canada *Exhibitions:* Museum of Modern Art, Mexico City; Museo de Arte de Sao, Paulo, Brazil *Education:* Cranbrook Academy of Art *Dealer:* Fuller Fine Art, Philadelphia

His photographic work makes use of atypical techniques to stretch the traditions of the medium. All of his work is produced with hand-made pinhole cameras in which the film is exposed directly without the use of a lens. Early photographs were 360 degree panoramas constructed by the unusual blending of overlapping exposures. Later portraits made use of direct negative imagery on photographic paper placed in the camera instead of film. Recent work is concerned with underwater light reflections, especially a curious optical phenomenon known as "total internal reflection". The resulting photographs, bilaterally symmetrical in composition, are views directly from nature, and yet display a subtle strangeness and sense of the unfamiliar.

RENOUF, EDDA (Painter, Printmaker)
20 W. Thirtieth St., New York NY 10001

Born: 1943 *Collections:* Museum of Modern Art; Metropolitan Museum of Art *Exhibitions:* Museum of Modern Art; Whitney Museum Biennial *Education:* Sarah Lawrence College; Art Students League; Columbia University *Dealer:* Blum-Helman Gallery, NYC; Yvon Lambert Gallery, Paris

Born in Mexico City, she studied at various art schools in Paris from 1963 to 1964, and in the late 1960s began to sew threads and fabrics onto the canvases. In 1969 paints were applied in thin coats "so as to let the structure of the canvas speak." Pencil was sometimes applied to primed canvas in tight spirals, also emphasizing the surface. In 1971 she decided to settle in Paris, and there during the next decade she pulled threads from the canvas in order to "reveal the life of the weave," as in the *Search* series. "Changing the structure of the base I add, remove, erase or sand. Not covering, but uncovering—not closing but opening—it is then what it is." Recent work after returning to America includes prints as well as ink drawings.

RENOUF, EDWARD PECHMANN (Painter, Sculptor)
12 E. 87th St., New York NY 10128

Born: 1906 *Awards:* Second Prize, Sculpture, Sharon Creative Arts Foundation *Collections:* Corcoran Gallery of Art; Herbert and Dorothy Vogel Collection *Exhibitions:* Whitney Museum Annual; Pennsylvania Academy of the Fine Arts *Education:* Phillips Andover Academy; Harvard University; Columbia University *Dealer:* Allan Stone Gallery, NYC

Born in Hsiku, China, this multi-media sculptor also studied painting and drawing with Carlos Merida in Mexico. Recent paintings are small-scale and monochromatic. Primitivistic metal sculptures using modern machine parts are assembled with wit and spontaneity, mask-like pieces such as *Toltec Rain God.* A recent self-portrait entitled *It's Me!* reveals the inside of the head through a jumbled lattice of wire bones, and includes a garden rake for fangs, a pair of horns and sheep's ears.

REYNOLDS, WADE (Painter)
c/o Louis Newman Galleries, 322 N. Beverly Drive, Beverly Hills, CA 90210

Awards: Prize, Miami Print Biennial *Collections:* Cleveland Museum of Art; Santa Barbara Museum of Art *Exhibitions:* California Palace of the Legion of Honor, San Francisco; Haggin Museum, Stockton, CA *Dealer:* Louis Newman Galleries, Beverly Hills, CA

Using reality as a starting point for his images, he transforms the immediately recognizable in his art. He works in a variety of media, including oil on canvas, acrylic on paper, Prismacolor pencil, and original lithography. He employs a technique of high contrast lighting and a palette of warm, rich, delicately colored glazes. His art attempts to capture the essence of his Southern California subjects.

RICHARDSON, SAM (Sculptor)
4121 Sequoyah Rd., Oakland CA 94605

Born: 1934 *Collections:* Smithsonian Institution; Denver Art Museum *Exhibitions:* Museum of Modern Art; Whitney Museum of American Art *Education:* California College of Arts and Crafts *Dealer:* Martha Jackson Gallery, NYC; Hansen Fuller Goldeen Gallery, San Francisco

An interest in landscape brought him to the use of formal elements from images of his native California. The content of the large constructions and installations consists largely in the arrangement of forms. Light, heat and activity on the desert are explored when wood, cloth, rope and paper are integrated by the effects of shadow, color, line and texture in the tent-like *Desert Image: Wedges/Area 5.* Pieces in series draw cumulative meanings as he seeks to express mankind's "universal relationship with the land—not to tell a story but to suggest a familiar experience, an illusion that will lead one to ponder rather than know."

RICKEY, GEORGE (Sculptor)
Rd. 2 Box 235, East Chatham, NY 12060

Born: 1907 *Awards:* National Fine Arts Honor Award, American Institute of Architects; Brandeis University Creative Arts Award *Collections:* Museum of Modern Art; Hirshhorn Museum & Sculpture Garden *Exhibitions:* Solomon R. Guggenheim Museum; Albright-Knox Art Gallery *Education:* Trinity College; Oxford University

For the past three decades he has been one of only a handful of sculptors who has composed with movement itself as his main medium. He studied painting in Paris with Andre Lhote, Leger, and Ozenfant in the 1930s, but not until after World War II, strongly influenced by the writings of Moholy-Nagy and the mobiles of Alexander Calder, did he begin to explore kinetic sculpture. First works were inspired by natural shapes and were designed to be hung on the wall, but soon thereafter he began to employ the simple geometric shapes fashioned out of steel and other metals that have become the characteristic aspect of his work. Slender blade-like forms balanced on knife edges and tipped by the wind and rain to fall and move in parallel rhythms were succeeded by rectangular planes that rotated upon on a conical base. Recent sculpture, fabricated in stainless steel and designed for outdoor installation, continues his progression from moving lines to moving planes to moving volumes.

RIDLEY, GREGORY D. (Sculptor, Painter)
1106 28th Ave. N., Nashville, TN 37208

Born: 1925 *Awards:* Gettysburg First Prize Gold Medal *Collections:* Fisk University; McDonald's Corporation *Exhibitions:* Fisk University Show; South Center Show, Nashville *Education:* Fisk University; Tennessee State University; University of Louisville *Dealer:* Nashville Artist Guild, Nashville

Figurative sculpture on biblical, mythological, and historical subjects in stone and wood, and repousse in metal comprise the majority of his work. African masks as well as classical sculpture have strongly influenced his sculpture. He has accepted a number of commissions to do work in repousse on the life of "great blacks", the life of George Washington Carver, and the great battles of the civil war, an eighteen year creative serial. Biblical subjects, in marble and repousse, have included the life of Christ, and Old Testament prophecies.

RIES, MARTIN (Painter)
36 Livingston Rd., Scarsdale, NY 10583

Born: 1926 *Awards:* Yaddo Fellowship *Collections:* Riverside Museum; Rose Art Museum, Brandeis University *Exhibitions:* Smithsonian Institution; Museum of Modern Art *Education:* American University; Hunter College *Dealer:* Aaron Berman Gallery, NYC

His early egg tempera paintings were characterized as mystic, with religious overtones of life and death. For the past few years he has been using photographic silk screens of other artists' images (e.g., da Vinci, Picasso, Warhol) to print into his own paintings and prints. He works on hundreds of paintings and parts of paintings simultaneously. Usually there is a large field of textured color into which painted or printed panels and/or other objects are attached, and into which he prints the images. His present work is concerned with an intellectual interpretation of world conditions couched in mythological terms.

RIVERS, LARRY (Painter)
92 Little Plains Rd., Southampton NY 11968

Born: 1923 *Awards:* Third Prize, Corcoran Gallery of Art *Collections:* Metropolitan Museum of Art; Corcoran Gallery of Art *Exhibitions:* Whitney Museum of American Art; Museum of Modern Art *Education:* Hans Hofmann School of Fine Arts; New York University *Dealer:* Marlborough Gallery

A versatile artist, he was first a jazz musician and also designed sets for plays. In the 1950s he combined influences from abstract expressionism with figurative elements, combining vague terms with precise details in undefined spacial planes. In 1960, with growing Pop tendencies, he began to employ mixed media in works featuring commercial and historical visual cliches such as *Dutch Masters and Cigars II,* a cigar box with a rendition of Rembrandt's *Syndics* on the cover. Multiple views of a single subject recall montage, and an interest in the coincidences between words and images make him akin to Pop Art, but a painterly treatment sets him apart from the anonymous styles of Pop. To him the method of execution is more important than the subject itself. Media have included figural sculpture in wood, metal and plexiglass; collage; printing; and shaped-canvas constructions.

RIZZIE, DAN (DURANT CHARLES) (Painter)
2008 Laws, Dallas TX 75202

Born: 1951 *Awards:* First Place, Texas Painting and Sculpture; First Place, Shreveport Annual *Collections:* Brooklyn Museum; Dallas Museum of Art *Exhibitions:* Brooklyn Museum; Dallas Museum of Art *Education:* Hendrix College; Southern Methodist University *Dealer:* Delahunty Gallery, Dallas; Watson/de Nagy, Houston

Born in New York State, he has spent much of his life in the Southwest and first gained recognition there. Since the mid-1970s small-scale, brightly colored collages have depicted rectilinear forms and geometrical shapes, as in the *Untitled Boxes* (1979), executed in acrylic, graphite and collage on wood. Symmetry and balance are achieved through the artist's hand and eye rather than through exact measurements. The straight lines are formed by the edges of antique paper and by thick, shiny applications of graphite. Rectangles and squares of varying sizes are made of raw paper in bold primary colors. He has worked as a college instructor in drawing, painting and lithography.

ROBBIN, ANTHONY STUART (Painter)
423 Broome St., New York, NY 10013

Born: 1943 *Collections:* Whitney Museum of American Art; Chase Manhattan Bank *Exhibitions:* Whitney Museum of American Art *Education:* Columbia University; Yale University *Dealer:* Tibor de Nagy Gallery, New York, NY

Earlier work is often included in "Pattern" theme group shows and reveals his fascination with the potential of geometric patterning for awakening perceptions of dimensional perspective. The current paintings are explorations in the visualization of space—the "fourth dimension." Many of these works involve a three-dimensional rod structure. He works closely with computers to develop a means of combining the fourth dimension with three-dimensional elements. By moving along these works while viewing them, the viewer experiences rotation, reversal, flattening, and expansion, allowing a progression of continually enriching readings.

ROBBINS, TRINA (Cartoonist)
1982 15th St., San Francisco, CA 94114

Born: 1938 *Awards:* Inkpot Award for Achievement in the Comic Arts *Exhibitions:* San Francisco Museum of Modern Art; Museum of Cartoon Art, NYC *Education:* Cooper Union

Generally considered the doyenne of women underground cartoonists, she has been drawing comics for publication since 1966. In 1970, the themes of her comics shifted from psychedelia to feminism. Today her work, while less blatantly political, still remains woman-oriented. Although her style is still characterized by the strong blacks and whites of the 1960s, it has evolved into "la ligne claire," a nostalgic reminiscence of the 1940s and 1950s.

ROBLES, JULIAN (Painter)
Box 1845, Taos, NM 87571

Born: 1933 *Awards:* Rosental Award, Pastel Society of America; Gold Medal, National Watercolor Association *Collections:* New Mexico State Permanent Collection; Diamond M Museum *Exhibitions:* Cowboy Hall of Fame; Hermitage Museum *Education:* National Academy of Art and Design; Art Students League *Dealer:* Trailside Galleries, Scottsdale

For more than fifteen years he has painted in the Southwest, depicting the Native Americans in portraits and views of their colorful ceremonials and costumes. He also represents the Hispanic and Anglo cultures, the landscapes of Northern New Mexico and Arizona, and

paints many formal portraits. He works in pastel and other mediums, using a realistic and representational style. Working directly from life, either from models in the studio or out of doors, he records the subjects with authenticity and great accuracy of detail. His paintings carry a sense of pride in tradition and the culture.

ROGERS, P.J. (Printmaker, Painter)
954 Hereford Dr., Akron, OH 44303

Born: 1936 *Awards:* Fellowship, Ohio Arts Council; Award, Cleveland Museum of Art *Collections:* Cleveland Museum of Art; Cleveland Art Association *Exhibitions:* Philadelphia Print Club International; Boston Printmakers National *Education:* Wells College; University of Buffalo *Dealer:* van Straaten Gallery, Chicago

Early work as an expressionist painter, led to an interest in graphics and specifically woodcuts, etchings, and the aquatint media. Since 1975 she has worked full time with the aquatint etching process with its transparent and reflective properties to represent the importance of what is fleeting and unpredictable. She uses geometric and semi-abstract forms that do not express ideas literally but only inferentially through their relationships between our minds and the arrangements of lines and shapes. The shapes are flat but evoke space through their relative tonal values. She produces black and white aquatints, color aquatints, color aquatint collages and color aquatint reliefs.

ROLLINS, JO LUTZ (Painter)
7500 York Ave., Apt. 845, Edina, MN 55435

Born: 1896 *Awards:* Grant, Rockefeller Foundation *Collections:* Minneapolis Institute of Arts; Tweed Museum, University of Minnesota *Exhibitions:* Walker Art Center; College of St. Catherine, St. Paul, MN *Education:* Minneapolis School of Art; Hofmann School, Munich

Inspiration for her art is derived from the visual world, but she does not treat it photographically. While still a student she became interested in Minnesota history and painted many watercolors of what remained from earlier times. These works depict churches, homes, ruins of mills, abandoned hotels, and quiet Main Streets. Her method is to work on the spot, directly, using transparent watercolor broadly applied. She considers color relationships and design as important as subject matter. She adds pen and ink if she needs detail. Her oils have always been done in the studio, based on sketchbook material and the watercolors.

ROLOFF, JOHN (Sculptor)
2020 Livingston St., Oakland, CA 94606

Born: 1947 *Awards:* Award, John Simon Guggenheim Memorial Foundation; Visual Arts Fellowship, National Endowment for the Arts *Collections:* San Francisco Museum of Modern Art; Oakland Museum *Exhibitions:* Whitney Museum of American Art; San Francisco Museum of Modern Art *Education:* University of California, Davis; California State College, Humboldt *Dealer:* Fuller Goldeen Gallery, San Francisco

His early works are mainly clay objects that emphasize landscape and process. Geology studies in college became a natural ally of his ceramic interests. The ship as a symbol of personal voyage and transformation has been a recurring theme in his art. Most recently he has done "site" works of fired ceramic structures. Incorporated with the fired elements are living plants trained over shaped trellises. The images are often ship forms, though floral and botanical images may occur. In these new works his interests in process, landscape, and nature are operating on a larger scale.

ROSEN, JAMES MAHLON (Painter)
513 Benton St., Santa Rosa, CA 95404

Born: 1933 *Awards:* National Endowment for the Humanities; Artist in Residence, Ferrara, Italy *Collections:* Museum of Modern Art; Victoria and Albert Museum *Exhibitions:* Betty Parsons Gallery, NYC; San Diego Museum of Art *Education:* Cooper Union; Cranbrook Institute of Art; Wayne State University *Dealer:* Bluxome Gallery, San Francisco

His oil and watercolor paintings draw from Minimalism for many of their technical devices, developing a kind of Minimalist, sometimes almost subliminalist, impressionism hovering on the mere threshold of vision. His paintings allow the viewer to reconstruct for themselves the forms and associations—psychological, historical, cultural, spiritual—that he has distilled within the work. Very often themes of his paintings are taken from other art—for example, "after Grunewald and Goya".

ROSEN, JEANIE (Painter)
7258 Empire Grade Rd., Santa Cruz, CA 95060

Born: 1954 *Exhibitions:* Laguna Beach Museum of Art; Western Design Institute, San Francisco *Education:* University of California, Santa Cruz; American River College *Dealer:* Walter/White Fine Arts, Carmel

A concern with the different qualities of light is evident in her photo-realist oil paintings, watercolors and drawings of floral scenes and rock formations. Working from a series of color photographs she selects aspects of each to arrive at a formal composition and quality of light that transmits an almost cloud-likeethereal quality to her large (4' x 5') oil paintings. Color is emphasized to bring out aspects of light, exaggerating the reflection of water on a petal or the shadow on a leaf in her floral works. It varies from the soft, ephemeral beauty of the floral works to the discomfortingly raw color combinations employed in the rock formations. Space is flattened out and altered both through the perspective of the closely-cropped photographs and her formal composition to produce a sense of disorientation and mystery.

ROSENBLUM, RICHARD (Sculptor)
44 Ballard St., Newton Center, MA 02159

Born: 1941 *Collections:* Columbus Museum of Art *Exhibitions:* Museum of Fine Arts, Boston; National Academy of Design *Education:* California School of Fine Arts; Cranbrook Academy of Art *Dealer:* Allan Stone Gallery, NYC

He has worked with the predominating themes of the landscape and the figure in his mixed media and bronze sculpture. Natural and found objects, such as roots and stumps of trees, are coated, cast in epoxy, and transformed into composite forms with a multitude of visual associations. Some of these are later cast in bronze. In a current work entitled, *Manscape,* the figure and the landscape come together in a haunting piece constructed of gnarled roots and epoxy. The "earthy" surface texture is built onto a skeleton of roots. The form struggles upward touching base on only two points which read as feet. A peculiarly anthropomorphic form, it is embued with a primal energy.

ROSENQUIST, JAMES (Painter)
Box 4, 420 W. Broadway, Aripeka FL 33502

Born: 1933 *Awards:* Torcuato di Tella International

Prize, Buenos Aires *Collections:* Metropolitan Museum of Art; Museum of Modern Art *Exhibitions:* Museum of Modern Art; Solomon R. Guggenheim Museum *Education:* Art Students League *Dealer:* Leo Castelli, NYC

Early work was abstract, but employment as a Times Square billboard painter in the late 1950s led to the application of commercial art imagery, producing paintings in day-glo colors that resembled randomly arranged advertising fragments like the different layers of a billboard. These Pop works were made by splicing blow-ups of commercial motifs and then creating for them a new context, sometimes readable and other times elusive to the viewer. An interest in depicting "visual inflation" continued in montages incorporating such modern materials as neon, plexiglass, plastic and Mylar in free-standing constructions, murals and picture-assemblages.

ROSENTHAL, GLORIA M. (Painter)
92 Main St., P.O. Box 1322, Gloucester, MA 01930

Born: 1928 *Awards:* Medal of Honor, National Association of Women Artists; National Award Winner, American Artist Magazine *Collections:* Bankers Trust, NYC; Transverse National Bank, PA *Exhibitions:* Brooklyn Museum; National Academy *Education:* University of Cincinnati; Provincetwon Workshop

She derives inspiration from peeling paint, rust, the sea, sky, and flowers. An early color field series used granules of mica as inspiration and technique. The content of her experimental works deals with energy, space, and communications. Lush, finished surfaces characterize her paintings. Current works deal with the power of flowers, including the lotus and the orchid. Meditation on the subjects is the focus of these paintings.

ROSENTHAL, RACHEL (Performance Artist, Sculptor)
2847 S. Robertson Blvd., Los Angeles, CA 90034

Born: 1926 *Awards:* Fellowship, National Endowment for the Arts *Exhibitions:* The Woman's Building, Los Angeles; Franklin Furnace, NYC *Education:* New School of Social Research, NYC; Sorbonne, Paris

A Paris-born American performance artist, she comes from a multiple background of visual art, dance, and theatre. She studied art with Hans Hoffman, dance with Merce Cunningham, and theatre with Jean-Louis Barrarlt and Erwin Piscator. In l956 she founded Instant Theatre, an experimental theatre group based in Los Angeles and in the late sixties emerged as a sculptor and one of the leaders of the Women's Art Movement. It was in l975 that she switched to performance art and since has focused on that form. Early performances took the shape of personal, autobiographical exorcisms with allusions to ancient ritual, Zen Buddhism, healing rites, and more. Her current solo performances, as in the recent *Traps,* encompass all humankind in the exorcisms. With great sensitivity to the power of the dramatic persona and with surprising visual images, she presents intimate, poetic pieces addressing social and political problems and offering hope.

ROTHENBERG, SUSAN (Painter, Printmaker)
c/o Willard Gallery, 29 E. 72nd St., New York NY 10021

Born: 1945 *Awards:* Fellowship, John Simon Guggenheim Memorial Foundation; Creative Artists Public Services Program Grant, New York State Council on the Arts *Collections:* Museum of Modern Art; Whitney Museum of American Art *Exhibitions:* Museum of Modern Art; Zeitgeist, W. Berlin *Education:* Cornell University; Corcoran Museum School *Dealer:* Willard Gallery, NYC

In the 1960s she briefly studied sculpture but soon turned to painting. She achieved success in the mid-1970s as a New Image painter with a new brand of expressionistic figuration. An early series of acrylic and tempera paintings featured a single horse on each canvas, placed on a monochrome ground and divided diagonally or vertically by one or a few lines. "The horse was a way of not doing people," in a time when the human figure was out of style; "it was a symbol of people, a self-portrait, really." In 1980 an increasing interest in the painted surface led to a large-scale series of heads and hands, as well as of floating figures. Oil paintings of the following year depicted outdoor subjects, and in the last two years sun-drenched scenes feature figures often taken from her own life, attempts to "catch a moment, the moment to exemplify an emotion." She has also made aquatints and lithographs.

ROTHSCHILD, JUDITH (Painter)
1110 Park Ave., New York, NY 10028

Born: 1932 *Awards:* Welesley College Distinguished Women Award *Collections:* Solomon R. Guggenheim Museum; Whitney Museum of American Art *Exhibitions:* Iolas Jackson Gallery, NYC; Palazzo Grani, Venice *Education:* Hans Hofmann *Dealer:* Annely Juda, London; Galerie Gmurzynska, Cologne; Iolas Jackson Gallery, NYC

Her work is derived from a Dada-Constructivist style. The paintings always have featured elements from a close study of nature, frequently including landscape motifs in abstracted space. For the past twelve years her collages have increasingly reflected an interest in the connection between naturalistic and abstract representations. At the same time, since 1971, she has focused on a technique of relief painting in her large-scale paintings.

ROZMAN, JOSEPH (Painter)
4419 Linderman Ave., Racine, WI 53405

Born: 1944 *Awards:* Mr. & Mrs. Frank G. Logan Medal and Prize, Art Institute of Chicago; John G. Curtis, Jr. Prize, Art Institute of Chicago *Collections:* The Milwaukee Art Museum; DeCordova Museum *Exhibitions:* Milwaukee Art Museum; Wustum Museum *Education:* University of Wisconsin at Milwaukee *Dealer:* Joy Horwich Gallery, Chicago

His medium scale three-dimensional acrylic on lucite paintings, collages and constructions are highly detailed, and colorful fantasies derived from landscapes. Works are a careful combination of various media—acrylics and ink—displaying sometimes symmetrical composition and a focused point of vision. His collagraphs—prints made with cardboard plates cut down with knives or built up with acrylic—often are designed in partitioned areas and evoke the mystic moods of old carved doors, walls, or facades ornamented with ancient emblems. He has also made several collage animated films.

RUBENSTEIN, LEWIS W. (Painter)
153 College Ave., Poughkeepsie, NY 12603

Born: 1908 *Awards:* Fulbright Grant; Fairfield Award, Silvermine Guild of Artists *Collections:* Busch-Reisinger Museum, Harvard University; Vassar College

Stephen Rybka, *Twilight,* 62 x 32, acrylic.

Lolo Sarnoff, *Chinese Windows,* 17 x 6, plexiglass & brass. Courtesy: Gallery K (Washington DC)

Marco Sassone, *Venetian Garden,* 28 x 28, serigraph. Courtesy: Bernard Galleries (Laguna Beach CA)

Art Gallery *Exhibitions:* National Academy of Design; Whitney Museum of American Art *Education:* Harvard University

His early work was in true fresco, in which he executed several mural commissions. Over the years he has worked in oil, watercolor, Chinese bark, and lithography. On a Fulbright grant to Japan he painted in ink and in horizontal scroll form. He originated "time painting"—continuous scroll painting he designs to be seen moving through the window of a specially constructed viewing frame. He paints his time paintings on continuous 30-foot linen canvas, using watercolor and ink. In all his work his point of view is essentially representational, aspiring to realize the life spirit.

RUBY, LAURA (Sculptor)
509 University Ave., #902, Honolulu, HI 96826

Born: 1945 *Awards:* Purchase Award, Erie (PA) Art Museum; Best in Show, "Exhibition for Poets and Artists," Columbus (GA) Museum of Arts and Sciences *Collections:* Hawaii State Foundation on Culture and the Arts; Castle and Cookie, Inc. *Exhibitions:* Contemporary Art Center, HI; Utah Museum of Natural History *Education:* University of Southern California; University of Hawaii

She creates large-scale sculpture, free-standing sculpture, wall pieces, and serigraphs. Her works are initiated by ideas first, and then a variety of media may be employed appropriate to the idea or theme. One ongoing theme is neolithic stone monuments, such as her *Stonehenge* series and a large exterior sculpture, *Cromlech*. Another theme is dinosaur bones, as analogous to framing of shelters, ribbing of vessels, and vaulting of Gothic churches. She also derives themes from Hawaiian and Asian culture, including her *Diamond Head* series, her *Samurai* series, and her installation sculpture *China Arch—A Site of Passage.*

RUDQUIST, JERRY JACOB (Painter, Printmaker)
2322 Seabury Ave. South, Minneapolis, MN 55406

Born: 1934 *Awards:* Purchase Award, Walker Art Center; Edition Purchase Award, World Print Council *Collections:* Minneapolis Institute of Arts; Walker Art Center *Exhibitions:* Walker Art Center; Minneapolis Institute of Arts *Education:* Minneapolis College of Art and Design; Cranbrook Academy of Art *Dealer:* Suzanne Kohn Gallery, St. Paul

His early paintings and prints were built on careful observation of nature. These nature studies evolved to more expressionistic works in which color and form were distorted. An interest in the character of "chance" and "accident" led him to nonobjective composition which emphasized process. Recent work fuses all of the earlier approaches to experience. Spontaneous and improvisational sketches of figure and landscape themes are developed into larger paintings and prints. Once more expressionistic in style, the compositions reveal his close study of nature.

RUSCHA, EDWARD JOSEPH (Painter, Conceptual Artist)
1024 3/4 N. Western Ave., Hollywood CA 90029

Born: 1937 *Collections:* Museum of Modern Art; Whitney Museum of American Art *Exhibitions:* Whitney Museum of American Art; San Francisco Museum of Modern Art *Education:* Chouinard Art Institute *Dealer:* Leo Castelli Gallery, NYC

Early Pop paintings were hyper-realistic depictions of garages—some on fire—and other buildings. A hu-morous series described proper word and name usage. *Every Building on the Sunset Strip* was just that, in a montage showing both sides of the street. He is known for books of photographs of ordinary things, such as *Twenty-six Gasoline Stations* and *Real Estate Opportunities,* in which typography and pictures are combined to make a cohesive whole. He wants to discard any notion that these books are artistic. Text is eliminated; they are simply reproduced snapshots; the books do not "house a collection of art photographs—they are technical data like industrial photography."

RUSSELL, COBIE (Painter)
3702 Harvard Ave., Dallas, TX 75205

Born: 1947 *Collections:* American Airlines; Fulton Murray *Exhibitions:* Museum of Fine Arts, Monroe, LA; Contemporary Gallery, Dallas, TX *Education:* Wells College, Aurora, NY *Dealer:* Contemporary Gallery, Dallas, TX

A sense of light and space identifies her work. Her earlier, non-representational canvases were acrylic on primed surface. They achieved a shimmering effect through the use of small amounts of intense overlapping color. Her recent work has evolved into acrylic paint poured onto raw canvas. Her subject matter is a more recognizable landscape. She continues to employ overlapping color, but this time the colors are more pastel and on a larger scale, creating a translucent quality.

RYBKA,STEVEN (Painter)
319 W. 83rd, Chicago IL 60620

Born: 1956 *Awards:* Society of Illustrators; Art Directors Club *Collections: Skrebneski Collection Education: Self Taught*

Works are medium- and large-scale paintings in a realistic style with elegant composition. Subject matter is often figurative, either faces or full bodies placed within unspecific backgrounds. He mixes elements of surrealism to achieve psychological effect through juxtaposition of color elements, yet the handling never interferes with the stylized realism of his figures. Often uses symbolism. The paintings are expressive without being overly "painterly".

RYMAN, ROBERT (Painter)
17 W. Sixteenth St., New York NY 10011

Born: 1930 *Collections:* Museum of Modern Art; Whitney Museum of American Art *Exhibitions:* Solomon R. Guggenheim Museum; Kunsthalle, Basel, Switzerland *Education:* Tennessee Polytechnical Institute; George Peabody College *Dealer:* Daniel Weinberg Gallery, Los Angeles; Rhona Hoffman Gallery, Chicago; Blumhelman Gallery, NYC

Since the early 1960s white pigment applied to square surfaces of aluminum, plywood, canvas, steel, paper or fiberglass explored the process of painting. Each kind of white pigment produces its own distinctive effect, and variations in brushstroke and paint application also make for modifications in the overall composition. Over the years his style has remained unchanged. Small- and large-scale square white paintings challenge the viewer's expectations, forcing one to discover the essence of the painting process: the look of a touch of paint next to bare surface, the texture of a short stroke, the difference between enamel and oil—each painting is a new configuration, a new lesson in perception.

SAHRBECK, EVERETT (Painter, Photographer)
P.O. Box 401, S. Harwich, MA 02661

Monica Steinhoff, *La Fonda*, 28 x 32, oil on linen on masonite. Courtesy: Jamison Galleries Ltd. (Santa Fe NM)

Edvins Strautmanis, *One O'Clock On* (1984), 78 x 86, acrylic on canvas. Courtesy: Allan Stone (New York NY)

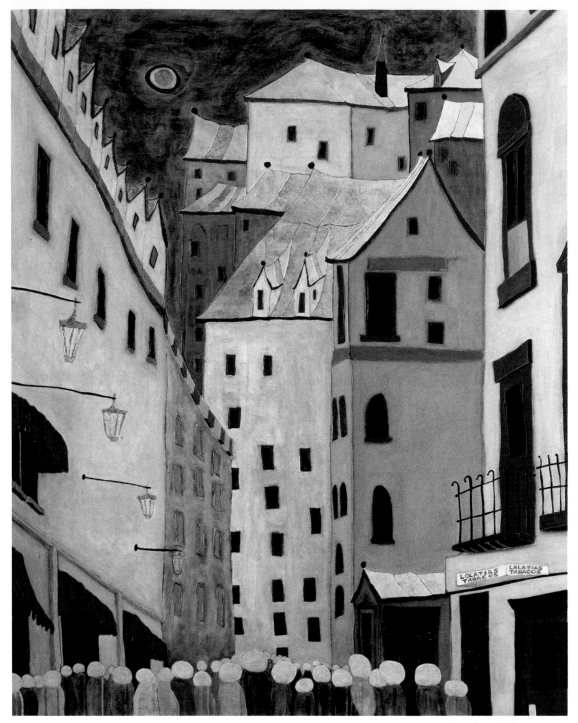

Skynear, *Green Window Street Spirits,* 48 x 45, oil. Courtesy: Gallery Christine Plus (Harbor Spgs MI)

John Squadra, *Music of the Orinoco,* 26 x 40, oil. Courtesy: Yoland Fine Arts (Chicago IL)

Miriam Sowers, *Phrophetess,* 30 x 48, oil and copper leaf. Courtesy: Sowers Studios & Gallerie (Albuquerque)

Anthony Toney, untitled, Courtesy: ACA Gallery (New York NY)

Lauren Uram, *Peter Lorre,* 10 x 14, ripped paper.

George Stillman, *Trellised Vineyard,* 48 x 48, oil. Courtesy: Foster White (Seattle WA)

Meryl Treatner, *Reaganomics,* 20 X 30, mixed media.

Ann Taylor, *Red Riding,* 84 x 52, oil on canvas.

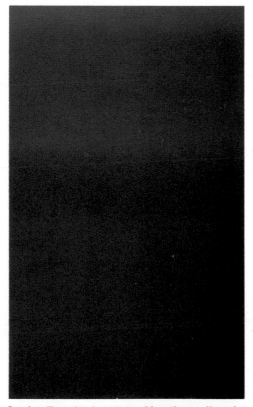

Stanley Twardowicz, *Exit,* 66 x 40, acrylic polymer.

Ray Vinella, *Aspen Grove,* 36 x 42, oil. Courtesy: Taos Art Gallery (Taos NM)

Stanislaus, *Return of the Elements to the Elements,* 17 x 22, mixed media. Courtesy: Arnolds Archives

E. J. Velardi, *Ladybug Ladybug Fly Away Home* (1984), 36 x 30, egg tempera. Courtesy: Orlando Gallery (Sherman Oaks CA)

Donald S. Vogel, *Full Bloom,* 48 x 36, oil on panel. Courtesy: Valley House Gallery (Dallas TX)

Hans Van de Bovenkamp, *Crescendo* (1984), 23 ft. high, stainless steel. Courtesy:
Cristiania (Tarrytown NY)

Veloy Vigil, *Quarter Moon,* 60 x 72, acrylic on canvas.
Courtesy: Driscol Gallery (Vail CO)

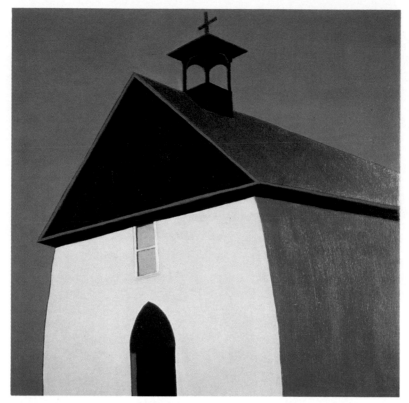

Harold Joe Waldrum, *Triangalo Rosado,* 30 x 30, acrylic on canvas.
Courtesy: The Gerald Peters Gallery (Taos NM)

Sue Wall, *Victorian Memory,* 17 x 19, acrylic on canvas.
Courtesy: Gallery Madison 90 (New York NY)

Sylvia Wald, *Ceromonial Suite X,* 26 x 24 x 4, painted canvas/paper/string.

Dyanne Strongbow Weber, *Winter Pueblo,* 18 x 24, watercolor. Courtesy: Adobe Gallery (Albuquerque NM)

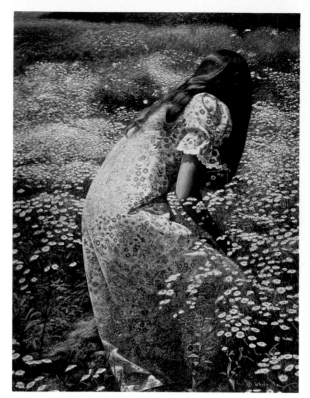

Philip B. White, *Wildflowers,* 18 x 24, oil.

Don Weller, *Bull Rider,* 15 x 20, watercolor.

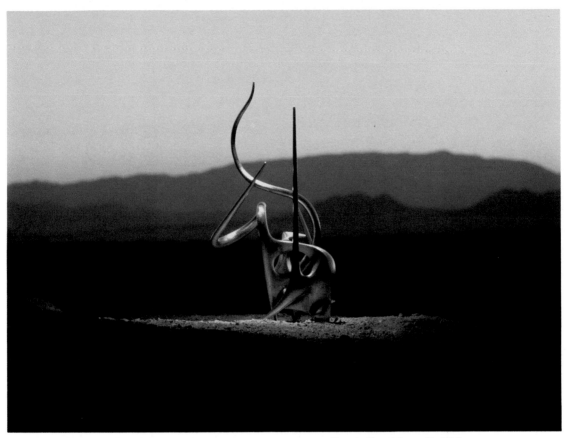

Donald Wright, untitled, 25 high, bronze. Courtesy: The Selective Eye Gallery (Santa Fe NM)

Emily Guthrie Smith, *Lily Pond*, 22 x 32, pastel. Courtesy: L & L Gallery (Longview TX)

William Zacha, *Cherry Blossoms at Kambara,* 8 x 13,
serigraph. Courtesy: Bay Window Gallery (Mendocino CA)

Louise Dunn Yochim, *In the Park,* 28 x 36, mixed media.
Courtesy: 4 Arts Gallery (Evanston IL)

Del Yoakum, *Flower Farm,* oil. Courtesy: Masters (Sedona AZ)

Lee Weiss, *Quiet Stream,* 36 x 46, watercolor. Courtesy: Fanny Garver Gallery (Madison WI)

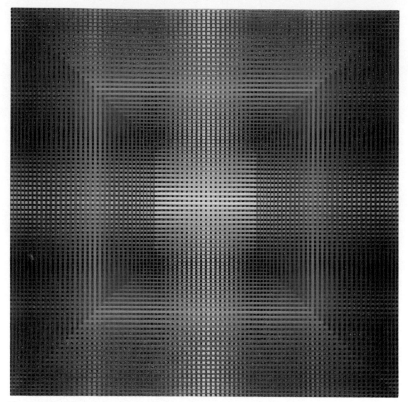

Kazimieras Zoromskis, *TDS #241,* 42 x 42, oil. Courtesy: State Museum
(Vilnius Lithuania)

Erma Martin Yost, *Flaming Paintbrush,* 64 x 37, oil and
quilt. Courtesy: Ned & Cindy Stoll li

Born: 1910 *Awards:* Silver medal, New Jersey Watercolor Society; First honorable mention, American Watercolor Society *Collections:* DeCordova Museum; Newark Museum *Exhibitions:* Art Directors Club, NYC; Munson Gallery, Chatham, MA *Education:* Self-taught

Work is primarily in watercolors with additional pieces in charcoal, pastels and acrylics. Conventional landscape and seascape studies are done with a naturalistic eye and a fresh and fluid watercolor style. They are painted wet into wet with a loaded brush. The painter is now embarking on a two year study of both men and women of all ages and marked by character delineation related to occupation or profession. These are renderings with careful detail on faces with fluid backgrounds.

SALERNO, STEVE (Illustrator)
75 East 7th St. #3E, New York, NY 10003

Born: 1958 *Collections:* The Franklin Library *Exhibitions:* 9th International Miniature Print Exhibition *Education:* Parsons School of Design

His political drawings have appeared on the op/ed page of the *New York Times* since 1980 as well as in the magazines *New York, Esquire, Horizon,* and *Life.* He is presently working on an animated film with artist Martin Kozlowski entitled *Anyone can grow up to be President,* a satirical film on the life and presidential policies of Ronald Reagan.

SALLE, DAVID (Painter)
c/o Mary Boone Gallery, 420 W. Broadway, New York NY 10012

Born: 1952 *Awards:* Creative Artists Public Service Program Grant *Collections:* Whitney Museum of American Art; Kunstmuseum, Basel, Switzerland *Exhibitions:* Art Institute of Chicago; Albright-Knox Art Gallery *Education:* California Institute of the Arts *Dealer:* Mary Boone Gallery, NYC

Part of a developing European and American conceptual movement of painting ranging from the totally abstract to a combination of abstraction and figuration, he operates in a figurative vein. Diptychs and triptychs present strong figures, often nudes who appear to be looking on interacting figures. Subtle use of color, often soft on one side, powerful on the other, typifies his new expressionistic style. Since his emergence as a gallery artist in 1981, he has used the empty rhetoric and art conventions of the 1980s with deliberate insignificance to make ironic commentaries on the diminished state of language, as in *The Mother Tongue.*

SAMARAS, LUCAS (Assemblage Artist)
c/o Pace Gallery, 32 E. 57th St., New York NY 10023

Born: 1936 *Awards:* Woodrow Wilson Fellowship, Columbia School of Art *Collections:* Museum of Modern Art; Whitney Museum of American Art *Exhibitions:* Museum of Modern Art; Museum of Contemporary Art, Chicago *Education:* Rutgers University; Columbia University *Dealer:* Pace Gallery, NYC

Born in Greece, he moved to America in 1948 and later studied with Alan Kaprow and Meyer Schapiro. In the late 1950s and early 1960s sculptures were made of plaster-dipped rags or tin foil, and pastels featured images related to both Pop and Surrealism. A *Boxes* series of the 1960s was a group of approximately eighty small-scale assemblages which incorporated knives, pins, tacks, scissors and razor blades. Other fetishistic assemblages and constructions included yarn, string,

sand, plastic, nuts, bolts, sand, mirrors, nails, pencils, kitchen utensils and the like. An interest in theater brought him to participate in "happenings," and more recently in Performance and Body Art. This self-exploration was manifested in several series of Polaroid photographs of himself, notably *Phototransformations,* and sometimes of others, often nude, in which the emulsion pigments were altered. Recent works include miniature anthropomorphic beings in bronze as well as pastel drawings and ink washes.

SARGENT, MARGARET HOLLAND (Painter)
2750 Glendower Ave., Los Angeles, CA 90027

Born: 1927 *Awards:* Nacal Award Outstanding Achievement in Oil Painting; Painter and Painting of the Year, Painters Club of New York *Collections:* Time, Inc.; United States Military Academy Museum *Exhibitions:* Frye Art Museum; West Point Museum *Education:* University of California, Los Angeles *Dealer:* Portraits International, Los Angeles

Presidents, heads of state, members of prominent families, government leaders and celebrated personalities have been the subjects of her portraits in oils on linen or textured ground on Masonite. President Ford and Carter, Margaret Thatcher, Dr. Jules S. Stein, Alexander M. Haig, Jr. and Tennessee Williams have all been captured in likeness in her fresh light style of portraiture. She strives to capture the subject's personality in all her works, executing them in realistic proportions and natural color.

SARKISIAN, PAUL (Painter)
c/o Nancy Hoffman Gallery, 429 W. Broadway, New York NY 10012

Born: 1928 *Collections:* Metropolitan Museum of Art; Art Institute of Chicago *Exhibitions:* Museum of Contemporary Art, Chicago; Corcoran Gallery of Art *Education:* School of the Art Institute of Chicago *Dealer:* Nancy Hoffman Gallery, NYC

In the early 1970s large-scale canvases portrayed clusters of items from American porches. A trompe l'oeil artist, he employed acrylics to create highly realistic paintings resembling collages consisting of old newspapers, wrappers, pieces of paper, envelopes, postcards and other such items. Recently he has abandoned the collage imagery, depicting abstract rectangular planes patterned with dots or stripes in brilliant colors which seem to float above the canvas, appearing to cast shadows.

SARNOFF, ARTHUR (Painter)
6462 Woodbury Rd, Boca Raton, FL 33433

Born: 1912 *Awards:* Nassau Art League *Exhibitions:* National Art Museum of Sports; Grand Central Galleries, NYC *Education:* Industrial School of Art; Grand Central School of Art *Dealer:* Deligny Art Galleries, Fort Lauderdale, FL

He achieved early success as a magazine illustrator, but he is also known for his portrait paintings, as well as his landscapes, seascapes, florals, and sports paintings. Though he is a realist, he dislikes photorealism. He familiarizes himself with his subject matter through extensive research or direct experience, and then interprets life as he sees it. He has done portraits of John and Jackie Kennedy, Bob Hope, Loretta Young, Arnold Palmer, and the presidents of many corporations such as Xerox, Allied Chemical, and P&F Industries.

SARNOFF, LOLO (Sculptor)
7507 Hapden Ln., Bethesda MD 20814

Born: 1916, *Awards:* Medaglio al Oro, Academia Helio delle Arte. *Collections:* National Air & Space Museum; Chase Manhattan Bank, NYC *Exhibitions:* Agra Gallery, Washington DC; Corning Museum of Glass, Corning, NY *Education:* Reimann Art School, Berlin *Dealer:* Gallery K, Washington DC

A relative late-starter but accomplished sculptor, she only started her professional career as an artist in 1968 after retiring from her job as a scientist at the National Heart Institute. She is one of very few sculptors who incorporate light as a main element in her pieces. Her initial middle-to-large scale sculptures combined the mediums of plexiglass and fiber optics; perhaps the most prominent of these pieces being one entitled *The Flame* commissioned for the Kennedy Center for the Performing Arts in Washington, DC. Her work is mostly abstract although representative pieces such as *Spiral Galaxy* at the National Air & Space Museum display a strong influence of forms and events from nature. Current work is primarily in plexiglass and metal although she continues to produce some pieces that employ light as the main medium.

SASSONE, MARCO (Painter, Printmaker)
1414 Mar Vista Way, Laguna Beach, CA 92651

Born: 1942 *Awards:* Official Knight of the Italian Republic; Gold Medal, Academy of Arts, Literature and Science *Collections:* Los Angeles County Museum of Art; National Art Gallery, Wellington, New Zealand *Exhibitions:* Laguna Beach Museum of Art; National Academy of Design *Education:* Instituto Galileo Galilei, Florence; Academy of Fine Arts, Florence *Dealer:* Bernard Galleries

A native of Italy and an official knight of the Italian Republic, his paintings in oil are commonly contemporary interpretations of landscape and marinescape settings. Children too, are often a common subject matter of his paintings. In 1974 he began exploring the possibility of employing serigraphy. His personal style, derived from the imagery of his oil paintings, along with his bold use of color, dominate his serigraph prints. Work now is primarily in this medium.

SAUL, PETER (Painter, Sculptor)
383 Lovell St., Mill Valley CA 94941

Born: 1934 *Awards:* New Talent Award, Art in America Magazine; National Endowment for the Arts Grant *Collections:* Museum of Modern Art; Whitney Museum of American Art *Exhibitions:* Museum of Modern Art; Whitney Museum of American Art *Education:* Stanford University; California School of Fine Arts; Washington University *Dealer:* Allan Frumkin Gallery, Chicago

Cartoon characters and other images from mass-madia popular culture were used in a way which dismissed the Pop movement, parodying various facets of American contemporary life from politics to nostalgia. Caricatured figures in day-glo colors filled the canvas with absurdly exaggerated objects, misspelled words and puns, all often viewed at unexpected angles. These iconoclastic works both affected and were influenced by the underground comic books of the early 1970s. *Spirit of '76* is a large Disney-like sardonic rendering of that patriotic image, an example of the manipulation of a cultural symbol in order to invite collusion between himself and the common man.

SAUNDERS, RAYMOND JENNINGS (Painter)
6007 Rock Ridge Blvd., Oakland CA 94618

Born: 1934 *Awards:* Fellowship, John Simon Guggenheim Memorial Foundation; Fellowship, National Endowment for the Arts *Collections:* Museum of Modern Art; Whitney Museum of American Art *Exhibitions:* Museum of Modern Art; San Francisco Museum of Modern Art *Education:* Pennsylvania Academy of the Fine Arts; University of Pennsylvania; Carnegie Institute of Technology; California College of Arts and Crafts *Dealer:* Terry Dintenfass, NYC; Stephen Wirtz Gallery, San Francisco

The loose brushstrokes and large color fields of Abstract Expressionism were combined with Pop images such as cartoon characters, with stencilled letters or numbers, and with graffiti to create a variety of humorous and enigmatic works reflecting personal experiences and Black history in an urban environment. During the 1960s he did not produce art of protest but rather was more interested in the art of genre. His media have also included collage and assemblage, as well as watercolor *(Suite of Flowers).*

SAVOY, CHYRL LENORE (Sculptor)
P.O. Box 573, Youngsville, Louisiana 70592

Born: 1944 *Awards:* Samuel Weiner Sculpture Award, 51st Regional Exhibit; Award, New Orleans Museum of Art *Collections:* Maison Mere des Dominicaines, France; Our Lady of the Bayous Convent, Abbeville, Louisiana *Exhibitions:* New Orleans Museum of Art; Southwestern Louisiana School of Art and Architecture *Education:* Wayne State University; Academy of Fine Arts, Florence

A versatile artist known first as a sculptor, her work includes painting and multimedia presentations. Although her sculptural media includes bronze, steel, stone, plaster and wax, wood is the favorite material. Directly carved and assembled pieces of sculpture deal primarily with religious themes and philosophical questions. Her oil and acrylic paintings are landscapes and figurative subjects leading to more recent abstract works. Concurrent with her visual art of the past ten years is an involvement with live, multi-media pieces. Slides, props, sound, and dance are included in these collaborations.

SCALISE, NICHOLAS PETER (Painter)
59 Susan Lane, Meriden, CT 06450

Born: 1932 *Awards:* First Prize, Connecticut Watercolor Society; Award, 28th New England Exhibition *Collections:* Meriden Memorial Hospital; Pepperidge Farm, Norwalk, CT *Exhibitions:* National Academy of Design; Butler Institute of American Art *Education:* Horace C. Wilcox Technical School; Paier Art School, New Haven, CT *Dealer:* Munson Gallery, Santa Fe, NM; A. Haney Gallery, San Diego, CA

He has worked in many media, predominantly oils. His subject matter includes still lifes, florals, cityscapes, landscapes, and portraits. He paints in a traditional manner in an impressionistic style, using heavy paint applied with brush and some palette knife work. His colors are subtle, muted, and serene. In recent years he began to use watercolor exclusively, which forced him to draw more carefully. Each shape and form became more clear. He continues to study the works of other artists, as well as nature, to find inspiration.

SCANGA, ITALO (Sculptor)
6717 Vista Del Mar, La Jolla CA 92037

Born: 1932 *Awards:* Cassandra Foundation Grant; National Endowment for the Arts *Collections:* Metropolitan Museum of Art; Museum of Modern Art *Exhibi-*

Chyrl L. Savoy, *Goddess I Goddess II Goddess III*, 18 x 3 x 3, wood.

Anthony Schepis, *Composed Silence IX*, 36 x 50, oil on canvas. Courtesy: Robert L. Kidd Assoc. (Birmingham MI)

tions: Museum of Modern Art; Whitney Museum of American Art *Education:* Michigan St. University *Dealer:* Delahunty Gallery, NYC and Dallas

Born in Italy, he settled in America in 1947 and after service in the U.S. Army and formal study in sculpture, began to employ mixed media, including found objects, to create installations which presented "unresolved cultural value cohabiting the integrated structure." For example, room-sized presentations display religious kitsch sprinkled with red paint, hung near the floor, resembling icons. Urns containing grains or spices, like chili powder, are to be smelled or tasted as the viewer kneels to see a painting of Christ or the Madonna. Menacing farm implements often lean against the wall and dried herbs are hung from the ceiling. Thus a kind of parodical shrine is created using the imagery of martyrdom typical to poor households in Italy. His complicated iconography points to the disparity between the wrongful violent suffering of martyrs and the religious devotional images which glorify this pain, yet it does more than that, creating a new kind of provocative folklore.

SCARFF, THOMAS S. (Sculptor)

Born: 1942 *Awards:* National Endowment for the Arts Grants *Collections:* Museum of Science and Industry; Dayton Hudson Collection *Exhibitions:* Museum of Science and Industry; Chicago Public Library Cultural Center *Education:* School of the Art Institute of Chicago

This Chicago artist produces many series of monumental metal sculptures, outdoor pieces which are integrated with a building and its surroundings. *Sailboat* motifs are prevalent throughout his work, tapered triangles inspired by the boats often seen on Lake Michigan. Although the sculptures made of such materials as burnished aluminum often weigh as much as a ton or more, there are always kinetic elements which suggest movement. Each piece depicts a "moment in time—the instance before motion." In *Aridise*, for example, five small triangular "flags" on wires attached to triangular "sail" structures were mounted on three pedestals and a tripod, suggesting the workings of a sailboat. He has also made *Fragments of a Light Year,* a film that was part of his exhibition at the Museum of Science and Industry. Recent sculptural media include neon.

SCHAPIRO, MIRIAM (Painter, Collage Artist)
393 W. Broadway, New York NY 10012

Born: 1923 *Awards:* Skowhegan Award; National Endowment for the Arts Grant *Collections:* Museum of Modern Art; Whitney Museum of American Art *Exhibitions:* Museum of Modern Art; Museum of Contemporary Art, Chicago *Education:* University of Iowa *Dealer:* Barbara Gladstone Gallery, NYC

First known as a second-generation Abstract Expressionist, she began in 1962 to create completely different works called "shrine paintings," consisting of a mirror, a female symbol, a fragment of a great art work, and a crowning arch. These feminist productions were followed by paintings depicting self-referring sexual images. The computer was sometimes used as a creative tool to make Abstract Illusionistic work. Then in 1972 she participated in *Womanhouse,* a project involving many women artists who presented the arts and crafts of women. Her contribution was a doll house, each room symbolically built to represent her own female world. After this project, paintings incorporated handkerchiefs, lace and other fabrics in metaphoric statements of liberation. She calls recent large-scale works "femmages," and continues to advocate the recognition of women in current art and art history.

SCHARY, EMANUEL (Painter, Printmaker)
536 Kirkby Rd., Elmont, NY 11003

Born: 1924 *Collections:* National Fine Art Collection, Smithsonian Institution; Vatican Museum *Exhibitions:* Guild Gallery, NYC; Brooklyn Museum *Education:* Carnegie Institute Technol School of Fine Arts; Art Students League *Dealer:* Jem Publishers, Elmont, NY

Stylized acrylic paintings, depicting both Jewish and everyday life in America, portraits, scenes of New York—both old and new, and experiences and images from his native Israel, comprise the major portion of the artist's output. He paints in a designed realism style, simplifying elements of the composition for the sake of clarity and effect. In addition to his work in acrylic he produces pastels, limited edition original lithographs, and serigraphs with similar subject matter. He refers to himself as "the unrivaled master of human realism".

SCHEPIS, ANTHONY JOSEPH (Painter)
34720 Sherwood Dr., Cleveland, OH 44139

Born: 1927 *Awards:* Ohio Arts Council Individual Fellowship; Special Mention, Cleveland Museum of Art 59th Annual Exhibition *Collections:* Butler Institute of Art; Akron Art Museum *Exhibitions:* Columbia Fine Arts Center, University of Missouri; Lake Erie College *Education:* Cleveland Institute of Art: Cooper School of Art; Kent State University *Dealer:* Robert L. Kidd Associates, Birmingham, MI

Early work in abstract surrealism included non-mimetic forms in an ambiguous yet personal space. The subtle surfaces echoed the softly modulated patterns of light and color found in the works of Matta and Tanguey. This same quality characterizes his present oil paintings which are figurative still-lifes imbued with Neo-Metaphysical overtones. Their dimensional illusion ranges from the sharply defined to examples that utilize soft edges and tonal transitions. He strives to evoke the enigmatic and disquieting nature of reality through charged negative spaces. His involvement is with the expression of magic that can be imparted through the subtleties of light, color and composition of the simplest objects.

SCHMALZ, CARL, JR. (Painter)
40 Arnold Rd., Amherst, MA 01002

Born: 1926 *Awards:* First Prize in Watercolor, Cambridge Art Association Annual; Purchase Award, Watercolor U.S.A. *Collections:* Bowdoin College Museum; Kalamazoo Art Center *Exhibitions:* Benbow Gallery, Newport, RI; Government House, Hamilton, Bermuda *Education:* Harvard University *Dealer:* Harmon-Meek Gallery, Naples, FA

Transparent watercolor landscapes emphasizing brilliance of color, luminosity, and atmosphere have been the artist's trademark for nearly forty years. In the 1960s earlier broad wash handling was supplanted by dominant painterly strokes. Recent work focuses attention on surface manipulation of paint on hard, untextured paper. Dramatic patterns of subtle light and vibrant dark hues enliven contemporary subjects, fundamentally tied to nature, natural structures or architecture. In addition, he occasionally works in oils and silkscreen prints.

SCHNABEL, JULIAN (Painter, Conceptual Artist)
24 East Twentieth St., New York NY 10003

Born: 1951 *Collections:* Whitney Museum of American Art *Exhibitions:* Whitney Museum Biennial; Royal Academy of Art, London *Education:* University of Houston; Whitney Independent Study Program *Dealer:* Pace Gallery, NYC

Part of a developing European and American conceptual movement of painting ranging from the totally abstract to a combination of abstraction and figuration, he works in the figurative vein, operating within the constructivist collage tradition of Pablo Picasso's creations of 1908-1914. Since a recent emergence as a gallery artist he has intrigued and puzzled the art world with his enigmatic language. His crude intensity has been described as ''over-kill'' and ''ugly,'' even by his admirers. Large-scale, ponderous figurations are expressionistic, sometimes chaotic and violent images in oil with such additions as fiberglass, broken crockery and encrustations of plastic.

SCHNEEBAUM, TOBIAS (Painter)
463 West St., New York, NY 10014

Born: 1921 *Awards:* Fulbright Fellowship; Creative Artists Public Service Grant *Collections:* Museum Estado, Guadalajara, Mexico *Exhibitions:* Peridot Gallery; Art Institute of Chicago *Education:* Brooklyn Museum Art School

He started painting full time while studying with Rufino Tamayo in 1946. His work was influenced by Mexican painters, and then by Jackson Pollock; later still he was influenced by de Kooning and the Abstract Expressionist school. After traveling in Peru, his painting became more realistic. During the past seven years he has worked on an autobiographical trilogy and has not painted. He recently returned to painting, and the new works are strongly influenced by his recent stay in New Guinea, where he lived among a group of carvers and former headhunters.

SCHNIER, JACQUES (Sculptor)
4081 Happy Valley Rd., Lafayette, CA 94549

Born: 1898 *Awards:* Berkeley Citation, University of California; Artist of the Year Award, San Francisco Art Commission *Collections:* San Francisco Museum of Modern Art; The Clorox Corporation *Exhibitions:* San Francisco Art Commission Gallery; Walnut Creek Civic Arts Gallery *Education:* Stanford University; University of California, Berkeley *Dealer:* Victor Fischer Galleries, Oakland, CA

His style, though not realistic in a literal sense, has been limited to recognizable subject matter. Sensuous, curvilinear, rounded mass are dominant in his works. Carved wood has been a favorite medium, and he became well known for sculpture in this material. Midway in his career he resolved the question of the figurative versus the non-figurative in art, and turned to a completely abstract idiom with major emphasis on the geometric. Since then he has constantly searched for new sculptural form to express his ideas. For twelve years he explored carved crystal acrylic as a medium. His current works are large-scale stainless steel sculptures for outdoor sites.

SCHOLDER, FRITZ (Painter, Printmaker)
118 Cattle Track Rd., Scottsdale AZ 85253

Born: 1937 *Awards:* Distinguished Achievement Award in the Arts, Arizona St. University; Governor's Award, New Mexico *Collections:* Philadelphia Museum of Art;

Museum of Fine Arts, Boston *Exhibitions:* Corcoran Gallery of Art; Smithsonian Institution *Education:* Sacramento City College; Sacramento St. University; University of Arizona *Dealer:* Marilyn Butler Fine Art, Scottsdale, AZ; A.C.A. Galleries, NYC

A one-quarter Mission-Luiseno Indian, his early influences came from Sioux painter Oscar Howe as well as from English painter Francis Bacon and Pop artist Wayne Thiebaud. At first he was painting striped canvases and nudes. In 1964 he turned to American Indian subject matter, breaking from the folkloric mode previously used to portray Indians, and instead portrayed them in a dramatic expressionist style. He has been making lithographs at the Tamarind Institute since 1970: series of flowers; a dream series; and a *Portrait* series which reveals a new kind of imagery tending towards a more abstracted human form. Recent paintings on canvas are done in broad brushwork, expressionistic with abstract qualities.

SCHRANIL, YOSHIKO (Ceramicist)
6255 Prestonshire, Dallas, TX 75225

Born: 1937 *Awards:* Best of Show, Dallas Museum of Art *Exhibitions:* DW Gallery, Dallas; Frontroom Gallery, Dallas, TX *Education:* Southern Methodist University

Her work has been greatly influenced by the traditional role of ceramic art in Japanese society after her seven year stay in Japan in the 1970s. Works have been mainly in porcelain in the last nine years, for the precision and clarity that it can express. Thrown works are technically very traditional with some adaptation of modern genre.

SCHWARTZ, CARL E. (Painter)
13872 Pine Villa Lane S.E., Fort Myers, FL 33908

Born: 1935 *Awards:* Logan Medal, Art Institute of Chicago; Best of Show, Union League *Collections:* Art Institute of Chicago; British Museum, London *Exhibitions:* ''Art Across America,'' Mead Corporation: Smithsonian Institution *Education:* School of the Art Institute of Chicago

During the 1960s he employed figures juxtaposed in vegetable still lifes in his paintings. His involvement with the play of light patterns formed by plants on the nude figure led to his major theme, the *Rock Garden* series. These works show an influence of abstract expressionism. An interest in the effects of light assumed a central importance in his work. By manipulating the eye movement of the viewer, he attempts to bypass the apparent appearance and synthesize the absolute structure of the paintings.

SCHWEBEL, RENATA MANASSE (Sculptor)
36 Silver Birch Drive, New Rochelle, NY 10804

Born: 1930 *Awards:* Medal of Honor, Audubon Artists; Medal of Honor, National Association of Women Artists *Collections:* Southwest Bell; Columbia University *Exhibitions:* Sculpture Center, NYC; Pelham Art Center *Education:* Antioch College; Columbia University; Art Students League *Dealer:* Sculpture Center, New York, NY

She has worked both figuratively and abstractly in various media, including clay, wood, plastics, and bronze, but during the past decade she has worked primarily in stainless steel and aluminum. Most of her work consists of welded structures, but she has also done constructions. Present works are abstract, non-objective, and in the hard-edge tradition. Pieces range from small table

pieces to free standing sculpture up to nine feet tall. Occasionally she does humorous pieces, which are figurative, though often abstracted.

SCOTT, ARDEN (Sculptor)
73 Leonard St., New York, NY 10013

Born: 1938 *Awards:* Fellowship, John Simon Guggenheim Memorial Foundation; Grant, New York State Council of Arts *Collections:* Nassau County Museum of Fine Arts; Public Sculpture in Riverhead, NY *Exhibitions:* Whitney Museum Biennial; OK Harris Gallery, NYC *Dealer:* Manhattan Art, NYC

Her sculpture is primarily large scale work executed in wood and stone. Rooted in abstract formal concepts, the basic influences have been Brancusi and David Smith. The early work was predominately constructivist and environmental, emphasizing line and space. Present work is concerned with the composition of carved elements in wood or stone. The inherent character of the material itself is emphasized while careful attention is given to the interaction of shape, surface, color, and spatial design. The sculpture moves past purely formalist concerns and makes strong abstract statements expressive of human faith and aspiration.

SCOTT, JOHN (Painter)
478 N. Salem Rd., Ridgefield, CT 06877

Born: 1907 *Awards:* Shape Award, Northwest Rendezvous *Collections:* Oil Museum, Midland, TX; Mormon Church, Salt Lake City *Exhibitions:* Settlers West Gallery, Tucson, AZ; Oil Museum, Midland, TX *Education:* La France Art Institute, Philadelphia *Dealer:* Settlers West Gallery, Tucson, AZ

He began as an illustrator for Western and detective pulp magazines, followed by a stint as combat artist/correspondent for *Yank* magazine during World War II. He worked for three decades as an illustrator for *Sports Afield*. At this time he also did a series of paintings of fishing areas, and another series illustrating the early days of the Texas and Oklahoma oil fields. His largest works to date are two twelve by thirty-two foot murals commissioned by the Church of Later Day Saints in Salt Lake City. Since then he has worked almost exclusively to recreate the early West and its people in his paintings.

SCOTT, JONATHAN (Painter)
P.O. Box 1154, Taos, NM 87571

Born: 1914 *Awards:* Award, California Watercolor Society *Collections:* Laguna Museum of Art; Lindsay Art Association *Exhibitions:* Occidental College; Ringling Museum *Education:* Heatherly School, London *Dealer:* Byck Gallery, Louisville, KY.

His preferred medium is watercolor, which he handles with imagination and fantasy. Inspiration for his work stems primarily from directly experiencing the life of human figures and animals. The artist's training in Germany, England, and Italy brought him close to the old masters and their humanist concerns. As well as the influences of the early 20th century masters of color and design, he also cites the Etruscans and the prehistoric cave dwellers of Lascaux as artists who speak to the spirit of his work.

SCRIVER, ROBERT MACFIE (Sculptor)
Box 172, Browning, MT 59417

Born: 1914 *Awards:* Medal, Cowboy Artists of America; Medal, National Academy of Western Art *Collections:* Glennbow Museum, Calgary, Alberta *Exhibitions:* Museum of Natural History, Denver, CO *Dealer:* Graham Gallery, NYC

He is a contemporary Western sculptor, whose past works include heroic statues of Buffalo Bill, Bill Linderman, and C. M. Russell. He also has completed a 33-piece rodeo series and a 53-piece series of the Blackfeet Indians. Currently he is doing a half-life-sized statue of Chief Earl Old Person and a half-life-sized statue of a cowboy on a bucking horse. His biggest project is a 210-foot statue of Christ, dedicated to the concept of peace in the world. This *World Peace Memorial* is an open pyramidal structure of pre-stressed concrete and granite topped by a colossal seated figure of Christ cast in bronze.

SEGAL, GEORGE (Sculptor)
Davidsons Mill Rd., New Brunswick NJ 08901

Born: 1924 *Awards:* Walter K. Gutman Foundation Award; First Prize, Art Institute of Chicago *Collections:* Museum of Modern Art; Art Institute of Chicago *Exhibitions:* Whitney Museum of American Art; Art Institute of Chicago *Education:* New York University; Rutgers University *Dealer:* Sidney Janis Gallery, NYC

First a figurative painter in 1956, he gained recognition two years later with experiments in plaster sculptures made of chicken wire and burlap, molds from live models placed in "environments" containing real objects such as chairs, tables, beds, baths, ladders, and traffic lights. His medium changed to the casting of plaster of paris directly from the human form, producing hollow molds which looked as if they might still hold the bodies inside, like mummies in eternal imprisonment. These sculptures have always been melancholy depictions of people in isolation, alienated from one another.

SEGAN, KENNETH AKIBA (Printmaker, Illustrator)
Studio 701, 909 4th Ave., Seattle, WA 98104

Born: 1950 *Awards:* Purchase Prize, West Publishing Co.; Award, Dakota Artists Guild, Dahl Fine Arts Center *Collections:* Graphische Sammlung Albertina, Vienna; Musee des Beaux-Arts, Budapest *Exhibitions:* Society of American Graphic Artists 60th; Boston Printmakers 34th *Education:* University of Missouri; Southern Illinois University, Carbondale *Dealer:* Ainsworth Gallery, Boston

His early prints and drawings were strongly influenced by the personal and expressive statements of the American social realists of the 1930s and 40s and the graphic works of the German Expressionists. Social commentary and political overtones run through his complex figurative compositions. In his etchings, drypoints, intaglios, as well as his mixed media drawings, he combines texture, line, color and value into highly personal interpretations. Composers, political martyrs, important Jewish figures, and contemporary historic personages appear in these intense and anxious compositions.

SEHRING, ADOLF (Painter, Printmaker)
Tetley Plantation, Somerset, VA 22972

Born: 1930 *Awards:* First Prize of Germany, Rias, Berlin *Collections:* Vatican Collection; Mellon Collection *Exhibitions:* American Realism at the Paris Grand Palais; St. Mary's Collection Museum *Education:* Academy of Art, Berlin, Germany

A classic realist painter, he paints with the traditional medium of oil. His canvases are primarily landscapes, still-lifes, portraits, and scenes from rural

Carl E. Schwartz, *Lush Effusion,* 32 x 47, acrylic.

Adolf Sehring, *A Summer Day,* 24 x 30, oil.

American life. Immigrating to the United States from Germany in 1949, the artist says of his work,"I paint the simple America; not the sophisticated city but the humble country folk." His style can be compared to Carot, Homer and Wyeth in the quiet, poetic studies and exacting realism. Paintings of fields and farm buildings, a weathered profile of a farmer by lantern light, a small boy gazing down river from the lush banks—are romantic visions of a vanishing American culture.

SERRA, RICHARD (Sculptor)
P.O. Box 645 Canal St. Station, New York NY 10013

Born: 1939 *Awards:* Skowhegan School Medal *Collections:* Museum of Modern Art; Whitney Museum of American Art *Exhibitions:* Museum of Modern Art; Whitney Museum of American Art *Education:* University of California, Santa Barbara; Yale University School of Art *Dealer:* Gemini G.E.L., Los Angeles; Leo Castelli Galleries, NYC

An interest in process art and in the quality of materials brought him to the construction of sculptures using neon tubes, rubber, metal slabs and molten lead. The first of several "Splash-pieces" was conducted in 1968, in which molten lead was flung onto the bottom of a wall. The next year large metal sheets were leaned against each other, exploring aspects of gravity in the *Prop* series. Site sculptures beginning in the 1970s such as *Shift* integrated the landscape with sculptural elements such as cement or metal sheeting in order to find "an awareness of physicality in time, space and motion. . . . one's relation to the breadth of the land." He has also engaged in graphic work and filmmaking.

SHADRACH, JEAN H. (Painter)
Artique Ltd., 314 G St., Anchorage, AK 99501

Born: 1926 *Awards:* Governors Award, All-Alaska Juried Exhibition *Collections:* Atlantic Richfield Corporation; Sohio Corporation *Exhibitions:* Anchorage Fine Arts Museum; Frye Museum, Seattle, WA *Education:* University of New Mexico; University of Alaska *Dealer:* Artique, Anchorage, AK

The subjects of her paintings are the vistas and the people of Alaska. She uses color, design, and image to express her feelings about this large, variable state. She achieves a luminosity of color by spreading layer on layer of acrylic over the canvas with a palette knife. Her works are direct, spontaneous, and expressionistic. All of her paintings can be viewed as chronicles of the Alaskan way of life.

SHAPIRO, DAVID (Painter)
315 Riverside Dr., New York NY 10025

Born: 1944 *Collections:* Solomon R. Guggenheim Museum; Museum of Modern Art *Exhibitions:* Roy Boyd Gallery, Chicago; Alexander Milliken Gallery *Education:* Skowhegan School of Art; Pratt Institute; Indiana University *Dealer:* Alexander Milliken Gallery, NYC

Graphic symbols representing emotional states were first exhibited in the early 1970s. Geometrical shapes and symbols from Eastern cultures such as the spiral and the knot have often been included in subsequent drawings and acrylic paintings. These works are small-scale, subtle and intimate visualizations of abstract ideas. Because his approach is philosophical and mystical, his works are more like those of Paul Klee and Mark Tobey rather than solely pattern paintings.

SHAPIRO, DAVID (Painter)
RFD 77, Cavendish, VT 05142

Born: 1916 *Awards:* Fulbright Fellowship; grant, National Endowment for the Arts *Collections:* Metropolitan Museum of Art; National Museum of Fine Arts, Smithsonian Institution *Exhibitions:* Associated American Artists; Galleria Dell'Orso *Education:* Education Alliance Art School *Dealer:* Associated American Artists

His expressionistic paintings of the 1930s and 40s dealt with people and social concerns. His work contained images that were always recognizable, realistic but not naturalistic, with a "stained-glass" look. Painted landscapes were executed in much the same manner. Work now is more abstracted although still recognizable as containing images from the real world. He rarely paints the figure, but after his recent move to Vermont from New York, new feelings for nature have emerged that are expressed in a free-flowing lyrical quality in his abstract compositions.

SHAPIRO, DEE (Painter)
28 Clover Dr., Great Neck, NY 11021

Awards: Award of Excellence, Heckscher Museum *Collections:* Solomon R. Guggenheim Museum; Albright-Knox Art Gallery, Buffalo, NY *Exhibitions:* Everson Museum of Art, Syracuse, NY; Andre Zarre Gallery, NYC *Education:* Queens College; University of Mexico *Dealer:* Andre Zarre Gallery, NYC

In her early work, she explored the possibilities for visual patterning generated by number progressions. Black-and-white works dating back to the early 1970s used a formal vocabulary. With the introduction of color, seemingly woven or beaded impasto surfaces created new levels of pictorial complexity. An awareness of modern technology in the resemblance of color-coded works to computer printouts, and consistent experimentation with photocopying, are other aspects of her work. The current gouaches on paper make specific references to the multitude of patterns expressed in different cultures, exploring their intrinsic similarities and cultural complexities.

SHAPIRO, JOEL ELIAS (Sculptor)
c/o Paula Cooper, 155 Wooster St., New York NY 10012

Born: 1941 *Collections:* Metropolitan Museum of Art; Whitney Museum of American Art *Exhibitions:* Whitney Museum Biennial; Museum of Contemporary Art, Chicago *Education:* New York University *Dealer:* Paula Cooper Gallery, NYC

Miniatures of monumental sculptural pieces placed on gallery floors gained him recognition in the 1970s. The small scale of these geometrical forms is disorientating, giving the impression that a compressed vastness lurks in the world of the bare floor, turning the observer into a giant. Shrunken worlds recall outdoor monumental sculptures made of strong metals such as bronze; scattered across the floor they emphasize the weightiness of space. Recent work includes cast-bronze stick figures, some of them over six feet tall, which lean at impossible angles yet manage to stand. He also continues to create small-scale pieces in bronze and iron.

SHARP, ANNE (Painter)
20 Waterside Plaza, New York, NY 10010

Born: 1943 *Awards:* Pippin Award, "Our Town", NYC; Grant, A.I.R. *Collections:* Smithsonian Institution; National Air and Space Museum *Exhibitions:* Eatontown Historical Museum; Pace Editions, NYC *Education:* Brooklyn College; Pratt Institute *Dealer:* Arlene Levien, NYC

Bill Shepherd, *Superball II,* 40 x 60, oil on canvas.

Jean Shadrach, *Forget Me Nots—Alaska State Flower,* 15 x 30, acrylic. Courtesy: Artique, Ltd. (Anchorage AK)

She is known for the vivid color and expressive form of her works in oil, acrylic, and watercolor. Her repertoire of media includes collages, drawings, sculpture, environmental pieces, silkscreen prints, lithography, and etchings. Among her early works are *Film Star Portraits* that combine painted, textured papers with images from the mass media. In the early 1970s she exhibited her postcard collages at Pace Editions in New York City. Her recent series *American Landscapes* are large-scale works painted directly from nature, while her *Planetary Landscapes* are fantastic pictures of the cosmos.

SHATTER, SUSAN LOUISE (Painter)
26 W. 20th St., New York, NY 10011

Born: 1943 *Awards:* National Endowment for the Arts; Ingraham Merrill *Collections:* Boston Museum of Fine Arts; Philadelphia Museum of Art *Exhibitions:* Fischbach Gallery, NYC *Education:* Pratt Institute; Boston University *Dealer:* Fischbach Gallery, NYC

Working in the landscape idiom, she uses color and light to create paintings that combine her actual experience of the site and a painterly concern with the rhythms of natural forms. Her shows over the past 11 years demonstrate her enduring interest in unromanticized nature. The primary focus is not so much depicting the specific geography as it is the interaction of the disparate elements. In the oils there is the physicality of carved-out space that pulls the viewer into the painting. The watercolors depict the same intensified nature. By carefully layering color she achieves the degrees of opacity and light that make up the unique rhythms of a given location.

SHAW, DONALD EDWARD (Painter, Sculptor)
P.O. Box 7397, Houston, TX 77248

Born: 1934 *Collections:* Chase Manhattan Bank; Wilson Industries *Exhibitions:* Moody Gallery, Houston; San Angelo State University Museum *Education:* Boston Museum School of Fine Arts *Dealer:* Moody Gallery, Houston

Assemblages and boxes of a decade ago, have given way to two and three dimensional steel structures and oil on vellum works with bold symbolic images that attempt to transfer personal expression into the larger paradigm of a cultural identity. Much of his peculiar imagery springs from the life and landscape of the Southwest. For a number of years the artist has spent his summers in New Mexico, modifying the landscape and native symbols into a personal mythology. His latest work can be seen in terms of continuing perceptual investigation in which increased attention is given to structural clarity. He draws on plates of steel with a flame torch to create his images. The assorted drawings and polychromed steel structures create a dialogue between common geometric shapes and simple irregular forms, aimed at flexing the tension between two and three dimensionality.

SHECHTER, LAURA J. (Painter)
429 4th St., Brooklyn, NY 11215

Born: 1944 *Awards:* Grant, Creative Artists Public Service; Graphics Award, Brooklyn College *Collections:* Brooklyn Museum; Boston Museum *Exhibitions:* The Art Institute of Chicago; Brooklyn Museum *Education:* Brooklyn College *Dealer:* Tatistcheff & Co., NYC

Tight and lyrical, her glazing technique in oil and single hatch style in drawings, brings a special energy to her works in still life and interior settings. Work in watercolor, hard pencil, silverpoint, and lithography, as well as oil, accents the play of light and simplified elements of color in space to hold the viewer's attention. Perspective, both in the conventional and unconventional sense, bifocal vision, and the creation of form—"idealizing form"—out of everyday settings are common concerns in her paintings and drawings. In a large group of her work she has concentrated on horizontal still life, multi-shelf still life, interior, and semi-interior settings in both single canvas and and multi-panel paintings.

SHEEHE, LILLIAN CAROLYN (Glass Artist, Painter)
1333 Christopher St., Johnstown, PA 15905

Born: 1915 *Awards:* A.B. Chrichton Award; Best of Show, Allied Artists *Collections:* David Glosser Library; Flood Museum *Exhibitions:* All Allied Artists Show; All Pennsylvania Competition *Education:* Indiana University Pa. *Dealer:* Dreams in Glass, Johnstown, PA

Initial explorations were in oils, pastels, carved leather, sculpture, and ceramics, but for the last thirty five years she has devoted the bulk of her effort to experimenting with the firing of colored glass to create large pictorial renditions on "every conceivable type of subject matter". More recently she has completed "glass picture" commissions for permanent installation at the Pepsi corporation. Current work is in fired enamel pieces, combined in a similar manner to her glass pieces, to form pictorial representations.

SHEETS, MILLARD OWEN (Painter, Designer)
34800 S. Hwy. One, Barking Rocks, Gualala CA 95445

Born: 1907 *Awards:* Prize, Art Institute of Chicago; Prize, National Watercolor Society *Collections:* Metropolitan Museum of Art; Art Institute of Chicago *Education:* Chouinard Art Institute; Otis Art Institute *Dealer:* Kennedy Galleries, NYC

As part of the California Watercolor School he gained recognition with paintings characterized by bright colors, abstracted forms and flourishing lines. He is a versatile artist who worked as a war artist for *Life* magazine in the mid-1940s at the Burma-India Front, who served as director of the Otis Art Institute in the 1950s, and who has been commissioned throughout the years to compose mosaics and murals on banks, libraries, and other public buildings. Working directly from nature, recent California landscapes are simplified presentations of rural scenes in rhythmic line, light and shadow. He is known for energetic portrayals of horses, their manes tossed by the wind.

SHEPHERD, BILL (Painter)
105 Lugar de Oro, Santa Fe, NM 87501

Born: 1943 *Awards:* Special Jurors Prize, Washington College *Collections:* Amoco Oil Co.; I.T.&T. Co. *Exhibitions:* Blaffer Gallery; University of Houston *Education:* University of Wyoming

His early works were personal investigations into the principles of color according to Joseph Albers and the compositional attitudes of Juan Gris. These studies developed into paintings of contradictory relationships of time and space—that is, someone being somewhere and somewhere else at once. Current work investigates the various elements that emerge from interpreting a seen experience into a visual one. In these works, he investigates why things appear the way they do.

Philip Lawrence Sherrod, *Helena/Ari/King/Queen/& the Joker!*, 50 x 36, oil. Courtesy: Allan Stone
(New York NY)

299

SHERBELL, RHODA (Sculptor)
64 Jane St., Westbury, NY 11590

Awards: National Academy of Art and Letters; Louise Comfort Tiffany Foundation *Collections:* National Portrait Gallery; Jewish Museum *Exhibitions:* Morris Museum; Huntington Hartford Museum *Education:* Art Students League; Brooklyn Museum

In her early genre period, her sculpture was concerned with pedagogic vignettes, reflecting her interest in the writings of Boccacio and Chaucer and the Italian Renaissance painters and sculptors. She chose to sculpt in a narrative vein, highlighting events in daily life. The subjects were selected for their essence, intimacy, and general human concern. Her current works, *Sculpture Composites,* reflect the multidimensional aspects of different people and cultures. Love of nature, ecological issues, and art history have become her interests. In these works she expresses reverence for nature, painting on sculpture to which objects have been attached.

SHERMAN, CINDY (Photographer)
c/o Metro Pictures, 150 Greene St., New York NY 10012

Born: 1954 *Collections:* Museum of Modern Art; Metropolitan Museum of Art *Exhibitions:* St. Louis Art Museum; Rhona Hoffman Gallery *Education:* St. University of New York at Buffalo *Dealer:* Larry Gagosian Gallery, Los Angeles; Rhona Hoffman Gallery, Chicago; Metro Pictures, NYC

Early black-and-white 8″-by-10″ prints were similar to film stills in which images from middle-class popular culture, popular flicks, horror flicks and television programs were exploited. She photographed herself in various roles as model, director and photographer. Cibachrome prints featured Sherman in mini-melodramas, complete with theatrical settings and props. Recent works continue the role-playing as she poses as various glamourless models in very large color prints which parody designer-clothes fashion photography. These women are portrayed with a new sense of power and a sardonic sense of humor.

SHERROD, PHILIP LAWRENCE (Painter)
41 W. 24th St., Fourth Floor, New York NY 10010

Born: 1935 *Awards:* National Endowment for the Arts Grant *Collections:* Museum of the City of New York; Worcester Art Museum *Exhibitions:* Allen Frumkin Gallery, NYC; Allan Stone Gallery, NYC *Education:* Art Students League *Dealer:* Allan Stone Gallery, NYC

Work since 1959 has been expressionistic. Early paintings were moody and poetic portrayals of urban landscapes and figures. He has also created fragmented self-portraits and large-scale "symbolic mythologies." Recent work has been more energetic and lyrical, depicting fragments of color and visions of the imagination. The work has been described as "highly volatile both in brushwork and composition." His main aim is to render a subject both representationally and abstractly, inviting the viewer to participate.

SHERRY, WILLIAM GRANT (Painter)
51 Park Terrace, Mill Valley CA 94941

Born: 1914 *Awards:* Mr. and Mrs. Chauncey A. Steiger Purchase Prize; National Painting Contest, Laguna Beach Festival of the Arts *Collections:* Springfield (MA) Museum of Fine Art; William A. Farnsworth Library and Art Museum *Exhibitions:* John and Mabel Ringling Museum; M.H. de Young Memorial Museum *Education:* Academie Julian; Heatherly School of Art *Dealer:* Galerie de Tours, San Francisco

As a young man he painted with house paint on stretched window shades before switching to oil on canvas. During World War II he worked as an illustrator of surgical techniques for the Navy's medical journal. When the war ended, he pursued formal study in Europe, and for a number of years afterwards his paintings were highly influenced by the Impressionists. Recent work is a combination of American traditional painting and French Impressionism. The subject matter of his oil paintings varies from old houses, barns, and wagons, to sun-drenched countrysides.

SHIMODA, OSAMU (Sculptor)
300 Seventh St., Brooklyn, NY 11215

Born: 1924 *Collections:* Embassy of Japan, Ottawa, Canada; Kings Borough Community College, NY *Exhibitions:* Bertha Schaefer Gallery, NYC; Granite Gallery, NYC *Education:* St. Paul University, Tokyo; Academie de la Grand Chamiere, Paris *Dealer:* Andrew Crispo Gallery, NYC

His large abstract iron sculpture works are painted in flat black and seem to almost deny their own weight and hard texture. His pieces are subtle and simple in shape, while at the same time imaginary and lyrical. He believes that sculpture set in an open area should dominate and be in contrast with the surrounding objects. The energy emitted by the work should unite all surrounding objects to create artistic harmony. He strives for his sculpture to emanate an energy that conveys an emotional expression to the natural or man-made setting.

SHOOK, GEORG (Painter)
41 Union Ave. #3, Memphis, TN 38103

Born: 1934 *Awards:* Carl F. Sahlin Award, American Watercolor Society; Ellen F. Martin Purchase Award, Watercolor U.S.A. *Collections:* Brooks Memorial Art Gallery; City of Springfield Collection, Springfield, MO *Exhibitions:* Watercolor U.S.A.; American Watercolor Society Exhibition *Education:* University of Florida; Ringling Institute of Art

Watercolor paintings of landscapes and American life are executed in a realistic manner in the traditional sense. His technique is controlled by a dry brush method accented with wash overtones to achieve his special "sharp focus" style of watercolors. Works are often executed from photographs as well as natural settings to achieve the realistic precision apparent in his paintings. He is an active author of watercolor technique books as well as a painter; Two of his titles include *Sharp Focus Watercolor Painting,* published in 1981, and *Painting Creative Watercolors from Photographs,* published in 1983.

SHULTZ, DIANE (Painter)
1267 Lafayette St., Santa Clara, CA 95050

Born: 1945 *Awards:* Award, San Jose Institute of Contemporary Art; First Place, Hayward Annual Forum for the Arts *Collections:* Henrickson & Gee, Oakland *Exhibitions:* San Francisco Museum of Art; San Jose Institute of Contemporary Art *Education:* San Jose State University *Dealer:* The Slate Gallery, Sacramento

Her early drawings and mixed media on paper pieces were representational and narrative, often using autobiographical material. Characteristic of this early work, were the distorted interiors in which the stories and drama unfolded. Paintings on both canvas and paper

William Grant Sherry, *'Jus Restin'*, 24 x 36, oil.

Ben Shute, *Port Clyde*, 18 x 24, watercolor. Courtesy: Frances Aronson Gallery (Atlanta GA)

and colored pen drawings comprise the current work. The pictorial narratives evolve from creole proverbs and quotations and abound with human-animal images. Allusions to black humor within the askew interiors spike the work with tension.

SHUTE, BEN E. (Painter)
1002 Cardova Dr. NE, Atlanta, GA 30324

Born: 1906 *Awards:* National Casein Society *Collections:* High Museum, Atlanta; Columbia (SC) Museum *Exhibitions:* International Watercolor Show, Brooklyn Museum *Education:* School of the Art Institute of Chicago; Academy of Fine Arts, Chicago *Dealer:* Frances Aronson Gallery, Atlanta

His work is characterized by a vigorous and robust style. The scope of his work includes formal portraits, oil and watercolor landscapes, and, most recently, welded metal sculptures and bronzes. His watercolors use vivid color, accented by India ink. Working wet in wet, in his works he shows his personal signature. Some of his paintings go beyond a recognizable landscape, expressing spiritual insight and concern for the subject.

SIEGEL, IRENE (Graphic Artist)
421 W. Roslyn Place, Chicago IL 60614

Born: 1932 *Awards:* Tamarind Fellowship; University of Illinois Research Fellowship *Collections:* Museum of Modern Art; Art Institute of Chicago *Exhibitions:* Museum of Modern Art; Art Institute of Chicago *Education:* Northwestern University; University of Chicago; Institute of Design, Chicago

In the mid-1960s prints and drawings featured complicated scenes of home life, flattened figures in abstracted space. Formalist large-scale graphite drawings of the early 1970s depicted water, mountains and sheets in a search for greater neutrality. As a Chicago Imagist, more recent work has included pastel chalk drawings portraying many small forms within one work, such as decorative patterns, still lifes and surrealistic images. Carefully rendered repeated images emphasize modulations in color and form.

SILVERMAN, BURTON PHILIP (Painter)
324 W. 71st St., New York, NY 10023

Born: 1928 *Awards:* Gold Medal, American Watercolor Society; Altman Figure Prize, National Academy of Design *Collections:* Brooklyn Museum; Philadelphia Museum of Art *Exhibitions:* National Academy of Design; American Institute of Arts and Letters *Education:* Art Students League; Pratt Institute; Columbia University *Dealer:* Sindin Galleries, NYC

His painting has always been in the realist tradition. His work derives from direct observation of the world around him, but the art is involved with synthesizing objective fact with subjective "truths." His early work was influenced by the lighting, modeling, and palettes of Rembrandt and Eakins. Later influences were Degas and Lautrec. His latest oils and watercolors reveal an increasingly sympathetic view of figures. The paint surface in the oils is built up with pastel-like accretions, though the works remain painterly in feeling. The watercolors also are built up with layerings of color yet seem spontaneous and even more painterly than the oils.

SIMON, JEWEL WOODARD (Painter, Sculptor)
67 Ashby St. SW., Atlanta, GA 30314

Born: 1911 *Awards:* Bronze Jubilee Award; James

Weldon Johnson Award *Collections:* Atlanta Life Insurance Company; Ringling Museum *Exhibitions:* Afro-American Museum of Life and Culture, Bishop College, Dallas; Atlanta Artists Club *Education:* Atlanta University; Atlanta College of Art

She works in a variety of media. Her oil paintings and watercolors depict city scenes, landscapes, and seascapes. She also does figurative sculpture. More recently she has focused on printmaking. Several lithographs were done at the Tamarind Institute in 1981, and they have been widely exhibited through the Atlanta Artists Club traveling show in the Southeast.

SINGER, CLIFFORD (Painter, Printmaker)
510 Broome St., New York, NY 10012

Born: 1955 *Collections:* Aldrich Museum of Contemporary Art; Continental Group, Inc. *Exhibitions:* Alfred University; Tuthill-gimprich, NYC *Education:* Alfred University; Hunter College

Elements of Euclidean geometry and an emphasis on a method of geometric construction to form a visual language within the square are predominant aspects of his acrylic paintings and silkscreen prints. This diagonal movement of line construction was a fundamental path for Piet Mondrian and allowed Barnett Newman to derive his vertical divisions. "Building a visual image with a knowledge of geometric laws enables a spontaneity of creation for the dynamic progression." The result is a geometrical display designating behavior of elements to our perception and utilizing the universal language of geometry to form an energetic poem.

SIRENA, ANTONIA MASTROCRISTINO FANARA (Painter)
1035 Fifth Ave., New York, NY 10028 *Awards:* Gold Medal Award, Academy of Paestum; Artist of the Year Award, International Beaux Arts *Collections:* Museum of Modern Art, Rome; Museum Castello Sforzesco, Milan *Exhibitions:* Gallerie Andre Weil, Paris; C.W. Post University Gallery

She began painting after she recovered from a long illness, when she experienced visions of color. She abandoned a successful singing career and dedicated herself to painting, giving birth to a creative process she calls "Trans-Expressionism"—that which comes from within the artist's "spiritual" eye and finds its way to the viewer. Praise by Picasso helped her to get her first exhibit in Rome. In 1973 she was felled by another long illness, and didn't show her work for nearly 10 years. This period of silence ended in 1982, when she exhibited her work in New York City.

SISKIND, AARON (Photographer)
15 Elm Way, Providence RI 02906

Born: 1903 *Awards:* Gold Star of Merit, Philadelphia College of Art; Fellowship, John Simon Guggenheim Foundation *Collections:* Museum of Modern Art; Metropolitan Museum of Art *Education:* Self-taught *Dealer:* Light Gallery, NYC; Susan Harder Gallery, NYC; Paul Cava Gallery, Philadelphia

With no formal training in photography, he developed an interest in the 1930s after seeing exhibitions of The Photo League in New York City. In 1936 he created a social-documentary series which included *Dead End: The Bowery and Harlem Document.* Seven years later, more interested in the geometric beauty of architectural cityscapes, he abandoned deep space and began experimenting with close-up abstractions of urban walls, compositions which have been compared to Abstract

Clifford Singer, *Pentameter (Panel I Series II)* (1984), 20 x 20, acrylic on plexiglas.

Antonia F. Mastrocristina Sirena, *Sensuality* (1972), 36 x 24, oil.

Skynear, *Miner's Rock,* 20 x 13 x 7, white bronze sculpture.

Expressionist paintings. He met Willem de Kooning and other Abstract Expressionists at about this time and discovered a mutual interest in the expressive possibilities of pure forms. Subsequent work has consisted of flat studies of billboards and graffiti, and other abstracted scenes from urban life.

SKYNEAR (Painter, Printmaker)
P.O. Box 851, Prescott, AZ 86302

Born: 1941 *Awards:* First Award, California State Exposition First Award, Eighth West Biannual Art Exhibit, Grand Junction, CO *Collections:* Gallo Wines, California; First National Bank, Denver *Exhibitions:* Los Robles Gallery; Washburn University of Topeka *Education:* Western State College of Colorado; University of Colorado *Dealer:* Elaine Horwich Galleries, Scottsdale and Sedona AZ, and Santa Fe, NM; Contemporary Gallery, Dallas

Early mixed-media works combined layers of airbrushed lacquer pigment on heavy paper board with inlays of brass, aluminum and colored fiberglass. His work was influenced by his interest in the bas-relief tablets of ancient cultures. His subjects have included rural and urban landscapes as well as "his spirit people." Recent works describe subject matter from extensive travels in Colorado, Arizona and Europe. Many series of serigraphs recall the luminosity of the earlier mixed-media work. In current oil paintings, sculptural pieces are incorporated into the composition—either set into the actual painting in a niche, or placed upon a small shelf extending from the canvas. Maintaining a fascination with ancient ritualistic symbols such as steles, totems and reliquaries, he gives them new meaning through this innovative technique.

SLAYMAKER, MARTHA (Painter, Printmaker)
45l Gavilan Place NW, Albuquerque NM 87107

Awards: Award, Indiana Arts Commission *Collections:* Indianapolis Museum of Art; New Mexico Museum of Fine Arts *Exhibitions:* New Mexico Museum of Fine Arts; Galerie Motte, Switzerland *Education:* Edinboro College; Ohio State University *Dealer:* Mountain Road Gallery, Albuquerque; O'Grady Galleries, Chicago and Scottsdale

Her relief paintings and collagraph prints evidence her emotional bond to nature and appreciation for the earlier cultures. An interest in archaeology, anthropology, and philosophy have taken her throughout the world to the sites of great, ancient civilizations in China, Greece, Europe, South America, Mexico, and the Yucatan. Textures and tactile surfaces found in man-made and natural structures serve as source for the relief surfaces characteristic of her current work. The evolution of the human spirit in the natural environment and the material manifestations of this in the architecture, visual symbolism, religion, and other expressions of a culture, are the conceptual base of her art.

SLES, STEVEN LAWRENCE (Painter)
537l E. Fourth St., Tucson, AZ 857ll

Born: l940 *Awards:* Gold Medal, Accademia Italia delle Arti e del Lavoro, Parma, Italy; Prix Jericho, Diplome d'Honneur, Paris *Collections:* Her Royal Highness, Princess Anne, Buckingham Palace, London; Swarthmore College Collection *Exhibitions:* New Jersey State Museum; Ross Gallery, Scottsdale, AZ *Education:* Swarthmore College; Arts Students League

The work of this artist is characterized by diversity of media, scale, subject matter and style. The influence of expressionism and romanticism is revealed in the exuberant color and the emotion of the content. One body of work contains large scale paintings which deal with social commentary. The brush marks are strong, the style relates to the Art Brut, depicting pathos and tragedy. In contrast to these are his works of lyricism and romanticism. Delicate washes create landscapes of ethereal tranquillity, suggesting a concern for the mystical and spiritual aspects of man.

SLOAN, ROBERT SMULLYAN (Painter)
1412 Arlington St., Mamaroneck, NY 10543

Born: 1915 *Awards:* U.S. Army Art Show *Collections:* National Portrait Gallery; IBM Collection *Exhibitions:* Leger Galleries, White Plains, NY; Herbert F. Johnson Museum of Art *Education:* City College of New York

He has developed over the years a mode of genre painting perhaps described as a personal or romantic realism, characterized by strong attention to light and mood. His work is an expression of his belief that an artist's mastery of painting techniques is only a first step toward the communication of significant ideas. Recently his subject matter has probed into the nature of human thought and matters of human survival. He has resisted "fashions" in his painting, seeking to incorporate subject matter of a mature nature in all his work.

SLOANE, ERIC (Painter)
c/o Meinhard Galleries, 1502 Augusta Dr., Suite 100, Houston TX 77057

Born: 1910 *Awards:* Gold Medal, National Academy of Design; Freedom Foundation Award *Collections:* Sloane Museum of Early American Tools, Kent (CT) *Exhibitions:* National Air and Space Museum, Washington (DC); American Museum of Natural History *Education:* Art Students League; Yale University School of Art; New York School of Fine and Applied Art *Dealer:* Fenn Galleries, Santa Fe; Hammer Galleries, NYC; Meinhard Galleries, Houston

As a boy he ran away from his native New York City and became a landscape painter in Taos, New Mexico at the age of fifteen. He returned to the East for a formal education during the 1930s and by 1940 was a writer and lecturer on clouds and weather. He designed and built the Hall of Atmosphere, and created murals for clients in industry. In 1954 he began writing a continuing series of books on Americana illustrated with his own sketches and paintings. Sketchbooks such as *An Age of Barns,* for example, contain detailed authenticated diagrams and sketches as well as realistic paintings to illustrate his chosen subject. Landscapes are luminous, with an emphasis on cloud formations.

SLOTNICK, MORTIMER H. (Painter)
43 Amherst Drive, New Rochelle, NY 10804

Born: 1920 *Collections:* New Britain Museum of American Art; National Collection of Fine Arts; Smithsonian Institution *Exhibitions:* Whitney Museum of American Art; Hudson River Museum *Education:* Columbia University; City College of New York

A traditionalist painter in the realist-impressionist style, his subject matter ranges from portraits and still-lifes to seascape and landscape settings. Inspired by the beauty of nature along the lines of the Hudson River school, the artist's works have been published by art reproducers as Christmas cards, calendars and framed reproductions. Frequent subject matter includes landscapes of the Catskill and Adirondack mountains regions of

New York, and records the charming old barns and bridges that brought character to the scenery.

SMITH, EMILY GUTHRIE (Painter)
408 Crestwood Dr., Ft. Worth, TX 76107

Born: 1909 *Awards:* Award, Hall of Fame, Pastel Society of America; Top Award, 6th and 7th Annual Pastel Society of America *Collections:* Fort Worth Art Museum ; Dallas Museum of Fine Art *Exhibitions:* Wichita Falls Museum of Fine Arts; Pastel Society of America *Education:* Art Students League; University of Oklahoma *Dealer:* Carlin Galleries, Fort Worth; L & L Gallery, Longview, Texas; Moulton Galleries, Fort Smith, Arkansas

She is known primarily for her realistic painting in oils and pastels, although she also creates murals and mosaics. She has been an active artist for fifty years both exhibiting and teaching. Portraits compose a major portion of her work, including those of prominent educators, stage personalities, distinguished community members and children. Her other subjects are taken from studies of nature and human activities. The compositions are filled with light and color and her generally realistic style is tempered with impressionism.

SMITH, JAMES MICHAEL (Painter, Assemblage Artist)
4 Shireford, St. Louis, MO 63135

Born: 1949 *Awards:* Ada Bechtel Heuser Award in Painting *Exhibitions:* Joy Horwich Gallery, Chicago *Education: Dealer:* Joy Horwich Gallery, Chicago

For the last ten years he has been creating wood constructions of and about everyday environments. Doors and windows from the outside or inside of buildings are transformed through manipulation of scale and color. Brick window facades negated with black paint, and pristine doorways painted white with markings of graphite, test the viewer's perception of their environment against what they thought they knew.

SMITH, JAUNE QUICK-TO-SEE (Painter)
c/o Hoshour Gallery, 417 Second St. S.W., Albuquerque NM 87102

Born: 1940 *Collections:* Minneapolis Institute of Art; University of California, Davis *Exhibitions:* Heard Museum; Bernice Steinbaum Gallery *Education:* Framingham St. College; University of New Mexico *Dealer:* Brentwood Gallery, St. Louis; Custer County Art Center, Miles City, MT; Hoshour Gallery, Albuquerque; Bernice Steinbaum Gallery, NYC

A Native American of Salish, French-Cree and Shoshone ancestry and the daughter of an amateur painter and horseman, her pastel drawings, oils and large-scale paintings depict pictorial landscapes from childhood memories. Cheyenne, her horse, appears in all of the work, as in *Red Rock Canyon*. The Southwestern landscapes include such Indian cultural items as tepees, tools and terra cotta pottery. In recent work scraps of muslin or calico cloth were pasted to the canvas, then painted over, buried beneath a mesh of thin vertical drips and thick horizontal lines, creating a surface similar to a woven blanket. The chosen colors and the impasto surfaces suggest the physicality of landscapes, as in *Black Water Draw* or *Obsidian Cliff*, simultaneously evoking the feelings associated with them.

SMITH, LEE N. III (Painter)
2515 Andrea Lane, Dallas, TX 75228

Born: 1950 *Collections:* Museum of Contemporary Art,

Chicago; Atlantic Richfield Company *Exhibitions:* Fort Worth Art Museum; The Art Center, Waco, Texas *Education:* El Centro College *Dealer:* DW Gallery, Dallas

His large scale representational oil on canvas paintings offer a surreal view of childhood images derived from his growing up in Texas. Large fields of complementary colors are carefully orchestrated within the images from his childhood to bring a striking effect to the whole. People are often painted with surreal green or blue faces, the children depicted always seeming detached and introspective. He uses color in a bold way to both model the figures and direct our attention within the composition.

SMITH, NAN S. (Sculptor, Installation Artist)
4409 NW 27th Terr., Gainesville, FL 32605

Born: 1952 *Awards:* Research Grant, University of Florida; Individual Artist Fellowship, Florida Fine Arts Council *Collections:* Japan House, University of Illinois *Exhibitions:* Florida Gulf Coast Art Center; University of Florida *Education:* Ohio State University; Tyler School of Art; Temple University

She is an installation artist whose large-scale mixed media sculptures create evocative semi-private spaces and interior environments. A multiplicity of imagery characteristically is used to create both a sensory and an intellectual experience for the viewer. Manipulated realism, coupled with the portrayal of life-sized, disembodied human figures, creates surprising juxtapositions and illusionism. Thematically, the earlier installations deal with concepts of unity and harmonious interaction. The current works create a mysterious hushed reality, otherworldly and contemplative in feeling. Life-sized disembodied "void figures" populate the spaces and are the primary counterparts in these recent installations.

SMITH, VINCENT D. (Painter)
264 E. Broadway, New York, NY 10002

Born: 1929 *Awards:* Travel Grant, National Endowment for the Humanities; Art Grant, National Institute of Arts and Letters *Collections:* Museum of Modern Art; Brooklyn Museum *Exhibitions:* Portland (ME) Museum of Art; Reading (PA) Public Museum *Education:* Brooklyn Museum; Skowhegan School of Painting and Sculpture *Dealer:* Randall Gallery, NYC

His early work was in the expressionistic mode, strong in color and form. He was influenced by the German expressionistic painters and the Mexican painters, along with African sculpture. His subject matter consisted of landscapes and urban scenes that drew on both Southern and Northern motifs of the United States. In 1973, after a trip to Africa, his work changed and he began to concentrate on African motifs. Using different grades of sand, dry pigment, pebbles, and cut rope—combined with oil and collage—he creates textures and intricate shapes and patterns. The sand and dry pigment give the effect of weathered stones or rock surfaces.

SNIDOW, GORDON E. (Painter)
P.O. Box 2496, Ruidoso, NM 88345

Born: 1936 *Awards:* Gold medal, 19 Cowboy artists of America *Collections:* National Cowboy Hall of Fame; Phoenix Art Museum *Exhibitions:* Beijing, People's Republic of China; Societe des Artists Independants, Grand Palais, Paris *Education:* Art Center School, Los Angeles *Dealer:* Gray Fox Gallery, Ruidoso, NM

He is one of the first artists of his generation to chronicle the life of the contemporary cowboy. Although a versatile craftsman in all mediums of oil, watercolor, charcoal, pastel and sculpture, the body of his work is gouache paintings. Current work is in a photo realist style using strong light and shadows to create powerful compositions. Living and working on ranches in the American West, he uses as his models real cowboys to make a definitive statement about the contemporary American West.

SNOW, CYNTHIA REEVES (Painter)
13663 Mar Scenic Dr., Del Mar, CA 92014

Born: 1907 *Awards:* National Society of Women Artists; First Prize, Connecticut Watercolor Society *Collections:* New Britain Museum of American Art; Benton Museum of Art *Exhibitions:* Slater Memorial Museum; Slater Arts Festival *Education:* University of North Carolina, Greensboro; Peabody College *Dealer:* Deicas Art gallery, La Jolla, CA

Early experiments in watercolors and oils explored non-objective painting, but pressures from peers and teachers directed her work towards realism in subsequent years. Her paintings over the years have continued to explore rather experimentally several different art movements. Learning from this research, she refers to her recent paintings as "abstract lyricist" works. Current pieces are almost exclusively in watercolors.

SOLDNER, PAUL EDMUND (Ceramicist)
P.O. Box 90, Aspen, CO 81611

Born: 1921 *Awards:* Craftsmen's Fellowship Grant, National Endowment for the Arts; Louis Comfort Tiffany Foundation Grant *Collections:* Victoria & Albert Museum of Art; National Collection, Smithsonian Museum. *Exhibitions:* Elements Gallery, NYC; Thomas Segal Gallery, Boston; *Education:* Otis Art Institute; University of Colorado

His tall, slender forms of the 1950s, some as much as seven and eight feet in height, pushed the physical limitations of wheel-thrown clay. In the next two decades his interest in Japanese culture and philosophy led to major innovations in the use of Japanese Raku firing in the U.S. His work includes both wall pieces and pedestal pieces which maintain a balance of form with decoration. His subject matter includes the figure, calligraphy, and abstract forms. Recent work employs the technique of low temperature salt firing, in which the introduction of salt to the kiln during firing forms a startling, organic texture on the clay surface. This play of control versus chance in the creation of his pieces evidences the influence of expressionism as well as the oriental philosophies of Buddhism and Taoism.

SONENBERG, JACK (Sculptor, Painter)
217 E. 23rd St., New York, NY 10010

Born: 1925 *Awards:* Award, John Simon Guggenheim Memorial Foundation; Award, Creative Artists Public Service *Collections:* Museum of Modern Art; Solomon R. Guggenheim Museum *Exhibitions:* Grand Rapids Art Museum; Fischback Gallery, NYC *Education:* Washington University; New York University

His major new sculpture is low, raw pine constructions, stage-like arenas using a platform device of smooth and rough-milled boards over two by four inch studs. Both a sculpture base and an imaginary room, the work employs half-driven nails which stand up in grids that reveal the understructure and raise a forbidding barrier to physical intrusion onto the platform. The objects on the stage are cubes and chair forms, empty or overturned. The rough platform itself is designed on the mathematics of a square extended by its golden section. In the center of the square and section are small pegs that stand up as markers to order action.

SOUZA, AL (Graphic Artist)
415 Meadow St., Amherst, MA 011002

Born: 1944 *Awards:* National Endowment for the Arts; Massachusetts Council on the Arts Fellow *Collections:* Bibliotheque Nationale, Paris; Houston Museum of Fine Arts *Exhibitions:* Dallas Museum of Art; New Museum, NYC *Education:* University of Massachusetts, Art Students League *Dealer:* Moody Gallery, Houston, TX

During his ten years of making art, his concerns have shifted from the exterior world to his personal life. His recent works on paper employ camouflage, combined with photographs from his past. He no longer uses Kodak prints, as he did in his earlier work, but xerox transfers of slides. He believes this brings the painted image and the photographic image to the same level. The images from his personal photographs have an emotional, sometimes nostalgic impact. His works combine these visual reminiscences with a current understanding of his past experience.

SOWERS, MIRIAM R. (Painter)
3020 Glenwood Dr. NW, Albuquerque, NM 87107

Born: 1922 *Awards:* Toledo Art Museum; New Mew State Fair *Collections:* United Nations Gallery, NYC; Gerald Ford *Exhibitions:* American Bible Society Gallery, New York City; Texas A & I University, Kingsville, TX *Education:* Miami University, Oxford, OH; School of the Art Institute of Chicago; University of New Mexico *Dealer:* Symbol Gallerie, Albuquerque, NM

She paints to tell a story to the imagination. Her allegorical people are half-hidden in nature, giving glimpses of moral values. In the past she has done many watercolors and drawings, many on gold leaf, as are some of the oils. Her watercolors have been noted for their oriental feeling. The philosophical oil paintings are large and employ a transparent palette, with layered textures and moving planes of color. She also paints smaller, poetic canvases.

SOYER, RAPHAEL (Painter)
88 Central Park West, New York NY 10023

Born: 1899 *Awards:* Joseph H. Temple Gold Medal, Pennsylvania Academy of the Fine Arts; Walter Lippincott Prize *Collections:* Metropolitan Museum; Museum of Modern Art *Exhibitions:* Museum of Modern Art; Whitney Museum of American Art *Education:* Cooper Union; National Academy of Design; Art Students League *Dealer:* Forum Gallery, NYC

Born in Russia, he came to New York City at the age of thirteen. He is known for realistic urban views and interiors from everyday life. Early figures, which included artists and performers, were flattened and simplified, but he eventually developed a freer brush recalling Edgar Degas. Depression era paintings and lithographs included vagrants in dismal street scenes in a Social Realist mode. In 1940 women at work or sitting in the studio became a primary theme. For a while the works were sketchlike; then in the 1960s, undaunted by current artistic movements, he returned to a careful realistic style using brighter colors, paint-

Emily Guthrie Smith, *Taos Gardens*, 22 x 28, pastel. Courtesy: L & L Gallery (Longview TX)

Miriam Sowers, *Omni-Presence,* 48 x 54, oil & white gold leaf. Courtesy:
Sowers Studios & Gallerie (Albuquerque, NM)

ing lively subjects such as groups of Flower Children. He has written a number of books, including *Diary of an Artist.*

SPAFFORD, MICHAEL (Painter)
2418 Interlaken Blvd., Seattle, WA 98112

Born: 1935 *Awards:* Louis Comfort Tiffany Foundation Grant; Prix de Rome *Collections:* Pacific Northwest Bell; Seattle Art Museum *Exhibitions:* Utah Museum of Fine Arts; Seattle Art Museum *Education:* Pomona College; Harvard University *Dealer:* Francine Seders Gallery, Seattle

Early large scale oil on canvas paintings were influenced by the Abstract Expressionists, the German Expressionists and Mondrian. Then, during a three year stay in Mexico City, he first solidified his personal interest in figurative expressionism and explored certain classic Greek mythological themes, such as Leda and the Swan and the labors of Hercules, that would become the subject matter of much of his painting in the following two decades. His expressionistic, sometimes erotic canvases, are painted in a forceful style; He often applies paint liberally, building up successive versions of an image one on top of another until he arrives at the final image. His commissions have included murals for the Kingdome in Seattle, and a highly controversial work on the labors of Hercules in the chambers of the Washington state legislature.

SPALENKA, GREG (Painter, Illustrator)
95 Horatio St. #203, New York, NY 10014

Born: 1958 *Awards:* Acheson-Wallace Award, Society of Illustrators; Los Angeles Bicentennial Art Competition *Collections:* California Federal Savings and Loan *Exhibitions:* Art Center College of Design; Saddleback College *Education:* Art Center College of Design

Past studies have dealt primarily with the field of illustration, with an overall emphasis on editorial or social commentary. His works have almost always dealt with the figure. In an expressionistic way he has sought to communicate either a positive or negative feeling to the viewer. Currently he has undertaken a project of painting portraits of young artists living in New York City. The works are in oil and acrylic on paper. He has also recently finished a portrait of Alice Neel for the cover of *Interview* magazine.

SPEED, (ULYSSES) GRANT (Sculptor)
139 S. 400 East, Lindon UT 84062

Born: 1930 *Awards:* Gold Medal Award, Sculpture, Cowboy Artists of America Annual; Purchase Award, Men's Art Council, Phoenix *Collections:* Whitney Gallery of Western Art, Cody, WY; Diamond M. Museum *Exhibitions:* Phoenix Art Museum; Whitney Gallery of Western Art, Cody, WY *Education:* Brigham Young University *Dealer:* Texas Art Gallery, Dallas; Main Trail Galleries, Jackson WY

A Texan, he was first a rodeo cowboy and in 1959 earned a degree in Animal Science before pursuing an artistic career. Sculptures depicting subjects of pre-World War II cowboy life are meticulously researched before they are cast in bronze. "I'm interested in capturing the heart, soul and essence of my subjects as they are caught up in the basic themes of existence like man versus man, man against nature, man against horse." Commissions include bronze statues of Buddy Holly and of John Wayne. Most bronzes are relatively small, highly detailed, and often full of energy, as in *Recoverin' the Stolen Horses.*

SQUADRA, JOHN (Painter)
151 Highland Ave., Rowayton, CT 06853

Born: 1932 *Awards:* Top Ten Award, Irene Leache Memorial Exhibition, Norfolk Museum, VA; 2nd Prize, 25th Annual Darien (CT) Art Show *Collections:* Bridgeport (CT) Museum; San Francisco Museum of Modern Art *Exhibitions:* Mari Galleries, Mamaroneck, NY; Nonson Gallery, NYC *Education:* Rhode Island School of Design *Dealer:* Yolanda Kelley, Chicago

He views his earlier surrealistic paintings as "resting places on a road, not destinations." He believes the purpose of his work is not to inform the viewer, but to transform his concept of himself and the world around him. His paintings posit worlds of the imagination. He has lectured on surrealism at museums and universities and has designed sets for surrealist performances.

STAMELOS, ELECTRA (Painter)
4450 Fenton Rd., Hartland, MI 48029

Born: 1927 *Awards:* National Watercolor Society, California; Midwest Watercolor Society *Collections:* Kresgie Collection, Troy, MI; Jessie Besser Museum, Aldena, MI *Exhibitions:* Butler Museum of American Art; Foothills Art Center, Golden, CO *Education:* Eastern Michigan University; Wayne State University *Dealer:* Cantor Lemberg Gallery, Birmingham, MI

Transparent watercolor is her primary painting medium. She considers herself a "colorist," and her finished work goes beyond photorealism to combine with many abstract concepts. Although strongly influenced by Matisse, Mondrian, Hopper, and Sarkis Sarkesian, her brushwork is very different, consisting of layers of glazes. Flower forms trigger her representational images, but her strong compositional and design abilities add strength and uniqueness to her images. She also works with photography, stained-glass windows, lithography, etching, acrylic painting, and sculpture.

STAMOS, THEODOROS S. (Painter)
37 W. 83rd St., New York NY 10024

Born: 1922 *Awards:* Tiffany Foundation Fellowship; Brandeis University Creative Arts Award *Collections:* Metropolitan Museum of Art; Museum of Modern Art *Exhibitions:* Museum of Modern Art; Solomon R. Guggenheim Museum *Education:* American Artists School *Dealer:* Louis K. Meisel Gallery, NYC

One of the youngest Abstract Expressionists, his first solo show was held in 1943. Early works dealt with patterns of large biomorphic forms, shells, beach debris and sea creatures in colorful thinly applied pigments. In 1947 darkly colored bands seemed to float in an imaginary plane as light shone through translucent screens in the *Teahouse* series. The *Sun-Box* series begun in 1963 conveyed the effects of bright light in which rectangles floated like reflections of each other in an ethereal plane. During the 1960s he also produced works on paper, collages and prints. Later works suggested landscape with modulating earth tones and marine hues. In recent years he has continued to experiment with the possibilities of abstraction and color.

STANISLAUS (STANISLAUS BIELSKI) (Painter)
865 Oakdale Road Northeast, Atlanta GA 30307

Born: 1944 *Collections:* Fogg Art Museum; Humanities Research Center Museum of Fine Art, University of Texas *Exhibitions:* Forum International Gallery of Fine Art; Arnold's Archives *Education:* University of Texas

Stanislaus, untitled, mixed media. Courtesy: Arnold's Archives

John Squadra, *Distant Thunder*, 32 x 46, oil. Courtesy: Signature Fine Arts (Newport Beach CA)

After studying paintings in many major American museums and galleries in the northeast, he developed a technique he calls "alchmystical expression," a "tri-tempera" (three media) process. Figures are first drawn with colored pencils. Then, three chemical solutions are mixed with oil paints to create "violent reactions among colors"; Finally, the surface is finished in colored varnish, and "the final products are permanently sealed onto a wax coated paper." He explains his painting process as "actively volatile and moving," and says "each piece is one of a kind, never to be duplicated in the history of the universe."

STANLEY, BOB (Painter, Photographer)
3 Crosby St., New York, NY 10013

Born: 1932 *Awards:* Max Beckmann Scholarship, Brooklyn Museum of Art; Award, Casandra Foundation *Collections:* Whitney Museum of American Art; Fogg Museum, Boston *Exhibitions:* New York Cultural Center; P.S. 1, NYC *Education:* Brooklyn Museum of Art; High Museum *Dealer:* M. G. Herzka, NYC

In his figurative paintings the preoccupations of contemporary American life are depicted. Earlier work of the 1960s to the mid 1970s, he used photographs as the preliminary sketches for his paintings. The photographs were manipulated by reducing them into black and white formalities or translating them into intense complimentary color relationships, before enlarging the images to greater than life size. In addition to photographs, his current work includes coloring book figures, puzzles, graphs, and scientific diagrams as source material. Expanding also in color composition and complexity, he now uses a full range of color in his alterations of the initial image.

STEFFY, BILL (Sculptor)
2811 Colquitt, Houston, TX 77098

Born: 1933 *Collections:* Andrews, Kurth, Campbell, and Jones, Houston *Exhibitions:* Moody Gallery, Houston *Education:* Arizona State University; Chouinard Art Institute, Los Angeles *Dealer:* Moody Gallery, Houston

Since moving to Houston in 1961, he has become known for his streamlined gold and silver inlay work in jewelry and sculpture. During his earlier years in Phoenix, Az, he worked with Charles Loloma, and most of his pieces reflected the traditional media of the Southwestern silversmith. He casts or fabricates his smooth, geometric forms from sterling silver or 18-carat gold, often inlaying the designs with turquoise, lapis, ivory, wood, malachite, coral, and other natural materials. He also does cast-bronze sculpture.

STEIDER, DORIS (Painter)
Rt. 5, Box 5235, Albuquerque, NM 87123

Born: 1924 *Awards:* Special Award, Oils, National League of American Pen Women *Collections:* Holt, Rinehart, & Winston; West Texas Museum *Exhibitions:* Thomas Gilcrease Institute of American History and Art, Tulsa, OK; Montana State Historical Society Museum *Education:* Purdue University; University of New Mexico *Dealer:* Baker Gallery, Lubbock, TX; Aldridge Gallery, Albuquerque, NM

A visionary realist, she draws her inspiration from the deserts, mountains, and ghost towns of the Southwest, as well as from her travels in India, Kashmir, and the Greek Islands. Her paintings now are almost always in egg tempera on mirror-smooth gesso panels. The works are lustrous and meticulous, infused with her own mystical realism. In recent years she has also produced a group of small bronze sculptures devoted to Indian subjects.

STEINBERG, SAUL (Cartoonist)
c/o The New Yorker, 25 W. 43rd St., New York NY 10036

Born: 1914 *Collections:* Metropolitan Museum of Art; Museum of Modern Art *Exhibitions:* Museum of Modern Art; Art Institute of Chicago *Education:* University of Bucharest; University of Milan *Dealer:* Pace Gallery, NYC

Born in Rumania, he studied sociology, psychology and architecture, but became a cartoonist in Italy in the 1930s. He left there in 1940 and joined the staff of the *New Yorker* the next year, when he gained recognition as a satirist. After service in the U.S. navy he began to publish books of drawings, beginning with *All in Line*. Murals for buildings were also commissioned. Witty, biting cartoons possessing a childlike quality explore the roles people play in order to cope in the modern world, and express very little sympathy for rich and powerful American urbanites. Recent work includes cityscapes full of odd creatures and toy-like vehicles; still life assemblages; and "tables"—compositions of drawings, paintings, rubber-stamp seals, handwriting and cartoon images mounted on wooden boards.

STEINHOFF, MONIKA (Painter)
647 W. San Francisco, Santa Fe, NM 87501

Born: 1941 *Collections:* IBM Corporation; Smithsonian Institution *Exhibitions:* Albuquerque Museum; University of New Mexico *Dealer:* Jamison Galleries, Santa Fe, NM

Her explorations in color and design have included batik, graphics, watercolor, and oil. Much of her work has been abstract, influenced by Klee, Kandinsky, and Hans Hofmann. Most recently she has moved into more representational art. Her interest in people and their interior states and surroundings has led her to paint very detailed interiors with figures. These works tend to have smooth surfaces and very subtle color harmonies. They have a dream-like, fantasy quality, with only subtle deviations from "reality." Having gone through a period of abstraction, she is still incorporating elements from her earlier period of abstraction in her newer work.

STELLA, FRANK (Painter)
17 Jones St., New York NY 10021

Born: 1936 *Awards:* First Prize, International Biennial Exhibition of Paintings, Tokyo *Collections:* Museum of Modern Art; Whitney Museum of American Art *Exhibitions:* Museum of Modern Art; Whitney Museum of American Art *Education:* Phillips Academy; Princeton University *Dealer:* Lawrence Rubin Gallery, NYC

A first show in the late 1950s was a group of black canvases in which parallel bands, surrounded by bare canvas, echoed or opposed the direction of the frame's edges. Metallic or fluorescent pigments emphasized the artificiality of the work. A prolific painter, he worked on several series of metallic paintings of geometric shapes. These massive canvases were followed by other similar series, using stripes of color outlined in white, and later zigzags, arcs, and other shapes, in fluorescent polychrome. In the 1970s he was still employing flat, synthetic hues on large canvases, but the idea of structure had become more complex. Colors change value as one's eyes move across the paintings, the shapes and colors interacting in a constant state of flux.

STEPHAN, GARY (Painter)
c/o Mary Boone Gallery, 417 W. Broadway, New
York NY 10012

Born: 1942 *Collections:* Museum of Modern Art;
Rockefeller Collection *Exhibitions:* David Whitney
Gallery, NYC *Education:* Parsons School of Design;
Art Students League; Pratt Institute; San Francisco Art
Institute *Dealer:* Margo Leavin Gallery, Los Angeles;
Daniel Weinberg Gallery, San Francisco; Mary Boone
Gallery, NYC

Works of the early 1960s while studying in California
were figurative, anticipating the current Maximalist
movement. Odd anthropomorphic shapes dot the land-
scapes on Masonite painted in the mid-1960s. After
contact with Jasper Johns in the early 1970s in New
York City he experimented with such media as latex,
rubber and plastic to create "pictorialized sculptures."
Later works include painterly abstractions of Christian
themes or derivations from El Greco. Recent large-
scale abstractions express a cathedral feeling by ma-
nipulating space with thickly painted bars of bold color.

STERNE, DAHLI (Painter)
315 W. 70th St., New York, NY 10023

Born: 1895 *Awards:* Nunzio Vayana Medal of Honor,
Ogunquit Art Center, ME *Collections:* Crocker Mu-
seum of Art; Gracie Mansion, NYC *Exhibitions:* Col-
lege of Mount Saint Vincent-on-Hudson, Riverdale,
NY; Oklahoma Art Center Gallery

Born in Germany, she came to the United States with her
husband when she was 18 years old. Her art emerged
after the marriages of her children. The paintings are
known for their color, diversity, and emotional content.
She uses a palette-knife technique to create sweeping
forms in rich, opalescent colors. her subjects are drawn
from her travels in Europe and the United States, and in-
clude landscapes, seascapes, and still lifes.

STEWART, ARTHUR (Painter)
2969 Pump House Rd., Birmingham, AL 35243

Born: 1915 *Awards:* Atlanta Art Association; Birming-
ham Centennial Show *Collections:* Queen Elizabeth II,
England *Exhibitions:* Santa Barbara Museum of Art,
Art Institute of Chicago *Education:* School of the Art
Institute of Chicago

He specializes in portraiture, painting mostly in water-
color. He has been influenced by the works of Ingres,
early Flemish painters, and English Georgian portrai-
ture. In all of his portraits, the sitter's character is
enhanced by the composition. Originally from Ala-
bama, he interprets the South in his paintings, portray-
ing the daily routines of the people of Alabama and
Georgia. He also is known for his paintings of flowers,
which recall traditions in Dutch and Flemish painting.
Some of his compositions relate to the flower paintings
of Henri de Fantin-Latour. In these works, brilliantly
colored flowers are placed against very dark, nearly
black backgrounds.

STILLMAN, GEORGE (Painter)
1127 Franklin Ave., Ellensburg, WA 98926

Born: 1921 *Awards:* Bender Grant; Scottsdale Jurors
Award *Collections:* Oakland Museum; Washington
State Arts Commission *Exhibitions:* Lucien Labaudt;
National Painting Show, Cape Coral, FL *Education:*
California School of Fine Arts; Arizona State Univer-
sity *Dealer:* Foster/White Gallery, Seattle, WA

His style has developed from a very early concern with
form. He consistently has maintained an interest in the
emotional impact of line, color, form, and surface
within a two-dimensional format. The outward or obvi-
ous subject matter has been interchangeable, beginning
with academic concerns, then with abstract expression-
ism, and presently with realistic representation. Since
the late 1950s he has worked with recognizable subject
matter. His current techniques include oil, egg-oil emul-
sion, egg tempera, graphite, lithography, and etching.

STOLTENBERG, DONALD HUGO (Painter, Print-
maker)
947 Satucket Road, RD 1, Brewster, MA 02631

Born: 1927 *Awards:* Grand Prize, Boston Arts Festival;
Award, Worcester Art Museum *Collections:* Boston
Museum of Fine Arts; Addison Gallery of American
Art *Exhibitions:* DeCordova Museum; Art Institute of
Chicago *Education:* Institute of Design, Illinois Insti-
tute of Technology

The structural aspects of the man-made environment are
the primary subjects for his oil and watercolor paintings
and collagraph prints. Early works tended to be mono-
chromatic and heavily textured compositions of indus-
trial objects. In his current work color and tonal develop-
ment are emphasized as well as light and abstraction in
compositions of bridges, ships, and buildings. Specific
details are stripped away in favor of the universal and
essential form suffused with atmospheric light. Perspec-
tive elevates and enlargens the images into awesome
forms sometimes emerging from a crystalline structure
of scaffolding.

STRAUTMANIS, EDVINS (Painter)
69 Green St., New York, NY 10012

Born: 1933 *Collections:* Housatonic Museum of Art,
Bridgeport, CT; Kunsthaus, Zurich *Exhibitions:* Allan
Stone Gallery, NYC; Whitney Museum of American
Art *Education:* School of the Art Institute of Chicago
Dealer: Allan Stone Gallery, NYC; Jeremy Stone
Gallery, San Francisco; Grayson Gallery, Chicago

His large abstract paintings show a kinship with Ab-
stract Expressionism. He uses a water-based paint and
improvised brushes, sometimes brooms. In his works,
what appear to be structural beams criss-cross horizon-
tally and diagonally, propping, toppling, and squeez-
ing. His works suggest the energy of a life force in
endless search of a resolution. A recent visit to the
Prado to study Goya generated a series of paintings that
focus on the drama of light and dark, illuminating the
"theatre" of light.

STREETER, TAL (Sculptor)
Old Verbank School, Millbrook, NY 12545

Born: 1934 *Collections:* Museum of Modern Art; San
Francisco Museum of Modern Art *Exhibitions:* Touring
Exhibition, American Museum Association; Touring
Exhibition, Massachusetts Institute of Technology *Edu-
cation:* University of Kansas; Colorado College

His first exhibitions in the early 1960s showed linear
steel sculptures, painted black. Linearity was retained
during the 1970s while the sculpture grew in scale to
large, public works. These pieces acquired the distinc-
tive deep-red color that he has used exclusively since
1970. He developed his "sky" theme, shown in works
such as *Endless Column* (1970), a zig-zagging seventy
foot high red line that climbs up into the clouds. His
recent large-scale steel sculptures continue to develop
the sky theme. He also creates temporal kinetic works
utilizing polyethylene and helium, lifting his red lines
even higher into the sky, as in the 1,250-foot-high
Empire State Building Red Line.

STRIDER, MARJORIE VIRGINIA (Painter)
7 Worth St., New York, NY 10013

Born: 1939 *Awards:* National Endowment for the Arts; Longview Foundation *Collections:* Hirshhorn Museum and Sculpture Garden; Albright-Knox Art Gallery *Exhibitions:* Steinbaum Gallery, NYC; Hoffman Gallery, NYC *Education:* Kansas City Art Institute *Dealer:* Steinbaum Gallery, NYC

She works with familiar items such as brooms, packages, fruits, and vegetables, and unusual materials and techniques like urethane foam and paint on bronze. There is a continual dialogue between painted and sculpted volumetric space. She has always been concerned with the accessibility of her work and has done a number of street works and public sculptures. Her current pieces in painted bronze, steel, and aluminum use the images of fruits, vegetables, and flowers of the different states of the United States. These works make a formal statement based on her strengths, line and color.

STUART, MICHELLE (Painter, Sculptor)
152 Wooster St., New York, NY 10012

Born: 1940 *Awards:* Grant, National Endowment for the Arts; Award, Guggenheim Memorial Foundation Fellowship *Collections:* Albright-Knox Art Gallery; Walker Art Center *Exhibitions:* Museum of Modern Art; Moderna Museet, Stockholm *Education:* Chouinard Art Institute *Dealer:* Galerie Munro, Hamburg

She works in painting, sculpture, photography, and printmaking while combining such non-traditional materials as earth and soil in the pieces. In her wall pieces, a major body of work, earth is affixed to paper and then mounted on muslin. Sculpture includes small "books constructed of earth from specific sites as well as several large outdoor pieces in stone." She has also composed wall pieces, freestanding sculpture, and sound into total environments for interior installations. She continues to use the raw material of nature in her work. In recent paintings she has mixed earth with oil onto canvas. Figurative elements are incised into the surface and sometimes burnished or polished afterwards.

SUBA, SUSANNE (Painter, Illustrator)
470 W. 24th St., New York, NY 10011

Awards: American Institute of Graphic Art *Collections:* Metropolitan Museum of Art; Brooklyn Museum *Exhibitions:* Ansdell Gallery, London; The Art Institute of Chicago *Education:* Pratt Institute *Dealer:* Weythe Gallery, NYC

Representational paintings, executed in watercolor and gouache, along with pen and ink drawings, often times combined with watercolor washes, make up the body of the artist's work. Common subjects for her imagery include animals, children, boats, houses, people, ballet, and circus settings. Watercolor still-lifes of flowers are also frequently exhibited, and a gouache "resist" technique has produced particularly interesting results in paintings done after repeated stays in Venice. Recently, a study of spider monkeys resulted in the paintings for the book, *The Monkey and the Peddler*. Her pen and ink drawings also appear frequently in the New Yorker magazine.

SUGARMAN, GEORGE (Sculptor, Painter)
21 Bond St., New York NY 10012

Born: 1912 *Awards:* National Arts Council Award; Longview Foundation Grants *Collections:* Museum of

Modern Art; Art Institute of Chicago *Exhibitions:* Whitney Museum Annual; Los Angeles County Museum of Art *Education:* City College of New York; Atelier Zadkine, Paris *Dealer:* Robert Miller Gallery, New York, NY

Early sculpture was abstract, in a cubist mode. An interest in the articulation of space was manifested in pieces of wood carved asymmetrically, suspended and extended horizontally. Later the wood was painted in bright colors, in chaotic sequences which were like three-dimensional equivalents of Abstract Expressionist paintings. The subsequent use of acrylics on metal in a full range of color "forms a bridge between painting and sculpture" and helps to "articulate the formal problem set in each sculpture." With a disregard for industrially available materials he prefers to render complicated forms from the imagination in order to obtain a desired "particularity of the statement." Since the 1970s large outdoor sculptures for public buildings have explored the definitions of space, the relationships between forms, and the effects on the building in the context of the community.

SUMMERS, CAROL (Printmaker)
133 Prospect Ct., Santa Cruz CA 95065

Born: 1925 *Awards:* Louis C. Tiffany Foundation Fellowships; Fellowship, John Simon Guggenheim Memorial Foundation *Collections:* Metropolitan Museum of Art; Corcoran Gallery of Art *Exhibitions:* Museum of Modern Art; Brooklyn Museum *Education:* Bard College *Dealer:* Fendrick Gallery, Washington, DC; Associated American Artists, NYC and Philadelphia

Early woodcuts featured abstract biomorphic shapes. After 1958, preliminary rough sketches in ink and brayer were applied to paper before the final print was made. During the 1960s images of domestic life in cubist space were more recognizable such as *Bon Appetit*. The artist is known for simplified landscapes and mountainscapes, often each peak a different color. Sometimes color is printed on the back of the paper for the desired coloristic effect. Recent large and simple landscapes are multi-colored, each element saturated with color. Some of these woodcuts are executed in a technique similar to rubbings.

SURLS, JAMES (Sculptor)
P.O. Box 9, Splendora TX 77372

Born: 1943 *Awards:* Fellowship, National Endowment for the Arts *Collections:* Solomon R. Guggenheim Museum; Ft. Worth Art Museum *Exhibitions:* San Francisco Museum of Modern Art; Whitney Museum Biennial *Education:* Cranbrook Academy of Art *Dealer:* Delahunty Gallery, Dallas

Large and dramatic sculptures in wood echo the American Southwest. Handsaws, axes and crosscut saws are used to preserve the natural feel of the wood as much as possible. Indentations are cut in the wood so that wooden spikes or pegs can be added, making the pieces spiky, like cactus. Mythical images made in such woods as pecan, oak, elm, maple, pine and walnut are symbols taken from his dreams and quiet meditations. Over the years the pieces have grown increasingly graceful and spindly, resembling odd creatures, such as the pine and oak *Walking House*, standing on smoothed branches as "legs," or the rough-hewn *Sticker Woman*.

SWARTZ, BETH AMES (Painter)
5346 E. Sapphire Ln., Scottsdale, AZ 85253

Born: 1936 *Awards:* Arizona Arts and Humanities

Edvins Strautmanis, *Fox Harbor* (1984), 40 x 48, acrylic on canvas. Courtesy: Allan Stone (New York NY)

George Stillman, *Sage on Craig's Hill,* 30 x 40, graphite. Courtesy: Foster White (Seattle WA)

Commission; U.S. International Communications Embassy *Collections:* National Museum of Art, Smithsonian Institution; San Francisco Museum of Modern Art *Exhibitions:* Touring Exhibition, ''Israel Revisited''; First Western States Biennial Exhibition *Education:* Cornell University; New York University *Dealer:* Elaine Horwich Galleries, Scottsdale, AZ

Her trademark has been canvases with the weight and elegance of jewel-encrusted tapestries. Her work has evolved from muted watercolors through smoke-stained and torn paper. The present works reveal the transformation she is undergoing. The new paintings are marked by a symbolic use of color and mystical figures set in swirling, glitter-flecked canvases.

SWIGGETT, JEAN DONALD (Painter, Muralist)
3635 Seventh Ave., Apt. 9E, San Diego, CA 92103

Born: 1910 *Awards:* California-Hawaii Regional Award, San Diego Museum of Art; Award, San Diego Art Institute Annual *Collections:* San Diego Museum of Art; Murals, SS President Jackson, SS President Adams *Exhibitions:* Southwestern College; San Diego Museum of Art *Education:* Chouinard Institute of Fine Art; University of Southern California *Dealer:* Ankrum Gallery, Los Angeles

In his early career, he worked as an assistant to Norman Chamberlain and Paul Sample on their murals for Federal Post Offices. He continued to paint numerous murals of his own in both public and private buildings throughout Southern California. His paintings were primarily realistic with a period of experimentation in abstraction. Male and female nudes, flowers, and fruit and other natural forms are the dominant elements of his compositions. His large oil paintings are concerned with the use of symbolic imagery to make philosophical statements. Concurrent drawings in colored pencil and acrylic, are large and complex, making visual references to art history.

SZABO, ZOLTAN (Painter)
P.O. Box 26812, Tempe, AZ 85282

Born: 1928 *Collections:* New Britain Museum of American Art; National Art Gallery of Hungary *Exhibitions:* York Fine Art Gallery, Aurora; Challis Gallery, Laguna Beach *Education:* Hungarian National Academy of Industrial Art; Famous Artists School *Dealer:* Pivan Gallery, Boulder; El Prado Gallery, Sedona

While occasionally painting in casein and egg tempera, he is renowned for his realistic watercolors of nature. He paints primarily landscapes or close-ups of the flora. The views are unpopulated and serene—abandoned cabins the only evidence of one time human activity.The author of five popularly accepted books on the watercolor technique, he exhibits a sure facility with the brush and the pigments. Textural contrasts are emphasized—as between snow drifts and prickly bare branches or waving grasses tangling in the barbs of a cactus. Soft, poetic and emotional, these idyllic scenes are well suited to the watercolor technique.

TABACHNICK, ANNE (Painter)
463 West St., New York, NY 10014

Born: 1937 *Awards:* Fellowship, John Simon Guggenhiem Memorial Foundation; Grant, Bunting Institute, Harvard University *Collections:* Metropolitan Museum of Art; Hyde Collection *Exhibitions:* Ingber Gallery, NYC; Aaron Berman Gallery, NYC *Education:* Hans Hoffman School; Hunter College *Dealer:* Ingber Gallery, NYC

The human figure and a sense of space are emphasized within the landscapes, seascapes and cityscapes that comprise the body of her work. Painting in oil or watercolor in a variety of scales, she depicts the countryside of New Hampshire, the waters of the Caribbean, the buildings of New York City, and more. The compositions are spare with few lines and the paint applied in thin sheets. The influence of Oriental painting is seen in the austere ordering of natural elements. The expanses of sky and water are treated as volumes of space—barely defined and yet asserting a strong presence. In this setting, the human figures appear temporary and fragile.

TALBOT, JONATHAN (Painter, Collage Artist)
7 Amity Rd, Warwick, NY 10990

Born: 1939 *Awards:* Ranger Fund Award, National Academy of Design *Collections:* Smith College Museum; Byer Museum of the Arts *Exhibitions:* Everhart Museum; Byer Museum of the Arts *Education:* Brandeis University; San Francisco Academy of Art; The New School of Social Research *Dealer:* Gimpel & Weitzenhoffer, NYC

His painted collage constructions in oil and acrylic combine a surrealistic orientation influenced by Joseph Cornell with an emphasis on geometry and rectangular composition based on the work of Mondrian. Technology emerges as a prime culprit in the artist's images and structures. In many of the works, the human being is a tiny, threatened element enmeshed and entrapped in the inhuman grindings of an immense technological world. In essence he presents his vision of the struggle of modern man—of a world literally falling apart—in collage paintings that display a careful attention to both detail and craftsmanship, as if the positive attitude and structure of the work itself sought to overcome the destruction he depicts.

TANNER, WARREN (Painter)
118 Prince St., New York, NY 10012

Born: 1942 *Awards:* Rome Prize, American Academy in Rome; Artist-in-Residence, Helen Wurlitzer Foundation *Collections:* Aldrich Museum; Hunter College *Exhibitions:* American Academy in Rome; M.O.A. Gallery, NYC *Education:* Hunter College

His work from the late 1970s through 1981 was involved with geometry, geometric abstraction, and systematic painting. Work was hard-edged and utilized a restricted palette. More recent work, since living in Rome, has become more spontaneous and intuitive, full of color, vivid and direct. The geometric elements which were often the foundation of the early works, are superimposed upon by streaks of color and wiry drawn lines. The layering of the expressionist and patterned forms create a spatial density while the linear wiggles present the humorous and the absurd.

TAYLOR, ANN (Painter)
7209 E. McDonald Dr., #31, Scottsdale, AZ 85253

Born: 1941 *Collections:* Memorial Art Gallery, University of Rochester; Scottsdale (AZ) Center for the Arts *Exhibitions:* C. G. Rein Galleries, Houston; Indianapolis Museum of Arts *Education:* Vassar College; New School for Social Research *Dealer:* Gallery Henoch, NYC

Her paintings are minimalist landscapes of muted colors, executed with delicacy. For her, landscape is a basic tool with which to structure abstract elements of composition, color, and light. Her palette is gradual, soft, and

Ann Taylor, *Ghost of the Enchanted Range* (1984), 48 x 48, oil on canvas.

Anthony Toney, *Science & Humanity*, 18 x 20, oil on canvas. Courtesy: ACA Gallery (New York NY)

gentle, and her sense of space is ambiguous. Her recent paintings mark a shift in her development. The works in this *Acceleration Series* are composed of two pictorial motifs: vacant areas energized by a disturbance within the space, and the stylized representation of landscape forms. These paintings are marked by a new paint quality and a suggestion of oriental spirituality.

TAYLOR, JOSEPH RICHARD (Sculptor)
701 W. Brooks St., Norman, OK 73069

Born: 1907 *Awards:* First Place, Oklahoma Annual *Collections:* Fuller Gallery, Seattle; Oklahoma Museum of Art *Exhibitions:* Metropolitan Museum of Art; Whitney Museum of American Art *Education:* University of Washington; Columbia University *Dealer:* Gallery at Nichols Hills, Oklahoma City

Architectural and monumental sculpture makes up the early work of this artist. His work in stone, wood, ceramics, bronze and welded metal ranges from naturalism through degrees of abstraction. Rarely does his work become non-objective, although directly carved work tends toward more abstraction than the modeled pieces. Recently retired from forty four years of cattle ranching, he is presently concentrating on bronze sculptures, especially of animals and nudes. Current work is almost exclusively representational.

THIEBAUD, WAYNE (Painter)
Dept. of Art, University of California, Davis CA 95616

Born: 1920 *Awards:* Creative Research Foundation Grant; Citation, Most Distinguished Art Studio Teacher of the Year, College Art Association of America *Collections:* Museum of Modern Art; Whitney Museum of American Art *Exhibitions:* Whitney Museum of American Art; Sao Paulo Biennial, Brazil *Education:* Sacramento St. College *Dealer:* Crown Point Press, NYC

Before formal art training he worked as a cartoonist, a designer and an advertising art director—experiences that have influenced his paintings. With thickly applied paint, variations of images of single food items and other products are repeated in bright colors and artificial light. Realistic representations have also included lone figures on white backgrounds executed in a style reminiscent of advertising-copy. An alliance with the Pop movement is evident throughout his work although his style incorporates a characteristically more realistic approach. Currently he teaches art and produces educational films.

THOMAS, JOHN (Painter, Printmaker)
P.O. Box 1478, Kailua-Kona, HI 96745

Born: 1927 *Awards:* Grant, National Endowment for the Arts; Award, Yaddo Foundation *Collections:* Hirshhorn Collection; State of Hawaii Collection *Exhibitions:* Rice University; Whitney Annual *Education:* New York University; New School for Social Research *Dealer:* Malama Arts, Honolulu

Trained as an Abstract Expressionist in New York during the fifties, he studied with William Gaziotes and later in Europe. This early work in oil was primarily figurative. His relocation in Hawaii in 1965 profoundly influenced his style. Present work emphasizes purity of color, and complex geometric structuring within compositions including the figure and profuse tropical foliage. Hawaiian myth is prominent in a series of monumental paintings with such titles as, *Pele, the Volcano Goddess* and *Hina, the Moon Goddess*. Recent watercolors of orchids have led to a number of colorful serigraphic editions of this delicate flower.

THOMPSON, JOHN (Illustrator)
64 Ganung Dr., Ossining, NY 10562

Born: 1940 *Awards:* Silver Medals, Society of Illustrators; Gold Medal, CEBA Awards *Collections:* Adolph Coors Co. Heritage Collection *Exhibitions:* Society of Illustrators; The Brdigeport Museum of Art, Science, and Industry *Education:* Miami University of Ohio

Working exclusively in acrylics, his near photo realist illustrations have appeared in *Esquire, National Geographic, Time,* and *Fortune* magazines. Although, subject matter is mostly modern, his illustrations are often illustrated in a style that makes them look as if they could have been executed 100 years ago. He usually works from photographs, preferring to take the photos himself, and has done portraits of President Reagan and Mayor Ed Koch for, respectively, *Time* and *Fortune* magazines. He recently completed a series of illustrations for the swashbuckling tale, *Captain Castille*.

THOMPSON, JUDITH KAY (Painter)
5920 Bissonnet, Apt. 71, Houston, TX 77081

Born: 1940 *Awards:* Goldie Paley Award, National Association of Women Artists *Exhibitions:* Brooklyn Museum; Meredith Long Gallery, Houston, TX *Education:* Kansas City Art Institute; University of Cincinnati

A realist painter, the objects she paints are usually life-sized or larger-than-life-sized, and executed in meticulous detail. She paints from life, not photographs. The colors she prefers are usually vivid. In addition to her still lifes, she also favors the human figure as subject matter.

THOMPSON, RICHARD EARL (Painter)
80 Maiden Ln., San Francisco, CA 94108

Born: 1914 *Collections:* Milwaukee Art Museum; The Southland Corporation *Exhibitions:* R. W. Norton Art Gallery, Shreveport, LA; Leigh Yawkey Woodson Art Museum, Wausau, WI *Education:* American Academy of Art; School of the Art Institute of Chicago *Dealer:* Richard Thompson Gallery, San Francisco

His style of painting is linked to both the American and the French Impressionists. His earlier canvases included French genre, figurative, and landscape subjects, textured with gesso. The current contemporary landscape works use thick paint for a textured look. The subjects of his mature works are taken from nature. The luminous compositions of light and air reflect his techniques of painting depth of field and using color.

TINKELMAN, MURRAY (Illustrator)
75 Lakeview Ave. W., Peekskill, NY 10566

Born: 1933 *Awards:* Artist of the Year Award, Artist Guild of New York; Gold Medal, Art Directors Club of New York *Collections:* Brooklyn Museum; Smithsonian Institution *Exhibitions:* Society of Illustrators; New Britain Museum *Education:* Cooper Union Art School; Brooklyn Museum Art School

He began his career as an abstract expressionist painter, and so is fluent in the visual language of color, texture, and tone. But, while abandoning painting, he has fused these same elements of the modern and abstract with painstakingly traditional draftsmanship at the heart of his pen and ink drawings. His subjects are not delineated with long fluid lines. Rather they emerge from interactions taking place in the crosshatched swatches, fold, and fields laid down on paper. He uses a mosaic of completely abstract patterns to create realistic images. Subjects of politics, landscape or fantasy. There

is sometimes a satirical wit to his drawings. There is no line at all as contour, no boundaries, only a kaleidoscope of patches and endless, precise strokes that create a mesh and a network of impressionistic tapestry, patterns, and fields of soft tonal variation.

TONEY, ANTHONY (Painter)
16 Hampton Pl., Katonah NY 10536

Born: 1913 *Awards:* Emily Lowe Award; Medal of Honor, Audubon Artists Grumbacher Award *Collections:* Whitney Museum of American Art; Syracuse University *Exhibitions:* Whitney Museum of American Art; Art Institute of Chicago *Education:* Syracuse University; L'Academie de la Grande Chaumiere; L'Ecole Superieure des Beaux Arts; Columbia Teacher's College *Dealer:* ACA Galleries, NYC

An abstract artist, his paintings emphasize linear and planar movement in a brushstroke that recalls the work of Paul Cezanne. His aim is "a synthesis of sensuous impact, haunting associations, symbolic richness, natural references, even possible description, and an inventive organic structure in which each plane has its orchestral necessity." Compositions of figural elements and visual fragments in drawings and paintings seem improvised, "an non-descriptive and fragmented linear stream of consciousness."

TOOKER, GEORGE (CLAIR JR.) (Painter, Printmaker)
c/o Marisa del Re Gallery, 41 E. 57th St., New York NY 10022

Born: 1920 *Awards:* National Institute of Arts and Letters Grant; Governor's Award for Excellence in the Arts, Montpelier (VT) *Collections:* Metropolitan Museum of Art; Museum of Modern Art *Exhibitions:* Museum of Modern Art; Metropolitan Museum of Art *Education:* Phillips Academy; Harvard University; Art Students League *Dealer:* Marisa del Re Gallery, NYC

In the mid-1940s he studied under Paul Cadmus and Kenneth Hayes Miller; other influences were Balthus and Rene Magritte. Social Realistic works employing egg tempera used this medium of the Italian Renaissance to depict modern allegories of urban life. Precisely rendered scenes laden with psychological tension, such as the well-known *Government Bureau,* were also akin to Magic Realism. The people are replicas of each other in a crowded, claustrophobic world of artificial light and cool, dull colors; with identical looks of desperation they are alienated, trapped in their isolation, as in *Subway* (1950). Themes of dehumanization at the hands of an anonymous bureaucracy have continued in later paintings. An interest in existentialism has influenced works depicting psychological torment and the inevitability of death.

TREATNER, MERYL (Illustrator, Painter)
721 Lombard St., Philadelphia, PA 19147

Born: 1950 *Collections:* Huntsville Museum of Art *Exhibitions:* Vincent Kling Architects Building; Contemporary Courtroom Artists *Education:* Philadelphia College of Art

The majority of her earlier work consisted of editorial illustration for major newspapers and magazines. Over the last several years, the bulk of her work has been editorial, promotional, and advertising art for each of the major commercial television networks and for National Educational Television. More recently she has begun to produce book covers. Recent work is photorealist with attention to detail and at times a three dimensional effect while at the same time attempting to avoid a statue-like, cold appearance. Emphasis is on portraiture in all works.

TROVA, ERNEST TINO (Sculptor, Painter)
6 Layton Terrace St., St. Louis MO 63124

Born: 1927 *Collections:* Museum of Modern Art; Solomon R. Guggenheim Museum *Exhibitions:* Solomon R. Guggenheim Museum; Hirshhorn Museum & Sculpture Garden *Education:* Self-taught *Dealer:* Pace Gallery, NYC

During the 1940s and 1950s he was a painter influenced by Willem de Kooning. In the following decade anonymous men, alone or grouped in a circle, illustrated what was to become a recurring theme, the *Falling Man,* in paintings, prints and sculptural pieces. The sculptures were made of such media as glass, plexiglass, polished chrome-plated bronze, silver or epoxy, and featured anonymous men in a seemingly endless variety of situations. During the first half of the 1970s the *Gox* series evoked fragments of the *Falling Man* within a new context of painted stainless steel. In 1980 the *Poet* series consisted of sheet metal figures placed in miniature architectural and natural environments. Recent abstract bronze figural works continue the exploration of metaphysics and mankind's relationship to the environment.

TURRELL, JAMES ARCHIE (Environmental Artist, Installation Artist)
Box 725, Flagstaff, AZ 86002

Born: 1943 *Awards:* Fellowship, National Endowment for the Arts; Fellowship, John Simon Guggenheim Memorial Foundation *Collections:* Stedelijk Museum; Chase Manhattan Bank *Exhibitions:* Whitney Museum of American Art; Center on Contemporary Art, Seattle *Education:* Pomona College; University of California at Irvine *Dealer:* Flow Ace Gallery, Venice, CA

One of the few artists to employ light as his main medium, his installations are at the same time both minimal and evocative. His room installations employing nothing more than cut wall "apertures", white paint, and tungsten lights create an environment that evoke the ephemeral and numismatic and often remind viewers of fog or outer space. Subsequent installations have employed a variety of light mediums to create colorful "floating" walls or illusive spaces. Currently he is at work on a massive earthwork sculpture utilizing the special qualities of light and geography of a crater in the northern Arizona desert.

TUTTLE, RICHARD (Sculptor, Assemblage Artist)
c/o Jack Tilton Gallery, 24 W. 57th St., New York NY 10019

Born: 1941 *Collections:* Corcoran Gallery of Art; National Gallery, Canada *Exhibitions:* Museum of Modern Art; Whitney Museum of American Art *Education:* Trinity College; Cooper Union *Dealer:* Jack Tilton Gallery, NYC

In 1963 he began to explore the phases of dematerialization in Minimalist works. Since 1970 small objects were scattered strategically in large gallery spaces in order to fill the interior with imaginary relationships. Cubes of paper, plywood, wire, string, cloth and other materials in irregular shapes were attached, sometimes with staples, to walls or to the floor. The works are not self-contained, but installations, and therefore depend on the environment in which they are placed for a full understanding of their spacial significance.

TWARDOWICZ, STANLEY JAN (Painter)
57 Main St., Northport NY 11768

Born: 1917 *Awards:* Fellowship, John Simon Guggenheim Memorial Foundation *Collections:* Museum of Modern Art; Los Angeles County Museum of Art *Exhibitions:* Art Institute of Chicago; Museum of Modern Art *Education:* Meinzinger Art School; Skowhegan School of Painting and Sculpture

In a style reminiscent of Mark Rothko, medium and large-scale canvases are rendered in media that have included acrylic polymer and oil paints. The broad color fields bleed into one another in an ambiguous spatial plane which seems to hover over the surface. Subtle gradations of hue and tone create a calm and contemplative mood, inviting the viewer to ponder the paint itself and its innumerable evocations.

TWITTY, JAMES (Painter, Printmaker)
1600 South Eads St., Apt. 1234 S, Arlington, VA 22202

Born: 1916 *Awards:* Allied Artists American Award; Award, First Annual Exhibition, Miami *Collections:* National Gallery of Art; Dallas Museum of Art *Exhibitions:* Corcoran Gallery of Art, Washington, DC; McNay Museum *Education:* Art Students League; University of Miami *Dealer:* David Findlay Galleries, NYC

His acrylic paintings and silkscreen prints attain formal and technical sophistication through a fine balance of hard edge and organic elements. Texture and the horizontal aspects of the compositions are combined to suggest elusive landscapes. Architectonic structures function as windows through which one glimpses an evocative landscape, closely akin to the Renaissance "window on the world" stated in clean, contemporary lines. The rendering of perspective gives a strong sense of three-dimensional presence to his works. He molds forms in space using color relationships which range between intense and muted tones. These space renderings of geometric and organic elements are enigmatic illusions which draw the viewer in to explore the artist's unique perception of space.

TWOMBLY, CY (Painter)
c/o Leo Castelli Gallery, 420 W. Broadway, New York NY 10013

Born: 1929 *Awards:* Virginia Museum of Fine Arts Fellowship for Travel *Collections:* Museum of Modern Art; Whitney Museum of American Art *Exhibitions:* Whitney Museum of American Art; Solomon R. Guggenheim Museum *Education:* Boston Museum of Fine Arts School; Art Students League; Black Mountain College *Dealer:* Leo Castelli Gallery, NYC

After study with Franz Kline and Robert Motherwell in 1951 and 1952 he developed a style based on Abstract Expressionism and Paul Klee consisting of calligraphic scribbles in pencil and paint. Graffiti-like markings filled the canvases in energetic compositions, but by 1956 more empty spaces were present as he grew increasingly interested in the ground on which the doodles were placed. Backgrounds took on the look of deteriorating walls, as in *School of Athens,* of blackboards or of blank white paper. He has shown a versatility in the continuous exploitation of his characteristic marking motif, sometimes employing improvisational methods to create a wide variety of moods and effects—ethereal paintings of near emptiness or gloomy crowded canvases. He has lived in Italy since 1957.

URAM, LAUREN (Collage Artist, Sculptor)
251 Washington Ave., Brooklyn, NY 11205

Born: 1957 *Awards:* Award, Communication Arts Annual; Award, Arts Directors Annual *Collections:* American Telephone and Telegraph Collection; National Broadcasting Corporation Collection *Exhibitions:* Museum of Illustration *Education:* Cornell University; Pratt Institute of Design

Earlier art work was predominately mixed-media sculpture which made use of metal, paper, wood, and plaster. While continuing to use a variety of media, a large part of her present work is in paper collage. In the collages she uses bits of unevenly torn, soft papers that are printed with different values, colors, patterns, and print faces to piece and patch together images that are astonishingly realistic. Her range of subjects is as diverse as her collage papers. She depicts scenes with animals and figures, portraits, and even renderings of microchip test patterns. Some very new work involves a series of etchings that combine the two techniques of chin colle and monoprinting.

VAN DE BOVENKAMP, HANS (Sculptor)
Box 837, Tillson, NY 12486

Born: 1938 *Awards:* Nebraska Bicentennial Commission; Emily Lowe Award *Collections:* Estate of Nelson Rockefeller; Youngstown Museum *Exhibitions:* Arras Gallery, NYC; Medici Berenson Gallery, Surfside, FL *Education:* University of Michigan *Dealer:* Arras Gallery, NYC

A cubist influenced, constructivist sculptor, he works in stainless steel, steel, aluminum, and brass. His monumental outdoor sculpture is characterized by undulating lines, sinuous abstract forms, and reflective surfaces. Scale is the dominant factor in these works; their shape and proportions relate to the scale of the outdoors. He has done a series of surrealistic fantasy tables that portray "the plaza of life," and another series constructed of flat cutouts of circles and waves in brightly painted cor-ten steel. He continues to develop all three of these series, both for indoor and outdoor placement.

VAN VRANKEN, ROSE (Sculptor)
435 Tallowood, Houston, TX 77024

Born: 1919 *Awards:* Eliot Liskin Award, Salmagundi Club; First Prize for Sculpture, Los Angeles County Museum of Art *Collections:* Texas Commerce Bank, Houston; Coventry Cathedral, Coventry, England *Exhibitions:* Institute of Texas Cultures Museum, San Antonio, TX; Archway Gallery, Houston *Education:* Art Students League; University of Iowa *Dealer:* Sol Del Rio, San Antonio, TX; Hobe Sound Gallery, Hobe Sound, FL; Gilman Gallery, Chicago

She is a sculptor working in carved wood and stone forms and casted bronze. Her bronze castings, in limited editions of no more than ten, are made from the carvings and given a patina or polish. The early work is more figurative, with later work tending towards abstraction. The carvings are based on forms in nature such as plants, animals, and sea forms. When based on a human form, there is a feeling or mood conveyed rather than a direct copy of nature. Her simplified realism has been strongly influenced by archaic Greek, Chinese, and Egyptian art.

VAPOUR, MEL (Painter, Printmaker)
1442a Walnut St., Suite 281, Berkeley, CA 94709

Born: 1946 *Awards:* Albrecht Durer Research Grant;

Meryl Ticatner, *Heritage: Civilization and the Jews,* 20 x 30, mixed media.

Stanley Twardowicz, *NO. 18* (1956), 52 x 42, oil.

Prix de Slovenci Artista *Collections:* Winston Collection; Museum of Modern Art *Exhibitions:* Walker Art Center; Monterey Museum of Art *Education:* University of Wisconsin *Dealer:* ArtSupports, Berkeley, CA

He is an iconoclastic and eclectic artist who uses a variety of non-traditional media to express concerns with often environmental or political overtones. Older paintings are representative of what he refers to as his "angry young man trying to make his mark on canvas" period.More recent work has been with xerox art and various print media. Recurring themes of cellophane, vinyl, and nickel-plated steel dominates his cynical realism which he transmits through T-shirts, billboards, and bus placards.

VAUGHN, SALLE WERNER (Painter)
2235 Brentwood, Houston, TX 77019

Awards: Archives of American Art, Smithsonian Institution *Collections:* San Francisco Museum of Modern Art; J. P. Morgan Library, NYC *Exhibitions:* La Boetie Gallery, NYC; Whitney Biennial Exhibition, 1971 *Education:* Texas Women's University; Atelier Dix-Sept, Paris *Dealer:* La Boetie Gallery, NYC

She paints on a small scale, using precise geometric imagery. Patterning is introduced into spatial landscapes, often using devices such as the checkerboard and cylinder. Repeated and interrupted shapes and elements are set against a white background with graded shadings revealing an interaction between the texture of paper and color. Her work shows influences as diverse as the Italian masters of the 15th century and 20th century constructivism. Her interests include antiquities and illustrated books, and, in addition to painting, she has worked as a designer in film, graphics, and theatre.

VELARDI, ERNEST J., JR. (Painter)
9513 Jellico Ave., Northridge CA 91325

Born: 1924 *Awards:* Purchase Prize, Henry Ward Ranger Fund Exhibit; Huntington Hartford Foundation Fellowship *Collections:* Springfield (MO) Art Museum; Crown Zellerbach *Exhibitions:* National Watercolor Society; Orlando Gallery *Education:* University of Illinois; Whitney School of Art *Dealer:* Orlando Gallery, Sherman Oaks, CA

Early works in egg tempera were abstract paintings that featured vertical arrangements of bands of shapes, in colors similar in value. The subtle gradations of color were meant to suggest imaginary landscapes. In recent years the tempera paintings have become more representational, juxtaposing hyper-realistic images from the artist's subconscious mind "whose meanings are unfamiliar and disquieting." He explains, "art is magic, and basic to our human need. But it is enigmatic—even for those who practice it or benefit by it."

VELASQUEZ, OSCAR (Painter)
Rt. 1, Box 160, Abbeville, SC 29620

Born: 1945 *Awards:* Silver Medal of Honor, American Watercolor Society; Georgia Gold Award *Collections:* Joslyn Museum of Art, Omaha, NE; Erskine College, Due West, SC *Exhibitions:* Cannon Rotunda, Capitol, Washington, DC; Camden Art Center, SC *Education:* Cooper School of Art, Cleveland

Earthy tones dominate the unusual compositions in the paintings of this figurative painter. The tones are low key, with rich dark shadows. His current paintings are watercolors and oils, many with a figure in an activity. These works have blues or earth browns as the dominant color scheme. The watercolors tend to have detailed centers of interest, surrounded by strong washes, while the oils feature dramatic dark and light transitions.

VICKREY, ROBERT REMSEN (Painter)
Box 445, Orleans MA 02653

Born: 1926 *Awards:* Newton Memorial Award; America Audubon Artists *Collections:* Metropolitan Museum of Art; Whitney Museum of American Art *Exhibitions:* Museum of Modern Art; Whitney Museum of American Art *Education:* Yale University School of Art; Art Students League *Dealer:* A.C.A. Galleries, NYC

Subtle color and precisely rendered lines characterize this Objective Realist's enigmatic paintings. Egg tempera is employed in sun-drenched paintings of a style reminiscent of Andrew Wyeth, as in*Pulse,* (1972) although unlike Wyeth the subjects are romantic in tone, enveloped in a fine mist of introspection. The primary instrument of expression is light, often depicted in chiaroscuro or in bright highlighting. The streets of New York City, with their grey stone and long stretches of pavement serve as the backdrop for visions of childhood, notably boys, cats and bicycles, works which offer a large variety of human gestures including sadness, loneliness, boredom and reflection. He has also been able to imbue inanimate objects with these emotions.

VIGIL, VELOY JOSEPH (Painter)
110 Morada Rd., Taos, NM 87571

Born: 1931 *Awards:* Winslow Homer Memorial Award; National Watercolor Society *Collections:* Heard Museum, Phoenix, AZ; Portland Museum, Portland, OR *Exhibitions:* Smithsonian Institution; National Academy of Design *Education:* Colorado Institute of Art; Denver Art Academy *Dealer:* Veloy Vigil Studio, Taos, NM

An abstract expressionist painter of American Indian imagery in watercolor, acrylics, and pastel, his early work in oil and acrylic was monochromatic, allowing shapes to dominate the composition. His primary concern was the division of space into varied compositional elements, each working in harmony with the whole. As his awareness of color relationships progressed, he saw the strength that color could bring to the already well-developed compositions. This new freedom in the use of color coincided with his move to the West Coast and his studies with the abstract expressionists. When he began using Southwestern imagery as a vehicle for expression, he again saw a new direction in the use of color as a compositional element. Moving to Taos further crystalized his perception of color and shape in relation to the image. Freedom in the use of color has also brought about a freedom to interchange techniques. He uses paint, pastel, sprays, and collage in all his work.

VINELLA, RAY (Painter)
Box 1569, Taos, NM 87571

Born: 1933 *Awards:* B. Altman Award; Professional Award, New Mexico State Fair *Collections:* Diamond M Museum; Museum of Native American Culture *Exhibitions:* Museum of Native American Culture; First Exhibition of Southwest Art, People's Republic of China *Education:* Art Center College of Design *Dealer:* Taos Art Gallery, Taos, NM

Early work was in illustration before he turned to painting. In the sixteen years that he's been a painter, he has struggled for a feeling of light, form, and a painterly

Veloy Vigil, *Spring Moment*, 15 x 20, monotype. Courtesy: Veloy Vigil Studio

Lauren Uram, *1½ Months 17 Days 2 Nights,* 18 x 11, pencil.

Hans Van de Bovenkamp, *Confluence* (1976), 40 high, aluminum.

quality. He has developed a feeling for light in his work, and continues his search for content.

VIOLA, BILL (Video Artist)
324 Granada, Long Beach, CA 90814

Born: 1951 *Awards:* National Endowment for the Arts *Collections:* Museum of Modern Art *Exhibitions:* Institute of Contemporary Art, University of Pennsylvania; Whitney Museum of American Art *Education:* Syracuse University

Work has ranged from installations to video tapes, with an emphasis on perceptual and psychological concerns. Sometimes, as in his early piece *Amazing Colossal Man Video Piece,* humor is employed. That work utilized a video projector to rear project a giant image of his face, pressed up against a pane of glass, on a screen behind the third story window of his residential house, while his stereo, turned up full blast, amplified the sound of him banging and yelling loudly—much to the surprise of his neighbors. Recent installations and video tapes have reflected an interest in medical imagery. In *Anthem,* he skillfully combines exquisitely composed images of natural and industrial beauty with medical images of operations and autopsies to create a haunting work on life and death.

VODICKA, RUTH CHAI (Sculptor)
97 Wooster St. New York, NY 10012

Born: NYC *Awards:* Medal of Honor, Sculptors and Painters Society of New Jersey; F.J.W. Beatman Award, Silvermine Guild Artists *Collections:* Virginia Museum; Norfolk Museum *Exhibitions:* "Sculpture for the Dance", Hudson River Museum; Whitney Museum Annual *Education:* Brooklyn College; Empire State College *Dealers:* Meisel Gallery, NYC; Vorpal Gallery, NYC; A.M. Sachs Gallery, NYC

Bronze, brass, aluminum, steel, wood, stone, and concrete are transformed in her work into participatory environmental sculptures that combine space, time, and multi-dimensional inter-relationships into a total environment. Visual elements are often times representational and figurative narratives. Works incorporating dance, music, poetry, and theatre involve the spectator as an active participant. "Art and life combine, reality and unreality meet.", she says of her participatory installations. Smaller scale pieces, in bronze, brass, aluminum, and wood express similar figurative narratives.

VO DINH, MAI (Painter)
P.O. Box 425, Burkittsville, MD 21718

Born: 1933 *Awards:* Christopher Award, Christopher Foundation; Fellowship, National Endowment for the Arts *Collections:* Musee de Art Moderne de la Ville de Paris; Milwaukee Art Center *Exhibitions:* Washington International Art Exposition; George Mason University *Education:* University of Paris *Dealer:* Suzuki Gallery, NYC

Early works were a synthesis of elements from his far-Eastern background and his formal education at both the Sorbonne and the Beaux-Arts of the University of Paris. Later, strongly influenced by the work of the New York and Bay Area schools, oil and acrylic paintings became semi-abstract incorporating the use of chalk and woodcut collage. Since 1979, he has seldom worked in either oil or acrylic, but has returned to the traditional media of the far East—ink and watercolor on paper. Transparency, delicacy, and mystery are attributes of these more recent works.

VOGEL, DONALD S. (Painter)
6616 Spring Valley Rd., Dallas, TX 75240

Born: 1917 *Awards:* Bronze Medal, American Academy in Rome; Purchase Prize, Dallas Museum of Art *Collections:* Dallas Museum of Art; Mobile (AL) Art Gallery *Exhibitions:* Dallas Museum of Art; Philbrook Art Center, Tulsa, OK *Dealer:* Valley House Gallery, Dallas

He is a studio painter whose subjects are invented under the influence of the environment in which he lives. The direction of his work has been influenced by the French Impressionists. His early paintings emphasized the atmospheric effects of light through a figural composition. The subjects included figures in an interior or on a terrace, caught in a poetic, meditative mood. In his later work, dabs of compatible, often bright colors on a dark masonite ground enliven the more complex subject arrangements. These include greenhouse interiors, park scenes, dance parties, and garden landscapes. Figures are almost always present, painted with a minimum of features and functioning as compositional devices alone or in groups.

VON RYDINGSVARD, URSUAL (Sculptor)
210 Spring St., New York, NY 10012

Born: 1942 *Awards:* Fellowship, John Simon Guggenheim Memorial Foundation; Fellowship, National Endowment for the Arts *Collections:* Neuberger Museum; Aldrich Museum of Contemporary Art *Exhibitions:* Artpark; Rosa Esman Gallery, NYC *Education:* Columbia University; University of California at Berkeley *Dealer:* Bette Stoler Gallery, NYC

Cut, laminated, carved, and sanded cedar sculptural installations respond to the spaces for which the pieces are built. Interior sculpture works with the walls, ceiling and floor; the outdoor pieces resound to man-made dunes, gullies, hills and levees. Works are often modular, approaching a human life size scale, and the imagery appears derived sometimes from the figure sometimes from the rural landscape but always emanating a spiritual feeling.

VON SCHLEGELL, DAVID (Sculptor)
190 Dromara Rd., Guilford CT 06437

Born: 1920 *Awards:* Purchase Prize, Carnegie Institute; Fellowship, John Simon Guggenheim Memorial Foundation *Collections:* Whitney Museum of American Art; Hirshhorn Museum & Sculpture Garden *Exhibitions:* Whitney Museum Annual; Jewish Museum *Education:* University of Michigan; Art Students League *Dealer:* Pace Gallery, NYC

After working as a naval architect and aeronautical engineer, he was a painter for a number of years until he turned to sculptor in 1961, and began working with steamed wood. An interest in working in a large scale led to the use of metals, and he gained recognition in the mid-1960s with sinuous, gleaming sculptures of aluminum, notably *Wave.* He was interested in the reflective surfaces of metal when curved, and in using asymmetry to create imbalances. "If my forms look like sails or airplane wings, it is simply because these forms are strong and light and are composed of curved lines." He has become known for his large welded steel outdoor sculpture found in major American cities. In recent years he has returned to wood, crafting by hand small-scale pieces free of architectural associations, as well as large-scale delicately hewn sculptures suggesting figural elements.

Donald S. Vogel, *Greenhouse Pleasures,* 48 x 48, oil on panel. Courtesy: Valley House Gallery (Dallas TX)

E. J. Velardi, *Portrait of a Fallen Warrior,* 36 x 30, egg tempera. Orlando Gallery (Sherman Oaks CA)

Ray Vinella, *Manfred,* 17 x 14, oil

VOULKOS, PETER (Sculptor)
1306 Third St., Berkeley CA 94710

Born: 1924 *Awards:* Rodin Museum Prize in Sculpture, Paris Biennial; Silver Medal International Ceramic Exhibition, Ostend, Belgium *Collections:* Museum of Modern Art; Museum of Contemporary Crafts, New York *Exhibitions:* Whitney Museum of American Art; Seattle World's Fair *Education:* Montana State University; California College of Arts and Crafts *Dealer:* Braunstein Gallery, San Francisco; Exhibit A, Chicago; Charles Cowles Gallery, NYC

As an Abstract Expressionist painter in the 1950s, a class in ceramics turned him to sculpture. He helped to revolutionize the use of clay, breaking it free from its limits of craft. An abstract style in naturally colored fired clay suggested inummerable possibilities for the medium, and inspired many of his pupils. As an educator he has wielded a good deal of influence, inspiring the Funk Art of Robert Arneson and James Melchert, as well as the work of many other sculptors. He started making small-scale metal pieces while a teacher in Berkeley, California, pieces which led to large outdoor sculptures such as the thirty-foot-high untitled bronze commissioned by the San Francisco Hall of Justice. This three year project is an example of the continuous energy in his work, a sturdy tower inhabited by twisting and turning organic bronze forms.

WAGNER, RICHARD ELLIS (Painter)
13980 County Rd. 29, Dolores, CO 81323

Born: 1923 *Awards:* Purchase award, Denver Art Museum; Purchase award, Library of Congress *Collections:* Rochester Art Museum; Ford Motor Co. *Exhibitions:* Museum of Modern Art; Pennsylvania Academy of Fine Arts *Education:* University of Colorado; Antioch College *Dealer:* Saks Gallery, Denver; Thackeray Gallery, San Diego

Primarily a landscape painter working in oil and acrylic, his earlier work was impressionist and expressionist paintings based on New England landscapes, seascapes, and the quality of light in the city. Current work is more representational but continues a tradition of strong personal feeling for the landscape. He captures the light and form of western landscapes and the sea in particularly vivid style and free brush strokes. Many of his smaller works are painted on location, in Colorado, and around the world.

WALD, SYLVIA (Printmaker, Sculptor)
417 Lafayette St., New York, NY 10003

Born: 1915 *Awards:* Philadelphia Print Club *Collections:* Museum of Modern Art; Solomon R. Guggenheim Museum *Exhibitions:* Museum of Modern Art; Amerika Haus, Munich *Education:* Moore Institute, Philadelphia *Dealer:* Marden Fine Arts, NYC

Well known as a printmaker, she recently has turned to wall structures and sculpture. The newer works further extend her involvement with materials and layers of color. There is a spirituality in her art that suggests eastern mysticism more than western influences. In her wall structures, she uses natural and altered materials to reconstruct elements of nature. The large spatial sculpture is built of colored wire, composed into continuous circles and sinewy shapes.

WALDRUM, HAROLD JOE (Painter)
P.O. Box 855, Taos, NM 87571

Born: 1934 *Collections:* The Phillip Anschutz Collection; Museum of New Mexico *Exhibitions:* Fort Worth Gallery, Forth Worth; Tally Richards Gallery, Palm Desert, CA *Dealer:* Gerald Peters Gallery, Santa Fe, NM

Early paintings of windows, painted during 1954, were executed in an Abstract Expressionist vein. His "window series" focused on specific architectural forms, capturing the artist's sense of light and metaphysical completeness. For the past five years, he has exclusively painted the religious structures of Northern New Mexico. As part of his process of working, the artist takes Polaroid pictures of the structures he plans to paint, rather than sketching. His works are usually very large, 54 to 63 inches square. They are based on multiple layers of paint, acquiring a mysterious luminosity.

WALKER, JOY (Painter)
41 E. 57th St., New York, NY 10022

Born: 1942 *Awards:* Artist-in-residence, MacDowell Colony; Artist-in residence, Albee Foundation *Collections:* Sidney and Francine Lewis; Mint Museum of Art, Charlotte, NC *Exhibitions:* Andre Zarre Gallery, NYC *Education:* NY Studio School; Columbia University *Dealer:* Andre Zarre Gallery, NYC

A foremost colorist, working with geometric abstraction in a gestural way, her early work consisted of acrylic paintings heavily encrusted with color, intricately locked together. Other early paintings expressed color with templates and spray folds, conveying always a personal color emotion—an abstract diary of the artist's life. Currently she paints with oil stick on metal sheets. She installs these works in room corners, floor-wall junctures, and wall-ceiling junctures. The scale of these works ranges from very small pieces to large wallworks.

WALL, SUE (Painter, Printmaker)
230 West End Ave., Apt. 7 G, New York, NY 10023

Born: 1950 *Awards:* First Place, Laramie Art Guild, American National Show; Grumbacher Award, 79th Annual Catherine Wolfe Exhibition *Collections:* Cleveland Museum of Art; Canton Art Museum *Exhibitions:* Gallery Madison 90, NYC; Zanesville Art Center *Education:* Ohio University *Dealer:* Gallery Madison 90, NYC; Bonfoey Co., Cleveland; Foster Harmon Galleries, Sarasota

Her acrylic paintings are representational compositions dealing with architectural elements. She strives for clarity, a clean spareness, by eliminating the unessential elements from her compositions. Consistent with the content, her technique is concise—the pigment is applied simply and directly. The work builds naturally, allowing a coherent and logical development of a concept. The bare elements of architecture in the paintings seem imbued with a peculiar mortality. The images hold a sense of expectancy, of transience, of growth and decay.

WALLIN, LELAND DEAN (Painter)
151 W 28th St., New York, NY 10001

Born: 1942 *Awards:* Fellowship, University of Cincinnati *Exhibitions:* Harold Reed Gallery, NYC; Sotheby Parke Bernet Benefit *Education:* University of Cincinnati; Kansas City Art Institute *Dealer:* Harold Reed Gallery, NYC

Realistic still-life oil paintings in high-key colors and larger than life size scale comprise the majority of his work. Contrary to conventional still-life studies that display low-key color, dark backgrounds and a modest scale, his work features still-life groupings of especially

Harold Joe Waldrum, *La iglesia de Chamisul,* 45 x 45, acrylic on canvas.
Courtesy: The Gerald Peters Gallery (Taos NM)

Sue Wall, *Country House,* 24 x 22, acrylic on canvas. Courtesy: Bonfouy Co.
(Cleveland OH)

close-up detail set against luminescent backgrounds built up through successive applications of paint. The paint is layered sometimes six to nine layers thick, with each layer successively sharpening detail, heightening luminosity, and intensifying color modeling and depth. Metaphor, formal composition, and lighting and placement remain his primary concerns in his current still-life paintings.

WALTON, FLORENCE GOODSTEIN (Painter)
8066 Ruth St. NE., Minneapolis, MN 55432

Born: 1931 *Collections:* Martin Luther King Museum, Atlanta; Augsburg College *Exhibitions:* Peter Cooper Gallery, NYC; Los Angeles County Art Museum *Education:* Cooper Union; Hans Hofmann *Dealer:* Peter M. David Gallery

After studying with Hans Hofmann and working in an Abstract Expressionist mode, she turned to the inclusion of the image in her early work. She was strongly influenced by Goya, Picasso, Guaguin, and Jan Mueller, all of whom combined allegory successfully in abstract terms. Her current works deal with the events that cause anxieties of contemporary life, such as the Holocaust and nuclear weapons. These large-scale paintings employ brilliant color and the use of brush, palette knife, and rags in their calligraphy. The images of the new works show consistent development from earlier work.

WARHOL, ANDY (Painter, Filmmaker)
Andy Warhol Enterprises, 860 Broadway, New York NY 10003

Born: 1931 *Awards:* Sixth Film Cult Award; Los Angeles Film Festival Award *Collections:* Whitney Museum of American Art; Museum of Modern Art *Exhibitions:* Museum of Modern Art; Art Institute of Chicago *Education:* Carnegie Institute of Technology *Dealer:* Leo Castelli Gallery, NYC

In the 1950s he worked as an advertising illustrator. During the Pop movement of the 1960s, he took objects from advertisements and raised them to the level of art. Early work included rows of Campbell's soup cans, and silk-screens made from photographs of famous faces such as Marilyn Monroe and Jackie Kennedy. Three-dimensional arrangements of soup cans, Brillo boxes, and other product containers were also displayed. These mass-produced works attacked all notions of art. In 1962 he turned to making films which were often long and had little action, such as the eight-hour *Empire*, in which an unmoving camera recorded the front of the Empire State Building from night to dawn. Subsequent underground movies became notorious for their sexual frankness, and he gained a cult following. Later he opened a nightclub called The Exploding Plastic Inevitable, and managed the house band, The Velvet Underground. He publishes a gossip magazine, and has continued in an enigmatic way to influence and comment upon society.

WASSERMAN, BURTON (Painter)
204 Dubois Rd., Glassboro, NJ 08028

Born: 1929 *Awards:* State of New Jersey Grants for Creative Work in Art; Purchase prize, U.S. Information Agency *Collections:* Philadelphia Museum of Art; New Jersey State Museum *Exhibitions:* Pavilion Galleries, Mt. Holly, NJ; New Jersey State Museum *Education:* Brooklyn College; Columbia University *Dealer:* Benjamin Mangel Gallery, Philadelphia

Using bold, regular shapes, and non-representational forms he creates oil paintings and silkscreen prints that are free of any conscious reference to people, places or things. His pursuit of "purity" in art has been carried on consistently for twenty four years. Frequently, his grammar of form is described as hard-edged geometry because of the regular shapes that appear in his work. However, he never makes conscious use of either mathematical or scientific concepts. Instead, he feels his compositions are subjective expressions in which intellect and emotion are brought together in original esthetic terms. In addition, in his most recent oils and silkscreens, he has introduced angular shape relationships and rich nuances of color modulations to the vocabulary of pure horizontal relationships and plain surfaces which for more than a decade were virtually a trademark in his art. Of late, he has also begun using secondary colors (orange, green, violet) as well as neutral shades. These tones supplement the basic primaries he had explored exclusively in the past.

WATIA, TARMO (Painter)
1015 N. Tenth St., Boise, ID 83702

Born: 1938 *Awards:* 38th Idaho Annual Art Award *Collections:* Boise Gallery of Art; Herrett Museum *Exhibitions:* 51st Michigan Annual Exhibition; Watercolor USA *Education:* University of Michigan

Her colorful paintings are recognizable by the usage of high-keyed hues and very personal imagery. The early works were strongly eclectic and consisted of abstract, impressionistic landscapes and still lifes. The current works utilize a range of styles and media. The larger oils are dominated by color fields and abstracted figures. She also has concentrated on figure study from the model, and these drawings are resolved in compositional figure/ground relationships, including collage.

WEBBER, HELEN (Fiber Artist, Muralist)
410 Townsend St., San Francisco, CA 94107

Born: 1928 *Awards:* Award, Women in Design International *Collections:* Bay Area Rapid Transit Headquarters; Lesley College *Exhibitions:* Union Internationale des Femmes Architectes, Paris; Spirit of the Child, Burlington House, NY *Education:* Rhode Island School of Design

In the past decade, she has been noted for her fabric collage, tapestry murals, ranging in size from three to thirty-five feet. The work is bold, colorful, and "primitive" in feeling—containing abstracted images of recognizable objects. Her present tapestry work has become increasingly abstract and sculptural. New pieces are braided forms, some as long as twenty feet, in which she interlaces diverse materials to become meditations on the "essences of humanity and nature." Concurrent with this work, she is expanding her media to work in highly sculpted, bas relief ceramic tile murals.

WEBER, DYANNE STRONGBOW (Painter)
817 Jefferson, N.E., Albuquerque, NM 87110

Born: 1951 *Awards:* 1983 Official Poster Artist, Santa Fe Indian Market; First Place, Five Civilized Tribes Show, Muskogee, OK *Collections:* Red Cloud Indian School; Albuquerque Museum *Exhibitions:* Midland Hotel, Chicago; Indian Market, Santa Fe, NM *Education:* Southwest Texas State University *Dealer:* Adobe Gallery, Albuquerque, NM; Carol Thornton Gallery, Santa Fe, NM

Her past works were of a more traditional watercolor style, using the Texas landscape as subject matter. During this period she learned the techniques of overlapping and bleeding pigment and the importance of color placement. Her current works have been greatly influenced by her past career as an illustrator and de-

Sylvia Wald, *Cloud I,* 7 x 24 x 19, mixed media.

Dyanne Strongbow Weber, *Apache Devil Dancers*, 17x23, watercolor. Courtesy: Adobe Gallery (Albuquerque NM)

signer. Her work to date is characterized by clean graphic design, a strong use of negative space, and an understanding of placement to achieve balance.

WECHTER, VIVIENNE THAUL (Painter, Sculptor)
c/o Fordham University, Bronx, NY 10458

Born: NYC *Awards:* Grumbacher Prize for Oil Painting; Watercolor Prize, New Jersey Museum *Collections:* Museum of Fine Art, Houston; Jewish Museum *Exhibitions:* Everson Museum of Art; American Academy of Arts and Letters Purchase Show *Education:* Union Graduate School

Work encompasses acrylic and oil paintings, sculpture and poetry. Large scale oil and acrylic canvases are awash with color and shapes that relate to a free flowing and rich imagination. The images are wild and eccentric, done with seeking abandon, and primarily abstract in nature. Often times the canvases include texts, most often fragments from her own poetry, incorporated within the composition of the paintings. Often times, as in Chinese paintings, they are accompanied by transcriptions. Large-scale monumental sculpture is in stainless steel and bronze and implies a mix of abstract forms and geometric shapes.

WEEDMAN, KENNETH RUSSELL (Sculptor)
P.O. Box 790 Cc Station, Williamsburg, KY 40769

Born: 1939 *Awards:* Purchase award, Sixth Delta Exhibition; Purchase award, Arkansas Arts Center *Collections:* Cincinnati Museum of Art; Arkansas Art Center *Exhibitions:* Bienville Gallery, New Orleans; "Five American Sculptors", Baldwin-Wallace College *Education:* University of Tulsa *Dealer:* Pinkerton House Portfolio, Louisville

Organic asymetrical constructions in welded steel, whose bases become part of the overall work or spring from the edge of a steel plate, comprise his earliest sculpture. By 1963 he was experimenting with foam plastic burn-out bronze casting to produce box-like forms that play plane against edge. By the middle sixties he was creating painted steel works that gained their tension from the opposition of organic and geometric parts. All of the early sculpture has an enigmatic quality that stems from forms inside other forms, yet the two do not seem physically attached to each other. More recent sculpture utilizes metal and thermal plastics. With plastic, color is inherent to the material and the transparent quality has allowed the artist to suspend forms inside the exterior form. These recent sculptures use no bonding medium, but are created by twisting and tying plastic together, giving the illusion that they have retained the soft quality of heated plastic.

WEEGE, WILLIAM (Printmaker)
P.O. Box 185, Barneveld WI 53507

Collections: Art Institute of Chicago; Museum of Modern Art *Exhibitions:* Museum of Modern Art; Whitney Museum of American Art *Education:* University of Wisconsin *Dealer:* Richard Gray Galleries, Chicago; Nina Freudenheim Gallery, Buffalo

From his own printmaking operations called Jones Road Print Shop, he was influential in the revival of printmaking in the 1970s. Experimental works have included the sculptural use of handmade papers, including the *Barneveld String Symphony* series, in which multi-colored strings were stretched in lattices across wooden frames, dipped in paper pulp, and then several stitched together in layers. His works combine methods of printmaking and papermaking to create tactile and colorful three-dimensional "sculpture."

WEGMAN, WILLIAM (Photographer, Video Artist)
431 E. Sixth St., New York NY

Born: 1943 *Awards:* Fellowship, John Simon Guggenheim Memorial Foundation; National Endowment for the Arts Grant *Collections:* Museum of Modern Art; Whitney Museum of American Art *Exhibitions:* Museum of Modern Art; Whitney Museum Biennial *Education:* Massachusetts College of Art, Boston; University of Illinois *Dealer:* Holly Solomon Gallery, NYC

Video tapes, drawings and photographs are humorous, often parodic works, characterized by informality and deliberate artlessness. *Madam I'm Adam*, for example (in 1970), was a "visual palindrome"—two identical photographs, one printed backwards. In 1975 he began a four-year series of black-and-white over-exposed or under-exposed photographs, with comments drawn directly on the prints. He is known for photographs and video tapes which feature his dog, Man Ray, whom some say was his alter ego, in comical costumes and situations. He made large-scale color Polaroid prints of him which were published in a book in 1982, the year the dog died, entitled *Man's Best Friend*.

WEINER, DANIEL (Assemblage Artist)
Stephen Wirtz Gallery, 345 Sutter St., San Francisco, CA 94108

Born: 1954 *Collections:* La Jolla Museum of Art; Museum van Hegendaagse *Exhibitions:* Oakland Museum; Studio Marconi, Milano, Italy *Education:* Brown University, University of California, Berkeley *Dealer:* Stephen Wirtz Gallery, San Francisco

Earlier glass environments and constructions—or "combines" as the artist refers to them—incorporated shards of glass combined with wood, rocks, and wire to create suspended monochromatic reliefs attached to the wall or suspended within an installation. The shards have continued to evolve in his work and most recently they take on a different dimension with their surfaces obscured by paint. Painted found objects, such as bricks, wheel barrels, and window parts, have also become part of his surfaces. Current work continues to be suspended, but the brittle aspect of glass is achieved through constructions in which the painted surface itself creates the abrasion.

WEISS, LEE (Painter)
106 Vaughn Ct., Madison, WI 53705

Born: 1928 *Awards:* Medal, American Watercolor Society; M. T. McKinnon Award *Collections:* Smithsonian Institution; The Phillips Collection, Washington, DC *Exhibitions:* California Palace of the Legion of Honor; Minneapolis Institute of Art *Education:* California College of Arts and Crafts *Dealer:* Franz Bader Gallery, Washington, DC

Since the early 1960s, she has been involved exclusively in transparent watercolor, exploring techniques adaptable to natural subjects "writ large." She has developed layering techniques, mono-printing with watercolor and then direct painting. In her work she focuses on the details of nature, abstracting and enlarging in a free, wet-on-wet watercolor approach. The works are not pre-planned, allowing the paint-on-paper to dictate the subject and handling. Her subjects include water and stones, moss and rocks, grasses, trees, and occasional large landscapes.

WEISS, RACHEL (Sculptor, Telecommunications Artist)
108 Winthrop Rd., Brookline, MA 02146

Born: 1954 *Collections:* Centre George Pompidou; Na-

Lee Weiss, *Pebbles*, 27 x 40, watercolor. Courtesy: Fanny Garver Gallery (Madison WI)

Don Weller, *The Dam*, 15 x 20, ink.

tional Museum of Science & Technology *Exhibitions:* Helen Shlien Gallery, Boston; Center for Advanced Visual Studies, Cambridge *Education:* Massachusetts College of Art

Early works were concerned with a sculptural investigation of Platonic concepts of ideal form. Pieces were large environmental installations employing many media and materials, with an emphasis on new technologies such as holography. Current work is in two veins: Drawings, videotapes, performances and radio programs, using Antarctica as a central metaphor, explore questions of epistemology, perception, history, and contemporary social concerns. Telecommunications works, including satellite telecasts, slow-scan transmissions, and radio broadcasts, focus on an exploration of the nature of telecommunications media and the development of their use as artistic tools. The work is generally in the form of live, interactive performances, conceptually based on a juxtaposition of classical and/or Biblical myths with contemporary myths and issues.

WELDON, BARBARA (Painter, Printmaker)
6131 Romany Dr., San Diego, Ca 92120

Born: 1931 *Awards:* W. Paton Prize, National Academy of Design *Collections:* San Diego Museum of Art; Bank of America World Headquarters, San Francisco *Exhibitions:* San Diego Museum of Art; Laguna Beach Museum of Art *Education:* San Diego State University; University of California, San Diego *Dealer:* Thomas Babeor Gallery, La Jolla, CA; Ivory/Kimpton Gallery, San Francisco; Kathryn Markel Gallery, NYC; Clark Gallery, Boston

She is primarily a non-representational painter, and also a printmaker. Her earlier works are on paper, with many transparent watercolor washes and layers of rice paper collage. Among her influences are Matisse, Hofmann, Diebenkorn, and Rauschenberg. Current works are mixed-media paintings with collage, using a grid pattern and sometimes involving a small amount of figuration. Many of the newer works are large-scale canvases, but she also continues to work on rag papers. Portions of some of the early paintings and intaglios frequently appear in the layers of collage in her recent paintings.

WELLER, DON (Illustrator, Designer)
2427 Park Oak Dr., Los Angeles, CA 90068

Born: 1937 *Awards:* Lifetime Achievement Award, Los Angeles Society of Illustrators *Exhibitions:* New York Historical Museum

He is a designer and illustrator best known for his stylized watercolors. Working as a freelance artist he has prepared a wide variety of illustrations for such clients as *Time* magazine, *Road and Track* magazine, Warner Brothers Records, Capital Records, United Airlines, Flying Tiger Airlines, Datsun, and many others. His watercolor compositions are noted for their vibrant, clear colors and graceful renderings of predominantly figurative and natural elements. A sense of the surreal is present in the askew perspectives and fluid transformations of one form into another. Negative and positive sections of the design are treated playfully and switch back and forth as branches, grasses, seaweed, and tendrils of nature lead the eye of the viewer along complex paths.

WELLIVER, NEIL G. (Painter)
R.D. 2, Lincolnville ME 04849

Born: 1929 *Awards:* Fellowship, John Simon Guggenheim Foundation; Skowhegan Award *Collections:* Metropolitan Museum of Art; Museum of Modern Art *Exhibitions:* Whitney Museum of American Art; Art

Institute of Chicago *Education:* Philadelphia Museum College of Art; Yale University School of Art *Dealer:* Fischbach Gallery, NYC; Brooke Alexander, NYC

A student of Josef Albers, Burgoyne Diller, and Conrad Marca-Relli, he first gained recognition as a New Realist painter attempting "to make a 'natural' painting as fluid as a de Kooning." Early subjects included shoes *(Red Slips)* and erotic nudes. In the late 1960s and early 1970s nudes were placed in landscape, as in *Girl with Striped Washcloth*, but he eventually abandoned the nude and concentrated on landscapes only, scenes capturing the effects of reflected light in a Maine countryside unmarked by human presence.

WESSELMANN, TOM (Painter, Sculptor)
R.D. 1, Box 36, Long Eddy NY 12760

Born: 1931 *Collections:* Museum of Modern Art; Whitney Museum of American Art *Exhibitions:* Museum of Contemporary Art, Chicago; Sidney Janis Gallery *Education:* Cincinnati Art Academy; Cooper Union *Dealer:* Sidney Janis Gallery, NYC

An early interest in cartooning was replaced by painting, first in the popular style of the time, Abstract Expressionism, but quickly turning instead to a combination of painting and collage, anticipating Pop Art. The *Great American Nudes* were female nudes depicted in solid bright unmodelled areas of color, juxtaposed with advertisement clippings or mass-market products. Multi-media tableau featured similar nude females in three-dimensional environments such as *Bathtub Collage No. 3,* consisting of oil on canvas with objects attached. Later paintings are more *Great American Nudes,ro, often reduced to breasts, lips, or genitals only, as in Bedroom Tit Box.* The women, or their anatomical parts, are often accompanied by depictions of modern still life objects such as ashtrays, televisions, kitchen gadgets, cosmetics, and roses.

WESTON, BRETT (Photographer)
228 Vista Verde, Box 694, Carmel Valley CA 93924

Born: 1911 *Awards:* Fellowship, John Simon Guggenheim Memorial Foundation *Collections:* Museum of Modern Art; San Francisco Museum of Modern Art *Exhibitions:* San Francisco Museum of Modern Art *Dealer:* Weston Gallery, Carmel, CA; Portfolio, Oklahoma City

He began photographing at age thirteen while on a trip in Mexico with his father, the well-known photographer Edward Weston. Afterwards he learned photography from his father, with whom he shared a studio from 1928 until 1935. Abstracts of nature and landscapes are large-format silver prints. Although primarily influenced by his father, Brett Weston's photographs have more of a sharp tonality than his father's. Brett is reticent about his work. "My pictures speak only when we both listen."

WESTON, COLE (Photographer)
c/o Weston Gallery, P.O. Box 655, Sixth Ave., Carmel CA 93921

Born: 1919 *Collections:* Philadelphia Museum of Art; Fogg Art Museum *Exhibitions:* Witkin Gallery; Focus Gallery *Education:* Cornish Institute *Dealer:* Susan Spiritus, Newport Beach, CA; Weston Gallery, Carmel, CA; Witkin Gallery, NYC

He began a photographic career in the U.S. Navy, then worked for *Life* magazine. In 1946 he began working with his father, photographer Edward Weston, until the latter's death in 1958. Executor of Edward's estate, he has since spent a great deal of time printing his father's

negatives. Influenced by the work of his father and brother Brett, his photographs continue Weston concerns, with views of Point Lobos and Big Sur country. He, however, works in color, rendering sensuous landscapes in subdued and delicate earth tones. These large-format dye transfer prints are in precisely sharp focus. Very few black-and-white photographs are produced.

WHEELWRIGHT, JOSEPH (Sculptor)
551 Tremont St., Boston, MA 02116

Born: 1948 *Collections:* Phillips Academy *Exhibitions:* Alan Stone Gallery, NYC Lopoukhine Gallery, Boston *Education:* Yale University; Rhode Island School of Design *Dealer:* Allan Stone Gallery, NYC

Figurative sculpture based on natural found objects is his major concern. Works vary from small miniatures to floor pieces life-size and larger. Using trees, sticks, stones, and bones, he capitalizes on nature's already fanciful forms, turning tiny branches into splayed fingers or a thick, gnarled branch into a contorted hand. The tree and the figure become synonymous in his work. He applies paint and lacquer to the trees as he transforms them into, often humorous, characters.

WHITE, PHILIP (Painter)
710 Clinton Pl., River Forest, IL 60305

Born: 1935 *Awards:* Hallgarten and Clarke Awards, National Academy of Design; Goldsmith Award, American Watercolor Society *Collections:* Union League Club of Chicago; Borg-Warner Collection *Exhibitions:* Oehlschlaeger Galleries, Chicago *Education:* University of Southern California

His realistic paintings combine precise detail, a soft quality of light, and a careful study of the fleeting moment to create uniquely personal statements about his vision of life and the people around him. He works in oil, egg tempera, acrylic, watercolor, pencil, and pastel. His subjects include natural scenes, women, children, and people in general, painted in simple compositions with muted colors. His style has avoided fashions and trends and has remained constant over the years.

WHITE, RANDY LEE (Painter)
c/o Gallery West, 118 E. Kit Carson, Taos NM 87571

Born: 1951 *Collections:* National Museum of American Art; Art Institute of Chicago *Exhibitions:* Baumgartner Galleries; Elaine Horwitch Gallery, Scottsdale, AZ *Education:* Institute of American Indian Arts *Dealer:* Elaine Horwitch Galleries, Scottsdale, AZ; Harcourts Contemporary, San Francisco; Gallery West, Taos, NM

A Brule Sioux Indian, his full name is Randy Lee White Horse. He depicts images from a rich cultural heritage of storytelling, with abstractions of Indians like decorative pictographs expressing narratives about hunting, war, domestic life, and death. Mythical creatures suggest spirits of old, as do Indian symbolic objects and fetishes. Sometimes his own hand prints are applied with paint as a signature. He has also drawn a small white horse at the foot of a work as a way to sign his name. A versatile artist, his mixed media works include molded paper shapes on canvas representing such things as buffalo hides and buckskin jackets. Paintings on paper or canvas have been rendered in acrylic, oil, enamel and watercolor; he has also done graphic work.

WHITNEY, WILLIAM (Painter, Sculptor)
614 Summer St., Olivet, MI 49076

Born: 1921 *Awards:* Bronze medal, Society of Washington Artists; Award of Merit, Michigan Acad-

emy of Science, Arts, and Letters *Collections:* Cranbrook Academy of Art; Battle Creek Art Center *Exhibitions:* Corcoran Biennial; University of California, Davis *Education:* Corcoran School of Art; Cranbrook Academy of Art

He has produced works in a variety of media including oil, casein, and acrylic paintings, pen and pencil drawings, sterling silver chess pieces, jewelry, and ebony and ivory sculpture. Early paintings and conte drawings were heavily influenced by Rouault in an expressionistic manner. In the 1950s he explored both abstract and realistic modes of expression in casein paintings and silver jewelry, but by the 1960s he was drawn towards definitive realism in technical pen drawings and acrylic paintings. More recent work has been a continued interest in realistic technical pen drawings and acrylic paintings, strongly influenced by a year abroad in Europe. Subject matter consists of illustrations of Shakespeare's plays, portraiture and church landscape paintings.

WHYTE, RAYMOND A. (Painter)
30 Fayson Lakes Rd., Kinnelon, NJ 07405

Born: 1923 *Awards:* Notable Americans of Bicentennial Era; Gold Metal of Italy *Collections:* Crocker Art Museum; De Beers Museum *Exhibitions:* Philadelphia Museum of Art; De Saisset Art Museum *Education:* Art Students League; University of Toronto *Dealer:* Galerie de Tours, San Francisco

He paints in a representational and surrealistic style, depicting figures and animals extravagantly garbed in splendid costumes and jewels from another time and place. Lavish colors accentuate the figures and their magnificence. The backgrounds dissolve into misty plains and low, distant hills painted with a softer, subdued palette. In a characteristic composition, a sensuous female figure, dressed as a priestess-queen, steps through a paper drawing mysteriously suspended in mid-landscape. The symbols suggest transformation and "awakening" from a poorer state into one of abundance.

WIEGHORST, OLAF (Painter)
5037 Bluff Pl., El Cajon, CA 92020

Born: 1899 *Awards:* Gold Medal, Cowboy Hall of Fame *Collections:* Gene Autry; Burt Reynolds *Exhibitions:* Cowboy Hall of Fame; Thomas Gilcrease Institute of American History and Art, Tulsa, OK

The Danish-born artist was a working cowboy in Arizona and New Mexico and also a mounted policeman when he was first came to the United States. To depict horses and riders accurately, he believes it is essential to interact with them. At 46 he became a full-time painter. He has travelled to various Western states annually since 1945, camping, riding, making reference sketches, and taking notes. He has studied the cultures of the the Navajo, Apache, Sioux, Cheyenne, Ute, Crow, Blackfoot, and Nez Perce Indians. In addition to oil painting, he works in watercolor, pen and ink drawing, copper etching, and bronze sculpture.

WILCOX, JARVIS GEER JR. (Painter)
412 West 110th St., New York, NY 10025

Born: 1942 *Awards:* A Congor Goodyear Prize for Excellence in Art History, Yale University *Collections:* Metropolitan Life Insurance Co.; Chrysler Museum *Exhibitions:* Wally Findlay Galleries, Beverly Hills; Audubon Artists Show *Education:* Yale University *Dealer:* Sarah Rentschler, NYC

The landscape of upper New York State provides the

content for most of his early oil paintings in addition to a smaller number of still lifes. His style is a contemporary realism with broad, bold applications of color. After a move to New York City, studies of the urban peoples engaged in their daily activities dominate his subject matter. The colors are applied with a palette knife and while worked more delicately in the complex compositions of the city scenes—the forms are bold and the elements continue to be delineated by the meeting of color areas rather than a graphic line.

WILEY, WILLIAM T. (Painter, Assemblage Artist)
c/o Wanda Hansen, 615 Main St., Sausalito CA 94965

Born: 1937 *Awards:* Purchase Prize, Whitney Museum of American Art; William H. Bartels Prize, Art Institute of Chicago *Collections:* Museum of Modern Art; Los Angeles County Museum of Art *Exhibitions:* Museum of Modern Art; Art Institute of Chicago *Education:* San Francisco Art Institute *Dealer:* Hansen Fuller Goldeen Gallery, San Francisco; Allan Frumkin Gallery, NYC

Early paintings were expressionistic, full of mysterious symbols, but he gained recognition in the mid-1960s as a California Funk artist, painting images of minutiae related to surrealism and dadaism. Comic-strip figures and coloring book and children's book illustrations were combined with mystical landscapes in off-beat works related to Pop. Because he likes verbal puns, fragments of letters, logs and notebooks are used in collages and constructions. Objects such as feathers, string, rope and branches suggesting American Indian artifacts and children's games of cowboys-and-Indians are incorporated into three-dimensional works which show a love for the American West. Imaginative drawings such as *The Balance is Not So Far Away From the Good Old Daze* are meticulously drawn and show infinite spacial planes, imaginary charts, and metaphysical objects. He is an artist who defies categorization.

WILLIS, THORNTON (Painter)
85 Mercer St., New York, NY 10012

Born: 1936 *Awards:* Fellowship, John Simon Guggenheim Memorial Foundation; Fellowship, National Endowment for the Arts *Collections:* Museum of Modern Art; Whitney Museum of American Art *Exhibitions:* "American Painting: The 80s", Grey Art Gallery, NYC; Museum of Modern Art *Education:* University of Alabama *Dealer:* Oscarsson-Hood Gallery, NYC

Work is primarily oil and acrylic color-field expressionist paintings. His "Slat" or "Wall" paintings of the late 1960s indicated the potential for "form and field" painting as a direct outcome of the process of making "color-field" paintings. By 1972-73 he had arrived at the use of the triangle or "Wedge" shape in his canvases in which one can read, along the painted edges, a tangible tension between form and field and the formal implications of their mutual impingement. Since the early 1980s the artist has exhibited a series of *Zig Zag* paintings of interlocking triangulated volumes.

WILMARTH, CHRISTOPHER MALLORY
(Sculptor)
c/o Hirschl & Adler Modern, 851 Madison Ave., New York, NY 10017

Born: 1943 *Awards:* Fellowship, John Simon Guggenheim Memorial Foundation; Fellowship, National Endowment for the Arts *Collections:* Metropolitan Museum of Art; Art Institute of Chicago *Exhibitions:* Seattle Art Museum; Whitney Museum of American Art *Education:* Cooper Union *Dealer:* Hirschl & Adler Modern, NYC

Primarily an abstract sculptor in metal and glass, his early works were in wood. Influenced by Brancussi, he produced a series of works in which well-turned wooden spools were juxtaposed with heavy rectangular plate glass panes. Soon he moved into free-standing floor pieces and wall hung reliefs that combined curved forms of simple rectangular shapes of steel, bronze and etched glass to create non-objective pieces that evoked a variety of moods. In his more recent work he combines blown glass shapes with bronze to create reliefs with an enormous range of tone and depth.

WILSON, ANNE (Fiber Artist)
7361 North Greenview, Chicago, IL 60626

Born: 1949 *Awards:* Grant, Illinois Arts Council; Fellowship Grant, National Endowment for the Arts *Collections:* California Polytechnic State University; The Smith, Hinchman, and Grylls Architects, Corporate Collection *Exhibitions:* John Michael Kohler Arts Center; Visual Arts Center of Alaska *Education:* Cranbrook Academy of Art; California College of Arts and Crafts *Dealer:* Miller/Brown Gallery, San Francisco

Early work employed copper wire, linen, and rayon in netted and loom-woven wall constructions based on an underlying grid pattern. In subsequent pieces surfaces became denser and in greater relief; Color became more assertive leading to her current work. Present work encompasses two directions—"hair" pieces and "band" pieces—that have evolved out of research into indigenous clothing forms, especially protective clothing that responds to social environment and climate. The hair pieces grew out of a notion of "urban furs". Color is used for its emotive potential, influenced by punk hair and the visual impact of chemical color on natural materials. The band pieces respond to the hard exterior sensibility of warrior clothing, influenced by the Japanese obi tradition and samuri armor.

WILSON, DONALD ROLLER (Painter)
651-A Wilson Ave., Fayetteville, AK 72701

Born: 1938 *Collections:* Hirshhorn Museum and Sculpture Garden; Brooklyn Museum *Exhibitions:* Whitney Museum of American Art; Museum of Contemporary Art, Chicago *Education:* University of Kansas *Dealer:* Holly Solomon Gallery, NYC; Moody Gallery, Houston

His paintings are anti-modernist and eccentric works that deal with the artist's unusual and personal subject matter. He is highly narrative, and the story-like qualities in his work are as important as the visual characteristics of the work itself. Individual paintings are like chapters in an ongoing scenario that illustrates the interrelated activities carried out by characters in his work. Cats, monkeys, and dogs are dressed as humans, wandering about in empty, gray rooms. The surfaces are highly polished, highly refined, and very carefully and realistically rendered.

WILSON, GEORGE LEWIS (Painter)
4197 Park Ave. #6, Bronx, NY 10457

Born: 1930 *Awards:* Travel grant, Washington Square Outdoor Art Exhibit; First Prize for Figure Painting, Atlantic City Boardwalk *Collections:* Johnson Publications, Inc.; New Museum *Exhibitions:* Metropolitan Museum of Art; The National Academy of Design *Education:* Art Institute of Pittsburgh; National Academy School of Fine Art *Dealer:* Dorsey Art Gallery, Brooklyn

Young people and children are the predominant subject matter of his post-impressionist oil paintings. Earlier work was done in a very realistic manner, but in more recent work subjects are most often painted outdoors on location where the inability to control the light, sounds, and elements of the natural environment contributes to some exciting moments in the impressionistic execution of the paintings. Occasionally, the artist focuses on one child, as a solitary figure pondering private thoughts, silhouetted on a pastel tinted canvas. His loose, light-filled strokes gently modulate one hue with the next, violet to rose, blue to green, building shapes and sensitivities with colors rather than lines.

WILSON, JANE (Painter)
c/o Fischbach Gallery 29WS-7, New York, NY 10019

Born: 1924 *Awards:* American Academy and Institute of Arts and Letters Award in Art; Award, Louis Comfort Tiffany Foundation *Collections:* Metropolitan Museum of Art; Museum of Modern Art *Exhibitions:* Fischbach Gallery, NYC; Cornell University *Education:* University of Iowa *Dealer:* Fischbach Gallery, NYC

Her medium to large scale oil paintings alternate between still-life and landscape compositions. Her recent Long Island landscapes come out of the northern European landscape tradition that runs through Caspar David Friedrich, Constable and Turner. There are no people on her fields and beaches. The human world seems to be holding its breath, through different stages of a continuing, sometimes heated debate among earth, water, and sky. In *Storm Watch* the trees blow left, while storm clouds bear down to the right. In *Day into Night (Julia's Atlantic),* clouds in a big sky swirl, caress or almost mock the strips of grass, sand and sea beneath it.

WILSON, NICHOLAS JON (Painter)
1600 W. Mesa Dr., Payson, AZ 85541

Born: 1947 *Awards:* Third Prize, Watercolor Competition, Cowboy Hall of Fame *Collections:* Cowboy Hall of Fame; Valley National Bank of Arizona *Exhibitions:* Western Heritage Sale; American Miniatures *Education:* Self-taught *Dealer:* Settlers West Galleries, Tucson

Although he is best known for his highly detailed gouache paintings of Western mammals and southwest landscapes, he also works in sculpture, pottery, and stone lithography. His paintings are executed in a defined realism with opaque watercolor on board, and close detail scratched out of the surface with an engraver's tool. First of all a naturalist, all his art-related activities are an extension of his life-long fascination with the natural world. While many of the settings for his paintings are within walking distance of his home, his research travels have taken him all around the world and he has exhibited extensively both in this country and abroad. He is currently involved in producing a series of murals in New York City.

WILSON, RICHARD BRIAN (Painter)
1065 Old N. Oregon Trail, Redding, CA 96001

Born: 1944 *Awards:* First Prize, Grand Galleria National Painting Competition; Purchase Award, Downey Art Museum *Collections:* San Jose (CA) Museum of Art; IBM Corporation *Exhibitions:* Reed College; University of California, Davis *Education:* California State College *Dealer:* Hank Baum Gallery, San Francisco

His early work revolved around the use of shaped

canvases, strong color contrasts, and complex linear structure. He developed a sensitivity to the interplay between color and a restrained structural format. The present works are concerned with achieving a provocative illusion of light, space, and atmosphere. In these paintings he strives to transcend the technical components to create a particular mood.

WILSON, ROBERT (Set Designer, Sculptor)
147 Spring St., New York, NY 10012

Born: 1941 *Awards:* Fellowship, John Simon Guggenheim Memorial Foundation; National Endowment for the Arts *Collections:* Museum of Modern Art; Muse de Art Moderne *Exhibitions:* The Contemporary Arts Center; Whitney Museum of American Art *Education:* Pratt Institute; University of Texas

While primarily renowned for his work as a theater director and designer, he has worked in a variety of materials including wood, and metal sculpture and architectural installations as well as graphite drawings both as an aid in the visualization of his enormous theater pieces and as works of art in themselves. Early work included environmental installations constructed of poles and then was followed by a series of chairs that became important structural elements in his theater pieces *Einstein on the Beach* and *A Letter from Queen Victoria*. Recently he has produced a series of graphite drawings for his gigantic project *Civil Wars* that both convey the process of his visualization and function as emotive, expressive images.

WIMBERLEY, FRANK WALDEN (Painter, Sculptor)
9911 35th Ave., Corona, NY 11368

Born: 1926 *Awards:* Best in Show, Black Artists of Long Island *Collections:* Metropolitan Museum of Art; Art Institute of Chicago *Exhibitions:* Spectrum IV Gallery, New Rochelle, NY; Museum of Modern Art *Education:* Howard University *Dealer:* Peter S. Loonam Gallery, Bridgehampton, NY; Spectrum IV Gallery, New Rochelle, NY

Earlier work emphasized combinations of texture — particularly the collages and handmade paper reliefs. Sculptures were created with found objects arranged with strong design elements to produce pieces aesthetically pleasing yet dramatically bold. Newer sculptural pieces relate to these assemblages but move closer to a clean constructivism with much more of a feeling of weight. Both nature and surrealism are major influences on the extensive range of inventive lyricism in the new paintings. There are floating configurations that can be sensed as biomorphic and others that are transparent and suggest movements found within nature. Portions of the canvas are treated as a sparse field and other spaces filled with rippling and powerful thrusts of color.

WINTER, ROGER (Painter)
3228 Rankin, Dallas, TX 75205

Born: 1934 *Awards:* Top Award, Southwestern American Art; Top Award, Dallas Annual, Dallas Museum of Art *Collections:* Dallas Museum of Art; Museum of Fine Arts, Norman *Exhibitions:* Delahunty Gallery, Dallas; Whitte Museum *Education:* University of Texas; University of Iowa *Dealer:* Fischbach Gallery, NYC

Between 1966 and 1976 paintings in oil, silkscreens, and collages employed figures and objects as "fetishes", often times displacing space and time. Subjects

were essentially autobiographical showing family members, friends, Texas houses and landscapes, rural England, animals, trains and cars. Since 1977 works have been exclusively in oils, usually on a larger scale, where space and time are unified and the subjects more spontaneously chosen. Brushwork is more revealed and the paint thicker on these newer canvases. Often times, the brushwork may separate from the images making a secondary image of its own.

WIRSUM, KARL (Painter, Sculptor)
c/o Phyllis Kind Gallery, 313 W. Superior St., Chicago IL 60610

Born: 1939 *Collections:* Whitney Museum of American Art; Art Institute of Chicago *Exhibitions:* Museum of Contemporary Art, Chicago; Art Institute of Chicago *Education:* School of the Art Institute of Chicago *Dealer:* Phyllis Kind Gallery, Chicago and NYC

First recognized as a member of Chicago's Hairy Who group, his dynamic erratic forms in loud colors crowd the canvas in intricate arrangements, syncopated rhythms. Electrified letters and images in indiscernible spacial planes are organized only through their surface symmetry. Any other order is imposed by the observer, as with each viewing the images can be combined in new sequences to create a new visual interpretation. His medium is primarily acrylic, but he has also used ink, crayon and colored pencil, and has experimented with all kinds of surfaces such as acetate, ragboard and plexiglass. Occasional wood constructions painted in bright acrylics are energetic three-dimensional equivalents of the paintings, such as *Service Station*, in which a seemingly electrified muscle man prepares to serve a tennis ball.

WISON, CHARLES BANKS (Painter, Printmaker)
100 North Main St., Miami, OK 74354

Born: 1918 *Awards:* Governor's Art Award; Western Heritage Award, Cowboy Hall of Fame *Collections:* Metropolitan Museum of Art; Library of Congress *Exhibitions:* International Watercolor Exhibition, Art Institute of Chicago *Education:* School of the Art Institute of Chicago *Dealer:* Spring River Studio, Miami, OK Renowned as a painter, printmaker, muralist, and illustrator, he celebrates the heritage of the Southwest, especially his home state of Oklahoma. His works in egg tempera and oil record the life of the original Americans, the later pioneer Americans, and the present day descendents of both. Also a prolific portrait artist, his famous sitters have included Will Rogers, Sequoyah, the athlete Jim Thorpe, U.S. House Speaker, Carl Albert and many others. His major undertaking has been the preparation of four murals totaling 110 feet in length for the Oklahoma Capitol rotunda presenting the state's discovery, frontier trade, Indian immigration and settlement.

WISSEMANN-WIDRIG, NANCY (Painter)
Box 524, Southold, NY 11971

Born: 1929 *Awards:* Outstanding Realist, Western New York Artists Exhibition, Albright Knox Art Gallery; Childe Hassam Purchase award, American Academy of Arts and Letters *Collections:* University of Kansas Museum of Art; Canton Art Institute *Exhibitions:* Farnsworth Museum; Tibor de Nagy Gallery, NYC *Education:* Syracuse University; Ohio University *Dealer:* Tibor de Nagy Gallery, NYC

Her large scale interiors, still lifes, and landscapes are detailed, sensitive observations executed in acrylics and oils. From her earlier work in a more abstract manner she brings a concern for surface and structure, but since 1968 her work has been characterized as "painterly realism" heavily influenced by Vuillard, Bonnard, and Monet. Her work strikes a delightful balance between hard-edged realism and simplified flattened forms. The detail in her work is rarely gratuitous and her use of simplification informs rather than obscures the image.

WIZON, TOD (Painter)
109 Ivy Hill Rd., Ridgefield, CT 06877

Born: 1952 *Collections:* Metropolitan Museum of Art; Minneapolis Institute of Arts *Exhibitions:* Willard Gallery, NYC; Yarlow Salzman Gallery, Toronto *Education:* School of Visual Arts *Dealer:* Willard Gallery, NYC

In 1976 he began painting landscapes from memory, deliberately not using sketches of photographs so the works would contain a margin of invention. This gave rise to ambiguity, as his palette adapted to his emotions through the use of raw, unmixed color. In these early paintings, he tried to preserve the illusive nature and feelings of first seeing a place fresh and uninhabited. Emotional ways of perception gradually overtook him. Since 1978 his work has become confrontational, even psychedelic. He currently is working to distill atmosphere and spaciousness from a predominantly cathartic body of work.

WOJNAROWICZ, DAVID (Painter, Collage Artist)
c/o Civilian Warfare, 526 E. Eleventh St., New York NY 10009

Born: 1954 *Collections:* Eugene Schwartz; Don and Mira Rubell *Exhibitions:* Alexander F. Milliken Gallery; Civilian Warfare *Education:* Self-taught *Dealer:* Civilian Warfare, NYC; Hal Bromm Gallery, New York, NY

Collage paintings are like layers of old posters peeling off urban walls. Acrylics and spray paints are employed to create commercial-looking images of violence, often using stencils to apply the paint to such grounds as grocery store posters, world maps, garbage can lids and beach logs. Subjects include the military in Central America and Viet Nam, prison life, the drug culture, street murder and homosexual sado-masochism. He has also painted on abandoned buildings, piers and cars in Lower Manhattan, and has been called "the spirit of East Village art." He has published several books, including a group of monologues of boys in bus stations entitled *Sounds in the Distance;* he is a photographer and a filmmaker; and he has also made recordings as a member of the musical group called 3 Teens Kill 4 (No Motive).

WOJTYLA, W. HASSE (Painter)
2102 C St., San Diego, CA 92102

Born: 1933 *Awards:* Artist in Residence, KPBS Television *Collections:* University of Illinois; Bellas Artes, Mexico City *Exhibitions:* Brooklyn Museum of Art; San Francisco Museum of Modern Art *Education:* School of the Art Institute of Chicago; University of Illinois *Dealer:* Spectrum Gallery, San Diego, CA; Maple Gallery, San Diego, CA

He has experimented in the past with various art styles including surrealism, abstract expressionism, and non-objectivism. He also has been involved with filmmaking as an art form. Recently he completed a series of paintings titled *Nude in the Shower*. These canvases were abstracted in a highly individualistic manner, with human forms writhing beneath torrents of flowing

Del Yoakum, *Sunday Visit,* oil. Courtesy: Masters (Sedona AZ)

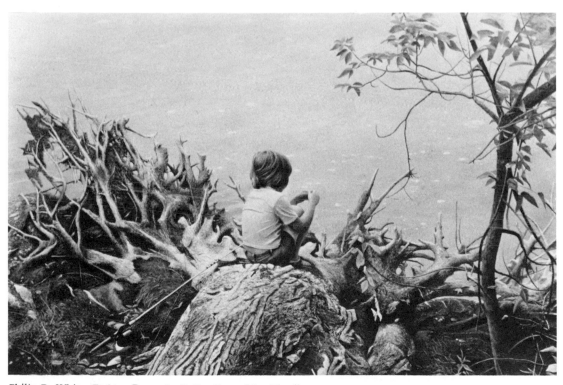

Philip B. White, *Fishing From the Fallen Tree,* 24 x 36, oil.

water. At present he is doing a series of "savagist" paintings. These works depict abstracted figures engaged in brutal confrontations. Each painting is taken from a true crime incident that has fascinated the artist.

WOLFE, BRUCE (Painter, Sculptor)
206 El Cerrito Ave., Piedmont, CA 94611

Born: 1941 *Awards:* Clio International Award of Excellence; Zellerbach Award *Collections:* Levi Strauss Corporation; Lucas Films *Exhibitions:* Pantechnicon Gallery; Corcoran Gallery of Art *Education:* San Francisco Art Institute; California State University at San Jose

Work is in representational oil paintings and bronze sculpture in an illustrative manner. Painting are primarily portraits and figurative work taken from folklore, mythological, or fantasy settings, and his canvases range from an almost photo-realist style to a colorful expressionism, but always within a realistic context. Work has been primarily for commercial advertising campaigns including Levi Strauss, Bank of America, San Miguel International and Sony Corporation. His bronze sculpture of Maestro Kurt Herbert Adler stands in the San Francisco Opera house. Current work is exclusively painting with an emphasis on people. Recent commissions have included *The Olympic Athlete* for Southern Pacific Corporation and a poster/program design for the San Francisco Chamber Orchestra Music Festival.

WOOLSCHLAGER, LAURA TOTTEN (Painter)
Rt. 1, Box 122 H, Omak, WA 98841

Born: 1932 *Awards:* Best of Show, National Western Art Show *Collections:* Carnegie Library, Lewiston, ID; Favell Museum, Klamath Falls, OR *Exhibitions:* Curtis Gallery, Spokane, WA; Museum of Native American Culture *Education:* Redlands University; Syracuse University

Her early paintings concentrated on common objects and a bold use of color. The pattern and design elements simplified but enhanced the subject. More recent works show a focus on the Northwest environment. Combining figurative and abstract forms has led her to develop a distinct, expressive style. Her use of Native American and wildlife themes emphasizes the spirit of the subject. She recently completed a series of hinged triptychs, and has expanded her media to include embossed etchings and bronze sculpture. Her current project is a suite of paintings, *Earth Issues,* inspired by American archaeological discoveries.

WRIGHT, DONALD (Sculptor)
c/o The Selective Eye Gallery, 118 Don Gaspar, Santa Fe, NM 87501

Born: 1930 *Awards:* Purchase Prize, Detroit Institute of Arts; First Prize, Metal Sculpture, New Mexico State Fair *Collections:* Detroit Institute of Art *Exhibitions:* Southwestern Craftsman Exhibition; International Jewelry Exhibition, Munich *Education:* Southwestern Missouri State University; Cranbrook Academy of Art *Dealer:* The Selective Eye Gallery, Santa Fe, NM

Since 1968, he and several assistants in his Santa Fe studio have used a lost wax-casting process to create his bold, complex non-representational forms in bronze and other materials. He also designs and casts gold jewelry. These are pieces formed to the body, echoing his sculptural style. He has also served on the faculties of Pennsylvania State University, Central Washington University, and Utah State University.

WUDL, TOM (Painter)
c/o L.A. Louver Galleries, 55 N. Venice Blvd., Venice CA 90291

Born: 1948 *Collections:* Marilyn Lubetkin; Santa Barbara Museum of Art *Exhibitions:* Santa Barbara Museum of Art; Documenta 5, Kassel, Germany *Education:* California Institute of the Arts *Dealer:* L.A. Louver Galleries, Venice, CA; Ruth S. Schaffner Gallery, Santa Barbara

Born in Bolivia, he came to California at age ten. An abstract colorist, he has continually experimented with media and techniques. *Untitled* (1972), for example, was acrylic polymer and gold leaf on perforated rice paper embedded with maple and bamboo leaves, laminated with polymer. In it a lattice of diamond shapes overlapped a checkerboard on a textured surface of additional minute patterns. A recent show included paintings, drawings, photographs and ceramic wall pieces which reflected current interests in metaphysics. Combining abstract and figural elements, the photographs featured female nudes decorated with paint, emotionally charged images which suggested mortality. A similar effect results in *Untitled* (1980), in which a drawing of a classical female nude is cropped by a frame and juxtaposed with a mass of intestinal organs in a blue rectangle place upon long expanses of yellow and black.

WYETH, ANDREW (Painter)
c/o Frank E. Fowler, P.O. Box 247, Lookout Mountain, TN 37350

Born: 1917 *Awards:* Carnegie Institute; Pennsylvania Academy of the Fine Arts *Collections:* Metropolitan Museum of Art; National Gallery of Art *Exhibitions:* Metropolitan Museum of Art; Museum of Fine Arts, Boston *Dealer:* Coe Kerr Gallery, NYC

His father, illustrator and mural painter N.C. Wyeth taught him the techniques of painting in watercolor and tempera. Andrew stayed in his birthplace of Pennsylvania and painted the surrounding landscape. Painterly representations of snow-covered fields brought him recognition in 1938 when he held first solo shows in New York and Boston. Dedicated to American tradition, he remains uninvolved in the contemporary art of experimentation. Highly detailed realistic paintings of life in Pennsylvania, primarily in earth tones, are meticulously composed to produce a sense of psychological isolation, melancholy or abandonment. Sentimental renderings of home-bound life have continued in popularity.

WYETH, JAMIE (JAMES BROWNING) (Painter)
c/o Frank E. Fowler, P.O. Box 247, Lookout Mountain TN 37350

Born: 1946 *Awards:* Honorary D.F.A., Elizabethtown College *Collections:* Museum of Modern Art; Smithsonian Institution *Exhibitions:* Pennsylvania Academy of the Fine Arts; Amon Carter Museum *Dealer:* Frank E. Fowler, Lookout Mountain, TN; Coe Kerr Gallery, NYC

Son of Andrew Wyeth, he was a child prodigy, studied with his aunt Carolyn Wyeth and at the age of nineteen had his first New York show. During a time when Abstract Expressionism and Pop Art were at the forefront, his careful realism went widely unnoticed. With a recent resurgence in the popularity of representational painting, his work has gained greater recognition. Uninterested in his father's use of tempera, he works primarily in oil, watercolor and gouache. Delicate meticulous details mark his luminous style in work which

Louise Dunn Yochim, *In Memorium,* 40 x 48, oil. Courtesy: Eilat Museum (Eilat Israel)

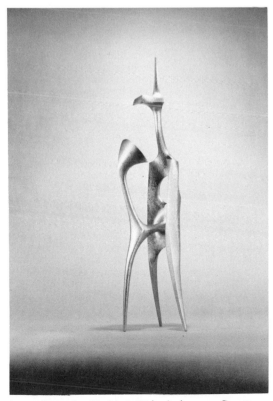

Donald Wright, *Untitled,* 71 high, bronze. Courtesy: The Selective Eye Gallery (Santa Fe NM)

William Zacha, *Carlo,* bronze. Courtesy: Bay Window Gallery (Mendocino CA)

includes portraits of personal acquaintances such as Andy Warhol and John F. Kennedy. Recently nature has become his subject matter, notably in a series of engravings and a set of four etchings entitled *The Farm,* which he did with Josef Werner.

YOAKUM, DELMER J. (Painter)
P.O. Box 149, Sedona, AZ 86336

Born: 1915 *Awards:* John Marin Memorial Award, Watercolor USA; Adahl Hyde Morrison Silver Medal *Collections:* Butler Institute of American Art; San Diego Art Museum *Exhibitions:* Los Angeles County Museum of Art; National Academy of Design *Education:* Chouinard Art Institute; University of Southern California *Dealer:* The Masters Gallery, Sedona, AZ

An oil and watercolor painter in a contemporary realism style, he paints a wide variety of subjects from his immediate environment and experience. Early works were dominated by realism while studying with his teacher, Thomas Hart Benton. During the 1950s and the 1960s an interest in abstract expressionism can be seen in his canvases. Carried over into his present work are his persevering strengths in design and colors. His compositions make use of lavish color chosen from a broad palette. He seeks to express the spiritual qualities which link the personal with the universal.

YOCHIM, LOUISE DUNN (Painter)
9545 Drake Ave., Evanston, IL 60203

Born: 1909 *Awards:* Gold Medal, Academia Italia; Nomination for the Illinois Governor's Award for the Arts *Collections:* Illinois State Museum; Eilat Museum, Eilat, Israel *Exhibitions:* Art Institute of Chicago; Spertus Museum *Education:* School of the Art Institute of Chicago; University of Chicago *Dealer:* 4 Arts Gallery, Evanston, IL

A versatile artist, she works in oil, watercolor, lacquer, gouache, and casein paintings, as well as lithography and prints. Works are an expressive and personal statement. "I paint that which expresses my feelings, my intuitions, my reflections, my fantasies and my beliefs —all within the context of artistic integrity." She strives to find a harmonious inter-relationship of line, form, color, and texture with her expressed need to address social and humanistic concerns.

YOSHIDA, RAY KAKUO (Painter)
1944 N. Wood, Chicago IL 60622

Born: 1930 *Awards:* Frank G. Logan Medal, Art Institute of Chicago; Walter M. Campana Prize, Art Institute of Chicago *Collections:* Art Institute of Chicago; Museum of the Twentieth Century, Vienna *Exhibitions:* Art Institute of Chicago; Museum of Contemporary Art, Chicago *Education:* University of Hawaii; School of the Art Institute of Chicago; Syracuse University *Dealer:* Phyllis Kind Gallery, Chicago

Born in Hawaii, he was first recognized as a Chicago Imagist. *Comic Book Specimens* is a series of collages consisting of picture fragments and balloon captions from super-hero comic books arranged into strange narratives. Figural and object fragments are included in many of the paintings, as in *Partial Evidences.* Wavy stripes often cover an entire composition, modulating the images, giving the figures striped faces and striped clothing. This interest in the gradual metamorphosis of form, and in the subtle modulation of color are prevalent themes throughout his work. Later work contains geometrical forms articulated in intricate patterns of dots and shapes and placed on backgrounds of the same minute patterning, as in *Unreliable Refuge.*

YOST, ERMA MARTIN (Painter, Collage Artist)
223 York St., Jersey City, NJ 07302

Born: 1947 *Collections:* Port Authority, World Trade Center; Pace University Art Museum *Exhibitions:* Pennsylvania State University; Jersey City Museum *Education:* James Madison University *Dealer:* Noho Gallery, NYC

She combines the techniques of oil painting and fabric patchwork in compositions populated with abstracted figures and nature motifs. Strongly influenced by the tradition of Mennonite quilts, she borrows from historic quilt patterns, adapting their images and characteristic repetition to her own aesthetic. The fragments of geometric "quilt" shapes appear throughout her landscapes providing an underlying structure. Isolated images emerge from this ground—a single tree, bone, or animal—which seem poised, and assume aspects of an icon.

YOUNG, OSCAR VAN (Painter)
2293 Panorama Terrace, Los Angeles, CA 90039

Born: 1906 *Awards:* Bartels Prize, Art Institute of Chicago; Purchase Prize, Frye Museum *Collections:* Los Angeles County Museum of Art; Palm Springs Desert Museum *Exhibitions:* San Francisco Museum of Modern Art; Los Angeles County Museum of Art *Education:* Art Academy, Odessa, U.S.S.R. *Dealers:* Copenhagen Galleri, Solvang, CA; Zantman Galleries, Palm Desert and Carmel, CA

His realistic paintings depict scenes comprised of cityscapes, landscapes, and traditional portraiture. The texture and color composition of the natural landscape become foreground elements in his paintings and the focus of much of his work. His stated interest in interpreting the inner essence of actual appearances has lead the artist to attempt to display the mystical elements of nature in his work.

YOUNG, ROBERT (Ceramic Sculptor)
47-734-7 Hui Kelu St., Kaneohe, HI 96744

Awards: Award, Hawaii Craftsmen; Award, Art Flora, Honolulu Academy of Arts *Collections:* Honolulu Academy of Arts; Contemporary Arts Center of Hawaii *Exhibitions:* Honolulu Academy of Arts; Convergence, NYC *Education:* University of Hawaii

His low-fire ceramic sculpture is constructivist and abstract with lightly airbrushed acrylic surfaces. Handbuilt forms and textured slabs are pierced by clay rods which slide through holes in the pieces to suspend and balance them in a seemingly precarious stance. The pastel shades used on his work of the 1970s is atmospheric and suggests a non-specific reverie that is reflected in such titles as *I'll certainly try to reach you, but . . .* and *Just Hanging Around.* Recent work employs crisper geometric forms such as pyramids and cubes which are pierced and supported by finely finished, thin rods of wood. These pieces are brushed with brighter colors and are encrusted here and there with gold leaf. Although small-scale, table sized pieces, they are assertive presences with an air of elegance and audacity.

ZACHA, WILLIAM (Sculptor, Painter)
484 Main St., Mendocino, CA 94560

Born: 1920 *Exhibitions:* Bay Window Gallery, Mendocino, CA; Kabutoya Gallery, Ginza, Tokyo *Education:*

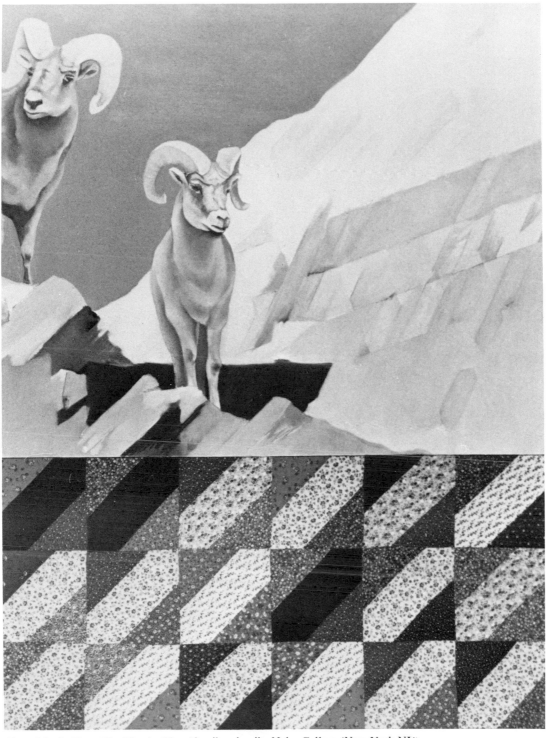

Erma Martin Yost, *The Watch,* 50 x 40, oil and quilt. Noho Gallery (New York NY)

George Washington University; Studio Hinna, Rome *Dealer:* Bay Window Gallery, Mendocino, CA

He works in watercolor, sculpture, and serigraphy. His sculpture, influenced by San Francisco sculptor Ruth Cravath, shows his love of the Renaissance bronzes he studied in Italy. He works primarily with the male figure in bronze. The watercolors employ a line drawing, with washes and color that accentuate mood. Presently he is working in serigraphy, preparing a series of fifty five serigraphs of contemporary scenes on the ancient Tokaido road that connects Tokyo and Kyoto, Japan.

ZEBOT, GEORGE JURIJ (Painter, Illustrator)
P.O. Box 4295, Laguna Beach, CA 92652

Born: 1944 *Awards:* Gold Medal, Illustration West 21; Commendation, City of Los Angeles *Collections:* City of Newport Beach Collection; Watt's Towers Art Center *Exhibitions:* Communication Arts Annual; Illustration West 23, Los Angeles *Education:* California State University, Long Beach

Working in watercolor and mixed media illustration he has developed a style of illustration that combines fantasy with the real in a careful combination of abstract and representational elements. Works are meticulously detailed renderings of natural objects and forms set in illusionary space to create effects that at first may pass unnoticed by the viewer because of the fluidity and ease of style with which they are executed. His illustrations are not expressionistic but derive there affect through subtle juxtaposition. Clients have included the National Football League, CBS, and Honda. Current work includes a public arts project with Richard Turner on Central America.

ZEISLER, CLAIRE (Sculptor)
c/o Rhona Hoffman Gallery, 215 West Superior, Chicago, IL 60610

Born: 1903 *Collections:* Art Institute of Chicago; Stedelijk Museum, Amsterdam *Exhibitions:* Whitney Museum of American Art; Art Institute of Chicago *Education:* Institute of Design, Chicago *Dealer:* Rhona Hoffman Gallery, Chicago

Her early fiber works were small employing a double weave and stuffed to form pillows. These were suspended in a filigree web like spiders' packets. Later work was monumental in scale and employed macrame and wrapping to create suspended forms with dramatic contrasts of hard, tightly controlled wrapping and free flowing unfettered ropes. In her more recent *Coil Series* she has employed natural hemp, wool, and polyester in bright primary colors wrapped over steel coil to give the works a new dimension and life.

ZHEUTLIN, DALE R. (Sculptor)
139 Sixth St., Pelham, NY 10803

Born: 1948 *Awards:* Sculpture Award, National Association of Women Artists; Sculpture Award, Hudson River Museum *Collections:* IBM Corporation; The American Banker *Exhibitions:* Hudson River Museum; Renwick Gallery, Smithsonian Institution *Education:* Rhode Island School of Design; Columbia University

Her constructions combine design, illusion, and texture. Her interest in architecture and archaeology is reflected in both her past and current work. She relies on ancient inspirations for her contemporary interpretations. Recent ceramic constructions are inspired by an old brick fort in San Francisco. These wall pieces are

mysterious, dynamic constructions of smoke-fired porcelain and stoneware. The works range in size from small, intimate constructions one foot square to large architectural installations.

ZIMMERMAN, ELYN (Sculptor, Installation Artist)
39 Worth St., New York, NY 10013

Born: 1945 *Awards:* Fellowship, National Endowment for the Arts; Creative Artists Public Service Grant *Collections:* Whitney Museum of American Art; Los Angeles County Museum of Art *Exhibitions:* Museum of Contemporary Art, Chicago; Hudson River Museum *Education:* University of California, Los Angeles *Dealer:* Koplin Gallery, Los Angeles

Her installations and constructions create spatial situations in which the perceptions of the viewer become the subject of the work. The environments are meant to be experienced through movement and over time. All aspects of the work are not seen at once—they are revealed sequentially through inspection. Each construction is conceived for its particular site. Recently, most of her outdoor commissions have used natural cleft and polished granite, often in conjunction with a pool or waterfall. The reflective aspect of polished stone and water are important elements in the work.

ZONIA, DHIMITRI (Painter)
4680 Karamar Dr., St. Louis, MO 63128

Born: 1921 *Awards:* American Artist Magazine; Purchase award, Drawing America *Collections:* Butler Institute of American Art; Oklahoma Art Museum *Exhibitions:* Minnesota Art Museum Traveling Exhibition; University of Missouri *Education:* Self-taught *Dealer:* Aaron Galleries, Clayton, MO

A self-taught artist who spent a great deal of his time in Europe faithfully copying the pigments, support, surface preparation and under-painting of the old masters, his paintings are executed in oils in a super realist style. Still-lifes, interior settings, and selections of objects based on commonality make up his subject matter. Formal requirements such as color, space displacement or function often dictate composition but not content. If the composition calls for a cube, he might employ a television set or a block of ice. He considers each design an informal gathering place in which sometimes unrelated elements are juxtaposed to create new meaning. His printmaking activities include engravings on copper as well as etchings and silkscreen.

ZOROMSKIS, KAZIMIERAS (Painter)
163 W. 23rd St., New York, NY 10011

Born: 1913 *Collections:* State Museum, Vilnius, Lithuania; Butler Institute of American Art *Exhibitions:* Corcoran Gallery of Art; Pace University Gallery, NYC *Education:* Vilnius Art Academy; Vienna Fine Arts Academy

From 1946 to 1949 he lived in Madrid painting in a post-impressionist style. In 1956 he settled in New York and turned to abstract expressionism. He painted his *Wall Surface Series* during the period 1962-70. For these works he adopted a "scraped billboard" style using remnants of print and shredded figures. The *Third Dimensional Series*, begun in 1970, combines systems of vertical lines, color, and tonal value suggesting curving surfaces and luminous space. His most recent works in this series employ crossed grids to achieve colorful illusions of space and light.

ZOX, LARRY (Painter)
c/o Andre Emmerich Gallery, 41 E. 57th St., New York NY 10022

Born: 1936 *Awards:* Fellowship, John Simon Guggenheim Memorial Foundation; National Council for the Arts Award *Collections:* Museum of Modern Art; Metropolitan Museum of Art *Exhibitions:* Whitney Museum Annual; Indianapolis Museum of Art *Education:* Drake University; Des Moines Art Center *Dealer:* Andre Emmerich Gallery, NYC

After studying with George Grosz and also studying Oriental art history, his minimalist works in acrylic of the 1960s featured geometrical shapes such as chevrons, diamonds and triangles, as in *Tyeen*. In the early 1970s large-scale color fields were centralized with bands of color along the sides sometimes as wide as the central color, moving diagonally or vertically downwards, singly or in groups. During the next several years colors were applied in looping lines with oil sticks and brushes, and larger areas were sometimes poured on and spread into wet grounds. Recent narrow panels such as *Catawba* emphasize color changes in the ground using many shades of one color often muted or darkened with grey, in thick, steady brushstrokes.

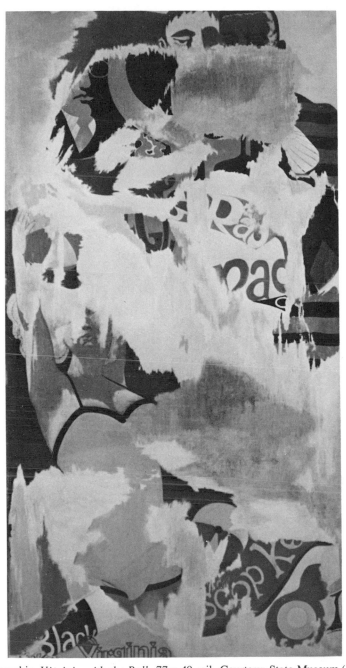

Kazimieras Zoromskis, *Virginia with the Ball,* 77 x 40, oil. Courtesy: State Museum (Vilnius Lithuania)

ALTERNATE ART FORMS

Artist Bookmaker: CALIFORNIA *Monterey:* Berry C, **Calligrapher: LOUISIANA:** *Ruston:* Berguson R J, **Environmental Artists: ARIZONIA:** *Flagstaff:* Turrell J A, **NEW YORK:** *New York City:* Christo, Heizer M, **Muralists: CALIFORNIA** *San Francisco:* Webber H, *San Diego:* Swiggett J D, **Filmmaker: NEW YORK:** *New York City:* Warhol A, **Kinetic Artist: PENNSYLVANIA:** *Pittsburgh:* Gruber A D, **Lithographer: MISSOURI:** *Kansas City:* McKim W W, **NEW YORK:** *New York City:* Lerner S R, **Papermaker: WASHINGTON:** *Longview:* Jaeger B K, **Paste Artist: NEW YORK:** *Brooklyn:* Grajales E, **Set Designer: NEW YORK:** *New York City:* Hockney D, Wilson R, Mandel H. **Silversmith: MICHIGAN:** *Grosse Pointe:* Krentzin E. **Telecommunications Artist: MASSACHUSETTS:** *Brookline:* Weiss R

ASSEMBLAGE ARTISTS

CALIFORNIA: Foulkes L, *San Francisco:* Conner B, Foolery T, Weiner D, *Sausalito:* Wiley W T, **ILLINOIS:** *Chicago:* Aubin B, Baum D, **MARYLAND:** *Landover:* Nevia, **MISSOURI:** *St. Louis:* Smith J M, **NEW YORK:**, *New York City:* Grooms R, Tuttle R, Samaras L, **OREGON:** *McMinnville:* Bell L A

CARTOONISTS

CALIFORNIA *Aromas:* Nutzle F, *San Francisco:* Robbins T, **NEW YORK:** *New York City:* Blechman R O, Steinberg S, **TEXAS:** *Plano:* Brewer B

CERAMICISTS

CALIFORNIA *Benecia:* Arneson R, *Los Angeles:* Glover, **COLORADO:** *Aspen:* Soldner P E, **FLORIDA:** *Key West:* Marks R B, **HAWAII:** *Kasneche:* Young R, *Aiea:* Kodma M, **ILLINOIS:** *Chicago:* Hoffman W, *Winnetka:* Kramer L, **NEW MEXICO:** *Taos:* Price K, **NEW YORK:** *Briarcliff Manor:* Hammond P B, *Pleasantville:* Harmon E N, **OHIO:** *Cleveland:* Conover C

COLLAGE ARTISTS

CALIFORNIA *Anaheim:* Macaray L R, **FLORIDA:** *Sarasota:* Marca-Relli C, **NEW JERSEY:** *Jersey City:* Yost E M, **NEW YORK:** *Brooklyn:* Uram L, *New York City:* Schapiro M, Wojnarowicz D, *Warwick:* Talbot J, **TEXAS:** *Atascocita:* Nadloski S L

DESIGNERS

CALIFORNIA *Gualala:* Sheets M O, *Los Angeles:* Weller D, **CONNECTICUT:** *Lyme:* Alcorn J, **NEW YORK:** *Irvington:* Nagengast W J, *Long Island City:* Noguchi I, **ARIZONIA:** *Scottsville:* Castle W K

FIBER ARTISTS

CALIFORNIA *San Francisco:* O'Banion N, Webber H, **HAWAII:** *Honolulu:* Anderson R, **ILLINOIS:** *Chicago:* Livingstone J, **ILLINOIS:** *Chicago:* Wilson A, *Lansing:* Bruggeman J, **MICHIGAN:** *Bloomfield:* Knoedel G, **NEW MEXICO:** *Santa Fe:* Mauro G, **NEW YORK:** *Brooklyn:* Cusack M, *New York City:* Harrison C, **TEXAS:** *Houston:* Fowler M J, Nicholson L F, **WISCONSIN:** *Milwaukee:* Michaels-Paque J

GLASS ARTISTS

CALIFORNIA *Carmel:* Marquis R, **MASSACHUSETTS:** *Boston:* Glancy M, **OHIO:** *Grand Rapids:* Labino D, **PENNSYL-VANIA:** *Johnstown:* Sheehe L C, **VIRGINIA:** *Richmond:* Ipsen K F, **WASHINGTON:** *Tacoma:* Chihuly D P

GRAPHIC ARTISTS

CALIFORNIA *Los Angeles:* Celmins V, **England UK:** *Devon:* Baskin L, **ILLINOIS:** *Chicago:* Siegel I, **MASSACHU-SETTS:** *Amherst:* Souza A, **MARYLAND:** *Baltimore:* Carlberg N K, **NEW MEXICO:** *Santa Fe:* Biss E, **NEW YORK:** *New York City:* Hickens W H, Oblinski R, Hirschfeld A, Glaser M

ILLUSTRATORS

CALIFORNIA *Aromas:* Nutzle F, *Laguna Beach:* Zebot G J, *Los Angeles:* Weller D, *Lyme:* Alcorn J, **CONNECTICUT:** *Old Lyme:* Peterson R T, **FLORIDA:** *Gainesville:* Halliday N R, *Miami:* James B, **HAWAII:** *Kaneohe:* Charlot M D, **ILLINOIS:** *DeKalb:* Factor Y, **MICHIGAN:** *Ann Arbor:* Gooch D B, **NEW JERSEY:** *Palisades Park:* Daly T, **NEW YORK:** *Brooklyn:* Brothers B, *Katonah:* Hess M, *Millbrook:* Duke C, *New York City:* Blechman R O, Bralds B, Clifford J, Fowler E, Huffman T, Hull C, Kliros T l, Mihaesco E, Peak R, Salerno S, Spalenka G, Suba S, *Ossining:* Cober A E, *Ossining:* Thompson J, *Peekskill:* Tinkelman M, **OHIO:** *Cincinnati:* Preiss A, **PENNSYLVANIA:** *Philadelphia:* Treatner M, *Pittsburgh:* Dzierski V, **TEXAS:** *Arlington:* Grandee J R, **WASHINGTON:** *Olympia:* Ingham, *Seattle:* Segan K A

INSTALLATION ARTISTS

CALIFORNIA *Los Angeles:* Irwin R, **FLORIDA:** *Gainesville:* Smith N S, **NEW YORK:** *Garrison:* Flavin D, *New York City:* Zimmerman E

PAINTERS

ALASKA: *Anchorage:* Shadrach J H, **ARKANSAS:** *Fayetteville:* Wilson D R, **ALABAMA:** *Auburn:* Hatfield D G, *Birmingham:* Stewart A, Martin L K, *Montgomery:* Klopfenstein P A, **ARKANSAS:** *Fayetteville:* Leslie A, **ARIZONA:** *Cave Creek:* Ehling K, *Flagstaff:* Hull G S, Nisbet P A, *Mesa:* Halbach D A, *Munds Park:* Carpenter E L, *Paradise Valley:* Prindiville J, *Payson:* Wilson N J, *Phoenix:* Dematties N, *Prescott:* McClure T, Skynear, *Scottsdale:* Fernandez R M, Gonske W, Mell Jr. E P, Reckling G, Scholder F, Swartz B A, Taylor A, *Sedona:* Yoakum D J, *Tempe:* Szabo Z, *Tuscon:* Sles S L, **CALIFORNIA** *Alameda:* Perez V, *Anaheim:* Macaray L R, Macaray L R, *Arcata:* Anderson W T, *Bakersfield:* Kerzie T L, *Benicia:* Chicago J,

Berkeley: Holland T, Kasten K A, Rapoport S, Vapour M, *Beverly Hills:* Green M L, Lazarof E B, Reynolds W, *Bodega:* Morehouse W P, *Burbank:* Asmar A, *Carmel:* Cost S A, Dooley H B, Ferguson B, Hu C C, *Claremont:* Benjamin K, Blizzard A, *Davis:* Thiebaud W, *Del Mar:* Kittredge N, Snow C R, *El Cajon:* Wieghorst O, *Emeryville:* Bechtle R A, *Encinitas:* Provder C, *Fallbrook:* Ragland J W, *Gualala:* Sheets M O, *Hollywood:* Ruscha E J, *La Jolla:* McReynolds J C, *Laguna Beach:* Sassone M, Zebot G J, Holman A S, *Los Angeles:* Albuquerque L, Biberman E, Bowman D, Broderson M, Bueno J, Byrd J, Celmins V, Civitello J P, Douke D W, Foulkes L, Francis S, Johnston Y, Lampert E, Lidow L, Mesches A, Reilly J, Sargent M H, Young O V, *Los Gatos:* Kruskamp J, *Malibu:* Ellison N, *Mendocino:* Zacha W, *Mill Valley:* Saul P, Sherry W G, *Modesto:* Remsing G, *Monterey:* Berry C, *Morgan Hill:* Freimark R, *North Hollywood:* Brommer G F, *Northridge:* Velardi Jr. E J, *Oakland:* Leon D, McLean R, Mendenhall J, Ramos M J, Saunders R J, *Orange:* Holste T, *Palo Alto:* Bergstrom E H, *Piedmont:* Wolfe B, *Port Costa:* De Forest R D, *Redding:* Wilson R B, *Rialto:* Mendes B, *Rimforest:* Jolley D C, *Salinas:* Crispo D, Ligare D, *San Diego:* Chan P P, Jung K Y, Swiggett J D, Weldon B, Wojtyla W H, *San Francisco:* Conner B, Dean N, Dickinson E C, Diehl G L, Facey M, Foolery T, Lew W, Martin W H, Thompson R E, *San Geronimo:* Raffael J, *San Pedro:* McCafferty J D, *San Rafael:* Dixon W, *Santa Ana:* Karwelis D C, *Santa Barbara:* Brown G H, Firfires N S, Garabedian C, Noble H, *Santa Clara:* Shultz D, Marx N D, *Santa Monica:* Rosen J, Hempler O F, *Santa Rosa:* Rosen J M, *Sausalito:* Wiley W T, *Sherman Oaks:* Clover S, *Sonoma:* Christensen J, *Studio City:* Brenno V, *Topang:* Alexander P, *Venice:* Arnoldi C A, Bengston B A, Dill L J, Wudl T, *Woodside:* Crabtree J F, *Yountville:* Clymer A A, **COLORADO:** *Boulder:* Goodacre G, *Colorado Springs:* Arnest B, *Creede:* Quiller S F, *Denver:* Michael G, *Dolores:* Wagner R E, *Lakewood:* Denton P, Knaub R L, *Wheat Ridge:* Dawson D, **CONNECTICUT:** *Bridgewater:* Abbett R K, *Clinton:* Grimm L D, *East Haven:* Gardner J A, *Easton:* Bogart R J, *Greenwich:* Motherwell R, *Meriden:* Scalise N P, *Newtown:* Cottingham R, *Old Lyme:* Peterson R T, *Ridgefield:* Scott J, Wizon T, *Rowayton:* Squadra J, *West Redding:* Natkin R, *Weston:* Cadmus P, Fogel S, *Westport:* Chernow A, *Woodbridge:* Lytle R, **DISTRICT OF COLUMBIA:** Davis G, Downing T, Forrester P T, Gilliam S, Jones L M, Lewton V E, **DELAWARE:** *Felton:* Kohut L, *Wilmington:* McFarren G, Mortellito D, **FLORIDA:** *Tampa:* Cardoso A, *Aripeka:* Rosenquist J, *Boca Raton:* Sarnoff A, *Fort Myers:* Schwartz C E, *Jacksonville:* Bear M L, *Miami:* Carulla R, *North Miami:* Curtiss G C, *Riviera Beach:* Hibel E, *Sarasota:* Chase J N, Hopper F J, Marca-Relli C, **GEORGIA:** *Atlanta:* Hough J, Laxson R, Shute B E, Simon J W, Bobick B, *Good Hope:* Ransom Jr. H C, *Mt. Berry:* Mew T, *Roswell:* Owen M B, **HAWAII:** *Kailua-Kona:* Thomas J, *Kaneohe:* Charlot M D, Hee H, **IOWA:** *Indianola:* Heinicke J, **IDAHO:** *Boise:* Killmaster J H, Watia T, **ILLINOIS:** *Bloomington:* Gregor H L, *Chicago:* Africano N, Amft R, Aubin B, Barazani M, Berns P K, Brown R, Conger W, Davidson H L, Edwards S, Erlebacher M M, Franklin J, Ginzel R, Halkin T, Hanson P H, Harker L, Haydon H, Hertz P B, Himmelfarb J D, Ito M, Klement V, Lanyon E, Lauffer A, Lostutter R, McCarthy F C, Michud S A, Middaugh R B, Olendorf B, Paschke E F, Ramberg C, Ramirez D P, Wirsum K, Yoshida R K, *De Kalb:* Ball W N, Factor Y, *Edwardsville:* Malone R R, *Elmhurst:* Jorgensen S, *Evanston:* Bouras H, Lopez J P, Yochim L D, *Glenview:* Bramson P H, *Highland Park:* Baber A, *Park Ridge:* Fedelle E, *Quincy:* Mejer R L, *River Forest:* White P, *Rockford:* Pinzarrone P, *Rolling Meadows:* Rebbeck Jr. L J, *Roscoe:* Bond O E, *Wilmette:* Nilsson G, Nutt J T, **INDIANA:** *Fort Wayne:* De Santo S, *Indianapolis:* Brucker E, Daily E M, *Munster:* Meeker B M, **KANSAS:** *Hays:* Jilg M F, **KENTUCKY:** *Lexington:* Moon J, *Owensboro:* Matlick G A, **LOUISIANA:** *Metairie:* Kohlmeyer I R, *New Orleans:* O'Meallie K, *Ruston:* Berguson R J, *Youngsville:* Savoy C L, **MASSACHUSETTS:** *Amherst:* Schmalz Jr. C, *Arlington:* Dahill Jr. T H, *Boston:* Hunter R D, *Brewster:* Stoltenberg D H, *Cambridge:* Mazur M B, *Chatham:* Miller G, *Gloucester:* Duca A M, Rosenthal G M, *Orleans:* Vickrey R R, *Provincetown:* Farnham E, *Rockport:* Nicholas T A, *S. Harwich:* Sahrbeck E, *Salem:* Bartnick H W, *Sharon:* Avakian J, *Stockbridge:* Garel L, *Wayland:* Dergalis G, **MARYLAND:** *Baltimore:* Koch P T, *Baltimore:* Maril H, Miller Jr. M O, Moscatt P N, Perlman B B, *Bowie:* Plaster A M, *Burkittsville:* Vo Dinh M, *Chevy Chase:* Asher L O, Carrington O R, *Hughesville:* Feltus A E, Irwin L H, *Landover:* Nevia, *Rockville:* Porter S, **MAINE:** *Lincolnville:* Welliver N G, *Ogunquit:* Palmer M A, *Portland:* Penney B B, *Vinalhaven:* Indiana R, *York:* Hallam B, **MICHIGAN:** *Ann Arbor:* Gooch D B, *Detroit:* Johnson L L, Johnson L, Muccioli A M, *East Lansing:* McChesney C, *Hartland:* Stamelos E, *Kalamazoo:* Hatch M, *Olivet:* Whitney W, **MINNESOTA:** *Albert Lea:* Herfindahl L, *Edina:* Rollins J L, *Minneapolis:* Burpee J S, Preuss R, Rudquist J J, *Minneapolis:* Walton F G, **MISSOURI:** *Kansas City:* McKim W N, *St. Genevieve:* Bowman D L, *St. Louis:* Chappell D W, Quinn W, Smith J M, Trova E T, Zonia D, *Webster Groves:* Boccia E E, **MISSISSIPPI:** *Summit:* Dawson B P, **MONTANA:** *Bigfork:* Fellows F, **CANADA** *Stratford, Ontario:* Green A, **NORTH CAROLINA** *Davidson:* Jackson H, *Greensboro:* Blahove M, *Greenville:* Reep E A, *Wilkesboro:* Nichols W H, **NEBRASKA:** *Kearney:* Peterson L D, **NEW HAMPSHIRE:** *Meredith:* Olitski J, **NEW JERSEY:** *Berkley Heights:* Gershon B, *Bloomfield:* Anderson R R, *Bordentown:* Barker A C, *Clifton:* Kostecka G, *Glassboro:* Wasserman B, *Jersey City:* Yost E M, *Kinnelon:* Whyte R A, *Madison:* Galles A A, *Mendham:* Hobbie L, *Montclair:* Maurice E I, *New Providence:* Hannay J, *Palisades Park:* Daly T, *Perth Amboy:* Hari K, *Rocky Hill:* Bannard W D, *Stockton:* Farnham A. *West Orange:* Krieger R, *Woodlynne:* Hoffman W M, **NEW MEXICO:** *Abiquiu:* O'Keefe G, *Albluquerque:* Smith J Q, Antreasian G Z, Long F W, Madsen S R, Sowers M R, Slaymaker M, Steider D, Weber D S, *Coyote:* Johnson D W, *Dulce:* Brycelea C, *Lamy:* Martin A B, *Ruidoso:* Snidow G E, *San Patricio:* Hurd P, *Santa Fe:* Axton J, Bacigalupa A, Biss E, Bradley D P, Erdman R, Levin E, Lind J, Lippincott J, Porter E F, Red Star K, Shepherd B, Steinhoff M, *Taos:* Barsano R, Crespin L, Daughters R A, Fenichel L R, Gorman R C, Hensley J M, Manzo A J, Robles J, Scott J, Vigil V J, Vinella R, Waldrum H J, White R L, Magar T, **NEW YORK:** *Astoria:* Gavalas A B, *Bayside:* Pershan M, *Bearsville:* Pantel R, *Bronx:* Judge M F, Kassoy B, Wechter V T, Wilson G L, *Brooklyn:* Baumbach H, Bertoni M H, Bertoni D H, Brothers B, Burns J, Burns J, Le Roy H M, Rand A, Shechter L J, *Cambria Heights:* Brown J, *Campbell Hall:* Greenly C, *Catskill:* Groshans W, *Charlottsville:* Artschwager R E, *Chatham:* Kelly E, *Clinton:* Palmer W C, *Corona:* Wimberley F W, *Deer Park:* Fukuhara H, *East Hampton:* Krasner L, *Elmont:* Schary E, *Great Neck:* Lederman S N, Shapiro D, *Harrison:* Margulis M B, *Honeoye:* Brown B R, *Huntington:* Brodsky S, Engel II M M, *Huntington Station:* Mann K, *Irvington:* Nagengast W A, *Ithaca:* Boyd M, Grippi S, *Katonah:* Hess M, *Toney A, *Long Eddy:* Wesselmann T, *Mamaroneck:* Sloan R S, *Millbrook:* Della-Volpe R E, *Mt. Vernon:* Prosperi A J, *New Rochelle:* Slotnick M H, *New York City:* Abrams R D, Allen R, Appel K, Arakawa S, Ascher M, Ashbaugh D J, Avlon H D, Bama J E, Barnet W, Barr-Sharrar B, Barth F, Bartlett J L, Basquait J, Bearden R H, Behnke L, Bell C S, Ben-Zion, Benglis L, Berman A R, Berthot J, Billian C R, Bishop I, Blackwell T L, Blaine N, Boothe P, Borofsky J, Borstein E, Bralds B, Brown J, Brown A D, Brown F J, Brusca J, Calcagno L, Chemeche G, Chen H, Chen C, Christensen D, Close C, Conover R F, Copley W N, Daphnis N, De Kooning W, Dennis D, Di Cerbo M, DiCerbo M, Diebenkorn R, Dine J, Dogancay B C, Downes R, Dyyon F, Eddy D, Eichel E V, Ensrud E W, Estes R, Evans J, Fischl E, Fish J I, Fitzgerald A, Flack A L, Fowler E, Fowler M, Frankenthaler H, Freckleton S, Freiman R J, Garet J, Gechtoff S, Gerardia H, Ginsburg M, Goell A S, Goings R L, Goldberg M, Golden E, Golub L A, Goodnough R A, Graves N S, Green D G, Grooms R, Gross C, Haas R J, Halaby S A, Haney W L, Hardy J, Harriton A, Havard J P, Held A, Hess E J, Hill C J, Hockney D, Holabird I, Impiglia G, Ingle J S, Inukai K, Jacobs J, Jenkins P, Johns J, Judson J A, Juszczyk J J, Kacere J C, Kanovitz H, Karwoski R C, Katz A, Kauffman R C, Kawabata M, Kim P, Kipness R, Kleemann R, Koursaros H G, Krigstein B, Krushenick N, Kurz D, Laderman G, Landifeld R, Lane L, Lerner S R, Lerner S, Levine J, Levinson M, Ligamari L, Longo R, Mandel H, Mangold R P, Mangold R P, Marden B, Mark P, Max P, Maxwell W C, Mendelson H, Metz F R, Miller R K, Mitchell J, Morley M, Moses E, Murray E, Neel A, Neiman L, Nesbitt L B, Neustein J, Newman E, Nice D, Okumura L, Olugebefola A, Peak R, Pearlstein P, Pellicone W, Pels A, Pinchbeck P G, Pletka P, Pond C, Poons L, Quaytman H, Rauschenberg R, Remington D W, Renouf E P, Renouf E, Robbin A S, Rothenberg S, Rothschild J, Ryman R, Salle D, Sarkisian P, Schapiro M, Schnabel J, Schneebaum T, Shapiro D, Sharp A, Shatter S L, Sherrod P L,

Silverman B P, Singer C, Sirena A M, Smith V D, Sonenberg J, Soyer R, Spalenka G, Stamos T S, Stanley B, Stanley B, Stella F, Stephan G, Sterne D, Strautmanis E, Strider M V, Stuart M, Suba S, Sugarman G, Tabachnick A, Tanner W, Tooker Jr. G C, Twombly C, Wald S, Walker J, Wall S, Wallin L D, Warhol A, Wilcox Jr. J G, Willis T, Wilson J, Wojnarowicz D, Zoromskis K, Zox L, *Northport:* Twardowicz S J, *Oceanside:* Laguna M, *Oneida:* Colway J R, *Port Washington:* Kleinholz F, *Poughkeepsie:* Forman A, Rubenstein L W, *Ridgewood:* Azaceta L C, *Riverdale:* De La Vega A, *Rocky Point:* England P G, *Sagaponack:* Butchkes S, Dunlap L, *Scarsdale:* Ries M, *Smithtown:* Lopina L C, *South Salem:* Noland K C, *Southampton:* Lichtenstein R, Rivers L, *Southold:* Wissemann-Widrig N, *Staten Island:* Healy J S, *Suffern:* Pousette-Dart R, *Valley Cottage:* Greene S, *Valley Stream:* Hart A M, *Warwick:* Talbot J, *Webster:* Mann W P, *Westbury:* Honig M, *Woodstock:* Bachinsky V, Chavez E A, *Richmond Hill:* Eres E, **OHIO:** *Akron:* Rogers P J, *Bay Village:* Kocar G, *Cincinnati:* Preiss A, *Cleveland:* Schepis A J, *Dayton:* Raffel A R, *Delaware:* Kalb M J, *Hamilton:* Phelps N D, *Kent:* Novotny E L, *Wyoming:* Dennis D W, **OKLAHOMA:** *Anadarko:* Littlechief B, *Miami:* Wison C B, *Norman:* Bavinger E A, *Creswell:* Prechtel D, **PENNSYLVANIA:** *Johnstown:* Sheehe L C, *Mechanicsville:* Bye R, *Media:* Hildebrandt W A, *Philadelphia:* Lasuchin M, Paone P, Treatner M, *Pittsburgh:* Dzierski V, *Susquehanna:* Laughlin M, *University Park:* Alden R, *Wayne:* Brodhead Q, *West Grove:* Allman M, *Wyndmoor:* Naftulin R, **SOUTH CAROLINA:** *Abbeville:* Velasquez O, *Bishopville:* Adams B, *Greenville:* Alberga A W, *Koons D J, *Hilton Head Island:* Bowler Jr. J, *Spartanburg:* Bramlett B J, **TENNESSEE:** *Lookout Mountain:* Lynch M B, Wyeth A, Wyeth J B, *Memphis:* Shook G, *Nashville:* Baeder J, Ridley G D, **TEXAS:** *Arlington:* Grandee J R, *Atascocita:* Nadloski S L, *Austin:* Bucknall M R, Frary M, Marianne, Milliken G, Pena Jr. A M, *Dallas:* Barta D E, Hernandez J A, Rizzie D C, Russell C, Vogel D S, Winter R, *Dallas:* Smith III L N, *El Paso:* Rakocy W, *Fort Worth:* Blackburn E, Blake J R, Smith F. G, *Houston:* Adickes D P, Alexander J E, Allison D, Casas F R, Kopriva S, Musick P, O'Neil J, Shaw D E, Sloane E, Thompson J K, Vaughn S W, *San Antonio:* Bristow W A, **UTAH:** *Mendon:* Morgan J, **VIRGINIA:** *Alexandria:* Marker M P, *Arlington:* Twitty J, *Charlottesville:* Crozier R L, *Fairfax:* Matternes J H, *Lexington:* Ju I H, *Somerset:* Sehring A, *Vienna:* Nash M, **VERMONT:** *Cavendish:* Shapiro D, **WASHINGTON:** *Edmonds:* Johnson D, *Ellensburg:* Stillman G, *Kent:* Broer R L, *Longview:* Jaeger B K, *Olympia:* Haseltine M, Ingham t, Woolschlager L T, *Seattle:* Bennett T, Bloedel J R, Johnston T A, Kuvshinoff B H, Lawrence J, Lundin N K, Mason A, Spafford M, **WISCONSIN:** *Madison:* Bohrod A, *Madison:* Weiss L, *Milwaukee:* Berman F J, *Racine:* Doll C, Rozman J, *River Falls:* Hara K, **WYOMING:** *Cody:* Fillerup M, Jackson H A, *Jackson Hole:* Kerswill J R

PERFORMANCE ARTISTS

NEW YORK: *New York City:* Acconci V, Anderson L, Burden C, Montano L, **CALIFORNIA** *Los Angeles:* Rosenthal R

PHOTOGRAPHERS

CALIFORNIA *Carmel:* Weston C, *Carmel Valley:* Weston B, *Los Angeles:* Baldessari J A, *Pacific Palisades:* Campbell R H, *Santa Cruz:* Marx N D, **CONNECTICUT:** *New Milford:* Feininger A B, **ILLINOIS:** *Glencoe:* Goldberg L, **MASSACHUSETTS:** *S. Harwich:* Sahrbeck E, *San Lorenzo:* Renner E, **NEW MEXICO:** *Santa Fe:* Caponigro P, Erdman B, Plossu B, **NEW YORK:** *New York City:* Avedon R, Callahan H M, Haas E, Harrison C, Mapplethorpe R, Meyerowitz J, Parks G A, Penn I, Porter L, Sherman C, Stanley B, Wegman W **RHODE ISLAND:** *Providence:* Siskind A **TEXAS:** *Austin:* Milliken G **Wisconsin:** *Milwaukee:* Berman F J

PRINTMAKERS

ARIZONA: *Cave Creek:* Ehling K, *Prescott:* Skynear, *Scottsdale:* Mell Jr. E P, Scholder F, **CALIFORNIA** *Alameda:* Perez V, *Anaheim:* Macaray L R, L R, *Arcata:* Anderson W T, *Berkeley:* Hoare T J, Kasten K A, Vapour M, *Beverly Hills:* Green M L, *Fallbrook:* Ragland J W, *Laguna Beach:* Sassone M, *Los Angeles:* Johnston Y, *Morgan Hill:* Freimark R, *San Diego:* Weldon B, *San Francisco:* Lew W, *San Geronimo:* Raffael J, *Santa Barbara:* Noble H, *Santa Cruz:* Summers C, *Walnut Creek:* Esaki Y, **COLORADO:** *Denver:* Graese J, **CONNECTICUT:** *Weston:* Cadmus P, **DISTRICT OF COLUMBIA:** Forrester P T, Meader J, **GEORGIA:** *Atlanta:* Mills L T, **HAWAII:** *Kailua-Kona:* Thomas J, *Kaneohe:* Hee H, **IOWA:** *Indianola:* Heinicke J, **ILLINOIS:** *Chicago:* Ginzel R, Klunk R E, Lanyon E, Olendorf B, Puryear M, *Edwardsville:* Malone R R, *Quincy:* Mejer R L, **KENTUCKY:** *Owensboro:* Matlick G A, **LOUISIANA:** *New Orleans:* O'Meallie K, **MASSACHUSETTS:** *Brewster:* Stoltenberg D H, *Cambridge:* Mazur M B, **MARYLAND:** *Chevy Chase:* Asher L O, **MAINE:** *York:* Hallam B, **MINNESOTA:** *Minneapolis:* Rudquist J J, **MISSOURI:** *Columbia:* Montminy T, *St. Genevieve:* Bowman D L, *Albuquerque:* Antreasian G Z, **NEW MEXICO:** *Albuquerque:* Long F W, Long F W, *Dulce:* Brycelea C, *Santa Fe:* Porter E F, Red Star K, *Taos:* Price K, *Elmont:* Schary E, **NEW YORK:** Appel K, *New York City:* Ascher M, Barnet W, Bishop J, Boxer S R, Christensen D, Di Cerbo M, DiCerbo M, Ensrud E W, Feigin M, Fischl E, Goell A J, Hardy J, Inukai K, Kipness R, Koppelman C, Lane L, Max P, Maxwell W C, Neustein J, Olugebefola A, Parks G A, Ponce De Leon M, Pond C, Reddy K N, Renouf E, Rothenberg S, Singer C, Tooker Jr. G C, Wald S, *Tuxedo Park:* Domjan J S, **OHIO:** *Akron:* Rogers P J, **OKLAHOMA:** *Miami:* Wison C B, **PENNSYLVANIA:** *Ardmore:* Atlee E D, *Philadelphia:* Paone P, *Washington Crossing:* Kemble R, **SOUTH CAROLINA:** *Greenville:* Alberga A W, **TEXAS:** *Austin:* Marianne, *Austin:* Pena Jr. A M, **VIRGINIA:** *Arlington:* Twitty J, *Somerset:* Sehring A, **WASHINGTON:** *Seattle:* Bloedel J R, Johnston T A, Lawrence J, Segan K A, **WISCONSIN:** *Barneveld:* Weege W, *River Falls:* Hara K

SCULPTORS

ALABAMA: *Birmingham:* Fleming F, **ARIZONA:** *Flagstaff:* Brookins J B, *Prescott:* McClure T, *Scottsdale:* Fernandez R M, **CALIFORNIA** *Benecia:* Arneson R, Chicago J, *Berkeley:* Hoare T J, Lipofsky M B, Voulkos P, *Bodega:* Morehouse W P, *Corona Del Mar:* Delap T, *Kentfield:* Moquin R A, *La Jolla:* Scanga I, *Lafayette:* Schnier J, *Los Angeles:* Abeles K V, Albuquerque L, Bueno J, Fine J, Irwin R, Rosenthal R, *Malibu:* Eino, *Mendocino:* Zacha W, *Mill Valley:* Saul P, *Modesto:* Remsing G, *Oakland:* Jensen C, Leon D, Levine M, Richardson S, Roloff J, *Piedmont:* Wolfe B, *Port Costa:* De Forest R D, *San Francisco:* Neri M, *Sherman Oaks:* De La Vega E M, *Venice:* Arnoldi C A, Dill G G, Dill L J, Eversley F J, **COLORADO:** *Arvada:* Balciar G G, *Boulder:* Goodacre G, *Denver:* Graese J, **CONNECTICUT:** *Cornwall Bridge:* Pfeiffer W, *Groton Long Point:* Fix J R, *Guilford:* Von Schlegell D, *Stamford:* Nakian R, **DISTRICT OF COLUMBIA:** Johnston B, **DELAWARE:** *Wilmington:* Mortellito D, **FLORIDA:** *Davie:* Hanson D, *Gainesville:* Smith N S, *Riviera Beach:* Hibel E, **GEORGIA:** *Atlanta:* Simon J W, **HAWAII:** *Honolulu:* Ruby L, **IOWA:** *Dubuque:* Gibbs T, **ILLINOIS:** *Baum D, Chicago:* Ferrari V, Halkin T. Jackson P, Hunt R H, Kearney J, Kowalski D A, Livingstone J, Peart J L, Puryear M, Scarf T, Wirsum K, Zeisler C, *Evanston:* Bouras H, Lopez J P, *Glencoe:* Jaffee F, *Norridge:* Andris R I, *Urbana:* Gallo F, **KENTUCKY:** *Williamsburg:* Weedman K R, **MASSACHUSETTS:** *Boston:* Wheelwright J, *Brookline:* Weiss R, *Chatham:* Miller G, *Gloucester:* Duca A M, *Newton Center:* Rosenblum R, *Northampton:* Offner E, *Truro:* Johnson J, **MARYLAND:** *Baltimore:* Carlberg N K, *Bethesda:* Sarnoff L, *Silver Spring:* Carter J W, **MAINE:** *Vinalhaven:* Indiana R, **MICHIGAN:** *Grosse Pointe:*

Krentzin E, *Olivet:* Whitney W, *St. Joseph:* Hansen S, **MISSOURI:** *St. Louis:* Trova E T, **MONTANA:** *Bigfork:* Fellows F, *Bozeman:* Butterfield D K, *Browning:* Scriver R M, **NEW HAMPSHIRE:** *Meredith:* Olitski J, **NEW JERSEY:** *New Brunswick:* Segal G, **NEW MEXICO:** *Espanola:* Naranjo M A, *Ruidoso Downs:* Knapp T, *Santa Fe:* Bacigalupa A, Wright D, *Taos:* Bell L S, **NEW YORK:** *Briarcliff Manor:* Hammond P B, *Bronx:* Buonagurio T L, Kassoy H, Wechter V T, *Brooklyn:* Fuerst S M, Shimoda O, Uram L, *Buskirk:* Johanson P, *Charlottsville:* Artschwager R E, *Chatham:* Kelly E, *Corona:* Wimberley F W, *East Chatham:* Rickey G, *East Hills:* Newmark M, *Garrison:* Flavin D, *Honeoye:* Brown B R, *Huntington Station:* Mann K, *Long Eddy:* Wesselmann T, *Long Island City:* Noguchi I, *Millbrook:* Streeter T, *New Rochelle:* Schwebel R M, *New York City:* Abrams R D, Acconci V, Andre C, Antonakos S, Arman, Avlon H D, Aycock A, Benglis L, Billian C R, Bourgeois L, Chamberlain J A, Christo, Crozier W, DeAndrea J L, Dehner D, Dennis D, Di Suvero M, Dine J, Dryfoos N, Febland H, Ferber H, Fowler M, Gianakos C, Graves N S, Gross C, Haacke H C, Heizer M, Hera, Hess E J, Hickens W H, Holt N L, Huffman T, Humphrey N, Ireland P, Judd D C, Karwoski R C, Katzen L, Kauffman R C, Levine L, Levinson M, Lewitt S, Liberman A, Lieberman L, Longo R, Lutz M B, Madsen L W, Mark P, Miller R M, Model E D, Morris R, Nauman B, Nevelson L, Niizuma M, Nonas R, Okumura L, Oldenburg C T, Oppenheim D A, Pinto J, Rabinowitch D, Reddy K N, Reginato P, Renouf E P, Scott A, Serra R, Shapiro J E, Sonenberg J, Stuart M, Sugarman G, Tuttle R, Vodicka R C, Von Rydingsvard U, Wilmarth C M, Wilson R, Zimmerman E, *Palisades:* Knowlton G F, *Pelham:* Zheutlin D R, *Pleasantville:* Harmon E N, *Rye:* Bisgyer B G, *Saratoga Springs:* Cunningham J, *Scottsville:* Castle W K, *Tillson:* Van De Bovenkamp H, *Warwick:* Miller D R, *Westbury:* Sherbell R, *White Plains:* Bowles M V, *Woodstock:* Chavez E A, **OHIO:** *Cleveland:* Conover C, *Grand Rapids:* Labino D, **OKLAHOMA:** *Anadarko:* Littlechief B, *Norman:* Taylor J R, **PENNSYLVANIA:** *Philadelphia:* Hoptner R, *Pittsburgh:* Gruber A D, **TENNESSEE:** *Nashville:* Ridley G D, **TEXAS:** *Houston:* Adickes D P, Lesher M P, Shaw D E, Steffy B, Van Vranken R, *Port Aransas:* Fridge R, *Splendora:* Surls J, **UTAH:** *Lindon:* Speed U G, **WASHINGTON:** *Anacortes:* McCracken P, *Bellevue:* Carter D C, *Seattle:* Kuvshinoff B H, **Wyoming:** *Cody:* Jackson H A, **England** *Devon:* Baskin L

VIDEO ARTISTS

CALIFORNIA *Long Beach:* Viola B, *San Francisco:* Fried H, *Oakland:* Almy M, *San Pedro:* McCafferty J D, **NEW YORK:** *New York City:* Davidovich J, Fox T, Davis D M, Graham D, Wegman W, *Putnam Valley:* Padovano A J

INDEX OF ILLUSTRATIONS

INDEX OF ILLUSTRATIONS

BIBLIOGRAPHY

Painting and Sculpture in California: The Modern Era, San Francisco Museum of Modern Art, San Francisco, 1977.

Phaidon Dictionary of Twentieth-Century Art, E.P. Dutton, New York, 1977 (Second edition).

Who Chicago?, Ceolfrith Gallery, Sunderland Arts Center, 1981.

BAIGELL, MATTHEW, *Dictionary of American Art*, Harper & Row, New York, 1982.

BAUM, HANK, *The Califoria Art Review*, Krantz Co. Publishers, Chicago, 1981.

BROWNE, T./PARTNOW, E., *Macmillan Biographical Encyclopedia of Photographic Artists & Innovators*, Macmillan.

GETLEIN, F./LEWIS, J., *The Washington DC. Art Review*, Vanguard/Krantz, New York, 1980.

GUENTHER, B./BURNS, M., *50 Northwest Artists*, Chronicle Books, San Francisco.

HANSON, H. W., *History of Art*, Prentice Hall/Abrams, Engelwood Cliffs NJ.

HOPKINS, H./JACOBS, M., *50 West Coast Artists*, Chronicle Books, San Francisco.

JEFFREY, IAN, *Photography—A Concise History*, Oxford University Press, New York, 1981.

JOHNSON, ELLEN, *American Artists on Art—from 1940 to 1980*, Harper & Row, New York, 1982.

KODNER, KAREN, *The Southwest Art Review*, Krantz Co. Publishers, Chicago, 1983.

KRANTZ, LES, *New York Art Review*, Macmillan, New York, 1982. *The Chicago Art Review*, The Krantz Co. Publishers, Chicago, 1981. *The Texas Art Review*, Gulf Publishing, Houston, 1982.

LUCIE-SMITH, EDWARD, *Art in the Seventies*, Cornell University, Ithaca NY, 1980.

MURRAY, PETER & LINDA, *The Penguin Dictionary of Art & Artists*, Penguin Books, New York, 1983 (Fifth Edition).

NAYLOR, C./P-ORRIDGE, G., *Contemporary Artists*, St. Martin's Press, New York, 1977.

PARSONS, JAMES, *The Art Fever—Passages Through The Western Art Trade*, Gallery West, Taos NM, 1981.

PIERRE, JOSE, *Pop Art—an Illustrated Dictionary*, Eyre Methuen Ltd., London, 1977.

SANDLER, IRVING, *The New York School—Painters & Sculptors of the Fifties*, Harper & Row, New York, 1978.

STYRON, THOMAS, *American Figure Painting*, The Chrysler Museum, Norfolk VA, 1980.

TUCHMAN, MAURICE, *The New York School—The First Generation*, New York Graphic Society, Greenwich CT.